CHROMATIC
MODERNITY

FILM AND CULTURE SERIES

FILM AND CULTURE

A series of Columbia University Press

Edited by John Belton

For the complete list of books in this series, see pages 349–350

CHROMATIC MODERNITY

Color, Cinema,
and Media
of the 1920s

SARAH STREET AND
JOSHUA YUMIBE

Columbia University Press
New York

Columbia University Press
Publishers Since 1893
New York Chichester, West Sussex
cup.columbia.edu

Library of Congress Cataloging-in-Publication Data
Names: Street, Sarah, author. | Yumibe, Joshua, 1974– author.
Title: Chromatic modernity : color, cinema, and media of the 1920s /
 Sarah Street and Joshua Yumibe.
Description: New York : Columbia University Press, [2019] | Series: Film and
 culture | Includes bibliographical references and index.
Identifiers: LCCN 2018041851 (print) | LCCN 2018051303 (e-book) |
 ISBN 9780231542289 (e-book) | ISBN 9780231179829 (cloth : alk. paper) |
 ISBN 9780231179836 (paperback : alk. paper) | ISBN 9780231542289 (e-book)
Subjects: LCSH: Color motion pictures—History. | Color in
 advertising—History.
Classification: LCC PN1995.9.C546 (e-book) | LCC PN1995.9.C546 S769 2019
 (print) | DDC 791.4301—dc23
LC record available at https://lccn.loc.gov/2018041851

Columbia University Press books are printed on permanent
and durable acid-free paper.
Printed in the United States of America

Cover image: Frame enlargement from *Le home moderne*
(France, Pathé Cinema, 1929). Courtesy of the Gaumont Pathé Archives.
Cover design: Chang Jae Lee

For Sue, Juliet, and Livia, who have been lovingly supportive during the life of this project and through our lives together ∾

Objects, lights, the colors that used to be fixed and restrained have become alive and mobile.

—Fernand Léger (1924)

CONTENTS

ILLUSTRATIONS

Color Plates

ACKNOWLEDGMENTS

This work in many ways dates back to the symposium "The Sense of Colour" organized by Stephen Barber and Carrie Tarr through Kingston University, UK, in 2005. Struck then by the color bug, we have been close friends and collaborators ever since. We each published our initial monographs on color and film in 2012—Joshua's *Moving Color: Early Film, Mass Culture, Modernism* and Sarah's *Colour Films in Britain: The Negotiation of Innovation 1900–1955*—yet even as these came out, we were already questioning what else we could say about color in silent cinema. It was clear to us at the outset of what has become this book that much more needed to be examined about the 1920s and the transnational and intermedial flows of color film and media. It was also clear that this should also be a collaborative project, given the necessary scope of such an undertaking. Thankfully, we have had generous support in this, from the Leverhulme Trust, UK, through a Research Project Grant that enabled us to conduct the project "Colour in the 1920s: Cinema and its Intermedial Contexts." This also allowed us to collaborate with two exceptional postdoctoral researchers, Victoria Jackson and Bregt Lameris, who worked indefatigably with us in researching the many diverse sources required for this study in archives and libraries in France, Germany, Italy, the Netherlands, the United Kingdom, and the United States. As part of this work, we co-organized a conference in 2015 with the EYE Filmmuseum to celebrate twenty years since the groundbreaking Amsterdam Workshop *Colours in Silent Film*, and we have been delighted to co-edit as a team *The Colour Fantastic: Chromatic Worlds of Silent Cinema* (2018) along with our remarkable colleagues

Giovanna Fossati and Elif Rongen-Kaynakçi, as a record of the conference and the many advances that have taken place in color cinema research since 1995. We were also fortunate to cocurate a series on color film with James Layton and David Pierce for Le Giornate del Cinema Muto, Pordenone, in 2014, another event that brought us into contact with many scholars, archivists, and artists working with silent color film.

We have enjoyed exchanges with numerous other scholars, archivists, and dear friends. This includes foremost our project's brilliant advisory board— Ian Christie, Frank Gray, Luke McKernan, and Lynda Nead—who offered excellent advice as our research progressed. We have also benefited immensely from exchanging ideas and materials with numerous friends and colleagues, including Richard Abel, Giaime Alonge, Thomas Beard, David Bering-Porter, Regina Lee Blaszczyk, Kevin Brownlow, Robert Burgoyne, Paolo Cherchi Usai, Michael Cowan, Scott Curtis, Bryony Dixon, Kirsty Sinclair Dootson, François Ede, Ken Eisenstein, Sonia Genaitay, Giovanna Fossati, Nicholas Gaskill, Elena Gipponi, Lyn Goeringer, Tom Gunning, Ed Halter, Kenneth Harrow, Jan-Christopher Horak, Yelena Kalinsky, Sarah Keller, Anthony L'Abbate, Nicolas Le Guern, Esther Leslie, Jodie Mack, Kristin Mahoney, Nick Marshall, Luci Marzola, Maria Federica Mazzocchi, Ellen McCallum, Mihaela Mihailova, Alexandra Navratil, Patrick O'Donnell, Federico Pierotti, Murray Pomerance, Tom Rice, Elif Rongen-Kaynakçi, Swarnavel Eswaran Pillai, Jonathon Rosen, Ulrich Ruedel, Céline Ruivo, Matthew Solomon, Jack Theakston, Elizabeth Watkins, Kieron Webb, Anke Wilkening, Tami Williams, Lily Woodruff, Jeffrey Wray, Josh Wucher, Paul Young, and Gregory Zinman.

We are extremely grateful to Barbara Flueckiger, her collaborators, and the Timeline of Historical Film Colors for generous criticism and assistance with a number of frame enlargements. We are also indebted to Serge Bromberg, Guy Edmunds, Cindy Keefer, Sophia Lorent, Laurent Mannoni, Stéphanie Salmon, and George Willeman, as well as the staff of the numerous archives listed in our credits, for further assistance with illustrations and research queries.

We are very grateful to Scott Higgins, James Layton, Kirsten Moana Thompson, and other anonymous readers for excellent feedback while reviewing the manuscript with such care. We also benefited immensely from the detailed suggestions from our wondrous friends Kaveh Askari and Justus Nieland, who read numerous sections of the manuscript. Lastly, we thank our editors, John Belton and Philip Leventhal, whose support and enthusiasm for the project have been a tremendous help and encouragement throughout the process. Their careful shepherding of the manuscript from start to finish has been invaluable, as has their understanding of the project's aims and contexts.

We are indebted to the various institutions that invited us to present papers on aspects of our research, including the Society for Cinema and Media Studies (Boston, 2012, and Seattle, 2014). Joshua would like to thank the Screen

Studies Conference, Light Industry, the Fondation Jérôme Seydoux-Pathé, the Orphans Film Symposium, Kalamazoo College, IULM University of Milan, and the Universities of Florence, Michigan, and Zurich. Sarah would like to thank the Barber Institute for Fine Arts, University of Birmingham; the Institute for Historical Research, University of London; King's College, London; and the Universities of Leeds, Liverpool, Oxford, Reading, and Zurich.

We are grateful to our various colleagues at Michigan State University, the University of Bristol, and the University of St. Andrews, as well as to the profound support these institutions have offered.

Finally (and foremost), Joshua would like to thank Juliet for enabling the final stages of this book to happen in the magical city of Torino, where we both were hard at work on our manuscripts in the best of locales, and for her patience, love, and brilliance; and Livia, whose laughter and verve are infectious. Sarah would like to thank Sue for her enthusiastic support throughout this project; as always, she has shared with me the pleasure of watching so many wonderful silent films at home and in Pordenone.

✳ ✳ ✳

For our introduction and chapter 5, we have adapted portions of Sarah Street and Joshua Yumibe, "The Temporalities of Intermediality: Colour in Cinema and the Arts of the 1920s," *Early Popular Visual Culture* 11, no. 2 (2013): 140–157. This article formed our early thinking on color and intermediality and helped to shape our collaborative approach to the writing of this book. In chapter 1, we have adapted portions from Joshua Yumibe, "Industrial Research Into Color at Pathé During the 1910s and 1920s," in *Recherches et innovations dans l'industrie du cinéma, les cahiers des ingénieurs Pathé: 1906–1929*, ed. Jacques Malthête and Stéphanie Salmon (Paris: Fondation Jérôme Seydoux-Pathé, 2017), 197–208; and in chapter 4, we adapted portions from Joshua Yumibe, "Colour Magic: Illusion and Abstraction in Silent and Experimental Cinemas," *MIRAJ: Moving Image Review & Art Journal* 2, no. 2 (October 1, 2013): 228–237.

INTRODUCTION

The modern vein in both business and art is predominantly that of color. The dull and the gray have no place in our modern scheme of things. It is only natural, therefore, that motion pictures, the very furthest step forward in twentieth century entertainment, should be filmed in color. Motion pictures reflect the age more sensitively than most of the arts. . . . The gift of color to the screen gives it a more powerful lever upon the emotions and instincts of the people. It can give the public more exhibition of beauty than any other one art medium for it combines practically all arts now that it has a voice and color.

—Roy Mack (1930)

One of the extraordinary high points of color cinema in the 1920s is Abel Gance's epic *Napoléon*, which premiered at the Théâtre de l'Opéra, Paris, in April 1927, approximately four hours in length. A nine-hour version subsequently screened at the Apollo Theatre in Paris the following month. Richly tinted and toned, the initial Opéra screening at its most grandiose featured two "Polyvision" sequences in which three projectors simultaneously exhibited reels side by side on adjacent screens to create an expansive, wide-screen image—sometimes a single composite image, at other points three shots in juxtaposition. At the conclusion of the film and as an homage to the French tricolor, the images of the triptych in their most

climactic moment are tinted in juxtaposition, blue on the left, red on the right, with (black and) white in the middle creating an expansive cinematic spectacle (color plate 0.1). In only a few seconds of screen time, the images vividly recall and compress highlights of Napoleon's struggle to victory in a final, avant-garde flourish that bombards the viewer successively through superimposition, graphic montage, and the contrast of color tints with black and white. It is a suitably chromatic end to one of the most epic of films, embodying an ambition of "total" filmmaking that is unique in scale for its multisensory invocation of the expansive power of cinema. As Paul Cuff has put it: "The final moments of *Napoléon* overlay time and space; mingle subjective and objective imagery; show simultaneously the past, present, and future."[1] Following Kevin Brown-low's multiple restoration projects of the film since 1980, audiences have once again been amazed by these Polyvision shots that encapsulate the film's ambition to create a utopian place of total spatial and temporal immersion in the world viewed. Indeed, Gance conceived of cinema as an expansive, intermedial experience, a "music of light" that could orchestrate prismatic effects at a scale never before attempted—in *Napoléon* through the tinted scenes in Polyvision and also in ultimately abandoned attempts to incorporate photographic color and stereoscopic effects through the Keller-Dorian process.[2] Indeed, it is at these moments of medial expansiveness, when cinema incorporates other cultural and technical forms, that color most often comes to the fore of the moving image as an embodiment of cinema's spectacular ambitions. As a high point of silent cinema, *Napoléon* is a modernist wonder of cinematic bravura in which image, color, and accompanying live music are central to its dynamic address— elements that resonated just as strongly in 1927 as they still do today through the film's electrifying performances around the globe.

Napoléon's archival history as a work that has existed in multiple versions, in color as well as black and white, touches upon concerns central to this book. Just as Gance saw color as fundamental to *Napoléon*'s expressive, polyvisual evocation of the past and potential future, it was also common for commentators of the 1920s to see color as an integral aspect of cinema's destiny to reveal the modern world in all of its prismatic glory. For art and cinema, as well as the global culture industries of the interwar era, the decade was defined intermedially by its resplendent aniline hues. Yet only now, after years of dust and neglect, is the total scale of this chromatic modernity coming into view with a renewed awareness of the saturated nature of the art and commerce of the era. This explains in part why so many films that were long remembered in black and white are now being increasingly restored in color. Recent recognition among archivists and film historians that 80 to 85 percent of silent films were colored in part or in whole has promoted the rethinking of the medium in terms of its multivalent, chromatic address as well as its relations to other media practices and aesthetic and cultural forms.[3]

A Decade of Color

Writing in 1930, only a few years after *Napoléon's* debut, American director Roy Mack describes how film was poised at a momentous point in its history. Adding "voice and color" to the moving image implied that a maturity of form had been reached over the past decade, rendering cinema a "powerful lever" on people's consciousness as a mass medium central to the "modern scheme of things."[4] Such optimism about color's centrality to motion pictures might, however, seem anachronistic since color subsequently decreased in usage and remained secondary to black and white as a format until the mid-1950s.[5] Yet Mack's confidence in color as a synthetic force touches upon the central theme of this book, which investigates the major spheres of color expression in and around motion pictures of the 1920s. Taking European and U.S. cinema as the galvanizing focus, we contextualize color's role in the arts—including commercial and print culture, fashion and industry, and modernism and the avant-garde—in order to situate color cinema firmly within the chromatic culture of the era. Focusing on the final decade of silent cinema recovers a sense of the power of color as experienced by contemporaries such as Mack, who placed film at the forefront of the chromatic modernity that this book traces.

In film history, color in the 1920s is a rich yet understudied field, particularly in light of the recent attention paid to both early cinema and 1930s Technicolor. The majority of films in the silent era included some form of applied color—predominantly hand coloring, stenciling, tinting, and toning. There are, though, large gaps in knowledge about how color conventions became established in a global context. The various phases and details of early coloring methods have attracted scholars from around the world to recover, after decades of historical and archival neglect, the intensely chromatic nature of early cinema before the 1920s. This prior oversight was due to the fact that for decades films were largely preserved in black and white for technical reasons (later color stocks on which they might be preserved were costlier and had a shorter shelf life) and also aesthetic assumptions (that color was an inessential add-on to early film). Following key events over the past two decades, such as the 1995 Amsterdam Workshop, whose proceedings were published as *"Disorderly Order": Colours in Silent Film*, color became the focus of various studies that have grappled with the considerable methodological and archival issues pertaining to early color film.[6] Not only were many of the films and their hues lost, but researching how color was applied across various prints and in different countries presented scholars and archivists with major challenges. The resulting attention has restored the centrality of color to early cinema through a number of key books, events, and high-profile restorations, as has been documented recently in *Fantasia of Color in Early Cinema*.[7] While this reappraisal encouraged silent

film historians to be color conscious, the emphasis has largely been on the pre-1917 period. This is understandable, in view of the exciting cultures of invention during those years, when the primary methods of manually applying color to silent films were developed. As Tom Gunning seminally noted, applied color was an integral aspect of the cinema of attractions, adding novelty, surprise, and spectacle that audiences relished during the first decade of film history.[8]

Indeed, such interest in the pre-1917 period has also been shaped by the strong historiographic orientation toward the study of early cinema since the famed 1978 Brighton conference of the International Federation of Film Archives (FIAF). At a point in the 1980s when the histories of various national cinema movements of the 1920s—for instance, classical Hollywood, German Expressionism, French Impressionism, and Soviet Montage—were seemingly well known, focusing on the neglected and supposedly primitive period of early cinema opened up powerful new vistas from which to reassess the emergence of the medium at the turn of the last century. The study of early color has been another important iteration of this move, in that it has redefined the chromatic genealogy of cinema, tracing color into the very fabric of the first moving images. From a technical perspective, silent cinema is a compelling era for color, given also the considerable experimentation with additive and subtractive photographic methods of color cinematography, tellingly described at the time as "natural color." Such an emphasis on the naturalness of photographic color ideologically valorizes it in relation to notions of realism and technical reproducibility. However, photographic color was not inherently aligned with the aesthetics of naturalism, and to name it "natural" problematically embeds and valorizes an aesthetic sense of realism into technical systems that emerged throughout the silent era to capitalize on their supposed naturalness.

Kinemacolor, developed by George Albert Smith around 1906 and exploited by entrepreneur Charles Urban, has received scholarly attention, in particular through Luke McKernan's *Charles Urban: Pioneering the Non-Fiction Film in Britain and America*. Early Technicolor is the subject of a recent major study, James Layton and David Pierce's excellent *The Dawn of Technicolor, 1915–35*, which is the only publication to focus primarily on film color in the 1920s.[9] However, its aim is to chart Technicolor's rise in the U.S. context, fending off rivals such as Prizmacolor to emerge triumphant by the 1930s as the dominant commercial system. The maturity of Technicolor as an exclusive business model had aesthetic implications for emerging conceptions about what constituted "good" film color, as explored by Scott Higgins in his important study of how Technicolor developed as a stylistic practice that could be smoothly integrated into classical cinema in the 1930s.[10] In more general studies of narrative cinema of the 1920s, color is seldom mentioned, even though the chromatic cultures of modernity that we focus on are structural drivers in many of the films of the era.

The time is now ripe to apply archival, historiographic, and theoretical insights similar to those developed to analyze these other periods to color cinema of the 1920s. The decade is in need of reassessment, as it has typically been viewed as either a period when the increasing length of narrative films meant that color was reined in as a disruptive attraction, or as a less interesting decade when Technicolor was in its infancy, prior to its commercial dominance from the mid-1930s on as a three-strip process. There are several other reasons for the relative neglect of film color in the 1920s, including the paucity of available documentation on color methods and conventions, and the complexities of evaluating color during this period as a holistic and intermedial cultural system rather than the provenance of a discrete media form.

Scholarship on more general aspects of cinema in the 1920s is also relatively limited in comparison with the attention paid to early cinema and the later sound-film decades. Recent important works by Kaveh Askari, Thomas Elsaesser, Lucy Fischer, Christine Gledhill, Lee Grieveson, Lea Jacobs, and Richard Koszarski are beginning to change this.[11] They contribute crucial if largely national perspectives to cinemas of the decade that have critically shaped our analysis. Fischer's and Grieveson's works are the most globally expansive of this recent scholarship and illustrate the complexity of cinema's international nature during the era. Emphasis on the response of European cinemas to the expansion of Hollywood, for example, has tended to accentuate national specificities, protective legislation, and conceptions of "art cinema" as oppositional to Hollywood's stylistic and industrial dominance, which accelerated during the 1920s and beyond with the coming of sound.[12] Our analysis takes into account such oppositional currents; however, the limitations of a narrow approach to national cinemas and Hollywood hegemony becomes clear when one turns to the history of color during the interwar period, as international flows profoundly shaped how it was incorporated into film. To understand the transnational impact of color during the 1920s, one must take an intermedial and culturally engaged approach. Cinema was part of a complex, transnational network of chromatic research and development that accelerated during the interwar period because of structural transformations in industrial production, research, and development predicated on new, international forms of knowledge transfer and invention. Such exchanges in the industrial sector paralleled movements in the artistic world, as aesthetic theories of color spurred a range of modernist and cosmopolitan experiments across painting, literature, architecture, and cinema.

The particular international boundaries of this study are European and North American, to take into account the changes in industrial knowledge that occurred after World War I, when reparations divested the German chemical and colorant industry of its international patents and factories, resulting in a surge in colorant production throughout Europe and the United States. In part,

this established the framework for what Olivier Zunz discusses regarding the industrial and hegemonic rise of the "American twentieth century."[13] Accordingly, we examine how U.S. classical cinema developed industrially within this global context, innovating new forms of color style and sensation that added a prismatic aura to the moving images of the Jazz Age. Technicolor's difficult rise to technical and industrial ascendency during the 1920s and 1930s is also part of this trajectory. However, such developments in U.S. cinema cannot be understood in isolation. This book emphasizes both the international contexts and the European cultures of invention that developed alternative possibilities (such as Gance's tricolored Polyvision), as well the transnational and at times cosmopolitan approaches to color that enabled networks of artistic production across international cinemas and intermedial cultural forms. Given its flows as an object of global production and consumption and as a marker of artistic distinction, color became foundational to the varieties of cultural production that defined the decade—from vernacular to avant-garde forms of modernism. Even as the book focuses on transatlantic exchange, it also contributes to thinking about how color technologies, styles, and conventions circulated more broadly through networks that spanned the globe, though a different and more expansive archival approach would be necessary to examine north-south flows in greater detail.[14]

A central theme of our analysis is rethinking the modernity of the 1920s in terms of its chromatic and technical aura. Vital to our project is the excavation of the transnational tropes and structures of color that typified the look and feel of the decade in film and related cultural forms. In this era, color was integral to the global development of consumer cultures, urban design, fashion, neon street lighting, and home furnishings. Color was also a defining aspect of modernist and avant-garde art of the era, allowing for new horizons of aesthetic and formal inquiry to be raised across media. This is exemplified by the fact that when many established artists of the decade—painters in particular, such as Fernand Léger and Hans Richter—turned to film to carry out cross-media experiments, color was one of the key registers that they explored. Indeed, color was instrumental for the cosmopolitan development of modernism across media, from the adaptation of the vivid palettes of so-called primitivist art in the work of figures such as Pablo Picasso and Antonin Artaud, to the ways in which occult systems such as Theosophy, Mazdaznan, and Eastern mysticism played pivotal roles in the color designs of abstract artists and filmmakers such as Wassily Kandinsky, Johannes Itten, and Oskar Fischinger. Relatedly, orientalist color that drew from the racially stereotyped chromatic cultures of Asia—where color usage and innate sensitivity were thought to be heightened—profoundly affected the palettes of Art Deco, Art Nouveau, and their refractions in cinema through works such as *Toll of the Sea* (Chester M. Franklin, U.S., 1923). The problematic appropriation of indigenous colors to

expand and globalize Western aesthetics has long been a transgressive device of cosmopolitan style.[15] This is evident in what James Clifford has theorized as the "ethnographic surrealism" of artists such as Georges Bataille, Antonin Artaud, and Luis Buñuel, who sought in ethnography a different model for critiquing Western rationality than that found in psychoanalysis: instead of going deeper into the psyche, they went beyond Western frontiers to harness alternative modes of reality.[16] With Artaud, for instance, the vivid colors of Balinese theater presented him with a model for the sensuous potency he crafted in his own theater of cruelty.[17] These are just a few of the areas enriched by chromatic experimentation during a time when the international expansion of industrially produced synthetic dyes literally increased the range and vibrancy of visible colors.

Studies of advertising and modernity in film have been important influences on our approach. Janet Ward describes the experience of Weimar Germany in the 1920s as "a stunning moment in modernity when surface values first ascended to become determinants of taste, activity and occupation."[18] In her remarkable study, visual culture is analyzed in all its multifarious forms, including film, as a means of documenting the decade's obtrusive display of consumer goods via electric advertising, billboards, posters, display windows, and cinemas. Relatedly, Michael Cowan's examination of Walter Ruttmann positions his work as an avant-garde filmmaker in close relationship to contemporary advertising, demonstrating how German abstract film was adaptable as an effective form for selling a range of consumer products. In this analysis, advertising film is part of, rather than oppositional to, modernist aesthetics, and conversely, abstract cinema of the era was also deeply informed by advertising theory and practice.[19] We take such exchanges seriously for what advertising theory and artistic practice reciprocally demonstrate about how the physiological effects of color were being used to harness both attention and creative experience during the interwar period.

Miriam Hansen's theorization of "vernacular modernism" is also apt, for our study seeks to delineate color's instrumental role in the "mass production of the senses" across a range of intermedial styles and cultural forms.[20] For instance, Walter Benjamin, who is central to Hansen's theory, reflects in *One Way Street* on how the once-privileged language of criticism is being replaced by the sensual and immersive experience of film and neon advertising: "the genuine advertisement hurtles things at us with the tempo of a good film. . . . people whom nothing moves or touches any longer are taught to cry again by films. . . . What, in the end, makes advertisements so superior to criticism? Not what the moving red neon sign says—but the fiery pool reflecting in the asphalt."[21] In other words, the chromatic density of the modern street, like that of the cinema screen, was creating a new sensory experience for the passerby— an abstract immersion into glowing, neon hues that made contemplation and

criticism increasingly obsolete. Following these provocations, we consider the colors of mass-produced, vernacular media in tandem with artistic cultural forms, placing mainstream narrative films alongside avant-garde practices in order to understand modernist connections across these areas as articulated through color.

Cultural practices such as advertising cut across media, including film, so that new products were promoted in shop window displays, magazines, "ideal home" exhibitions, fashion shows, and paintings, as well as in fiction and non-fiction films. As industrial exchange profoundly affected U.S. and European cultures during the decade, increased awareness or "consciousness" of color was at the heart of chromatic experimentation across the arts. The color revolution was a transformative force in international culture and design, as documented in Regina Blaszczyk's study of how color stylists, forecasters, and engineers affected U.S. industry and consumer taste.[22] In dialogue with her insights, part of our aim is to show how cinema was also a dynamic part of the color revolution of the day. By placing the moving image in relation to transnational practices of knowledge exchange and transfer, we examine in detail how the chromatic modernity of the era was a primary driver of cinema and, conversely, how cinema in its various cultural formations (as an institution, industry, art form, and defining site of mass entertainment) became emblematic of the color culture of the decade.

Color, Intermediality, and Cultural Production

Following the constraints of the First World War, there was an expansion of color across various fields of cultural production in the 1920s that is powerfully refracted in film and media. To appreciate this increase in color, it is important to understand the intermedial significance of color before the war, during the era of early cinema. For this, we draw from and revise André Gaudreault and Philippe Marion's analysis of the institutionalization and accompanying stylistic transformation of the cinema around 1910, as it emerged as an autonomous and self-sustaining narrative medium.[23] Initially at the emergence of the technology of film in the 1890s and early 1900s, cinema developed out of already established media, as a technological extension of a variety of what Gaudreault has termed "cultural series"—for example, the magic show and fairy play, the fairground, lantern slides, and vaudeville shows. The colors of early cinema were in line stylistically with these already existing series within the field of cultural production: the brightly saturated colors of the fairy play could be found replicated in the films of Georges Méliès and Segundo de Chomón, and the resplendent hues of vaudeville costumes were reflected in various dance films popular in the 1890s as epitomized by the hand coloring in Annabelle Whitford's serpentine

dance films for Edison in 1895. The manually added, applied colors of these early films were in many ways a technical extension of what already existed in other media, rather than having a medium-specific style of their own. With the institutionalization of cinema as an autonomous medium that began to develop at the end of the first decade of the 1900s through the establishment of medium-specific modes of production, distribution, and exhibition, the intermedial structure of color in film changed. If, at the turn of the last century, color film was defined technically, stylistically, and generically in relation to already established cultural series, as the 1900s progressed cinema developed into a medium of its own. As part of this process, color took on a different relational valence between cinema and the other arts, and as we will see, this transformation continued and accelerated from the 1910s into the 1920s.

The 1920s presents a vital, reorienting perspective on this history of media change, for during the decade, cinema and other media were profoundly influenced by an industrial color wave that extended across the arts and other forms of cultural production. Far from intermediality diminishing from the picture as Gaudreault and Marion contend, in the 1920s cinema was going through a particularly exciting and innovative phase, specifically because of its engagement with the other arts. As Ágnes Pethö suggests, intermedial perspectives illuminate the "intricate interactions of different media manifest in the cinema, emphasizing the way in which the moving pictures can incorporate forms of all other media, and can initiate fusions and 'dialogues' between the distinct arts."[24] Using color as the focal point, we trace how cinema's intermedial nature transformed in the 1920s. Color cinema pulled away from its earlier affiliation with fairground attractions and variety shows as it was crafted institutionally into a mass medium. Rather than embedding the cinematic medium within these preceding cultural traditions, institutionalization gradually broke the cinema free from the dominance of these traditions. Film producers sought instead to subsume the color effects of other artistic forms into the new medium, for cinematic ends. Conversely, with its strengthened institutional and medial identity, color cinema of the 1920s increasingly became an intermedial reference for other arts—from advertising media to the avant-garde. Our revisionist reading of the 1920s thus uses intermediality to track the negotiation of media positions within the cultural field of the time, from what was earlier an inchoate medium that emerged from a variety of cultural series to a medium-specific field of its own that was becoming a nexus of intermedial influence within the cultural sphere. This is not to say that cinema was the dominant field of chromatic art during the decade; rather, it was becoming one of several exemplars of the prismatic culture of the day, and as such it began to exert recognizable influence on other media forms and fields of cultural production.

To track this reversal of intermedial polarity, we draw on the insights of Pierre Bourdieu, particularly the notion that cultural production comprises a

"field" of social interaction and power that coexists competitively with other interconnected yet autonomous fields such as industry, politics, education, and economy.[25] On its own, intermediality provides a powerful method for mapping stylistic and intellectual exchanges across media cultures; however, given the types of hybridized exchanges occurring with color during the decade, it is necessary to expand our comparative study beyond media to also incorporate the social fields of power that Bourdieu examines. For Bourdieu, a field is a zone of social activity governed by power relations in which individuals engage in various forms of production—economic, cultural, and otherwise. Fields are autonomous, defined by their own sets of activities, rules, outputs, and forms of distinction, but as with intermedial networks, fields also interact with one another. Tracing these exchanges provides a means of mapping the relational topography of the chromatic modernity of the 1920s. As we delineate, color's intermedial expansion through cinema in the early twentieth century profoundly affected, and was shaped by, the fields of economics, industry, and cultural production.

We turn to Bourdieu's theory not only for a model of mapping color's complex interactions across media and fields of the 1920s, but also to account for the dynamism inherent to fields, which are open to constant transformation. As Bourdieu explains in the context of the literary and artistic fields of cultural production:

> Change in the space of literary or artistic possibles is the result of change in the power relation which constitutes the space of positions. When a new literary or artistic group makes its presence felt in the field of literary or artistic production, the whole problem is transformed, since its coming into being, i.e. into difference, modifies and displaces the universe of possible options; the previously dominant productions may, for example, be pushed into the status either of outmoded [*déclassé*] or of classic works.[26]

In other words, when new forces—such as alliances, technologies, and ideas—enter a given field, its internal structure shifts to accommodate the novelty. Taking synthetic color's introduction into the fields of production as a starting point, we are interested in delineating how color in the 1920s transformed, and was transformed by, the various media, industrial, and cultural spheres with which it interacted in, around, and through the cinema. These fields transform over time as new technical innovations, economic imperatives, and social and political pressures alter the system of relations. Seeing color as a rich, multifarious force in the 1920s—through which cinema was but one manifestation of innovation—enables us to chart both the connections and the tensions across fields, media forms, industries, and individuals who engaged with color theoretically as well as in practice.

For instance, with the influx of new printing technologies and colorants in the 1920s, a renewed emphasis was placed upon color's educational potential—its ability to uplift the "color consciousness" of the consumer for artistic as well as practical ends. Color consciousness is a key concept that gained traction in the 1920s, as we trace in the following pages, particularly in chapters 2 and 3, where we relate it to cultural prestige and taste as theorized by Bourdieu. The concept was applied in the late nineteenth century to describe the work of Louis Prang, a chromolithographer and educator who founded the Prang printing and educational company in Boston; his textbooks argued for the potential to educate the color sense of students to be more "conscious of the various hues produced by the varying decomposition of light."[27] When Prang retired, a contemporary report in 1900 reported that he had helped arouse "the first glimmerings of color consciousness in 'public taste.' "[28] Famously adopted later by Natalie Kalmus as part of a branding exercise for Technicolor in 1935, the concept had already been in vogue during the 1920s when a number of experts in film, as well as in fields such as fashion and industrial design, sought to improve the color taste of the general public.[29] With the commercial success of synthetic colorants, people were urged to be conscious of color choices in the home and garden, for personal attire, and in schools, civic buildings, and entertainment venues. The range of activities to which the term was applied expanded as the decade progressed, demonstrating how color consciousness became a shared sensibility across fields of cultural production.

A 1932 *Photoplay* article by Lois Shirley, "All Hollywood Has Now Gone Color Conscious," illustrates this by presenting a color chart by Natalie Kalmus that breaks down the emotional meanings of color in film. This, in turn, according to Shirley, can be adapted for personal fashion choices: by applying the chart, "you will be able to select the colors that will give you the right vibrations which will help you along the road to success and happiness."[30] Further, Shirley provides anecdotes primarily about female stars' fashion preferences for particular colors, and close-up photographs chart these choices, revealing a remarkable confluence of color consciousness and standardization, fashion, and star culture. It is as if the faces of the stars now comprise the color swatches of Kalmus's chart. We take such diffusion of the concept of color consciousness to be indicative of the type of bureaucratization of perception that Jonathan Crary has theorized, regarding how institutional power manifests through modes of attention training that systemize and regiment sensory experience to shape modern subjects who are conditioned, manageable, and productive, in this case by color and its cultural prescripts.[31] In addition to such critiques, we also examine how color consciousness generated new, productive approaches to color design and practice that reflected creative and at times utopian impulses that also must be taken seriously.

The Signiﬁcance of Color

Blacks and dark browns. Deﬁnitely depressive.

Gray. The lifting of sadness. A mixture of black and white. People who wear it are often in-between people.

Red. The strongest vibration of all. A stimulant. It is sex; it is life. Many emotional people cannot wear it because it throws them into chaos. Slow, unemotional, unimaginative people seek it to arouse emotional energy.

Scarlet. The come-hither color. An exaggeration of red.

Blue. It represents peace, harmony and home and deﬁnitely reﬁnes and cools. Excellent for those working at high tension.

Green. Fresh green means life; springtime. It is both a sedative and a stimulant, depending upon the person. And it is deﬁnitely the money-getting color; the indication of the ultra-ambitious; the intellect.

Heavy, dull green is indicative of laziness and envy.

Dull greens are splendid for the nervous, dynamic character but act almost as a sleeping potion to the slow-minded.

Pink. Youthful joyousness. Almost all young people should have pink rooms for soft radiations while character is forming.

Purple. Royalty; dignity; glory. Always used in religious rites and to pay homage to royalty, church dignitaries, etc. However, it is ponderous and adds weight.

Orange. The color of physical strength. It tends to submerge all about it.

Yellow. The highest of all. The sun. Gaiety; joy; glory; power; great love. Always stimulating. Lemon yellow, however, is soothing.

Orchid. Indicative of spiritual affections and when carried to great lengths forms a barrier against love.

Figure 0.1 Color chart by Natalie Kalmus, included in Lois Shirley's *Photoplay* article (1932).

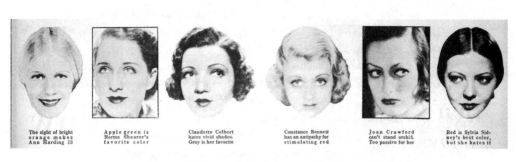

The sight of bright orange makes Ann Harding ill

Apple green is Norma Shearer's favorite color

Claudette Colbert hates vivid shades. Gray is her favorite

Constance Bennett has an antipathy for stimulating red

Joan Crawford can't stand orchid. Too passive for her

Red is Sylvia Sidney's best color, but she hates it

Figure 0.2 Film stars illustrating Natalie Kalmus's color chart in Lois Shirley's *Photoplay* article (1932). Clark Gable and Wally Beery were also part of the spread.

Tracking the diffusion of the concept of color consciousness illustrates the usefulness of a field approach to color and intermediality in that it permits a model of relational analysis, dealing with networks, mapping, and the interactions among various cultural, media, and industrial practices—for example, theater and film, art, advertising, fashion, architecture, and industrial design. A field approach also provides a crucial framework for considering the shifting dynamics during the 1920s, at points adversarial and at others complementary, between the avant-garde and vernacular entertainment as they engaged with chromatic innovation in an international context.

Navigating the Color Revolution

Viewed from an intermedial perspective, cinema was thus immersed in the chromatic world of the twenties, navigating a set of specific, symbiotic responses to the economic trends and artistic innovations that were galvanized by developments in color science. Even as the cinematic field coalesced institutionally at the end of the 1910s in Hollywood and elsewhere as an autonomous, classical medium, it remained remarkably influenced by and influential on the color culture of its time. Far from intermediality diminishing under the classical paradigm, cinema's chromatic engagement with the other arts was going through a particularly exciting and innovative phase as the global economy reestablished itself after the First World War. As commentators noted at the end of the decade, a chromatic revolution had occurred across media.[32]

Emerging in the 1920s as the most expansive form of vernacular entertainment, the prismatic world of the movie palace was a highly visible and interconnected element of this revolution, architecturally as well as on-screen. Designers immersed in Art Deco, Bauhaus, and De Stijl aesthetics found work in crafting the chromatic surface splendor of these new picture palaces. A visit

to a movie theater presented audiences with much more than a film show. Siegfried Kracauer described the architectural spectacle of the 1920s as a "total artwork" that assaulted "all the senses using every possible means . . . a visual and acoustic kaleidoscope."[33] This included seeing colored lighting effects in the auditorium and hearing the orchestra perform not only during but also before the film show, during prologues that often consisted of dance and pantomime performances. The white surface of the screen before film exhibition would then only be a brief interlude before it was prismatically engulfed by the shifting tints, tones, and stencils of 1920s travelogues, fashion films, and dramatic features that imaged dream worlds more resplendent than nature. As the decade progressed, color was increasingly registered on-screen through the innovative refinement of various photographic color processes, of which Technicolor's third system, its two-color dye-transfer system (1928), was the most renowned by the end of the decade. These cinematic colors of the 1920s illuminated silent as well as early sound films in a variety of hybridized and intermedial forms, all of which reflected and affected the cultural and corporate interests of the day.

In the 1920s, debates concerning color's cultural significance were intense. Building upon aesthetic and technical developments that began in the nineteenth century, international theorists and practitioners in a variety of media were keen to invest color with a utopian sensibility: the influx of new color media both transformed the public's visual environment and further democratized access to art. Color also led to dynamic exchanges between media, as explored in Adrian Klein's writings on and experiments with abstract color-music in Britain, as well as in those in France by Louis Favre, who saw color as expanding the affective dimension of art.[34] Theater designer Edward Gordon Craig was largely responsible for taking advantage of technical developments to introduce Expressionist colored lighting to the British stage through his pioneering use of incandescent lights and colored gels to enhance audiences' emotional engagement. British printmaking, awash in new colorants, was revolutionized by the influences of European avant-garde art, and German and Dutch artists such as Walter Ruttmann, Hans Richter, Johannes Itten, Theo van Doesburg, and Oskar Fischinger drew on this tradition as they explored multivalent approaches to the integration of color in film, visual music, architecture, and advertising. At the same time, many artists saw color's function as uniting the arts in the *Gesamtkunstwerk* spirit of total art.

Simultaneously, the new color culture had many detractors. Writing in the prestigious German art journal *Das Kunstblatt* in 1930, the critic H. Baer criticized the rapid expansion of color, noting that:

In graphic arts, colors are sometimes attractions, usually detours, rarely an enhancement of artistic techniques. . . . Color penetrates graphic arts as a heightened temptation for the eye. Primitives, in particular, are not satisfied

with black or white. Children, peasants, and indigenous peoples want color in its most enhanced state: colorfulness. But the audiences sitting in front of film screens are the primitives of large cities. This is why film is grasping after *colorfulness*. It promises a new attraction.[35]

Baer recapitulates many long-held aesthetic stereotypes about color, associating it with surface-level ornamentation rather than the purer essence of line and form. As a secondary quality, color was thought to be most appealing to "primitives," children, the poorer classes, and also women. Further, it was considered to be an attraction rejuvenated by new technologies of the Jazz Age, of which, for Baer, cinema was an exemplar. Rudolf Arnheim approvingly quoted Baer in his seminal chapter in *Film as Art* (first published 1932) on "The Complete Film," arguing in favor of the aesthetics of black-and-white film, implicitly rejecting attraction-based approaches to color that had predominated since the 1890s—though he did concede that color might be used artistically in film, but only if the hues were arranged "harmoniously."[36] Beyond a full rejection of color, many working in film during the decade attempted instead to subdue its distracting qualities. This was specific to the formation of classical narration, when the attraction-based elements of early cinema—like dazzling, saturated color—were repressed in favor of prioritizing a mode of unobtrusive narration in which stylistic effects were increasingly designed to enhance rather than distract from plot narration.

Cecil B. DeMille in the late 1910s and 1920s argued for such restrained and unobtrusive uses of color, intermedially relating his approach to the middlebrow illustrations and paintings of Edmund Dulac: "The moment the spectator says, 'Oh, look how green the grass is,' or 'How blue the sea,' the value of the color is gone; it has proved too greatly distracting. The color effect we get and these we are working for resemble somewhat the shades and color tones used in Du Lac's [*sic*] famous illustrations. These blend and harmonize, but are not too obvious."[37] DeMille would go on to argue that the tasteful solution for artistic color was to standardize its meanings in relation to film: "Today the problem has been reduced to an exact science. We have worked out a definite color code. Light blue, for example, is used to indicate either night or extreme cold, and the deeper shades of red are employed for the tinting of fire scenes and in certain productions to heighten sensational climax. The red tones, somehow, prepare one for dark deeds and violence."[38] Though DeMille's emphasis on an unobtrusive style for color is a hallmark of the classical paradigm—subsuming color's potentially distracting effects to narration—it is important to recognize that he does not frame this as an autonomous, medium-specific style, but instead contextualizes it through both art and scientific color standards. As we track, such blends of intermedial and cross-field aesthetics often come to the fore at points of technical and industrial transition in cinema.

As these examples illustrate, we range throughout this study across various vectors of the decade's chromatic modernity—from classical practice to avant-garde experimentation. By contextualizing these approaches to color within the larger framework that Bourdieu maps, we aim to historicize aspects of the rise of large-scale, cultural production (specifically classical cinema) that he refers to but does not analyze. As David Hesmondhalgh delineates, Bourdieu distinguishes between small-scale, "restricted" production (for instance, the avant-garde) and large-scale, commercial production (as in the culture industry). However, the bulk of his analyses problematically focus on restricted production and largely avoid addressing the radical transformations that commercial media underwent in the twentieth century.[39] We thus aim to historicize these changes through our focus on the cultural production of color during the 1920s.

Concentrating on the 1920s has implications for rethinking previous and subsequent decades in terms of color. It challenges, for example, the extent to which color's visual expression can be seen to have reached normative, unobtrusive stasis during early cinema. Rather, these years can be thought of as generating chromatic styles in an ongoing process rather than producing a set of fully formed classical conventions that were simply worked through in the 1920s. Also, when the decade is set as a vantage point, the 1930s appear less as an era of technical and stylistic progress in which photographic color was successfully mastered than as a decade of retrenchment in which screen color diminished and many of the groups involved in color's prior development disappeared from view. With hindsight, the ascendency of Technicolor in the 1930s is unthinkable without its origins being centered through the previous decade's rich culture of chromatic experimentation, which pushed the boundaries of what constituted screen color in narrative as well as avant-garde practice. Indeed, it is in moments of technical rupture and innovation that color in cinema often stands out, typically through intensified, spectacle-driven moments of intermedial and cross-field reference.

To explore the network of chromatic practice in and around the cinema, the book's chapters are organized into key themes that illustrate how the 1920s were a crucial decade in the history of color as well as for the media and fields with which it interacted. Chapter 1 provides the industrial context for the global expansion of the colorant industry after the First World War. The focus is on attempts to tame the notorious instability of color by codifying its terminology as well as developing new international standards for colorimetry. As an outgrowth of these developments, industrial research transformed and professionalized while new industrial models of knowledge transfer took root, profoundly affecting how modern research laboratories operated during the decade. Researchers such as Loyd Jones at Kodak and Leonard Troland at Technicolor played central, collaborative roles in developing colorimetric

standards not only at their firms but through national and international research boards that standardized and bureaucratized color as a means of spurring industrial production on a global scale. The colorimetric knowledge gained through these associations was foundational for the innovation of photographic color systems of the 1920s, in particular subtractive ones. Standardization is examined not only for its restrictive tendencies, but also for how it was generative of new technologies, aesthetics, and styles of color practice. Although standardization served disparate industries, the energies it unleashed often exceeded its role as a means of harnessing consumer desires in a top-down fashion. Rather, the color revolution energized debate so that consumers demanded more from designers as notions of stylistic expertise that had hitherto been the province of a small group of specialists were democratized.

Against this background of standardized and industrialized color production, chapter 2 charts the impact of color on consumers and examines attempts to influence consumer desire for particular tastes in fashion and home décor, as exemplified through the profound impact of the International Exposition of Modern Industrial and Decorative Arts in Paris in 1925. The relationship between Paris as a recognized center of fashion design and the development of trend forecasting in organizations such as the Textile Color Card Association of America highlights the transatlantic context of debates concerning color. In addition to print, film became increasingly important for the advertisement of products and fashions, particularly as theorists and color consultants advocated for the use of color in film for mass marketing campaigns. Such advertising tie-ins targeted the female consumer, who was assumed to be particularly receptive to new chromatic designs. Companies such as Pathé and Kodak produced color fashion newsreels displaying clothes and accessories to appeal to female consumers. Also, the color in feature films such as *The Phantom of the Opera* (Rupert Julian, U.S., 1925) occasioned marketing campaigns for a range of products. Across this material, we examine the ways in which the growth of mass consumption and new taste cultures during the 1920s profoundly influenced a network of pioneering cinematic approaches for advertising new color products, entertainments, and artistic expressions.

Color was at the center of modern innovation off-screen as much as it was on-screen in the 1920s, as chapter 3 demonstrates. As cities increasingly turned to artificial lighting for advertising and civic displays, moviegoers experienced a similar barrage of light and color in theaters in Europe and the United States. The use of colored lighting strategically cuts across several media practices, including film prologues that featured stage acts, musical performances, and light displays in theater foyers and auditoria. We focus on the many instances of such experiments during the decade as color became further prevalent across media. Even as cinema developed increasing medial autonomy in the 1920s,

as reflected in the boom in movie palace construction, at the same time these film-specific venues served as locations for color-light displays, color-music experiments, and elaborate stage productions preceding films. The variety of experiments with color, visual music, and lighting in the 1920s is analyzed in the context of the utopian desire for a synthesis of media forms that blurred boundaries between popular and avant-garde experiments. The preoccupation with ambient and mood lighting reflected interests in developing spectators' color consciousness as a means of negotiating the changing world. Such developments in the 1920s produced an important legacy that shaped the interrelationships among color, film, and sound in subsequent decades.

Turning to the interrelation of small-scale and large-scale cultural production, chapter 4 examines the nexus between avant-garde and vernacular approaches to color cinema during the decade. In many of the artistic movements of the time, color played a central role, as it seeped across media and internationally across borders to produce a cosmopolitan and at times critically utopian vision of the modern world. Viewing the era's modernist work through color provides an opportunity to interrogate some of the canonical works of the decade from a new perspective. Movements such as Expressionism, the Bauhaus, Dada, and Art Deco inherited a rich tradition of color experimentation that syncretically wove together ideas about synesthesia, abstraction, science, and the occult. The Bauhaus, for instance, codified a cosmopolitan rethinking of color in artistic design and practice that corresponded with German Absolute Film and in a more indirect way with Expressionist cinema in iconic films such as *Das Cabinet des Dr. Caligari* (Robert Wiene, Germany, 1920) and *Die Nibelungen* (Fritz Lang, Germany, 1924). Relatedly, the color work by filmmakers in France, such as Marcel L'Herbier with *L'Inhumaine* (1924), resonated with the industrial designs of Art Deco, and avant-garde filmmakers and artists such as Fernand Léger and Marcel Duchamp experimented with the ready-made nature of color as it derived from the standardization of the colorant industry. In a parallel strand of narrative art cinema in and on the fringes of Hollywood, a Pictorialist mode of filmmaking crystalized through filmmakers such as Maurice Tourneur, Rex Ingram, Alla Nazimova, and Dudley Murphy, who were also innovators of color style.

Chapter 5 covers the transformation of color aesthetics, particularly incidences of color hybridity in which a variety of coloring techniques are used in individual features and short films. Our concentration on the 1920s has brought out the richness of hybridized color in films such as *The Affairs of Anatol* (Cecil B. DeMille, U.S., 1921), *The Lodger* (Alfred Hitchcock, UK, 1927), *Napoléon* (Abel Gance, France, 1927), and *Lonesome* (Paul Fejos, U.S., 1928) and the variety of Pathé's stencil color films in the 1920s. Important photographic color developments such as two-color Technicolor, Prizmacolor, and European processes such as Friese-Greene's Natural Colour play a crucial role in the

hybridized aesthetics of the day. Running parallel to photographic color was the sustained use of applied color systems (hand coloring, stenciling, tinting, toning, and Handschiegl), all of which emerged and were refined over the first two decades of film history. At the outset of the 1920s, these processes were still widely in use, and oftentimes they were part of a syncretic approach to color design through which prestige films in particular often combined multiple color systems, heterogeneously in a single print: tinting, toning, stenciling, Handschiegl, as well as two-color Technicolor and Kelley Color might all be present in the same film. Examples of such hybrid variations include Cecil B. DeMille's *The Ten Commandments* (U.S., 1923), Rupert Julian's *Phantom of the Opera* (U.S., 1925), and Augusto Genina's *Cirano di Bergerac* (France/Italy, 1923/1925). This hybridized approach to color all but disappeared by the end of the 1920s.

Our final chapter examines the changes brought to color cinema by the widespread adoption of synchronized sound at the end of the decade. Critics at the time predicted that color cinema, too, would soon undergo a radical transformation: cinema of the near future would be predominantly in color. This of course did not occur until the 1960s, when color production outpaced black-and-white production. Nonetheless, color cinema did change radically at the end of the 1920s. Photographic color systems such as Technicolor, Vitacolor, and Keller-Dorian experienced a highly competitive surge in demand for several years, before the color wave waned with the onset of worldwide Depression. Part of the difficulty these various companies faced had to do with navigating problematic cultural and racial meanings of color for an international market, as the color designs in *Redskin* (Victor Schertzinger, U.S., 1929) and *King of Jazz* (John Murray Anderson, U.S., 1930) demonstrate. Applied color systems also diminished with the coming of sound, but by no means disappeared. As we discuss, Kodak's pretinted film stock, Sonochrome, was available until the 1960s and was used in the 1930s in films such as Ernst Lubitsch's *One Hour with You* (U.S., 1932) as well as Tod Browning's *Dracula* (U.S., 1931). The various technical and cultural issues that color raises during this transitional period are vital for thinking through color's place in the ensuing decades and specifically provide crucial international context for the rising dominance of Technicolor in the years to come.

In foregrounding the 1920s as an essential decade in the history of color and of cinema, *Chromatic Modernity* explores what it meant to be a color-conscious consumer, artist, designer, and filmmaker during the era. What emerges strongly is the extent to which films need to be understood as part of a broader exchange amongst interdependent chromatic systems, figures, international networks, and sensibilities. Encounters with color were multifarious, at times reflecting and reinforcing dominant taste cultures while on other occasions opening uncharted territories that exceeded restrictions imposed by the

standardization of the culture industry. Reflecting the variety of chromatic cultures foregrounded in the book, we offer a new interpretation of the 1920s as a profoundly chromatic decade in cinema and media history. In unprecedented ways, film was imbricated within the prevailing industrial, artistic, and commercial momentum of that era's chromatic modernity. Far from being intermediary, the period is rediscovered as one of the most significant in the history of color film and media.

CHAPTER 1

COLOR STANDARDS AND THE INDUSTRIAL FIELD OF FILM

[W]e must thank the chemists for liberating scores of new hues from the gummy darkness of coal tar and other plentiful substances.

—"A New Age of Color," *Saturday Evening Post* (1928)

Color today is by and large ready-made, purchased prefabricated, and mixed with the help of matchable color cards, charts, and digital indexes that allow one to choose the ideal hue, saturation, and combinations for the job at hand. This was not always the case, for at one time most pigments were profoundly expensive and required trained specialists to mix and prepare for each application. Our modern sense of color as a standardized commodity available off the shelf dates back to the nineteenth century. Beginning in the 1850s and accelerating rapidly after World War I, new forms of color revolutionized the spaces of modernity through an array of industrial innovations, standardizing procedures, and aesthetic experiments, and by the 1920s cinema in all of its various hues was at the vanguard of these transformations. The colorant industry went through fundamental changes during the era, as it shifted from the use of natural dyes to synthetic anilines. Aniline is a chemical compound synthesized from coal tar, a common industrial waste product. The German chemist Friedlieb Ferdinand Runge initially discovered coal tar's potential for producing dyestuffs in the 1830s, but it was

the British chemist William Henry Perkin who was first able to market aniline dyes after he distilled a deep purple compound he named and patented as mauveine in 1856. Mauveine inaugurated a massive expansion of color in the textile and chemical industries, as numerous other synthetic dyes were soon developed across Europe, particularly in Germany. It was not just new colors that emerged from these innovations, but also a whole host of chemical offshoots: pharmaceuticals, film and photographic stocks, fertilizers, and eventually tear, mustard, and chlorine gases, often as by-products from the waste of colorant production.

Synthetic dyes were cheaper and more colorfast than the colorants used previously, for before aniline, dyes were extracted from organic materials that by and large were relatively unstable and imported at great cost through colonial trade. With the tints of aniline flooding the market, new colored goods were transformative, making the world seem like a fantastic dream come to life. Aniline-dyed magic lantern slides and tinted theatrical lighting illuminated the spaces of popular entertainment, and urban sidewalks overflowed with passersby draped in the newly saturated fashions of aniline-colored fabrics, which came to define the fashion look of the New Woman. Print ephemera was also a major site for the expansion of color, as city streets were plastered with chromolithographed advertising posters and subsequently by neon signage. Wallpapers, reproductions of artwork, hand-painted photographs, and stenciled trade postcards colored the walls of domestic spaces. Meanwhile, color printing revolutionized the space of reading, as vibrant illustrations—in women's journals meant to be clipped out to decorate the home, in children's books, and on dime-novel covers—grew increasingly popular at the end of the century.[1] It is out of this synthetic prism that cinema emerged in the 1890s, and as the medium crystalized into its classical form of mass entertainment, the moving image became a hallmark of the chromatic modernity of the 1920s, resplendent in the tints, tones, and Technicolor hues that saturated the Jazz Age.

Color and cinema have entwined histories. Each expanded industrially as well as artistically in a global context after the First World War, and this growth necessitated new standards for color production. Within the industrial field, the codification of colorimetric values and meanings became essential for taming color's polyvalence and industrial unruliness. Color has always been uncontainable—it spills over borders and makes sparkling messes, and as such it is a constant variable in the industrial arts. Tints shift both chemically and in reproduction, depending on lighting conditions, ingredients, color juxtapositions, the physiology of the eye, and time, as dyes fade and decompose. But color is simultaneously a vital aspect of our lived environment and a hallmark of 1920s consumer culture as illuminated through the cinematic field. In particular, the hues of the screen illuminated new modes of female fashion as well

as a host of Orientalist and Primitivist fantasies through various Art Nouveau and Art Deco flourishes, which Lucy Fischer has shown, as we take up in more detail in chapter 2.[2] In order to better commodify and control such gendered and racialized excesses for the new mass markets, colorant firms began to distribute color card indexes increasingly in the latter half of the nineteenth century. At the same time, various aesthetic and industrial theories emerged for codifying color harmony in tandem with the development of aniline colorants. It is this process of colorimetric standardization within the industrial sector that we examine in this chapter. Not only restrictive in effect, these processes enabled forms of technical and aesthetic innovation in 1920s cinema and were generative for the new modes of production and reception that defined the modernity of the decade.

Our focus in this chapter is primarily on industrial history as opposed to film analysis, which we take up in detail in ensuing chapters. Specifically, our interest is in how new forms of chromatic standardization across the cinematic and industrial fields of production necessitated new, international modes of technical research. To these ends, Pierre Bourdieu's theory of cultural production is particularly useful, not only as a model for mapping color's complex interactions across media and cultural fields of the 1920s, but also for how it emphasizes the dynamic nature of fields, which are open to constant transformation.[3] When emergent forces—such as new corporations, trade alliances, technologies, and ideas—enter a given field, its internal structure shifts to accommodate the novelty. Taking synthetic color's introduction into the fields of production as a starting point, we delineate how color in the 1920s transformed, and was transformed by, the various intermedial, industrial, and cultural spheres that it interacted with—in, around, and through the cinema.

German corporations dominated the conglomerated chemical and colorant industry at the turn of the last century, but with the conclusion of the First World War and the ensuing reparations, the German industrial sector was forced to divest a portion of its international factories and chemical patents. Global colorant production diversified and surged in the ensuing postwar consumer markets, which necessitated new, transferable principles of research and design. The international history of color intersects with what Olivier Zunz has examined regarding the rise of U.S. power in the "American twentieth century." As he explains, one of the overarching drives of the United States at the turn of the century was "the creation of an industrial economy on a continental scale," which in turn would grow to dominate global trade, eventually overtaking the German industrial complex during the interwar period.[4] As the second half of this chapter details through comparative studies of Eastman Kodak, Pathé Frères, and Technicolor, part of this rise to global power relates to intersecting developments in the U.S. colorant and film industries during the 1920s. Tracking the industrialization of color and cinema in a global context illuminates

a structural transformation in knowledge production during the era. Laboratory research, particularly in Germany and the United States, was being professionalized through increasing partnerships between industry and technical universities that accelerated the rate of knowledge transfer. This change in the structure of industrial knowledge was one of the factors—alongside other professionalizing shifts, such as the rise of the studio system and the development of the trade press and organizations such as the Society of Motion Picture Engineers—that enabled cinema to crystalize as an autonomous mass medium.[5]

Industrialized and standardized, color became a hallmark of modernity and modernism, consumer culture, and film and mass media. To make sense of these overlapping concerns, we examine how the standardization of color drove its expansion across fields and media during the 1920s. The industrial networks running through and around cinema experienced new challenges, which developed and sustained symbiotic relationships across media. With the diversification and expansion of aniline production and distribution following the war, the standardization of color values through colorimetry became of increasing importance for the emerging cultures of mass production and consumption, and the professionalization and interconnection of research laboratories played a critical role in this industrial process. It is the development of industrial standards for color research to which we now turn to trace in brief its history before and after the war in order to assess its influence on film research laboratories of the 1920s.

The Color Chart

The synthesis of aniline colorants from coal tar in the middle of the nineteenth century defined an initial phase of chromatic innovation in the modern era. Though Great Britain and France had well-established colorant industries, it was Germany that came to dominate the trade as its empire coalesced, controlling upwards of 90 percent of the global market by 1900, a position it maintained until World War I. Lacking an expansive colonial network to supply raw resources for manufacturing in the middle of the century, Germany relied instead upon domestic innovation to compete internationally.[6] Beginning in the 1860s, emerging companies such as Badische Anilin- und Sodafabrik (BASF), Friedr. Bayer et comp, and Höchst AG far outperformed French and British colorant firms. These companies came to hold most of the modern dye patents and factories in the world, while also cultivating close ties to research centers at technical universities that trained a highly skilled workforce of chemists. Such a confluence of technical capability and trained ingenuity led to the continued innovation of aniline production as well as a growing variety of chemical by-products.[7]

Such changes in the industrial field of color enabled the chromatic expansion that occurred in the field of cultural production from the late nineteenth century through the 1920s. However, as aniline colorants flooded the market in the nineteenth and early twentieth centuries, reactions ranged dramatically in the cultural field as the world took on a synthetic face. For some, colored goods—from clothing to chromolithographs to home appliances—were thought beneficial for cultural taste. U.S. chromolithographer and educator Louis Prang, for example, in 1868 suggested that color printing increased access to art, allowing it to be "republicanized and naturalized in America," thus improving popular taste through increased color consciousness.[8] Relatedly, at the turn of the century, after devoting "decades of his career and large portions of his business to shaping the way that American children perceived color," Milton Bradley "played a crucial role in making bright hues an unquestioned fixture in the life of the child," according to Nicholas Gaskill. As Gaskill argues, "the ways of seeing fostered in the Bradley system prepared students to enter the emerging world of consumerism both as efficient producers and ready consumers." Intricately connected to this endeavor was the standardization of color materials that Bradley produced through his company.[9] New color standards corresponded across production, education, and consumption in his system. These imbricated approaches can be read as being relatively self-serving and utilitarian, as both Prang's and Bradley's business was to mass-produce and sell color goods. Yet, they also aspired beyond corporate interests to shape the color sense and consciousness of students for their betterment, in concert with broader pedagogical currents that were reshaping childhood education as well as art instruction, from Montessori to Waldorf and the Bauhaus (see chapter 4).

In the art world, the embrace of new color paints was extraordinary, encompassing the chromatic experiments in the Impressionism of Monet and the Neo-Impressionism of Seurat, the Fauvism of van Gogh, Picasso's Cubism, and the abstraction of Kandinsky. Moving away from the dull palettes of Analytic Cubism, Picasso enthusiastically embraced the vivid enamels of Ripolin house paint in works such as *Violin, Glass, Pipe and Anchor, Souvenir of Le Havre* (1912).[10] Few writers celebrated the utopian potentials of modern color more than the German journalist and science fiction writer Paul Scheerbart, who famously published in 1914 his utopian tract *The Glass Architecture*, comprised of 111 aphorisms about the uses and possibilities of glass and color in design. In this novelistic fantasy, he foresaw that modern color, as fused with transparent, colored-glass bricks, "will inevitably transform our whole lives and the environment in which we live. . . . So we must hope that glass architecture will indeed transform the face of our world."[11]

If these celebrations were one side of the vibrant reception of synthetic colors before the First World War, there were just as many writers and cultural

critics who disparaged the chromatic changes: the "metallic, nervous, and discordant effect of commercial dyes," as Arts and Crafts practitioners at the turn of the last century described the dangers of aniline colorants.[12] Max Nordau, the Austrian cultural critic, infamously attacked the influx of color for its effects on the human sensorium. Few escaped his judgments: in the vibrant clothing of the passerby on streets and of the aesthete at the opera, in the violet hues of Manet and the Impressionists, and through the fascination with synesthesia in Symbolist and Decadent literature, color became emblematic for Nordau of the degeneration of culture and the parallel rise of hysteria and other nervous disorders. As he argued, "The curious style of certain recent painters—'impressionists,' 'stipplers,' or 'mosaists,' 'papilloteurs' or 'quiverers,' 'roaring' colourists, dyers in gray and faded tints—becomes at once intelligible to us if we keep in view the researches of the Charcot school into the visual derangements in degeneration and hysteria."[13] Entwined with the idea that synthetic color caused physiological impairment was the notion that it was also indicative of the falseness of modern culture—with what Edwin Lawrence Godkin, in his 1874 polemic in the *Nation*, famously disparaged as the new "Chromo-Civilization."[14] Color in many of these critical traditions hinged upon its relegation in aesthetic theory to a form of ornamentation, secondary to the primacy of form and line—*disegno* over *colore*. As a form of ornament, color is also dangerous: prone to overuse, vivid saturations, ugly contrasts, and lethal bad taste. Functioning in an emotional register, it also could overstimulate and contaminate weaker, supposedly primitive minds, as we discussed in the introduction with regard to H. Baer's writings on color film.[15]

It was in the context of such polemics for and against color that colorant firms promoted their wares. In order to better commodify and control color in this uncertain market, German firms in particular produced color charts and guidebooks from the second half of the nineteenth century on—folios of color swatches ordered in abstract grids that demonstrated for buyers what a company's paints and dyes looked like on various materials, such as silk, paper, linens, leathers, and even feathers (color plate 1.1).[16] Initially the colors were labeled with their catalog numbers, sometimes along with their chemical compositions, but in the 1900s the charts increasingly described the colors with evocative, and at times deeply racialized, names: "Castilian red," "Goya" for a deep scarlet, "Narcissus" for a bright yellow, or "Hopi" and "Mesa" for shades of light brown. As we examine further in the next chapter, naming colors coincided with colonial projects of regulating "colored" peoples, regimenting indigenous cultures, and exporting native patterns and hues for commodification through tasteful control. Ann Temkin has noted pointedly that these charts emerged in the 1880s "as a direct result of the mass production of ready-mixed paints for household use and the de-professionalizing of the handyman's or house-painter's job. . . . paint companies mounted ambitious campaigns to convince

the general public that it could do its own painting."[17] The detail that went into many of these color charts was extensive, as they not only illustrated color's material properties and applicability but also helped codify its usage by demonstrating its effective use on a range of materials, often presenting tasteful combinations of contrasts and harmonies. Manufacturers drew on this material for the design and production of their dyed goods, just as homeowners, artists, and eventually filmmakers could use them to pick the ready-made paints they wished to use.

Given the variegated cultural reception of synthetic dyes, colorant guidebooks were meant to demonstrate that color could be tamed and made useful, meaningful, and valuable across an increasing spectrum of products. As the Textile Color Card Association of the United States (a color forecasting service managed by Margaret Hayden Rorke and popular in the fashion industry in the 1920s) defined color standardization in a 1921 pamphlet on the topic, it was meant as "a color language, so to speak—which could be understood by all related industries and trades" for "a great economic benefit"; rather than restricting creativity, it would expand innovation as part of the "evolution of industrial progress."[18] Simultaneously, the standardization of color in the industrial field overlapped with larger concerns about color meaning and symbolism, as well as with the physiology of color perception in the nineteenth and early twentieth centuries.[19] The study of color physiology was particularly dynamic during the era, with profound consequences for reshaping how human perception was understood as a subjective phenomenon filtered through the senses, as Jonathan Crary has delineated.[20] It was also essential for the invention of the cinematic apparatus, as the physiological study of color afterimages led to the theory of persistence of vision, which formed the scientific backdrop for understanding how moving images could be perceived from still photograms, tricking the subjective perceptions of the eye.[21] The recoding and manipulation of subjective vision that occur through devices such as cinema, in Crary's account, help regiment and standardize perception, making observers more attentive, productive, and susceptible to control—for instance, by the affective play of colors in advertising. Across these disparate areas, fields overlap and cross-pollinate color's multivalence, and exploiting this variability for industrial practice has since antiquity meant cultivating taste cultures to hierarchize color value. We take seriously the Foucauldian critique of control that grounds Crary's analysis—the sense of bureaucratizing perception to systemize and control experience and knowledge—but it is also important to note the productive nature of these developments in chromatic standardization. As discussed in later chapters, these processes were incredibly generative in the 1920s for fashion, modernist art and design, and certainly film, enabling the resplendent productions of the culture industry, as well as modernist critique of the decade's color culture.

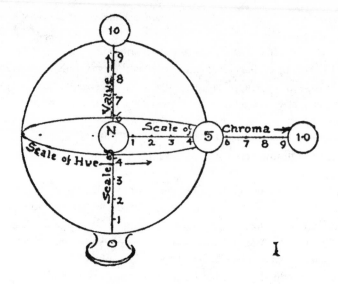

COLOR SPHERE

AND

COLOR TREE

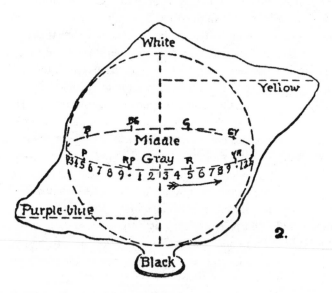

Figure 1.1 Color sphere and tree from Albert Henry Munsell, *Atlas of the Munsell Color System* (1915).

All colors grasped in the hand.

Figure 1.2 A tactile translation of a color sphere with one's hand, in Albert Henry Munsell, *A Color Notation* (1919).

Various other theorists and practitioners of color, such as Michel Eugène Chevreul, Wilhelm Ostwald, Robert Ridgway, and Albert Munsell, can be cited for their influence on the standardization of color culture. Munsell, for instance, established at the turn of the century the Munsell Color System, which became one of the most influential standards for color management in art education, design, and industrial production of the twentieth century.[22] His system was innovative in terms of how it separated hue, value, and chroma into different dimensions of a three-dimensional color space and accounted for both the physiological variations of human perception and standards for color harmony. He devised various evocative charts, color spheres, color trees, and color chips (like the later Pantone system) to illustrate his system. Importantly, Munsell, like most color theorists of the era, was in dialogue with a range of international

research. He had studied and met with Chevreul at the Gobelins national tapestry works in Paris, which Chevreul directed. Munsell was also well acquainted with Harvard's experimental psychology lab, which Williams James founded and Hugo Münsterberg directed; Münsterberg, in fact, invited Munsell to lecture at the lab in 1910, as did other psychologists of the era.[23] Building on the work of earlier pedagogues like Prang and Bradley, Munsell believed strongly in the importance of art education for training people's color sense, but he put an even stronger emphasis on the importance of providing them with systematic tools for accurately describing color values. This increased emphasis on standardization dominated 1920s pedagogy, particularly through the influence of the A. H. Munsell Color Company, which he founded just before his death in 1918 to continue the promotion of the Munsell Color System.

Based on the work of theorists such as Munsell, the field of colorimetry developed rapidly in the interwar period. Colorimetry originated in the second half of the nineteenth century through the work of Clerk Maxwell and Hermann von Helmholtz as the science of measuring color and color perception.[24] Its expansion in the 1920s came through national and international research boards such as the Optical Society of America (founded in 1916 to advance the study of light and optics), the U.S. National Bureau of Standards (founded in 1901 to systematize scientific measurement for laboratory research), and the International Commission on Illumination (CIE, founded in 1913 to coordinate standards of artificial lighting and color). These various collaborative research boards all dealt with color standards in various ways, constituting a form of scientific management applied to color design and production. Each was charged with developing new measurement and application standards for color that, in turn, were meant to spur industrial innovation and competition. As historian Sean Johnston explains:

> The industrial need for color metrics nevertheless continued to increase dramatically after the war. In the British dyestuffs industry, for example, the production of colors rose four-fold between 1913 and 1927. In America, the idea of "standardization" was touted as a means of reducing commercial complexity and improving the country's competitiveness in products. The regulation of light and color were key components of this scheme. The [National Bureau of Standards] instigated programs for setting standards for electric lamps, gas purity for lighting systems and the color of railway signal lamps.[25]

Thus, from color charts to signal lamps, the expansion of color in the nineteenth century necessitated a recoding of color meaning in a range of fields. The resulting attempt to standardize color's synthetic unruliness led to related, intermedial mappings of color that profoundly shaped the color horizon of cinema of the 1920s.

Color, Chemicals, and the War

What sets the 1920s off from an earlier period of chromatic innovation in the nineteenth century are the particular international transformations of industry caused by the First World War. During the war, trade embargoes severely

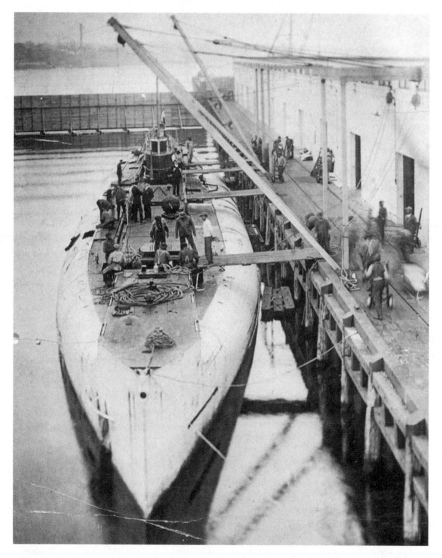

Figure 1.3 The German submarine *Deutschland* being unloaded of its aniline cargo in New London, Connecticut, in November 1916.

Courtesy of the Public Library of New London.

limited the availability of German dyes for the world market, though German companies developed elaborate smuggling networks. For example, in July and November 1916, Germany used the submarine *Deutschland* to run colorants through the allied blockade to North America.[26] As was reported at the time, and even documented in a Pathé newsreel:

> On July 10th the mercantile submarine *Deutschland* arrived in Baltimore with 750 tons of medicinal and coal-tar dye products. It appears that the weight of dyes in the consignment was 125 tons, and that they consisted mainly of Anthraquinone and Alizarin derivatives, which are patented in Germany and have not yet been prepared in the United States. A circular prepared by the Badische Company of New York states that theses dyes have been prepared in a highly concentrated form, in a few cases twelve times their normal strength.[27]

But this smuggling endeavor was only a brief stopgap for the colorant trade. When the United States joined the war the following year, the German Imperial Navy retrofitted the U-boat with torpedoes in place of aniline, just as the colorant-chemical industry itself recalibrated for the war effort, producing, among other things, chlorine gas.

During the shortages of the war, international color usage diminished overall but expanded outside of Germany, and following the breakup of Germany's chemical patents as part of war reparations, color production surged internationally. In the United States, this was an era of massive development for the domestic colorant and chemical industry, with the formation of American corporations such as the National Aniline and Chemical Company in 1917. As Mira Wilkins explains, "U.S. dyestuff production, which had been $2.5 million in 1914, by 1917 soared to $57.8 million. The general price index had risen, but nowhere near this extent." Much of this domestic production was through German subsidiaries, whose foreign holdings were seized during the war.[28] Reflecting upon this shift in domestic production, an editorial in a textile trade journal noted a corresponding change in the color consciousness of the U.S. public:

> Under the stress and storm of war excitement the emotional psychology of a nation becomes peculiarly disturbed and apparently this is directly reflected in the color consciousness of the people. Instead of fabric colors becoming more and more limited in range, they become more and more extended. Anyone noticing the riot of color shown in the shops during the past few years must acknowledge this fact. There was no relation at all between the public's desire for all manner of bright and bizarre color combinations and the dyestuffs available for the production of those colors of proper fastness.[29]

As with Louis Prang's praise of color printing in the nineteenth century, an editorial such as this can be read as being relatively self-serving, since the journal itself aimed at providing color advice to rein in the "bright and bizarre." In the midst of such perceived color crazes, there was also a growing push to codify the increasing riotousness of color design through the formation of colorant advisory boards. The Textile Color Card Association of the United States, mentioned earlier, was founded in 1915 to advise domestic fashion firms about desirable color schemes for the year and season, sometimes with lucrative tie-in campaigns with films, as we discuss in more detail in chapter 2.[30] These boards aimed to forecast color trends for better industrial exploitation as well as for improved taste cultures. Based on the changes to the colorant industry of the 1920s, cultural fascination with color was lively and ranged across media and disciplines in the art, advertising, architecture, and cinema of the era, creating an exciting, chromatically rich visual culture.

Cinema's embeddedness within these transformations was pronounced, for it was an exemplar of innovation in the cultural field in the early twentieth century. The medium's transformation into a classical form of entertainment and corporate structure at the end of the 1910s presaged the coalescence of mass culture in the 1920s, as industrial modes of production and consumption became increasingly integrated. In the midst of 1920s modernity, classical cinema, as Miriam Hansen has argued, became "the single most inclusive cultural horizon in which the traumatic effects of modernity were reflected, rejected or disavowed, transmuted or negotiated."[31] Cinema's technical appropriation and deployment of color during the period was a vital component of how it crafted, recoded, and mass-produced a chromatically appealing new sensorium within this cultural horizon.

Since the cinema's emergence in the 1890s, it reflected the intermedial splendor of turn-of-the-century chromatic culture, and the new medium showcased the transformation of the colorant industry over the ensuing decades. Edison, for example, screened two color films at his first public exhibition of projected moving images, in April 1896, at Koster and Bial's Music Hall in New York City: the Leigh sisters' *Umbrella Dance*, which began the screening, and a serpentine dance that ended it. These films were hand colored frame by frame, and throughout the silent period a variety of other applied color processes, including tinting, toning, stenciling, and Handschiegl, were used in film. Most of the early processes deployed before the First World War used German aniline dyes to create their wondrously saturated images. This influence can be seen particularly through the process of film tinting, in which films were dipped in vats of aniline dye so that color spread across the entire image to produce reds for fire, blues for night, greens for a pastoral scene, or yellow for a hot sunny day in the tropics. In the 1910s and 1920s, film-stock companies sold pretinted stocks; a

producer could print a film directly onto these stocks, thus alleviating the need to dye prints individually.

To market film tinting, toning, and pretinted stocks, in the 1910s and 1920s companies such as Pathé, Kodak, and Gevaert began to distribute tinting and toning guidebooks modeled on the aniline color charts produced by the colorant industry of the nineteenth century. These film-stock color charts typically came bound as short books, with technical data about the chemicals and formulas used in their opening sections, and in the latter sections, galleries of tinted and toned film frames mounted in cardboard stock. Like color charts for other media, these galleries were neatly organized, labeled in grids, and arranged by hue and process for easy selection. The colored frames often came from picturesque nonfiction films as well as from dramatic films, demonstrating the range of color effects possible for various genres. The Eastman Kodak guidebook from 1927, for example, showcases tinting and toning effects on both nitrate and safety base film stocks (color plate 1.2). Neatly organized in rows of three, the frame selections present a range of sparkling, classical close-ups and medium shots from dramatic films, as well as bucolic nature scenes of forests, bears, and the Grand Canyon and tinted shots in red and blue of the Luna Park at Coney Island, thus hewing close to American iconography.[32] Some of the film-coloring guides from the 1920s also take on a relatively more ornate look. Still rationally organized, tinting books by the Belgian company Gevaert for "Positif Color Film" (1925) and by Pathé for "Supports teintés Pathé" (n.d., ca. 1925) also take on a distinctly Art Deco look, through their symmetrical design and font patterns. The Pathé guide, for instance, is on gray cardstock with tasteful brick-red text and a patterned design forming a series of rectangular patterns, with the Pathé rooster logo at the bottom (color plate 1.3). Each page of the tinting section has three sample hues: on one page, 1. Rose, 2. Rouge, 3. Orange; on the next page, 4. Violet, 5. Bleu, 6. Vert; and so forth. Each tint is illustrated by several frames of clear tinted leader (approximately four frames on the left and right and five frames in the center), and above each leader of pure color is a single exposed frame of different scenes in the hue. The pages are remarkably abstract, yet tasteful, in their reference to Art Deco style.

Like the earlier color charts and colorimetry guides, tinting books were meant to expand the color market by demonstrating the technical possibilities of color design in film. They also helped to codify color usage, particularly in the 1920s, for the manuals not only included technical descriptions of tinting but also provided aesthetic suggestions that often recapitulated the sensory prescriptions for color design deployed in other fields. Their aim was to tame and professionalize the unruly application of color in film, which might otherwise overpower narrative legibility if color's attractive powers were not held in check. Cecil B. DeMille, along with promoting standardized color codes for tinting and toning, advocated using color "to heighten a certain effect . . . and

in most cases the audiences are not conscious that a color is ever used," which is a hallmark of the unobtrusive style of classical Hollywood cinema.[33] Paralleling DeMille's aesthetics for color, Kodak also took a standardized approach to color meaning with the Sonochrome pretinted film stocks it developed at the end of the 1920s. One description of the Kodak stock notes: "A table of psychological values for Sonochrome tints has been worked out on a scientific basis in the expectation that changing tints may be used—where natural color is too expensive—to influence the mood of the various scenes of a photoplay."[34] The emphasis on the scientific nature of these claims was grounded in color theory of the time, which emphasized the physiological aspects of color perception. Indeed, one discussion of Sonochrome explains, "Our response to this color ["Verdante" green] has become so definitely fixed by association with it in Nature that wherever it is used it tends to produce the same physiological effect, which is a step away from the feeling of complete ease and tranquility towards the stimulative side."[35] At the same time, the physiological nature of color is inseparable from the psychological—the mood-inducing potential of color to underscore, like unobtrusive musical accompaniment, the emotional and narrative legibility of a film. Such ideas at Kodak were also grounded in color literature of the era. In his various writings, Loyd Jones, who was instrumental in developing Sonochrome at the Kodak Research Laboratory, references work on color psychology, metrics, and nomenclature by theorists such as George Field and Matthew Luckiesh, as well as the Committee on Colorimetry of the Optical Society of America, which was at the time attempting to "construct a rational terminology" for color research and usage.[36] These interweaving ideas indicate how the new chromatic sensorium of the 1920s was scientifically conceived through collaborative knowledge production that sought to contain the distractions of color while innovating new stylistic modes of design.

Film-coloring guidebooks also reveal much about the transformation of the colorant industry after the First World War. Based on their chemical formulas, in the teens film-stock companies primarily used German dyes, but during and after the war, there is a marked shift. In the United States, for instance, Kodak had relied solely on German dye companies with distribution centers in New York City, but according to the Kodak guides, during the war there was a decline in color films because of the Allied blockade of German dye exports. The preface to Kodak's second edition of its tinting guide (1918) notes, "Owing to the difficulty of obtaining foreign made dyes, a revision of the first edition of the publication has been made necessary."[37] The revisions of the guide detail that Kodak had to turn from the German companies to less-established U.S. dye manufacturers such as the National Aniline and Chemical Company. After the war, at least in the United States, film companies continued to work with domestic suppliers, even if most of these firms employed German émigré chemists and German dye formulas. Our inquiry for the remainder of this chapter,

then, pertains to what happened to color in the 1920s, in and around cinema, during this period of intense chromatic expansion and standardization.

Knowledge Transfer in the 1920s

Grounded in pre- and postwar developments in colorant production, chromatic standardization and innovation accelerated during the 1920s in ways that profoundly affected the film industry. These changes both expanded the reach of colored commodities and inculcated a new color consciousness amongst public taste cultures. As Kodak's tinting guidebooks illustrate, the effects of World War I and its aftermath on these changes are significant. In terms of the globalization of colorant and chemical innovation, the disruption of Germany's dominant chemical industry not only spurred the development of national industries elsewhere but also expanded the process of knowledge transfer on a global scale, in the forms of colorant patents, expertise in engineering and chemistry, technology, and aesthetics, all of which became increasingly interconnected through transnational circulation. Tracing the flows of technical and aesthetic knowledge in the 1920s provides a way of mapping these intermedial and cross-field connections of color as it surged internationally.

At the turn of the century, for instance, U.S. production of synthetic colorants was underdeveloped in comparison to that of European firms, yet the United States had one of the largest textile industries in the world, which the German colorant industry profited from immensely.[38] In the decades before the war, the U.S. approach to trade tariffs fluctuated between protectionist and minimalist policies; to bypass import fees, various German companies such as Bayer purchased controlling interests in some of the few U.S. dye producers, such as Hudson River Aniline Color Works in Rensselaer, New York, and brought in German chemists to recalibrate production. German companies also founded a variety of sales and distribution offices in the United States to coordinate these efforts. In the lead-up to the American entry into the war, German subsidiaries operating in the United States increased domestic production to avoid escalating tariffs; during the war, the U.S. Office of Alien Property Custodian was established to take control of German properties, including patents, which also boosted the domestic industry. The situation after the war was complex and mired in legal challenges, as the Office of Alien Property Custodian attempted to liquidate German holdings by selling them to domestic corporations. Eventually, over the course of the 1920s, many German companies were able to reenter the market and reclaim much of their holdings, though the U.S. colorant corporations were by this time more firmly established. Following the consolidation of the German colorant and chemical industry into IG Farben in 1925, Germany dramatically expanded its global holdings once again, though

in a diversified way in which German exports were increasingly balanced by German-controlled production overseas, in the United States and elsewhere. This global diversification of the colorant industry in the 1920s produced some of the earliest multinational chemical corporations of the modern era, and it is their innovations that led to the dramatic expansion of chromatic culture during the decade.

Importantly, the United States was not the only market targeted in these international ventures, though much of the secondary research into the colorant-chemical industry has focused on U.S.-German corporate relations. Akira Kudo has traced similar industrial developments in Japan during the interwar period, analyzing IG Farben's trade history and industrial investments aimed at controlling the Japanese and East Asian markets; Ulrich Marsch has delineated a different, though related, pattern in Great Britain.[39] The war—and specifically Germany's chemical weaponry that was an outgrowth of the colorant and pharmaceutical industry—spurred Great Britain to seek increased independence from German colorant and chemical imports by fostering the growth of domestic industry, though modeled on the research and technical structure of Germany. These developments in Britain also influenced industrial changes in the United States, where corporations such as E. I. du Pont de Nemours and Company followed this model in the 1920s by developing its own domestic chemical products based on German innovation while attempting to avoid control by foreign interests. As Wilkins explains, "Du Pont wanted German technology, yet it did not want to be in any way junior to the Germans. It wanted to be informed. It was ready to cooperate only on its own terms. It was fiercely competitive. DuPont was far happier cooperating with the British or the French chemical industry than with the German one."[40] For these reasons, to break into the film-stock industry and to find an outlet for the excess nitrocellulose it was producing as a by-product from it synesthetic textiles and explosive divisions, DuPont partnered with Pathé in 1924, forming the DuPont-Pathé Film Manufacturing Company, to produce color and black-and-white film stocks. In these ways, such international constellations become vital for the expansion of color film technologies during the decade.[41]

An examination of the global restructuring of the colorant industry in the 1920s makes it clear that a highly advanced process of knowledge transfer was emerging across the industrial field. Increasingly, the colorant industry became globally interconnected and intermedial in how it modernized a range of chemical products emerging from innovations in Germany. Wilkins delineates this process in the U.S. context:

> The German chemical companies brought to America their experience and introduced to Americans state-of-the-art "high technology" products. The companies dispatched German chemists to America, who trained Americans.

They hired German immigrants already in the United States, many of whom had gone to Germany for their education. . . . The German chemical companies in America transferred to the country new products and generated a demand for these goods. There was a transfer of technology—albeit . . . American companies faced major obstacles in absorbing, learning, and adopting the new technologies.[42]

This difficult but steady absorption of German chemical ingenuity and corporate structure drove the color boom of the 1920s by making color competitive through increased global production and more affordable dyes in the marketplace.

In the film industry, these developments affected not only the types of dyes used on films during the decade but also the transfer of technical knowledge and skills among a network of technicians and researchers that dynamized the innovation of photographic color processes. A variety of earlier color film processes had been developed prior to the war, the best known being William Friese-Greene's various systems, Kinemacolor, and the first Technicolor additive process. These color systems were remarkable but also by and large difficult and unwieldy two-color additive systems that required complex equipment to capture as well as project color images. Because of these complications, they were never widely adopted, though Kinemacolor was the most successful in both the UK and the United States.[43] The development of subtractive color processes became the focus of innovation at the end of the 1910s and throughout the 1920s, and key aspects of this work can be connected to the transfer of knowledge that was occurring after the war. While earlier additive systems were complex at the level of the apparati deployed for image capture and projection, subtractive systems required a new level of chemical complexity within the emulsion of film, and mastering these systems necessitated increased technical expertise. The three comparative case studies that follow—of Eastman Kodak, Pathé, and Technicolor—illustrate this international diffusion of knowledge and expertise throughout the film industry.[44]

The Kodak Research Laboratories

Eastman Kodak's production of color film stock was directly affected by the shifting contours of international trade during World War I. With the disruption of Germany's global exports, Kodak turned to U.S. producers to source aniline dyes for film tinting, and the company largely continued this practice after the war. More importantly, in terms of industrial research, Kodak was at the forefront of technical and chemical innovation in the United States during the 1910s and 1920s, largely through the work of the Kodak Research

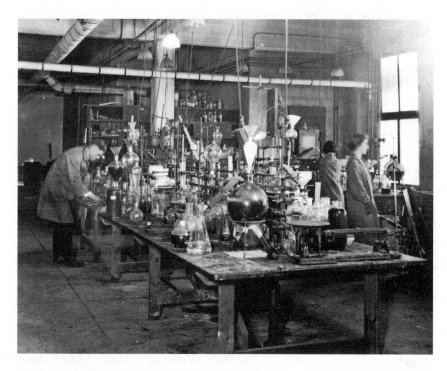

Figure 1.4 The Kodak Research Laboratories (1921).

Courtesy of Kodak.

Laboratories. The company founded the labs in 1912, creating one of the first industrial research facilities operating in the United States that by and large followed the German model of institutionalizing and professionalizing research and development work. As its founding director Kenneth Mees recalled in 1947, the facility was based in part on the industrial research program of General Electric (though more autonomous within the corporation than the GE "demand-based" labs, as Luci Marzola points out) and especially on "the laboratories of the great German dye works," in particular the Bayer Company.[45] Research laboratories increasingly were comprised of university-trained researchers, at times with ongoing academic affiliations, who were also interconnected across corporations through research societies, such as the International Commission on Illumination. This academic approach to industrial research is fundamentally different from the earlier models of invention that tended to focus on a single genius inventor, as epitomized by Thomas Alva Edison, the Wizard of Menlo Park—even if, as is well known now, Edison was a figurehead for the work of many of his technicians, particularly in the case of film.

The Kodak Research Laboratories closely followed international technical developments and research methods. Mees, for instance, was British, educated at the University of London; Kodak hired him from the London firm Wratten and Wainwright, Ltd., where he was a co-owner. Mees's work at Wratten and Wainwright focused on the development of panchromatic stocks and aniline-dyed color filters for balancing light temperatures in photographic work; the numbering system he developed at the company for grading the filters, "Wratten numbers," is still in use today.[46] His first major publication on color, *The Photography of Coloured Objects*, derived from this research.[47] It was this innovative work that led Kodak to acquire the entire company in 1912 as a means of recruiting Mees to Rochester, New York, where he took over the Kodak's research division until his retirement in 1955. Mees wrote extensively about industrial research and laboratory organization, particularly in the early years of the laboratories.[48] In these early writings, color features prominently, particularly in the charts used to delineate the organization of research at Kodak: dyes, color filters, colorimetry, and color-sensitive materials were all investigated in relation to physics, chemistry, and optics.

In order to master these various areas of research, Mees brought together and managed a remarkable team of university-educated scientists such as John G. Capstaff (Armstrong College, now Newcastle University), hired by Mees from the UK, and Loyd Jones (B.S. and M.S. in Physics, University of Nebraska), recruited in 1912 from the U.S. Bureau of Standards, where he had worked on a variety of projects related to standardization, colorimetry, and visual sensitivity.[49] As Mees's obituary notes, he "gathered around him a brilliant staff, and inspired them with his remarkable philosophy, which was a blend of pure, unfettered intellectual research, and the practical down-to-earth development of the fruits of this research."[50] Under Mees, Jones became Kodak's chief physicist in charge of research in 1916, a position he maintained until his retirement in 1954. Growing out of their earlier work, Mees, Jones, and Capstaff, together with the rest of the lab, innovated a range of color technologies and standards at Kodak throughout their careers, particularly with their work on Kodacolor, Kodachrome, and Kodak's various pretinted film stocks in the 1920s, including Sonochrome. A fitting graphic emblem of the Research Laboratories' technical organization can be found in Mees's 1917 article on research laboratories, which outlines the expertise in physics, chemistry, and photography required for running a research facility such as Kodak's, with colorimetry playing a key role.[51]

Mees marshalled a wealth of international expertise for this work and guided the Research Laboratories not only to follow closely international technical innovation but also to shape it. This was carried out in part through the close participation of laboratories' technicians in national and international research associations such as the Optical Society of America, founded in 1916 in response to the war, under the leadership of Kodak researchers Perley Nutting

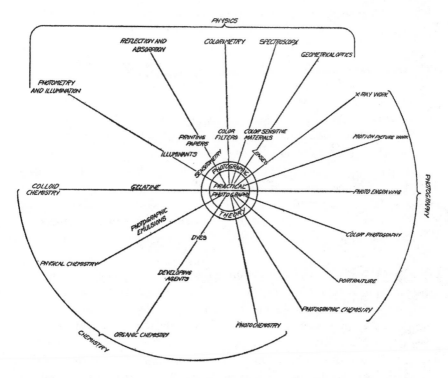

Figure 1.5 Kenneth Mees's outline of the areas of photographic inquiry carried out by the Kodak Research Laboratories, in "The Production of Scientific Knowledge," *Science* 46, no. 1196 (November 30, 1917).

and Loyd Jones, to promote U.S. innovation in optics as a means of countering Germany's technical dominance.[52] Still in existence today, it was conceived as a scientific society that comprised academics and industrial researchers, and numerous figures from the film industry were closely aligned with it, including Nutting and Jones (who served as its president in 1930–1931) as well as Mees, Capstaff, and Leonard Troland of Technicolor (who served as its president in 1922–1923). Kodak researchers were also closely aligned with other research societies such as the U.S. National Bureau of Standards (where Perling and Jones had previously been employed), the International Commission on Illumination, the Inter-Society Color Council, and of course the Society of Motion Picture Engineers, whose founding bylaws of 1916 included as a primary goal increased standardization in the film industry.[53] Through active participation in organizations such as these, and with the network of researchers they brought together, Kodak became a major collaborative force in developing color knowledge across international fields in the 1920s, particularly in the area of colorimetry. In his study of colorimetry during the interwar period, Sean

Johnston describes this cooperative approach to color research in the industrial and scholarly fields:

> In the post First World War political climate, such technical panels embodied growing efforts to improve the cooperation of science and technology on an international scale. The war had demonstrated the benefits of national organization in and between technologically intensive industries; after the war, these concerns shifted from military to commercial competition. The new committees sought the consensual solution of pressing industrial problems and the promotion of scientific activities by rationalizing standards. The situation for light measurement was a particular case of the increasing bureaucratization of international science.
>
> The case of colour measurement highlights how this new bureaucratization operated. During the 1920s, the problem of quantifying colour came to the fore.[54]

The effects of Kodak's participation in these national and international societies can also be seen in the specific research that its laboratories carried out, as documented in its published journals, *Abridged Scientific Publications* (beginning in 1913) and *Monthly Abstract Bulletins* (beginning in 1916). *Abridged Scientific Publications* collected research articles published by the laboratories, while *Monthly Abstract Bulletins* reviewed and summarized technical developments and patents from around the world. Read together, these journals provide a complementary and interrelated perspective on the inward as well as outward research going on at Eastman Kodak, as the innovative work the company was carrying out in its Research Laboratories and documented in *Abridged Scientific Publications* was inseparable from the study and absorption of international technical and scientific developments reviewed in *Monthly Abstract Bulletins*. Within these journals, one can trace the development of Kodak's color technologies from the 1910s into the 1920s and beyond, along with its investigations of international patents and research developments, particularly of German, British, French, and U.S. origin.

The *Monthly Abstract Bulletins* were divided into five sections covering a range of innovations in photography, physics, chemistry, technology, and international patent summaries. For example, in one entry just after the war that abstracts a German article regarding the current state of research laboratories (specifically of the electrical engineering firm, Siemens and Halske, today Siemens AG), the *Monthly Abstract Bulletins* translates and summarizes:

> The shortage of raw material, the use of substitutes, the change of the sales territory, increased requirements of the buyers and the absence of skilled labor during the war have placed the German industry face to face with several tasks which could have been solved only with the co-operation of the industrial

ABRIDGED

SCIENTIFIC PUBLICATIONS

FROM THE

RESEARCH LABORATORY

OF THE

EASTMAN KODAK COMPANY

1913-1914

PUBLISHED BY THE

EASTMAN KODAK COMPANY

ROCHESTER, NEW YORK

Figure 1.6 Kodak's *Abridged Scientific Publications*, beginning in 1913.

Monthly
ABSTRACT
Bulletin

January, 1917

Issued by the Research Laboratory
EASTMAN KODAK COMPANY
Rochester, New York

Figure 1.7 Kodak's *Monthly Abstract Bulletins*, beginning in 1916.

laboratories. The required results would have been carried out with less dif-
ficulty, better, quicker, and more cheaply if these laboratories had been suit-
ably installed for the purpose. New conditions and peace will bring new tasks,
preparations for which should be made at an early date.[55]

With the aftereffects of the war being felt industrially around the world, Kodak
was clearly following international research developments. During and imme-
diately after the war, the patent summaries were largely dominated by U.S. and
British research; in October 1919, fifty U.S. patents, seventeen British patents,
but only seven German patents were summarized. By the 1920s, however, these
numbers began to shift dramatically; in June 1920, fifty-two of the patent sum-
maries were American, thirteen British, and thirty-nine German, indicating
the reemergence of German industry in the film and photography fields. These
numbers shifted monthly in the 1920s, but Germany's technical and chemical
innovation continued as a major focus throughout the decade.

Under Mees's guidance, the film and photographic topics summarized in
the *Monthly Abstract Bulletins* were broad ranging—from tripod heads and
Carl Akeley's innovations in camera technologies to the nitrate industry in
Chile to developments in aerial photography. Thus, the journal provides a cross
section of technical development during the period, but within this, on almost
every page during the late 1910s and 1920s, color features prominently. New
innovations in tinting and toning formulas from Europe and the United States
were outlined; patents filed by Technicolor, Kodak, Gaumont, and a variety of
German firms for various color systems were detailed; and essays on the physi-
ology of color perception—for instance, by Harvard professor and Technicolor
engineer Leonard Troland—were summarized.[56]

From the remarkable overview of research and development during the
period provided by Kodak Research Laboratories' *Monthly Abstract Bulletins*,
one can map the ways in which international innovations and new technical
standards permeated the industrial field of the time. Further, by comparing
the journal to Kodak's *Abridged Scientific Publications*, one can see how knowl-
edge transfer also produced the technical basis for new innovations in chro-
matic technologies at the company. Over the same period in which the Kodak
researchers were reviewing international technical and chemical developments
on color, they were also carrying out their own well-known innovations in film
and photographic technologies and publishing widely about them, as summa-
rized in the journal. Mees wrote articles on the laboratories' development of
the Kodachrome process.[57] Loyd Jones published on the physiological optics
of two-color perception and on submarine camouflage through physiologi-
cal trickery (a research project he worked on for the U.S. government during
World War I); with Lewis Townsend, he explored the heritage and potentials of
color music with reference to Alexander Scriabin, Mary Hallock Greenewalt,

FIG. 8—This was used on the curtains previous to the feature picture.

FIG. 10—Blended effect used for framing photograph of the star in the feature to follow.

Figure 1.8 Loyd Jones and Lewis Townsend's experiments with projecting color music on theater curtains before screenings, from Townsend and Jones, "The Use of Color for the Embellishment of the Motion Picture Program," *Transactions of the Society of Motion Picture Engineers* 21 (August 1925).

and Thomas Wilfred and describes the experimental projection of colored light onto theater curtains before screenings.[58] Jones's 1913 article on physiological optics is useful for showing the networked and international nature of the research going on at Kodak—and importantly, optics is a field he mobilized in his later discussion with Townsend of color music, referencing standardization research carried out by the Optical Society of America.[59] Displaying a clear sense of the color science of the day, Jones began his earlier essay on physiological optics by noting:

> It is a well known fact in physiological optics that if two or more colors are viewed in rapid succession the resultant sensation will be a color which is a mixture of the colors viewed. For instance, if a disk of which one half is red and the other green be rotated rapidly, the entire disk will appear to be yellow. This mixing is due to what is known as the persistence of vision; that is, the sensation produced by a given stimulus continues to exist for a period of time after the stimulus has ceased to act.[60]

Beyond being versed in contemporary physiology and theory, Jones grounded the study in international color experimentation, using Mees's Wratten filters for the study while also citing research published in German, as well as experimental color work carried out by the British firm of Adam Hilger Ltd., summarized elsewhere in the *Monthly Abstract Bulletins*.[61]

A profound engagement with international technical and theoretical research was at the core of Kodak's innovative work on color in the early twentieth century, and it is these types of technical and aesthetic flows of knowledge that established and standardized the industrial framework of the chromatic world of the 1920s. The approach to industrial research at Eastman Kodak can best be summarized by Mees: "Scientific research is the yeast of business. . . . It leavens the mass, transforming it into a system which results in the continuous production of new and valuable inventions. At the same time, like yeast, science grows as it is nourished by the industry which it is transforming. Thus the association of science and industry strengthens both, and this is reflected in material prosperity and intellectual progress."[62] For Mees, as Marzola delineates, the success of industrial research was based on the open exchange of scientific knowledge: "Mees held the view that confidentiality in scientific research was basically impossible, and he showed little concern about it [. . . and] encouraged his staff to present at conventions of national scientific societies."[63] Based upon its innovative research and development, Kodak flourished in the 1920s even in the face of increased competition from firms such as DuPont. It expanded internationally into France in 1927 with the establishment of Kodak-Pathé, and even into Germany in 1931, through Kodak AG in Stuttgart, with the purchase of the camera equipment company Nagel.

The Cahiers des Ingénieurs Pathé Frères

From Kodak as an exemplar of the industrial research into color taking place in the United States in the 1920s, it is worth shifting national focus for a comparative view, specifically to France and Pathé Frères. As Zunz points out, one of the issues in France that restricted industrial research during the interwar period was that corporate laboratories tended to be more secretive and proprietary than those in the United States and Germany. Even as the French government attempted to encourage industrial and academic collaboration, corporate management tended to resist such moves to protect their intellectual property, making investigation difficult.[64] Fortunately, in the case of Pathé, the recent discovery and preservation of the *Cahiers des ingénieurs*—138 engineering and manufacturing notebooks of the firm—shed light on the company's research into color during the silent era, particularly in relation to its competitor and then partner, Eastman Kodak.[65]

As Stéphanie Salmon has thoroughly examined, a long history of industrial exchange between the two companies preceded the formation of Kodak-Pathé in 1927.[66] Negotiations between Pathé and Kodak date back to the early 1900s, particularly around the establishment of the Motion Picture Patents Company in the United States, which George Eastman was instrumental in convincing Charles Pathé to join in 1908.[67] Again in 1916, Eastman visited Pathé's Vincennes factory on the outskirts of Paris in an attempt to negotiate, unsuccessfully, the purchase of its factory in Bound Brook, New Jersey. Significantly, these maneuvers on the part of Kodak were to keep international innovation in check. George Eastman hoped to hold Pathé within Kodak's sphere of influence for the sale of film stock, thus limiting Pathé's need to produce its own stock and also keeping it out of the hands of Kodak's competitors, Lumière and especially Agfa, both of which were renovating their film-stock lines at the end of the first decade of the 1900s. One can clearly see Kodak's influence at the time in the Pathé notebooks, as Pathé's technicians such as Dubois frequently tested the capabilities of Eastman film stocks, along with the stocks of Lumière and Agfa—all during the period when George Eastman was visiting Charles Pathé in France to negotiate terms for the MPPC in 1908.[68] Pathé was clearly trying to determine technically as well commercially if an agreement should be made.

The engineering notebooks also shed extensive light on the precision of the technical innovations that Pathé was carrying out in its various color processes during the silent era. The notebooks include extensive lab records about the refinement of tinting, toning, and stenciling methods—dye formulas and rich technical details that are worth further study for what they reveal about the international colorant trade before and after the First World War. A telling example is a September 1908 report by the technician Dubois on "organic toning," which

Figure 1.9 Dubois's study of Eastman-Kodak emulsions (June 10, 1908, *Cahier de recherche* no. 33333).

Courtesy of the Fondation Jérôme Seydoux-Pathé.

is a version of dye toning, or "mordanting," in which the film image is bleached and then dipped into a dye that seeps into the emulsion in the darker areas of the image that had been bleached away. Significantly, Pathé was drawing primarily from the German firm of Bayer AG for its toning colorants (for example, for its blue tone number 3, the company used 250 gr. of "Bleu rhoduline Bayer"), with some additional materials sourced from the German firm Farbwerke vorm. Meister Lucius & Brüning AG, aka Hoechst AG (for blue tone number 1, "Bleu de méthylène B.B. [Meister Lucius]").[69] Given Germany's preeminence in the colorant field before the First World War, it is of little surprise that German chemicals were dominant in Pathé's colorant laboratory. As Alan Milward and S. B. Saul explain regarding the colorant situation in France before the war, "By 1914 only 11 percent of the synthetic dyestuffs consumed in France were produced there, the rest were imported from Germany or Switzerland; and of the synthetic dyestuff factories only one, the Compagnie des Matières Colorantes de St Denis, was French, the rest were German-owned works."[70] After the war, Pathé began to test a more diverse range of non-German colorants from sources such as the Swiss Geigy Company of Basel and the French St. Denis company.[71]

Also of interest regarding the international nature of tinting and toning experimentation at Pathé are the technician Pinel's reports in August 1924. Chemical sources are not listed, but the report reveals how the company was systematically examining and charting the recipes by Kodak and Agfa, among others, in relation to its own, thus tracking closely developments in the international field.[72] Other Pathé technicians in the 1920s, such as Vacher, were also

ACTINE et REFERENCES	MORDANT	MORDANÇAGE	BAIN de TEINTURE	OBSERVATIONS
			Pour 200 l.	
Eastman 1918: Tinting and Toning of Eastman Positive motion Picture Film.	Ferrocyanure d'argent et de cuivre	Sulfate de cuivre 800gr, Citrate neutre d'Am. 500gr, Ferricyanure K 800, Carbonate d'Am. 400, Eau p.f. 200	Ton J : Rouge.- Safranine A (NAC) 200gr +Ac.acétique glacial 1000cc; Ton K : Orange.- Chrysoïdine 3R(NAC) 80gr +Ac.acétiqueglacial 1000cc; Ton L : Violet.- Violet méthyl (NAC) 80gr +Ac.acétique glacial 1000cc	Durée de mordançage: 5 à 10'; Suivi de lavage 10'; Durée du virage 10'; Suivi de lavage 5 à 10'
Eastman 1922: Tinting and Toning of Eastman Positive motion Picture Film	Ferrocyanure d'argent et de cuivre	Nitrate d'urane, Acide oxalique, Ferricyanure K, Eau p.f.	Pour 200 l. Colorant 40%+ac.acétique 100%; Ton Rouge.- 320gr Safranine A (NAC) 160; Ton orange.- 160 Chrysoïdine 3R(NAC) 200 l. Acridine orange (NAC); Ton Jaune.- Auramine 2209 (K & C°) Phosphine (NAC); Ton Vert.- Vert Victoria (NAC) Vert Malachite (NAC); Ton bleu.- Bleu méthylène BB (NAC) Bleu Victoria (NAC); Ton Violet.- Violet Méthyl (NAC)	Durée du mordançage: 1 1/2 à 2'; Suivi de lavage 10 à 15'; Durée du virage 2 à 15'; Suivi de lavage 5 à 10'

Figure 1.10 Pinel's comparative study of tinting formulas by Kodak (August 18, 1924, *Cahier de recherche* no. 33691).

Courtesy of the Fondation Jérôme Seydoux-Pathé.

looking comparatively at tinting to figure out new ways and mechanisms for the rapid application of colorants at Pathé-Cinéma, and he sketched out new technical systems in his notes from October 17, 1923.[73] Significantly, if one looks only a few pages and days later in the notebooks, to October 31, 1923, it is clear that Vacher was carrying out international research on parallel developments, as he provides a close analysis of U.S. patents that overlap with his early sketch for rapid tinting.[74] This type of research thus parallels what is found in the Kodak lab journals regarding keeping up to date on international patent innovations in order to spur in-house development.

With regard to photographic color systems, it is worth noting that Technicolor's J. A. Ball and Kodak's Loyd Jones both make appearances in the Pathé notebooks. Barbier's reports from the Society of Motion Picture Engineers conference in the United States in May 1924 detail Ball's early work at Technicolor, as presented at the meeting—though Ball could not attend and sent his paper to be presented by someone else who, according to Barbier, unfortunately read it so poorly that it was completely unintelligible.[75] Six months earlier, at the Society of Motion Picture Engineers conference in Ottawa in October 1923, Barbier's reports reference Jones on the "Thermal Characteristics of Motion Picture Film."[76] These examples illustrate the ways in which Pathé's research laboratory was becoming internationalized and outward looking.

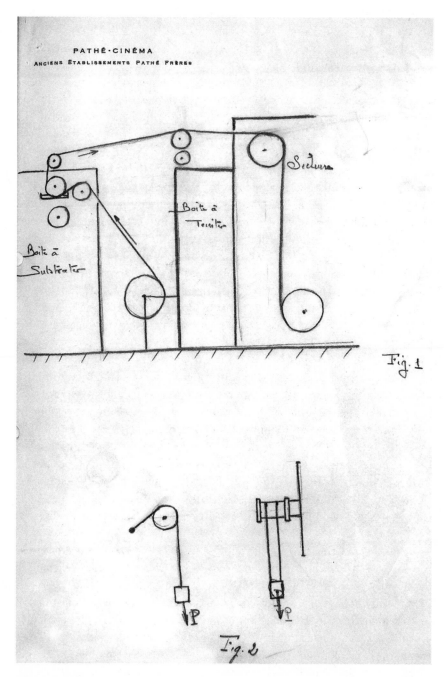

Figure 1.11 Vacher's sketches for a rapid tinting machine (October 17, 1923, *Cahier de recherche* no. 33926).

A final case in point is worth examining with regard to the relationship between Kodak and Pathé around color processes during the era.[77] In her industrial biography of George Eastman, Elizabeth Brayer discusses the development of the Kodachrome process in Kodak's Research Laboratories in the 1910s. Significantly, Kodak devised the process in reaction to international innovation, specifically by Pathé. Brayer quotes an internal report from George Eastman in January 1914 noting, alarmingly, that Pathé "is about to bring out a color process which will revolutionize the industry. . . . Invented by a man named Berthon . . . the colors are in the film, reproduction is simple . . . finished positives costing scarcely anything extra for color . . . and projected by any machine with trifling alterations . . . on the market in four months."[78] Brayer then explains that "Eastman stepped up in-house efforts and by the fall of 1914 John Capstaff had devised a two-color subtractive process that produced seductive portraits but unsatisfactory colors for landscapes. Known by a new trademark—*Kodachrome*—the negatives were taken through red and green filters and transformed directly into positives."[79] Rodolphe Berthon was a Lyons engineer and astronomer who had been working on color photography and film since the early 1900s. He drew from the work of Gabriel Lippmann to develop a lenticular system of color photography, for which he applied for patents in France, the UK, and the United States in 1908 and 1909. According to the research of François Ede, Berthon worked with the industrialist Albert Keller-Dorian in the 1910s and 1920s to apply his lenticular system to film.[80] Before the rediscovery of Pathé's engineering notebooks, the known connection between Keller-Dorian and Kodak was specific to the 1928 development of Kodacolor for amateur 16mm color cinematography, which was thought unrelated to Pathé. The Société du Film Keller-Dorian struggled throughout the late 1920s to turn a profit with its color technology; to make up for losses, in 1928 it sold patents to Eastman-Kodak, which became the foundation for Kodacolor. According to Kenneth Mees in Kodak's *Abridged Scientific Publications*, discussions about patent sales between Keller-Dorian and Kodak had been going on since 1925.[81]

Pathé's engineering notebooks further illuminate the history, specifically in relation to Brayer's comments about Pathé's involvement in these exchanges dating back to 1914: it was not just Kodacolor that was connected to French color innovation, but also Kodak's earlier subtractive two-color process, Kodachrome, from 1915. Kodachrome was not based on Berthon's lenticular system but was motivated by it, as Capstaff's earlier 1913 innovations at Kodak for subtractive color photography were hurriedly adapted for cinematography in 1915. The Pathé notebooks confirm this and add another chapter to the history of Berthon. Before working with Keller-Dorian, and after working with Maurice Audibert, Berthon worked at Pathé trying to implement his color patents between 1913 and 1914, which is documented through the large notebook

of his reports regarding his experiments with color cinematography and other technical matters for Pathé.[82] It was this work that pushed Kodak competitively to bring the Kodachrome process to market in 1915.

The history found in the engineering notebooks adds significant details about the long relationship of Pathé and Kodak and the types of corporate as well as research exchanges that were occurring. The back-and-forth interrogation of international patents, especially around color technologies beginning in the 1910s, is what led to the massive expansion of photographic color processes in the 1920s. In comparison with Kodak's two in-house journals founded in the 1910s, *Abridged Scientific Publications* and *Monthly Abstract Bulletins*, Pathé's engineering notebooks are not as formally polished and published, as they were proprietary in the French industrial mode of the time. But they are also incredibly well organized and convey similar intentions—to formalize international research strategies for industrial innovation and document breakthroughs in an era not only of expanded invention but also of international litigation. Coming out of the patent battles of the first decade of the 1900s, when Edison was filing lawsuits against everyone else in the film industry for patent infringement, these documents were meant not to conceal technical secrets but rather to protect and enable invention, as the rate of laboratory innovation greatly accelerated in the scientific modernity of the early twentieth century.

Technicolor Research

A final comparison is worth making with the Technicolor Motion Picture Corporation, as similar patterns of professionalized research and international development can be traced from the company's founding in 1915 and throughout the 1920s as it developed its subtractive color processes, Technicolor systems #2 and #3. Technicolor was significantly smaller and more focused than Kodak and Pathé in its pursuit of a functional and lucrative color system for the film industry, but it was well funded for a firm of its size. Like Kodak, Technicolor grounded its technical innovations on the professionalization of research. Famously paying homage to their alma mater MIT in the naming of the company—"Techni" coming from the Massachusetts Institute of Technology's student yearbook, *Technique*—Daniel Comstock and Herbert Kalmus, along with inventor W. Burton Wescott, organized the company to draw heavily from the academic sector. Comstock and Kalmus had both earned B.S. degrees in 1904 from MIT, where they became close friends studying with Willis Whitney, who was both a professor and the lead researcher for the GE Research Laboratory. After MIT, on the advice of Whitney, they both studied abroad in Switzerland to earn their doctorates—Kalmus from the University of Zurich, after first studying in Berlin, and Comstock from the University of Basel. They returned

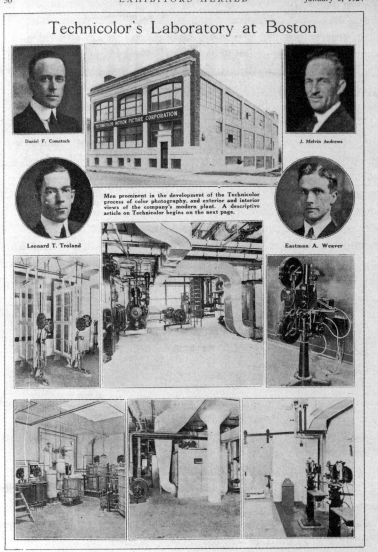

Figure 1.12 Overview of Technicolor's lab and staff, "General Use of Color Photoplays Seen in New Development," *Exhibitor's Herald* 18, no. 2 (January 5, 1924): 50.

to the United States and took up academic posts, both initially at MIT, and then Kalmus moved to Queen's University in Kingston, Ontario. Kalmus held his post until 1915 and Comstock until 1917, when each committed fully to their ongoing corporate collaborations. Comstock and Wescott (a mechanical engineer, though without advanced degrees) founded Comstock and Wescott, Inc., in early 1912 as an engineering research firm; it became Comstock, Kalmus, and Wescott, Inc., in late 1913 when Kalmus joined.[83] The company researched and consulted on a range of technical devices, but beginning in 1912, the primary project that it turned to was photographic color film, and by late 1914, the company and its investors formed the Technicolor Motion Picture Corporation to focus its research and development.[84] From the outset, Comstock, Kalmus, and Wescott, Inc., developed and innovated the various technologies that Technicolor exploited commercially, a symbiotic corporate relationship that lasted until 1925, when Comstock and Wescott split from Kalmus over managerial differences, with Kalmus retaining control over Technicolor.[85]

Parallel to the professionalization of the Kodak Research Laboratories, the success of Technicolor was grounded in the talent of the technicians that Comstock, Kalmus, and Wescott recruited from the academic sector. They included engineers such as the British chemist Edward J. Wall, hired in 1916, who was a professor at Syracuse University; Joseph A. Ball, also hired in 1916, who had just graduated from MIT with a B.S. in physics; and Leonard Troland, hired in 1918, who completed his B.S. in biology at MIT in 1912 (taking courses with Comstock) and went on to complete his Ph.D. in psychology in 1915 at Harvard.

Troland's career in particular is worth focusing on with regard to the company's attention to international research trends. During the 1915–1916 academic year, he was a Harvard Traveling Fellow at General Electric's Nela Park Research Laboratory in Ohio, where he began investigating the physiological aspects of vision (color perception, afterimages, flicker effects), along with his ongoing research into psychophysics, metaphysics, and the occult (psychic phenomena, telepathy, ESP, and conjuring); his work was also read with enthusiasm by Theosophists of his day.[86] Troland returned to Harvard in the fall of 1916, becoming the Richard Hodgson Fellow in Psychical Research and an instructor of psychology based in Hugo Münsterberg's psychology lab, and in 1922 an assistant professor. It is unclear if Troland studied with Münsterberg for his Ph.D., though they certainly knew each other on Troland's return to Harvard, overlapping in the psychology lab during the fall of 1916. As Troland's contract was finalized, Münsterberg even forwarded him a copy of his recently published *The Photoplay: A Psychological Study* on April 30, 1916: "I take pleasure in sending you today a little book from the periphery of the field of optical psychology, a study of the photoplay. I become more and more interested in this art of the film."[87] Though they would share a profound interest in film and psychology, based on the correspondence, Münsterberg was concerned that

Troland's psychic research would harm the lab's reputation and tried to block some of that research; Münsterberg was overruled.[88] Ultimately, they would overlap in the lab for only a few months because of Münsterberg's untimely death in December 1916.

During his research at Harvard, Troland concurrently joined Comstock, Kalmus, and Wescott, Inc., as chief engineer in 1918. From his start at the company, he focused largely on developing the imbibition printing system for Technicolor system #3, though he also worked on a range of innovations, including monopack color stocks, and theoretical research that he prolifically published. When Comstock, Kalmus, and Wescott split in 1925, Troland continued with Kalmus at Technicolor and was promoted as the company's director of research; there, along with continuing his work on imbibition printing, he was largely responsible for investigating competing technologies and patents domestically as well as internationally. As Troland recounts in his research journal from March 11, 1926, "Dr. Kalmus tells me of the plans to push Technicolor extensively in Europe, and asks for data on our patent situation," and in the ensuing years, one can find entries on his examination of, among others, Kodacolor, Prizma, DuPont, and Gaumont technologies and patents.[89]

While working officially for Comstock, Kalmus, and Wescott, Inc., Troland was able to remain in the Boston area to maintain his ties with Harvard, but the transfer to Technicolor, which was by then centered in Los Angeles, reduced his ability to juggle his many commitments, and he eventually resigned his academic post in 1929. A letter from Kalmus calls attention to the difficulty of this decision for Troland. Illuminating the personal complexities of corporate-academic collaborations at the time, Kalmus notes that he does not want to get "into the Harvard situation again at length" with Troland:

> I have already iterated and reiterated that my experience satisfies me that a double connection with an active industry and with a University or technical school invariably works out unsatisfactorily to one or the other of the two connections. I can remember when Dr. Whitney, head of the General Electric laboratory, tried to do both. He had to give up his Technology connection. . . . Both Comstock and I tried it, etc. for a long list. Not only has it considerable to do with energy and hours, which we have already discussed at length, but it has even more to do with attitude and point of view or with freedom to move from one place to another for moderate periods of time practically without notice. . . . The practical point, however, my dear Leonard, is that a decision must be made and in this instance I prefer to leave that decision to you.[90]

With Kalmus likely still feeling the repercussions of the break with Comstock and Wescott, it is clear that he was attempting to apply careful pressure to Troland to give up Harvard and commit himself fully to Technicolor, as he

ultimately did. Even if industrial and academic crossovers such as Troland's could be rich and vital for industrial research and development, as Kalmus's letter reveals, the time constraints and differing aims were difficult to negotiate.[91]

The knowledge base that Troland gained and expanded through his Harvard affiliation was immense and profoundly influenced his work on color, both theoretically and technically, through his engagement with international color technologies and patents. Particularly in his theoretical writings, one can see the ways in which his academic grounding in psychology helped adapt aesthetic and theoretical knowledge about color, particularly of German origin, into the industrial sector. As Sean Johnston has delineated, Troland's physiological and chemical research was crucial to the innovation and standardization of industrial color practice during the 1920s.[92] This can be particularly seen in his work with the Optical Society of America, where he was intimately involved with the Society's Committee on Colorimetry and authored its influential 1922 "Report of the Colorimetry Committee of the Optical Society of America," with the collaboration of Loyd Jones and others.[93] In the extensive report, Troland worked through the color systems of Munsell, Ridgeway, and Ostwald, seeking to establish a coherent system of quantifying color for industrial application. Troland's contribution to the committee as a psychologist was vital, as it was otherwise comprised entirely of physicists who approached color as an optical phenomenon in ways broadly in line with a Newtonian view, seeing color as an aspect of light rather than a perceptual-physiological phenomenon. As Johnston details, Troland, particularly with his background in the German theories of perception that Crary maps out in *Techniques of the Observer*, was crucial in introducing a psychophysiological perspective into the Colorimetry Committee, which sought to balance optical approaches to standardization with physiological ones. Troland's perspective was moderated through Gestalt psychology as well as Hermann von Helmholtz, whose theory of trichromatic vision in the 1850s was central to the emerging discipline of physiology as well for the development of additive and subtractive color systems.[94] The blending of optical and perceptual approaches to color that Troland brought to the committee can be seen from the outset of his 1922 report, in which he defines color as "the general name for all sensations arising from the activity of the retina of the eye and its attached nervous mechanisms, this activity being, in nearly every case in the normal individual, a specific response to radiant energy of certain wave-lengths and intensities."[95] Establishing ways of standardizing those wavelengths and intensities for industrial application then became the focus of the report, but Troland's continued emphasis on psychology and physiology in the 1920s became increasingly important for expanding the committee's approach to colorimetry. Beyond studying the optical nature of color, it also took into account color's perceptual aspects, thus combining objective and subjective approaches to colorimetry.

Troland's psychophysiological approach not only influenced domestic industrial applications in the United States during the 1920s, but also shaped international color standards. In 1913, the International Commission on Illumination (CIE) was established to help coordinate uniform standards of artificial lighting and color around the world. Its official languages were initially French, German, and English, but during and following the war, German was dropped, and German researchers were by and large ostracized from the commission during the 1920s. As Johnston explains, "in 1919, the International Research Council, sponsored by the Allies, had advocated policies of ostracism for German scholars. This exclusion was in effect during the formative years of the CIE. German attendance at conferences and commissions such as the CIE was almost nil early in the 1920s, and only increased in 1926 when the IRC lifted its bar against the Central Powers."[96] Because of this exclusion of German researchers, U.S. as well as British methods of colorimetry came to dominate. Troland's approach was crucial for navigating between optical and perceptual approaches to the matter, a psychophysical approach that eventually came to dominate CIE and the establishment in 1931 of the CIE color space, which continues to affect color standards and define digital color formats today.[97]

Beyond Troland's importance within the international field of colorimetry, his work at Technicolor illustrates the overlapping fields of industrial and cultural production in the 1920s. The focus of this chapter has been on the ways in which new structures of industrial research and knowledge enabled innovative forms of color technologies to emerge out of the aniline industry, specifically the various subtractive processes in the 1920s that were profoundly complex in chemical and technical composition. Troland was at the epicenter of these transformations in both the industrial and cultural fields. His theoretical straddling of the divide between the optical and physiological aspects of colorimetry was essential for Technicolor innovation, particularly as the company turned to two-color subtractive processes in the early 1920s. The technical detail of these systems was profound, requiring all of Troland's expertise to finesse them into workable systems of dyes, prisms, gears, and nitrate. Close attention to the optics of color was obviously essential for this work, as Troland's Technicolor diaries illustrate in their detailed critiques of Technicolor as well as various other color systems and patents. A two-color image cannot reproduce a full spectrum of color only through red and green filters. To fake it, to trick the spectator's eye to sense color that is not optically there—a blue sea in *The Black Pirate* (1926) or Gershwin's *Rhapsody in Blue* in *The King of Jazz* (1930), both of which could actually only be shown in Technicolor shades of turquoise—also required attention to the psychology of vision, how colors feel even when they are absent and appear where they are not. This was where Troland's genius lay, working out the technical and chemical problems of the systems' optics as well as their perceptual ones in the research laboratory of Technicolor.

Figure 1.13 Leonard Troland's Technicolor notebook covering patent research. Technicolor Online Research Archive.

Courtesy of the George Eastman Museum.

Figure 1.14 Section 8 on "Coloring" patents from Troland's Technicolor Notebooks. Technicolor Online Research Archive.

Chromatic Networks

From the perspective of the end of the 1920s, color had come to dominate industrial and artistic design during the decade, and cinema was one of the exemplars of the era's surging chromatic culture. A central reason for this, as the present chapter has traced, is the way in which cinema's industrial configuration, and in particular its various research laboratories and scientists, played a central role in innovating and standardizing color technologies for the emergent mass culture. Given our primary emphasis in this chapter on the industrial field, it is important to see how the actual products—the films—demonstrated these chromatic innovations. There will be an increased emphasis on this in the following chapters, but as a closing example, we turn to *The Taming of the Shrew* (Sam Taylor, U.S., 1929) with Mary Pickford and Douglas Fairbanks, the only feature film in which they costarred and one of the few sound films each would make at the end of their careers. The film is by no means a high point of film coloring in the 1920s. It is instead a relatively mundane and monochromatic example, but its production history with regard to color brings together many of the industrial threads and chromatic networks discussed throughout this chapter.

The farcical costume drama was promoted heavily, and in its early stages was even planned as a "talker in color," specifically two-color Technicolor, which Fairbanks was well acquainted with from *The Black Pirate* (1926).[98] The Shakespeare adaptation, however, had to be filmed in black and white because in 1929 with the success of Technicolor's third system, its two-color imbibition process, demand for Technicolor had expanded beyond the company's production capacity. As Kalmus explained in a letter to Troland, the key developer of the imbibition process:

> Such is the state of camera shortage in terms of work on hand that we have been obliged to disappoint Mr. Fairbanks and refuse to take the Pickford-Fairbanks pictures. Later they said they would be satisfied if we would do a short sequence at the end and only by the most awkward rearrangement of our time and inflicting a penalty on our other customers, are we able to do the work, tests of which we are doing tonight during the small hours.[99]

The Technicolor ending of the film did not materialize, and though the film was far from a flop, it is not widely remembered today.[100] However, in a 1930 article on "The Evolution of Film," Kodak curiously cited the film for its use of color, specifically for incorporating the company's Sonochrome colored stock in release prints: *The Taming of the Shrew* "used a single, uniform tint throughout to suffuse the picture with a warm Italian atmosphere."[101] As detailed earlier,

K. O. Rahmn

DOUG AND MARY—TOGETHER!

Here they are, alone at last! Mr. and Mrs. Douglas Fairbanks of Beverly Hills, California, offer their first co-starring motion picture, "The Taming of the Shrew," an all-talker, from the comedy by W. Shakespeare. The scene shows Doug as *Petruchio* and Mary as the capricious *Katherine*.

Figure 1.15 *Taming of the Shrew*, "Doug and Mary—Together!" *Screenland* 19, no. 6 (October 1929): 77.

films had been tinted since the 1890s, and beginning in the 1910s, companies such as Kodak began to sell pretinted stocks. According to "The Evolution of Film," tinting provided films "greater expressiveness and the more pleasing appearance on the screen made possible by the addition of hues," though curiously enough *The Taming of the Shrew* apparently restrained its expressiveness to only one hue.[102]

With the coming of sound, and specifically sound-on-film prints, film tinting had proven problematic. As Kodak explained in "The Evolution of Film," the inclusion of soundtracks set off a myriad of changes in the film industry, "One of the most marked" from Kodak's perspective was

> to throw out the tints that had been almost universally used for motion picture prints in the preceding years and to bring in the original black and white instead. The reason for this was that the tints then in existence had a strong tendency to interfere with the passage through the sound track of the light to which the photo-electric cells were most sensitive. As a result, tints in prints seriously distorted the sound reproduction. Consequently tints were abandoned.[103]

Rather than abandoning its product line of tinted stocks, Kodak instead recalibrated it in 1929, deploying its Research Laboratories, and in particular Loyd Jones, to refine the aniline colorants used in its stocks so as not to interfere with the soundtracks of positive prints. Once this work was completed, the company, as well as Jones, began to promote the technical achievements of the stock in an attempt to sway the industry back to tinted films through a series of advertisements and articles, including "The Evolution of Film."[104]

An important context for this technical development was the expansion of color in commodity and media production throughout the 1920s—a "chromatic revolution," as commentators noted.[105] Cinema was vital to this transformation, industrially as well as aesthetically. The scientific research into color carried out by the film industry led to a range of new standards for application and design, and Technicolor's third system in 1928 was a benchmark of industrial innovation. Given the technical precision of the imbibition dye-transfer process, Technicolor was able to keep its dyes isolated to the image without seepage into the soundtrack. However, it was an additional expense for producers to use the process, and as Kodak's advertisements noted, one of Sonochrome's main appeals was that it was more affordable: "The public wants color. These positive films supply it, through beautiful, over-all tints—at black-and-white cost. The public's appetite for color has been whetted. Colored Pictures are the cream of the show."[106] Thus, film producers could appeal to the color craze that was expanding at the end of the decade through Kodak's new, more affordable stocks.

Ultimately, Kodak's effort with Sonochrome was only a minor success—much like Pickford and Fairbanks's *The Taming of the Shrew*. The stock worked with soundtracks, but the industry did not return to film tinting in the 1930s in any major way, though as we discuss in greater detail in chapter 6, it remained a minor practice in feature films until the 1960s when Kodak phased out the Sonochrome stock. Pretinted stocks still required splices in a positive print if one were to alternate the colors, and such splices would make optical soundtracks crackle and pop when passing over a projector's soundhead. These problems made the stocks less appealing, and then as well as now, the use of pretinted stocks in the 1930s and beyond was overshadowed by the continued development of Technicolor into its three-strip phase.

The issue of crackling soundtracks is perhaps why *The Taming of the Shrew* was reduced to a single Sonochrome, which is a stark shift from the chromatic hybridity exhibited only a few years earlier in films such as *The Phantom of the Opera* (Rupert Julian, U.S., 1925), as discussed further in chapter 5. Promotion, if not usage, of Sonochrome largely ended in 1930, yet despite its lack of success, the type of technical labor, innovation, and promotion by Kodak is instructive, as it exemplifies the industrial and intensely competitive standardization of color that was taking place in the 1920s. Colorants were constantly being refined and calibrated for new fields throughout the decade across mass media and commodity markets.

In this process, it was not just the technical aspects of new colorants that were being refined; it became vital as well to standardize the meanings and effects of color for the cultivation of new chromatic taste cultures, as we discuss in the next chapter. In these ways, color played a pivotal role in the emergence and proliferation of mass society, bringing together the industrial and affective fields. This industrial emphasis on codifying the meanings of color within the film industry is readily apparent in the work of scientists such as Jones, Troland, and others who were actively in dialogue with one another through institutions such as the Optical Society of America and the International Commission on Illumination. Research into colorimetric values was carried out to help regiment, standardize, and restrain the connotative meanings and physiological effects of color, making it relatively unobtrusive for filmic narration. This is reflected in Kodak's description of the single tinted hue of *The Taming of the Shrew*, which was supposed to "suffuse the picture with a warm Italian atmosphere," yet in its singularity, it could slip unobtrusively into the background of the image and not compete for attention with the narrative. The specific tint used on the film was not noted by Kodak and remains unknown, but the embellished description of the hue is indicative of manuals of color standardization of the period, such as Matthew Luckiesh's influential *The Language of Color*: yellow and orange "are symbolic of light and warmth."[107] Luckiesh's work was well known in the film industry. He was the director of General

Electric's Lighting Research Laboratory at Nela Park, Ohio, and he interacted with researchers such as Troland and Jones through organizations such as the Illuminating Engineering Society; Jones even cites *The Language of Color* in his writings on Sonochrome.[108]

As these networked examples indicate, cinema was vital to the processes of knowledge transfer in the 1920s, both as a chromatic exemplar of the decade's new culture of mass entertainment and as an industrial system that was integrated into broader structures of research and production. As we have largely focused on the industrial field here, what emerges are the ways in which the film manufacturers, and in particular their various research laboratories and scientists, played a central role in innovating and standardizing color meaning and technologies for the emergent mass culture. The new subtractive color systems that developed from this industrial work ushered in a color revolution during the decade, and the networks of knowledge that circulated both nationally and internationally through these research centers—from Germany through Europe to the United States and back—helped new ideas about color flourish. Beyond the technical proficiency necessary to master subtractive color systems, innovative notions about the affective use of color in advertising, fashion, and décor grew influential just as new practices of color design exploded in architecture and the arts. Cinema's prismatic views of the 1920s were shaped by such new aesthetic horizons. It is these types of technical and aesthetic flows of knowledge that established and standardized the industrial framework that enabled the chromatic world of the 1920s to flourish. In the midst of a rapidly expanding color culture in the 1920s, cinema helped codify and instrumentalize color's role in art, advertising, fashion, and design around the world. It is to these fields of cultural and industrial production that we now turn, demonstrating in the next chapter how color's impact on the consumer was increasingly harnessed in the 1920s when film played a critical role in the dissemination of ideas about color consciousness, fashion, and taste.

CHAPTER 2

ADVERTISING, FASHION, AND COLOR

Color cinematography will play a great role in the future, in influencing public taste in the choice of dress, household furnishings, wall and floor coverings; will make the public color conscious, teach them something of color harmony, of the effect of complementaries, altogether have an influence which we who are too close to our subject generally overlook.

—John Seitz, *Cinematographic Annual* (1930)

As a modern ready-made, color's impact on the consumer was increasingly harnessed in the 1920s. Inherent in the drive for industrial standardization in design and production, manufacturers appealed to consumers by drawing on a range of chromatic methods and media through various advertising tie-up campaigns that targeted cinema audiences. In addition to print, film became increasingly important for the promotion of products and fashions, particularly as advertising consultants advocated the advantages of using color in mass marketing campaigns. This chapter illustrates the decade's many examples of film's vitality within a chromatically rich, transnational advertising and fashion culture that was responsive to the growth of mass consumption within the field of cultural production. A network of different groups pioneered new media approaches for advertising color products, entertainments, and artistic expressions, in which fashion in

film played a pivotal role. Fashion refers here to more than dress. As cinematographer John Seitz noted, it also includes home décor, commodity culture, and design, as well as the dynamic commercial environment that was increasingly informed by ideas about psychology and what was at the time termed "color consciousness."

For Pierre Bourdieu, the field of cultural production encompasses both high and vernacular art, what he terms "restricted" and "large-scale" production, each with its own internal economies and audiences.[1] In terms of fashion, the former is characterized by expensive, *haute couture* designs with restricted circulation, and the latter refers to the widely available, off-the-shelf fashions of mass production and consumption. Within each area, competitive forces jockey for dominance, and although distinctions can be drawn between their separate economic drives, both *haute couture* and mass-produced fashions are reducible and interrelatable at a certain level to economies of prestige.[2] As we have seen, Bourdieu offers a general model that is useful for thinking through color's varied impact on the media comprising the field of cultural production in the 1920s. In its demonstration of how color accelerated the reach of fashionable trends associated with *haute couture*, this chapter examines the complexity around the actual operations of fashion as it negotiated between the highs and lows of cultural production. Rather than maintaining a rigid separation between high fashion and mass production during the 1920s, the boundaries between the two were increasingly blurred, and cinema played a crucial role in this development. Advertising media such as film were instrumental in disseminating images of high fashion to a wider audience, inculcating a culture in which luxury design was not exclusive to the upper classes. The marketing of knowledge about color, fashionable clothes, and décor worked to bring the worlds of high fashion and mass consumption closer together, even if at times that relationship could appear strained and unequal. In this sense, Bourdieu's theories of economic and cultural capital can be productively extended to understand how the transmission of taste cultures through film and media is not a static but a dynamic and reciprocal process.

The newly formed mass medium of cinema did much to democratize taste cultures during the 1920s, broadening spectators' horizons to encompass new, fashionable ways of living, dressing, and thinking about color's impact on the physical environment. Miriam Hansen's theory of "vernacular modernism" captures cinema's interrelationship with both high and vernacular forms, arguing that "modernism encompasses a whole range of cultural and artistic practices that register, respond to, and reflect upon processes of modernization and the experience of modernity."[3] Color was central to this mediating process among cultural practices that hitherto had been hierarchically organized, including clothing, architecture, and décor. Although standardization was driven in part by economic and corporate concerns, at the same time it

enabled individuals to negotiate modernity through the acquisition of chromatic competences. As argued by New York art lecturer and self-proclaimed color consultant Louis Weinberg, knowing about color was a marker of taste that gave individuals power in making choices for clothes and décor. He even went so far as to suggest that "democracy in color expression" enabled people to critique designers who might be carried away by aberrant fashion trends using colors that were not harmonious.[4] An emphasis on creating "tasteful" color compositions in everyday clothing, home décor, and lighting designs, as well as on-screen, resonated widely, involving a large number of professionals and consumers with different motivations for negotiating their way through the color revolution of the day.

The 1929 Pathé-Cinéma film *Le home moderne* (France) provides a useful illustration of these symbiotic connections and will serve as a thematic guide to the areas explored further in the rest of the chapter. *Le home moderne*, a short nonfiction film from the Pathé-Revue cine-magazine series, is colored using the Pathéchrome system, a stencil process discussed further in chapter 6. The film advertises Leroy paints and wallpapers by presenting five examples of domestic interior décors to illustrate, according to an intertitle, "a perfect harmony of style and color between furniture and wallpaper." The rooms—a dining room, bedroom, living room, home office, and living room/boudoir—are displayed to suggest connections and contrasts between furniture and wallpaper in a well-to-do French household. As an applied technique, film stenciling was an excellent means of highlighting detail and color for images that required the addition of a rich, sumptuous textural style. This was particularly appropriate for highlighting the intricacy of Leroy wallpapers, which were also colored by *pochoir*, a traditional, stencil-based printing technique dating to antiquity that was adapted for film by Pathé in the early 1900s.[5] *Pochoir* was revived in Paris in the 1920s as part of Art Deco design to embellish the modern interior as a tasteful, integrated ensemble. The crafted, textured, graphic look of *pochoir* inspired fashion designers, including Paul Poiret, as well as architects and designers—a notable example being French architect and film set designer Robert Mallet-Stevens, whose influential illustrated design album *A Modern City* featured *pochoir* colored plates of civic and municipal buildings in an "ideal town."[6] Poiret's *pochoir* prints were widely reproduced, and interior designers were encouraged by Poiret's example to "think of their work as part of a fashion system."[7] In *Le home moderne*, the geometric, streamlined look of Art Deco furniture was thus softened by wallpaper patterned by *pochoir* with organic shapes such as floral motifs. The modern home in this instance was a unification of shapes, colors, textures, and intermedial forms, both living and nonliving. The Art Deco font used for the intertitles, with its striking resemblance to Poiret's visual style, makes the film appear as an illustration come to life, exemplifying its strong connections with decorative art, print media, and fashion.

Le home moderne's aim is to showcase its various products. After an establishing shot of each room, there is a shot of a fashionably dressed person occupying the space, adding a crucial human dimension to the film's depiction of décor, chromatic harmony, and modern living. The bedroom, for example, has Art Deco furniture, its geometric lines contrasting with blue wallpaper patterned with swirling designs of bows and floral motifs. The creation of a relaxing atmosphere is further emphasized when a woman is shown primping her hair in a long mirror, her dark, plain-cut dress contrasting with the decorative *pochoir* effect of the walls. This approach is also evident in the living room, with its Chinese-themed wallpaper embellished with gold temple and floral motifs highlighted against a Chinese cabinet, upon which a large vase of flowers is being arranged by a woman with bobbed hair wearing a drop-waist, "garçonne style" day dress.[8] The strategy of fitting the room to its function, with color and décor establishing mood, continues in the home office, where the wallpaper has reddish colors with yellow detail that resonates with a yellow lampshade on an Art Deco occasional table. A man, presumably the bourgeois owner of the house, is seen making a telephone call and writing in this room, which is described in the intertitle as "warm and bright." In the last room, the salon-boudoir, brown-orange wallpaper with a large, floral pattern contrasts with furniture colored in pale shades of blue (as the colors are described in the preceding intertitle); a woman sits reading on the Deco sofa before standing to smoke a cigarette (color plate 2.1), once again creating a sense of a total composition in which colors are showcased through strategies of contrast, complement, associative mood, and ambient sensation.

The film serves as a telling example of how by 1929 ideas about color, taste, and psychology were widespread, indicative of the types of knowledge transfer occurring across media and industrial and cultural fields of the time, as discussed in chapter 1. The connection between colors and moods was clearly evident, as was the notion that rooms inspired certain behaviors and fashions for clothes as well as décor and furniture. That the occupant was part of an entire composition resonates with ideas evident in other areas of 1920s culture, as demonstrated in chapter 3's discussion of synthesizing color music and the aspiration toward total art. In keeping with this philosophy of fashion, the body and the physical environment were seen as parts of a single ensemble—a composition to be refined, embellished, and above all *experienced*. The impact of Art Deco was emphasized when placed in spaces that also contained styles from earlier periods that were compatible with a "moderne" look. Although the parts of the whole may be different, together they create the overall impression of an interdependent, creative enterprise. Film was the ideal medium to animate these connections, its visual dynamism capturing the multilayered, collaborative nature of contemporary 1920s design.

This total-art aesthetic was evident in a range of other intermedial contexts. According to 1920s fashion theorist Emily Burbank, stage designers including Léon Bakst, Max Reinhardt, and Granville Barker "taught us the new colour vocabulary" of this expansive mode.[9] She refers to "the dependence of every decorative object upon background" and how their designs demonstrate clearly "how fraught with meaning can be an uncompromising outline, and the suggestiveness of really significant detail."[10] Burbank was inspired by the ideas behind English theater designer Edward Gordon Craig's innovative lighting effects for the stage.[11] These highlighted key details while eliminating unnecessary objects that might detract from the overall desired theatrical atmosphere. Burbank argued that nonnaturalistic effects were important because "by the judicious selection of harmonics, the imagination is stimulated to its utmost creative capacity."[12] She found that styles of home decoration and women's costume were similarly influenced by the judicious selection of harmonious and contrasting colors; clothes highlighted décor and vice-versa "as part of the composition."[13] As an example, she explained how delicate-shaded gowns were best shown against a dark chintz, silk damask sofa in one or several tones, or a solid color. She also referenced how color was "portable"—how in drama the strategic placement of a scarf or a cushion could alter the chromatic dynamics, contrasts, and harmonies of a setting, allowing for changes within a space that could underscore shifting narrative concerns. Other examples of contemporary reportage similarly noted correspondences between décor and feminine fashions as a kind of symbiotic artistic arrangement, as when Gabrielle Amati interviewed Lillian Gish in Florence in 1924 in the studio of Italian textile and fashion designer Maria Gallenga. Even though the interview was with a major Hollywood star, Amanti spent considerable time describing the chromatic impact of velvet dresses, furniture, and even the color of Gish's eyes.[14]

These examples illustrate the collapsing of boundaries between design, fashion, and art. They point to the conscious agency of individuals in arranging spaces and personal attire in strategic ways and demonstrate how color worked as a catalyst for holistic design. The competences required to produce satisfying ensembles depended upon knowledge about the effects of light on specific colors, how colors related to each other, and how the textures of fabrics and solid materials affected color when applied in different contexts. The spread of electric lighting in domestic homes in the 1920s accentuated color's role as part of a planned scheme—a development that represented a departure from the darker interiors of dwellings in the late nineteenth century.[15] This cohesive approach was also at the heart of the highly influential Exposition internationale des arts décoratifs et industriels modernes held in Paris in 1925, to which we now turn to examine the transnational reach of color consciousness.

The Exposition des Arts Décoratifs and Transnational Exchange

Initially scheduled for 1915, but postponed because of the war, the exposition grew out of the French decorative arts tradition and was meant to showcase and revivify France's preeminent design traditions.[16] Many designs and products that used color in dynamic, innovative ways were on display at the exposition. The Pavilion de l'Elégance was devoted to the work of more than sixty couturiers, with displays organized by designers Paul Poiret and Sonia Delaunay. Delaunay's "Simultané Boutique" replicated the Paris studio she opened in 1924 with her husband Robert Delaunay. The display showcased her embroidered and geometrically patterned coats, bags, scarves, and jackets, all of which demonstrated her fascination with color, texture, and contrast. "Simultanism" was the term the Delaunays used for their Chevreul-inspired exploration of the rhythms of contrasting colors in various forms from painting to textile design. This also extended to "color-poems" and the use of colored letters and text in paintings and even to clothes, through which Sonia Delaunay sought to suggest "a transnational language of chromatism" that was conceived as musical ("*l'audition colorée*") rather than linguistic.[17] The philosophy behind this idea is also indebted to Wassily Kandinsky's theorizing that when different media are comingled, new sensibilities result that transcend their discrete forms and meanings: "The methods of the different arts appear from the outside to be perfectly different from each other. Tone, colour, word! [. . .] But at the deepest level, these methods are perfectly similar: the ultimate aim eliminates their external differences and unveils their intimate identity."[18] Delaunay's fashion designs and connections with film will be considered in more detail later, but it is worth noting here that her involvement in the Exposition des arts décoratifs reflected the event's innovative celebration of color in a number of contexts that were underpinned by similar synthesizing philosophies. The mid-1920s were clearly an appropriate time to take stock of the latest developments in color technology and tastes.

In this spirit, Léon Deshairs, 1920s conservator and art historian, felt compelled to publish a book in 1926 of paintings illustrating the relationship between colors and interiors at the exposition so that future generations might be inspired by its demonstration of how French designers in particular thought about color.[19] He charted their shift from late-nineteenth-century tastes for "insipid . . . exhausted shades" toward more confident chromatic choices selected according to prevailing notions of harmony, gradation, and contrast. As an apposite example, he referenced the room designed by Louis Sognot, who collaborated with the Atelier Primavera, which was founded in 1912 by the department store Printemps. The bedroom shown at the exposition's Primavera

Pavilion displayed two screens in antique red lacquer; a carpet with an abstract design in brown, gray, and white; a Makassar ebony bed with a brown fur bedcover; and a cabinet and standard lamp in Art Deco style. An office interior designed by Paul Foliot was dominated by orange-red soft furniture with brown accents achieved with an Art Deco desk, small tables, surrounding bookshelves, and a wall frieze patterned with classical bronze figures and symbols that were a typical feature of Art Deco décor—which, as Lucy Fischer has noted, combined modernist design with a fascination for "Ancient" forms and motifs.[20] A dining room with cement-colored walls featured a red-brown-bordered central rug with a black-and-yellow geometric Greek design. To create further dramatic contrast, Jules Leleu and Da Silva Bruhns dressed the room with Makassar ebony furniture. Deshairs commented: "This simple range goes well with a recent innovation: some ceilings colored silver or aluminium have replaced, as reflectors, the white ceilings. Aluminium gray, another color of the day—but that will perhaps stay a color to be put on display—is pale and dull in natural light. It can, as shown by Auguste Perret in his theater, come to life by the pleasant shimmering of electric light."[21] This last remark can be related to the growing perception of color and light as relational, mutually reinforcing yet potentially transformative ("coming to life") elements, whether in a painting, in a dress, or as part of a décor ensemble.

The publication in 1930 of a book featuring subsequent French designs enabled Deshairs to reflect on developments in interior design since the mid-1920s, particularly the increased use of steel, metal, and wood in conjunction with electric and neon lighting effects: "Light, glistening rustless steel furniture, and soft and mysterious lighting effects—obtained by refraction or diffusion—which entail a minimum of visible fittings and cumbersome supports, typify the taste of 1930 in the domain of interior decoration."[22] Orange once again featured as the dominant color for an Art Deco office by French designer Etienne Kohlmann that emphasized angular furniture, mirrors, and motifs associated with streamlining and industry (color plate 2.2).

While French designs dominated, the exposition was highly influential in the United States and throughout Europe. Inherent in its celebration of Art Deco was a distinct commercial dimension, with major manufacturers and department stores displaying their products, including bathroom accessories, innovative kitchen designs, luxury merchandise, Art Deco furniture, glassware, ceramics, fabrics, and costumes. At the exposition, Sonia Delaunay met Joseph de Leeuw, owner of Metz & Co, a small luxury department store in Amsterdam. He bought scarves, fabrics, and accessories that Delaunay subsequently had branded "Sonia" for sale in the store, initiating a long business relationship that lasted into the 1960s.[23] Many designers showcased their work in adjacent Parisian boutiques, transforming the event into a celebration of modern

consumerism. This influenced the American delegates who visited Paris for the exposition, inspiring subsequent events, including the Metropolitan Museum of Art's 1926 traveling exhibition of selected pieces imported from Paris and the Met's collaboration in 1927 with Macy's for an "Art in Trade" exhibition in New York. As Regina Blaszczyk has noted, the impact of the exposition extended from couture to industrial products, "pushing some American manufacturers at the upper end of the market to create designs that could rival those of French manufacturers in originality."[24]

The exposition's emphasis on color also reverberated in Britain, as reflected in subsequent Ideal Home exhibitions at Olympia, London, an annual event initiated in 1908 by a daily newspaper to showcase the latest fashions in manufactures and designs for the modern home.[25] An enhanced focus on color is striking in the 1927 catalog, which listed products ranging from "Rowlian Coloured Lacquer Furniture" for sale in a Kensington Gallery in London to a special exhibit by Story & Co., London, celebrating "colour in all its splendor" for carpets, hand-painted curtains, and loose-cover fabrics.[26] The catalog featured a special article that declared that "colour is the keynote of present-day decoration. . . . To-day no colour is regarded as too bright, provided that it is used discriminately and harmonises with its surroundings."[27] It remarked upon the vast range of newly available colored paints, wallpapers, wood inlays, tinted glass, silks, fabrics, and painted linens, all with arresting chromatic features. Anticipating Pathé's *Le home moderne*, these were contextualized within discourses of color consciousness that connected color with psychology, mood, and taste education:

It is now generally realized that cheerful surroundings have a psychological value. A sympathetic room is a tonic or a rest, as the case may be, and wisely chosen will help to ease the worries of life. Then, too, personality can be definitely expressed in rooms by the use of colour, so that one's home need not be a replica of somebody else's, but an expression of individual outlook. An Exhibition such as this is of inestimable value to those who need help in their choice, for it is not everybody who can visualize what a certain colour scheme will look like when it is presented to them in rolls of material. Here they may see schemes actually worked out, can study them at ease, see where they synchronize with their own ideas, and definitely decide what appeals to them most.[28]

In this way, the influence of the exposition in Paris was widespread and transnational. While much of what was showcased there was far from affordable, the celebration of new furniture designs, décors, and clothing established a kind of cultural register for merchandising that informed public taste, resonating across cultures and classes.

Advertising and Merchandising Trends

Advertising theorists increasingly emphasized color's importance as an aid to merchandizing in the 1920s. Matthew Luckiesh of the General Electric Company in the United States made a persuasive case:

> Color may attract attention by being applied to the depicted product or package, to the trademark, to the text, to any selling point, or to its use. It may lend realism to the advertisement but also upon human figures or appropriate surroundings. It may attract attention by use in the border, background, printed matter, illustration or in other ways. Even a single note of concentrated color is emphatic. Doubtless the chief advantage of color is generally the faithful representation of the product or package but even for merchandise which cannot be illustrated in prominent colors, advertisements in color are effective. Color may be used to suggest or impress various qualities of a product such as attractiveness, refinement, dignity, smartness, delicacy, coldness, warmth, purity, cleanliness, solidity and ruggedness.[29]

These associative terms, connecting color with moods and sensations, signal a growing recognition of the commercial potential of color-conscious advertising, as Sally Stein has shown.[30] They also reinforce the idea that personal preference is an important consideration, especially for female clothing. Paul Nystrom, a U.S. retail theorist in the 1920s, studied the market and suggested thinking about fashion and color in terms of classifications, such as those devised by Bullock's department store in Los Angeles. Women were categorized into six personality types, including "artistic," referring to "a type that may accept vivid colors, bizarre embroideries, eccentric jewelry . . . welcomes the revivals of Egyptian, Russian and Chinese motifs or colorings"; and the "picturesque . . . essentially feminine" woman, who preferred "soft, unassertive fabrics . . . no eccentric color combinations."[31] This approach was also evident in a number of fashion manuals designed to inform consumers about appropriate choices. Manufacturers were advised on product styling, such as in the 1929 campaign for Lady Pepperell, a linens manufacturer in Boston, for "Personality Bedrooms." Lupe Vélez, a Mexican actress who became a successful film star in Hollywood beginning in the late 1920s, was used to advertise the range. Described as a "vivid personality" with "rich coloring," her bedroom features green sheets and outer drapes contrasting with the red/orange bedspread and inner drapes (color plate 2.3). Customers were urged to send for a leaflet that would similarly help them match their personality to appropriate colors from a range consisting of peach, rose, blue, orchid, Nile green, shell pink, maize, and white.[32] *Photoplay*, the magazine in which the advertisement appeared,

published an article in the same issue titled "How the Stars Make Their Homes Attractive," which detailed the domestic interiors of various film stars, including Doris Kenyon, Corrine Griffith, and Bebe Daniels.[33] Doris Kenyon, described as a "real blond with golden hair and blue eyes," had different bedroom colors and tones from Lupe Vélez. Rather than vivid red/orange and greens, Kenyon's bedroom was "all feminine charm . . . pale green and pale rose . . . the walls are cream colored and the sheets a blush pink."[34] This reflects assumptions of ethnic stereotyping collapsed into the general category of "personality," a theme we will return to later in this chapter. The consumer was advised to follow these examples by choosing colors selectively in the bedroom, using "Lady Pepperell sheets of a becoming color that best expresses you—precisely as you express yourself in choosing clothes."[35] The collapsing of divisions between intimate, interior domestic spaces and dressing up for the outside world is a striking feature of contemporary discourses. Using stars to advertise fashions was a shrewd move; they became intermediaries who conferred credibility on the products, much as Bourdieu observes regarding the legitimizing function of catwalk models in more recent times.[36]

Being conscious and knowledgeable about color was advocated as a must, particularly for the modern woman, across a range of publications relating to the home, dress, and advertising. Their democratizing rhetoric advocated that color expertise should be available to all, as one contemporary American manual advised: "In order to develop the expression of your character, of your personality in your dress, develop your taste. Continually study colors and designs, textures and effects, with your practical color and figure needs in mind. You do not have to be an artist to pick out a sketch from a fashion magazine, and change its lines and color scheme to suit your own complexion needs and type of figure."[37] Advertisers unlocked the mysteries of color harmony, selling the "aesthetic of the ensemble" so that one new purchase promoted another in a cascading effect: a new item of furniture, carpet, or even clothing depended on its coordination with an existing or new color scheme.[38]

These initiatives were encouraged in the United States by high-profile commercial institutions such as the Textile Color Card Association (TCCA), founded in 1915. As detailed in chapter 1, the disruptions to international trade caused by the First World War opened up space for the American synthetic chemical industry to prosper. The TCCA developed two key strategies to assist the business community in the exploitation of new chromatic initiatives: forecasting color trends and providing color consultancy services. The TCCA's professionalization of color consciousness aimed "to record the colors of everyday fashion and to distribute this information widely, in line with the Taylorist belief that experts had a moral obligation to devise cost-effective practices that would benefit the common good."[39] The rhetoric of color consciousness was highly invested with a sense of national mission, as Margaret Hayden Rorke,

the TCCA's color expert and public advocate, articulated in a speech to the New York Editorial Conference in 1928: "The temperament of a nation is reflected in its color sense. . . . The more we train and develop our color sense applying it to our everyday life in our dress, our home, our industries as well as our arts and crafts the greater we shall become as a nation and centre of culture."[40] The language used by the TCCA was steeped in contemporary discourses around color. As early as 1922, the TCCA was pronouncing: "What we need is really to have a 'color consciousness' developed in our culture; this will then open up the unexplored fields of color expression and appreciation. Color can then become another medium of expression through which we can relate our own minds with those of others, and by which we can gain a much wider knowledge of the world around us, as well as extending our conception of its meaning and purpose."[41] Hayden Rorke's annual report in 1926 made an interesting musical analogy to how the fashionable ensemble demonstrated "color rhythm" from hats, clothes, and accessories.[42] Appreciation for variation in color accents, harmony, the role of pastel shades, color complements, and their impact on consumer psychology underpinned the organization's activities throughout the 1920s.

The TCCA's major contribution was the introduction in 1915 of its Standard Color Card of 110 basic shades.[43] Swatch examples of colors were produced to advise manufacturers of appropriate colors for hosiery, shoes and leather, woolens, crayons, and other goods. In addition, forecast cards, designed to anticipate new seasonal accents in a small group of colors, offered greater variation than the Standard Card. The card for fall 1922, for example, featured a red named "salvia" that looks very similar to one named "spark" on the fall 1923 card.[44] Some color names were fairly obvious in their object associations, such as a "strawberry" red; others were more obscure, such as "ophelia" for a pink shade and "titania" for a reddish pink, colors that have no obvious chromatic link to the Shakespearean characters they are presumably named after.[45] This approach of naming colors after fictional and nonfictional characters was questioned in the press: "We have no reason to suppose that Ophelia was particularly partial to that shade. Then there is the Cleopatra blue, very near a royal blue, and the Rameses blue a shade darker. Why Cleopatra and Rameses any more than Salome and Herod, and why not any other color in the spectrum?"[46] A rose named Ophelia, however, demonstrated a similar shade, so it is possible that the TCCA had this in mind.[47] Hayden Rorke explained the rationale behind the naming of colors:

With its method of color names, and system of numbering, which give identity and personality to every tint and shade, the silk buyer is offered a fund of reliable color information as well as a helpful and simple way of matching and ordering colors. How attractive, descriptive, and interesting are these names! With them, one can wander in imagination through the realms of romance,

history, and art, or dip into the story of jewels, flowers, or mythical lore. In spite of Avon's Bard, there is *much* in a name, and the Association gives careful thought in baptizing its chromatic children. The merchandising value of a name is given first consideration for the name that tells a story, appeals to the imagination, or helps to visualize the color, is the one which helps to sell the fabric.[48]

This openness to flexibility within a system designed to simplify and stabilize choice demonstrates how, in competitive markets, fashion products were nevertheless subject to the fluctuating demands of novelty. This somewhat paradoxical situation required the TCCA to always appear to be one step ahead of trends, so that by changing color terms for textiles and materials for the products available in the market, it could make colors appear to be different from season to season even if they actually looked similar. This strategy required understanding and even, as one report argued, education, particularly for men asked to purchase particular shades by their wives.[49]

Aloys Maerz and Morris Rea Paul in 1930 published a *Dictionary of Color* "to serve as a common ground for the proper appreciation of all existing terms."[50] This comprehensive manual arranged 7,056 different colors into seven hue groups using names compiled from sources including the TCCA and various manufacturers. The lack of consistency in color nomenclature for clothing frustrated their desire for standardization:

> The tendency in the change of styles in clothing has from very early days been largely responsible for the introduction of definite styles in color for coming seasons, and with them always appeared new names. The names apparently need not necessarily describe the colors but must only possess sufficient oddness to impress themselves on the mind of the layman, for therein lies the sales value. Of the various names so conceived, few are remembered by the following season, but some unfortunately continue to persist. Careful study, however, by the writers has failed to reveal, save in a few instances, any indication of the common continuance of a name unless that name possesses some enlightening term that will be instrumental in conveying to the mind of another some suggestion of the color's identity.[51]

This rather dismissive opinion of fashion as an unscientific, disruptive force in the quest toward color standardization links the *Dictionary of Color* to contemporaneous trends identified in chapter 1. In their advocacy for the "proper use" of color, Maerz and Paul were inclined toward tracking color terms that were used consistently, giving the impression of progress toward "serious color recording."[52] Like later examples of racialized and politicized color terms—including the British Colour Council's standardization in 1934 of "nigger black,"

which subsequently became "nigger brown" and was listed into the 1950s—the *Dictionary of Color* also reveals prevalent assumptions around naming that demonstrate how color is "a discourse of race, skin tone."[53] The TCCA's spring season for 1923, for example, named a very dark brown-black "Congo," and in 1926 "plantation" was dark brown, even though neither the geographical area (Congo) nor the location (plantation) was necessarily associated with the color, other than the racial overtones that the pairings imply. "African brown" appeared the following year.[54] This theme was evident earlier with "Negro" listed in the *Dictionary* as being named a color in 1915.[55] Inventing terms to refer to colors was clearly far more than a descriptive activity, exposing the ideological predispositions of those in a position to pronounce, codify, and disseminate information about color. The idea that understanding color required education opened up a space for naming practices that were in many respects prejudiced. Consumers were nevertheless addressed with discourses of empowerment: to know about color enabled you to make more confident choices about how you dressed, decorated your home, and made sense of the ever-increasing number of commercially available colors.

Professional services were established in a similar spirit of unlocking the mysteries of color, so that manufacturers and consumers could be confident about their choices in a rapidly developing and chromatically rich commercial market. Many manufacturers and retailers joined the TCCA and took advantage of independent specialist advisory services such as that established in New York in 1927 by Tobe Collier Davis, reputedly the first professional fashion stylist in the United States.[56] She was representative of the 1920s trend for women to occupy senior positions in a range of institutions involving color expertise. Margaret Hayden Rorke's key role at the TCCA is another example, as is the work of Hazel H. Adler, who established a consulting business based on the Taylor System of Color Harmony to advise manufacturers from the motor industry to suppliers of kitchens.[57] In the UK and elsewhere, women were also assumed to have advanced skills of color acuity, including Grace Cope, "a great authority on the psychology of colour," who covered international developments in civic color for the "Townscape Campaign" launched by *Colour*, a London-based magazine that advocated greater consciousness in color design in cities.[58] Beatrice Irwin was a British engineering expert in color lighting with interests in theater. Her work was known in the United States, where reports recorded her views on color's profound effects on health, clothes, and houses.[59] Dorothy Nickerson was a color scientist who joined the Munsell Color Company in 1921 and in 1927 went on to work for the Department of Agriculture, where for many years she held a top, highly specialized position as a key scientist working on fields including colorimetry and standardization of light sources.[60] She was a founding member of the Inter-Society Color Council (ISCC) in 1931. The ISCC's purpose was to coordinate the activities of leading

technical societies relating to "the description, specification, and standardiza-
tion of color and promoting the practical application of this knowledge in sci-
ence, art, and industry."[61] While Irwin and Nickerson were less typical in their
roles as women involved in color science rather than culture or psychology,
they were nevertheless also a product of the world of opportunity created for
women by color developments in the twentieth century. The rise of Technicol-
or's Color Advisory Service, headed by Natalie Kalmus, toward the end of the
1920s was thus part of a wider trend of employing women as color experts in
a range of contexts.[62] These appointments somewhat challenged essentialist
conceptions of color science as being primarily a "masculine" domain, as the
breadth of expertise extended to accommodate the drive toward product differ-
entiation in a number of fields, from agriculture to fashion.

The work of the TCCA and ISCC represented a desire to be less dependent
on German and French expertise in synthetic chemistry and fashion design.
The historic reputation of Paris as the center of *haute couture* persisted, how-
ever, influencing ready-to-wear garments across Europe and America.[63] As we
have already noted, the Exposition des arts décoratifs signaled the centrality of
Paris to contemporary design, manufacturing, and fashion. Margaret Hayden
Rorke toured Europe in the summer of 1925, visiting France, Britain, Switzer-
land, and Italy. She reported that her trip had three major objectives:

> First and primarily, to establish special contacts in Paris, through various
> sources, that would supply us with information pertinent to our needs, and
> enable us eventually to build up a more extensive color fashion service for the
> benefit of our members. Secondly, to meet as many of our foreign members as
> was possible in so short a time; to make a general survey of the color trend, and
> its adaptation by the leading textile producers, and fashion creators, as well as
> the interpretation and application of color at the Exposition of Decorative arts
> and other art influences. And, last but not least, to meet and establish contacts
> with trade associations, Chambers of Commerce, and other important indus-
> trial factors, so that we could open new channels and create interest in our
> promotion of color standardization and the American cards.[64]

Rorke's visit was highly influential in Britain, where her seasonal color fore-
casts and trend reports were consulted by businesses and manufacturers. In
1928, the Bradford Dyers' Association proposed the formation of a TCCA-
style committee "to consider and prepare ranges of shades for general use." The
result was the incorporation, in August 1930, of the British Colour Council Ltd,
modeled on Rorke's aim to influence the textile and fashion industries as well as
public taste.[65] As well as influencing European initiatives, Rorke learned much
from her overseas travels. As discussed later in this chapter, after seeing *The
Phantom of the Opera* (Rupert Julian, U.S., 1925) in Paris, Rorke was inspired

to name a specific color "Phantom red," and in 1928 the fall season color card was dedicated to France in celebration of the anniversary of Romanticism. This theme indicates respect for European culture and design in spite of rhetoric that emphasized American commercial independence.[66] Sixteen "evening hues" were inspired by nineteenth-century French painting.[67] A TCCA leaflet paired Romanticism with femininity as "the synonyms of fashion," associating both with emotion, passion, and individualism.[68] The use of such gendered language, however, implies more than admiration for French creativity. In her report, Rorke conversely aligns America with the serious "masculine" business of dominating international commerce through color standardization. In this case, her knowledge of dominant rhetorical positions on color was used to strategic advantage.

The Fashion Film

Film played an important role in the dissemination of Parisian fashions, as well as in advertising the latest designs, products, and color trends of the 1920s. A report on the activities of the T. Eaton Company, Canada's largest department store chain, for example, details how the company's buyers in Paris selected garments by designers including Paul Poiret, Bernard Madeline & Madeline, Worth, Jeanne Lanvin, and Jenny and Lina Mouton, and then filmed them on Parisian models. The films were shown in Canadian stores several times a day for a week to audiences that exceeded five hundred. The report notes: "The general consensus of opinion among American houses is that this is the best method of showing the season's fashions in an authoritative manner. . . . They state that when French garments and hats are shown on American and Canadian women the Parisian touch is sometimes lost and that our women want to see models as they are worn in Paris even though they do not imitate them."[69] Although no further information is given other than that "a direct lumiere process of film photography" was used, some of the films were in color.[70]

Clothing and fashion were striking subjects for film color and spectacle in the silent era. Marketa Uhlirova has remarked how "the two quintessentially modern industries of fashion and cinema courted each other, resulting in a variety of direct, and regular, interactions that were sustained throughout the twentieth century and continue today."[71] Fashion's visual sumptuousness provided a theatrical sense of spectacle in early actuality films and then in newsreels and cinemagazines. Colored films further enhanced the appeal of new designs for consumers while drawing attention to the quality of particular coloring methods, as with the Pathé-Revue stencil-colored newsreels that were produced throughout the 1920s. As Hanssen has pointed out, these films advertised clothes but are also fascinating for their display of décor, design, and social

milieu more generally.[72] Stenciling was an appropriate color process to celebrate the chromatic vibrancy of clothes, wallpaper, furniture, flowers, accessories, and settings. This exemplifies the integrative trend referenced earlier in this chapter toward the creation of a total artistic composition, with color occupying a central role. At the same time, the newsreels also deployed cinematic form astutely to emphasize, through close-ups and angled shots, particular details of the garments, shoes, hats, and accessories as well as the models. Hanssen observes: "The display of clothes and of women wearing them is represented in these films through a dynamic use of distance and framing, from long shots of models placed within specific surroundings to close-ups and extreme close-ups fragmenting the body and giving visual access to (often multi-colored) details of the garments: embroidery, textures, etc."[73] With an emphasis on depicting the upper classes and celebrities, the newsreels also advertised aspirant lifestyles and social mobility. Color and fashion consciousness were themselves linked both to economic capital—as the clothes being advertised were often expensive, even if their styles could be adapted for cheaper, ready-to-wear manufacture—and to the cultural capital their acquisition and imitation conferred on the purchaser and wearer.

The Pathé-Review fashion films were included as featured items in *Eve and Everybody's Film Review*, the cinemagazine launched in 1921 that ran in the UK until 1933. The popular *Fashion Fun and Fancy* series was primarily aimed at women patrons, although men would also have seen them as part of the supporting film program for a feature film.[74] An examination of the films shows how, in the fashion items, stenciling accentuates different fabrics, highlighting details such as shimmering, sequined gowns, the contrasting hues of silken textures, and examples of luxury footwear. The movement of the models ensures that gowns are showcased from multiple perspectives. Color differences are highlighted through contrast, as in one film in which each of the models walks toward the camera and off-screen, enabling a closer view of each gown to be achieved without cutting to a close-up. This choreographed effect was enhanced by a pale, pleated curtain in the background that the models stood out against. In the final shots, they assembled to show how the dresses benefited from the addition of silk capes and flowing outer garments.[75]

Another film, *Belles of the Bath*, showcased swimwear, including bathing hats. Filmed at Chiswick Baths, London, the close-fitting cloche-like hats in particular were exquisitely stenciled, with four women modeling their respective chromatic contrasts of white, red/maroon, pale green, and gold/yellow. Each hat was embellished with motifs, as shown by close-ups, and the detail on the bathing suits was displayed by shots of the women climbing down stairs to the pool.[76] The suits resemble the bathing costumes by French designer Patou, rejecting older, more cumbersome swimwear in favour of minimal, androgynous styles. Outdoor activities were increasingly popular in the 1920s, and it

was important for sportswear to be practical while aiming for a streamlined, athletic look. The *sportif* style promoted by Chanel crossed over to casual clothing worn by both sexes.[77] One woman in *Belles of the Bath* is shown in a peaked "jockey cap," and an intertitle advises viewers to go for an imitative approach to explain a bird emblem on one of the swimming costumes: "If your best boy is a flyer—wear a corresponding motif." Chanel's launch of the "little black evening dress" in 1926 popularized black as a flattering color that made bodies appear leaner and more athletic while connoting sophistication and elegance. In a further move toward standardizing women's fashion, American *Vogue*'s advertising compared Chanel's modernist designs to the streamlined forms of Ford automobiles.[78] The nonconstricting, mass-produced versions of Chanel's clothes indeed gave women the physical freedom symbolized by sleek, black enamel automobiles and "epitomized the practical modernity of the New Woman."[79]

Gaumont Graphic newsreels also feature numerous fashion items. The ingenuity behind the staging of fashion on-screen is demonstrated in one case in which a model sitting at a dressing-table and looking into a mirror examines a hat with a decorative feather. To ensure that the hat is the focus of the image, the camera's angle avoids showing the mirror's reflection. Instead, the exquisitely stenciled hat is in the center of the frame and the audience is encouraged to admire it, as does the woman shot in medium close-up. We finally see her trying on the hat, shown in greater detail from an angle that reveals more of the back and how the material of her dress matches the hat in coloring (pale green) and similarity of lace embellishment. The ensemble is completed with the addition of a shawl with a decorative flower fastened on the front. Thus, in a very short film, the essential details of the hat, dress, and accessories are fully displayed, without the distractions of a mirror image that the staging nevertheless included as part of the performance.[80] An *Eve's Review* film, *Fashions in Hairdressing*, includes a more realistic mirror effect to demonstrate the full dimensions of various hairstyles but still uses close-ups and focus to accentuate the model rather than her reflection.[81] Full-length mirrors are used in many fashion films so that both back and front of a dress are visible.

Other films similarly exploited particular shots to enhance the desired fashion address. *The Shoe Show*, a film informing viewers about which shoes are most appropriate to be worn at different times of the day, is largely made up of close-ups.[82] On occasion, however, the women modeling the shoes are shown in long shot, again demonstrating the ideal of "matching" clothes and accessories, before a close-up followed by an intertitle that includes quite detailed information about "attractive combinations," such as for "Manon" evening shoes with sequins, brocade, satin, beads and diamanté. The emphasis on textural detail is important in this example, because an understanding of colors, fabrics, and materials was all part of the desire to present products as constituent parts of

an artistic creation, involving expertise and tips that consumers could pick up from the films. The use of close-ups for shoes and more intimate items such as undergarments provide an additional titillating function because, as news films, *Eve's Review* films did not have to be submitted to the British Board of Film Censors. The shots thus provided both sartorial and sexual spectacle, a fact that the films took full advantage of in witty intertitles that on occasion addressed "Adams" accompanying their "Eves" to the cinema.[83]

As with the choreographing of movement, with models moving toward the camera and appearing to walk out of the frame, the use of perspective was an important element of the screen performance and staging of fashion. When the presentation took place in a grand house, furniture and wallpaper would generally be on display as well as clothing. On occasion, it was not entirely clear which took precedence, and within a film this could change from scene to scene. In *Fashions in Colour* (1925), for example, a model in a drop-waist flapper dress, with its sleeveless top colored ruby and a ruched golden skirt, stands in the foreground at the right of the frame so that an open doorway in center-frame reveals a plush sofa, almost as if this is as important as the gown being displayed. The deep perspective is emphasized because in a previous shot several women were visible through a doorway lounging on the same sofa, implying that this is an inhabited space.[84] The impression of fashion as a "lived" experience was thus evident in the films, as women were photographed in different situations—having tea, talking, arranging flowers, and modeling clothes for each other.

Since most of what is shown was "high fashion," in *Eve's Review* films featuring the work of *haute couture* designers, including Jeanne Lanvin, Lucile Ltd, Lucien Lelong, Maison Worth, Maison Redfern, Joseph Paquin, and Revile Ltd, direct marketing is not always present. Instead, the women simply model the latest fashions to communicate a sense of new styles, pleasing color combinations, textures, fabrics, and how to match accessories such as hats, bags, shoes, and gloves with garments. Far from being wooden clotheshorses, the models often appear with animated expressions, clearly enjoying the experience and thus giving the films an air of familiarity, even though the fashions on display were far from affordable. As Emily Crosby has noted, women viewed the films in a spirit of "copy culture," so that the examples of glamorous high fashion might be adapted to some extent: "Plenty of anecdotal evidence exists to suggest that cinema audiences did copy their favourite styles from films."[85] Fashions seen on-screen were therefore not inaccessible. Rather than aim to produce exact replicas, however, adaptations were often designed to suit women's everyday requirements, a point made by Hollywood designer Gilbert Adrian when advising women how to adapt dresses seen in films.[86] Women's magazines provided tips on how to copy the latest fashions at home. One film trade paper suggested that expertise in fashion design could be communicated to audiences

eager to learn tips: "Fashions in hats, handbags, sunshades, footwear and other feminine vanities will flicker across the screen, and we may yet see the arrival of the period when women will descend on kinemas equipped with notebooks in which to record the ideas they glean from these animated fashions."[87]

Advertisements relating to clothing, however, were aimed more at the everyday consumer. One such example is *Changing Hues* (1922), a humorous film produced in the UK by the London Press Exchange. The film used stencil, hand-painted, and tinting effects in a spectacular way to advertise Twink Dyes, manufactured by Lever Brothers, who sponsored the film. The title is hand painted in vivid colors of literally changing hues of red, yellow, blue, and green (color plate 2.4). The film begins, however, in black and white with an artist (described as "an artist/lover," played by Albert Jackson) painting a picture of a young woman (Jean Millar), telling her that while he likes her wearing gray or white clothes, "in pink you'd be adorable!" A scene follows using a stencil effect of her looking into a mirror and seeing what her gray dress would look like in pink. Approving of the imaginary color change, she despairs that all her dresses are gray. An intertitle tells us that her housekeeping money is earmarked for the children's clothes, referring to the younger siblings she cares for along with her father (Burton Craig). Her desire for color is intensified when her father asks why she does not wear "pretty colors" like her mother used to. An intertitle then informs us that a shopping expedition intended "for the children only, results in something unexpected for herself." Looking into a shop window advertising Twink Dyes, the woman peeks inside to spot brightly colored clothes, the film now using stenciling to show them in pink/mauve, green, orange/beige, and blue (color plate 2.5). The sales assistant demonstrates swatches of different colored dyes until the desired pink shade is found and presumably purchased. A hand-painted intertitle follows, "Goin' thro' the dye," and we see her begin the dyeing process at home, the film once again reverting to black and white.[88] The laborious task is shown, including pink ("the pink of perfection") added by stenciling to show the fabric changing color in the bowl before the final garment is revealed and then paraded for her father to appreciate. The next frames are of sheet music with lyrics based on a popular song, "Gin a bod-y meet a bod-y Goin' thro' the Dye," first seen painted orange and then with streaks of green and blue. The film's final shots are of the woman dancing in her pink dress, presumably to the song, with her younger brother in a blue sailor suit and her sister wearing a yellow dress, clothes that have also been dyed with Twink, shown for us to admire from both front and back (color plate 2.6). Finally, the artist/lover joins their joyful celebration of the chromatic transformation of the clothes.

This film is remarkable for its wit and charming engagement with the increasing range of color products available to the consumer. Color's transformational potential is also vividly present, as the woman is able to adapt

her entire look as well as that of her siblings by using the dye. The narrative hints that color is also good psychologically, implying that the gray worn after her mother's presumed death is associated with grieving and that purchasing the dye can restore the colors worn by her mother once again to the household that has become sad and drab. Also, at the start of the film, the artist in his enthusiasm for color states that in pink she would be more attractive. In addition, the fact that all of the clothes have been dyed with the housekeeping money advertises that the dye is not too expensive and that existing garments can be transformed. In all these ways, the film conveys clearly that life, and reflexively cinema, is enhanced by color. The hybridized forms are applied strategically, featuring the visually arresting, chromatic aberration of several intertitles with their hand-painted colors appearing to seep into each other almost like an abstract painting, as well as the stenciled pink dress shown at first as a figment of the woman's imagination and then for real once she has dyed the clothes. This astute progression adds to the film's advertising prowess, making the point that color of the imagination can indeed be realized through the wonder of synthetic dyes.

The display of fashions was not confined to stenciling techniques. In 1926, Sonia Delaunay made *L'Elegance*, a color fashion film using a French lenticular additive process known as Keller-Dorian that was coinvented by Rodolphe Berthon, whose son was a friend of Robert and Sonia Delaunay.[89] The film demonstrates a selection of Delaunay's designs and at first appears to be a typical fashion short, featuring a woman pulling scarves one by one out of a box, but it becomes increasingly abstract as it progresses, in line with French *Cinéma pur* aesthetics of the time. The scarves are variously patterned, but with Delaunay's characteristic penchant for zig-zag, harlequin, and striped geometric patterns. As the woman decorously removes the scarves, their silken fabrics create a swirling sensation as they cascade into her lap. Orchestrated in this way, the geometric shapes do not seem static; within the frame, they are moving spectacles of color and form. The film's emphasis on vibrant simultaneous contrast is also of particular note. In one shot, a woman robed in a black and light orange contrasting-square dress stands in front of a tall gradated blue disc, rotating it. In another, a woman in orange garments stands in a long shot against a contrasting light blue background; she strips the orange skirt and top off, revealing a layer of blue garments beneath, and as she does, she moves to screen left to stand against an orange backdrop, again playing on the abstract potentials of simultaneous contrast to heighten color effects in fashion and the lived environment. At the end of the film, two fashion models and a man in a dark suit stand in front of vertical blocks of draped fabrics, which show more of Delaunay's designs. One of the models takes off her fur-lapelled coat to reveal a black-and-white dress with the hard-lined, geometric hallmark style of Art Deco.

Another of Delaunay's fashion films, *Mademoiselle Y* (1920), similarly uses models to show off her fashions in front of draped fabrics that reveal the entirety of the design before it has been cut to make dresses. In a single shot, this provides a graphic illustration of the interrelationship between designs, fabrics, and their creative adaptation for fashion. The film opens, in a striking variation of this technique, with a woman standing sideways in front of a large color wheel showing shades of blue. As the wheel gradually turns, she stretches out her arms to follow its movement, rotating in one direction and then the opposite. Her black-and-white patterned dress contrasts with the wheel, yet the image communicates an idea of how color theory is integral to design; the movement of both wheel and figure suggest a work of fashion in progress. Beyond these fashion films, Delaunay was also famous for incorporating her chromatic innovations into the Dadaist costumes she did for Tristan Tzara's plays, as well as for collaborating on feature films with Marcel L'Herbier, who used her fashion designs in his film *Le vertige* (*The Living Image*, France, 1926), and with René Le Somptier in *Le p'tit parigot* (*The Small Parisian One*, France, 1926).

Whereas Delaunay and the Pathé-Revue films rarely featured celebrities, in 1925 an American company, the Educational Film Exchanges, publicized *McCall Fashion News*, a new series shot in two-color Kodachrome. Kodak had been experimenting since 1912 with applying Kodachrome to motion pictures. In 1922, test shots were taken in Fort Lee, New Jersey, and in Hollywood of stars including Mae Murray, Hope Hampton, Guy Bates Post, and Gloria Swanson. Their cooperation had been secured largely through Jules Brulatour, an influential film executive and sales director at Kodak who had extensive connections throughout Broadway and Hollywood. The reels were exhibited to mark the grand opening in 1922 of the new Eastman Theatre in Rochester, New York, and a color demonstration reel toured selected venues in the United States. Hampton, who married Brulatour in 1923, was singled out in particular as a popular star with "exceptional coloring"—red hair, a pale complexion, and blue eyes— for Kodachrome. As Natalie Snoyman notes, this accorded very much with prevailing conceptions of beauty that privileged Caucasian skin tones.[90] Building on this success, Brulatour persuaded the McCall Publishing Company and the Educational Film Exchanges to produce and distribute the *McCall Fashion News* films from January 1925. The first of these films featured Hampton modeling clothes designed by Paul Poiret, Jeanne Lanvin, and Jacques Doucet in *Paris Creations* and *Paris Creations in Color*. Hampton often traveled to Paris and was instrumental in selecting the clothes she demonstrated in the films, which were distributed widely and greeted enthusiastically by the press. The McCall company was best known for publishing *McCall's*, a popular women's pattern magazine, and was proud of bringing Parisian fashions within the reach of women who it hoped would use the patterns to make dresses that would otherwise be

too expensive for them to buy. Designers whose patterns were made available in this way included Chanel, Vionnet, Patou, Moyneux, and Lanvin. *McCall's* also published patterns based on the fashions worn by Hampton in the *Fashion News* films. The patterns were printed in color to "guide the dressmaker in the finishing details accurately."[91] In 1926, Hampton went to Europe to purchase the latest Parisian gowns, which she wore for the next installments of the *McCall Fashion News* series, which this time featured "ornate" settings. The trend for advertising clothes as part of an appropriately opulent ensemble that extended to décor and furnishings was clearly evident here. The series was produced until the end of 1927, and the films were screened regularly in American cities, often in anticipation of the sale of spring styles and as the accompanying short before feature films targeted at female audiences, including *The Dressmaker from Paris* (Paul Bern, 1925), *That Royal Girl* (D. W. Griffith, 1925), and *Mademoiselle Modiste* (Robert Z. Leonard, 1926).[92] There was a productive commercial and educative symbiosis between the films, the sale of McCall's patterns, department stores, and local newspapers. Above all, the series was an interesting experiment in demonstrating how films could "cascade" the advertisement of both color and fashions.

Although the development of two-color Kodachrome was frustrated by technical and financial problems and competition from Technicolor, the *McCall Fashion News* films influenced *Fashion News*, a biweekly series produced from 1928 to 1931 by Fashion Feature Studios, Inc., and filmed in two-color Technicolor.[93] Film actresses—"virtually every star in the film capital"—modeled clothes that were described very precisely in the intertitles.[94] Corliss Palmer is seen wearing, according to an intertitle, "a striking feminine chapeau in wavecrest green with Pascecan ecru lace trim, in large flare style." The TCCA's spring card for 1929 includes "wavecrest," confirming that the films directly referenced the latest trends. Technicolor was cognizant of the TCCA's astute commercial strategy of seasonal color forecasting and skilled in exploiting color's dual role in advertising the process as well as clothes. As Snoyman observes, the company was careful to ensure that the clothes featured in its films emphasized the greens and reds that most suitably showed off the narrow range of the two-color process.[95] The intertitle's use of "chapeau" further accentuated the U.S. absorption of French couture while promoting up-to-the-minute designs. In another film in the series, actress and pioneer aviator Ruth Elder models an "*ensemble pour le sport*," a red coat with an embroidered lining and collar over a straight white dress with red trimming. Elder's reputation as a "new woman" clearly influenced the clothing choices made for her, the red contrasting with white to resemble sportswear but with additional visual interest provided by the exquisite embroidery seen as she turns around to display the coat's lining. The film also features Raquel Torres, showing her driving an automobile before getting out to show off a two-piece felt set, hat and bag designed to match

with appliquéd felt flowers "for early spring wear." Once again, the fashions on display are identified as appropriate for the modern, mobile woman (color plate 2.7). The films were widely distributed; in 1930, for example, the *Hollywood Filmograph* reported that *Fashion News* was releasing three hundred first-run prints in leading theater circuits throughout the United States.[96] George W. Gibson, president of *Fashion News*, promoted the films assertively, adding sound commentaries by fashion experts by July 1929 and signing a long-term contract in March 1930 with Fox West Coast theaters for exclusive releases.[97] One report implied that the fashions were designed in Hollywood, referring to it as the "fashion center of the world," while other reports stressed the availability of the clothes shown in the films for purchase in local stores.[98]

In 1926, Colorart Pictures, a prolific producer of Technicolor shorts, released *Clothes Make the Woman*, a one-reel fashion film.[99] Starring Sigfrid Homquist, a Swedish actress working in Hollywood, the film tapped into the idea of clothes as a passport to social mobility via a transformation narrative in which a poorly dressed young woman ends up modeling the latest Parisian fashions.[100] Distributed quite widely through the Tiffany exchanges, contemporary reports noted the film's novelty: "Heretofore fashion pictures just paraded models in front of the camera, but in this latest Colorart production there is a human interest story in it which will appeal to those of both sexes."[101] Although the reproduction of color on-screen was by no means stable at the end of the 1920s, Technicolor's confidence in fashion advertising is indicative of the company's ambitions to dominate the market into the sound era.

Fashion and the Fiction Film

While the short and promotional film market was clearly much utilized for showcasing fashions in clothes, furniture, décor, etc., fiction films presented further opportunities, both directly and indirectly. A striking example of an item of clothing playing a central narrative role is *Der karierte Regenmantel* (*The Checkered Raincoat*, Max Mack, Germany, 1917), a German comedy about mistaken identity (color plate 2.8). A husband suspects his wife of being unfaithful when he sees her walking out with an unknown man. The woman he sees in the distance is in fact his wife's friend who has borrowed her distinctive checkered coat to meet her fiancé; the assumption of adultery is based purely on seeing the coat. The coat's centrality to the plot required it to be visually distinctive in a tinted and toned film. Its graphic, geometric design of pale squares highlighted against darker, heavy fabric, is shown against two different tints and tones: orange/reddish brown for interior shots when the coat is being tried on and admired, and yellow when worn outside. The comic situation exploits how the coat practically conceals the identity of its wearer, an impression accentuated

by its voluptuousness and high fur collar, especially when worn with a hat. It stands out more prominently than any other object, its striking appearance paradoxically working as a disguise and leading to erroneous judgments.

It is unusual to find an item of clothing playing such a dominant role in a fiction film, yet clothes were made to stand out in other ways that connected them with contemporary advertising cultures. As Louise Wallenberg notes, cinema acted as a "seductive shopping window," not only "displaying fashion and fashionable goods to its spectators and would-be consumers" but also "as a fashion show or fashion spread in which its stars are involved in displaying fashionable costumes."[102] Color could only intensify this impact. This was the case in *Love* (1920), an American film directed by Wesley Ruggles that reviewers criticized on first release in the UK as "a thin and unconvincing story, redeemed, only by the sympathetic acting of the star, Louise Glaum."[103] Pathécolor was added to prints for a subsequent rerelease, and the trade press enthused about the addition of color as a welcome experiment: "Exhibitors who number a good proportion of women among their patrons have got something here on which they can make a special appeal. The colouring and texture of the various dresses are unusually fine, and from the point of view of women patrons the film is an animated fashion book, for Louise Glaum wears numerous exquisite creations."[104] Thus, what was at first more or less written off as a poor box-office attraction was given a second life through the addition of color, even if in the opinion of the trade press, the story was still lacking in narrative value.

As we have already seen, film stars were often used in advertising campaigns, and designers dressed stars such as Jeanne Lanvin, who was working with Mary Pickford.[105] Cecil B. DeMille was one of the first U.S. directors to surround himself with experts from the fields of costume, interior décor, and set design for "modern photoplays" such as *For Better, For Worse* (1919), *Why Change Your Wife?* (1920), and *The Affairs of Anatol* (1921)—comedies that "perfected a display aimed at the fashion-conscious."[106] His use of color in many of these films was also innovative. As Sumiko Higashi has noted, "for advertisers, the streamlined Art Deco design that DeMille used so inventively with the Handschiegl color process in *The Affairs of Anatol* in 1921 became a signifier of modernity."[107] *The Affairs of Anatol* was an extravaganza of modern design, Orientalist-inspired décor, ornate fashions, and color. Adapted from Arthur Schnitzler's 1893 play *Anatol*, it follows the quests of Anatol de Witt Spencer (Wallace Reid), a wealthy newlywed, to reform women he thinks need rescuing. This tries the patience of his wife Vivian (Gloria Swanson), who becomes jealous of the time he spends on various adventures. These involve women being tempted, for various reasons based on necessity that Anton at first does not comprehend, by jewels and money. A showcase for consumerist desires, three episodes, particularly the first and last, involve the conspicuous display of jewels, clothes, and other goods.

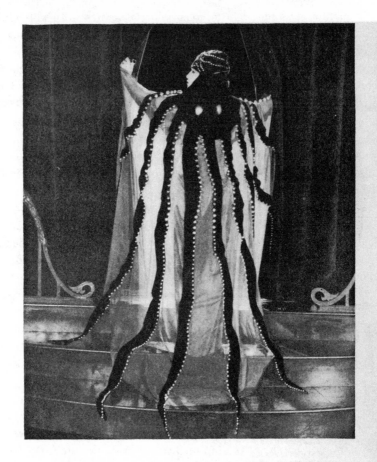

That Octopus Gown

OCTOPUS: A molluscous animal having ten long arms furnished with sucking cups by means of which it attaches itself tenaciously to other bodies, two of these arms being longer than the rest. It is very dangerous to men, as when it once entangles them within its long, powerful tentacles escape is practically impossible. It is known also as the devil fish, seizing its prey and holding them clasped against all opposition. Men have met death often in combat with the octopus.

This is the dictionary definition.

There isn't any definition—as yet—of the octopus gown.

But the sartorial creation evidently possesses most of the attributes of its deep sea name-sake.

We thought the last word in "vamp" gowns had been said.

But that was before Clare West—special designer for Cecil B. deMille—conceived the octopus gown, which is worn by Bebe Daniels as the wickedest woman in New York, which role she plays in "The Affairs of Anatol."

The gown is unique in that it lacks any feature of decolletage. You could make all the costumes for the "Queen of Sheba" from it—yet it is hailed as the most seductive thing on the screen.

It is composed of exquisite pale gray georgette, upon which are fastened the arms of the devil fish in black chiffon velvet. The arms are outlined with enormous pearls and the two enormous eyes in the black velvet head are also of gleaming pearls. The sheath effect beneath is of steel gray velvet.

The head dress is of loose strings of pearls woven into the hair and fastened in front with a large jet buckle.

It's a mighty deadly looking piece of wearing apparel. Any man that ever gets within reach of those arms is never going to escape.

But will anybody want to?

Figure 2.1 The Octopus Gown, *Photoplay Magazine* 20, no. 4 (Sept 1921): 20.

In one scene, Bebe Daniels wears an "octopus gown" by Clare West, a designer whose work with DeMille represented a significant move toward greater professionalism and sophistication in Hollywood film costuming.[108] The visually striking gown was composed of "exquisite pale gray georgette, upon which are fastened the arms of the devil fish in black chiffon velvet. The arms are outlined with enormous pearls and the two enormous eyes in the black velvet head are also of gleaming pearls. The sheath effect below is of steel gray velvet."[109] The very specific referencing in a fan magazine of fabrics such as georgette, a thin, semitransparent and dull-finished crêpe fabric named after French dressmaker Georgette de la Plante, demonstrated precision in costume description and implied that readers would both appreciate and understand a high level of sartorial expertise. The film's costumes were clearly inspired by the style of Erté, the Russian-born stage designer and illustrator who emigrated to France in 1912 and subsequently worked with Paul Poiret. Although Erté did not go to Hollywood in an official capacity until 1925, when he designed for a number of MGM films including *Ben Hur* (1925), *The Mystic* (1925), and *Paris* (1926), West's gowns were similar to Erté's illustrations at the time that *The Affairs of Anatol* was in production, particularly his use of black velvet, pearls, and theatrically inspired cape designs.[110] In the film's final section, Gloria Swanson wears a dress with a distinctive zigzag pattern that was used by Erté. Even accessories that feature in the film—most strikingly, an umbrella made of translucent fabric, thus showing the women gathering underneath it—is reminiscent of a contemporary Erté design. In this instance, "copy culture" appears to apply to film costumers like Clare West, even though she claimed that Hollywood led Paris in fashion.[111]

The octopus gown was celebrated as one of the film's attractions. It was worn by Daniels as Satan Synne, a seductive cabaret artiste referred to as "the most talked of woman in New York." She becomes the focus of attention for Anatol when, estranged from his wife, he visits a risqué rooftop establishment where Synne is performing. We learn before he does that she is desperate for money to pay for an operation for her invalid husband, wounded in the war. As his condition becomes critical, Synne is forced to present herself to Anatol as a vamp, a ruthless seductress who invites him to the Devil's Cloister. This decadent locale is coded as a brothel with "outlandish art direction, where the hedonistic drives of consumerist excess are mocked through the details of Synne's orientalist boudoir."[112] Inside her boudoir, the octopus design of her attire is fully shown from behind when she rises to embrace Anatol. The impression of an octopus enveloping him is created by a cape with floor-length, tentacle-like strands of black fabric adorned with giant, iridescent pearl-effect beads and connected by a diaphanous, translucent fabric. Her headdress, also black and with giant beads arranged in an octopus-like shape, completes the spectacular impact of the ensemble. As Fischer has noted, such visually excessive

imagery resembled sea-creature motifs in Art Nouveau jewelry while in this context conveying "morose overtones of strangulation."[113] The scene is toned in deep orange, and color accents while not being necessary to show off the black cape with its distinctive beading. Color is used more boldly, however, for a close-up a few moments later, through the Handschiegl method on a pink monogrammed cigarette (color plate 2.9)—or something stronger, as indicated by Anatol's surprised expression when he inhales it. This is the first of three items of temptation Synne offers Anatol, the others being perfume ("Le Secret du Diable") and the spirit d'abstinthe. The last is not highlighted in green, an effect one might have expected, but its corruptive reputation is indicated when, after drinking it, Anatol catches sight of his reflection in a mirror and is shocked to see a skeleton.

Art direction is credited to Paul Iribe, a Parisian designer who had previously collaborated with Jacques Doucet and Paul Poiret. Emboldened with resultant touches of continental flair, the film represented the epitome of DeMille's Jazz Age texts, featuring, as Lucy Fischer has noted, "ostentatious levels of consumption both as spectacle for visual appropriation and as a showcase that set fashion trends in apparel and interior decorating."[114] Many of the clothes and commodities seen in the films became readily available from manufacturers in the late 1920s, furthering the symbiotic relationship between cinema and merchandising. The opulent bathrooms seen in DeMille's cycle of comedies, for example, tapped into the transformation that domestic bathrooms were undergoing in the United States during the decade as new ranges of standardized materials, fixtures, and fittings became available.[115] The Affairs of Anatol combined elaborate décors to display Art Nouveau touches in the Spencers' apartment, including a floral-patterned Japanese screen leading to Vivian's bedroom and elaborate floral motifs on lampshades and stained-glass windows, as well as modernist-influenced reflective surfaces such as an electrically operated sliding mirrored door.[116]

In conjunction with these stylistic effects, The Affairs of Anatol deployed several methods of coloring, including tinting, toning, and the Handschiegl/Wyckoff process, used previously in Joan the Woman (1916), The Devil-Stone (1917), The Woman God Forgot (1917), The Little American (1917), and Forbidden Fruit (1921). As discussed in more detail in chapter 5, Handschiegl was a lithographic, dye-transfer process developed by lithographer Max Handschiegl, with the help of DeMille, Alvin Wyckoff, and Loren Taylor. It rendered visually stunning, standout coloring effects that were usually applied to significant objects—for instance, the flames that consume Joan at the end of Joan the Woman (Cecil B. DeMille, U.S., 1917) and the gold tooth and various other objects in Greed (Erich von Stroheim, U.S., 1924). DeMille was generally enthusiastic about color effects, particularly the coding implications of tinting and the impact of light on color.[117] In The Affairs of Anatol, Alvin Wyckoff is

credited for the film's photography, and the intertitles are embellished with various Handschiegl-colored designs of flowers, often with witty caricatured motifs to accompany the text. One establishing shot for the Green Fan, a decadent midnight cafe, has striking Handschiegl coloring: a combination of pink/mauve for the façade and blue/green for domed roofs above that appear to be made of glass, with light emanating from the interior shining through them. A spectacular visual effect comes when the name of the club on the central dome above the entrance of the café is gradually revealed, with each illuminated letter uncovered in a fanlike movement until "The Green Fan" appears. Amber tints are used for the sumptuous interior where Anatol sees Emilie Dixon (Wanda Hawley), described in the title as a "bobbed-headed Jazz Girl," whom he remembers as a former school classmate and who is the first woman he tries to rescue. Her costume is the epitome of expensive taste: she wears a headband, plenty of jewels, and a dark-sheened evening dress with a chiffon overlay. With the emphasis in this particular sequence on the materialism represented by the jewels she has acquired as gifts from an older man, however, other aspects of her attire are less highlighted. It is as if the film's narrative structure, including the second sequence in which Anatol and Vivian are in the country, is building up to the more extreme excesses of Satan Synne's Devil's Cloister.

The Affairs of Anatol demonstrates how Handschiegl could be used to embellish tinted and toned films as an additional, spectacular chromatic surprise. It was designed to rival stenciling, which, as we have seen, was also an impressive technique for showcasing clothes and other detail. Yet even without deploying the emphatic abilities of stenciling, foregrounding fashion was an important feature of French tinted and toned films. Films Albatros, a company formed by Russian émigré Alexander Kamenka, provided a creative studio base in Montreuil, north of Paris, for many other émigré directors and key set designers of the period, such as Lazare Meerson. Their work is known for its "staged exoticism and pictorial traditions of the *Ballets Russes*," which was combined with "a more spectacular, monumental dimension to cinema décor than was common in France at the time."[118] Albatros's output demonstrated an eclectic engagement with many styles, including Art Deco, Orientalism, avant-garde modernism, and associated displays of contemporary fashions. Although the surviving record of tinted prints is variable, recent restorations confirm that color was a distinguishing, vibrant feature of Albatros's output.[119]

Jacques Feyder, a Belgian-born director who worked mainly in France, made several successful films for Albatros. The first was *Gribiche* (1926), a story of a working-class boy, Antoine "Gribiche" Belot (Jean Forest), who returns a lost purse to its American owner, Edith Maranet (Françoise Rosay), after she drops it on a crowded street. In gratitude, Edith, a wealthy philanthropist, offers to adopt Antoine so he can be well educated. His widowed mother, to whom he is very close, is surprised that the boy is agreeable to this arrangement.

Antoine does not tell her that he believes her chances of marriage to her current suitor would improve if he were to be adopted. So, he goes to live with Edith, giving the impression that he is at first happy. The film subsequently explores Antoine's mixed, at times painful, experiences of adapting to unfamiliar social expectations and the relative isolation of living a totally different lifestyle.

Designed by Lazare Meerson, the film's rags-to-riches narrative inspired sets that conveyed both urban tenement life and sumptuous Art Deco interiors. Edith's mansion anticipates the attention to interior detail of *Le home moderne*, with its shots of a luxurious Deco bathroom shown in a pale yellow tint and large, well-furnished living spaces shown in different tints of rose and sepia (color plate 2.10). These are generally shot with sufficient depth of field to convey details of furniture, carpet patterns, and décor, on occasion showing the details of adjacent spaces through open doors and archways. The film portrays Edith as generous but somewhat cold, not able to offer Antoine the loving home he had with his mother. The film's comedic play with class difference is emphasized when Edith recounts to fellow philanthropists the story of how she rescued Antoine, conveyed in a series of flashbacks, each depicting a more dramatic scenario as her tale is embellished for each listener. These settings are far drabber and more squalid than we know to be the real conditions of his poor, but far from destitute, background as seen at the beginning of the film. The warm, yellow-orange tints for his maternal home, with its decorated wallpapers and his own cozy bedroom, provide a chromatic contrast to the vast spaces of Edith's mansion, which are generally depicted in cooler-hued tints. A "below-stairs" scene of the servants eating together in the kitchen, however, appears in the same yellow-orange tint used for Antoine's maternal home, indicating how color underscores the film's broader social observations. In terms of costume, while Edith's generosity has provided Antoine with formal suits that make him appear serious, grown-up, and well-to-do, the film's depiction of Antoine when he escapes from the house to go to a Bastille Day fireworks display is very different. He wears his old clothes and beret and appears far happier away from the well-ordered, somewhat sterile confines of Edith's house. Edith's pride in transforming Antoine's life is conveyed through her admiration of his formal clothes, yet she fails to understand that he needs more than this, a realization she only comes to at the end of the film when he is reunited with his mother.

Shifting from tinted and toned films in France to photographic color in the United States, a very different fate befalls the child in *The Toll of the Sea* (Chester M. Franklin, 1922), the first U.S. feature film to use the two-color Technicolor II subtractive process. The film also uses color and costume to denote character identity, but in this case inflected with Orientalist, racial ideologies that are primarily expressed through the *mise-en-scène*. As theorized by Edward Said, Orientalism is "a Western style for dominating, restructuring, and having authority

over the Orient" by emphasizing a basic dichotomy between East and West, the other and self.[120] Said's analysis concentrates on European culture, primarily literature and painting, which "gained in strength and identity by setting itself off against the Orient as a sort of surrogate and even underground self."[121] This attitude toward the East was widespread across media and cultural fields and was frequently relayed by Hollywood and European cinema as a conventional narrative construction. Matthew Bernstein has noted that by 1920 films were "typically titillating viewers with the thrills of unbridled passion, miscegenation, and wild adventure in a raw and natural setting," as locales, costumes, and colors became identified with exoticism, physical danger, and visual spectacle.[122] In the early twentieth century, Orientalist fashion was primarily identified with Paul Poiret's designs for kimono coats and harem trousers in vivid colors and with exotic patterns. Serge Diaghilev's Paris-based Ballet Russes was also influential in displaying brilliant colors on stage, as with Léon Bakst's designs for *Schéhérazade* in 1910.[123] As we have seen, these works resonated strongly in Hollywood (DeMille) and in France (Albatros), with vivid color exaggerating the impact of sets and costumes. Used selectively, Orientalist fashions constituted a sophisticated *mélange* of styles, frequently operating within a complex system as "a series of overlaps, codependencies and shared redefinitions hiding behind a simplistic binary."[124]

When demonstrating its new process, Technicolor was strategic in emphasizing wherever possible the red and green colors captured by the camera's beam-splitting prism. These colors were well suited for depicting an Orientalist narrative that identified its central character and China with strong reds and lush greens, as opposed to the browns and neutral colors applied for the American characters. Like other Western recreations of the East, *The Toll of the Sea* was shot entirely in California, using mostly outdoor settings.[125] The film demonstrates how Technicolor took advantage of Orientalist attitudes, which in this case provided a context for the very colors Technicolor II was best at reproducing—reds and greens. Advertisements boasted that with *The Toll of the Sea*, "the era of NATURAL color comes to the screen," a point that subtly aligns "natural" color with the film's unquestioning depiction of the East in Orientalist terms. These were naturalized at the level of narrative, as is made clear when the advertisement quotes the claim of the *New York Evening World* that the film would have pleased patrons even if it had been in "the drab grey and whites of an ordinary movie."[126] The film is thus promoted as a double winner: a "realistic" depiction of China in keeping with prevalent Western imagery of the East and an acceptable narrative about the fate of a Chinese woman who has a sexual relationship with an American man, gives up their child, and kills herself.

Set just after the First World War, *The Toll of the Sea* is loosely based on the tale of *Madame Butterfly*, in a scenario written by Frances Marion. It starred

Anna May Wong as Lotus Flower, a Chinese woman who discovers Allen Carver (Kenneth Harlan), a shipwrecked American washed up on the seashore near where she lives. Allen stays in China for the spring and marries Lotus Flower, but then abandons her when he is recalled home. She thinks he intends to return and bring her back to the United States. Lotus Flower, as her name suggests, is presented as naturally beautiful, an innocent young woman dressed in soft silk clothes that emphasize the green and red hues of Technicolor's process. These colors are also associated with the lush, verdant garden where Lotus Flower is frequently shot, particularly the red flowers that equate her with nature, exoticism, and the East (color plate 2.11). Knowledge of the color codes associated with East and West is clear: when Allen is summoned home, in anticipation of accompanying him to America, Lotus Flower changes into "appropriate" clothes—a brown traveling suit with a short jacket, long skirt, fur collar, and dark hat. The new outfit presents her quite differently: she is no longer associated with nature's colors, coy and almost childlike, but seems worldly, as if she is has become a modern American woman. This image potentially transgresses the rigid color codes the film otherwise seeks to impose, as Lotus Flower's masquerade shows her awareness of the ideological associations of costume and color. But it also lays bare the limits of clothing as a racial referent, because wearing American clothes is not presented in the film as an acceptable form of transformation for Lotus Flower: her clothes are not modern but outdated and do not provide her with the disguise Allen requires to render her racial identity invisible.

He leaves her behind and, unbeknownst to Lotus Flower, subsequently marries an American woman. While waiting for his return over several years, Lotus Flower's costuming again reflects her change of fortune: she is now seen wearing drabber browns and olive greens—colors associated with nature but less vibrant than before, indicating her lower mood. This is another interesting indication of her character's awareness of color codes, perhaps gesturing to contemporary discourses about the impact of color on psychology. Her situation is made especially poignant when we learn she has had a son, "Little Allen," a young toddler whom she promises will meet his father when he soon returns. Her young son's clothes initially emphasize the sumptuousness of red and green silks, his attire reflecting her color choices and heritage. This celebration of Eastern costuming is even more obtrusive when she learns of Allen's return to China. She dresses in an exquisite flowing, patterned bridal robe made of green, red, and white silks and adorned with jewels. But Allen is accompanied by his new wife, Barbara, who has forced him to return and apologize to Lotus Flower for deserting her, without knowing he has a son. Significantly, Barbara's clothing is much more muted than Lotus Flower's when they meet. The American wears a tasteful light green dress and hat, yet the green still connects her to the natural setting of the garden; lightly hued flowers on her hat continue this

theme, suggesting that even across racial difference, there is a bond of femininity between the two women. In a painful scene in the garden so identified with Lotus Flower, they meet her son, now stripped of Eastern colors after a bath and dressed in a white American sailor suit. At first, she pretends he belongs to American visitors, but following the tragic, sacrificial logic of *Madame Butterfly*, Lotus Flower subsequently tells Allen's wife the truth and gives up her son, so he can go to live in America (color plate 2.12). The film ends with the "restless sea" claiming Lotus Flower, as the sun sets slowly on the horizon as a symbol of her presumed suicide.

The Toll of the Sea served a number of interrelated purposes for Technicolor, from showcasing the colors identified with the company's new process to locating the East as "other" by being identified with color, nature, exoticism, and silken fabrics. The very purpose of the film's color scheme, however, introduces elements of contradiction within its narrative closure. The West is white, brown, and pragmatic, as seen in Allen's uniform-like suits, Barbara's dull dress, and Little Allen's white sailor suit, which appears to instantly turn him into an American child.[127] But visually the East is far more attractive; we remember Lotus Flower's gorgeous, opulent bridal gown, the silken fabric of her son's contrasting green and red clothes, and the lush flowers in her garden far more than the unremarkable visual referents and colors associated with the West. From this perspective, the film reveals the instabilities of Orientalism, while highlighting the work that color is capable of doing toward its exposure. Technicolor's desire to highlight vivid color presented the East as an extraordinary locale, elevating the visual pleasure of those images far above the muted, unremarkable hues associated with America. The latter was equally exposed as a construction that served the film's Orientalist narrative, as it bore little relation to the colorful chromatics of contemporary America or to the vibrant fashions available to color conscious moviegoers. *The Toll of the Sea* is consequently a remarkable film for reasons that exceed its reputation as an early example of Technicolor's innovative subtractive two-color system.

As these examples have shown, fiction films deployed a number of chromatic effects, ranging from the obtrusive object embellished by Handschiegl or Pathécolor to the suggestion of ambient, contrasting, or socially demarked locales through selective tints and tones. *The Affairs of Anatol*, *Gribiche*, and *The Toll of the Sea* demonstrate how the latter could be sophisticated, subtle, and graphic, underscoring thematic concerns and ideological perspectives, as well as displaying costumes, fabrics, and décors. Color was clearly important in delineating contrasts between opulent, exotic, and ordinary domestic spaces in which the viewer is invited to contemplate differences in locale and mood. At the same time, a certain degree of consistency is apparent around chromatic conventions for underscoring the narratives of silent cinema.

The Fashion Show Within Film

Another means of highlighting fashion more directly was the inclusion of fashion shows within a narrative film. These were sometimes distinguished by using a different color process such as Technicolor for a special reel, as in the comedic satire *Fig Leaves* (Howard Hawks, U.S., 1926). In such cases, both the fashions and the process stand out as a dual spectacle within the film. In *Fig Leaves*, the Technicolor fashion show serves an additional purpose because the film is a modern morality tale, using Adam and Eve as names for a couple whose relationship is strained by Eve's desire to work as a fashion model. Her disapproving husband behaves as if this ambition were a sexual rival, particularly when he discovers she has deceived him by modeling clothes for the House of André, owned by a somewhat caricatured couturier. As Jeanne Thomas Allen notes, this conflict adds suspense to the sequence as Adam watches the show without realizing that his wife will shortly appear in it as a model wearing a tight-fitting red décolleté evening gown: "In this sense, the eight-minute fashion show is not a point of narrative stasis but rather a climactic crescendo."[128] As well as being tight-fitting, the shimmering gown worn by Eve for the grand finale has flesh-exposing cutaways between her breasts and to highlight her waist. These additions heighten the gown's sexualized impact as she twirls to reveal the contours of its intricate, geometric design. The fashion world is nevertheless presented as alluring and associated with Eve's bid for greater independence within her marriage. The show's costumes, by Hollywood designer Gilbert Adrian, were described in one review as "the last word in feminine appeal."[129] Appearing as a spectacular intervention in a film otherwise unremarkable for its lighting and design, the fashion show serves as a visual delight coded as a feminine space (color plate 2.13).

Similarly, *The American Venus* (Frank Tuttle, U.S., 1926) features three sequences in two-color Technicolor to embellish its comedic-romance plot concerning the Miss America beauty pageant in Atlantic City. This involved the display of bathing-suit fashions, including those modeled by Louise Brooks, as seen in a few seconds of recently discovered color outtake footage at the British Film Institute from a film that, apart from its trailer, is otherwise lost. Although Brooks's image is classically identified with the black-and-white cinematography of *Pandora's Box* (G. W. Pabst, Germany, 1929) that emphasized the striking contrast between her pale skin and dark bobbed hairstyle, in the mid-1920s she was associated with pioneering color experiments such as the films that sought to arrest audiences' attention with color fashion inserts and spectacle.[130] Fay Lanphier, winner of the Miss America beauty contest in 1925, was cast as the leading player, and the film's trailer refers to the models' wearing "the latest, loveliest creations from Paris." Louise Brooks was Miss Bayport, and judging

from the film's miscellaneous surviving materials, she appeared in a sleek, all-in-one black swimming costume that was in keeping with the contemporary fashion for athletic-themed designs. In the outtake footage, however, she is wearing a more daring, midriff-exposing, Orientalist showgirl costume made of diaphanous, jeweled fabric. Her placement behind what appears to be a square-patterned steel grid invests the image with additional risqué connotations: she appears to be imprisoned, perhaps in a harem, and the audience's view of her provocative pose is in part obscured, which heightens the suggestive nature of the shot.[131]

Using color to showcase fashion was clearly high on the agenda of Technicolor, and the company produced many shorts featuring fashion shows toward the end of the 1920s. Color enhanced the pleasure of viewing clothes in all of their prismatic glory, while at the same it suggested the exotic allure of French couture. In accordance with Bourdieu's model, the cultural capital associated with Paris persisted as an image of sophistication and taste. Apart from the visual pleasure provided by clothes with harmonious or exotic colors, European fashions provided U.S. films with a cosmopolitan élan. Even though the TCCA was trying to generate a widespread culture of Americanization concerning color taste, the reputation of French *haute couture* was an enduring one that was exploited in multiple contexts.[132] In this spirit, *Monte Carlo* (Christy Cabanne, U.S., 1926), another American film featuring a fashion show shot in Technicolor, was filmed partly on the French Riviera.[133] In the fashion show, an American woman models the work of a famous French designer. Her performance highly impresses an American man in the audience, specifically because she has modeled the French designer's exquisite collection. In this example, both the character and Technicolor are distinguished by their association with French sartorial elegance. Hollywood's use of French fashions could, however, be critically selective, as Érte discovered when his designs for MGM's *Paris* (Edmund Goulding, U.S., 1926) were considered too radical, and he soon returned to Paris.[134]

The phenomenon of the fashion show within a film was not confined to Hollywood. In Germany, a popular genre known as *Konfektionskomödien* (fashion farces) focused on the independent lifestyles of female fashion models working in Berlin. While much of the drudgery of doing the generally low-paid job was depicted in the films, fashion shows took up a high proportion of screen time as "pure visual extravaganzas," advertising the latest designs from Berlin's fashion houses.[135] The role of color in the *Konfektionskomödien* is not known, but films such as *Die Kleine aus der Konfektion* (Wolfgang Neff, 1925) offered audiences access to sumptuous fashion shows that would have been more expensive to see in department stores and designer salons.[136] Much as in *Fig Leaves*, fashion in the German films was a locus of aspiration both in relation to the independent fashion models whose lives they depicted and for the female patrons to whom they were primarily addressed.

The Film-Inspired Tie-In

As Charles Eckert observed, "If one walked into New York's largest department stores toward the end of 1929 one could find abundant evidence of the penetration of Hollywood fashions, as well as a virulent form of moviemania."[137] A key indication of Hollywood's close relationship with the consumer marketplace was the "tie-in," sometimes also referred to as "tie-up." Predating cinema, the tie-in referred to how theatrical producers and later film studios forged symbiotic advertising connections—for example, when Macy's in New York designed and supplied gowns for stage plays. Tie-ins for early films included publishing prose versions of their stories in fan magazines or sheet music of songs that had been composed for films. The gowns seen in Pathé's short film series *Florence Rose Fashions* (1916–1917) were advertised in the New York press and then available to buy in stores.[138] Colored images, particularly enhanced by the precision of stenciling, contributed toward the identification of products as novel, desirable, and markers of taste and affluence. Film and print culture advertised products both indirectly and directly and were at the heart of the consumer revolution of the 1920s. Exhibitors also used color in advertising, launching promotional campaigns that involved tie-ins such as for *The Christian* (Maurice Tourneur, U.S., 1923), a film that inspired store-window displays of canary yellow silks and flowers—yellow being the color of gowns worn in the film by the star Mae Busch.[139] It is unclear whether the gowns were particularly highlighted, but the director Maurice Tourneur was very skilled in expressive tinting and toning effects, as *The Blue Bird* (Tourneur, U.S., 1918) demonstrates.[140] When *Fig Leaves* was promoted to American and British exhibitors, tie-ins were recommended in which movie theaters and cinemas would stage fashion shows featuring materials available to purchase at local drapery stores. Exhibitors were encouraged to be resourceful and imaginative because "almost every picture has some point which gives one an excuse for tying up with something or other."[141]

As we have seen, the naming of colors by the TCCA aimed at their broad dissemination in the market. It would be reasonable to expect that films presented an opportunity to popularize shades or even coin new color terms, and indeed, in a few significant instances, this was the case. Yet, as the cases demonstrate, the instabilities around film color reproduction in the 1920s made it problematic to look to feature films to generate specific color nomenclature and associated meanings that could be reproduced in other media with any degree of consistency. Attempts to tie colors down were frustrated by inconsistent reproduction during a period when, as we have seen, prints were subject to variation in terms of tinting, projection illumination, and the variation of coloring effects on different prints of the same film, as when a specific, expensive

craft technique such as Handschiegl was applied only on certain prestige prints. Since the majority of films were tinted, it would have been difficult to discern particular colors for gowns without the precision of stenciling or hand coloring. Experiments in natural color, however, presented further possibilities (and problems) of displaying specific fashions and colors.

Two interesting cases of colors being very much tied to particular films are "Alice blue" and "Phantom red." As Victoria Jackson and Bregt Lameris demonstrate, these were connected to an extensive range of tie-ins, demonstrating how a particular shade could function as advertising for many different products, often with very different connotations.[142] "Alice blue" was originally named in 1905 after the gown Edith Roosevelt wore to her husband's presidential inauguration ceremony. This was a shade of blue that had been selected by her stepdaughter Alice, who had seen it the year before at the World's Fair in St Louis, Missouri. To honor her stepdaughter's choice Edith wanted the color henceforth to be known as "Alice blue." It was subsequently used for silks, fabrics, accessories, and a range of other commodities, and in a popular song, "Alice Blue Gown," which featured in *Irene*, a 1919 stage musical. When *Irene* (Alfred E. Green, U.S.) was adapted for the screen in 1926, its star Colleen Moore wore a dress referred to as "Alice blue" in a fashion sequence in Technicolor. By this time, the color had been adopted in a range of commercial contexts, with varying connotations of bourgeois social mobility, the growing confidence of American (as opposed to Parisian) fashions, nostalgia, loss, and melancholy. In *Irene*, "Alice blue" became further invested with the star persona of Colleen Moore as a modern flapper, as well as by its diegetic appearance in the fashion-show sequence advertising the latest seasonal fashions. Advertisements for the film emphasized the fashions displayed in the Technicolor sequence, including the famous blue gown.[143] In this case, the film had not generated a new color name but was a strong means of continuing and developing its presence in commercial markets. For specialist commentators such as Matthew Luckiesh, however, this demonstrated a frustrating degree of imprecision. In his influential book *Color and Its Applications*, Luckiesh cites "Alice blue" as an example of "inexact, unwieldy, and often totally non-descriptive" color naming.[144]

"Phantom red" had a more direct link with the TCCA: it was reportedly named as a shade after Margaret Hayden Rorke saw Universal's *The Phantom of the Opera* (1925) in Paris.[145] With its striking Technicolor sequence featuring the skeletal phantom appearing in front of the horrified crowd wearing a voluminous red cloak, the costume and the color were certainly memorable (color plate 5.5; see chapter 5 for a closer analysis). Universal exploited the novelty of both the scene and Technicolor to use the newly coined color term for many tie-ins, ranging from cosmetics, clothes, and hats to milkshakes and ice cream.[146] With evidence of international currency as a term, "Phantom red" featured intensively in advertisements for different consumer products into the

early 1930s. Once the color was doing the promotional rounds, its connotations became somewhat removed from its filmic context. Although red is often associated with desire and danger, these sensations were a variable presence in marketing products described as "Phantom red." The horror associated with the phantom, for example, was not related to "Phantom red" lipstick when it was advertised by Mary Philbin, a star whose innocent image was described in fan magazines as "fresh and as wanting in artifice as the flowers she holds." In this instance, any sexual connotations were downplayed, demonstrating how the word "phantom," with its suggestion of mutability, could be useful when seeking to tie products to particular film stars.[147]

Universal Pictures released *Midnight Sun* in 1926 (Dimitri Buchowetzki, U.S.), and again there was a direct link with the TCCA, whose fall card announced a burnt-orange shade of the same name.[148] The film, a drama set in Imperial Russia, was reported to feature a "Ballet of Jewels" sequence in color.[149] *Universal Weekly*, a trade magazine published by the studio aimed at exhibitors, noted the commercial impact of both the film and the color in store-window dress displays and cutouts of Laura la Plante, the film's star.[150] A further report noted an international impact and, again, the copresence of direct advertising for the film as well as products celebrating textiles in the color: "'MIDNIGHT SUN YELLOW,' the brilliant color named after the Universal super, is proving good tie-up material in England as well as in the United States. Clement West, Liverpool manager of the European Motion Picture Co., Universal distributors, arranged with W. Owen Ltd., one of the largest stores in the north of England, for a display of various kinds of cloth of this color. The store in arranging this display made generous use of stills from the picture and Universal posters."[151] The Parisian milliner Madame Agnès selected "midnight sun" as a shade for her latest millinery collection in 1926.[152] Other tie-ins were more basic, such as Midnight Sun-dae soda fountains in a San Francisco theater as well as in other American cities.[153] Because no prints survive showing clearly how the color sequence looked, it is difficult to judge how "midnight sun" was referred to in the film. It would seem that exhibitors could not be sure of receiving color prints of the film at the time of release, according to one report from the UK. In this case, the black-and-white prints were resourcefully hand colored in some sections, reportedly using twelve colors and at no extra cost to exhibitors.[154] Some reviews refer to natural color, so it is likely that the sequence was in Technicolor.[155]

Universal's interest in color names continued with *King of Jazz* (1930), a Technicolor musical revue film with a "Rhapsody in Blue" sequence that celebrated Gershwin's popular piano and jazz-band composition written in 1924 (also see chapter 6). When the film was released, numerous tie-ins were announced, with "Rhapsody blue" as a signature color, including a necktie with a "background design being symbolical of the picture. The color even ties in.

It is 'Rhapsody Blue.' "[156] Margaret Hayden Rorke is reported to have intro-
duced the shade, described as "a soft blue with a violet tint," for use in autumnal
collections. She predicted it would "far outdistance the success of Phantom
Red."[157] This comment shows that the naming of colors after, or in association
with, films was not a regular occurrence but still an important one; "Phantom
red" appears to have been the most sustained example. It was again referred to
in the press in 1936 when Rorke named "Sutter's gold" as a new color for the
TCCA's spring season card in the midst of an expansive tie-up campaign by
Universal for the film of the same name, directed by James Cruz (U.S., 1936).[158]
The color, described as "a rich, glamorous hue, recalling the colorful days
of the discovery of gold in California," was inspired by adventurer John A.
Sutter, the subject of the Universal biopic. Once again, there was a direct tie-in
between the TCCA and the studio.[159] There were, however, degrees of conflict
between the advocates of greater standardization in the naming and recogni-
tion of color terms and the fashion industry's seasonal demand for novelty.
Films occupied an intermediate space in this struggle because, in a figurative
sense, the tie-in/tie-up offered limited benefits to the films inspiring the terms.
As we have seen, in time "Phantom red" became divorced from *The Phantom
of the Opera*, the connection between the two having served an intense, mutu-
ally beneficial, but short-term purpose.[160]

This chapter has examined color's centrality in the 1920s to a range of pro-
motional contexts, from advertising clothes, accessories, and Art Deco fur-
niture to synthetic dyes and individual films. Across this material, a vibrant
culture of chromatic experimentation was underpinned by a productive sym-
biosis between retail analysis, merchandising, and a diverse range of artis-
tic practices. The decade was also marked by the formation of institutional
structures—including the TCCA in the United States and the *Daily Mail* Ideal
Home exhibitions in the UK—advocating color by advising consumers how to
make informed, color-conscious choices. In addition, the seminal impact of the
Exposition internationale des arts décoratifs et industriels modernes resonated
beyond Europe. What emerged was a dynamic, transnational nexus between
the United States and Europe, as Parisian styles were admired, copied, and
transformed. The distinctions between *haute couture* and ready-to-wear fash-
ion were increasingly blurred in the wake of a copy culture that the medium of
film was in an excellent position to exploit. The range of films discussed in this
chapter has shown that in both nonfiction and fiction, film was a prime motiva-
tor encouraging people to be more aware and informed about the impact of the
colors they wore, decorated their homes with, and enjoyed on the screen. As
the next chapter demonstrates, chromatic competence could also be acquired
through the architecture, décor, and lighting design of contemporary public
entertainment venues, which functioned as vibrant sites of chromatic, visual,
and aural experimentation.

CHAPTER 3

SYNTHETIC DREAMS

Expanded Spaces of Cinema

The public is definitely color-conscious. Automobiles used to be sold on their mechanical perfection, but today the color of their bodies is an important factor. Fountain pens are colored, glassware is colored, there is color everywhere, and why shouldn't people coming to your theatre to release themselves temporarily from a drab existence, also enjoy color?

—Edwin Sedgwick Chittenden Coppock, *Motion Picture Herald* (1934)

In the 1920s, the full impact of developments in synthetic coal-tar chemistry began to find chromatic expression in a range of artistic and commercial forms, particularly advertising, fashion, film, print culture, theater, architecture, and design. Widespread interest in color across these fields was shared through ideas about the unity of art forms—of synthesizing media to create effects that transcended the capabilities of discrete forms, as epitomized by Wagner's notion of the total work of art, or *Gesamtkunstwerk*. Connections among hitherto disparate modes of experimentation were forged in the 1920s as a number of practitioners and theorists saw color as a revelatory force. The word "synthetic" is therefore doubly appropriate, referring not just to the application of vibrant synthetic colors produced chemically but also to the utopian synthesis of medial forms. The latter found expression in manifestations of what came to be known as "color music"—also called "visual

music" or "mobile color," terms used increasingly from the 1920s on—which referred to cross-medial artistic practices that combined colors, light, and/or music in a range of abstract patterns that were exhibited in a variety of venues. As cinema was developing as a classical institution characterized most visibly by the picture palaces that flourished in the 1920s as purpose-built structures for film exhibition, these glamorous venues were nonexclusive sites for a host of media practices exhibited in conjunction with feature films. Beyond narrative films, newsreels, and other short programs, picture palaces of the twenties also showcased chromatic light displays, color-music experiments, and resplendent stage prologues for films. These variety programs around feature films is where abstract, experimental practices were often integrated with more vernacular forms of cinematic entertainment, similar to what was later referred to as "expanded cinema," in which mixed or multimedia exhibition events widened the synthetic field of vision "so far that they dissolve cinema itself as a separate entity."[1] In the 1920s, an immersive exhibition environment and culture extended beyond the projected image. A combination of high and low, avant-garde and vernacular forms exhibited at the same time and in the same space invited spectators to experience a synthesis of effects. The emphasis was—literally and metaphorically—on widening the field of vision in order to craft holistic experiences of art and entertainment that were uplifting, sensuous, and aurally and chromatically rich.

In Pierre Bourdieu's conceptualization, avant-garde and vernacular art are usually seen as divergent, even competing, traditions within the field of cultural production, involving distinctive aesthetic forms and requiring acquired "aesthetic competence" from critics or spectators to appreciate their artistic value.[2] While avant-garde experiments of the 1920s often represented the shock of the new, this chapter proposes that the simultaneous expansion of mass entertainment and instances of intermedial performance in popular venues promoted interrelationships between experimental and vernacular forms, constituting a chromatic version of what Miriam Hansen has described as the "vernacular modernism" of classical cinema.[3] Even as there are crucial distinctions between avant-garde and vernacular forms of modernist expression, there were also dynamic exchanges occurring across these modes of production during the decade. Mobile-color and color-music practitioners did not rely on audiences' having prior aesthetic competence about related artistic conventions. Much as avant-garde artists working in Germany, such as Walter Ruttmann, saw public advertisements as legitimate platforms for their work, the appeal of color music and mobile color was not confined to a narrow cultural elite. Commercial cinemas were appropriate places to showcase experimental innovations in lighting technology and electrical devices that manipulated color and music to accompany screenings of art and popular films. While the motivations for showcasing such developments ranged from commercial competition to claims

that they provided the basis for new art forms that promoted a revitalized color consciousness amongst the audience, there is no doubt that the decade saw many examples of cross-fertilization between media. The explosion of color in conjunction with new forms of mass entertainment in the 1920s promoted a reinvigoration of older traditions such as color-organ technology, as well as inciting correspondences between diverse cultural spheres. Experts in lighting technology turned to practitioners of color music, and vice versa, as the collision between modernist experiment and a rapidly expanding classical cinema produced a fusion of cross-media activities.

A crucial emphasis of this chapter is on how the variety of experiments with color, music, and lighting can be related both to the utopian desire for a synthesis of medial forms and to discourses on educational uplift and the inculcation of a color consciousness in a mass audience. The decade saw an advance of intertwined cultural, industrial, aesthetic, and educational approaches to color, which shaped how sound, music, and mood were thought of and deployed in film, particularly with Technicolor. Both Loyd Jones's and Natalie Kalmus's ideas about color consciousness (in 1929 at Kodak and in 1935 at Technicolor, respectively) were clearly rooted in earlier color discourses.[4] The phrase "color conscious" had appeared with increasing frequency in a range of contexts from the late nineteenth century on, in engineering manuals and art curricula, in discussions of advertising psychology, and in the popular press as the phrase entered popular parlance. People were urged to be more widely conscious of color choices in the home and garden, in personal attire, and in schools, civic buildings, and entertainment venues. In theaters, in anticipation of the color films screened in the 1920s, ambient mood lighting was often used to induce a receptive state of color consciousness in the spectator. These lighting systems exploited new technical developments, especially the ability to vary hue, tint, and illumination intensity, as a growing belief in the efficacy of influencing mood and ambience through colored lighting gathered momentum. As we shall see, there were many diverse topographical locations for color experimentation, on occasion challenging expectations about typical venues, class of patronage, and audience response. Prevailing trends toward a total intermedial experience of cinema encouraged avant-garde practices and vernacular entertainment to comingle in venues not typically associated with modernist experimentation. The accumulating rhetoric about color consciousness and its incursion into homes, theaters, streets, stores, fashion, and public buildings enabled synthetic forms of color music to traverse these various boundaries.

One such space was the combined restaurant, cinema, and dance hall at the Café Aubette in Strasbourg, a large multipurpose structure built in the late eighteenth century. It had fallen into disuse after a fire in 1870 but was redecorated in 1928 by Dutch artist and theorist Theo van Doesburg, with the assistance of German-French poet and abstract artist Hans Arp and Swiss painter

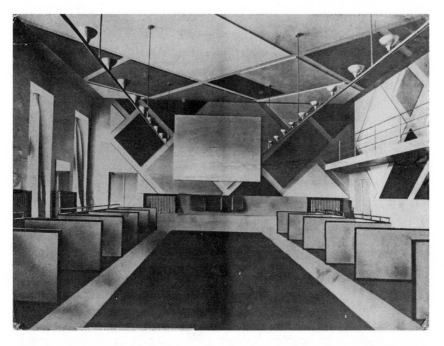

Figure 3.1 The ciné-dance-hall of the Café Aubette in Strasbourg designed by Theo van Doesburg with Jean Arp and Sophie Taeuber-Arp (1928).

and sculptor Sophie Taeuber-Arp. An interior arcade connected the various spaces: on the ground floor, a café, restaurants, shops, and bars; and upstairs, the cinema-dance hall. The spaces were not designed to be discrete: visitors walking through them experienced them as interconnected parts of a singular design. The Café Aubette's revolutionary interior featured walls and a ceiling with mounted, largely rectangular, geometric shapes in green, red, blue, black, cream, yellow, and gray (color plate 3.1). As van Doesburg explains, the complex contours of the space allowed for its structural animation through color:

> I did not have any unbroken surface at my disposal. The front wall was interrupted by the screen and the emergency exit, the rear wall by the entrance door, by the door of the small banqueting hall and by the openings for the cinematic projectors, as well as by the reflector. The left-hand wall was broken up by the windows extending almost to the ceiling, and the right-hand wall by the door to the kitchen offices. Now, since the architectural elements were based upon orthogonal relationships, this room had to accommodate itself to a diagonal arrangement of colors, to a counter-composition which, by its nature, was to resist all the tension of the architecture. Consequently, the gallery, which crosses the composition obliquely from the right-hand side, was

an advantage rather than a disadvantage to the whole effect. It accentuates the rhythm of the painting.[5]

This was in keeping with the influential De Stijl movement's geometric primary colors that dominated their nonrepresentational "new plastic art." The Café Aubette's façade was lit by neon, and the building represented a high point of ultramodern design for urban leisure, with cinema as a central activity.

Cinema spaces such as the Café Aubette were thus sites of experimentation within a culture that was going through an exciting, chromatic period of intermedial exchange. The fundamental principles behind the site's design represented the spirit of the decade to synthesize media forms and produce total effects through tone, mood, hue, and illumination. As we shall see, this synthetic approach subsequently informed the sound era of film, when color, in combination with music, dialogue, lighting, and other elements of *mise-en-scène*, was conceived as an orchestrated element of a film's complete design.

A Color-Conscious Decade

With a greater understanding of color's synthetic uses in entertainment and in the broader public sphere, a variety of artists, designers, and architects looked to color as a means of negotiating the modern world. *Colour*, a magazine produced in the UK from 1914 to 1932, for example, featured a series of articles on "Colour—The Townscape Campaign." The aim was "to extend the influence of colour towards improving the amenities of our cities," while advocating: "There is a very close reaction between colour and the business of to-day, and the stress and strain of modern life demands every psychological aid. Congenial, artistic colour in our townscapes would add immeasurably to the feeling of well-being."[6] Multipurpose entertainment venues such as the Café Aubette epitomized this kind of expansive approach to color design in urban life.

As artificial lighting technologies developed, an awareness of color consciousness became marked across cultural, scientific, and industrial fields. Connections between hitherto disparate modes of experimentation were forged, as a number of practitioners and theorists saw color as a revelatory force. Cities increasingly converted to artificial lighting for advertising and civic displays, and moviegoers experienced a similar barrage of light and color in theaters. The increasing ubiquity of neon lighting in major cities increased the incidence of exterior electric signage used for cinemas, and the colorful experience of entering into these spaces was aimed at creating a heightened sense of anticipation for the movie presentation. The Warners' Theatre on Broadway, New York, for example, applied a "color absorption" technique above the marquee at the entrance that manipulated overlapping and contrasting colored lights to

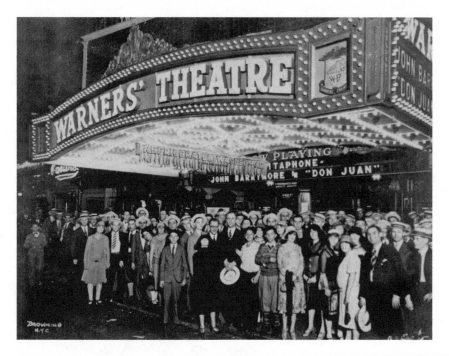

Figure 3.2 Warners' Theatre on Broadway advertising *Don Juan*, ca. 1926.

enhance or absorb one another in alternating intervals. A sign painted with yellow and pink images of John Barrymore in *Don Juan* (Alan Crosland, U.S., 1926) and one of his female costars was illuminated at night by alternating red and blue-green colored lights to give the impression of animation. A report described how the effect worked:

> The principle of this type of display lies in the scientific discovery that colors of equal light intensities reflected against one another produce a white, or "colorless" effect. In other words, when two reds are reflected against one another, there is a "fade out," leaving only the blue background visible to the eye. In this manner, only certain of the postures are seen when either of the lights flashing alternately, strike the surface of the painting.[7]

Other displays designed to bring color into lobbies included the "Crystal Sign," in which pieces of crystal were bonded into shapes, mounted on a background of red and purple glass, and then adjusted to a flash box. Intermittent flashes of light made the crystals appear like diamonds. Color was also added to lobby displays and posters.[8] Such illuminations shared with visual music the linking of colored lighting with mood, tone, space, and rhythm.

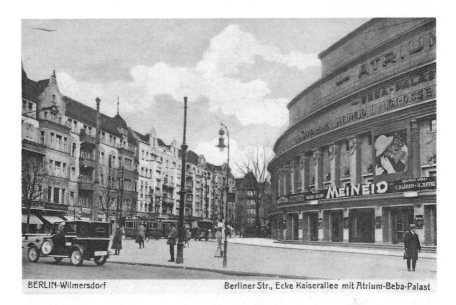

BERLIN-Wilmersdorf Berliner Str., Ecke Kaiserallee mit Atrium-Beba-Palast

Figure 3.3 Exterior of the Atrium Theatre in Berlin (1929).

Foyer spaces were particularly important for refocusing the spectator's consciousness from everyday reality to "the make-believe world of the screen and screen conventions."[9] Some German architects, such as Friedrich Lipp, thought the change should be abrupt "in order that a violent, dramatic contrast may be produced"; he applied this idea in his designs for the Atrium Theatre in Berlin, which had a foyer with "bizarre overhead lighting" to create "a profusion of light to dazzle the spectator."[10] The foyer of the Atrium, opened in 1926 and demolished in the mid-1950s, was illuminated by ceiling fixtures arranged in consecutive rectangular shapes that appeared stark because they were the only form of artificial light within a generally dark ambience. By contrast, the Kammer Lichtspiele in Chemnitz, designed by Erich Basarke, displayed a more gradual approach, with the foyer featuring subtle decorative inflections and soft lighting. An intermediary approach was to have cornice lighting in foyers shifting from a suffused glow of indirect lighting in different colors to "a blaze of brilliance before the principal doors giving access to the auditorium."[11] Such examples were underpinned by theories about the specific affective and physiological influences of artificial lighting, usually connected with large corporations interested in exploiting these effects for commercial purposes. At the same time, atmospheric colored light became a central element of the debate pertaining to its aesthetic as well as distracting potentials, acting as a fascinating vector of possibility that transcended purely technical details.

A key figure in colored lighting during the 1920s was Matthew Luckiesh, who directed applied science at the Nela Park research laboratory of General Electric in the United States and became its overall director in 1924. In 1916, he wrote about how colored lights could be used for their "psycho-physiological effects," an important scientific field of the time that derived from German research that related physical stimuli to sensations and perceptions, as discussed in chapter 1.[12] These ideas challenged a purely optical understanding of color analysis as enshrined in turn-of-the-century color science. Proposing that psychological and physiological processes, in addition to the optical properties of color, were vital to color analysis resulted in a more nuanced, variable model. This highlighted the impact of different color effects and "modes of appearance," which included those dependent on time, or even memory.[13] Luckiesh's ideas were based on a general conception of warm and cold colors (a notion popular from the nineteenth century on, and famously later adopted by Natalie Kalmus of Technicolor), the former being reds and oranges and the latter blue, with green seen as neutral. Greater or lesser saturation was a means of intensifying a mood or lessening it. As Luckiesh put it: "The lighting specialist may accomplish much of his own accord by utilizing the coldness, warmth, and neutrality of colors which may be obtained in any degree by a proper selection of hue, tint, and illumination intensity. He may study the symbolic uses of color and gradually extend these to lighting. There is no reason why we should not *paint* with light; in fact, this is an excellent description of an artistic lighting effect."[14] There were variations on these ideas, but in general an understanding of color consciousness was developing that depended on using color's impact in a variety of contexts and media. Color and lighting expert Beatrice Irwin lectured to city planners in Los Angeles on restricting colors and combinations according to area. She advocated that city illuminations should be guided by "the minimum amount of red, blue and violet, the moderate use of orange and indigo, and the maximum of green and yellow and white," and that some streets should be demarked for advertising which "might call forth new ideas in architecture and illumination."[15] As detailed below, a number of color theorists, including British advocate of color music Adrian Klein and Kodak scientist Loyd Jones, were similarly enthusiastic about the aesthetic possibilities of controlling colored illumination. This opened the door to a plethora of mobile effects that modulated hue and intensity to create artistic color designs in keeping with Luckiesh's analogy with painting.

During the 1920s, the growing fascination with color psychology and closely related ideas about color consciousness influenced thinking around color, cinema, and the interconnected avant-garde and vernacular forms that underpinned visual music. Disparate individuals were connected through their advocacy of these ideas, albeit from different professional fields. Some were interested in improving public taste, while others used color to advertise new

products and fashions. As psychologist and psychophysicist Leonard Troland—
an assistant professor at Harvard who also worked for Technicolor from 1918
on—observed:

> What a remarkable medium for the production of novelty we possess in color,
> with its infinitude of tones, saturations, shades and contrasts! It may not be the
> function of illuminating engineering to light our streets with green in order to
> inhibit robbers and gun-men, or to flood our dining rooms with red to stim-
> ulate digestion. On the other hand, to provide us with an infinite fancy of the
> hour, may be a real service not only for the pleasure of the instant, but indi-
> rectly for our mental and moral efficiency, as it is governed by our satisfaction
> in living.[16]

Troland's interest in applied psychology and color reflects many of the broad
interests of Harvard's psychological laboratory, and he overlapped briefly with
Hugo Münsterberg at the lab in fall 1916. As discussed in chapter 1, Münster-
berg even gave Troland an inscribed copy of *The Photoplay: A Psychological
Study* (1916). Perhaps informed by Münsterberg's fascination with cinema, and
given its growing ubiquity at the time, it is not surprising that Troland saw
the medium as a primary outlet for chromatic expression. At Technicolor, he
worked on all manner of color innovations, such as exploring how the process
could best enhance image depth and precision: "When color is used . . . a new
medium becomes available in terms of which the details of the picture can
be rendered and color contrast can take the place to a large degree of bright-
ness contrast. At the same time the truthfulness of the representation is greatly
improved."[17] Toward this end, he worked tirelessly to perfect the company's
imbibition printing process.[18] He was also involved in broader areas of public
debate about color and was instrumental in helping establish new standards for
colorimetry during the 1920s.

Both Luckiesh and Troland contributed to the Exhibition on the Art and
Science of Color held in New York in 1931, which brought together industrial-
ists, scientists, educators, artists, and technicians in what was described as "the
first comprehensive effort yet made to indicate the use and future possibilities
of color in virtually all departments of modern life and will bring to the public
a better understanding of both the scientific and artistic aspects of color."[19] It is
clear that advocates of color consciousness promoted it as a means of conferring
cultural capital on those whose competences could be sufficiently developed
about color codes.[20] In this sense, Luckiesh, Troland, and others were educators
with a mission to enlighten people, regardless of wealth, about color choices.

Notable chromatic experiments during the 1920s were influenced by
such views. These grew out of ideas and practices that had been developing
over many years through experimentation with color music. In the 1920s,

artists became interested in film's potential as a platform to "put paintings in motion."[21] As noted earlier, a variety of terms were used to describe interactions among light, color, and music, including "mobile color," "color music," and "visual music." Mobile color was generally associated with projections of colored light onto moving forms, as with stage performances, and also with the ability to change the colors of shafts of projected light, giving the impression of movement and dynamism. Those interested in color music, as detailed below, typically combined music with colored light to intensify depths of emotive power, with an interest in sensorial transference and synesthesia. Direct correlations between musical notes and colors were not always sought, however, as artists experimented with the total interactions between media designed to transcend the impacts of discrete forms. Visual music was a synonymous term for exploring the fluidity and nuance associated with auditory music but in visual forms, as in abstract films, which again were not tied to convention or code.[22]

Experts in color research were affected by these ideas as they engaged in a broad spectrum of related enterprises. For example, even though Luckiesh is most associated with his lighting work throughout the 1920s, he also experimented with color-organ technology. He invented a "Byzantine jewel box" that was demonstrated publicly at the Exhibition of the Science and Art of Color in New York in 1931. This was described as "a constantly changing panorama of color designs projected on a screen. Beginning with ordinary geometric patterns in black and while, the designs gradually assume more and more color, rising to a climax in a series of gorgeously patterned stained glass windows."[23] Leonard Troland was similarly interested in the efficacy of experiments in color music in relation to electrical engineering, advocating that these fields should be closely connected: "The illuminating engineer should lend his assistance to this new artistic enterprise, as to the world of artistic endeavor in general."[24] At Kodak, Loyd Jones experimented with kaleidoscope forms of color music, both through the orchestration of projected light and through abstract film experiments shot on two-color Kodachrome, much of which he demonstrated at the Eastman Theatre in Rochester, New York (color plate 3.2).[25] In addition, in his writings with reference to Luckiesh, Jones explicitly advocated for the development of the motion picture public's "color consciousness" through chromatic experimentation.[26] This advocacy of the benefits of color consciousness was evident in Luckiesh's utopian claims that it would make "the world a happier place to live in."[27] The desire to link different colors with particular attributes or moods could, however, be in tension with the knowledge that it was culturally and aesthetically problematic to tie colors to specific universal meanings. Most forms of color experimentation during the 1920s negotiated this issue, with something of a consensus emerging around the desirability of color consciousness among artists and the general public.

As the concept of color consciousness became more frequently cited, particularly in the U.S. press after 1925, its applicability extended internationally across media, as exemplified in the writings of Adrian Bernard Klein. An influential British writer, filmmaker, and color theorist, Klein (who later went by Adrian Cornwell-Clyne) was also fascinated by color music. His classic text, *Colour-Music: The Art of Light* (1926, revised in 1930), surveyed the field and its future possibilities. He was skeptical of seeking to attribute universal effects to particular colors, preferring instead to stress the importance of context:

> It is insufficient to assert that red and red-orange will be exciting. The luminosity of a hypothetical red might be less than that of a blue-green preceding it, and less than, say, a light-violet succeeding it. In which case, the effect of the red might be momentarily restful; an effect due to its luminosity context. The attention will be held, and the highest exciting influence, physiological and psychological, exerted by the bright blue-green following a sequence of very "hot" colours, such as low oranges, crimson, and salmon. The effect will be in relation to the whole, and dependent upon the logic of the entire "movement."[28]

The freeing-up of color and image to motion and mutability was an important conceptual move that permitted greater experimental variability: color became dynamic. This produced debates between enthusiasts from various backgrounds. For example, British lighting engineer Fred Bentham, who in the 1930s installed a color-music light console at the King Street Strand Electric Theatre, London, read and indeed critiqued some of the positions outlined in Klein's book, particularly those parts that sought visual equivalents to musical notes.[29] No single constituency, class, economic, or creative group owned color or its experimental applications.

Color music was experimented with widely in 1920s in ways frequently overlapping with cinema. For instance, prevalent ideas about color consciousness influenced not only color cinema but also a new phase of color-organ technology. Relatedly, the emergence of the avant-garde and notions of Absolute Film in Germany dynamized color music's relation to popular forms of screen entertainment. Drawing further on Bourdieu's analysis of the field of cultural production, these examples illustrate that the 1920s was a classic period of "continued rupture." As Bourdieu explains, such ruptures occur when "a new art of inventing is invented, in which a new generative grammar of forms is engendered, out of joint with the aesthetic traditions of a time or an environment."[30] As we have seen, profound changes in the synthetic-dye industry, shifts in commercial production, and rapidly expanding film industries across Europe and the United States enabled a dynamic range of artistic possibilities, all jostling for attention within the broad field of cultural production. Although cinema was becoming more institutionalized, its codes were not fixed; in Bourdieu's terms,

a stable *habitus* (the acquired norms that guide behavior) for aesthetic practice was not yet in place. This created a space for engagement between practitioners who wanted to develop new codes (significantly, many of the experiments discussed below were pitched at developing new art forms) while drawing on technical and ideological trends encountered outside of their usual *habitus*, such as advertising. In part, this offers an explanation for why the decade is typified in many ways by the lure of standardization. Those interested in color consciousness were reaching toward the institution of new codes. Although Bourdieu argues that innovative work can only be fully appreciated as such when one is cognizant of prevailing or established codes that appear to be challenged, in the 1920s conventions were far from established or stable. The themes discussed in the following sections demonstrate how continued rupture was conducive to works that both revitalized older traditions of color music and claimed new artistic approaches, as well as new spaces and material locations. While the lure of standardization promised to quell the anarchy of continued rupture, this very condition promoted—and necessitated—new alliances.

Color-Film-Music

To understand the surge in experiments with color music in and around film in the 1920s, it is useful to examine the practice's aesthetic roots. Associations between color and music have a long history, dating back to Plato, Pythagoras, Aristotle, and Newton—philosophers intrigued by affinities between the two. Various technical devices were developed to demonstrate correspondences between color and music, such as Alexander Wallace Rimington's color organ, introduced in the late nineteenth century.[31] This consisted of two keyboards, one to play music and the other to play colors, aided by electricity that illuminated arc lamps that radiated through colored filters. The performer decided which colors matched the musical notes best rather than adhering to a strict correlation between music and colors, although of course many working in the tradition were keen to create links based on color psychology. A similar device called the Chromola, apparently based in part on Rimington's innovations, accompanied Russian composer Alexander Scriabin's *Prometheus: A Poem of Fire* in 1915 at its New York premiere, and the colors were indicated on Scriabin's score.[32] The development of artificial lighting, particularly incandescent lamps, was profoundly important in advancing research into color, often originating in the scientific field but with broader applicability in the arts. This gave new impetus to those who dreamed of uniting art forms, with color providing the essential connecting force. Loïe Fuller, a Chicago-born skirt or "serpentine" dancer who became famous at the Folies Bergère in Paris, experimented with lighting effects that proved influential on those later interested in mobile color.

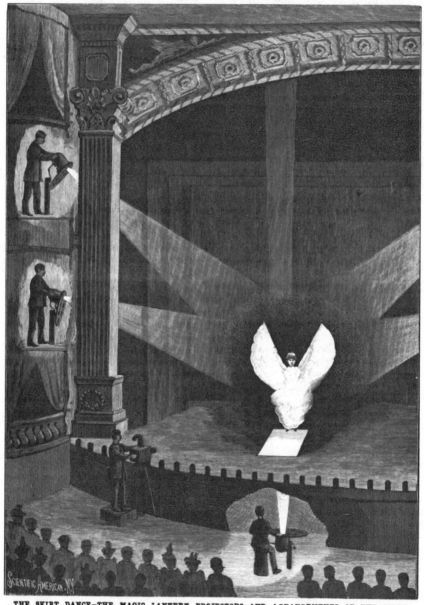

THE SKIRT DANCE—THE MAGIC LANTERN PROJECTORS AND ARRANGEMENTS OF THE STAGE.

Figure 3.4 Illustration of the color effects used by Loïe Fuller in her skirt dances, from *Scientific American* 74 (June 20, 1896): 392.

Klein notes: "She began by using vertical shafts of light projected upwards from beneath the stage. In these narrow cones of light the dancers whirled, twisting shreds of gauzy fabric, whilst the beam was rapidly altered in colour; and the effect was like that of a figure enshrouded in an iridescent column of flame."[33] The skirt dance was incorporated into early hand-colored films, such as Edison's various films with Annabelle Whitford and the Lumières' serpentine dance films (most early film companies distributed some version of the serpentine dance).[34]

These earlier trends entered into a new phase of experimentation in the 1920s as incandescent lighting technologies developed and awareness of color consciousness became marked across several fields. The general shift during the decade toward mass spectatorship also had an impact on the heterogeneity of exhibition venues and the intermedial nature of public presentation. The emphasis on dynamic color through variable illumination in particular attracted those interested in exploring relationships between music and color, often departing from the idea that exact or fixed correspondences could be achieved. Practitioners in the 1920s were more interested in experimenting with mood and psychology and in creating empathetic correspondences between color and music for public performances in a range of different venues. These initiatives were less embedded within scientific discourse, nor did they seek a formula that linked colors to specific musical notes. Mobile color was premised instead on variable effects on the senses as a pleasurable form of synesthesia,

One of the Thousand or More Color Forms, Constantly Changing in Tone and in Hue, and the "Organ" with Which They Are Projected on Screen Before Audience at the Touch of an Artist upon Its Keys; the Result Has Been Hailed as the Creation of a New Art

Figure 3.5 Thomas Wilfred performing his Clavilux color organ, from *Popular Mechanics* 41, no. 4 (April 1924): 514.

referring not exactly to the medical condition in which the sensory nerves literally becoming mixed (for example, hearing colors or tasting sounds) but to a more generalized sense in which mobile colors were thought to induce a range of resonant sensations and stimuli that people responded to in diverse ways. As the following examples demonstrate, a number of mixed-media presentations were designed to transport spectators into other realms—sensorial, color-conscious, mystical, and multidimensional. In their exploration of new codes and mobilization of diverse sensual experiences, these experiments appealed to a range of viewers with different aesthetic competencies, including a growing familiarity with the norms of classical cinema.

Danish-born singer Thomas Wilfred was interested in movement, color, and form in a series of experiments based on the Clavilux, a color organ he developed and first introduced in 1922 in New York for "lumia" (art created by light) performances that were capable of showing a "continual metamorphoses of color."[35] In his practice, "the visual rhythm of the moving forms of his lumia dictated how they were thematically characterized more than the selection of colors used."[36] Rather than assuming that a direct correlation between colors and meaning could be produced or understood, this left room for metamorphoses—"music for the eye," as he described it. The description is apt because, much as music's aural impact can transpose listeners to imaginative realms, Wilfred's lumia combined motion and color to produce a variety of perceptual sensations that did not depend on the presence of music to achieve their complete, almost mystical impact, so that "viewers could commune with the hidden spiritual force surrounding and inside objects in the world."[37] Wilfred described lumia as an aesthetic concept, "an independent art-medium through the silent visual treatment of form, color and motion in dark space with the object of conveying an aesthetic experience to a spectator." The physical means through which this was achieved was "the composition, recording and performance of a silent visual sequence in form, color and motion, projected on a flat white screen by means of a light-generating instrument controlled from a keyboard."[38] Music did not accompany the demonstrations, but was included only for the orchestra's opening program. George Vail described the experience:

> By almost imperceptible changes the hitherto invisible screen becomes a stage for the play of vague, groping, half-defined shapes. Two gossamer-like curtains appear, their silken folds agitated by a breeze whose breath we do not feel. They are drawn to the sides of the frame leaving a central space free for the entrance of the theme. The latter emerges from below—some simple adaptation of a motif drawn from nature, but lacking the stiffness of most conventionalized forms. It proceeds upward, slowly, majestically, as though floating in a transparent fluid, and pauses at the center of the picture. Here the transformations begin.[39]

The same viewer went on to describe a series of "subtle metamorphoses which at times suggest the unfolding of a symphony, a sonata, a series of variations [. . .]. Most of Mr. Wilfred's color recitals consist of four distinct but related compositions, differing in rhythm, treatment, and thematic material, and separated by brief intervals of darkness."[40] The images were suggestive of shapes and forms that were constantly in flux. Responding to them did not rely on spectators' deploying acquired cultural competences, thus extending the potential reach of Wilfred's performances.

The Clavilux was presented in a number of venues in downtown New York in 1922 and also on Broadway at the Rivoli Theatre. The entertainment was described in a report that conveys the effect of the multiple mutations of form, color, and light created by Wilfred's invention:

> Projected upon the regular screen, which was suffused with a mellow shade of lavender, two white columns of light arose. They were window-shaped at the top, and had a green tapering base. As these forms neared the top of the screen they gradually faded, and as the background changed to a lovely, delicate shade of green, there arose right in the centre of the screen a cluster of crimson buds. These were replaced by a revolving sheaf of half a dozen white columns which held the centre of the screen while multihued and variformed beams of light played on the sides.[41]

Other recorded demonstrations included one at Vassar College in April 1923, when Wilfred also gave a lecture on his lumia experiments over the years and spoke of his hopes for color schools and colleges, "leading to an immense theater for color organ recitals."[42]

Wilfred realized this last ambition when he coordinated lighting in the Bal Tabarin Room, a dance-band venue, in the Sherman Hotel, Chicago, with the effect of "making a display that holds the patrons spell-bound throughout the evening."[43] This practical application of the Clavilux transformed the Bal Tabarin's blank walls into decorated surfaces. As noted in a contemporary report, light projections from the ceiling created effects such as the appearance of Grecian pillars with "changing colors against what appears to be a sky of infinite depth. A sea opens up behind the columns, ships loom out of the dim horizon, then disappear. The entire scene dissolves and gives place to a performance of slowly whirling light masses that suggest the nebulae of the heavens."[44] The electrical display was described as "a sort of mechanical séance" controlled from a projection room and operated by an electrical engineer "playing" at a light keyboard.[45] In addition to installations like the one at the Bal Tabarin Room, Wilfred also envisioned smaller versions, such as the Clavilux Junior series from 1930 that was meant for home viewing, and also much larger, unrealized projections from the top of skyscrapers, for which he painted plans in

Artist's Drawing of the Bal Tabarin, Hotel Sherman, Chicago, Showing the Installation of Thomas Wilfred's "Clavilux" and the Effects It Produces on the Walls, Which Are Literally Painted with Light

Figure 3.6 Thomas Wilfred installation of the Clavilux color organ in in the Bal Tabarin Room in Chicago, from *Popular Mechanics* 53, no. 3 (March 1930): 401.

1928 (color plates 3.3 and 3.4). The aim of all of his mobile-light performances was to produce in the spectator a state of transcendence, of four-dimensional space: "His abstractions served as gateways of sorts, perceptual phenomena that began in one world, but launched spectators into another."[46] Wilfred's color-music abstractions were associated with artistic explorations of the "fourth dimension" of space beyond immediate perception that influenced contemporaries in the New York art world, particularly Claude Bragdon (discussed below).[47] The response to these demonstrations was positive, as reported by Vail: "After witnessing a performance on the Clavilux, it is difficult to avoid the conclusion that here we may have a new art form—that of mobile color—as pure and unconditioned, as limitless in its possibilities, as the medium of Bach and Beethoven."[48] The analogy with music is particularly interesting because the proposition—based on a general notion of synesthesia—is that mobile color can evoke similar sensations without music actually being present.

In contrast, another proponent, Mary Hallock Greenewalt, saw light displays as a means of enhancing musical appreciation and understanding and, in so doing, producing a new art form. Greenewalt, a Syria-born Philadelphia pianist, invented and patented color organs designed to project a sequence of colored-light projections to go with specific musical programs.[49] Her first experiments date from 1905, but she is best known for inventing a keyboard in

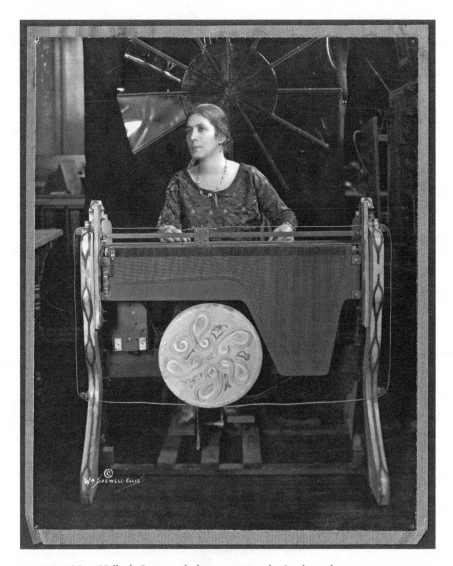

Figure 3.7 Mary Hallock Greenewalt demonstrating the Sarabet color organ.

Mary Elizabeth Hallock Greenewalt papers [Coll. 867], courtesy of the Historical Society of Pennsylvania.

1919 called the "Sarabet" (named after her mother Sarah Tabet) that operated a light show alongside a piano.[50] Claiming her patents heralded a new art form, Greenewalt persuaded General Electric to manufacture a color console, on which she gave public performances. She invented a rheostat to create modulated fade-ins and fade-outs of light to enhance the ambience of a concert performance, particularly of Chopin and Debussy (color plate 3.5). She thought

performers should decide on the relationship between colors, musical notes, and chords as they found appropriate to convey the mood of a particular piece. This disregard for the notion of a static code around music and color broadened the potential reach of her work—something she was clearly interested in doing, in view of the venues where the Sarabet was demonstrated. Besides music concerts, Greenewalt's color organs were installed in cinemas, such as the Strand Theatre, New York, and dimmers were used to create color effects to support musical performances.[51] She was in frequent dispute with those whom she considered guilty of infringing her patents, as light shows were introduced in cinema chains in Philadelphia, New York, and Washington.[52] Correspondence with the Paramount Famous Lasky Corporation regarding this issue, for example, demonstrates how dimmers were adapted "to afford illumination of different colors, to smoothly and gradually vary the intensity of the light and to merge one color to another. The operator uses a cue sheet which he follows to give the proper lighting effects in timed relationship with the music. These lighting effects involve variations and graduations in light intensity, change and merging of colors, etc., all in sympathy with the music."[53] Although there was no lawsuit against Paramount Famous Lasky, Greenewalt's frequent recourse to defending her patents attests to incidents of similarly conceived presentations in a number of public venues.[54] It also demonstrates the disadvantages of new art forms in the making. Their very openness to creative agency and spectator response left them relatively unprotected by the strictures of robust patent descriptors required to distinguish them clearly from more general lighting effects.

As with Thomas Wilfred, there was a utopian, almost messianic aim behind Hallock Greenewalt's experiments and her claims of heightened emotional sensation. She referred to mobile color as a "sixth art," which she termed "Nourathar" (a combination of the Arabic words *nour* and *athar*, forming "the essence of light"). She claimed this new art went beyond painting, poetry, music, architecture, and sculpture by forming a sympathetic union of the arts appealing to "the emotions through color with the same delicacy and keenness of sensation that music makes its appeal through sound."[55] The use of dimmers to convey color variation was key to her idea of augmenting emotion in this way, as a contemporary report of demonstrations in New York described: "Mrs. Hallock Greenewalt's experiments have already resulted in a production of 267 color tints by a 1,500-Watt light."[56] She also experimented with hand painting rolls of film that most likely performed the function of scores. Bruce Elder notes: "They would not have been visible to anyone but the performer—and even the performer would only have seen them as narrow strips passing over an illuminating bar. Their roll film function was to mark time and to indicate something about the mood of the piece."[57] The markings appear to have been similar to those more commonly associated with artists such as Hans Richter and Viking Eggeling.

A number of other experiments with color music were notable but not commercially exploited. In the United States, Claude Bragdon was an architect, theater designer, and theorist and practitioner of the fourth dimension. He expressed this in several ways, including drafting axonometric technical drawings and, less concretely, through his interest in Theosophy, a metaphysic movement inspired by Eastern and Western esotericism in the late nineteenth and early twentieth centuries and by Spiritualism. Bragdon was involved in a "Festival of Song and Light" held in Central Park, New York, in 1916, which featured multicolored lanterns and screens "designed according to the principles of four-dimensional projective ornament."[58] The following year, these were carried beside the lake and put on boats to add "a dynamic element of motion."[59] Bragdon was a member of the Promethians, an artists' society devoted to exploring abstract patterns of light that he cofounded with Thomas Wilfred and the painter Van Dearing Perrine. After internal differences, the Promethians split up, but Bragdon made several solo attempts to build instruments for the purpose of seeing how colors influenced spectators' emotions.[60] The Luxorgan, first built in 1917 and subsequently developed in the 1920s, featured a screen illuminated from behind by electric lightbulbs that were controlled by switches on a keyboard. Massey explains: "Projective ornament patterns separated colors from one another . . . and each key corresponded to a bulb behind the projective ornament screen, so that when Bragdon played a musical composition, its chromatic analogue lit up within the ornamental design."[61] Building on these experiments, Bragdon believed that animated film was the perfect medium with which to test ideas about "the symbolical significance and characteristic 'mood' of each of the spectrum hues at different degrees of intensity."[62] He aimed to produce film animations of color-music compositions in which colors "should meet, wax and wane, and undergo transformations not unlike those retinal images one sees with the eyes closed. Superimposed upon this changing, rhythmically pulsating color-background, like an air upon its accompaniment, would next appear forms suggesting the crystalline and the floral, but imitative of nothing, developing, moving, mingling, expanding, and contracting in synchronization with the music, and in harmony with its mood."[63] Bragdon failed to interest producers in an idea for dramatizing an episode in Beethoven's life that caused him to compose "The Moonlight Sonata," followed by a related color-music interlude that exemplified Bragdon's attempt to fuse dramatic action, choreography, music, *mise-en-scène*, music, light, and mobility "in such a way as to induce emotional reactions more powerful than any of these could compass separately."[64] In 1922, however, Prizmacolor filmed the same creative episode in Beethoven's life for one of its color-music demonstration films. The advertisement boasted: "With the film can be secured a synchronized music 'key' for an orchestra or single piano accompaniment."[65] Even if such attempts were ultimately unsuccessful, they demonstrate how, in their quest for discovering

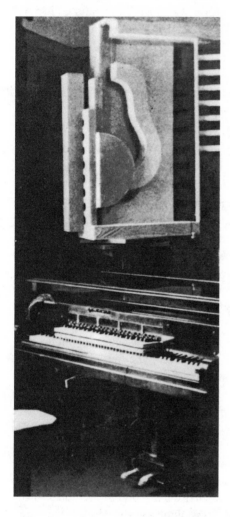

Figure 3.8 Zdeněk Pešánek's "Spectrophone" (ca. 1926).

new methods of synthesis between art forms, color-music artists sought to make strategic connections with commercial media by choosing popular classical pieces. The transition from Bragdon's work to Prizma's aspirations for color music demonstrates the evident fluidity between experimental practices and broader commercial market forces. Even if an experimental approach was limited in its immediate exposure, its capacity to resurface via another route is testament to how the "continued rupture" within cultural production during the 1920s resulted in diverse temporal, thematic, and artistic connections.

Designing an instrument could often lead to new discoveries in different phases of its life. In Czechoslovakia, for example, light-kinetic artist

Zdeněk Pešánek made three versions of his Spectrophone between 1924 and 1930. The first experiments involved a color piano that connected a light keyboard to a four-octave music keyboard; a three-color (red, green, blue) register was developed so that a color lit up when a key was played. He demonstrated his instrument in Prague in 1928 using compositions by Scriabin, but in keeping with the move away from this approach, the instrument was criticized for crudely combining color and music as a common scale. This led to refinements whereby color harmonies matched melodies, and vice versa. A final version of Pešánek's instrument was presented in 1930 at the Second Congress for Color-Tone Research in Hamburg, accompanying Wagner's "Siegfried Idyll." In spite of enthusiastic reviews, Pešánek could not obtain manufacturing contracts for his instrument. As Adrian Klein noted about color music more generally, it was often the case that the complexity of instruments deterred commercial sponsors. He argued that practitioners should take inspiration from the potential of spectacular urban civic displays of light and color to prepare the public for color music and to involve themselves in that enterprise.[66] It is no surprise, therefore, that Pešánek went on to create the world's first kinetic public sculpture in Prague, which operated from 1930 to 1937. With interests in lighting public spaces and street advertisements, Pešánek is another example of a practitioner whose activities were not confined to a single field. His work highlights the acute interest of the 1920s in exploiting forms that fused media with new knowledge about color's diversity, gradations, and multiple hues, informing inquiries that looked afresh at long-held ambitions to create instruments that related color to music. Beyond color-organ technology, this was also evident in broader avant-garde interests in combining color, light, and music, so much so that the boundaries between them became increasingly porous as the decade progressed.

Absolute Art and the European Avant-Garde

One of the prime examples of color music through film in an avant-garde context is Walter Ruttmann's *Lichtspiele Opus No. 1* (1921, color plate 3.6), an abstract film that, as William Moritz explains, was prepared "with single-framed painting on glass and animated cutouts. The film was colored by three methods—toning, hand-tinting, and tinting of whole strips—so there was no single negative, and each print had to be assembled scene by scene after the complex coloring had been done."[67] The music—intended to go with the film—was composed by Max Butting, and Ruttmann played the cello in the string quartet that performed live with each screening at several German cities in the spring of 1921. To be sure of the exact correspondence between film, color, and music, Ruttmann drew color images on the musical score so all could be synchronized

exactly: "Ruttmann limited the imagery to a confrontation between hard-edged geometric shapes and softer pliant forms, and allowed the colors not only to characterize certain figures, but also to establish mood."[68] Michael Cowan has pointed out that, far from being an isolated aesthetic practice, much of German Absolute Film in the 1920s, particularly Ruttmann's work, was tightly integrated with discourses around advertising psychology, demonstrating an interrelation of high modernism with the systems of mass production in ways that resonate with Hansen's concept of vernacular modernism.[69] Contemporary experiments in memory and perception theory used mathematical shapes that resonate with those in Ruttmann's films. Playing with color contrasts for maximum impact in the same way, these correspondences encouraged avant-garde artists to make advertising films in Germany. Contemporary critic Rudolf Kurtz noted in 1926: "The strong appeal of Ruttmann's films lies in the psychological stimuli which make them continually effective. His compositions are dramatic, employing as actors geometric shapes which reverberate with a wealth of organic echoes [. . .] the viewer is pulled into a whirlwind of motion and integrated into an atmospheric blend of colours that never leave him for an instant."[70] Ruttmann's awareness of the affective power of color can also be tracked through similarities between his animated advertising films and the recommendations of contemporary advertising theorist Theodor König that color contrasts of green and red or yellow and blue created maximum impact on consumers.[71]

Theorized in relation to the notion of Absolute Music, Absolute Film refers to the film movement Ruttmann was part of with Hans Richter, Viking Eggeling, and Oskar Fischinger—a practice of nonrepresentational "pure" cinema, divorced from the distractions of conventional narrative, that aimed to engage the spectator "more as an embodied object of psycho-physical testing than as a hermeneutic interpreter."[72] According to William Moritz, central to the movement was the idea that "the most unique thing that cinema could do is present a visual spectacle comparable to auditory music, with fluid, dynamic imagery rhythmically paced by editing, dissolving, superimposition, segmented screen, contrasts of positive and negative, color ambiance and other cinematic devices."[73] Visual rhythm was key to these works, so that scripts were like musical scores that drew attention to film's basic mobile elements of light, the material frame, and time.[74] Although there had been attempts to create films according to these principles before the First World War, Ruttmann's *Lichtspiele Opus 1* (1921) was the first Absolute Film that was available for commercial distribution.

Ruttmann's experiments influenced others, including German filmmaker Oskar Fischinger and Hungarian composer Alexander László, the latter known for *Farblichtmusik* performances using his color organ piano and projected colored lights in 1925–1927. Fischinger and László collaborated in 1926, presenting *Farblichtmusik* in Munch and elsewhere. Subsequently, between May

and October 1926, László gave approximately 1,200 performances to more than forty thousand people at the GeSoLei trade fair and exhibition of Health (Ge), Social Welfare (So), and Body Culture (Lei) held in Düsseldorf.[75] Ruttmann's film *Der Aufsteig* (*The Ascent*, 1926), shown at the same event, advertised the festival's broader educational aim of promoting postwar regeneration of the Rhineland and of Weimar Germany. Ruttmann's abstract color film shows an "everyman" figure at first seen as thin, ravaged by the war, and attacked by a green snake. Attending the GeSoLei fair signals a return of his vitality, as he performs gymnastics and ascends stairs toward a red circle symbolizing new energy. Color music and experimental forms were thus utilized for a broader public purpose, attracting new audiences. Fischinger went on to devise his own independent multiple 35mm projector performances, which included color filters and slides. He later adopted the term *Raumlichtkunst* (space light art) for these events, which he described as "an intoxication by light from a thousand sources" (color plate 3.7).[76]

The Absolute Film pioneers' work came together at a historic screening in Berlin in 1925 (see chapter 4). The program included a live performance by Bauhaus artist Ludwig Hirschfeld-Mack of *Dreiteilige Farbensonantine* (*Three Color Sonatinas*), using a special color-music apparatus; Eggeling's *Symphonie Diagonale* (Germany, 1924); Ruttmann's *Opus 2, 3*, and *4* (Germany, 1923, 1924, 1925); René Clair's *Entr'acte* (France, 1924); Dudley Murphy and Fernand Leger's *Ballet mécanique* (France, 1924); and Hans *Film ist Rhythmus* (Germany, ca. 1925). This influential program, which later screened at the Bauhaus in 1926, has tended to locate avant-garde moving-image experimentation with color in the 1920s primarily in Germany, although its influence spread far beyond.[77]

At the Bauhaus, Kurt Schwerdtfeger's *Reflektorische Farbenspiele* experiments of color-light play and Ludwig Hirschfeld-Mack's *Farbenlichtspiele* aimed to appeal to a broad audience in an attempt to democratize art. In 1922, they collaborated for a brief period before developing their individual color-light projections. These German demonstrations, developed alongside a color seminar at the Bauhaus initiated by Hirschfeld-Mack, brought abstract forms and colors into movement on a screen through the superimposition of transparent colored panels in front of floodlights.[78] The intention was to promote emotional engagement with projected, nonrepresentational moving colored shapes as a means of broadening the appeal of abstract painting.[79] A sense of visual dynamism was created through "the two-dimensional movements of color-form and the three-dimensional depth created by the overlapping color-forms. The constant vertical and horizontal and forward and backward movements of the color-forms cause the Farbenlichtspiel image to shift unceasingly."[80] Hirschfeld-Mack was particularly interested in perfecting the device and making it commercially available, whereas Schwerdtfeger's concerns were with exploring colored moving shapes as artworks with educational

potential.[81] Their works were performed on several occasions, including at the 1925 Absolute Art screenings, as mentioned, and at the Farbe-Ton-Forschung (Congress for Color Tone Research) hosted by Georg Anschütz in Hamburg in 1927.[82] Such gesturing toward democratization and education is indicative of the ambition evident in the 1920s to extend experimental color devices, forms, and practices to people not conventionally associated with aesthete culture. The decade of continued rupture thus produced a plethora of cross-media practices that challenged categorizations of color in terms of both its form and its address.

Vernacular Forms

It is clear from an examination of a variety of examples and sources that experimentation with light, color, and music was evident in several forms and with different emphases from those associated with the avant-garde. There were significant attempts to inculcate some of the aspirations of color music through film in the broader realm of vernacular entertainment. All were premised on the idea that appreciation of color in particular could be cultivated, to enhance cultural capital and add to the continuing artistry of cinema. The term "color consciousness" again becomes highly relevant, cutting across aesthete and popular forms.

Loyd Jones, an American scientist who worked for Eastman Kodak (discussed briefly in chapter 1) was convinced that color enhanced screen drama through its ability to appeal to and develop an audience's color consciousness: "If there is in the human mind, or, more specifically, in the collective mind of the motion picture public, a color consciousness, even though it be at present latent or but slightly developed, is it not worth considerable effort in thought and experimentation to develop a technique such that color can be applied to the screen in such a way as to enhance the emotional and dramatic values of the motion picture of the future?"[83] Jones experimented with mobile color projections at the Eastman Theatre in Rochester, New York, where various devices were developed to show a range of changing color hues, using pattern and design plates to project forms and other effects "as a means of artistic or emotional expression entirely independent of the art of music."[84] Based on the kaleidoscope, Jones invented a cinematic lens attachment for film projectors that was patented in 1924. The resulting effects could be projected on their own or recorded on color film stock to create abstract effects, as in *Mobile Color*, a short film shown regularly at the Eastman Theatre in the mid-1920s, accompanied by Debussy's *Arabesque* (color plate 3.2).[85] Although Jones was interested in how his device might be used to underscore emotional emphases in narrative films, there are no known applications of its being used in this way.[86] His

views on linking color with mood were reaffirmed at the end of the 1920s when he helped to develop Sonochrome, a pretinted film stock designed for films with soundtracks (see chapters 1 and 4).

The effectiveness of color music through film therefore depended not only on practitioners interested in experimenting but also on audiences being receptive to color as an essential part of the synthetic triad. The general enthusiasm for the idea that colors related to moods and emotions was evident in avant-garde practice as well as in more popular forms, in narrative films and broadly within commodity production marketing. As notions of hue and saturation led to colors' being seen as multifarious, complex, and subject to great variation, it was possible to apply this in a wide range of contexts that promoted technical ingenuity and creativity. At the same time, the desire to standardize color was also present as industrial and commercial applications involved branding exercises that sought to capitalize on the color revolution. While tinting and toning were the most common forms of color in popular film entertainment, the interest in how a film could be supported by appropriate music and colored lighting extended to the entire experience of going to the cinema. The mood established in a cinema theater was a key part of this process.

Beyond the Screen

Cinema architect Ben Schlanger expressed his views on the use of color in 1931:

> In the motion picture theater, color is employed to create a mood in the patron. It is my feeling that color in the film should be used for the same purpose—to create a mood for the particular action on the screen rather than to show detail of color of the objects depicted. It is a delicate question as to what color will arouse the proper mood in the person viewing the film.
>
> Color will be tremendously important in the future for the reason that theaters will become simpler in design and will not rely upon colored decorations on the walls, ceilings, domes, *etc.*, for creating mood, as is at present done. The color on the screen might be utilized to take the place of colored decorations, the color being chosen so as to arouse the particular mood desired, and its reflection onto the simple decorations of the theater would provide the color projection which has before been suggested for the interior walls of a theater.[87]

The members of the Society of Motion Picture Engineers were discussing how colored decorations in motion picture theaters were integral to establishing an ambient, chromatic mood for film presentations. Cinema exhibition culture of the 1920s was imbued with a desire to move spectators with a totalized, ambient chromatic experience that began as soon as they entered the theater.

In addition to avant-garde films, color organs, and theoretical writings about the melding of media into new forms, theaters and cinemas were locations for colored light displays that were often intended to interact with or complement film screenings. In both North America and Europe, cinemas sought to incorporate new lighting devices to accompany film presentations. As the fascination with color spread, a rhetoric of color consciousness recurred. According to one contemporary survey of "the architecture of pleasure" in Europe and the United States, modernism was the perfect style to ensure that "we think less of splendor and more of light, air and color."[88] From the late nineteenth century, electrification transformed cities with electric trolleys, street lighting, and the rapid growth of amusement parks, particularly in the United States.[89] The key developments in the 1920s, however, were the spread of neon lighting displays and the greater incursion of electricity into homes. For some time electrical advertising signs had assaulted spectators with awe and wonder at "the technological sublime," as Kirsten Moana Thompson has described, but "a major transformation of the urban skyline was the emergence of neon as a new colour technology."[90]

Following the rare-gas experiments in 1898 pioneered in the UK by William Ramsay and Morris Travers, neon colors were first developed for commercial advertisement in France by electrical engineer Georges Claude to promote the "Palais Coiffeur," a Parisian barber shop, in 1912 and then exported to the United States. Neon signs began to appear in New York in the early 1920s, but it was not until 1925 that the iconic red- and blue-rimmed Packard sign in Los Angeles, often taken to be the first neon sign in the United States, was publicly erected.[91] The popularity of neon spread to other major cities and reached its height in the 1930s.[92] Exhibitors in the UK were advised to install neon signs because "scintillating signs are most effective in announcing current or forthcoming features."[93] The visual clarity of neon—with its brilliant reds, greens, purples, yellows, orange, and blues—was perfect for advertising. Besides being more easily seen in daylight, darkness, and poor weather conditions than incandescent lighting, neon signage had the advantage of requiring less electrical current. As Thompson has noted, the color aesthetics of electrical advertising related strongly to trends in the graphic arts, including posters "in which the eye was arrested in surprise at a pleasing or startling colour design."[94]

Advertising World, a contemporary British journal, published articles on numerous aspects of color design for advertisements, including input from American graphic artist E. McKnight Kauffer, who worked mainly in the UK and designed intertitles for Hitchcock's *The Lodger: A Story of the London Fog* (1926). He commented that color is "an interesting problem with surprises" in terms of strategic application of bold colors, or red in addition to black and white, as a standard for basic poster design.[95] Awareness of and contributions to debates surrounding the psychological impact of color are evident in a special

issue of the journal's "Outdoor Publicity Supplement," which advocated study-
ing color's "emotional values" along with science because of the "dual power of
color to express physically, by its hue, tone and contrast, some fact about the
product, and at the same moment by the same colour to *impress* the observer
physically with its importance."[96] Similar attractions are evidenced by the pleth-
ora of neon signs, with their clear, graphically designed colored lines of text,
figures, and objects creating spectacular optical effects to stimulate spectators.
These developments expanded the notion of cinematic experience to encom-
pass the full barrage of chromatic visual effects emanating from posters, ani-
mated advertisements, pulsating neon signs, shop window displays, and movie
theater interiors and exteriors.

There were also strong associations in France between advertising theory,
visual display, color, and creative experimentation. American theories about
the psychology of advertising were popularized by Pierre Clerget, a profes-
sor at the Ecole Supérieure de Commerce in Lyon, focusing on the impact of
attention-arresting sensations to force passersby glancing at an advertisement
to stop.[97] Color was central to this impact, even if used sparingly, as in many
poster designs, to create stark but striking contrasts with forms outlined in
black and white. This compositional approach was evident in both Europe and
the United States; spectators were addressed by using "cinematic techniques to
achieve motor and sensory stimulation" with the aim of achieving a kinetic per-
ception that was "in line with the spectatorship shaped by advertising theory."[98]
Indeed, the visual cultures associated with modernity, from advertising posters
reused in experimental films to Léon Gimpel's autochrome plates that captured
the vibrant colors of neon illuminations in Paris, provided artists with iconic
commercial imagery to draw upon.

German theaters and *Kinos* were considered very advanced, leading in mod-
ernist design, electric signage, decoration, and internal lighting schemes. The
"gaze-capturing" façades of Berlin movie theaters decorated by Rudi Feld, for
example, "brought an unabashed celebration of the cinematic viewing experi-
ence out onto the street."[99] Feld's designs were arresting celebrations of light,
"an intoxication of color" that often connected thematically with the films
being shown.[100] To Siegfried Kracauer, however, city dwellers were aesthetically
numbed by the "cult of distraction" as the "glassy columns of light, as tall as
houses, the bright overlit surfaces of cinema posters, a confusion of gleaming
neon tubes behind mirror panes" in Berlin represented an "uninhibited spark,
which does not only serve advertising, but is also self-serving."[101] Struck with
the irony that the Kaiser Wilhelm church in Berlin was bathed in light from
neon advertisements "in a glow that replaces any divine type of spark or illu-
mination," Kracauer was not impressed by the "cathedrals" of mass entertain-
ment.[102] He further described the *Gesamtkunstwerk* of spectacles in Berlin's
movie palaces:

This total artwork of effects assaults all the senses using every possible means. Spotlights shower their beams into the auditorium, sprinkling across festive drapes or rippling through colorful, organic-looking glass fixtures. The orchestra asserts itself as an independent power, its acoustic production buttressed by the responsory of the lighting. Every motion is accorded its own acoustic expression and its color value in the spectrum—a visual and acoustic kaleidoscope that provides the setting for the physical activity on stage: pantomime and ballet. Until finally the white surface descends and the events of the three-dimensional stage blend imperceptibly into two-dimensional illusions.[103]

For Kracauer these "total artwork" spaces were not expressions of higher art forms but rather "picture-palaces of distraction," with their overwhelming appeal to the senses acting as a palliative to the spiritual emptiness of urban living.[104]

Despite Britain's reputation for being not as advanced as Germany in introducing modernist architecture and appropriate décor for theaters, innovative experimentation with colored lighting did occur. Holophane, a British manufacturer of lighting-related products founded in 1896, pioneered in promoting its mobile-color lighting equipment. Its name derives from Greek *holos*, meaning wholly, and *phainian*, meaning luminous. Based on the inventions of French and Greek scientists André Blondel and Spiridion Psaroudaki, international affiliates were established in the United States, France, and the UK. The British company supplied equipment to cinemas, and the products were marketed with great enthusiasm by Rollo Gillespie Williams, Holophane's chief color engineer and consultant. The Holophane Theatre Lighting Division was "dominated entirely by a passion for mixing coloured light," and this led to inventions designed to illuminate auditoriums and decorative light fittings capable of changing color.[105] The system employed three or four colors (red, blue, and green, or red, blue, green, and white), and by combining two or more of these in different proportions, any desired third color could be obtained by the use of dimmers in circuit with lamps. The ability to produce color mixing—to change color combinations—was at the heart of Holophane's marketing pitch for "painting with light." In 1923, thanks to its reputation for quality and innovation, the company was entrusted with lighting St. Paul's Cathedral in London. In the 1920s, both cinemas and places of worship were subject to increasingly elaborate lighting effects. Kracauer's judgment that artificial lighting represented spiritual poverty fails to acknowledge that mobile color was also seen as a means of enhancing religious enlightenment. "Cathedrals of the Movies" were somewhat ironically connected to broader ideas about displays of light and color affecting the spirit, senses, and emotions. Taking full advantage of developments in electrical engineering in the 1920s, Holophane was thus poised to corner the market in lighting public entertainment venues. Lamps, colored filters, prismatic reflectors, footlights, spotlights, wing floods, dimmers,

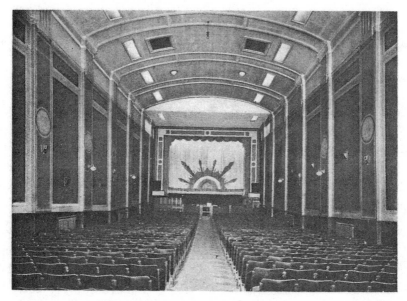

THE STAGE, EUREKA CINEMA, HULL.

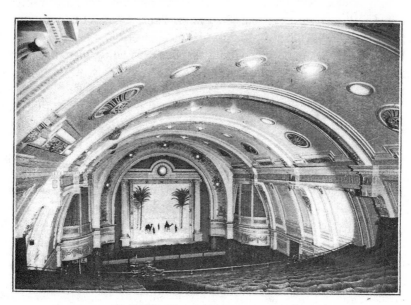

VAUDEVILLE CINEMA, READING.
(Lighted by Holophane White and Colour Hemisphere Units.)

Figure 3.9 Examples of Holophane lighting in cinemas, from *Holophane Illumination: The Journal of Better Lighting* 11, no. 3 (1929).

and switchboards were used to create displays that were shown before and even during a film performance. Holophane battens were designed so the reflectors lit vertical planes, giving a powerful intensity of light in multiple directions. It was claimed in 1929, "Many Picture Palaces to-day utilize a mobile colour-lighting equipment frequently superior to that used in the theatres. Colour-effects tend to be used more and more as a supplement to the display of the film, to create the desired atmosphere and to emphasize the story."[106]

Examples of Holophane applications ranged across the UK, but one interesting report referred to a "music, colour and dancing" show being staged in November 1928 as part of the Electrical Exhibition in Swansea, South Wales. The show was intended to demonstrate what could be done with colored lighting; it lasted one and a half hours and used local dancers for a musical-color revue. The show began with the front curtains illuminated by colors changing to a musical accompaniment. Twelve performances followed, including a shadow dance in which the backcloth and dancers were illuminated with white light, but "the shadows of the dancers were sharply outlined in all the colours of the rainbow."[107] The show was so popular that people had to be turned away, and repeat demonstrations were organized. It was noted that "exhibitors in small towns sometimes raise the objection that while colour-lighting may appeal to city audiences, they do not feel that small towns will understand or appreciate colour-lighting artistically applied."[108] These assumptions about urban sophistication and modernism produced surprise at the success of the displays in an area badly hit by unemployment and with audiences "of no higher level of education than the public in other towns."[109] The experience at Swansea proved that the attractions of mobile color and lighting spread across locations, classes, and tastes.

Holophane's "Duo-Phantom" color lighting system appeared to change a cinema's decoration by lighting it in different colors, often changing as combinations of colors produced varying effects.[110] The first UK cinema to install a complete Holophane Duo-Phantom system was the Ritz Cinema in Birmingham. The modern décor was planned in conjunction with Holophane so that "one moment the interior of this theater may appear in beautiful shades of refined and delicately blended tones, and immediately the scheme can be changed, and the auditorium flooded with rich and glowing colours, the whole atmosphere of the hall and the colouring of the decorations being different."[111] Advertising implied that colored lighting effects were intended to support the film drama, enabling films to "float in a mist of color"—it seems that prologues were common for films and that this was an intended use, as well as coloring curtains framing the screen.[112] Preparing the audience for a particular film involved lighting performers in appropriate colors to match the main film's theme and even characters. Holophane claimed to have championed the benefits of film prologues featuring colored lighting "long before they were really

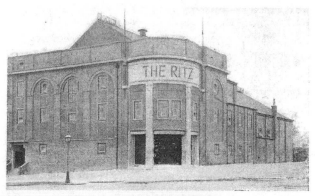

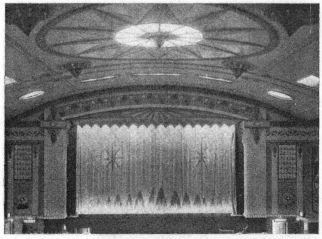

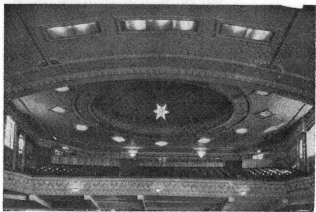

Figure 3.10 Holophane lighting at the Ritz Cinema, Birmingham, from *Holophane Illumination: The Journal of Better Lighting* 11, no. 3 (1929).

tried out" in the UK. The role of color in cueing an audience to appreciate a film can be related more broadly to silent cinema aesthetics, in which devices such as an opening emblematic shot (a shot that encapsulated the essence of a film drama) served a similar function.

These practices of lighting were integrally connected to color music, as explained by Rollo Gillespie Williams in a lecture given to exhibitors in 1927. The report on his lecture noted:

> For orchestral interludes it was demonstrated that the use of color on some simple lines, producing a sunset on a desert scene, the colors gradually changing all the time, materially increased the effect of the orchestra and held the audience far more than the music alone would. A film was then projected and was made to float in a surround of color, this color changing as the film went on. The film picture could be tinted with color if desired by means of the control gear of the equipment. The lecturer contended that the color bordering should be changed to suit the emotional change of various scenes just a little in advance, so that in conjunction with the music it would tend to suggest to the audience what was shortly coming in the story. When the title came on the screen, the wording stood out in a colored instead of the ordinary black background.[113]

It seems that the colored lighting was an enhancement to the screen entertainment, preparing audiences for it and intensifying its impact throughout. In addition, Holophane produced "atmospheric stage curtains" made of a fine white gauze specifically designed to display colored lighting with musical accompaniment. The curtains were "specially festooned, draped or tucked in such a way that the manipulation of the colours produced at any moment by the Holophane batten and footlight will create on the gauze a series of beautiful colour-contrasts, broken by intermediate splashes of pastel tints."[114] The emphasis was on creating different atmospheres "to emphasize the psychological appeal of the programme."[115]

Alvin Leslie Powell, an authority on theater illumination, wrote about the situation in the United States, where experiments with colored lighting were also widespread. He noted: "Most of the larger motion picture houses have color lighting installations which they use during the playing of the overture or musical interlude. Some have cove or cornice lighting in which colored lamps are concealed, and light from these is directed on the ceiling and walls; other houses employ large ornamental fixtures fitted with several circuits of colored lamps, and still others are able to flood a neutral tinted curtain with colored light from above, below, and the sides."[116] As for the future, Powell predicted that musicians would be very prominent in the control of color lighting, more

so than electricians, and that musical scores would "contain a schedule of color changes prepared jointly by a musician and psychologist."[117] The commentary included observations about public taste in music being improved by the combination of music and lighting, echoing the views of Mary Hallock Greenewalt and many others. In turn, the reputation of the motion picture house would be improved, and its prestige enhanced immeasurably. In this vein, Loyd Jones's kaleidoscopic effects were used as preludes to film shows in Rochester, New York, as discussed earlier.[118] Belief in the efficacy of color consciousness thus created links between avant-garde and popular forms in numerous ways while it pushed discussion of and concern about color from the screen into the auditorium and beyond.

Adrian Klein similarly advocated using cinemas as venues for color music and illumination experiments, citing the Capitol Theatre in New York:

> The usual practice of this theatre is to interpose between two films an orchestral performance (the theater possesses a magnificent symphony orchestra) sometimes with ballet. The orchestra plays upon the stage below the screen. The background is a vast semicircle of diaphanous drapery upon which the battery of projectors plays a continuous, perhaps somewhat disordered, but nevertheless remarkably beautiful series of lighting schemes. Perhaps the American cinema will witness the first ordered displays of coloured light, and so assist the development of the technical equipment for which the light composer longs.[119]

Douglas Gomery confirms the opulence of 1920s movie theaters and the importance of lighting: "Lighting played a key role throughout the performances. Auditoriums were lamped with thousands of bulbs, often in three primary colors. Thus a silent film with live music could also be accompanied by changing light motifs through the show."[120] In the New Gallery Cinema, London, lamps concealed in cornices lit the roof. The lamps were colored and controlled by rheostats, and between performances the lights were changed rhythmically in time with the music. The general hybridity of color in the 1920s—when films could include different forms, such as the tinting, toning, Handschiegl, and two-color Technicolor used in *The Phantom of the Opera* (Rupert Julian, U.S., 1925)—thus extended to lighting effects, colors suggested by music, and the establishment of ambient moods in exhibition spaces. As previously noted, these were often established before a film began, as with the stage prologues in London for *Broken Blossoms* (D. W. Griffith, U.S., 1919) and *Southern Love* (Herbert Wilcox, UK, 1924), which were reportedly "flooded with colour-symphonies of light."[121] There were also colored lighting displays at the highly influential International Exhibition of Decorative Arts in Paris, 1925, indicating interest in the form across the arts.

Other, perhaps less expected, venues were affected by experiments with colored lights, as in a 1921 report on their use in St. Mark's Church, New York, at a service given by Rev. William Guthrie:

> As he preached multi-colored electric lights were played upon the worshippers. The rector explained that his idea was to synchronize the light hues with the mood of the congregation as it was influenced by his address. He believed, he said, he could bring the recalcitrant mood of the parishioner into harmonious juxtaposition with the thought of the speaker by diffusing pink, blue, red, and amber rays through his church. It was an attempt, he continued, to blend applied science, psychology, and religion, and to lead men through their changing moods to incline their thoughts Heaven-ward.[122]

The lighting scheme was designed by Rochester architect Claude Bragdon, who, as we have seen, was also interested in color organs and stage lighting. For St. Mark's, he designed chandeliers with stained-glass panels that reflected different colors from inside. These could be individually dimmed "so that any color or combination of colors can be made to appear on the diffusing glass, while when all the colors are used, the glass assumes a prismatic appearance."[123] On East Tenth Street, cut off from the usual resources of a neighborhood parish, St. Mark's attracted "many people whose week-day concern is with arts or letters, and who naturally favor improving the aesthetic appeal of the church."[124] Religious analogies crept into descriptions of the restorative impact of colored lights and décor in cinemas in industrial cities; for example, one visitor to the Futurist Cinema in Birmingham, UK, described the color mural designs as "a riotous feast of colour . . . an emotive temple erected to this new faith of the silent screen . . . an antidote to Birmingham lies in this huge cavern of colour, where jaded nerves find soothing, and the consciousness is mesmerized by a subtle blending of colour and sound. The real aptness of the temple exists: the real sense of a remove from the world."[125] The Metropole Cinema, opened in Victoria, London, in 1929, had large curved skylight windows as the focal point of the foyer. Designed by cinema architect George Coles, the windows were made of amber, yellow, and blue stained glass in geometric patterns. Drawing the eye upwards, the skylight functioned in a similar way to overhead stained-glass lights in churches; artificial lighting was not necessary to wonder at the visual impact of the colors. These examples attest to the longevity of experiments across media with color, magic, spirituality, and transcendence.[126] In this way, the rise of mass entertainment was likened to religion, with cinemas and churches similarly benefitting from displays of light and color. Rather than replacing spirituality, as in Kracauer's critique of Berlin's city illuminations, much of the rhetoric around mobile color and color music (such as Bragdon's fourth dimension or Hallock Greenewalt's

Nourathar) demonstrated how secular emotions could also be profoundly moved by the power of color and light.

Toward Media Synthesis

Interest in experimenting with films and other media was intense in the 1920s. Developments in synthetic color and a heightened sense of color consciousness invaded a variety of cultural fields, including advertising, film, theater, music, architecture, fashion, and design. This broad inundation inspired a desire to meld media forms in pursuit of utopian aims: works of art that were innovative, immersive, total, and uplifting. Mobile color was precisely that: it was both in and beyond the screen. As we have seen, a variety of lighting, coloring, and musical effects coalesced as intermedial performances, of which film was often a prominent element. At its most extreme, the synthesis of forms gestured toward intense levels of spectator engagement, even spiritual transcendence. The magical triad of film, music, and color was thought to galvanize the senses—the sight of mobile colors accentuating the corresponding sound of music. As we have seen, there was much excitement about what this made possible, grounding the belief that a well-developed color consciousness was an essential part of modern living, of negotiating a world that was rapidly changing. But how effective was the melding of these media and forms?

In the areas surveyed—mobile color displays, lighting designs for cinemas, color organs, Absolute Film, and related theoretical constructs—some of the personnel and ideas crisscrossed various fields. For example, lighting expert Matthew Luckiesh was quoted by Adrian Klein, and Leonard Troland was a key figure both in psychology and in Technicolor's research in the 1920s. Luckiesh experimented with his own color-organ device at the same time that he was researching and theorizing color and public illumination. From various perspectives, interest in color consciousness connected many individuals throughout Europe and the United States. The impact of these various displays, lights, films, and ideas reverberated into subsequent decades. Oskar Fischinger's experiments continued into the 1950s, Powell and Pressburger experimented with "the composed film" in the late 1940s and early 1950s, and color-music initiatives with film persist to this day.[127] Thomas Wilfred noted in 1947 that color music "still pops out at least once a year as a brand-new idea," even though it is impossible to categorically link each note in the musical scale with a definite color.[128] But perhaps that is precisely the key to the idea's longevity: the propensity toward "metamorphoses" evident in the 1920s enabled experiments to be dynamic, without a specific code, and teetering on the utopian brink of a new art.

We know least about how music related to color in narrative fiction films in the silent period—there was undoubtedly interplay, but this left much room for

variation.[129] At the level of generality, there is some correlation between colors and moods—the classic observations about blue for night and red for fire—but whether this extended to consistent musical motifs is unclear. Complete standardization was not possible between film prints, and musical accompaniment for films depended on the particular venue, availability of musicians, etc.[130] This degree of variability means it is difficult to go beyond general remarks about the relationship between color, film, and music in narrative cinema. Sergei Eisenstein's theorizing helps to some extent, offering a method for analyzing a particular film's color system in relation to other formal elements.[131] It is likely that scoring for film was to some extent color conscious in the same way that establishing a mood was crucial in narrative cinema: color or music that was inappropriate would stand out and be ill advised. As one contemporary American manual noted:

> Good music enhances the entertainment value of any program. The most exceptional program can be spoiled by poor music; but it should be remembered that, important as music is, the musical accompaniment of the photoplay is secondary and not paramount. Music should accompany and not pre-dominate. It should never distract. . . . A conflict between the music and the screen, or the evident effort of musicians to attract attention to themselves or to their music, is detrimental.[132]

In the UK, too, there was appreciation of the importance of music's unobtrusive role in "fitting" a film "like a glove."[133] This suggests that color-film-music was somewhat of an unequal triad, depending on who was using it. For Mary Hallock Greenewalt, music was the dominant sphere in the pursuit of the art of light-music; for Adrian Klein, the film drama was most important. Thomas Wilfred privileged the effects of light, color, and rhythm, and at the Bauhaus the dynamism of pulsating, undulating color shapes was considered the primary force behind the emotional impact of mobile color. The key theme, however, was interdependence, even if the emphases differed according to different practitioners, theorists, and exhibitors.

Enhancing film entertainment was a major focus. As with advertising, color was seen as contributing to the total, immersive experience of cinema, from entering the lobby and waiting for the film to begin to the show itself. A contemporary American study, *Building Theatre Patronage*, described how cinema managers used standard "cue sheets" and recommended the establishment of libraries catalogued so that musical motifs suggested different moods, such as *agitato* for fire, storms, or battles. It also noted that color and light could make an overture more effective, preparing the audience for a film through lighting effects on a curtain: "If the theatre program carries in synopsis form what can be called 'the story' of the overture, with an explanation of the attempts

being made to interpret this story in color, not only more attention will be aroused, but more appreciation also for the overture. Perhaps some day, music cues will carry color cues for overtures. Until that time experimentation at the switchboard and dimmers is suggested."[134] A. L. Powell was preoccupied with synchronizing musical mood, counterpoint, or staccato with color effects that could be said to intensify aural impact: "The numerous themes offer great possibility for changing colors. Flashes of one color can be superimposed on another, A shrill, piercing note can be accentuated by a brilliant, momentarily exposed light. At times, the change from one color to another will take place gradually, at other parts abruptly."[135] Amsterdam's richly chromatic Tuschinski Theater, opened in 1921 by Abraham Icek Tuschinski, installed a special cooling system of fans that blew over blocks of ice (color plate 3.8). Known for the quality of its orchestral musical accompaniment, the cinema also featured a cabaret called La Gaité offering revues, plays, and dance performances. The opulent interiors designed by Pieter den Basten incorporated rich coloring in the styles of Art Deco and Art Nouveau, and some of the lighting fixtures were part of the decorative design; for example, bulbs surrounding the balconies were arranged as butterflies, and, as Lucy Fischer notes, "the huge light fixture on the cavernous auditorium ceiling is said to represent the inside of a peacock's feather."[136] In the UK, cinema exhibitors were exhorted to think about the relationship between organ or orchestral accompaniment and color, so that musicians were "color conscious" as well as responsive to the images on-screen: "In a summer scene, for example, if a girl is walking through a flower-covered meadow, then combinations of the *delicate* strings are used to suggest light blues and greens. It is well known that the deeper timbres used for a storm at sea do not only reproduce the rumblings of the elements, but also convey a suggestion of the darkness of the sky and the atmosphere."[137]

When *The Glorious Adventure* (J. Stuart Blackton, UK, 1922) was shown at the Royal Opera House, Covent Garden, London, a film shot using the natural Prizmacolor process, it was reported that Laurence Rubinstein presented "a special Old English" musical score that was reportedly color conscious.[138] Felix Orman, author of the scenario, noted: "In the musical score the first effort was made to suit musical notes to both colour and dramatic action, though in some cases this has been claimed for ballets and operas. Certainly, this was the first case where this union of the arts was accomplished in a way that could be extended to a universal audience."[139] Although details of the exact correspondence between music, narrative, and colors are not known, it seems the score supported the picture appropriately: "An ambitious attempt was made to accompany the film with the music that was of the period of the story and actually painted the moods of the characters, as well as suggested the dramatic action. Melodies of the 17th century were woven together and with clever improvisations created effects that were haunting without exhausting

the hearers."[140] Further references detail that the music drew upon Purcell, as well as contemporary composers, folk songs, and old English madrigals, in an endeavor "to introduce corresponding colour into the orchestral mood painting."[141] One report was critical of both the performance and the "musical setting," but acknowledged that the idea of using the madrigals was very good.[142] Rubinstein replied that he did not conduct the orchestra on that occasion and rehearsal time had been limited, but the reviewer's criticism of the "musical fitting" remained nevertheless.[143] Celebrated English conductor and composer Eugene Goossens, addressing members of the Stoll Picture Club in 1922, praised the aim of linking music and film through color correspondence, noting, "The possibilities are incalculable for the making of [original] musical scores for the 'kinema' . . . The orchestral colour, for example, might well be studied and developed to synchronise with photography in colour."[144]

Prizma experimented with music in a series of twenty-six short color "Music Films" in 1922.[145] To achieve greater synchronicity between the film and its live musical accompaniment, the bottom of the film frame showed the conducting of a specific piece of music. By paying close attention to this, the musicians in the cinema could maintain the correct tempo and so stay in sync with the action in the film.[146] An account of one such screening at the Rialto in New York evokes the excitement created by this experiment, even if the execution of the synchronized musical accompaniment was not particularly successful:

> These Music Films are, indeed, something more than a novelty on the screen. As compositions of movement, color, mass and line, they are cinematographic creationism entertaining in themselves and significant of the beauty and expressiveness which may be achieved through the medium of kinetic photography. An additional value possessed by them is that they may be shown accompanied by music played in time to the dancing, wherever a screen and one or more instruments can be brought together, because the arms of a director beating time are shown in the foreground of each picture and, according to Mr. Leventhal [producer/director], all the musicians have to do is follow the lead of this figure on the screen. If this is the case, however, the films have not been exhibited to the best advantage at the Rivoli and Rialto, for, instead of sitting down and letting the orchestras follow the leader in the pictures, the real leaders at these houses remained on their platforms and directed as usual. As a result, spectators have been disconcerted by seeing simultaneously the unsynchronized movements of two leaders.[147]

This technique was also used for a series of Prizma films with narratives about famous composers and pieces of music.

Such initiatives did not lead to sustained exploitation, but their emphasis on photographic color and musical synchronization anticipated later developments

associated with sound cinema. Indeed, one theory about Technicolor's increasing domination of the photographic color market in the 1930s was that its laboratories had always included a key silver print on top of which the dyes were imbibed. This was advantageous "owing to the opportunity to develop the key positive bearing the track to ideal gamma without making any sacrifice to picture quality, the making of which was completely independent of the positive development stage."[148] This enabled Technicolor to enter the 1930s with a technical advantage as the film industry converted to sound. It is the issues raised by the coming of sound that we turn to now, in closing, to examine how the debates, theories, and practices of color music in films of the 1920s contributed to the major realignments that took place as motion pictures experienced the most significant technological shift since their invention.

The End of the 1920s and the Coming of Sound Cinema

By 1930, after a decade of experimentation, Adrian Klein thought the time was right for the public to be receptive to the art of color music, as spectators were by then well prepared through colored lighting displays, as exemplified by illuminated fountains and electric advertising signs. As experiments increasingly refined the technical ability to differentiate hue, luminosity, and chroma, he considered that the potential for color-music correspondence was extensive and correlative. Color music could at last break away from the simplistic fixed coding of aural notes to the seven hues of the visible spectrum to engage instead the infinite variability of hue, luminosity, and chroma combinations, thus matching the depth available in music. Klein was frustrated that color music had not advanced more quickly but was convinced it retained potential to reach a wider market through new technical advances. The costs of electric displays and apparatus, however, remained high, limiting the uptake of complex systems by exhibitors who were skeptical of their ability to attract patrons. In the United States, the onset of the Depression and the novelty of the coming of sound distracted attention away from color music and mobile lighting, even though the basic infrastructures of many theaters remained welcoming environments for lighting and ambient mood effects. As live musical accompaniment for films decreased when sound films became standard, the dream of a synthesis of color, film, and music would appear to have retreated. Referring back to Bourdieu, sound constituted a momentous rupture within the film industry that took emphasis away from the diversity and aesthetic range of intermedial activities that occurred in conjunction and interwoven with the cinema. Emphasis on sound's potential to provide a realistic addition to the screen's diegetic world for a time rendered color and visual music extraneous, even if attendant issues subsequently resurfaced through the development of

Technicolor in the late 1920s and early 1930s. As Charles O'Brien has observed, "sound-era commercial pressures were clearly unfavorable to the cinema's modernist and avant-garde movements," as sound cinema looked to new sets of intermedial relations with radio and the electric gramophone.[149]

As far as color was concerned, the relative weakening of the applied-color techniques of tinting and toning is explained by a number of factors, as discussed in chapter 6. Films tinted through dye immersion interfered with soundtracks, heralding a decline of applied-color techniques and a shift to photographic color experimentation. While pretinted stocks were less troublesome technically once the dyes were recalibrated for sound reproduction, as with Kodak's Sonochrome stock, pretinted prints still were problematic for sound-on-film processes, as the splices needed for alternating tints also interfered with sound quality. In addition, the continued development of moving camera techniques, as well as the introduction of panchromatic stock with its greater capacity for rendering tonal difference than was possible with previous orthochromatic stock, lessened the need to use tints to indicate the mood of scenes. In a sense, as Erwin Panofsky argued, the dynamization of space by these techniques in late silent film made other stylistic flourishes redundant.[150]

A film such as Paul Fejos's *Lonesome* (U.S., 1928) that combined sound and applied color in a few scenes remains a rarity, a late example of chromatic hybridity that reflected contemporary ambivalences around changing technologies and modernity, as we discuss in detail in chapter 5. Photographic color processes were poised to exploit sound film, even if during the sound transition, companies such as Technicolor struggled to gain popular acceptance with audiences, which took the emphasis off ambitious thinking about broader, intermedial synthesis through experimentation with chromatic and aural hybridity.[151] Some popular films continued to engage with these issues— for example, John Murray Anderson's *King of Jazz* (1930), a musical revue of twenty-six self-contained song and comedy sequences that featured the music of Paul Whiteman (also see chapter 6). Shot in two-color Technicolor, the film used a prerecorded soundtrack of the musical numbers that was played back during the filming of the sequences. The musicians matched their actions to the recording, and at a later stage the film was synchronized with the soundtrack. The opening shots of the trailer for *King of Jazz* feature a background design similar to that used in Loyd Jones's *Mobile Color/Kaleidoscope* (c. 1925) experiments, demonstrating an interesting reuse of abstract imagery for a more vernacular purpose. Similar effects are invoked in the film's finale when Whiteman stirs the "melting pot" like an alchemical wizard, creating an abstract swirl of colors. As Charles O'Brien notes, *King of Jazz* anticipates later Technicolor films "where color often performs an aesthetic

function linked to musical accompaniment . . . intense, eye-catching hues frequently coincide with musical flourishes."[152]

Ideas about the correspondences of color, music, and sound did not disappear; instead, they were transformed by the coming of sound cinema. These ideas became foundational for principles of color design in narrative sound films, as in Natalie Kalmus's notion of "color scoring" Technicolor design. Adrian Klein (writing as Adrian Cornwell-Clyne), looking back in 1951 at the development of color in sound film, noted: "The motion picture in colour represents the first opportunity for the creation of color compositions in which the combinations are subject to continuous change, the emotional significance being built up in sequential form, so exploiting the basic principles of music and the drama."[153] This insistent return to musical analogy for "composing" mobile color for film was a prelude to Klein's call for careful color design that enhanced, underscored, but never unduly distracted from a film's narrative: "the color treatment has the sole function of emotional and intellectual emphasis."[154] Klein's emphasis on color underscoring matched earlier, classical theorizing from the late 1920s. At Technicolor, for instance, it was felt that the palette of *The Black Pirate* (1926) had to be somewhat restrained, emphasizing browns and greens, because, as cinematography expert James Arthur Ball explained,

> many directors are afraid of color, feeling that it presents too many additional problems in composition, good taste, etc. This frame of mind is greatly eased if the maximum obtainable color is not excessive. It gives them the feeling that they can't go wrong. So I am quite persuaded that at the present time dilution of color as a motive in itself is correct. As color gets more and more used so that we no longer have to contend with the novelty reaction and when producers get greater familiarity with it and lose their fear, we can then, of course, afford to raise the limits gradually.[155]

Loyd Jones also subscribed to this view, recommending in 1929 that "the use of too strong or saturated colors is in general not good, since such colors are usually obtrusive or distracting and may defeat rather than promote the attainment of the desired effect."[156] This became the dominant, classical approach to screen color, as it was enshrined in Natalie Kalmus's codes for color scoring of Technicolor films, complete with attention to the "law of emphasis" and the efficacy of color complements.[157] The idea of combining color and music to augment the emotional impact of motion pictures was advocated well into the early 1930s.[158] The origins of designing color for sound films can thus be located in the synesthetic color-film-music experiments of the 1920s when differentiation, tonal complexity, hue, saturation, metamorphoses, and other variable categories entered the vocabulary of color consciousness. Rather than disappearing

with the coming of sound cinema, the practical demonstrations on screens, in cinemas, and in concert halls during the 1920s provided an experimental testing ground for new directions in and correspondences of color, film, and music. The next chapter takes up these issues in relation to how artistic and avant-garde traditions responded to the creative opportunities opened up by the decade's chromatically vibrant culture.

CHAPTER 4

COLOR IN THE ART AND AVANT-GARDE OF THE 1920s

The strong appeal of Ruttmann's films lies in the psychological stimuli which make them continually effective. . . . the viewer is pulled into a whirlwind of motion and integrated into an atmospheric blend of colours that never leave him for an instant. Squares and rectangles shoot forward, multiply, disappear, turn up in unexpected points in space, and exchange energies with one another in the most astonishing fashion. A resonance with the soul is generated, as in an internal combustion fashion. Then wavy motions, now gentle, now violent, overrun the image; they tear off into shapes and join together harmoniously. The colour shading, graded into the tiniest detail, trickles grace and sweetness, passion and agitation, into the viewer's heart.

—Rudolf Kurtz, *Expressionism and Film*

I n *The Glass Architecture* (1914), the German science fiction writer and journalist Paul Scheerbart explores the utopian possibilities of color for transforming the material dynamics of the lived environment. The work is a novelistic fantasy made up of 111 aphorisms describing how, in the near future, steel and colored glass would replace wood and brick structures to create an empathetic and technologically infused world around us. Not only would glowing hues illuminate homes and work spaces, but even the skies and

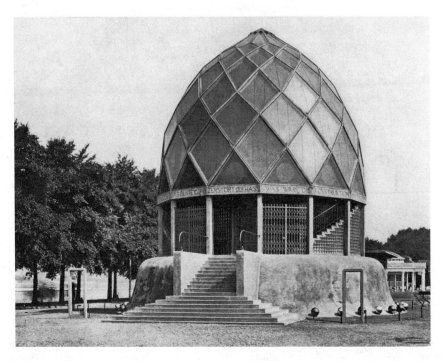

Figure 4.1 Bruno Taut's *Glashaus* at the Cologne Deutscher Werkbund Exhibition, 1914.

Photograph by Armin Herrmann, courtesy of Collection Werkbundarchiv—Museum der Dinge Berlin.

waterways would radiate color: boats and aircraft would be equipped to project prismatic lights across landscapes, forming a second nature transformed by technology. In a curious digression in this utopian fiction, Scheerbart reflects upon the occult movement of Theosophy and its approach to color: "I am convinced that every constructive idea will appear in many heads at the same time and quite irrationally; one should therefore not speak carelessly about the seemingly confused and crazy; it generally contains the germ of reason."[1] It is this "germ of reason" pertaining to color that is of interest in this chapter, for what it reflects about how scientific and aesthetic as well as occult knowledge of color circulated in the 1920s through various modernist and avant-garde movements in and around cinema.

In tracking modernist approaches to color, Scheerbart's reflections serve as a leitmotif, marking the ways in which color functions as a trope of cosmopolitan visual style.[2] Though he died in 1915, his work was posthumously influential both through his writings and through his collaboration with the architect Bruno Taut on the *Glashaus* (Glass Pavilion), an elaborately colored, glass-dome structure at the Cologne Deutscher Werkbund Exhibition in 1914.[3] An architectural work of prismatic splendor, the pavilion used Luxfer Prism

glass tiles to cast colored light throughout the space. In addition, it contained a small room in which a projecting kaleidoscope was installed to rear-project abstract color images onto a specially designed four-foot glass screen at the back of the house.[4] An expanded form of cinema was thus integrated into the chromatic wonder of the space, creating hybrid medial engagements with projected color, parallel to those we tracked in chapter 3.

Taut, a colorist extraordinaire, would go on to interact with Walter Gropius during the early years of the Bauhaus through the Crystal Chain Letters group, an Expressionist consortium of utopian-minded architects, many of whom were also influenced by the occult—for instance, Gropius's wife at the time, Alma Mahler, was a well-known Theosophist.[5] Across such creative networks, Scheerbart's ideas about glass and color have been traced at the margins of modernist design through figures such as Taut and Gropius as well as Mies van der Rohe and Le Corbusier. The International Style associated with these architects is by and large monochromatic, yet recovering the syncretic place of color in modernist design, art, and cinema is vital for assessing the technical and aesthetic ideals that proliferated within modernism. Scheerbart's utopian vision, as Walter Benjamin notes in a perceptive essay, "was of a humanity which had deployed the full range of its technology and put it to humane use"—a counterpoint to what Benjamin described elsewhere as humanity's "bungled reception of technology."[6]

From Scheerbart to Gropius and his collaborators at the Bauhaus and on to various other artists working in the 1920s such as Walter Ruttmann, Fernand Léger, and Sonia Delaunay, what is significant is how, through their innovative uses of color, they outline a new media ecology. Faced with a rapidly expanding chromatic culture that aimed to codify and instrumentalize color's affective and sensorial role in advertising and mass production in order to sell products more effectively, these artists were often part of this process even as they experimented with more humane forms of color practice: to transform bungled receptions into media architectures worth living in.

Color was integral in these exchanges. It was as important to the international formation of modernism as it was to industrial modernity. The synthetic revolution of colorant production in the nineteenth and early twentieth centuries was quickly adapted for painting. New artist-grade pigments—such as cerulean blue, alizarin crimson, and viridian green—emerged with increasing frequency, enabling chromatic experiments on the modern canvas by Impressionists, Pointillists, Postimpressionists, Fauvists, and beyond.[7] The development by the American painter John Goffe Rand in 1841 of premixed pigments, available in portable, tin paint tubes, enabled painting *en plein air*; Sherwin Williams's refinement of linseed-oil paints in the 1880s was also groundbreaking for painting. In conjunction with such technical changes, the artistic palette of the nineteenth century produced a standardized and technically refined

color image that spurred the chromatic revolution of the twentieth century, particularly in the 1920s. Color became a type of ready-made that no longer required expert preparation before application.

If one topic traced here is the influence of industrial innovation on creative practice, another focus is the circulation of cultural knowledge about color within cosmopolitan networks. Taking a cue from Scheerbart, the best-known instance of this involves Theosophy, with its elaborate theory of color, which sought to standardize occult meaning. In Annie Besant and C. W. Leadbeater's syncretic, Eastern-influenced work *Thought Forms*, mental states, emotions, and their auratic emanations are color coded. For example, in their richly illustrated system, variations of red "indicate anger" and "animal passion," while blues "indicate religious feeling"—meanings that pulse across the spiritual plane as chromatic auras.[8] Corresponding to the color guidebooks of the aniline industry discussed in chapter 1, Besant and Leadbeater's works were lushly illustrated with a standardized color chart that allowed users to identify with ease the occult codes they elaborated. By knowing a color's standard meanings, one could defend against spiritual and emotional attack and, conversely, project harmonious auras toward others. Even if one might today dismiss such esoteric claims for color, historically they profoundly shaped how color was systemized and deployed in abstract art of the early twentieth century.[9] Though idealist in nature, these various artists were also materially oriented and aimed to use color to uplift the spiritual awareness and color consciousness of their audiences through sensory experience, providing a coded way of entering "the spiritual realm through earthly sensations."[10] As Bernard Smith has pointed out regarding early abstraction, "grounded in the hope for and belief in a universal religion, [the occult] provided innovatory content to an art that might have otherwise been dismissed as 'decorative.' "[11] Long denigrated against the rationality of form in Western aesthetic theory, color was a central aspect of this transformation in abstract art—reversing the polarity by giving radical meaning to what had previously been thought of as surface-level ornamentation.

The occult was not the only source of color knowledge among modern artists in the 1920s. Color science, too, was prominent. Chemist Michel Eugène Chevreul's ideas about color contrast from the nineteenth century remained in currency, as did Albert Munsell and Wilhelm Ostwald's more contemporary studies that were influential on artists such as Paul Klee, Piet Mondrian, Sonia Delaunay, and Claude Fayette Bragdon, as well as on filmmakers and visual musicians such as Walter Ruttmann, Thomas Wilfred, and Oskar Fischinger. Physiological and psychophysical variants of color science influenced much of the experimental work being carried out by the avant-garde in the twenties and underpinned their engagement with aesthetic theories such as *Einfühlung* (empathy) and abstraction. Indicative of this, for example, is the emphasis placed on color in László Moholy-Nagy's influential *Malerei, Photographie,*

Film (*Painting, Photography, Film*): "The biological functions of colour, its psycho-physical effects, have as yet scarcely been examined. One thing, however, is certain: it is an elementary biological necessity for human beings to absorb colour, to extract colour."[12]

The expansive, cross-field, and intermedial nature of these influences was not by chance but was grounded in artistic exchange during the period, which operated in parallel ways to the industrial forms of knowledge transfer discussed in chapter 1. Through the ever-expanding networks of cosmopolitan collaboration and exhibition in the 1920s, color styles, theories, and artistic practices flowed globally in the form of avant-garde polemics, utopian visions, and the emerging International Style. What happened in Germany influenced French, Dutch, British, and U.S. artistic practices, and vice versa, creating transnational circuits of color knowledge and practice across artistic media. This provided the outlines of a new cosmopolitan *habitus* of modern color, in Bourdieu's sense—connecting restricted and large-scale modes of cultural production that wove through both the avant-garde and the culture industry.[13] Through such connections, ideas about color, as Scheerbart noted, appeared seemingly irrationally in the heads of various artists at the same time. Tracking the exchanges that color fostered allows us to reconsider many of the canonical avant-garde works and movements of the decade. Just as color generated new approaches to painting in the nineteenth and early twentieth centuries, it was also integral to modernist engagement with the moving image, often with Arts and Crafts influences, ranging from the Bauhaus and Expressionism to the French avant-garde and Pictorialist experiments in and on the fringes of Hollywood. As an emerging mass art, cinema's chromatic palette became increasingly appealing to artists—particularly for the avant-garde, who were by and large fascinated by the vulgar and sensorial attractions of cinematic technology. Focusing on the modernist attraction to color allows us to reassess why and how the 1920s was the decade in which artistic engagement with cinema flourished.

Useful Abstraction at the Bauhaus

Following from Scheerbart, we turn first to the German context of color in the 1920s. Given Germany's rich industrial history of colorant production, as well as its Romantic traditions of color theory and practice, color provided fertile ground for artistic experimentation throughout Weimar Germany. During the 1920s, this was most readily apparent in the curricular experiments of the Bauhaus, which we use here as context for thinking through the useful, pedagogical functions of color, abstraction, and empathy as they intersected with industrial prerogatives, art education, and the Absolute Film movement. "Usefulness" has recently been theorized in relation to the moving image by Charles Acland and

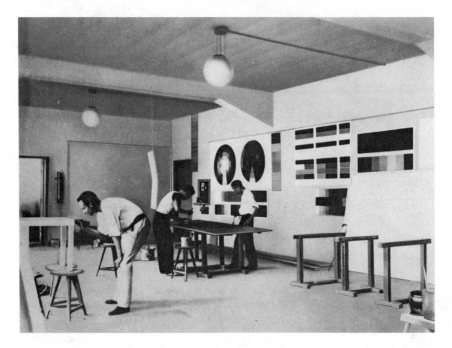

Figure 4.2 The mural workshop at the Bauhaus, Dessau, 1926, with color charts on the wall.

Courtesy of Bauhaus-Universität Weimar, Archiv der Moderne.

Haidee Wasson, as a category for thinking through the ways in which various nontheatrical institutions have used the moving image as a functional medium for ends other than art and entertainment.[14] In examining the practical uses of the moving image, they aim to trace the diverse forms of cultural capital that accrue within various fields of production. Accordingly, we are interested in how color and abstraction in film intersected and functioned within the parameters of the Bauhaus for aesthetic goals particular to the field of art education at the time, related both to the occult and to the notion of *Einfühlung* as taken up at the school.

As has been well established, cinema was an interest, though one not fully realized, at the Bauhaus.[15] By contrast, color was fundamental to its curriculum and legacy, and in the limited examples of cinematic experimentation at the school, there are important intersections between the two. A fitting example is Herbert Bayer's design for a cinema, "Kinogestaltung" (1924–1925, color plate 4.1), which he produced at the end of his time as a student of the Bauhaus in Weimar under the tutelage of Johannes Itten and Wassily Kandinsky, just before he was hired in 1925 as the director of the printing and advertising workshop when the school moved to Dessau.[16] Comprising four sketches, Bayer's imagined cinema

is functional and minimalist—a striking counterpoint to the ornate movie palaces that dominated the decade. The theater's façade is a flat and functional square meant to be plastered with posters—magazine images of Harold Lloyd and Calvin Coolidge are the examples—and the entrance is a modern revolving door, much like the one in Murnau's *The Last Laugh*, also from 1924. Passing through the brief foyer into the cinema hall, one is faced with a near op-art design, as the upper left image of Bayer's plan reveals. Centered in the rear of the theater, one sees a virtual, multistable pyramid (as if viewed from above, or conversely from below) of receding hues stratified in space. Seating perhaps two hundred, the theater is in fact rectangular, with three color-coded sections of flooring and seating that shift, back to front, from light to medium to dark gray, paired with matching colored sections on the walls progressing from yellow to orange to red. On the back wall is the tip of the pyramid reaching into space, which is the white cinema screen surrounded by a black and red proscenium. Though minimal in design, there is an essential dynamism to this cinema space, elaborated through the optical movement of the color pattern and schematically by the illustrated film beams vectoring from projection booth to screen. These still illustrations optically project movement, a key trope of the period among avant-garde artists, and one with which both cinema and color were closely aligned.

The chromatic dynamism of Bayer's cinema is significant: its colors are ordered as the warm hues of Johannes Itten's color sphere, a pattern that Itten himself had experimented with in the same flowing order—yellow, orange, red—in the center of his abstract painting *Horizontal Vertical* (1915). These same three colors were also interconnected and projective in Kandinsky's color theory: "Warm red, intensified by yellow, produces orange. Through this admixture, the movement of the red becomes the nucleus of the impulse, spreading out towards the spectator."[17] In juxtaposition, the gray flooring of Bayer's plan recalls the studies carried out in in the 1910s on color value by the German chemist and color theorist Wilhelm Ostwald. Ostwald aimed to quantify and standardize color theory and practice, and he drew from the emerging fields of colorimetry as well as psychophysics to theorize new optical and physiological standards for color harmony. Innovatively, Ostwald argued that harmony is based upon the variation of color values—a hue's shifting tonality from lightness to darkness as in Bayer's design—rather than through the balancing of color contrasts, which was the dominant view held since Michel Eugène Chevreul's delineation in the nineteenth century of simultaneous and successive contrast. Ostwald did not just theorize color harmony, but contentiously, he insisted that artistic practice should be based upon his system and urged that it be incorporated into educational curricula. His color theory was of interest throughout the 1920s to Kandinsky and others at the Bauhaus, yet its prescriptiveness was also scorned by Itten and Klee.[18]

Ostwald became affiliated officially with the Bauhaus at the end of the 1920s as a member of the school's board of trustees, and Bayer, along with Gropius and Moholy-Nagy, corresponded with him in 1926, which led to a week of lectures at the Bauhaus in June 1927.[19] Later, when Bayer had immigrated to the United States, he worked closely at the Container Corporation of America with Egbert Jacobson, the chief proponent and publisher of Ostwald's work in the United States.[20] In other words, Bayer had a lengthy interaction with Ostwald's theories, and he brought these various influences together in his three-dimensional sketch for a movie house, a cinema conceived as a geometric color space that dynamically enveloped the spectator as much in its architectural hues as in the filmic space of the screen. Reimagined by Bayer as an immersive color space, cinema functioned as a modern, industrial medium that was conducive to the new abstract language of color, light, and movement being articulated at the Bauhaus and beyond.

Following Bayer's cinema design, it is worth elaborating further the central role that color played at the Bauhaus and its multivalent associations with science, the occult, aesthetic theory, and moving-image practice.[21] Established in 1919 by Walter Gropius, the Bauhaus developed in part out of the Arts and Crafts movement in Germany, in particular from the Deutscher Werkbund—the German Association of Craftsmen that aimed to raise the standard of German labor and humanize industrial craft for the emergent mass society.[22] The Werkbund was a crucial meeting point for a number of the figures discussed here. Its first public exhibition in Cologne in 1914 was also the site of Scheerbart and Taut's Glass Pavilion, alongside a model factory and office building designed by Gropius and Adolf Meyer. Ostwald also made an appearance in Cologne in 1914, as the Werkbund allowed him to arrange a show of German paints and dyes at the exhibition.[23] Across this network of relations, Gropius shared the Werkbund's and Scheerbart's utopian perspective, which is reflected in the Bauhaus's aim to rethink art education for an industrial age, particularly as the school developed in the 1920s.

From the beginning, color was crucial for negotiating the relation between art and industry in the curriculum of the Bauhaus, and it helped foster the school's unique approach to the aesthetics of technology. In Gropius's initial outline of the curricula of the school in 1919, the "physical and chemical theory of color" is listed as being part of the study of "science and theory."[24] Of the initial instructors hired at the Bauhaus, it fell to Johannes Itten to develop the study of color within the school's "preliminary course," which Itten designed as a trial semester for students to help guide them into apprenticeships in more advanced, specialized workshops for the rest of their studies.[25]

Besides Gropius, Itten was the most experienced pedagogue at the school. In tandem with color studies, he developed a holistic approach that paired theoretical with practical training, alongside physical exercise. His method

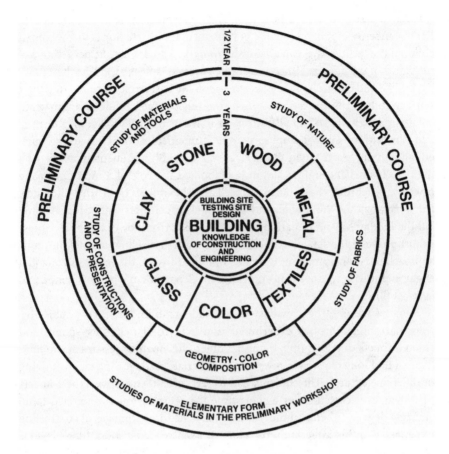

Figure 4.3 Walter Gropius's 1923 diagram of the curriculum at the Bauhaus (translation), foregrounding the importance of color and color composition.

was steeped in the occult—in part under the influence of Theosophist Alma Mahler, who earlier had encouraged his interest in mysticism while also introducing him to her then husband Gropius in 1918, just as the school was being established.[26] Occult influences such as these were relatively common in art education at the time, particularly in relation to color and how it was taken up aesthetically in school curricula as a means of developing the color consciousness of students, as discussed briefly in chapter 1. The expansive nature of the notion of color consciousness allowed it to be interpreted as both a sensory-perceptual capability and a spiritual one, depending on context. Rudolf Steiner, for instance, in his lectures on color and pedagogy, wrote of the ways in which color could expand the spiritual consciousness of students, and this is a crucial component of his Waldorf system, founded in 1919 in Germany and

Austria, and rooted in Goethe's *Color Theory* as much as it was in the occult. For instance, Steiner notes that the purpose of color instruction is to "awaken in children the feelings that can arise only from a spiritual scientific perspective of the world of color."[27] He aimed to educate students' spirits as well as their practical skills, and color played a vital, experientially based role in cultivating their sensory abilities. At the Bauhaus, Itten similarly pursued a holistic approach to color pedagogy. He was an adept teacher in the Mazdaznan religion, a form of neo-Zoroastrianism that emphasized the attunement of the body for spiritual enlightenment. As a gifted teacher, he was incredibly influential, converting many to his beliefs, and he famously embodied the role of a mystic, wearing priestly scarlet robes he designed himself and shaving his head. This ultimately led to rifts within the school, and after growing conflicts with Gropius, Itten left the Bauhaus in 1923, marking a relative break from the occult and Expressionist phase of the school. Nonetheless, it is worth dwelling in brief on Itten's approach to color, as it opens ways for thinking through the Bauhaus's ongoing engagement with sensory education after his departure in ways that connect to abstract film.

Some of Itten's earliest lessons guided students to find their own subjective color harmonies through experimentation with color materials—paints and colored sheets of paper. Itten describes one of his opening lessons at the Bauhaus: "I had long chromatic rows of real materials made for the tactile judging of different textures. The students had to feel these textures with their fingertips, their eyes closed. After a short time the sense of touch improved to an amazing degree. I then had the students make texture montages of contrasting materials."[28] In his integration of color with sensory education, Itten's lessons were broadly synesthetic in nature, mixing the senses—of visual with haptic perception, color with touch—so that the study of color allowed one to feel into chromatic objects and architectural spaces through their textures, an approach he developed in part with musician Gertrude Grunow, who taught influential courses at the school on harmonization.[29] Itten's emphasis was also drawn from German aesthetic theory of the time, specifically the notion of *Einfühlung*— literally, feeling into (*sich einfühlen*) something—which is a forerunner to the aesthetic concept of empathy.[30] The German philosopher and psychologist Theodore Lipps and art historian Wilhelm Worringer were two of the key theorists of *Einfühlung* at the turn of the last century, and Itten and others at the Bauhaus were familiar with their analyses of the ways in which humans empathize with inanimate objects as well as with living beings.[31] One feels into them, mimicking their physical states, as when a spectator unconsciously sways to the rhythms of a dance performance or taps a foot along with the montage sequence of a film. These types of aesthetic responses provide useful, embodied knowledge. For Itten, color was one of the key entry points to his occult-inflected version of *Einfühlung*—a synesthetic nexus that allows one to feel into the aura of things.

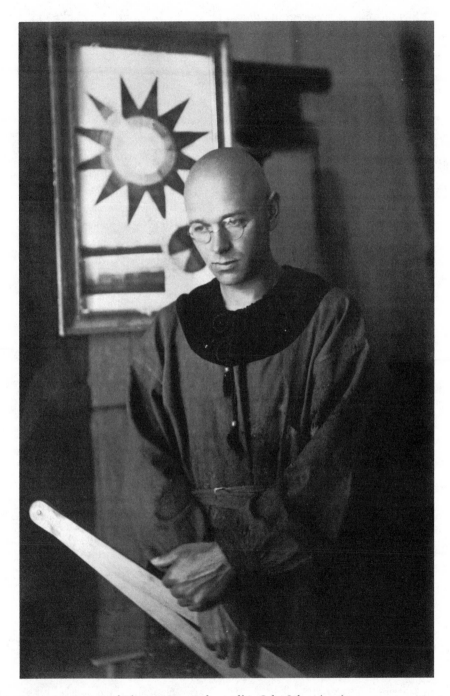

Figure 4.4 Portrait of Johannes Itten in front of his *Color Sphere* (1921).

Significantly, the concept of *Einfühlung* was also used to analyze film in the 1920s. In Rudolf Kurtz's seminal *Expressionism and Film* from 1926, he draws on psychophysics to describe the embodied and empathetic nature of Absolute Film, in line with Lipps's understanding of *Einfühlung*:

> The viewer empathizes with [*fühlt sich*] the mathematical shapes and calls forth corresponding sensations. The procedure takes place unavoidably, sub-consciously: the elementary lines and relationships between shapes, together with their movement, direct the emotion along its courses, through their gra-dations of light, so that an emotional counter-image arises which correlates to the struggle, the harmony, and the reconciliation of those relationships between shapes. Thus, the abstract work of art is unequivocally ranged into the conventional psychological proprieties of the masses. These elemental proce-dures get even richer colourations from the accompanying feelings that grasp the viewer as a result of memories and associations he has experienced in his concrete life.[32]

Kurtz exemplifies the ways in which pedagogical notions of color and aesthetic experience were being deployed in film criticism to describe the sensuous nature of spectatorship. Kurtz brings together both psychophysics and *Einfühlung* in this passage, *fühlt sich* being the conjugated verb form (*sich einfühlen*) of *Einfühlung*—to feel one's way, or to project into or empathize with an object.[33]

Such theories of color were central for the moving-image work carried out and viewed at the Bauhaus, particularly following Itten's departure in 1923. This transition also marked an industrial change in the school's direction that reshaped its approach to color: away from occult and Expressionist influences toward Gropius's new unity of "*Kunst und Technik*" ("art and technology"), his famous motto for the school, as articulated at the Werkbund's annual confer-ence in 1923. Moholy-Nagy's work in particular reflects this change toward a more technical and scientific approach to color, and it is from this matrix that educational experiments with moving-image technology were also carried out at the school. Moholy-Nagy was the chief, but by no means the only, proponent of film at the Bauhaus. Though he carried out little actual film work during his time at the school, his interest in the medium is the best known of the Bau-haus, in part because of his later films and also because he engaged extensively with the moving image in his influential writings—even proposing an "exper-imental film center" ("*Versuchsstelle für Filmkunst*") in his 1925 script outline for "Dynamics of a Metropolis," which could not be realized at the school because of the lack of funding.[34] Moholy-Nagy's critical engagement with film frequently dovetailed with his long-standing interest in color. In fact, the nexus of ideas that Moholy-Nagy developed regarding film and color illustrates their

entwined importance at the Bauhaus. For Moholy-Nagy, the moving image as an industrial art was interwoven with the renovations the school was making to its curriculum in painting, sculpture, performance, and architecture, as the faculty and students attempted to synthesize a new unity among them. Across this intermedial engagement with the moving image, color continued as a key device for binding the school's pedagogical experiments: it was one of the unifying threads that interconnected across disparate media, theories, and creative practices.

Active in Constructivist, Dada, and De Stijl circles, Moholy-Nagy was recruited by Gropius in 1923 specifically to take over the preliminary course after Itten and to direct the metal workshop. He carried out the preliminary-course assignment in collaboration with Josef Albers, who had been promoted from student to teacher, and together they helped institute Gropius's merger of art and technology within the curriculum.[35] As Moholy-Nagy recalls in his "Abstract of an Artist" (1944), discovering color's nonrepresentational power in 1919 marked "a turning point" in his early aesthetic development: "Color, which I had so far considered mainly for its illustrative possibilities, was transformed into a force loaded with potential space articulation and full of emotional qualities. I started to clarify how different colors behave when organized in relation with each other."[36] Suggesting a confluence with Scheerbart, his work then progressed to incorporating "machine technology" that drew on light, glass, scrap-metal parts, and color to produce new modes of "glass architecture" that would use transparency to recalibrate the viewer's sense of modern space.[37] These dual emphases for color—on systematizing harmony and on engaging humanely with new chromatic technologies—are in part what made Moholy-Nagy such an ideal candidate for the Bauhaus. After Itten, Gropius needed collaborators more open to the new industrial direction of the school, as he sought to prove the practical value of the Bauhaus for manufacturing, ideally to attract corporate sponsorship.

Moholy-Nagy approached color as a Constructivist, thinking scientifically and technically about creative production.[38] He was also well acquainted with Ostwald's scientific work and engaged with it throughout his time at the school. For instance, in 1924, he wrote about the usefulness of "Ostwald color charts" for creating his *Construction in Enamel* series (aka *Telephone Pictures*, 1923) in that they allowed one to designate over the phone the exact, standardized colors to be used by a factory printer.[39] He was also involved, with Bayer and Gropius, in arranging Ostwald's visit to the school in 1927, during which he learned of Ostwald's color organs, which were twofold. On the one hand, as Ostwald had explained in an article in *De Stijl* in 1920, he constructed his "Farborgel" (color organ) as a cabinet for organizing the harmonies of color powders.[40] This was not a color-music device, but rather drew from the musical analogy with color to create an elaborate, three-dimensional boxlike device for charting

color harmony. According to Ise Gropius's diary, he donated a version of the *Farborgel* to the Bauhaus during his visit.[41] In addition, however, she describes a color-music device that Ostwald also developed and offered to the school:

> He told us also about a new invention of his, an apparatus for color-light-music which is supposed to become very superior to the one by Laszlo. He only hasn't the time and inclination to concern himself with the realization of this thing and offered it to G[ropius] who, of course, had to decline since we have neither the people nor the money to successfully get it going.[42]

In these comments, Ise Gropius provides a remarkable confluence of color standardization with color music through Ostwald's connection to the Bauhaus. Like Newton, who proposed a harmonic connection between color and the diatonic scale, Ostwald attempted to extend the color-music analogy inherent in his *Farborgel* into actual practice through a new apparatus for color and light projection.

This was certainly of interest to Moholy-Nagy, for as Ise Gropius indicates, by 1927 he had been engaging with color-light-music in conjunction with cinema for a number of years, as is evident from his dazzling and polemical *Painting, Photography, Film*. First published in 1925 and revised in 1927, the book brings together color-music, science, and film at the Bauhaus. Assembled, written, and designed in the summer of 1924 at the end of his first year at the school,

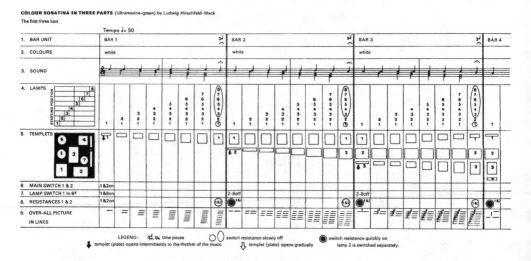

Figure 4.5 The score for Ludwig Hirschfeld-Mack's version of *Farben Licht-Spiele*, printed in Moholy's *Painting, Photography, Film* (translation, 1969).

the book famously called for, and embodied in its layout and imagery, a new mode of seeing and sensing through machine technology, including film and color music. Delving into debates about photography and art, the book was at the forefront of modernist interest in film and photography, and it would prove influential on aesthetic developments in Weimar Germany. It was, for instance, an exemplar of the New Typography movement of the decade and was also taken up extensively by theorists such as Walter Benjamin, from *One-Way Street* through his seminal writings on photography and film.[43]

The first forty-five pages of *Painting, Photography, Film* are brief essays—some new, some drawn from Moholy-Nagy's earlier publications. Its second part comprises illustrations, primarily photographs collected from illustrated magazines (and a few by Moholy-Nagy, particularly in the second, 1927, edition of the book) along with filmstrips, with a section in the middle on the score for the Bauhaus color-music experiment *Farben Licht-Spiele* (*Color Light Display*) developed by Ludwig Hirschfeld-Mack and Kurt Schwerdtfeger. The book concludes with Moholy-Nagy's unfilmed scenario, "Dynamic of the Metropolis," which he worked on between 1921 and 1924.

Recent analyses of *Painting, Photography, Film* have called attention to how its visual design plays a pivotal role in the book's overall theoretical arguments about photographic and cinematic perception.[44] For Moholy-Nagy, new technologies of production and reproduction expanded human perception: the photographic camera could "make visible existences which cannot be perceived or taken in by our optical instrument, the eye; *i.e. the photographic camera can either complete or supplement our optical instrument, the eye.*"[45] Situated firmly within Bauhaus pedagogy, *Painting, Photography, Film* was meant to educate the viewer into this new mode of perception, not only with its text but fundamentally through its design and visual composition. For Moholy-Nagy, new technologies transformed the style of modern design in tandem with developments in the human sensorium; aesthetically, these are reciprocal changes in his theory and practice.[46] The technical abstraction of modernist practice thus served a useful function in the educational reform tradition that Moholy-Nagy, and more broadly the Bauhaus, worked within. He noted of photography (which Benjamin cited several times): "The limits of photography cannot be determined. Everything is so new here that even the search leads to creative results. Technology is, of course the pathbreaker here. It is not the person ignorant of writing but the one ignorant of photography who will be the illiterate of the future."[47] Photography and film were thus useful forms for the production of a basic visual literacy.

Further, the design and organization of *Painting, Photography, Film* aims reflexively to educate the reader and viewer of the book about the dynamics of the modern pictorial environment—to inculcate a new mode of visual literacy. However, in considering the photographic and pictorial significance of

the book, it is also important to recognize what it leaves out: color—an element central to its theoretical work but unrepresented visually, given the technical and financial confines of color reproduction at the time. Moholy-Nagy also positioned photography with the chiaroscuro effects of light, which, along with the technical reproduction of newspapers, had led to a growth of "colourlessness and grey" in the rapidly moving modern world, which *Painting, Photography, Film* visually replicates.[48] This did not diminish the importance of color but amplified its necessity in artistic creation to protect against a diminishing of the color sense through the "atrophying of our optical organs" in a black-and-white medial environment.[49] Color, largely beyond the mass reproduction of photography of the time, remained firmly within the domain of painting, as in the abstractions of "absolute painting," and in an expanded way "kinetic compositions," "color music," and Absolute Film. In these ways, the moving image for Moholy-Nagy was surprisingly more aligned with painting, even as it surpassed it, than with photography. While the visual element of the book is rooted in black-and-white photography, color lies visually beyond its static nature within the domain of painting and its successor, the moving image.[50]

In making these arguments, Moholy-Nagy delineates how photography has transformed image production and reception, and he presents an important and often repeated argument about modern painting: rather than being invalidated by photography, the technology has liberated painting from the confines of realistic representation "to concern itself with pure color composition."[51] Focusing on color thus allows painting to leave the tradition of representational composition behind and focus instead on "the pure inter-relationships of colours and light-values, similar to what we know in music as composition in acoustical relationships; that is, the composition of universal systems, independent of climate, race, temperament, education, rooted in biological laws."[52] It is significant that in Moholy-Nagy's account of the movement of painting into the nonrepresentational, he draws both on the parallel between color and music and also on science. As examined in the previous chapter, the correspondence between color and music has a long history dating back to the Greeks, but it also takes on particular valences in the 1920s. Before that decade, the notion of color music was predominantly connected to the occult and synesthesia. In line with what Itten developed through the preliminary course, such occult traditions of color continued through the decade and beyond. However, particularly for education, this approach to color was increasingly balanced by science and reconfigured for sensory uplift as a primary means of engaging and training the senses empathically to deal with the modern environment. As Moholy-Nagy delineates, moving images, or "kinetic composition so to speak enables the observer's desire to participate to seize instantly upon new moments of vital insight" through images that are attuned to "the rhythm which governs our manner of living."[53] Abstract color in this configuration enables the viewer to

feel into the rhythms of such kinetic art and realign sensory perception in ways in keeping with the notion of *Einfühlung*. This approach epitomizes what we have termed *useful* abstraction, or the practical ways in which nonfigurative color harmony could be used to educate the viewer's senses, making them more color conscious.

Moholy-Nagy's secular emphasis on the "biological laws of science" and the "psycho-physical" elements of color furthers such useful claims for abstraction and is indicative of the ongoing transformation of educational approaches to color at the Bauhaus.[54] In addition to the liberation from representation brought by photography, such renovations of color allowed for the rise of Absolute painting: "Biologically conditioned expressions of these relationships or tensions—be it conscious or unconscious—results in the concept of absolute painting. In fact these conditions have at all times been the true content of *colour composition*."[55]

In relation to this chromatic mode of education, it is helpful to return to the place of moving-image technology in *Painting, Photography, Film*. Progressing from a section on color and easel painting, Moholy-Nagy takes up static and kinetic optical works and provides a remarkably contemporary account of color music and Absolute Film. Contextualizing the moving image in relation to painting, he notes the technical basis of recent changes in aesthetic practice:

> The development of new technical means has resulted in the emergence of new fields of creativity; and thus it is that contemporary technical productions, optical apparatus: the spotlight, the reflector, the electric sign, have created new forms and fields not only of representation but also of *colour composition* [. . .] The moving, coloured figures (continuous light displays), however, which are today deliberately screened with a reflector or projector open up new expressional possibilities and therefore new laws.[56]

Later accounts of filmic abstraction in the 1920s typically begin with color organs and color music, particularly when emphasizing the spiritual roots of these movements. Writing about Fischinger, for instance, William Moritz notes that "having studied Pythagoras, alchemy, and Buddhism, he was fascinated by the notion that every element and object contained an essential personality that could be revealed by the visionary artist who found a technical formula through which the material could speak for itself."[57] These are important connections, and indeed, Moholy-Nagy turns shortly to color music—to Isaac Newton's, Louis Bertrand Castel's, and Alexander Scriabin's use of color organs. However, before doing so, he begins his account with electrical signs and spotlights—with popular culture and advertising technologies—rather than the occult, in keeping with the industrial bent of the Bauhaus that he helped usher in.[58] Unlike Itten, Moholy-Nagy's approach to color pedagogy is related instead

to the technical emphasis of the book—that medial innovation transforms sensory-aesthetic practice. This line of argument illustrates the ways in which the historical avant-garde was fundamentally engaged with vernacular practices of the time, interrogating their potentials to transform creative practice and its relation to the public. In fact, the modernist turn to film was part of this vernacular engagement, specifically with a new medium that was becoming one of the most pronounced emblems of interwar mass culture.

It is within this vernacular context that Moholy-Nagy lays out a brief but cogent account of recent experiments with the moving image, drawing connections from Absolute painting and popular light displays through, among others, Scriabin, Ruttmann, Viking Eggeling, and Hans Richter. Even as their work with color emerges from painting, they transform it by incorporating time and motion into their dynamics. As Moholy-Nagy notes of Richter, he "has thus come near to creating a light-space-time continuity in the synthesis of motion."[59] Through this configuration, the stakes of his interest in electric signs and spotlights become clear for his account of moving images: in building

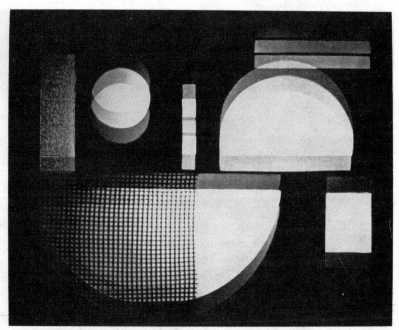

K. Schwerdtfeger / Bauhaus: Reflektorische Lichtspiele Foto: HÜTTICH & OEMLER, WEIMAR
Ein Moment aus der fließenden, formverändernden Bewegung.

Figure 4.6 Kurt Schwerdtfeger's *Reflektorische Farblichtspiele*, as reproduced in Moholy's *Malerei, Fotographie, Film (Painting, Photography, Film* 1925/1927).

Courtesy of © 2018 Estate of László Moholy-Nagy / Artists Rights Society (ARS), New York.

from the work of painting, these works expand the place of artistic practice into everyday life, along with the sensory capacity to perceive and empathetically experience it.

Moholy-Nagy further develops his argument through his discussion of *Farbenlichtspiele*, the Bauhaus color-music experiments carried out separately by Kurt Schwerdtfeger and Ludwig Hirschfeld-Mack. He notes that Hirschfeld-Mack's version:

> worked with reflected light and shadow plays which in the overlapping and movement of coloured planes represent the most successful practical moving colour-composition yet. Hirschfield-Mack's intensive work has produced equipment specifically designed for shooting continuous film. He was the first to reveal the profusion of the most delicate transitions and unexpected variations of *coloured* planes in *motion*. A movement of planes, prismatically controllable, which dissolves, conglomerates. His latest experiments go far beyond this point, which resembles the colour-organ in character. The establishment of a new space-time dimension of radiating light and controlled movement becomes ever clearer in his spinning and plunging bands of light.[60]

Hirschfield-Mack has received more attention for these light displays, but it was Schwerdtfeger who initially experimented with colored projection at the school in collaboration with Josef Hartman (color plate 4.2).[61] Schwerdtfeger, a student specializing in sculpture developed *Reflektorische Farblichtspiele* ("Reflecting Colour-Light-Play"), which was first displayed at Kandinsky's home on June 21, 1922, as part of the Bauhaus Lantern Festival. Schwerdtfeger's work was conceived as an abstract play in which an operator would manually adjust a cardboard stencil system in front of a light source that would rear-project moving colored shapes onto a screen. Hirschfield-Mack was a student of the printing workshop who had previously studied color with Adolf Hölzel and concurrently led a color seminar at the Bauhaus. Over the next year, he adapted Schwerdtfeger's idea, adding additional operators to the projection device. He premiered it in 1923 at the Bauhaus and continued to exhibit versions throughout the 1920s. The most renowned example is *Dreiteilige Farbensonantine: Reflektorische Farbenspiele*, which was performed at the famous Absolute Film matinee screenings at the sold-out, 900-seat Ufa Palast in Berlin on May 3 and 10, 1925, alongside Eggeling's Symphonie Diagonale (1924), Ruttmann's *Opus 2, 3,* and *4* (1923, 1924, 1925), Richter's *Film Ist Rhythmus* (a likely mixture of his *Rhythm 21* and *Rhythm 23*, 1921 and 1923, that was only ready to be screened at the second showing), and curiously shifting to French material as we will discuss later, Fernand Leger and Dudley Murphy's *Ballet mécanique* (1924) and René Clair's *Entr'acte* (1924). The screening, with variations, was repeated in Hannover on May 22, and yet again at the Bauhaus, in Dessau on March 21, 1926.[62]

DER ABSOLUTE FILM

EINMALIGE FILMMATINEE
veranstaltet von der
NOVEMBERGRUPPE
in Gemeinschaft mit der
KULTURABTEILUNG DER UFA

PROGRAMM

Dreiteilige Farbensonatine Reflektorische Farbenspiele	Hirschfeld-Mack Bauhaus Dessau
Film ist Rhythmus	Hans Richter Berlin
Symphonie Diagonale	Viking Eggeling Berlin
Opus 2, 3 und 4	Walther Ruttmann Berlin
Images mobiles	Fernand Leger und Dudley Murphy, Paris
Entr' Acte	Scénario de Francis Picabia adapté et réalisé par René Clair

Holmkm - Presse, Charlottenburg, Fasanenstraße 13

3.5.25

Figure 4.7 The program of Der Absolute Film screening, UFA Palast, Berlin, May 3, 1925.

Image courtesy of Deutsche Kinemathek—Museum für Film und Fernsehen, Berlin, Schriftgutarchiv.

Published in the same year as the Berlin screenings, *Painting, Photography, Film* brings together Schwerdtfeger's and Hirschfield-Mack's Bauhaus experiments in color music with Absolute Film and underscores key aesthetic traits shared by these various works. All were invested in the abstract potential of light and movement, though certainly in differing ways, particularly with *Entr'acte*. Most of the works also brought color into the mix, as with *Dreiteilige Farbensonantine: Reflektorische Farbenspiele*, the *Opus* films, *Rhythmus 25*, and likely *Ballet mécanique*. These were not viewed as autonomous works of *l'art pour l'art*, divorced from utilitarian and industrial aims. Indeed, just as the Bauhaus was seeking industrial support at the time, the Berlin screening was cosponsored by the socialist, avant-garde Novembergruppe (with which

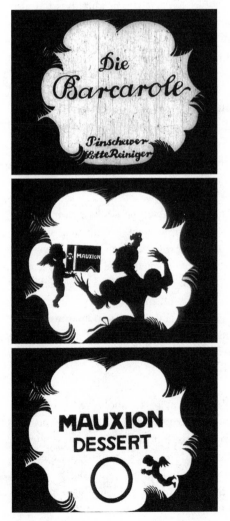

Figure 4.8 Lotte Reiniger's sponsored film *Die Barcarole* (1924, produced by Julius Pinschewer) for Mauxion candies. Tinted in the original.

Gropius, Moholy-Nagy, and Bruno Taut were affiliated) and the educational division of Universum-Film AG (Ufa), the largest and most renowned German studio of the day.[63] They are thus cinematic exemplars of the cross-field and intermedial networks around color that we track throughout this book.

The Berlin screening and the moving-image works that Moholy-Nagy traces in *Painting, Photography, Film*, are also chromatic exemplars of useful abstraction in the 1920s. These works have significant ties to the aesthetic culture of their time, as well as to industrial production and especially educational pedagogy. The moving image was central to the visual transformation of the urban world of Weimar Germany, as film was a thriving aspect of its intermedial display culture, not only through the feature films produced but also with its incorporation into advertising.[64] Filmmakers such as Ruttmann and Lotte Reiniger were important not only for their artistic productions but also for the sponsored filmmaking they engaged in, particularly in collaboration with Julius Pinschewer, who was the most prominent producer and distributor of advertising films in Germany during that era.[65] Indeed, as Michael Cowan has examined in detail, rather than being isolated activities, the imbrication of artistic and sponsored filmmaking was key in Germany for the circulation of aesthetic knowledge and practice. Advertising theory turned to educational, aesthetic, and psychophysical research into *Einfühlung* to pioneer new modes of visual display, and this in turn was appropriated back not only into advertising films but also into Absolute Film and Bauhaus practice.[66] Kurtz also noted these confluences in reference to the color in Ruttmann's works (color plate 4.3):

> The colour is particularly exciting. Ruttmann uses an unusually rich palette, with a new mellow hue for every nuance of movement. Sentimental, sharp, happy, and cheerful gradations of colour change with the progression of curves, the lurching forward and the twitching back of his squares and rectangles. One feels that these organically swelling shapes eat each other, devour each other, charge at each other in combat, embrace each other lovingly: it's a drama of colourful shapes that automatically compels an emotional reaction. Ruttmann has attained considerable success with an industrial advertising film of this sort, which clearly demonstrates how expressive these colourfully-moving shapes are.[67]

Framing color in Absolute Film in relation to technology, science, and industry illustrates how knowledge transfer, as discussed in chapter 1, was also being adapted for aesthetic and pedagogic ends. Filmmakers and artists such as Ruttmann, Richter, and Moholy-Nagy believed that in order to release the moving image's power, they had to purify its form, reducing it to the basic, essential technical properties of the medium—light and moving colour—as opposed to espousing an iconic, photographic ontology. Richter argued for the revelatory

function of abstract form: "It is obvious that to get to the spirit, the idea, the inherent principle and essence one has to *destroy* the appearance. Not in a physical way as much as in one's own eye. To forget about the leaf and to study the oval; to forget about its colour and to experience its sensation."[68] He worked toward realizing this ideal through his experiments with color in *Rhythmus 23* (1922)—originally titled *Fuge in Rot und Grün* (*Fugue in Red and Green*)—but because of the amount of labor involved in hand coloring, he was unable to complete the film in color. However, he continued to experiment with color in his vertical-roll works on canvas, such as *Orchestration der Farbe* (*Orchestration of Colour*, 1923), and in his nonextant film *Rhythmus 25* (1925), a work that he meticulously colored frame by frame.[69] In these experiments, the pictorial base of the image gives way to the contrapuntal play of contrasting colors and shapes embedded in the emulsion of the films. When experiencing color's orchestrated movements and transformations in these abstract works, Theo van Doesburg argues:

> The spectator will look into a completely new world, he will be able to follow the whole process of this dynamic light-sculpture rather like the orchestral work of Schonberg, Stravinsky, or Antheil. From this it follows that the spectator space will become part of the film space. The separation of "projection surface" is abolished. The spectator will no longer observe the film, like a theatrical presentation, but will participate in it optically and acoustically.[70]

Doesburg's relationship with the Bauhaus was critical and tempestuous, even more so than Itten's, but he was also influential on many of its members, and he and Moholy-Nagy were well acquainted before Moholy-Nagy even came to the school.[71] The idea of optical and acoustic participation in the moving image runs through Moholy-Nagy's work and his theories of color and light projection, and indeed gets to the pedagogical center of the interest in color and the moving image at the Bauhaus. Bayer's sketch for a cinema in 1924–1925 provides another version of this chromatic space, as does the kaleidoscopic projector in the Glass House of Scheerbart and Taut. Combining the industrial art of film with chromatic abstraction, these utopian works of pedagogy aimed to craft a useful and empathetic forms of aesthetic experience, in which, as Moholy-Nagy puts it, "eyes and ears have been opened and are filled at every moment with a wealth of optical and phonetic wonder."[72] Framed in institutional relation to art education at the Bauhaus, color and the moving image function in this abstract register to produce a sensuous mode of visual literacy—an avant-garde version of color consciousness. Aligned initially with pedagogies rooted in the occult, such as the Waldorf system, and subsequently with more scientific and standardizing approaches of the 1920s such as Ostwald's, this hybrid avant-garde mode of useful abstraction aimed to train the senses, making them more capable of navigating the chromatic landscapes of the 1920s.

The Saturated Screen of German Expressionism

Alongside the avant-garde works of Absolute Film and the Bauhaus, there was also a range of chromatic experimentation in German narrative cinema of the decade that forms a crucial context for the more abstract work simultaneously being produced. More than simply a background for the avant-garde, it is also worth delineating the aesthetic parallels between such restricted and large-scale forms of chromatic production, particularly in light of Kurtz's expansive account in *Expressionism and Film*. To trace these relations, our analysis shifts emphasis formally and technically to take into account the archival legacy of color in German cinema. Given the years of archival disregard for applied forms of color in silent cinema, it is only now, in light of recent restorations such as *Das Cabinet des Dr. Caligari* (Robert Wiene, 1920), *Der müde Tod* (Fritz Lang, 1921), *Nosferatu* (F. W. Murnau, 1922), and *Die Nibelungen* (Fritz Lang, 1924), that the tinted and toned hues of the iconic works of German Expressionism can finally be assessed in terms of their saturated palettes.

Expressionist cinema is of course a contested category of the Weimar era, as Thomas Elsaesser and others have detailed, and we recognize the various cultural, stylistic, and economic currents at play in these films of the early 1920s that Expressionism does not fully encompass.[73] Indeed, for our purposes, it is their hybridized mode that makes these works exemplars of the intermedial style of the decade, for it is through those hybridized junctures that color comes to the fore. The films work across various fields of aesthetic production, and their use of tinting and toning reflects chromatic adaptations of theatrical and painterly Expressionist style, German Romanticism, and modernist design. For instance, as we discuss in more detail below, there are direct continuities between these works and Absolute Film through Ufa's employment of Walter Ruttmann on Fritz Lang's *Die Nibelungen: Siegfried* (1924) to animate the "Dream of the Hawks" sequence—a foreboding dream that Kriemhild has about the tragic fate of her future (yet unknown) husband Siegfried, in which a white/lavender hawk is killed by two black eagles.

In terms of cultural prestige, Ufa producer Erich Pommer's famous explanation of the Expressionist phase of production was that it was primarily a marketing gambit following the economic hardships of the war: "The German film industry made 'stylized films' to make money. . . . Germany was defeated: how could she make films that would compete with the others? It would have been impossible to try and so we tried something new; the Expressionist or stylized films."[74] In many ways, this was the inverse of Gropius's charge and Moholy-Nagy's implementation of the merger of art education and the avant-garde with industrial and scientific practice: Pommer moved in the opposite direction, from the industrial to the avant-garde, yet with similar vernacular

modernist results. Economic and industrial pressures certainly shaped artistic style during the decade, and Expressionism served as a useful marketing label of cultural distinction for Ufa, yet at the same time the aesthetic innovations of many of these works were substantial.[75] This was not only the case in Germany, for in many ways such economic and industrial pressures on stylistic form parallel what Richard Abel has characterized as the "narrative avant-garde" in France during the same decade, in which modernist techniques were also adapted for narrative cinema, including dynamic color design.[76] Such modernist adaptations in Weimar film were relatively more Romantic in nature, invoking Expressionist as well as Vienna Secessionist Arts and Crafts traditions that were more in line with the Bauhaus's Weimar phase than with its forward-looking Constructivist-scientific approach in Dessau. In practice, though, such distinctions are not always clear-cut, as analyses by critics such as Kurtz and Lotte Eisner demonstrate through their invocation of Romanticism, psychology, and psychophysics to explain both Expressionism and Absolute Film.

In the popular imagination, the works of Expressionist film were long thought to have been in black and white, in part because of their rich chiaroscuro effects, such as the iconic shadow of Count Orlok climbing the stairs in *Nosferatu*. Production designer Hermann Warm famously suggested that "the filmed image must become graphic art [*Graphik*]"—translated as a "drawing

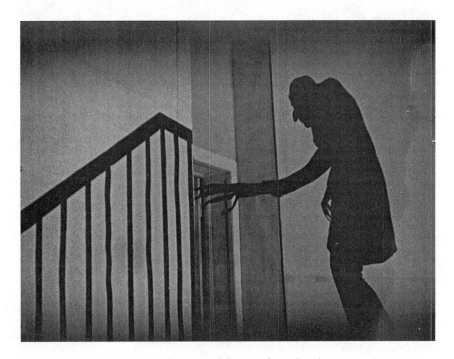

Figure 4.9 The iconic shadow of Count Orlok in *Nosferatu* (1922).

brought to life" by Siegfried Kracauer and "engraving" by Eisner, emphasizing the films' distinctive uses of light and shade.[77] Later, in *The Haunted Screen*, Eisner discusses the black-and-white style of Murnau's *Nosferatu*: "the grisaille of the arid hills around the vampire's castle"—grisaille being a gray, textural style of painting.[78] Her influential book and Kracauer's *From Caligari to Hitler* were richly illustrated with black-and-white production stills, which coincided with the circulation of black-and-white reduction prints, and eventually video copies, that were the main means through which Expressionist films were accessed and canonized after the 1920s. As a result, the provenance of these works, as of so many silent films, has been stripped of color for much of the past century. Yet, as recent restorations illustrate, these films were intricately colored through tinting and toning effects when they were originally released. In Eisner's defense, she was one of the first critics to note this, specifically regarding *Caligari*: "modern prints of this film (originally tinted in green, steely-blue and brown) give no idea of the unity of composition afforded in the original by the images and their titles."[79] In line with her suggestion regarding the unity of chromatic design found originally in *Caligari*, it is worth examining how the tinting and toning patterns in Expressionist film resonated more broadly with the aesthetic culture of Weimar Germany.

Throughout silent cinema, there were a variety of reasons for tinting and toning films. The monotone or duotone (when tinting and toning were combined) color schemes that dominated the era in part helped distinguish denotatively scenes and settings from one another. A green tint might indicate a shift to a wooded scene, whereas an amber tint could illuminate an interior scene under artificial light, and of course red would often be used for fire and blue for night scenes. This blue tinting was particularly useful, given the amount of day-for-night filming that occurred during an era when the insensitivity of film stocks precluded actual night shooting—hence the use of blue to provide a clear indication of the hour. Beyond such denotative schemes, tinting and toning were also used connotatively, to convey the mood and atmosphere of scenes: pink might indicate a romantic scene, light blue a calm one. In *Theory of Film* (1960), Kracauer reflects back upon these uses of color in silent cinema, noting that tints were meant to "canali[ze] the spectator's emotions": "Shades of red helped amplify a conflagration or the outbreak of elemental passions, while blue tints were considered a natural for nocturnal scenes involving the secret activities of criminals and lovers. The different hues plainly served to establish audience moods in keeping with the subject and the action."[80]

Such ideas about the interrelation of color and emotion are ancient, running back at least to the Greeks. However, the proximate connections for Kracauer and Weimar color theory run through psychophysics and *Einfühlung*, as discussed earlier. The emotive and physiological aspects of color were thought to canalize, shape, and direct spectator reception across the domains of film, advertising,

architecture, and art. Such aesthetic approaches to tinting and toning can be seen in various exemplars of Expressionist film. At times these hues function denotatively, at others connotatively, and both of these approaches could be harnessed for narrative legibility. However, given the variability of the coloring patterns in the print records of many of these films, in which competing tinting and toning patterns often exist for the same film across multiple prints, definitive narrative readings of the hues are difficult. It is often impossible to determine what the narrative colors might have been originally when the patterns varied from print to print, particularly between domestic and foreign release versions. Intermedial analysis, though, does bring out much in these films, for even if the specific hues often varied, their saturations and generalized color palettes resonate strongly with their contextual referents and aesthetic paradigms.

Take, for instance, Fritz Lang's two-part epic *Die Nibelungen: Siegfried* and *Kriemhild's Rache*, which at first seems to be an outlier in terms of its tinting scheme. The film is an adaptation of a thirteenth-century epic poem about the exploits and subsequent murder of Siegfried and the ensuing revenge wrought by his widow Kriemhild. Lang's two-part adaptation is nearly five hours long, and curiously most (though not all) surviving prints and negatives of the film suggest that it was tinted almost entirely in a golden-orange hue when released.[81] The only major alternation found in most of the extant prints is Ruttmann's brief "Dream of the Hawks" sequence foretelling Siegfried's death, which was tinted lavender. Considering both parts together, a film of this length that is almost entirely colored in a single tint seems strange, as the standard was to use multiple, alternating tints and tones with black-and-white sequences to create spatial and emotional distinctions. However, Anke Wilkening, who restored the film for the Friedrich-Wilhelm-Murnau-Stiftung, has noted examples of other German features tinted in similar ways at the time: a U.S. export print of *Herr Tartuffe* (F. W. Murnau, 1925), for instance, was also tinted in a golden-orange hue, as were export prints of *Faust* (F. W. Murnau, 1926). A technical explanation might be that the hue may have made it difficult for foreign exhibitors to dupe the prints illegally, as orthochromatic stocks would not have easily distinguished the tinted hue from the grayscale image because orthochromatic stocks, unlike panchromatic ones, cannot register the reddish-orange color spectrum.[82]

Such uniform approaches to tinting may have also resulted from technical changes in print processing during the decade. With the predominate move from shorts to feature films in the 1910s as the international film industry was solidifying, there was a growing need to reduce the number of physical splices in positive film prints. By the mid-1920s, internegative stocks became available that allowed for the duplication of a camera negative, which allowed for easier printing with less wear and tear on the original negative.[83] This coincided with various laboratory changes in print production. Negative cutting, print timing,

and continuous-contact printing became more refined during the era. Negative cutting—editing a negative into final narrative order—allowed laboratories to produce spliceless positive prints that held up better, with fewer breaks during projection. Companies such as Bell & Howell developed high-precision negative-splicing machines to facilitate this process.[84] The timing of internegatives for positive printing—to ensure that each shot of a finished film print was properly exposed—also became much more elaborate and automated. As Kodak technician J. I. Crabtree explains, before the process became increasingly systematized in the 1920s, printing-machine operators carried out print timing by judging the exposure of the image by eye and adjusting the exposure light manually shot by shot.[85] Beginning in the 1920s, light sensitometers were deployed to analyze shots in advance for printing, leading to the integration of timing cards (containing exposure information for each shot) with continuous-contact printers that allowed for the mechanical adjustment of light exposure during printing, thus automatically compensating for variations in exposure across shots on the negative.[86] Before the development of this relatively automatic printing system in the mid-1920s, negatives were assembled in exposure and tinting order for easier processing, as tinting continuities tended to follow exposure changes—for example, interior versus exterior scenes or day versus night. After duplication, release prints would then have to be spliced individually into continuity, with the shots properly ordered. With the shift to more automated modes of duplication, negatives could be cut into continuity, which simplified the printing and editing process, as the processed positive prints required less editing. However, tinted and toned sequences would still need to be color processed after printing and spliced back in for continuity, along with intertitles. Colored sequences continued to be grouped together in tinting order during printing, but there is evidence that with the move toward automatic duplication and internegatives, tinting and toning patterns became less complex and more uniform to avoid unnecessary splices, as in the examples of *Die Nibelungen* and *Herr Tartuffe* and, as will also be discussed, of *Caligari* and *Nosferatu*.

For these various technical reasons, single-tinting practices may have been relatively widespread in Germany, though it is difficult to ascertain from surviving print records, as this style of tinting was not seen as being important to preserve. Later copies were typically made in black and white (with panchromatic stock that could register the tinted image into grayscale effectively). In archival practice after the silent era, there was a general disregard for preserving tinting and toning in nitrate prints, as this type of color was by and large believed to be an inessential addition to silent film—the black-and-white shapes and lines were primary, as opposed to the ornamentation of color. Uniform tinting likely exacerbated the archival bias, as it functions largely outside of the denotative or connotative modes that were dominant during the era.

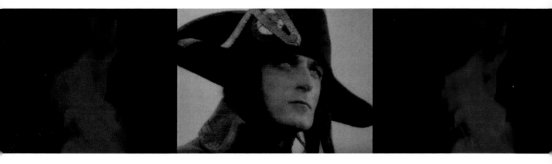

Color Plate 0.1 Tinted Polyvision scene at the conclusion of Abel Gance's *Napoléon* (France, 1927).

Color Plate 1.1 Color guidebook illustrating the application of aniline dye to feathers (Farbenfabriken vorm. Freidr. Bayer & Co, 1910). Item MSS 563 Dyeing Catalog Collection 1893–1960, courtesy of Special Collections, University of Delaware Library, Newark, Delaware.

EASTMAN TINTED NITRATE BASE FILM

1 — Red / Tinted Nitrate Base / Page 7
2 — Pink. / Tinted Nitrate Base / Page 7
3 — Orange / Tinted Nitrate Base / Page 7

4 — Amber / Tinted Nitrate Base / Page 7
5 — Light Amber / Tinted Nitrate Base / Page 7
6 — Yellow / Tinted Nitrate Base / Page 7

7 — Green / Tinted Nitrate Base / Page 7
8 — Blue / Tinted Nitrate Base / Page 7
9 — Lavender / Tinted Nitrate Base / Page 7

EASTMAN TINTED SAFETY BASE FILM

10 — Red / Tinted Safety Base / Page 7
11 — Pink / Tinted Safety Base / Page 7
12 — Orange / Tinted Safety Base / Page 7

13 — Amber / Tinted Safety Base / Page 7
14 — Light Amber / Tinted Safety Base / Page 7
15 — Yellow / Tinted Safety Base / Page 7

16 — Green / Tinted Safety Base / Page 7
17 — Blue / Tinted Safety Base / Page 7
18 — Lavender / Tinted Safety Base / Page 7

EASTMAN KODAK COMPANY, ROCHESTER, N. Y.

Color Plate 1.2 Eastman Kodak's guidebook, *Tinting and Toning of Eastman Positive Motion Picture Film* (1927). Photograph by Martin Weiss, ERC Advanced Grant FilmColors, courtesy of the Timeline of Historical Film Colors.

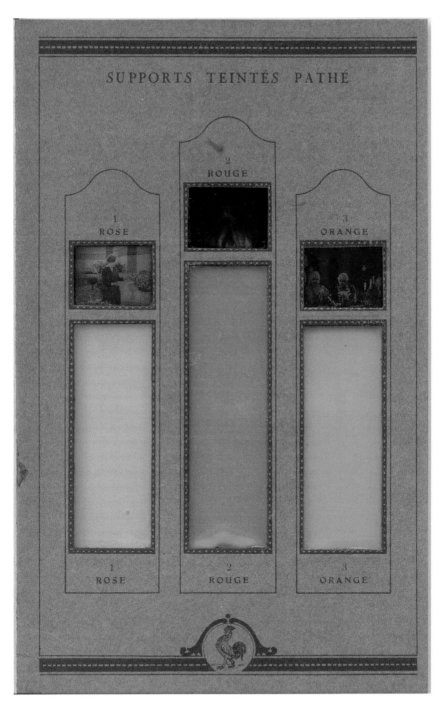

Color Plate 1.3 Pathé Frères' guidebook, "Supports teintés Pathé" (ca. 1925). Courtesy of Laurent Mannoni and the Cinémathèque française.

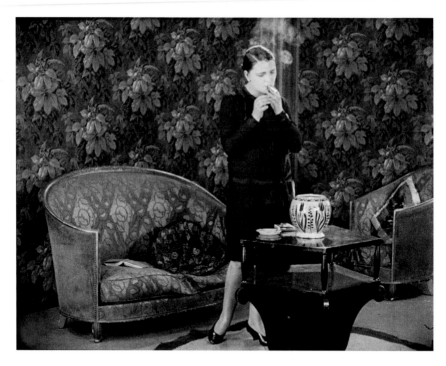

Color Plate 2.1 *Le home moderne* (France, 1929). Courtesy of the Gaumont Pathé Archives.

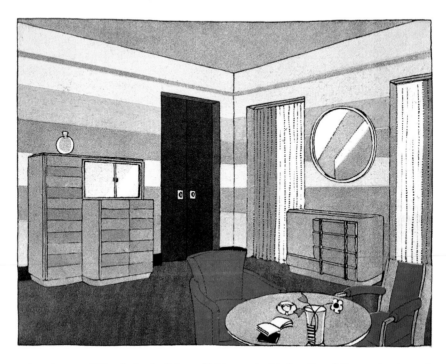

Color Plate 2.2 Office design by Etienne Kohlmann in *Modern French Decorative Art*, 2nd series (1930), 25.

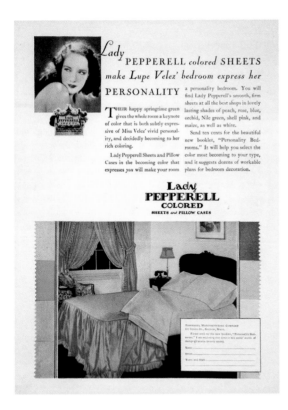

Color Plate 2.3 Lady Pepperell campaign in 1929 feature
Lupe Vélez's bedroom colors, *Photoplay* 35, no. 5
(Feb 1929): 80.

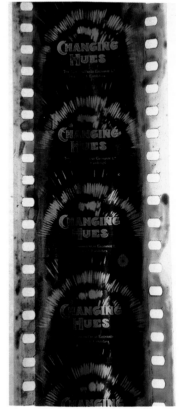

Color Plate 2.4 The hand-colored title of
Changing Hues (UK, 1922).

Color Plate 2.5 The stenciled Twink Shop window in *Changing Hues* (UK, 1922).

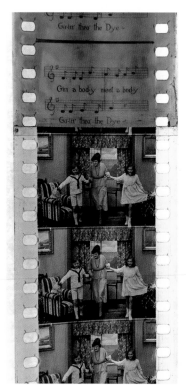

Color Plate 2.6 The final hand-colored and stenciled shots in *Changing Hues* (UK, 1922).

Color Plate 2.7 Raquel Torres in Technicolor's *Fashion News* (U.S., 1928). Courtesy of the Academy Film Archives.

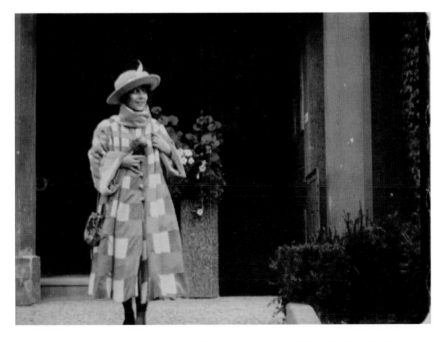

Color Plate 2.8 A tinted exterior in *Der karierte Regenmantel* (*The Checkered Raincoat*, Marx Mack, Germany, 1917).

Color Plate 2.9 A Handschiegled pink cigarette in *The Affairs of Anatol* (Cecil B DeMille, U.S., 1921).

Color Plate 2.10 An Art Deco–styled room tinted rose in *Gribiche* (Jacques Feyder, France, 1926).

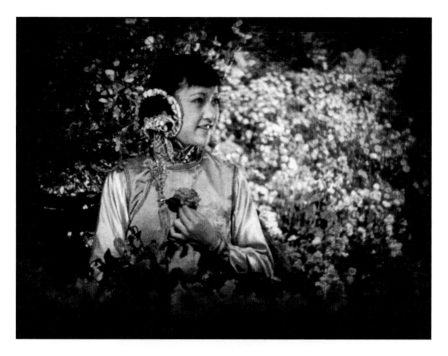

Color Plate 2.11 Lotus Flower in green framed against the red flowers of her garden, in
The Toll of the Sea (Chester M. Franklin, U.S., 1922).

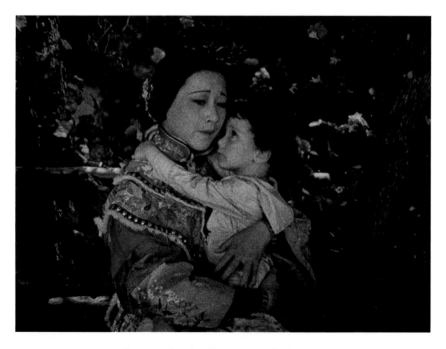

Color Plate 2.12 Lotus Flower and Little Allen, now washed clean of his Eastern colors, in
The Toll of the Sea (Chester M. Franklin, U.S., 1922).

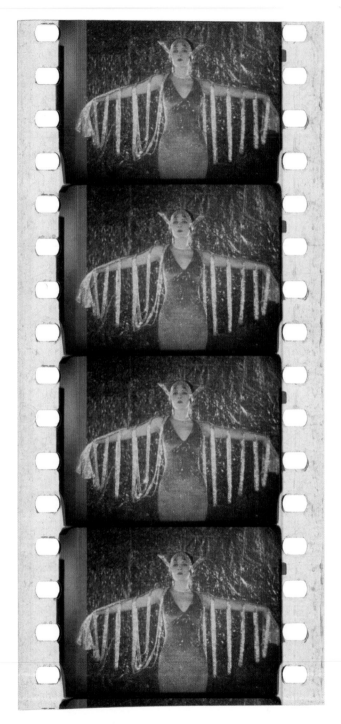

Color Plate 2.13 Eve's dress in the fashion show of *Fig Leaves* (Howard Hawks, U.S., 1926). Courtesy of Karl Thiede.

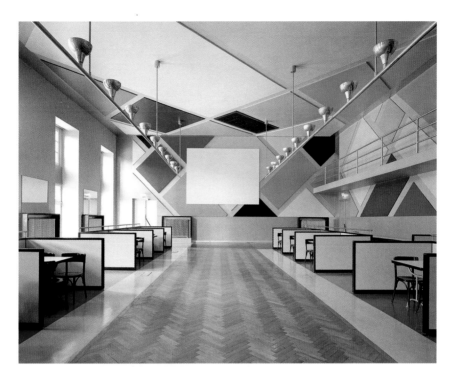

Color Plate 3.1 The ciné-dance-hall of the Café Aubette in Strasbourg designed by Theo van Doesburg with Jean Arp and Sophie Taeuber-Arp (originally completed 1928; restored 2006). Photograph by Jean-Pierre Dalbéra.

Color Plate 3.2 [*Kaleidoscope*] by Loyd Jones (U.S., 1925). Courtesy George Eastman Museum.

Color Plate 3.3 Thomas Wilfred's "Unit #85," from the *Clavilux Junior (First Home Clavilux Model)* series (1930; 66 x 25 x 14 in.). Photo courtesy Yale University Art Gallery, Collection of Carol and Eugene Epstein.

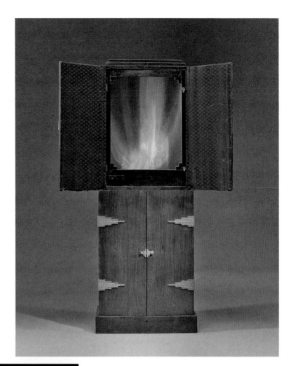

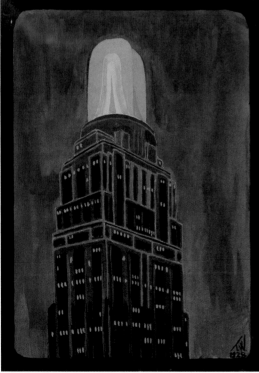

Color Plate 3.4 Thomas Wilfred's sketch for mounting the Clavilux on top of skyscrapers, "The Clavilux Silent Visual Carillon" (1929), Thomas Wilfred Papers (MS 1375), courtesy of Manuscripts and Archives, Yale University Library.

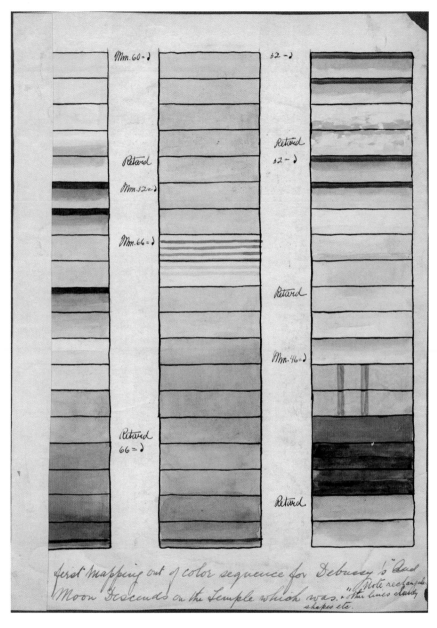

Color Plate 3.5 Mary Hallock Greenewalt's "first mapping" of the color score (ca. 1906) for Debussy's "The Moon Descends Upon the Temple That Once Was." Mary Elizabeth Hallock Greenewalt papers [Coll. 867], courtesy of the Historical Society of Pennsylvania.

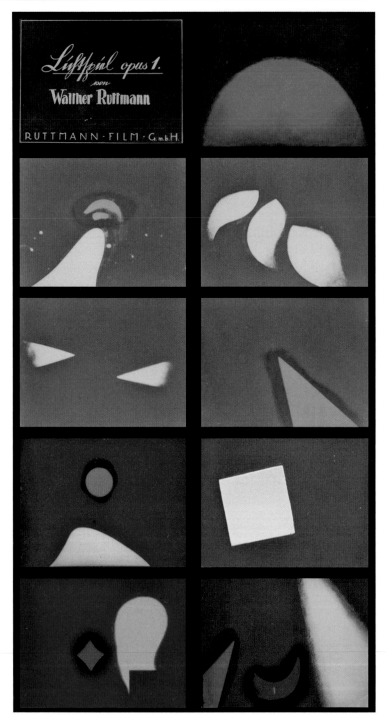

Color Plate 3.6 Frame stills from Walter Ruttmann's *Opus 1* (Germany, 1921).

Color Plate 3.7 Oskar Fischinger, *Raumlichtkunst* (Germany, 1926/2012), reconstruction by Center for Visual Music from 1920s nitrate film originals. Installation view at the Whitney Museum of American Art, 2016, © Center for Visual Music.

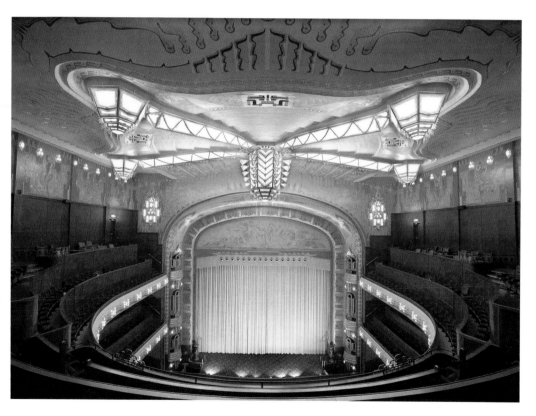

Color Plate 3.8 The Theater Tuschinski in Amsterdam (1921), now the Pathé Tuschinski.

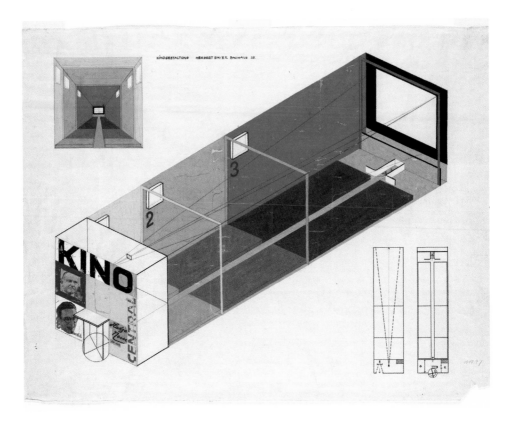

Color Plate 4.1 Herbert Bayer's design for a cinema, "Kinogestaltung" (1924–1925). Gouache, collage elements, black ink, graphite, on paper; 18 x 24 in. Courtesy of Harvard Art Museums/Busch-Reisinger Museum, gift of the artist, BR48.97 © Artists Rights Society (ARS), New York / VG Bild-Kunst, Bonn. Photo: Imaging Department © President and Fellows of Harvard College.

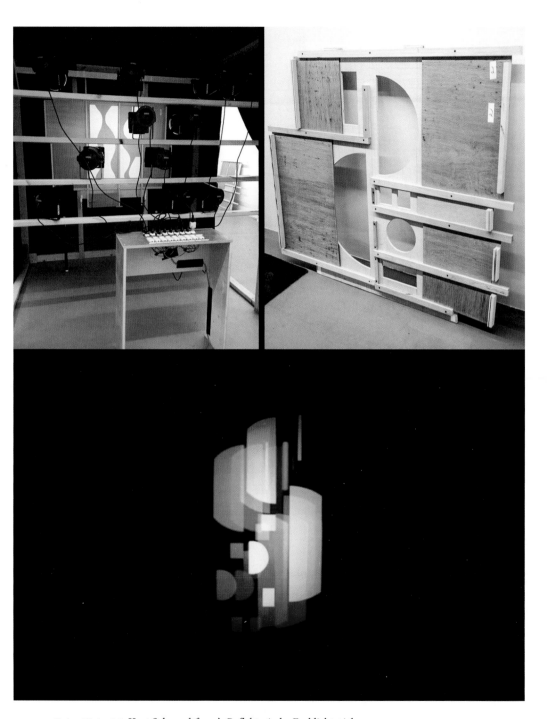

Color Plate 4.2 Kurt Schwerdtfeger's *Reflektorische Farblichtspiele*
(*Reflecting Colour-Light-Play*, 1922, reconstructed in 2016 by Daniel Wapner).
Courtesy of the Microscope Gallery.

Color Plate 4.3 Walter Ruttmann's *Opus III* (Germany, 1924). Courtesy of EYE Filmmuseum Netherlands.

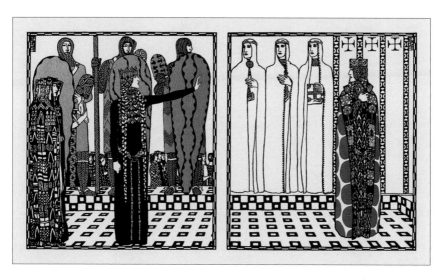

Color Plate 4.4 The confrontation of Brunhild (left) and Kriemhild (right) in Carl Otto Czeschka's illustrations of *Die Nibelungen* (1909).

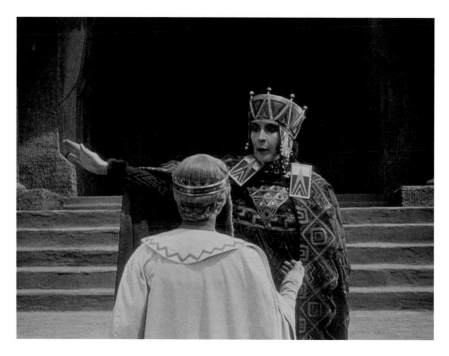

Color Plate 4.5 Brunhild blocking the way of Kriemhild in *Die Nibelungen: Siegfried* (Fritz Lang, Germany, 1924).

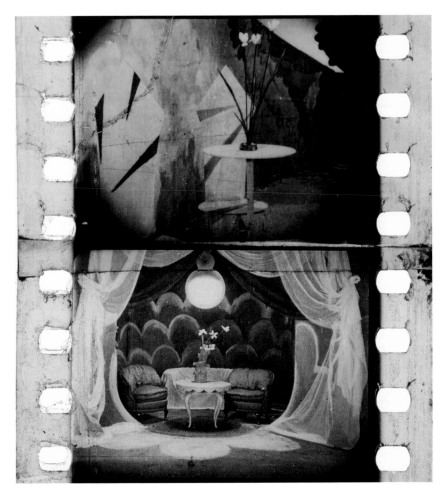

Color Plate 4.6 An example of the variety of tinted and toned colors, as well as the positive cutting found in the print of *The Cabinet of Dr. Caligari* (Robert Wiene, Germany, 1920), from the Archivo Nacional de la Imagen–Sodre, Montevideo/ Cineteca di Bologna. Photograph by Barbara Flueckiger, courtesy of DIASTOR, the Timeline of Historical Film Colors, and Friedrich-Wilhelm-Murnau-Stiftung.

Color Plate 4.7 Hand tinting in the Netherlands Filmliga print of *Ballet mécanique* (Fernand Léger and Dudley Murphy, France, 1924). Courtesy of the EYE Filmmuseum, Netherlands.

Color Plate 4.8 Representative frames from the resurrection scene in *L'inhumaine* (Marcel L'Herbier, France, 1923), nonsequential. Restored by Lobster Films.

Color Plate 4.9 The opening Handschiegl-illustrated sequence in *Salomé* (Charles Bryant and Alla Nazimova, U.S., 1923). Nitrate frame enlargement by Jesse Pierce, courtesy George Eastman Museum.

The Mystery of Love
is greater than the
Mystery of Death.

Color Plate 4.10 The execution of Jokaanan in *Salomé* (Charles Bryant and Alla Nazimova, U.S., 1923). Nitrate frame enlargement by Sophia Lorent, courtesy George Eastman Museum.

Color Plate 4.11 Pictorial shifts in tinting and toning in *Danse Macabre* (Dudley Murphy, U.S., 1922). Nitrate frame enlargement by Sophia Lorent, courtesy George Eastman Museum.

Color Plate 5.1 Amber tinting in *Smouldering Fires* (Clarence Brown, Charles Dorian, U.S., 1925).

Color Plate 5.2 Romantic, violet tinting in *Smouldering Fires* (Clarence Brown, Charles Dorian, U.S., 1925).

Color Plate 5.3 Tinting and Handschiegl effects in the climactic blaze of *The Fire Brigade* (William Nigh, U.S., 1926). Photograph by Barbara Flueckiger, courtesy of the Timeline of Historical Film Colors and Library of Congress National Audio-Visual Conservation Center.

Color Plate 5.4 Tinting and Handschiegl in *Wings* (William A. Wellman, Harry d'Abbadie d'Arrast, U.S., 1927).

Color Plate 5.5 The Phantom in Technicolor in *The Phantom of the Opera* (Rupert Julian, U.S., 1925).

Color Plate 5.6 The Phantom in Handschiegl in *The Phantom of the Opera* (Rupert Julian, U.S., 1925).

Color Plate 5.7 The Golden Swan in *The Glorious Adventure* (James Stuart Blackton, UK, 1922). Courtesy of the BFI National Archive.

Color Plate 5.8 Paul Wegener as Samlak, tinted in purple, in *Das Weib des Pharao* (*The Loves of Pharaoh*, Ernst Lubitsch, Germany, 1921).

Color Plate 5.9 The tinted and toned opening of *The Lodger* (Alfred Hitchcock, UK, 1926).

Color Plate 5.10 Color separations through stenciling between foreground and background, in *Cirano di Bergerac* (Augusto Genina, France/Italy, 1923/1925). Courtesy of EYE Filmmuseum Netherlands.

Color Plate 5.11 Stenciling at the Tartar encampment, just before Strogoff (Ivan Mosjoukine) is blinded, in *Michel Strogoff* (Viktor Tourjansky, France/Germany, 1926).

Color Plate 5.12 Stenciling of Maria, the Duchess de Lardi, and Casanova (Diana Karenne and Ivan Mosjoukine) at Carnival in *Casanova* (Alexandre Volkoff, France, 1927). Photograph by Barbara Flueckiger, courtesy of the Timeline of Historical Film Colors and the Cinémathèque française.

Color Plate 5.13 Blue toning and pink tinting used to convey natural beauty in *Napoléon* (Abel Gance, France, 1927).

Color Plate 5.14 Blue toning at National Assembly Hall in *Napoléon* (Abel Gance, France, 1927).

Color Plate 5.15 Ghosts appear in amber tinting at the National Assembly Hall in *Napoléon* (Abel Gance, France, 1927).

Color Plate 5.16 The colors and lights of Coney Island in *Lonesome* (Paul Fejos, U.S., 1928).

Color Plate 5.17 Fringing effects in *The Open Road* (Claude Friese-Greene, U.K., 1925).

Color Plate 5.18 A woman and child in *Cosmopolitan London* (Harry B. Parkinson and Frank Miller, UK, 1924).

Color Plate 6.1 Wing Foot discovering oil, in *Redskin* (Victor Schertzinger, U.S., 1929). Photograph by Barbara Flueckiger, courtesy of the Timeline of Historical Film Colors and the Library of Congress National Audio-Visual Conservation Center.

Color Plate 6.2 Jacques Cartier performing in blackface in the prelude to *Rhapsody in Blue* in *King of Jazz* (John Murray Anderson, U.S., 1930).

Color Plate 6.3 The Sisters G and Jacques Cartier performing *Rhapsody in Blue* in *King of Jazz* (John Murray Anderson, U.S., 1930).

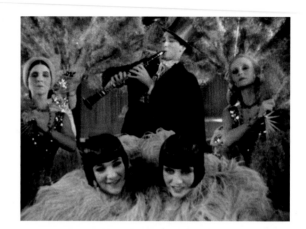

Color Plate 6.4 The film bursting into flames in *The Death Kiss* (Edwin L. Marin, U.S., 1932).

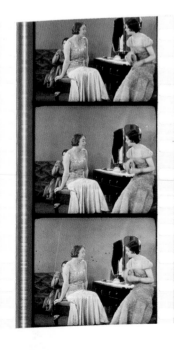

Color Plate 6.5 A stencil-sound film from the Kodak Film Samples Collection. Photograph by Barbara Flueckiger in collaboration with Noemi Daugaard, courtesy of the Timeline of Historical Film Colors and the National Museum of Science and Media/Science and Society Picture Library.

As Wilkening suggests, there may have been additional reasons for the uniform coloring—specifically, the reduction of contrast in the image.[87] Lang, with his cameraman Carl Hoffman, had been experimenting for some time with elaborate lighting effects that allowed them to shoot night scenes at night, thus avoiding the predominant mode of day-for-night filming that subsequently required blue tinting to code the scenes as night. As Lang later explained in a letter to Lotte Eisner in 1968, "I never liked the blue paint which was used in those times to 'tint' day-for-night scenes so that they became 'night scenes.' "[88] Such an emphasis on dynamic lighting effects and night filming is in keeping with the trend of late silent cinema that Erwin Panofsky identified as a "dynamization of space," in which the *mise-en-scène* becomes increasingly expressive through lighting and unchained camera effects.[89] In the context of color, such expressive effects would make tinting relatively redundant for a formally innovative filmmaker such as Lang. However, given the nature of orthochromatic stock in the 1920s, night scenes filmed in low light would have suffered from high contrast, and the dominant golden tint may have been used to mute the chiaroscuro effects and reintroduce a level of relative grayscale within the image. In addition, during the silent era, some people believed that exposing viewers to too much contrasting black-and-white imagery for a prolonged period of time might damage their eyesight, much in the way that snow blindness occurs.[90] Thus, this technical use of tinting may have been thought to serve specific physiological purposes.

Beyond technical explanations, there is also an intermedial case to be made for the uniform coloring of *Die Nibelungen* as being in keeping with the "total design" look of the film in which, as Tom Gunning has noted, "Nothing . . . is natural."[91] In the set and costume designs for the film, Lang famously drew from Carl Otto Czeschka's eight double-paged, relief-printed illustrations for a children's edition of the epic poem from 1909.[92] Czeschka was part of the Vienna Secession, an Austrian Arts and Crafts movement established in 1897 under the leadership of Gustav Klimt. Like the Bauhaus two decades later, the movement was immersed in a variety of modern styles—including Romanticism, Postimpressionism, Expressionism, and Jugendstil—and aimed for a unity of aesthetic expression across the arts, from painting to architecture to graphic design and folk art. Lang, who was born and educated in Vienna, began his professional career there in the 1910s as a graphic artist, influenced by Viennese modernism.[93] His borrowings from Czeschka are readily apparent: the illustrations of Kriemhild's and her sister-in-law Brunhild's costumes, with their Jugendstil surface designs, are systematically replicated in the film's costumes, as are various other architectural and design motifs.

In this sense, Lang's *Die Nibelungen* embodies Hermann Warm's Expressionist dictum that film "should become graphic art." However, Lang's intermedial adaption went beyond the formal line art of Czeschka's illustrations.

As the book prints reveal, color too was a vibrant element of Czeschka's graphic art. Blues and reds are present, but gold is the hue that dominates these illustrations—the color most associated with the Vienna Secession, as in Gustav Klimt's "golden phase" of paintings that were made with actual gold leaf marking their opulent and critically successful style. Gold is everywhere in Czeschka's images: in Kriemhild's hair and necklace, across shields, lances, and boat sails. As with Klimt's layering of materials to produce a heavily textured and haptic quality across the surface of his paintings—as in his famous *Adele Bloch-Bauer I* (1907)—Czeschka's golds, while uniform in their relief-printed application, also shimmer on the page because of the ink used, which was likely produced by trapping golden-hued bronzing powder in printed varnish. It is this type of textural density that the golden-orange tint brings to the gray-scale of Lang's *Die Nibelungen*, making apparent the film's chromatic affinity with the prestige of Czeschka and the Vienna Secession.

One must be judicious in such a reading, though, given the apparent usage of uniform tinting in Germany at the time, as the matching colors could simply be coincidental. There is, however, other contextual evidence in the film's promotional material that its golden aura was designed in reference to the illustrations. One of the iconic posters for *Siegfried* illustrates a scene from the film in which the hero, astride a horse along with his twelve kingly vassals, crosses a drawbridge over the moat into the castle of Worms. Siegfried is positioned in the upper right of the poster, nearest the castle entrance, and also nearest the sun, against which he is silhouetted. Picking up on the film's tint and Viennese influence, radiant and dappled golden-orange light flows out from Siegfried across the poster. The scene is also illustrated by Czeschka, but at an earlier moment than the poster: just as the drawbridge is being lowered to welcome Siegfried and his vassals, all clad in gold. Similarly, even in certain editions of Thea von Harbou's tie-in novel *Das Nibelungenbuch* (1923), the illustrations, derived from film and production stills, are toned in orange-brown hues, likely through the photogravure or rotogravure printing processes.[94]

Given the intermedial emphasis on color in and around the film, its golden-orange tints appear to be more than a technical afterthought. Deployed not only to mute the contrast of the image, the color provides a resplendent and shimmering aura grounded in the Viennese decorative aesthetic to illuminate the mythic world of the film. For instance, in an ill-fated scene outside the cathedral of Worms, Brunhild ignores Kriemhild's and Siegfried's royal courtly ranks and insists that, as the queen of Burgundy, she should enter before Kriemhild. The confrontation that emerges sets in motion the fated tragedy that climaxes in Siegfried's murder. This pivotal scene was also illustrated by Czeschka in a double-page illustration, showing Brunhild and her maids-in-waiting on the left page robed in black and Kriemhild on the right page in blue, with her maids in white. With their eyes locked on one another

across the double-page layout, Brunhild raises her hand, barring Kriemhild's way forward. Textured gold paint sparkles across their elaborately designed geometric costumes, triangular jewelry, and crowns, and over the shields and armor of soldiers behind Brunhild (color plate 4.4). In Lang's version, he both emulates and expands Czeschka's illustration (color plate 4.5). In a series of shots, the two women confront each other repeatedly, raising their arms in succession to block the other's way into the cathedral as the confrontation escalates. As in Czeschka, Brunhild is dressed in a black dress, while Kriemhild is in white rather than blue, and their maids are robed similarly. The two women's triangular jewelry and crowns pick up the golden-orange tints of the film, making the designs shimmer across the shots. These graphic elements are further drawn out in the scene, as in much of the film, through the slow staging of the performance that sculpts the characters into the total composition of the *mise-en-scène*. In their drawn-out confrontation, the golden aura Romantically illuminates—and allows the viewer empathetically to feel into—a mythic past beyond the natural world yet positioned at its fated point of dissolution: the golden aura of the image is destined to end in the apocalypse that follows in *Kriemhild's Revenge*.

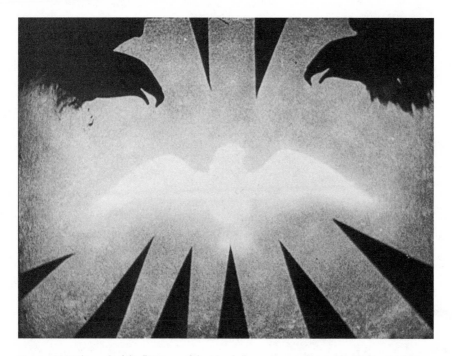

Figure 4.10 The end of the "Dream of the Hawks" sequence animated by Walter Ruttmann in *Die Nibelungen: Siegfried* (1924), reproduced in black and white.

As Kurtz describes the film, specifically referring to Ruttmann's animated contribution, "Decorative space is created through nuance of colour, through rhythmically ordered movement—without a search for counterpart in the organic world."[95] This fits the film's overall, total design, both in its golden application of the Viennese design aesthetic and in its major digression from it, into the Absolute Film style of Ruttmann's "Dream of the Hawks." The shift in tinting, from golden-orange to lavender, marks both the diegetic movement into Kriemhild's retelling of her dream and the relative change in film style. Lavender was a color that Ruttmann had worked with before—some of the swooping shapes in *Opus 1* (1921, color plate 3.6) were momentarily hand colored in the hue—yet it never dominated any of his films as it does in the *Siegfried* insert, and it is doubtful that the precise tint would have been selected with Ruttmann's previous films in mind.

Rather than working from Czeschka's elaborate illustration of the dream, Ruttmann's sequence picks up visual motifs from the film itself, merging them with the Romantic tendencies of his Absolute style of the time. The preface to the dream sequence entails Kriemhild's recounting the vision to her mother; the film cuts from an irised-in medium close-up in golden-orange of Kriemhild to the lavender animated sequence. Within Ruttmann's body of work, the sequence

Figure 4.11 Matching triangular violence in Walter Ruttmann's *Opus 1* (1921), reproduced in black and white.

closely aligns with his *Opus I* (1921) and his parallel, sponsored advertising film *Der Sieger: Ein Film in Farben* (1922), which he produced for Julius Pinschewer for Hannover Gummiwerke Excelsior.[96] The dream begins abstractly against a black background with a rounded, irislike movement upward that reveals a roughly textured, chalk-drawn background, tinted lavender, against which a series of four black pillars with rounded tops pulses upward in the right corner of the frame. *Opus 1* similarly opens with a sequential series of rounded, tower-like shapes pulsing upward, though in alternating blues, greens, and eventually reds and against a relatively smoother background. In the dream, the black pillars are then covered by black waves cresting over them, from the left and the right, eventually leaving the frame divided between a black bottom right corner and the left upper corner in lavender. A light lavender circle shape then appears, swirling around the upper left of the frame, moving much like the abstract shapes in *Opus I*, but as in *Der Sieger*, it then shifts into a figural object: a lavender hawk flitting through what now reads as the sky, in the upper left, until it rests upon the blackened ground in the bottom right. Two abstract, swirling shapes then begin to flit across the sky, until they stir the hawk from its perch and chase it across the frame. The blackened shapes transform into

Figure 4.12 Further matching motifs in Walter Ruttmann's *Der Sieger: Ein Film in Farben* (1922), in which the abstract shapes become an automobile tire and anthropomorphic triangles, reproduced in black and white.

eagles that attack the hawk, culminating in the finale in which they go in for the kill, driving their beaks into the hawk at the center of the frame, as the frame itself collapses in abstract, triangular shards (similarly found in *Opus 1* and *Der Sieger*) that also stab into the hawk, blackening the image as the dream ends.

The anthropomorphic nature of Ruttmann's sequence calls attention to the Romanticism of his abstraction. As Gunning argues, the light shading of the hawk reflects the light-colored robes that Siegfried wears throughout the film, whereas the black eagles correspond to the dark robes and winged helmets of Brunhild and Hagan, who conspire against him.[97] What unifies the sequence with the broader film, across the shifting tints and aesthetic styles, is the abstract surge toward total design in both line and color, exemplified by the back-and-forth merger of figural and abstract design elements in Ruttmann's sequence, as well as in the film. These textured images craft empathetic spaces that are meant to resonate and emote through their elaborately constructed material effects. As detailed earlier, Ruttmann's other works of Absolute Film are much more polychromatic, yet *Die Nibelungen* still works formally through the materiality of color, line, and shape to evoke emotional and empathetic resonances—even through the relatively monotonous yet auratic color design. Embedded in industrial as well as aesthetic codes, the systematic and technical nature of the film's color effects makes them resonate with the modernist impulses delineated through the Bauhaus. Further, these intermedial and cross-field contexts provide the logic for the film's color, much more so than narrative concerns.

It is difficult to make similarly dense readings of the colors in films such as *The Cabinet of Dr. Caligari* and *Nosferatu*, as their relations to visual works such as Czeschka's are not as proximate. However, various intermedial connections are certainly present, as scholarship on the films has examined extensively. Kracauer claims, for instance, that *Caligari*'s set designers—Hermann Warm, Walter Röhrig, and Walter Reimann—were established Expressionist artists associated with the "Berlin Sturm group" and its journal *Der Sturm*, which "promoted expressionism in every field of art."[98] David Robinson further details the collaborative work that went into the production and resulted in its unique look, though he pointedly notes that Kracauer overstated the designers' connection to *Der Sturm*.[99] The films' intermedial context is vital for considering their hues, for Expressionist motifs and colors were widely adaptable at the time. Kurtz explains: "Wherever the decorative elements of Expressionism can be applied, people appropriate them. Wallpaper patterns wander about in jagged, garish colours, blankets are embroidered with cubes and cylinders, lamp shades light up secret expressionist signs in lurid yellow and icy blue."[100] Such garish and sensational hues derive from Expressionist theater and paintings. In this stylistic mode, as J. L. Styan delineates, "décor was often made up of bizarre shapes and sensational colours" that dramatized the subconscious as

a kind of "scripted dream."[101] It is this type of intermedial dream imagery that suffuses the tinted hues of *Caligari* and *Nosferatu*, as is evident in the recent restorations. However, with both films, there are no surviving nitrate prints that were originally tinted for the German market. As discussed in detail by Anke Wilkening and Barbara Flueckiger regarding *Caligari* and by Enno Patalas and Luciano Berriatúa regarding *Nosferatu*, the prints used for their recent restorations derive from various export (non-German-market) sources.[102] With *Nosferatu*, the recent restorations in 1995 and 2006 derive from a faded export print preserved at the Cinémathèque française. Patalas points out, though, that this export print was made and tinted in Germany, so its coloring may have been close to what was originally distributed in Germany.[103]

For *Caligari*, six different tinted and sometimes toned prints from around the world served as the basis for reconstructing its tints in 2014 (color plate 4.6).[104] The restoration also used the incomplete, but pristine, camera negative that was newly available, and the colors were digitally reapplied. Missing material—the film's first act and scattered frames—was supplemented from other sources, and Wilkening, in conjunction with Flueckiger and her research team, carried out research on the six surviving colored prints. They determined that the earliest surviving prints, dating from between 1920 and 1923, were two export copies from Montevideo, now housed at the Filmmuseum Düsseldorf and at the Cineteca di Bologna, which provided the basis for the color reconstruction. The tints and tones of these Latin American prints deployed blue-green-toned and yellow-orange-tinted sequences for the frame story in the garden, with night scenes in blue-green, Jane's room in yellow (though pink in the restoration, drawing from the Cinémathèque française print), and the other interiors primarily in orange. These hues, as Wilkening explains, more closely matched the color schemes and saturations of other Decla Filmgesellschaft productions of the early 1920s than did the nitrate prints of the film produced later in the decade.[105] The two Latin American prints also showcase the signs of manual printing, with many more splices than the later ones, such as those at the British Film Institute and the Cinémathèque Royale, which show signs of negative editing, automatic contact printing, and simplified color schemes in which night scenes are tinted blue and most of the rest of the film is tinted orange, similar to *Die Nibelungen*.[106]

As these cases illustrate, silent films vary significantly from print to print, particularly when it comes to color. Cinema is, after all, an art form produced as a multiple. With these caveats, then, what is one to make of the hues of *Caligari* in light of Expressionist style of the time? In terms of intermedial production, it is worth noting that the promotional materials for the film also reflected the garish and sensational hues of Expressionist art. This is exemplified in particular by the film's original posters, created by Erich Ludwig Stahl and Otto Arpke. One of their iconic posters from 1919 features an empty, candlelit room

with a distorted table and chair, and as Stephen Eskilson has noted, the artists "introduce a fiery palette of reds and oranges that complements the distorted space and eerie lighting."[107] Another Stahl-Arpke poster for the film features, in the same hues, a man grasping at the words "Du musst Caligari werden" ("You must become Caligari"). In both cases, the posters' reds, oranges, and yellows contrast strongly with their greenish-blue background, heightening the sickly madness of the image. Although Eskilson claims that these colors are particular to the graphic designers and assumes that the film's production team could only work in black and white, clearly this was not the case.

The colors of the film are in fact closely aligned with the posters—at least in the Latin American prints, which use similarly hued, sensational colors. In the film's famous opening story frame set in an asylum, the aforementioned green-blue toning and yellow-orange tinting provide a remarkable contrast of hues, much in the way that the Stahl-Arpke posters work. Through simultaneous contrast, these complementary colors visually amplify the subjective contrast of the image, creating a saturated and sickly atmosphere that undergirds the introduction of Francis and Jane, and Francis's recounting to an older man of the horrors that led them there. When the film returns to the garden at the end, the color scheme has shifted to a simpler blue tint used elsewhere in the film to indicate nighttime—the evening has passed during his long retelling of the horrors of Dr. Caligari and Cesare. In the concluding shots, the film then moves inside what the audience quickly comes to discover is an asylum, and the orange tint that was used previously for interiors returns. Thus, instead of a simultaneous contrast of blue and orange, as in the opening, the film creates successive contrast from shot to shot.

There are certainly films from the period that are more complexly tinted and toned, but complexity is not the point. *Caligari* deploys certain conventional approaches to tinting and toning—the shift to blue at the end to indicate the darkness of night—but what is significant about its coloring is the way in which it interacts with the film's total design. Fused to the angular and painterly *mise-en-scène* of *Caligari*, the heavily saturated tints and tones amplify the expressive force of the film. As Kurtz explains in his chapter on *Caligari*, Expressionist art and film base their aesthetic work on the emotional effects of their formal elements: "It is a simple law of psychological aesthetics that out of empathy with shapes, precisely analogous aspirations arise in the soul. A straight line leads the emotions differently than a slanted one; bewildering curves have different emotional correlations than harmoniously gliding lines."[108] As has often been commented on, many of *Caligari*'s pictorial effects were achieved by painting the *mise-en-scène*—creating the illusion of light and shadow through brush. In many ways, the painted-on tints and tones of the shots double this work, enhancing the empathetic power of the film by facilitating one to feel into its visceral dream world. The combination of design and color in *Caligari* is

remarkable for how it embodies Expressionistic color aesthetics of the time. Yet of course, not all were enthralled. In France, Blaise Cendrars famously derided it for being "hybrid, historical and pernicious," "pictorial" rather than "optical."[109] Similarly, Jean Epstein issued a polemic against the film, arguing that its use of painting on the set is "an unpardonable sacrilege in the cinema" as it is "nothing more than a still life, all its living elements have been killed by the strokes of a brush."[110] These painterly, hybrid effects, though, were exactly the point of Expressionist style, and as Kurtz points out, it is through this intermedial nexus that color's empathetic and emotional valences come to the fore, just as they do in the abstraction of Absolute Film. However, with such critiques by Cendrars and Epstein in mind, we shift now to examine parallel cinematic approaches to color in the experimental and narrative avant-garde work of France during the 1920s.

France, *Cinéma pur*, and the Narrative Avant-Garde

To return to the earlier discussion of the Absolute Film screenings at the Ufa Palast in May 1925: the program was a curious amalgamation of German and French films, exemplars of both German Absolute Film and French avant-garde works that are associated with Dada and *Cinéma pur*—the supposedly "pure" elements of cinema, including form, motion, rhythm, and composition.[111] These French films were Fernand Léger and Dudley Murphy's *Ballet mécanique* (1924), credited as *Images mobiles* in the program, and René Clair's *Entr'acte* (1924, written by Francis Picabia). Like the Bauhaus's interest in the industrial medium of film and, conversely, Erich Pommer's adaptation of avant-garde style to narrative filmmaking, French filmmaking of the era points to parallel attempts to merge various intermedial registers of cultural production—between the high and the low, the restricted and the large-scale. Thus, similar motifs emerge around color relating to its industrial and scientific as well as occult and utopian energies.

Two points can be made specifically about *Ballet mécanique* and *Entr'acte* that provide insight into the broader chromatic horizon of French avant-garde cinema of the time, in both narrative and experimental veins. First, just as these French films were screened alongside German Absolute films, they point to the collaborative networks that generated an expansive circulation of films, styles, and techniques across national boundaries—again, to invoke Scheerbart, similar ideas in the heads of many at the same time.[112] Significantly, both *Entr'acte* and *Ballet mécanique* were themselves products of intensive collaborations: for the former, Clair and Picabia along with Eric Satie and numerous others who appeared in the film, such as Marcel Duchamp, Man Ray, and Georges Auric; and for the latter, Léger and Murphy with Man Ray,

Figure 4.13 The cover of the Dada periodical *391*, no. 7 (August 1917) designed and edited by Francis Picabia.

Courtesy of the International Dada Archive, University of Iowa Libraries.

Katherine Hawley Murphy, Alice Prin aka Kiki de Montparnasse, and Ezra Pound, who brought together Murphy, Ray, and Léger.[113] *Ballet mécanique's* title was likely related to a 1917 cover of the Dada periodical *391* designed and edited by Picabia. As this diverse range of artists suggests, both films were also indicative of the cosmopolitan collaborations occurring at the time among the avant-garde. French and U.S. artists were explicitly involved with the production of *Ballet mécanique*, while the cast of cameo appearances in *Entr'acte* give it a similarly international pedigree.

Second, these films—particularly when examined in relation to the Absolute films that screened with them—point to different aesthetic valences of color during this era. In many ways this parallels the distinctions that Cendrars and Epstein made about *Caligari* and that Moholy-Nagy made between the black-and-white optical world of photography and the chromatic world of abstraction in *Painting, Photography, Film*. *Ballet mécanique* in part and *Entr'acte* in its entirety are photographically based. *Entr'acte* was almost certainly presented in black and white. While it is not known which, or whose, print of *Ballet mécanique* screened in Berlin, there are extant versions that were colored during the 1920s, primarily with the film's abstract geometric sequences of circles and triangles brush-tinted in blues, yellows, greens, oranges, and reds. This is the case in the nitrate version preserved at the EYE-Filmmuseum, Netherlands, the provenance of which derives from the Netherlands Filmliga, a film society that promoted avant-garde film from 1927 until 1931 (color plate 4.7).[114] The film's colored shapes resonate strongly with German Absolute films of the time. Calling attention to the psychophysical aspects of color, the abstract shapes resemble the types of color tests used in psychology labs of the time to study sensory perception. In contrast to these sequences, the film's black-and-white photographic montage of objects and people pairs well with the Dadaist elements of *Entr'acte*, as well as the city symphony aspects of Moholy-Nagy. Of course, while *Ballet mécanique* sets up these differences between color and black and white and between abstraction and objecthood, fundamentally it challenges such divisions through its associative montage, just as the film's very name juxtaposes two seemingly incongruous things, mechanization and balletic grace. The inherent hybridity of the film is in fact a microcosm of the broader mixing of chromatic styles found in the Absolute Film screenings of 1925.

Ballet mécanique's investment in crossing boundaries also delineates a debate in French filmmaking practice and criticism in the 1920s regarding color that in some ways aligns with the critique of the painterly and pictorial effects of *Caligari* as opposed to the praised optical aspects of cinematography. As Bregt Lameris has shown, this debate spilled into the pages of the film journal *Cinéa-Ciné pour tous* in 1926 and 1927 when the young critic Bernard Brunius called for a "Ligue du noir et blanc"—a league established polemically,

and perhaps somewhat facetiously, to promote black-and-white cinema while attacking photographic color cinema.[115] Brunius explained in his initial 1926 article: "Let's save the cinema from theatre after having saved it from literature. Let's save it from the postcards after having saved it from painting. I expect many more protesters, and I suggest to create the 'Ligue du noir et blanc.' "[116] Signatories to his league included filmmakers and critics such as Jean George Auriol, Jean Mitry, Jean Tedesco, Alberto Cavalcanti, and René Clair. For context, the 1920s was an era when debates began in earnest about the aesthetic specificity of film—that is, claims about what made the medium a specific type of art.[117] For some, including Brunius, the medium's specificity was grounded in its photographic, black-and-white base, and the league sought to champion this filmic ideal. Color at the time, in France and elsewhere, was becoming increasingly connected to advertising and consumer culture. Within the cinematic field, American Technicolor was expanding rapidly, with Douglas Fairbanks's *The Black Pirate* (1926) making international waves. For French cinema, which had previously dominated color film production through Pathé and Gaumont's stencil films, this was a technical reversal of fortune that, as Lameris suggests, likely informed Brunius's polemics. Though predating the Ligue du noir et blanc by two years, *Ballet mécanique*'s black-and-white footage resonates with a certain monochromatic emphasis on the photographic image.

Still, *Ballet mécanique* is by no means thematically opposed to consumer culture, and its Dadaist underpinnings in many ways embrace the blurring of popular and avant-garde art rather than espousing a regressive black-and-white art cinema. Indeed, the early upside-down images in the film of Katherine Hawley Murphy, sitting on a swing while wearing elegant but antiquated Victorian garb, counter any backward glance at traditional, auratic notions of beauty—such conceptions are literally turned on their head in these shots. The film's contrary emphasis on the flapper-modernism of Kiki and its interest in mass-produced kitchen objects, newspaper headlines, and Charlie Chaplin epitomize the vernacular-modernist underpinnings of the film. Its use of color functions along these lines as well, yet in ways that still harmonize with the emerging black-and-white aesthetics of French film criticism. In French discourse of the time, proper use of color was in fact seen as having an affinity with *Cinéma pur*. Critic and historian René Jeanne makes this exact point in his article on "La controverse de la couleur," which was published on the same page as one of Brunius's polemics: color in cinema should be aligned with the tradition of abstraction, *Cinéma pur*, and Cubism.[118]

Cinéma pur was a contested and variable concept, yet most of the works associated with it were in black and white—for example, *Cinq minutes du cinéma pur* (*Five Minutes of Pure Cinema*, Henri Chomette, 1926), *Emak-Bakia* (*Return to Reason*, Man Ray, 1926), *Anémic cinéma* (Marcel Duchamp, 1926), and *Thèmes et variations* (Germaine Dulac, 1928). However, Dulac in particular

articulated a conceptual thread found in *Cinéma pur* that connects broadly to color, an idea that can also be found in the writings of Léon Moussinac and Henry Fescourt. Dulac's ideal aspired to "a visual symphony made up of rhythmic [representational] images."[119] Her emphasis on representational images— ones that are iconic rather than abstract and nonrepresentational—aligns with notions of filmic specificity and black and white, but her invocation of a musical analogy also connects *Cinéma pur* to the tradition of color music, which, as discussed in chapter 3, was tightly interconnected in the French avant-garde context with color cinema. A touchstone for *Cinéma pur* was Léopold Survage's painterly experiment with color music and film in *Le rythme coloré* (*Colored Rhythm*) between 1912 and 1914, which resulted in a sequential, moving series of abstract paintings that were meant to be photographed as film frames, but never were.[120] Further, just as *Ballet mécanique* engaged in a vernacular-modernist approach to its material, Survage's experiments also delineated an intermedial blurring of highbrow and lowbrow production. As the influential poet and critic Guillaume Apollinaire famously noted of Survage's project, "it draws its origins from fireworks, fountains, electric signs, and those fairy-tale palaces which at every amusement park accustom the eyes to enjoy kaleidoscopic changes in hue."[121]

The critical place of color in this strand of French avant-garde cinema is further delineated by Marcel Duchamp, whose *Anémic cinéma* was also an exemplar of *Cinéma pur*, given the film's distilled exploration of depth and motion. The work developed out of a series of psychophysical experiments that Duchamp carried out in the early 1920s, initially with the assistance of Man Ray, to test the notion of persistence of vision.[122] In 1920, Duchamp and Ray built a motorized device, *Rotary Glass Plates (Precision Optics)*, that spun a painted glass plate that created optical, three-dimensional pulsations for the viewer when in motion, akin to numerous advertising windows displays that would come into use during the era, such as those portrayed in Fritz Lang's *M* (1931).[123] Duchamp continued this work, producing in 1923 a series of ink-and-pencil-drawn cardboard discs, *Disques avec spirales* (*Disks Bearing Spirals*), that could be played on a turntable. This would develop into his *Rotoreliefs* of the 1930s, in black and white and color, and a revised device in 1925 like the one from 1920, *Rotary Demisphere (Precision Optics)*. A further version of this optical play with movement and depth is found in *Anémic cinéma* (1926), which continued Duchamp's experimentation with persistence of vision, moving spirals, and punning texts.

If Duchamp's cycle of optical experiments drew from color theory and physiology, even when the works were mostly in black and white, his preceding painterly canvas works from the 1910s foreground the contemporary world of color more concretely. His rectified ready-made *Apolinère Enameled* (1916–1917) and his final painting *Tu m'* (1918) literalize the intermedial context of color

during the era.[124] In *Apolinère Enameled*, Duchamp modified a paint advertise-
ment for Sapolin Enamel, changing the title to dedicate it to Apollinaire, whose
poetry, art criticism (regarding Survage and Picasso), and plays (for example,
Color of Time) were richly chromatic in nature.[125] Addressing issues of con-
sumption, gender, domesticity, and mass-produced color, *Apolinère Enameled*
presents a girl painting a white bed frame, presumably in her bedroom, with
enamel paint—reds, yellows, blues, and pinks. The white bed frame, through
its stark contrast with the background, stands out from the image, abstracted
and almost stereoscopic, in a play with depth that his later rotary experiments
explore. The addition of the painted slats of the bed frame create flat, modern-
ist, and codified surfaces that further contrast against the bourgeois interior of
the room, with its lace curtains, Art Nouveau wallpaper, and oriental rug.

Duchamp's critical attention to the mass production and standardization of
color continues in *Tu m'*, which was made on commission for his close friend,
patron, and collaborator Katherine Dreier to adorn her home in the United
States. Its title, like most of Duchamp's titles, is a linguistic pun in French—an
open-ended fragment that has most often been interpreted as being short for
"tu m'embêtes" (you bore me), though numerous other constructions work,
for example, "tu m'aimes" (you love me), or "tu m'emmerdes" (you annoy me).
Who the "tu" is in this case is unclear—perhaps Dreier, or even painting itself,
given that it was Duchamp's final work of painting. As a swan song, it is a tour-
de-force assemblage of materials, an inventory of many of his works: shadows
of past and potential ready-mades (a bicycle wheel, a corkscrew, and a hat
rack); an homage to his earlier *Three Standard Stoppages* (1913–1914) in the
bottom left of the painting; a real bolt and safety pins holding together a phys-
ical gash in the center, from which an actual bottle cleaner sticks straight out,
casting a shadow on the canvas, depending on the lighting; and prominently,
a series of paint swatches, on both the left and right sides of the image, that
recede into cosmic depth.[126] As Ann Temkin points out, part of the thrust of the
paint swatches connects back to *Apolinère Enameled*, in that Duchamp again
draws attention to the ways in which modern color itself is a mass-produced
and standardized ready-made; as he explained later, in 1961: "Since the tubes
of paint used by an artist are manufactured and readymade products we must
conclude that all the paintings in the world are 'readymades aided' and also
works of assemblage."[127] In these works produced on the cusp of the 1920s,
Duchamp presciently took up the industrialized and standardized nature of
modern color in ways that paralleled his interest in the ready-made aspect of
physiological perception in his subsequent rotary experiments. The chromatic
modernity that ensued in the interwar period followed in *Tu m'*'s wake.

To return to *Ballet mécanique*, against this backdrop of the ready-made as
well as emerging notions of *Cinéma pur*, there is a certain logic to the incor-
poration of abstract color shapes into the mixture of mechanically reproduced

objects in the film. Like the swatches of *Tu m'*, the chromatic sequences are also types of found objects, with specific aniline roots in the standardized colorants available at the time. These geometric color swatches were clearly planned into the structure of the film from an early stage. As Léger's description of the film in 1924 indicates, color was used to weave together the corresponding structures of the film: "The film is dived into seven vertical parts (flat, without depth, moving surfaces) which go from slow to rapid. . . . To inspire variety in each of these parts they are crossed by rapid horizontal penetrations of similar forms (colour)."[128] In other words, at least at the planning stage, the color tints were meant to create interstitial harmonies across the rapid montage of objects.

Color was important to both Murphy's and Léger's other works. Tinting played an integral role in Murphy's earlier films made in the United States, such as *The Soul of the Cypress* (1921) and *Danse Macabre* (1922), discussed below. Color was also famously central to Léger's aesthetics of the time—a "vital necessity," as he repeated often in his writings. His approach to color was steeped in the artistic design culture of the era. He first studied color at the École nationale des arts décoratifs (National School of Decorative Arts) beginning in 1903, and his career expanded from there amid a resurgence in French design and artistic traditions in the early twentieth century. Reflecting back on the period in 1938, Léger recalled how in France the First World War disrupted many of the creative and chromatic developments: it was "grey and camouflaged; light, color, tone were forbidden on pain of death," but in the 1920s, as postwar advertising culture exploded,

> through the open window, the wall across the street, violently colored, comes into your house. Enormous letters, figures twelve feet high, are hurled into the apartment. Color takes over. It is going to dominate everyday life. . . . Manufacturers and merchants face each other brandishing color as a weapon of advertising. An unprecedented, confused riot of color explodes on the walls.[129]

In the midst of this chaotic resurgence of color in everyday life, Léger in 1924, perhaps taking a page from Scheerbart's *The Glass Architecture*, wrote an extensive treatise on color and the moving image that bemoans the badly "orchestrated" modern world with "its daily assault on the nerves" leading to "hypertension."[130] The solution for Léger, though, was not a retreat from color but instead a better organization of the chromatic world, to craft a parallel version of what we have termed "useful abstraction" with regard to the Bauhaus color experiments:

> Color and light have a social function, an essential function.
> The world of work, the only interesting one, exists in an intolerable environment. Let us go into the factories, the banks, the hospitals. If light is required

there, what does it illuminate? Nothing. Let's bring in color: it is as necessary as water and fire. Let's apportion it wisely, so that it may be a more pleasant value, a psychological value; its moral influence can be considerable. A beautiful and calm environment.

Life through color.

The polychromed hospital.

The colorist-doctor.[131]

Léger's call to tame the new riot of color comes amid an explosion of chromatic design, specifically of Art Deco, as exemplified in 1925 by the Exposition internationale des arts décoratifs et industriels modernes in Paris, discussed in chapter 2. Léger, along with other French Orphists such as Sonia Delaunay, was at the center of the avant-garde collaboration with the Art Deco movement as well as with French filmmaking. This intermedial collaboration is exemplified by another film that Léger worked closely on during the period: Marcel L'Herbier's *L'inhumaine* (*The New Enchantment*, 1924). An exemplar of the French narrative avant-garde of the 1920s, L'Herbier described it as a "fairy play of the modern decorative arts." As in the French fairy films of the early 1900s, color played a crucial role: it was complexly tinted throughout, at points with rapid bursts of pure color montage.[132] Similar to other French narrative films of the era, particularly those produced by Films Albatros, *L'inhumaine* was planned as a synthesis of a variety of modern design styles that could serve as an introductory manifesto for the Exposition des arts décoratifs, where the exhibit for his company Cinégraphic featured the film.[133] To carry out this vision, L'Herbier enlisted a number of collaborators to create the sets and fashions for the film, including Léger, architect Robert Mallet-Stevens, soon-to-be filmmakers Alberto Cavalcanti and Claude Autant-Lara, fashion designer Paul Poiret, jeweler Raymond Templier, and furniture designers Pierre Chareau and Michel Dufet. The resulting interior designs were remarkable, in particular the Art Deco banquet hall by Cavalcanti and the laboratory by Léger in his machine-aesthetic style.

In constructing his *histoire féerique*, L'Herbier in many ways returned to Georges Méliès's approach to storytelling, in which the scenario was merely a pretext for presenting a series of dazzling attractions. The film recounts the romance of a famous opera singer, Claire Lescot, and her suiter Einar Norsen, a Swedish scientist. As their relationship develops, another jealous suitor poisons her with an asp, whereupon Norsen performs a scientific miracle and resurrects her in his lab. Through this simplistic narrative, L'Herbier showcased a variety of dazzling designs and colors through an explicitly synesthetic approach in which he deployed the "admittedly poor" scenario as a musical structuring guide: "a little like composers use what they call the bass clef. On this bass clef, I constructed chords, plastic chords, and what was important for me was not the

Figure 4.14 Marcel L'Herbier's exhibit at the Exposition internationale des arts décoratifs et industriels modernes in Paris (1925).

horizontal parade of events but vertical plastic harmonies."[134] Such a Wagnerian outlook, using musical harmony as a metaphor to describe cinema's ability to unite the arts, was a powerful trope for the emerging aesthetics of *Cinéma pur*. Developing alongside cinema's growing institutionalization, the syncretic approach that undergirds *Cinéma pur* points to the changing structure of intermediality at the time, as discussed in the introduction to this book. Ricciotto Canudo, for example, famously pronounced in 1911 that cinema was the "sixth art" that harmonically brought together spatial forms (painting and sculpture) with the temporal ones (music and poetry), an argument he continued to develop into the 1920s: "we will recognize cinema as the synthesis of all the arts and of the profound impulse underlying them."[135] Rather than being a subservient extension of other media (a relationship that characterized cinema's intermedial emergence in the nineteenth century from existing technologies and cultural series), cinema, as it developed into an autonomous medium, actively co-opted the other arts into its medial form. This shift of polarity in intermediality defines the structure of cinema's relation to other cultural fields in the 1920s and delineates the syncretic impulse of L'Herbier's work. Canudo, though, was not sympathetic to these attempts; he dismissively described L'Herbier's films as "all creaking under an antiquated aestheticism," a criticism shared by others of the time and since.[136] However, while pointing backward to Symbolist and Decadent traditions, L'Herbier's aesthetic was not nostalgic in the sense of wanting to return to the past, but rather palimpsestic in how he superimposed a range of new and old aesthetic registers within his work.

This intermedial structure is also apparent in L'Herbier's use of color tinting and toning in *L'inhumaine*. Indeed, as with other cases traced in this chapter, intermediality provides the logic for the color design of the film, particularly in its more avant-garde moments, much more so than the parameters of narrative style, though the narrative coding of color also has its place in the film, as we will see. The colors of the film have been difficult to assess historically, as its tints and tones were lost for decades. L'Herbier pointed out in an interview in 1968 that surviving versions were only available in black and white, as the last tinted print housed at the Cinémathèque française was destroyed in a fire.[137] However, for the film's initial release, he explained, "at certain moments of excitement, I inserted fragments of film stock of different colors, so that suddenly you seemed struck by flashes of pure white, and two seconds later, flashes of red, or blue, before the image reappeared."[138] L'Herbier oversaw a restoration of the film in 1972 in black and white by the Centre national du cinéma et de l'image animée (CNC), and Frantz Schmitt carried out a second restoration at the CNC in 1986 in collaboration with Jean Dréville, who had previously assisted L'Herbier on the original production and attempted to reconstruct the tints from memory.[139] Although Dréville's reconstruction was useful for reimagining what the colors might have looked like, Lobster Films undertook

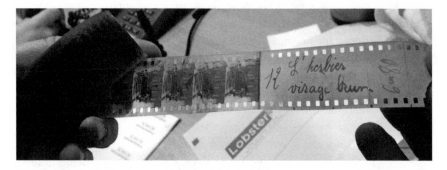

Figure 4.15 One of the original frame slugs with color information (indicating brown toning) for *L'inhumaine* (1924).

Courtesy of Lobster Films.

a more systematic restoration in 2014 in coordination with the CNC. For this work, they were able to return for the first time to the original nitrate negatives of the film, which had been edited in tinting order in the 1920s with labeled coloring slugs indicating the original tints and tones.[140] Lobster Films scanned the negatives at 4K and digitally restored the tints and tones.

The colors of the 2014 restoration closely match L'Herbier's description, particularly in the film's climactic and most successful scene in the Léger-designed laboratory where Norsen resurrects Lescot. Originally keyed to Darius Milhaud's percussive score, the rapidly alternating tints illuminate the transformation in rapid montage, akin to "a series of explosions, an over-revving of the machines," as L'Herbier envisioned the scene.[141] The tinted colors of the laboratory's interior point to a layering of aesthetic registers. Corresponding to the music and montage, the hues form an abstract composition akin to nineteenth- and early-twentieth-century synesthetic experiments from Baudelaire and Rimbaud to Survage, Ruttmann, and particularly Léger and Murphy. As a pair of intertitles describes the scene, "everything is animated . . . like a symphony of labor" ("tout s'anime . . . comme dans une symphonie de travail"). Color's place in this moving symphony, along with much of the sequence's imagery, aligns closely with *Ballet mécanique*, which Léger and Murphy produced and released almost simultaneously with *L'inhumaine*, and according to Freeman, Léger's experience with *L'inhumaine* led to further revisions to *Ballet mécanique*.[142] The laboratory itself is a curious amalgamation of two-dimensional painted flats and backdrops in Léger's signature style with three-dimensional scientific props. Within this *mise-en-scène*, Norsen and his technicians carry out their ritualistic resurrection among spinning pendulums and bursts of electricity. This mixing of planes calls to mind both the haptical space of Méliès's *féeries*, as Antonia Lant has delineated, as well as the mixture of spinning objects and painterly surfaces

found in *Ballet mécanique*.[143] Twirling pendulums and rotating cones correspond across the films, and the flexing human arms with moving machinery in *L'inhumaine* match the machine aesthetic of *Ballet mécanique*.

The use of tinting also forms a connection between the two films. Throughout much of *L'inhumaine*, the color scheme is relatively codified in line with established film conventions—applied as a kind of standardized ready-made. At many points, the tints and tones are used diegetically: gold is primarily keyed to the opulent décor surrounding Claire Lescot, purple cues Orientalist scenes, blue corresponds to exterior night scenes, and red dominates Norsen's laboratory and is seemingly coded to the electrical experiments being undertaken to resurrect Lescot (akin to red for fire). Yet the climactic scene also pushes beyond such staid conventions, as the tinted hues explode in harmonic cadences amid the accelerating montage of close-ups of Norsen's face, pumping arms at work, spinning machines, pressure valves, and twirling pendulums and cones. Conveying an electric surge of wonder among the montaged images, fraction-of-a-second shock flashes of color appear: blue-, yellow-, lavender-, and red-tinted frames on clear leader (color plate 4.8). These physiological shocks of pure hue and cinema correspond to the abstract color sequences of *Ballet mécanique*, developing a new, intermedial layer of harmony amid the clatter of moving images.

The sequence significantly precedes the similar experimentation with rapid chromatic montage that Sergei Eisenstein carried out in the ecstatic cream-separator scene of his *Staroye i novoye* (*The Old and the New*, 1929). (aka *The General Line*, 1929). In that scene, Eisenstein intercut tinted shots of water streams, which in their "monochromatic splendor [. . .] leapt into another dimension."[144] If for Eisenstein the chromatic abstraction was meant to dynamize the materialist transformation of cream from milk that resulted from the collective labor of the farm, for L'Herbier the colors leap instead into a mystifying fantasy of labor and resurrection: the hues represent the laboratory miracle of life reborn. The chromatic explosions culminate in *L'inhumaine*'s final scene: in lavender, Lescot revives with Norsen lovingly at her side. Through the fusion of these colors, as well as the film's interior designs and various styles, *L'inhumaine* points to cinema's potential to negotiate and interweave color's multiple aesthetic registers in the 1920s, even amid the calls to purify and essentialize the aesthetic essence of the medium. As with Léger and Murphy's *Ballet mécanique*, L'Herbier's tinting and toning, as well as his appropriation of Art Deco aesthetics, strongly counter the desaturated polemics of the Ligue du noir et blanc.

The aesthetic hybridity in *L'inhumaine* defines the use of color in the modernist moving-image works of France in the 1920s. Related experiments can be seen in other works of the narrative avant-garde, as we explore in more detail in chapter 5—for instance, in the tinting and toning patterns of Albatros films such as *Le brasier ardent* (*The Burning Crucible*, Ivan Mosjoukine, 1923) and

Gribiche (Jacques Feyder, 1925), and in other features such as *Michel Strogoff* (Viktor Tourjansky, 1926) and *Casanova* (Alexandre Volkoff, 1927), both of which add stenciled sequences into the chromatic mix. Although France did not dominate chromatic production in film in the same way that it did before World War 1, the expansion of filmic color through modernist engagement with the medium was dynamic, particularly in how it led to new intermedial and international collaborations with artistic design movements from Orphism and Dadaism to Art Deco.

International Color Culture

This chapter has focused primarily on the German and French contexts of moving-image work during the 1920s, largely because these were the international epicenters of modernist experimentation with the moving image during the decade. Still, there are certainly other examples worth noting in brief, as they point to the increasingly international nature of artistic experimentation with color. At times, these lines of influence were connected through cosmopolitan circulation; at others, they were simply parallel ideas about the occult, science, and technology, as Scheerbart observed. In such repetitions, the contours of the era's chromatic modernity take shape.

In the UK, for instance, Anthony Asquith's remarkable *A Cottage on Dartmoor* (1929) provides a startling example of the use of color in the narrative avant-garde. The film melds Expressionist style with French and Soviet montage in key scenes to convey the mad obsession of a love triangle in which a barber, Joe, is in love with his coworker Sally, who becomes engaged to Harry, one of their salon's frequent clients. During one of the most dramatic moments, Joe literally sees red—three tinted frames of clear leader—after he spies an engagement ring on Sally's finger. At the moment, unfortunately, he is also shaving Harry with a straight razor while Sally is giving him a manicure. Through a series of rapid cuts, his mind snaps, literalized in associative montage by a snapping wire and a series of battleship cannons firing (disjunctively flipping the axis of the shots back and forth in Eisenstein-like fashion) before the red tint floods the screen for a fraction of a second. Joe moves his razor closer to Harry's throat and threatens to slice it. A tense standoff ensues that results in Joe's cutting Harry in Kuleshov fashion, in which the cut is not actually shown but implied across the sequence's rapid and repetitive editing. The red rage, literalized through the tinting, metaphorically bleeds over into the unimaged violence, giving particular weight to the final shot of the action when a bottle of hair tonic slowly spills onto the floor creating a dark, viscous mess. The references to Eisenstein are clear, through the associative montage of red, as in the red flag of *Battleship Potemkin*, as well as through the disjunctive cannon fire.

Figure 4.16 Abridged montage sequence in *Cottage on Dartmoor* (1929); three tinted red frames were originally inserted after the cannon fire.

Embedded in a psychological melodrama, however, the red tinting also functions akin to L'Herbier's pure montage of colors, launching the narration into the abstract dimensions of inner speech and associative imagery.

The influential British-Swiss film journal *Close Up* critiqued *A Cottage on Dartmoor*'s overly metaphoric and unnuanced montage, with critic and filmmaker Oswell Blakeston sharply commenting, "To take refuge behind the names of Eisenstein and Pudovkin is natural (and naturally) cowardly."[145] Though Blakeston dismissed what he saw as slavish emulation, the journal was positive overall toward Soviet cinema, and Eisenstein in particular. Indeed, many of Eisenstein's writings appeared in translation in the journal, including in the same issue the chromatically rich "The Fourth Dimension in the Kino," along with a rave review of a conversation with Eisenstein at a public screening in Paris of his *Staroye i novoye* (*The Old and the New*, 1929). At the screening, Eisenstein discussed color film in detail, predicting that it would soon replace black and white. Perhaps in reference to Brunius's recent Parisian crusade, he noted, "There will remain only a few isolated enthusiasts who will crusade against colour film in the name of the black-and-white principle."[146]

Blakeston showed himself to be attuned to developments in color in a number of other articles for *Close Up*. During 1929, he reviewed *The Colour Symphony*, which presumably was a Colorart short film by Tiffany-Stahl Productions. The Hollywood company made a series of shorts under the Color Symphony name using two-color, dye-transfer Technicolor.[147] Blakeston relates the film to color music, "which everyone has heard of," and proceeds to carry out an analysis of its formal properties and how they generate physiological reactions, very much in line with the aesthetics of *Einfühlung* that held sway in Germany:

> In the experiment, under review, there is a flow of kaleidoscopic patterns. There is no cutting; in its place a constant merging, melting, and splitting of figures. . . . What is so surprising, and important, is the dramatic power of juxtaposed colours. A red that suddenly explodes, a soft green infusing the screen after a wash of scarlet, black stars that unfold from a sea of gold: all react on the spectator in a definite, psychological manner. An audience can be thrilled, soothed, startled, by a transient colour glimpse. A chain of emotions could be inspired by points of luminous shades, growing, converging, sinking back.[148]

Blakeston's aesthetic interest in color and form in *Close Up* delineates the international horizon of chromatic art during the decade and sets the stage for what follows, particularly in the UK with Len Lye's vernacular-modernist experiments with color and sound in the mid-1930s through the GPO Film Unit, in well-known works such as *A Colour Box* (1935), *Rainbow Dance* (1936), and *Trade Tattoo* (1937).[149] The abstract physiology of color in motion thus had a potent, if minor, influence on British art cinema during these years.

In the United States, a limited number of experiments also overlap with the work of the European avant-garde. These works encompass what Jan-Christopher Horak has described as the "first American film avant-garde" made by amateurs, "lovers of cinema."[150] In terms of color, an exemplar in this mode is Alla Nazimova's *Salomé* (Charles Bryant and Nazimova, 1923), which Kristen Thompson examines in the context of experimentation on the fringes of Hollywood in Horak's volume.[151] However, no criticism has yet focused on the complex coloring deployed in the film. Produced by and starring Nazimova as Salomé and directed by Charles Bryant with designs by Natacha Rambova, the film is richly Decadent in late Victorian style, adapting Oscar Wilde's play and its famous Art Nouveau illustrations by Aubrey Beardsley. Beardsley's illustrations were black and white, but Wilde planned his opening production of the play at the Palace Theatre in 1892 as a synesthetic symphony of color and smells, dressing everyone in yellow but Salome, who was to be either green like a poisonous lizard or naked save for strings of jewels.[152] Wilde's text is replete with synesthetic language, as when Salome describes Jokanaan, sound becoming perfume and vision music: "Thy voice was a censer that scattered strange perfumes, and when I looked on thee I heard a strange music."[153]

Nazimova's film works to adapt these synesthetic motifs not only through its famous composition and design, but also through its use of tinting and Handschiegl, as the 1922 nitrate print preserved at the George Eastman Museum reveals. Primarily tinted in green (perhaps in reference to Wilde's suggestion), the film also contains briefer yellow-, peach-, blue-, and red-tinted sections, as well as brief Handschiegl sequences, largely inserted for stylistic and symbolic effect. For instance, Handschiegl is used on the opening titles and all ensuing shots depicting the Beardsley-inspired image of Herod's castle, positioned atop a cliff where the film takes place. Over green tinting, red Handschiegl is applied pictorially to the castle itself, foreshadowing the bloodshed that is to come (color plate 4.9). This is realized in the pictorial juxtaposition of red and green tints later in the film when Jokaanan's head is severed off-screen. The scene focuses on Salomé's reactions, shifting from a green-tinted long shot of her brandishing a sword and calling for his execution, to a red-tinted shot of an animated moon slowly being covered by clouds, to a longer framed, green-tinted shot of Salomé walking toward the entrance to the dungeon that is intercut with another red-tint of the moon (color plate 4.10). As the dramatic moment passes of Jokaanan's execution off-screen, the shot then shifts back from red to green tinting. These changes in tinting—the most pronounced in the film—occur both for dramatic effect, emphasizing the blood-red moment of execution, and for intermedial emphasis, to evoke the synesthetic aura of Wilde's text using color pictorially to literalize and heighten the composition and its hybrid shifts between photographic action and animated illustrations.

As we have seen before, it is in these hybrid, intermedial moments that color moves to the foreground of filmic style.

Color in the first American film avant-garde both evoked the other arts, as in *Salomé's* post-Victorian Decadent aesthetics, and was entwined with the origins of American art cinema, specifically in the pictorial strain that Kaveh Askari has explored in *Making Movies Into Art*. As Askari delineates, the flowering of artistic thinking about cinema in the United States in the 1910s and 1920s was both intermedial in nature (how films and writings about them looked to the other arts and industry for guidance) and grounded in Arts and Crafts aesthetics (which this chapter has traced in an international context, from the Bauhaus to the Vienna Secession to Art Deco).[154] These connections are evident, for instance, in the highly composed, sculpted, and tinted-and-toned films of Maurice Tourneur, as in *The Blue Bird* (1918), and Rex Ingram, as in *The Four Horsemen of the Apocalypse* (1921) and *The Magician* (1926). Both filmmakers were deeply imbedded in the aesthetic cultures of their day, as Askari has shown. Tourneur had famously studied under August Rodin and Pierre Puvis de Chavannes in France, and Ingram frequently promoted his background studying sculpture at Yale from 1912 to 1913. This initial grounding in the fine arts provided intermedial context and cultural prestige for the art cinema they both went on to produce.

Dudley Murphy's U.S. work can also be situated at the fringes of these more established yet also unconventional Hollywood figures. After he returned from France, Murphy even collaborated with Ingram on *Mare Nostrum* (1926), which Murphy noted in advertisements self-promoting his work, even though the collaboration was not what he had hoped for.[155] Like Ingram, Murphy was deeply rooted in cosmopolitan aesthetic culture. His parents, Caroline Bowles Murphy and Hermann Dudley Murphy, were well-established painters in Boston and founding members of the Winchester Arts and Crafts Society. After his parents' divorce in the 1910s, his mother relocated with him and his sister to Southern California, and it was there, through the Krotona Institute, that Murphy, like so many others in this chapter, came under the occult influence of Theosophy and its theories of color.[156] In the early 1920s, Murphy also spent a month at Dartmouth College collaborating on the development of new camera lenses with Adelbert Ames, the founder of the Dartmouth Eye Institute, which was dedicated to researching physiological optics.[157] As William Moritz has hypothesized, this is quite possibly where Murphy developed his unique kaleidoscopic lens attachment, which he used in *Ballet mécanique* and other films.[158] During this period, through his Theosophical connections, Murphy also met and interacted with Danish artist and inventor Thomas Wilfred, who developed the Clavilux color organ in the 1910s. Murphy described his reaction to Wilfred's color experiments as "one of the most ecstatic experiences of my life."[159]

These various currents of art, science, and the occult run parallel to those affecting many of the European artists already examined in this chapter, particularly in how they inform the use of color in Murphy's cinematic work produced in the early 1920s, before *Ballet mécanique*. Indeed, four of his early films—almost certainly including *Soul of the Cypress* (1920) and *Aphrodite* (1920)—were praised as being "beautifully colored" by Sidney Woodward in the *Boston Post* on September 2, 1920.[160] *Aphrodite* is a lost film (and his first starring Katherine Hawley), but *Soul of the Cypress* is extant. The surviving version derives from Library of Congress print materials, where two versions are preserved, though in black-and-white safety prints. Film historian and curator Bruce Posner made a reconstruction of the material, and retinted and toned the resulting version based on notes from the library's original duplication of the nitrates before they were discarded.[161] The film is lushly tinted orange through most of its first two-thirds and then shifts to an equally rich blue tone and purple tint. The film Romantically recounts a Greek-inspired myth of a musician who falls tragically in love with a beautiful and diaphanously clad tree dryad who is drawn to his music (played by Murphy's first spouse, Chase Herendeen). The dryad's home is a cypress on a cliff above the ocean, and when the musician is unable to possess her, he throws himself off the cliff, so that his song will merge with the sea and be with her forever. Filmed at Point Lobos, along the majestic California coastline near Monterey, the film emulates the style of Pictorialist photography, in particular the work of Anne W. Brigman, who also mystically featured dryad-like women merging into the landscape and trees of the Californian coast.[162] The tints and tones work to bring out these connections, emulating the coloring and spiritualist style of Pictorialist photography draped in painterly hues. Murphy also based the film in part on Claude Debussy's *Prelude to the Afternoon of a Faun*, and the musician in the film was a composer he had meet in Theosophical studies at Krotona.[163]

After producing a few other short films, Murphy formed Visual Symphony Productions with Universal financer Claude Macgowan, and it is likely that Murphy also rereleased his earlier films through the company—one of the film's promoted by the company was "Debussy's *Faun*," which was almost certainly *Soul of the Cypress*.[164] The company aimed to produce short filler films, which exhibitors could use as overtures to begin a screening or to slot in among other musical features. Each would be distributed with an accompanying score for orchestra, to synchronize live sound with moving image. Implicit in Murphy's project was creating a type of Wagnerian total artwork that synesthetically combined the moving images with classical music. As part of this endeavor, color was also integrated into his total vision, at least from the evidence of the surviving films—*Soul of the Cypress*, presuming it was repackaged as a Visual Symphony film, and the company's first production, *Danse Macabre* (1922), which was tinted, toned, and hand colored, as in the nitrate print preserved at the George Eastman Museum.

Danse Macabre was developed around Camille Saint-Saëns' symphonic tone poem of the same title and starred well-known ballet artists and choreographers Adolph Bolm and Ruth Page. The film portrays a young couple who hide in a desolate Spanish castle while fleeing the plague, only to have Death appear personified as a superimposed skeleton with a violin who forces them to dance through the night without sleep if they are to survive. As in *Soul of the Cypress*, the colors of the film are saturated and impressionistic, even as they partially follow tinting and toning conventions of the time. The varying hues register the changing shades of evening, from the opening purple tint at midnight to an amber tint that begins early in the film, mid-shot at the moment the young man lights a candle to illuminate the room he and the woman have just entered in the castle. The amber hue persists throughout most of the film, until the woman begins to pass out from exhaustion, at which point (in a cut-in) the scene shifts to a rich and dramatic blue tone. The man half-wakes her, carrying her to a couch, and the film changes to a light blue tint with sepia toning (much of the light blue tint has faded in these sequences of the nitrate print). As he struggles to wake her, Death dances with joy in superimposition, during cuts back to the rich blue toning. However, as Death is about to claim the woman, the sun rises in an animated shot behind a crowing rooster, and the film cuts to blue toning with pink tinting, which persists through the rest of the film (color plate 4.11). The woman stirs in the man's arms as they realize they have vanquished Death.

Earlier, in the first appearance of Death, he appears as a still, illustrated image in medium close-up, with distinctly red hand-colored eyes. The hand coloring makes the eyes of the otherwise still image quiver in uncanny and deathly fashion. For such a relatively short film of the time, these various coloring effects are relatively elaborate and go beyond conventional diegetic cues (as in the lighting of the candle and the passing of the night) and, like the effect on Death's eyes, add an affective, supernatural layer to the film in keeping with the synesthetic aims of Visual Symphony Productions.

Cinematic color was not a major area of interest for Murphy after he returned to the United States from making *Ballet mécanique*, though racialized color became a core feature of his filmmaking in the African-American-focused works he produced in the late 1920s and 1930s, such as *Black and Tan* (1929) and *The Emperor Jones* (1933). Still, his films from earlier in the decade were received as being in line with the chromatic aura of international art cinema. For instance, Murphy was prominently featured in an article from 1926 on the emergence of the Little Cinema movement, which aimed to create in the United States an alternative exhibition network for past and present international art cinema.[165] The article delineates the emerging vernacular modernist aesthetics of U.S. cinema practices of the time, noting that in Little Cinema, "Chaplin and Harold Lloyd slapsticks are mingled with German expressionist films, and are equally liked"; further, the aim of such international

amalgamations was "uplifting the public taste."[166] This, of course, was not particular to the United States at the time; one could imagine such programming also playing in Herbert Bayer's envisioned abstractly colored "Kinogestaltung" at the Bauhaus. Amid discussions in the article of *L'inhumaine* and *The Cabinet of Dr. Caligari*—chromatic works featured prominently in this chapter—there is a lengthy section on Murphy: "one of the figures in the art-film movement. His revolutionary *Ballet of the Machine* was booed and hissed and laughed at. . . . He is home talent which has absorbed the ideas about modern art that are current in Europe."[167] The article proceeds to quote Murphy noting that his next project will explore New York and bring "the fantastic speed and rhythm of this jazz age into a film." Jazz and rhythm would indeed be the focus of many of his later race films, but in the middle of the decade his work also resonates with the chromatic modernism of F. Scott Fitzgerald and the golden hues of Gatsby's roaring world.

 Ballet mécanique's early history in the United States also attests to this rhythmic context. When the film first screened in the United States, it accompanied the premiere of *L'inhumaine*, on March 14, 1926, at the Klaw Theatre in New York City.[168] Though *New York Times* critic Mordaunt Hall frequently commented on color developments in his reviews, he made no mention of color in *L'inhumaine* in his criticism of the film. However, he did note the use of color in *Ballet mécanique*: "After [*L'inhumaine*] had been shown an even stranger production was put forth in which there was everything from pots and pans to a swinging girl, a glimpse of an amusement park and red circles—a film which would make the most confused effort of a futurist or cubistic artist seem as plain as a pikestaff."[169] Futurist, Cubist, and with red circles: the film is a hallmark of the chromatic modernism of its day. Critic William Reilly also contextualized the film as a "cubist painter's dream," explaining that "Murphy went to work to give his audiences an emotional kick by utilizing the many powerful qualities that the motion picture possesses and which are used only occasionally today. For instance, the power of shock by percussive effects, the power to soothe by fluent effects, the power to excite by dynamic repetition—contrasts—surprise—repetition to the extent of hysteria-rhythmic suspense as opposed to the usual plot suspense."[170] In New York, though, the hysteria produced by the red circles of the Cubist painter also coincided with Murphy's future as a race-film producer. For the Cameo screenings, Murphy explained, "There being no score to accompany the film, I got a Negro drummer from Harlem, who played on drums, tin washpans and washboards, and who would watch the film as he played interpretations in his own far-out manner, to the images which excited him on the screen. The audience at these showings got so excited that they would create near-riots in the theatre."[171]

 This Jazz Age mix of color and cinema surfaces repeatedly during the 1920s and defines the artistic horizon of the decade's chromatic modernity. Just as

classical cinema was solidifying into a medium of its own, modernist experimentation surged in cinema and across the chromatic arts—a phenomenon that challenges the idea that cinema was becoming estranged from other media as it developed its institutional structures. Rather, the nature of intermediality was changing, as cinema absorbed artistic currents into its medial composition, and it is at these junctures that color flourished in film. From Europe to North America and beyond, avant-garde experiments were accompanied by utopian, scientific, and occult thought about the potential of art forms to intermingle and collide. Color cinema was integral to ideas about the arts' ultimate aesthetic synthesis in dynamic movements such as Absolute Film and *Cinéma pur*, as well as in the first American film avant-garde. Color provided these works—which emerged sometimes in dialogue with one another, and in other instances simply irrationally at the same time—with an aesthetic logic and aura of cultural prestige within the field of artistic production.

CHAPTER 5

CHROMATIC HYBRIDITY

Back in the illuminated color space of the city, color is in a constant state of beginning and ending, of switching on and switching off, of being born and dying out. Color comes and goes of its own accord but also in the eye and the mind of its beholder. The slightest turn of the head or the blink of an eye will bring colors into being and will wipe them away. This is color in a constant state of inconstancy, of beginning and ending; it is always there and always changing, and it is never quite there, or quite the same as it was a moment ago.

—David Batchelor, *The Luminous and the Grey*

D avid Batchelor's consideration of color constancy calls attention to the vital mutability inherent in color and the moving image. This pertained especially to the silent era, when a variety of coloring techniques were deployed in individual short and feature films. The 1920s are often characterized as a decade when film color was largely achieved by tinting and toning, along with important examples of stenciling and Handschiegl, as well as experiments in photographic color processes, particularly as the decade progressed, such as two-color Technicolor. But the decade has by and large been viewed as being less distinguished in chromatic terms than the vibrancy of earlier hand-colored and stenciled films, or when

compared to the assertive promotion of three-strip Technicolor in the early 1930s. This chapter will argue that, on the contrary, the 1920s were a crucial decade for film color, demonstrating a wide variety of chromatic experimentation that ranged across various methods and techniques. As we have seen, film was related to broader developments in color technology and aesthetics within a culture that was characterized by chromatic hybridity—a mixing of color styles and techniques. As cities became kaleidoscopic in their color displays, motion pictures and theaters were closely related sites of dynamic experimentation.[1]

The concept of chromatic hybridity provides an important conceptual means of understanding how film colors were being presented in the 1920s. Richard Misek claims that prior to the 1960s "chromatic hybridity required explanation," whereas in the 1960s a trend emerged in which "black-and-white and color sequences alternate apparently at random."[2] Drawing on Raymond Williams's concepts of the dominant, residual, and emergent, Misek argues that in the 1960s "unmotivated chromatic hybridity was an example of emergence. It was a new practice that developed in dialectic response to Hollywood's codification of black-and-white and color, and formed part of a broader rejection of the classical Hollywood paradigm of motivation."[3] While the hybridity of the 1960s was specific and historically defined along the lines that Misek lays out, here we use chromatic hybridity differently, as applied to silent cinema during a decade when the classical paradigm was newly emergent and relatively less established than in subsequent decades. We consider Hollywood and European films that not only juxtapose color and black-and-white but also deploy different coloring techniques within the same film. From this perspective, chromatic hybridity in the 1960s can be related to earlier, residual trends that permitted color to be unruly, not subject to easy codification, an unmotivated attraction within otherwise conventional narratives, and a primary visual address of avant-garde practices.

In our usage, chromatic hybridity in the 1920s generally refers to using a combination of coloring techniques—for example, Handschiegl in tinted and toned films, or the partial use of Technicolor amid other coloring practices—within a single film. Cecil B. DeMille's *The Ten Commandments* (U.S., 1923), for example, was mostly a tinted film with shots filmed in Technicolor of the Israelites in flight, being pursued over the plains. For DeMille, this was something of an experiment: Technicolor offered him the use of a camera; if he liked the footage shot by Ray Rennahan, he could buy it.[4] There was no sense that the combination of color techniques might be problematic or that the Technicolor shots would be considered superior to the tints. DeMille was confident enough to include a relatively new experimental process as part of the film's technical monumentality that was deployed to match its epic subject matter. DeMille next used two-color Technicolor in

King of Kings (1927), an otherwise blue-hued religious epic that also featured hand-colored moonlight effects for the Garden of Gethsemane sequence by Gustav Brock, an important craftsman discussed in more detail later in this chapter and the next. Technicolor was used to illustrate two key scenes occurring at the beginning and end of the film—the feast at the palace of Mary Magdalene and then for the Resurrection. The film thus offered a range of chromatic interest while reflecting DeMille's commitment to visual storytelling. In the 1920s, the idea of psychological realism residing in black-and-white film was not as strongly established as in later decades. The frame of reference for filmic realism during this decade was invariably a color-tinted and -toned one, against which other color effects could be perceived and evaluated. The effect of mixing different ways of coloring within a single film elicited a modernist, abstract sensibility, even in films that were presented as conventional entertainments.

Colorists Discuss Color

Practitioners of applied color were convinced of its role in enhancing film drama through its affective, emotional influences on the spectator. Danish-born hand-coloring expert Gustav Brock worked in the United States on *Foolish Wives* (Erich von Stroheim, 1923), *The White Sister* (Henry King, 1923), *The Navigator* (Buster Keaton, Donald Crisp, 1924), and a number of films starring Marion Davies, including *Little Old New York* (Sidney Olcott, 1923); he continued hand coloring films well into the 1930s, as we discuss in the next chapter.[5] He also hand colored sections of a 16mm print of *Ballet mécanique* (Fernand Léger and Dudley Murphy, France, 1924), donated by Léger in 1939 to the Museum of Modern Art in New York.[6] It is likely that his labors were only seen in first-run theaters, as he had a close working relationship with S. L. "Roxy" Rothafel, who was famous for the prestige cinemas he managed and produced shows for in New York City in the 1920s and 1930s, including the Roxy Theater and Radio City Music Hall.[7]

Brock's well-publicized views on hand coloring as a form of craft labor drew attention to color's effect on spectators' sensorium:

> The greatest advantage of hand-coloring is that it can be applied to the finished production, of which various portions can be enhanced and important contrasts emphasized by coloring. For example, following the players from a frosty outdoor scene into a heated room, the contrast between the two temperatures and the coziness of the room may be strongly emphasized by coloring the flames in the fire-place in the same manner as a Broadway scene at night is very much enhanced by the coloring of the electric signs.[8]

Brock focuses here on color's relation to the senses—that varying hues are capable of suggesting physical sensations of cold and hot through contrast. Although he emphasized that in tinted films additional hand coloring added realism, he also highlighted its ability to create color consciousness among spectators, "because the coloring has made these scenes more outstanding and impresses itself stronger on their mind."[9] From this perspective, color's addition within hybridized forms satisfied the desire for greater realism, while at the same time it drew attention to itself as spectacle by completing, as it were, the suggestion of realism through affective sensation. The stark, punctuating impact of color also depended on its relation to other scenes and backgrounds; for Brock, the step toward color consciousness was intimately dependent on positioning colored images within contrasting contextual frameworks. The "life" brought by hand coloring that Brock describes articulates this idea: "As a rule handcoloring is most successfully added to tinted or toned film or to tinted and toned film and by a close cooperation of the laboratory and the artist. The most beautiful effects can be obtained specially in night scenes and interiors, and add much life to the picture."[10] Again, the emphasis is on the *relative* use of color, rather than undifferentiated chromatic bombardment. Brock further elaborates on this in relation to color's suggestion of skin tones and complexion: "The coloring of a picture is like the touch of color on a girl's face; it can enhance if judiciously used, and its effectiveness, beauty, and force rest with its restriction."[11] This emphasis on the creation of subtle, yet gendered, tactile and impressive (note the use of the word "force") effects through the selective application of color is a key idea in Brock's case for hybridized forms as a means of creating affective impressions on spectators' consciousness.

Debates about the impact of tinting and toning also provide insight into contemporaneous ideas about psychological and cultural responses to color. Native American producer, director, actor, and screenwriter Edwin Carewe argued in 1922 that tinting and toning add "class," eliciting a "quick, warm response" when natural features such as sky are colored.[12] Carewe argued that colors make films "talk," particularly when used selectively: "A little tinting accentuates the beauty and quickens the imagination . . . too much is monotonous, I am using colored film only where I think it most effective . . . where I wish to lay stress on the power of melody over the emotions of mankind."[13] The language used here is interesting for its allusion to music, indicating an additional affective register created by color that operated alongside, or over, the imperatives of narrative.

We can observe such contrasting tints used for emotional affect in *Smouldering Fires* (Clarence Brown, Charles Dorian, U.S., 1925). Tints in the film convey a shift of mood when the opulent interiors of a grand house are first seen in amber tints and subsequently infused with a violet tint for a fireside scene, introducing a romantic theme (color plates 5.1 and 5.2). A violet-tinted fantasy sequence from the heroine's perspective of a romantic cruise with her

would-be lover is inserted into the scene, before the return to normality is signaled by amber. Later, when the heroine starts to lose confidence in holding onto her younger husband, a dancing scene is unusually tinted red, apparently to evoke the heightened emotions of the scene. Brown's deployment of color to enhance mood anticipates Loyd Jones's theories on the artistic potential of tinted stock, as developed at Kodak. In his consideration of the Sonochrome tint "purplehaze," for example, "a bluish-violet or lavender, rather pastel in character," Jones observes:

> The mood induced by this color is particularly dependent (more so than many of the other colors) upon contextual factors. For instance, to a twilight scene on the desert with distant mountains it imparts a feeling of distance, mystery, repose, and languorous warmth; used on a scene containing snow fields, glaciers, snow-capped mountains, etc., it has a pronounced cooling effect.[14]

In this way, colors are dependent on judicious application rather than an overt sense of rigid convention, as noted by British color specialist Colin Bennett.[15]

The color of fires and flames is another topic that generated discussion in the trade press. For tinting, it was a long-held, commonplace assumption that bright scarlet was the color to use for scenes featuring a conflagration of fire or even for scenes with smoke indicating a fire, as used in *London's Free Shows* (Harry B. Parkinson, Frank Miller, UK, 1924), an otherwise sepia-toned travelogue shown as part of a varied film program. Bennett argued in 1923, however, that tinting and toning could only reproduce "a mental impression that in the main conveys something of the idea aimed at" rather than true realism, since "flames of fire do not really burn bright scarlet red. The color of them is slightly orange yellow."[16] This generated further debate in the *Kinematograph Weekly* when "a Layman" complained about how the red used for fire in a film he had seen was too vivid and crude, neglecting to convey the orange, even bluish color of flames he observed in real fires.[17] Somewhat accidentally, yet perhaps resourcefully on the part of James Stuart Blackton, convincing fire effects were achieved in *The Glorious Adventure* (UK, 1922). Blackton used Prizmacolor, a recently developed two-color subtractive process that had a tendency toward "fringing," in which moving objects left a color trail behind them. The film's drama climaxes with the Great Fire of London, in which the flames and light are particularly effective, appearing as dynamic, flickering shades of orange and red, often shown through doorways and windows. In this respect, any indication of fringing does not matter, as the vitality of the flames and their changing hues are enhanced by the visual sensation of movement.[18]

In the main, flames were thought best rendered using color effects that could also capture their visual dynamism. Arnold Hansen was an artist hired by Columbia Pictures in 1925 to hand color inserts for a number of their

productions, including *Fighting the Flames* (B. Reeves Eason, U.S., 1925), *The Danger Signal* (Erle C. Kenton, U.S., 1925), and *The Unwritten Law* (Edward J. LeSaint, U.S., 1925). In *Fighting the Flames*, scenes of flames were colored for a dramatic rescue sequence. The fascination with fire in these films recalls amusement park attractions such as Luna Park, Coney Island's "Fire and Flames" disaster exhibit in which live performers enacted thrilling fire and res-cue spectacles.[19] Hand-colored fire sequences in the 1920s pick up on this inter-medial tradition by heightening excitement at strategic points in the films. *The Fire Brigade* (William Nigh, U.S., 1926) features a costume party sequence in Technicolor No. 3 (subtractive two-color, dye-transfer), but its climactic scene of burning flames was reserved for dramatic orange and red tints combined with the Handschiegl process (color plate 5.3). Indeed, Gustav Brock argued that hand coloring was perfect for dramatizing fire effects, particularly when used against otherwise black-and-white film, in keeping with his conception of the relative power of color referred to above. For Brock, "true realism" was the result, making a great impression on the audience by instilling color con-sciousness through varied chromatic effects.[20] As detailed below, Handschiegl represented a high point of the hand-coloring craft, with its ability to convey a particularly intense, tactile experience of chromatic depth and form that real-ized the artistic and conceptual ambitions of its skilled practitioners.

Handschiegl/Wyckoff Chromatic Effects in *The Phantom of the Opera*

Impressive effects could be achieved using the Handschiegl/Wyckoff process, as in *Wings* (William A. Wellman, Harry d'Abbadie d'Arrast, U.S., 1927), where it was applied for shots of aerial combat featuring orange, explosive gunfire from planes and the fiery flame trails from successfully targeted planes as they crash to the ground (color plate 5.4). The color effects enabled the damaged planes to appear chased by a subtle flickering orange mixed with black to capture their fatal downward-spiraling velocity. The process was initially conceived by Max Handschiegl, a craftsman from St. Louis who specialized in lithography and photoengraving, and he collaborated with Cecil B. DeMille, Alvin Wyckoff, and Loren Taylor to develop the coloring process.[21] Handschiegl was used in a number of motion pictures between 1916 and 1927, by itself or often intermixed with other coloring processes, such as Technicolor, tinting, and toning. The process was complex and labor intensive, developed as it was from the chromo-lithographic process but on a miniature scale. Dye-transfer printing matrices were prepared for each color to be applied in a sequence. The matrices were developed from duplicate negatives, and each section to be colored was chem-ically treated to absorb dye. Once prepared, the matrix would then be pressed

in registered alignment against the final, positive print of the film to transfer the dye to the print.[22] Handschiegl arrests and appears to punctuate an image, attesting to its intermedial heritage, with its emphatic, engraved appearance almost appearing to halt a drama's narrative progress. Other high-profile films that used Handschiegl include *Joan, the Woman* (Cecil B. DeMille, U.S., 1916, the first film showcasing the process), *The Affairs of Anatol* (Cecil B. DeMille, U.S., 1921, discussed in chapter 2), *Greed* (Erich von Stroheim, US, 1924, featuring 185 shots of golden props, such as a tooth and coins), *The Big Parade* (King Vidor, U.S., 1925), *The Lights of Old Broadway* (Monta Bell, U.S., 1925), and *The Phantom of the Opera* (Rupert Julian, U.S., 1925).

In keeping with its arresting quality, Handschiegl was used strategically to enhance the effect of particular shots rather than for an entire film. This was in part because it was such a labor intensive, expensive process, but also because it was thought that using too much of it would distract from the narrative. However, it could be used to announce significant, dramatic moments in a film drama. While the rationale for selective application to achieve maximum visual impact is in keeping with the views of hand colorists such as Brock and Carewe, with Handschiegl the impression of crafted quality is especially heightened. As a punctuated effect, Handschiegl represents the epitome of both intermedial and hybridized color. As Paolo Cherchi Usai observes:

> The Handschiegl image has the look of early films, but its pastel colors have a much greater transparency and a subtler texture, which gives an atmospheric quality to the scene. While direct coloring appears as imposed upon the objects represented, like a lacquer overlay altering contrast values and drastically weakening detail, this system seems to coexist well with the photographic image, and to endow it with a liquid softness that is almost tactile.[23]

In *The Phantom of the Opera*, for example, shots of the Phantom's red cape colored by the Handschiegl process, as seen when he is atop the opera house, were able to emphasize color value and saturation to great effect.

This film also includes a Technicolor sequence in which the Phantom's sumptuous red cape is first presented as an impressive chromatic effect. In this way, the cloak's redness, presented via different yet mutually supportive color techniques, acquired an emphatic presence, which was also used extensively for a tie-in campaign for the hue "Phantom red," as discussed in chapter 2. Two-color Technicolor was similarly imbricated with a hybrid color aesthetic, which is strikingly evident in its use in *The Phantom of the Opera* among other coloring methods. The film combined various color styles and techniques, including tinting throughout most of the film, toning, Handschiegl, and Technicolor's first subtractive two-color process, Technicolor No. 2, used for the Bal Masqué de l'Opera sequence and other scenes that are now lost. The Bal

Masqué sequence was originally planned in Prizmacolor, but Technicolor was able to win over Carl Laemmle, the head of Universal, for the final contract.[24] Several versions of the film have been preserved, including one with sound; the most complete version is Kevin Brownlow and David Gill's 1996 reconstruction through Photoplay Productions. Brownlow and Gill drew primarily from a George Eastman Museum–preserved safety copy of a 1930 international release print. However, for the Technicolor sequences, they used a separate nitrate copy discovered by David Shepard from the 1929–1930 rerelease; this material, though shot in Technicolor No. 2, was reprinted in 1929 through the company's imbibition, dye-transfer process, Technicolor No. 3.[25]

The surviving Technicolor footage is stylistically powerful in the Bal Masqué scene, which occurs approximately forty-nine minutes into the film and is broken into two sequences, the first of which lasts four minutes and the second one minute, separated by a four-and-a-half minute sequence on top of the opera house.[26] Given that the Technicolor scenes are preceded entirely by tinted scenes, at least as preserved, a more intricate color look is immediately signaled at the beginning of the scene, first through the Technicolor title card announcing the Bal Masqué in two-color flourishes of reds and greens, and then by the ensuing shots of the grand staircase of the theater's foyer. Beginning with a dramatic extreme long shot that tilts down to showcase the grandeur of the staircase, the scene is populated with rushing, masked figures dressed in red, black, and green-accented costumes. Closer shots allow fuller appreciation of the costumes as the crowd—caught in a frenzy of excitement as the disguised try to identify each other—appears to be waiting for something momentous to happen. The title, "Into the midst of the revelry, strode a spectral figure, robed in red," cues what is to come. The people make way as a figure—the Phantom, unknown to the revelers—descends the stairs, and a medium cut-in permits full sight of his red costume, black and red-plumed hat, and skeletal-masked face. To complete this terrifying appearance, a contrasting green cane held by the Phantom is topped by a small skull being pecked by a bird's beak. The contrast between the gray death's-head visage and the bright red costume is striking, revealing Technicolor in a richly layered image that connotes opera, theatre, melodrama, and horror all at once (color plate 5.5).

The Photoplay reconstruction also illustrates tinting effects for particularly atmospheric scenes, such as the Phantom's shadow in purple (keyed throughout the film to backstage and underground scenes) as he manipulates the chandelier high above the stage, as it shakes, falls, and sabotages the performance twenty-five minutes into the film. Later, this version of the film displays shots of the Phantom in his red cloak, on the roof of the opera house, that were originally achieved by the Handschiegl color process, though Brownlow and Gill have again reconstructed this footage through colorization. The Handschiegl shots are in the middle of the Technicolor sequences, and this time the

Phantom's deep red cloak is foregrounded against a blue-toned background for maximum impact, drawing attention to the depth of color achievable with the Handschiegl process (color plate 5.6).

The prevalence of color hybridity meant that *The Phantom of the Opera's* layered, almost painterly look invited audiences to appreciate its textures and distinguish new developments in color technology. Introducing Technicolor and Handschiegl to punctuate particularly dramatic moments had a double impact, both as announcing key narrative moments and as impressive color spectacles with broad associations. The concentration of red invited the audience to relish chromatic density and, particularly with Handschiegl, a deeply textured saturation. As we saw in chapter 2, the film inspired the U.S. Textile Color Card Association to develop "Phantom red," a new shade that adorned numerous products, including shoes, lipstick, bags, hats, slippers, and gowns. The trade press reported, "*Phantom Red* Becomes the Rage," as commercial tie-ins accompanied the film's exhibition in the United States and beyond. In this way, the film image was far from being closed off from other medial influences. As the Handschiegl shots attract the eye to experience textures and a tactile sense of color, at the same time the effect is redolent of other media, drawing the viewer both inward and outward as color hybridity invites comparison with paintings, with clothing, with stage sets, and with opera. This exemplifies a central idea of intermediality—that "within a single text of a particular medium, attention can be called to the artifice of that medium by re-creating (or attempting to re-create), referencing, imitating, or evoking the sense of another distinct medium."[27]

As a text, *The Phantom of the Opera* also has a profoundly intermedial heritage, first published as a popular French serial written by Gaston Leroux in the newspaper *Le Galois* in 1909–1910, and then collected and revised as a novel in 1910. The film adaptation was very much a vehicle for actor Lon Chaney, who had starred in a similar role as Quasimodo in *The Hunchback of Notre Dame* (Wallace Worsley, U.S., 1923), and the monumental theatricality of the sets is central to the appeal of both films. The first screenings further exploited this theme with elaborate, theatrically inspired presentations that unleashed the drama of the story as soon as patrons entered the theater. In the Astor Theatre, New York, for example, an effigy of the Phantom, dressed in red robes, occupied a niche over the entrance. A report notes: "His skeleton face grinning at the throng below sent cold shivers up and down the spines of those who caught sight of him for the first time."[28] The screening was preceded by a ballet performance adapted from *Faust*, after which the magician Thurston appeared as the Phantom to heighten suspense for the film presentation. In addition, the ushers were in character, wearing red robes to match the Phantom's costume, their faces partially hidden by masks. Color in the film was also central to the film's appeal, according to the same report: "The first showing of the gorgeous,

natural color sets of the great Paris Opera House . . . and the celebrated masked ball, a kaleidoscopic riot of color, drew cries of astonishment and wonder."[29] In this way, the film's different chromatic modes and sensibilities underscored the vitality of its public presentation as a hybrid, multimedia experience that resonated with audiences beyond a single viewing. Indeed, the subsequent exploitation of Phantom-related products such as lipstick and fabrics is also testament to the film's outward-facing and sustained commercial appeal as much more than a stand-alone motion picture.

Intermediality and *The Lodger*

A single, identifiable aesthetic signature was not always evident in color films of the 1920s, arising as they did from diverse intermedial cultures. What was often deployed was a mediated, multiple application of color that imported conventions and techniques already in use in other fields. Once again, color style demonstrates a great degree of hybridity, even when new processes were being showcased. Although Blackton's *The Glorious Adventure* (1922) demonstrates Prizmacolor as a new subtractive process, the film also encompasses approaches to color associated with tinting, toning, and stenciling. So, while Prizma is the technical "star" of the film, aesthetic approaches derived from applied coloring persist. The set of the "Golden Swan" ship in the film, for example, provides an occasion for an establishing shot with the ship on the horizon framed against the deep blue sea and red clouds (color plate 5.7). The almost translucent qualities of the shot are an example of the lantern-like, stained-glass color effect of Prizmacolor, which stands out as visually striking in ways similar to Pathécolor stenciling of the 1910s.[30] Such signature shots alert one to the fact that color was still an attraction that drew on earlier color films seen by audiences. This eclectic, occasionally spectacular approach affected tinting and toning style as well: far from being a mere backdrop, tinting and toning could be vibrant. The tints of the reconstructed *Das Weib des Pharao* (*The Loves of Pharaoh*, Ernst Lubitsch, Germany, 1921), for example, are strikingly varied and saturated, as was typical of the period (color plate 5.8).

The increasingly prismatic environment of modern cities was reflected in films, and tinting and toning functioned as appropriate affective registers of this transformation. Far from being a crude addition to a codified scheme, on occasion tinting could relate to a film's broad modernist themes. A striking example of elaborate interior and exterior color design from the 1920s is *The Lodger: A Story of the London Fog* (Alfred Hitchcock, UK, 1926). Color underscores a design that unsettles the idea that the interior of one's home can be safely insulated from contemporary developments. The film uses tinting and toning to associate color primarily with exteriors, modernity, fear, and the

unknown. The narrative raises suspicions that a lodger (Ivor Novello) living in a large Victorian London house might be a serial killer of young women on London's streets, one who stabs them and leaves behind a triangular piece of paper signed by "The Avenger." The film has deeply intermedial origins, as is well known, in Marie Belloc Lowndes's popular novel of the same name (1913) and in a stage adaptation by H. A. Vachell, *Who Is He?*, which Hitchcock saw in 1915. It is also indebted to Hitchcock's experiences in Germany in the 1920s, particularly his familiarity with set-design techniques steeped in modernist theatricality. British crime fiction inspired the "internationally circulating visual vocabulary for London" that is replicated in *The Lodger*, as in German films of the 1920s, including Paul Leni's *Das Wachsfigurenkabinett* (*Waxworks*, 1923), and later films such as Hans Steinhoff's Anglo-German coproduction *Nachtgestalten* (*The Alley Cat*, 1929) and E. A. Dupont's *Piccadilly* (UK, 1929).[31] *The Lodger* betrays these influences in its exteriors and interiors, from London's dark streets to the studio construction of a three-sided house with narrow walls and ceilings that facilitate varied lighting effects and the glass ceiling constructed to visualize the novel's anxiety caused by the unsettling sound of the lodger pacing back and forth in his room. British cinema of the 1920s, as Christine Gledhill has noted, was steeped in a "pictorial-theatrical-narrative mode" that involved adapting theatrical staging and pictorial imaging to the needs of narrative cinema.[32] Such a convergence of media and cultural traditions was integral to Hitchcock's early films. At the same time, his experiences filming in Babelsberg Studios, Berlin, in 1924 brought him into contact both with F. W. Murnau, a director profoundly influenced by the theater and lighting designs of Max Reinhardt, and with cinematographer Baron Ventimiglia, who shot *The Lodger* with such luminary precision.

The company Deluxe 142 worked on the British Film Institute's restoration in 2012. Since the negative no longer exists, the sources for the digital restoration were nitrate prints dating back to the 1940s. Colorist Stephen Bearman worked to replicate the iron blue tone and amber tints that are so important for the film's color scheme: the combination of the two colors for exteriors sought to produce "an effect similar to that of the old London pea-soup fogs, the 'London particular' the scenes were intended to represent."[33] At the same time, these hues are also used to delineate spatial boundaries between interiors and exteriors. The "blue for night" coloring is invested with associations that go beyond realistic replication. Rather, iron blue toning underscores the film's broader theme of encroaching modernity by representing city life as being prone to coldness, to social isolation, darkness, and danger.

The film also uses spatiality to underscore the conflicts of modernity by delineating different, conflicting time frames present in its décor: the interiors of the house are decorated from an earlier, Victorian era even though the film's narrative takes place in the 1920s. Its large rooms with high ceilings are cluttered

with bric-a-brac, candelabras, flowers, ornaments, and pictures, all tinted warm amber. The outside world, however, is full of suspense, the unknown, and danger; it is dominated by the cold, iron blue toning, which not only forms a contrast with the safe, amber interior of the house, but by dual processing the blue tone with amber tinting, also problematizes the safe warmth of the interior. The film's opening accords with this scheme: after elaborately animated opening titles that are tinted amber and toned blue, a close-up of the face of a terrified and screaming curly-haired woman fades in as she is about to be murdered (color plate 5.9). The tinting and toning replicate the amber and blue title cards that both precede and follow the shot. The preceding title card is an animated frame that splits into triangular shards to reveal the film's iconic image of a man in trench coat and hat, toned blue against an amber background. The following animated title card continues the amber and blue scheme, depicting a pulsating amber sign that reads "To-Night Golden Curls." Complexly, the montage of the two titles and shot in the middle presents the presumed murderer, his victim, and the outcome: tonight, the woman with golden-amber curls has been murdered. The ensuing shot confirms this—her stilled body collapsed on the ground in a dramatic foreshortened low angle shot, with abstract city lights in the background, still in the dramatic amber and blue tinted and toned color scheme. The amber "gold" tint with the blue tone thus provides a key linkage across the cuts, particularly from the victim's curls to the curls of the sign.

The film's distinctive titles were by E. McKnight Kauffer, a painter and poster designer who developed an avant-garde graphic style, working also with artists such as Wyndham Lewis and T. S. Eliot. The particular, pulsating title about golden curls is emblematic of the way the film's thematic concerns are underscored by color. Indeed, there are close associations between color, artificial light, modernity, and the sexualized nighttime blue world of showgirls. Throughout the film, the amber-tinted interiors of the house appear to separate it from the dangers associated with the city, most often coded with blue. The irony of this is that the house may not be a safe haven—from another time and out of danger—because the lodger might very well be the killer, as he is set up to be through the film's staging and *mise-en-scène*.

The location of a lodging-house in a modern city indeed further problematizes the demarcation between exterior and interior that the film's color system initially encourages us to believe. As Murray Pomerance points out regarding the film, "in modernity . . . just as exteriors come inside, so interiors are exteriors."[34] When Daisy and the lodger are outside in the dark, illuminated under a streetlight whose effect is shown by an amber tint against a blue tone, the all-pervasive blue surrounding them serves to emphasize their isolation as vulnerable innocents in the dangerous city. Color is used for a nightmare sequence when the policeman's growing suspicions are shown: amber-tinted objects such as the lodger's bag and the quivering ceiling lights as he paces

above are superimposed against a blue background to visualize his worst fears. Blue is used to support the dramatic narrative most obtrusively toward the end of the film when an angry crowd frantically turns into a lynch mob and chases the lodger, who they think is the murderer. In this way, the film's color supports an interior-exterior schema that works toward symbolizing the colliding worlds of the time, just as the color wave emphasized change and the unexpected. The intermingling of colors, media, and spatiality in *The Lodger* is an important indicator of cinema's multiplicity and centrifugal connotations. Gustav Brock's remarks on the impact of contrasting tints quoted earlier in this chapter are indeed exceeded by Hitchcock's complex use of tinting.

Color and French Historical Cinema

Color hybridity lends itself to particular generic themes, as seen from the varied examples of *The Ten Commandments*, *The Glorious Adventure*, and *The Phantom of the Opera*, all of which are costume dramas of varying historical reference. French historical cinema also demonstrated a range of hybrid color effects, often to enhance the gravity of their monumental canvasses and to draw attention to their status as quality cinema. It is striking how, within well-known historical narratives, a variety of color effects were considered to be appropriate for underscoring dramatic high points, while also invoking a painterly, tactile sensibility. Color effects in these films often emphasized chromatic differentiation, with hybrid techniques providing a variety of palettes, textures, and styles. There was no question of a film's color going relatively unnoticed; rather, hybridity added visual pleasure and pictorial embellishment, often alluding to established iconography. Tinting could be supplemented by Pathé's stencil color, as in *Cirano di Bergerac* (Augusto Genina, France/Italy, 1923/1925), *Michel Strogoff* (Viktor Tourjansky, France/Germany, 1926), and *Casanova* (Alexandre Volkoff, France, 1927). In *Cirano di Bergerac*, the addition of stencil color gives the film a precise, painterly look, especially for the seventeenth-century settings and costumes. The precision that was possible with stenciling—undertaken by printing colored stencils onto 35mm film on a frame-by-frame and color-by-color basis—enabled the images not only to render specific colors but also to convey a material sense of fabrics, patterns on shirts and skirts, and intricate details such as feathery plumes on hats, white ruffs, or shoe buckles. Stenciled frames could also give the impression of depth, with objects in the foreground sharply separated from those further back in the shot, as if each detail was an important addition to the overall spectacle, layer by layer. The scenes early on in *Cirano di Bergerac*, for example, show people in Paris trying on hats and bustling crowds watching street performers, before the central players are introduced. Setting the scene is thus an elaborate, visually

striking performance to convey both historical verisimilitude and spectacle (color plate 5.10).

This was also the case in *Michel Strogoff*, in which stenciling was used to heighten the drama of two sequences: the opening court grand ball and scenes of the Tartar encampment. The latter, a festival at which the captured Strogoff (the luminous Ivan Mosjoukine) is blinded, provides the occasion for elaborate stenciling (color plate 5.11).[35] Similarly, in *Casanova*, stenciling was used for the Carnival festivities and to embellish sets and costumes, particularly those worn by Catherine II (Suzanne Bianchetti), including "a magnificent dark blue cloak emblazoned with the czar's gold emblem," and the red, pink and black satin harlequin costume worn in Venice by Casanova (Mosjoukine, color plate 5.12).[36] The Carnival sequence's beautiful effects included fireworks and magnificent gondolas festooned with balloons, leaving trails of color behind them as they glided through the water. Color was thus an integral part of the appeal and attraction of these historical, Russian-shaped films that were prized for their visual magnificence and reputation as quality, prestige cinema.

In many ways, Abel Gance's epic *Napoléon* (1927) represented the apotheosis of French cinema's technical ambitions, complete with expressive tinting and toning, as discussed in the introduction to this book. Gance, in collaboration with Segundo de Chomón, even filmed a reel in the Keller-Dorian photographic color process, but ultimately this was cut from the final edit. As Kevin Brownlow explains, the original prints were toned in five separate colors, though with some versions also in black and white. The 2000 film restoration completed by Brownlow and Gill attempted to re-create the original colors, but as Brownlow explains, "we have still not managed to get the print to look exactly the same. We have been unable to reproduce the blue tone-pink accurately."[37] For the digital restoration of 2016, the tinted and toned colors were reproduced more accurately, with many stunning effects, such as in Act One when light amber tones appear strategically after a succession of black-and-white scenes. The light amber replicates shafts of golden light shining through the window of the great hall of the Club des Cordeliers when the revolutionary crowds hear "La Marseillaise" for the first time. The top of the set, designed by Alexandre Benois, was painted on glass, thus adding even more impact to the luminosity of the shots. Color, light, and music combine to convey the crowd being swept away, as if in a trance.[38] When the mob's fervor escalates into violence, a flagrant pink tone is used as a dramatic backdrop that accentuates the constellation of angry, jostling bodies and flickering shadows, as Napoleon watches from a rooftop attic. After shifting back to sepia for scenes of the National Assembly, the intertitle "The Revolution is a Furnace" is followed by a deep red tint that graphically matches the sentiment. Then Corsica blue-tone, pink-tint shots, which Brownlow refers to, convey in their restored form the beauty of the ocean with the sun glistening on waves (color plate 5.13). In this way, Napoleon's

Figure 5.1 A composite tryptic image in *Napoléon* (1927).

rise to power is underscored by chromatic choices that punctuate his watching and waiting for greatness. In Act Two, green tints are used for the murder of Marat, and the action then shifts to amber for the first scenes of the Siege of Toulon. Color here punctuates the narrative development, as when the English commander's confidence in his fleet necessitates an intercut shot of the ships waiting offshore in a blue-green tint. A blue-tone, pink-tint combination is then used again for the preparations for battle, and this changes dramatically to red when Napoleon orders the canons to be fired and battle commences. While the red expresses the gravity of the conflict, it also serves a practical purpose by highlighting action that took place in poor light and wet weather conditions. To some extent, this made up for the poor illumination provided by the arc lights used in filming. Tinting and toning are then used for the conclusion of this episode, Napoleon's first military victory, as if the chromatic register is heightened to convey its significance.

In the film's fourth act, contrasting tints are used to enhance the impact of a key scene when Napoleon is alone in the National Assembly hall and he sees the spirits of those who set the French Revolution in motion. A blue tone is used for this nighttime scene, but when Napoleon looks to the seating area, we see from his viewpoint the ghostly figures slowly appearing, shown in an amber tint (color plates 5.14 and 5.15). As the shots cut between Napoleon and the figures, the tints alternate from blue to amber, as we understand that he is being urged to lead France to spread the ideals of the Revolution to the rest of Europe. As we noted in the introduction, the film's final images—a succession of widescreen frames, consisting of three triple-projected images placed side by side—encapsulate the importance of color to the film's artistry. In some of the frames a tricolor effect for the French flag is created across a single screen: blue, black-and-white, and red. Expanding to a tryptic of images accentuates the three colors' relative impacts as they contrast with one another. The three shots are at times synchronized to create a single composite image, but in

other instances they show different, juxtaposed battle scenes, time frames, and symbolic imagery, such as an eagle's head contrasted with shots of Napoleon, marching soldiers, mathematical equations, and the rushing sea (color plate 0.1). As the sequence climaxes, the frames create a kaleidoscopic effect of superimposed images, punctuated by Napoleon in close-up. The succession of tricolor images works as a quick montage summary of his triumph; it is an avant-garde flourish at the end of the film that graphically encapsulates the sum of its heroic sentiment through an aura of historical monumentality. While *Napoléon* is excessive in its total scope when compared to most silent films, it is significant that its extraordinary technical ambitions included color. The multitude of its effects, including triptych sequences, rapid cutting, and audacious swirling camera movements, are impressive enough, yet the strategic chromatic tinting and toning scheme wields profound visual and emotional resonance when added into the mix.

Color Hybridity in *Lonesome*

With the use of Handschiegl and various photographic color processes in the United States and elaborate color schemes for tinting, toning, and stenciling in French historical dramas, color in narrative films was largely associated with prestige, quality filmmaking through much of the decade. Hungarian-born Paul Fejos was notable for his experimental, European-styled approaches to late silent American cinema. As noted in chapter 3, his first studio film, *Lonesome* (U.S., 1928) for Universal, is distinguished by its chromatic hybridity through the three tinted, stenciled, and hand-colored sequences that are used to embellish the Coney Island scenes that comprise the middle of the film. These sequences are relatively unusual for U.S. productions of the time, as they present the three most common forms of applied color relatively late in the decade, when the foci of technological innovation had shifted to subtractive color and sound. Previously, we have analyzed the film's intermedial connections, from brightly colored illustrations in children's fairytale books to the increasing ubiquity of colored, neon advertising signs in cities.[39] In doing so, *Lonesome* both celebrates and critiques modernity by drawing attention to color's mutability in terms of both affect and meaning. Its use of hybrid color provided an ideal reflection of the film's complex meditation on the need to foster strong human connections against the monotonous, alienating effects of urban life, as critiqued by Siegfried Kracauer in a review of the film.[40]

The colored sequences pull the film spectator into a vivid, reflexive experience of the modern world depicted in the film. Color is used to create sensory impact when the film's central couple, Jim and Mary, escape the drudgery of their daily lives and meet on a trip to Coney Island during a public holiday.

The first color sequence—just as their romance begins to flourish during a long conversation on the beach—involves tinting and then stenciling that dynamizes the emotional register of the scene. The couple's excitement is matched by pulsating neon lights at the amusement park that dissolve over them, rendered through stencil coloring against the dark night sky (color plate 5.16). The impact of this neon spectacle is all the more impressive because it appears as a temporary attraction, with the film reverting to black and white when the sequence is over. The film's second colored sequence also involves stenciling, combined with toning for a music-hall setting that combines color, music, and dancing as forms of synesthetic illumination for both the characters and the audience. As we have elaborated elsewhere:

> As the crowd in the film moves within the warm, colored glow of the "Dancing" sign, the ambient light of the film's projection reflects off the screen and into the crowd in the theater (a reflection doubled by the camera movement). The synaesthetic illuminations that saturate the collective of the dance hall in *Lonesome* can also be read as reflexively enveloping the theater audience, expanding the colored abstraction of Coney Island into the cinema space.[41]

Finally, the film's last color sequence is hand colored in reddish-orange to create burning flame effects as disaster strikes at the fairground. No longer experienced as a site of visual play and chromatic dynamism, the accident "calls attention to the disastrous potentials harbored by modern technologies."[42] As befitting the earliest of coloring methods—hand coloring—the sequence reminds the audience of what is at stake in technological progress, as red unambiguously signals danger.

Experiments with Photographic Color, Prizmacolor, and Technicolor

The development of photographic color occurred throughout the 1920s, alongside uses of tinting and toning, and instances of standout color effects such as hand painting, stenciling, and Handschiegl. Although it is tempting to interpret the decade as one in which the foundations of Technicolor's future market domination were firmly laid, due acknowledgment must be accorded to the persistence of applied modes during a period when many critiqued "natural color" as deficient. A recurrent technical problem with processes such as Prizmacolor and Claude Friese-Greene's Natural Colour was fringing, when colors appeared to "bleed" with movement across successive frames, as discussed earlier with regard to *The Glorious Adventure*. The resultant flickering occurred because the frames were taken successively and were therefore not

identical. As a result, directors would often try to avoid quick-paced scenes, opting instead for creating pictorial effects, as in Friese-Greene's popular travelogue *The Open Road* (UK, 1925). While the travelogue was an appropriate genre to showcase colorful shots of breathtaking natural scenery, on the whole, fringing, or even the obtrusive avoidance of it, created problems for the acceptance of new, photographically created methods (color plate 5.17).

When Charles Urban saw Prizmacolor demonstrated in 1916, for example, he reported that the films were shot in such a way as to conceal fringing, often avoiding movement or restricting it to action either toward or away from the lens:

> The most severe test which can be applied to any color process known is to march a body of red-coloured soldiers across the lens of an ordinary march step and reproduce the same without excessive color fringing. . . . Referring directly to the Prizma exhibit which I saw yesterday afternoon, the photographer has been exceedingly careful in his selection of subjects, both as to color, harmony, lack of action, and insistence on distance. . . . The portraits of beautiful ladies were most pleasing, only the slightest movements of the hands, body, eyes, and facial muscles were discernible. If one of those ladies started to raise her hand, the moment the hand began to raise [*sic*] the picture ended abruptly, and any movement close-up in these pictures, as recorded by Prizma methods, would have occasioned very extreme fringing. All of the pictures taken showed action either to or from the lens, at a calculated distance, to the sacrifice of distinctness and detail.[43]

This report is significant because Urban was particularly sensitive to the defects it describes, given his expertise. Urban's attempts to develop Kinemacolor ten years earlier were similarly fraught with fringing issues.[44] Prizma was unable to sustain further momentum after Blackton's chromatic experiments with *The Glorious Adventure* were only partially followed up in *The Virgin Queen* (UK, 1923). Blackton returned to the United States, and Prizma's Jersey-based laboratories did not move with the rest of the film industry to Hollywood. Claude Friese-Greene's travelogue was similarly plagued with fringing, and the film was often shown at the wrong projection speed so that its pictorial virtues were lost on the harsh critics of the trade press. Friese-Greene did not continue to experiment with color, reflecting later that the only viable way forward was color values being "embedded in the emulsion," as in the subtractive approach being developed by Technicolor and others.[45]

For any photographic color process to gain acceptance, fringing had to be overcome—something that was eventually achieved by Technicolor, but only after considerable experimentation. Technicolor grappled with considerable technical difficulties in developing its early systems, particularly problems

with implementing its complex subtractive techniques, both the glued and dyed print method of Technicolor No. 2 and the imbibition printing process of No. 3.[46] Photographic color continued to be an expensive choice for filmmakers, so the tendency was to use it for spectacle, exotic scenes, or the embellishment of quality historical dramas, which detracted from how it might be used for more everyday scenes. A key issue was the frequently made claim that photographic color processes were capable of reproducing greater chromatic realism than applied coloring techniques. Realism is, of course, a loaded term; as we have seen, hand colorists such as Gustav Brock used it inclusively, to demonstrate how a color could convey the impression of tactile sensations in addition to appealing to notions of verisimilitude. But with reference to photographic color processes, invoking realism tended to serve as a rather limited rhetorical position to differentiate them from tinting, toning, and other applied color forms. This inevitably set up expectations that disappointed viewers, particularly when green and red two-color registers failed to deliver the full range of the visible spectrum, detracting from the wonder of color as sensational effect.

Two-color Technicolor had problems, for example, rendering blue and yellow. This deficiency appeared in films that perhaps mistakenly promoted a color that the process had difficulty reproducing. In *Irene* (Alfred E. Green, U.S., 1926), a fashion show sequence in Technicolor No. 2 featured the film's star, Colleen Moore, wearing an "Alice blue gown," as discussed in detail in chapter 2. But when the best that Technicolor No. 2 could deliver in *Irene* was pale green, the problems of using specifically named colors on-screen became apparent. Moore later stated in an interview, "I had a sweet little Alice green gown . . . Technicolor couldn't make blue."[47]

Such visible deficiencies influenced debates among Technicolor personnel. Caution prevailed to such an extent, as noted in chapter 3, that the color scheme for *The Black Pirate* (Albert Parker, U.S., 1926) was designed to be restful, with no distracting bright colors. Restraint was the watchword, advocated by Albert Parker and lead performer Douglas Fairbanks as the most appropriate style: "Greens of all the softer shades, and brown running the whole gamut from the lightest tint of old ivory to the deepest tone of mahogany."[48] This strategy paid off and the film's color was praised, but problems including "incorrect handling and sloppy projection standards" and variable environmental conditions in theaters meant that the company's business soon slumped.[49] In spite of the care taken over the film's color palette and Fairbanks's meticulous historical research with illustrations and paintings, Technicolor was unable to control how the film was exhibited. Color continued to be a frustrating technical challenge, leading to intensive work on the development of Technicolor's dye-transfer process, the new imbibition-blank process (I. B.) that eventually constituted its unique selling point.

Cinematic Dynamism

As we have seen, the range of methods of coloring films in the 1920s created a dialogue about color that intersected with discourses found in advertising, retail, color forecasting, philosophy, and psychology. If Handschiegl emphasized deeply arresting imagery with a tactile appeal to the senses, Technicolor's concern over color's distracting nature led the company to distinguish its technology in terms of address: precision, taste, and a limited concept of realism. Generic considerations were, however, starting to become significant in the development of photographic color aesthetics, as fashion reels and musicals created a more open space for experimentation and intersected with the arrival of sound, as discussed in the next chapter. The high costs of producing entire films in photographic color tended to prolong the life of hybridized color. Technicolor sequences at the beginning or end of a film made them a spectacle, and their strategic placement meant that they did not disrupt narrative cohesion. More numerous black-and-white and color sequences, as, for example, in *Cytherea* (George Fitzmaurice, U.S., 1924), enhanced color's Impressionist impact. In this case, the depiction of Cuba in color in a dream sequence rendered it "as a land of colorful beauty," while in black and white its "reality" was rendered as "hot, filthy, drab." As Fitzmaurice explained: "The drama in color is therefore rendered with much greater force than if both the dream and the actuality were shown in black and white."[50] Colors were permitted to conform less to perceived notions of realism in fantasy sequences, as unfamiliar locales tended not to invite direct comparison with everyday experience. They often, however, reinforced stereotypical images of exotic, Orientalist ideologies, as in Technicolor's second feature film, *The Toll of the Sea* (Chester M. Franklin, U.S., 1922), discussed in chapter 2.

Similar ideological predispositions are evident in nonfiction, as in *Cosmopolitan London* (Harry B. Parkinson and Frank Miller, UK, 1924), a short film in the *Wonderful London* series produced by Graham Wilcox Films. *Cosmopolitan London* takes viewers on a tour of London's districts shot from the perspective of those curious to see what the first intertitle describes as "strange faces and scenes reminiscent of foreign climes."[51] As with other travelogues depicting "foreign climes," scenes that take us to relatively safe—in terms of the film's address—white areas, such as the Italian and French restaurants of Soho or "Little Italy" in Clerkenwell, are contrasted with locales where the people are presented as strange, exotic, or even threatening, such as the Jewish inhabitants of Whitechapel or the Chinese of Limehouse. Although the film is sepia toned, it nevertheless uses lightness and darkness in the composition of shots to further emphasize the ideology of the intertitles that are steeped in discourses of racial otherness. Berwick Street, for example, is described as a

"Ghetto of the West," and the following frames are very dark, showing glimpses of shadowed figures at market stalls rather than highlighting their faces or expressions, in comparison with the lighter images of Little Italy that follow an intertitle that jauntily references the pleasures of "macaroni, chianti, hokey-pokey and ice cream." A woman dressed in flapper attire and wearing a cloche hat walks briskly past a French café to indicate a fashionable locale associated with sophisticated taste and modernity. But when the tour takes us to what is described as "the unsavory Whitcomb Street district," we see a white woman apparently thrown out of a restaurant "famous for its negro clientele" and where "white trash are not encouraged." As the film documents Limehouse and then Pennyfields, the word "sinister" is used to describe an environment associated with opium dens and people who do not readily look at the camera. Yet an image of an Asian woman and her mixed-race child challenges this perspective, inviting us to share an intimate encounter that transcends the film's otherwise condescending tone (color plate 5.18). The final sequences of *Cosmopolitan London* once again lighten—visually and thematically—to show sites associated with Britain's colonial heritage, such as Australia House and the spectacle of marching guards. In this way, a film that uses only a single tint strategically varies lightness and darkness in the filming of its different locations to underscore its message; color, shade, and tone are never neutral but imbricated with ideologically inflected sensibilities.

As these examples indicate, perceptions of cinematic color were multifarious in their appreciation so that the apparent conventional uniformity of a tinted frame by no means indicated a *mise-en-scène* that was unremarkable or unrecognizable. The continued interest in hybridized color attests to the pursuit of variety, attraction, and experimentation at a time when the institutionalization of cinema was supposed to have curtailed these intermedial impulses. The key point is that cinema's confidence was not associated with a sense of static maturity, accompanied by a loss of momentum and innovation. Rather, cinema's dynamism in the 1920s was characterized by flux, repetition, and difference as it negotiated its place across multiple contexts. The total experience of color during this period was essentially an intermedial one, informed by the many intersecting areas of life, art, and commerce. As cinema was becoming more institutionalized, the many influences with which it interacted were similarly at different stages of development. The resulting collision of manifestations of the color world underlines the complexities of mapping intermedial exchange during this dynamic period. While a growing perception of what cinema was capable of and what made the medium distinct was evident, its profoundly intermedial connections, more typically associated with an earlier phase of development, were not foreclosed in the 1920s. Instead, intermediality produced a chromatic vibrancy in the art and cinema of the era that still resonates today.

CHAPTER 6

COLOR AND THE COMING OF SOUND

The industry is rapidly becoming color conscious. With the major problems of sound successfully solved, the studios and color processes are now bending their efforts to the further development of color cinematography [. . .]. Color is in the ascendency as sound was last year, and 1930 will be marked with outstanding achievements in this field.

—Jack Alicoate, ed., *Film Daily Yearbook* (1930)

I n May 1931, at the spring meeting of the Society of Motion Picture Engineers, the organization held a series of one-day symposia, the first being a Symposium on Color and the second a Symposium on Sound Recording.[1] At the turn of the decade, these two arenas were at the forefront of technical and aesthetic innovation in cinema, and particularly at the Symposium on Color, the delivered papers provide seminal perspectives not only on what was to come but also retrospectively on the achievements of the prior decade. The event was chaired by Kenneth Mees, director of the Research Laboratory at Eastman Kodak, and papers were delivered by Harold Franklin on color style, Joseph Ball on Technicolor, Russell Otis and Bruce Burns on Multicolor, William Kelley on Handschiegl, and Gustav Brock on hand coloring. Most of these papers were published afterward in the *Transactions of the Society of Motion Picture Engineers*, and they have since become crucial

texts for subsequent histories of color cinema. Collectively, they attest to the radical changes that occurred at the end of the 1920s: the adoption of synchronized sound systems along with the technical strides made by photographic color systems and the transformation of applied color processes. The papers presented at the Symposium on Color provide a striking case study of how technical developments could transform the structure of possibilities within the cinematic field at a time when many in the film industry optimistically predicted that black-and-white film would soon be a thing of the past. For Pierre Bourdieu, such changes are indicative of the ways in which technical revolutions transform what is aesthetically possible as new technical agents enter the field, shifting power relations and stylistic norms to form a new mode of color consciousness.[2]

Among the many transformations that sound technology brought to cinema are the ways in which it affected the technical and stylistic application of color in the moving image. Indeed, the sound transition in cinema occurred during a parallel transformation of color culture—what the *Saturday Evening Post* referred to in 1928 as a "chromatic revolution" in mass society.[3] As similarly noted in the first issue of *Fortune* in 1930, "In this post-war period of broken precedents, of weakened traditions, it is not surprising that the old chromatic inhibitions should be shaken off and that the American people should gratify its instinct for color by bathing itself in a torrent of brilliant hues."[4] Such predictions about an increasingly chromatic future were overly optimistic, as the effects of the developing Depression in fact weakened color's dominance in the 1930s. The iconic black-and-white documentary photographs from the era by photographers such as Dorothea Lange and Walker Evans exemplify this monochromatic dominance. Thus, the Depression in the economic field stifled, to a degree, chromatic innovation in the cultural field. However, this was also the era of *Whoopee!* (1930), *Becky Sharp* (1935), *The Wizard of Oz* (1939), and *Gone with the Wind* (1939), as well as the wondrous advertising experiments by experimental filmmakers such as Oskar Fischinger and Len Lye in Gasparcolor and Dufaycolor. Such fantastically chromatic worlds serve as opposite, escapist refractions of the decade that gave new life to the prismatic aura associated with the preceding Jazz Age.

As we have shown, the chromatic modernity of the 1920s was evident internationally in fashion, interior design, commodity and artistic production, and most certainly in the cinema. The Color Committee of the Society of Motion Picture Engineers noted in 1930, "The demand for motion pictures in color which began in the summer of 1929 continues without abatement. It is reported that some of the larger producers would willingly change back to the black and white pictures but say that the demand for color pictures by the public is so insistent that they do not dare to change."[5] In light of the subsequent history

of color film—it was not until the 1950s and 1960s that color usage actually exceeded and then dominated film production—the Color Committee's predictions were overly optimistic, fueled in no small part by the success of the transition to sound. As John Belton has theorized regarding the relation of sound and color during the era, histories of different technologies take inherently dissimilar shapes, even if it is nearly impossible not to assume synchronicities—as in the assumption that the transition to color would occur with the same speed as the sound transition.[6]

A remarkably incisive article in the *Observer* of London in 1929 posited this parallel between sound and color innovation: "It is only the advent of the talking film that has made the advent of colour film inevitable. America is seriously concerned, for the first time, with the production of something better in colour than cheap picture-postcard painting, and the elimination of black-and-white photography, like the elimination of silent photography, is now little more than a matter of time."[7] Indeed, such comparisons come easily because of the long entwined history of color and sound, originating in antiquity through notions of synesthesia, as discussed in chapter 3. The combination of color and sound in film occurred in numerous configurations after the emergence of the medium at the end of the nineteenth century. The earliest cases involved sound accompaniment paired with screenings of some of the first hand-colored films—for instance, at Koster and Bial's music hall in April 1896, where two hand-colored films were presented with musical accompaniment, the Leigh Sisters' *Umbrella Dance* and a serpentine dance.[8] Other early examples include the hand-colored Phono-Cinéma-Théâtre works of the early 1900s that were synchronized with wax cylinder soundtracks, and the stencil-colored sound films of Gaumont's Phonoscène productions in the 1910s.[9] While attention has been paid to these early color and sound films recently by Lobster Films, by the Cinematheque française, and at Pordenone, there has been less focus on the interrelated changes that occurred between sound and color at the end of the 1920s. In particular, we are interested in how many of the applied coloring techniques of silent cinema—that is, hand coloring, stenciling, tinting, and toning—were orphaned to an extent at the end of the 1920s, both because of the coming of sound and because of developments in photochemical and dye-transfer photographic processes such as Technicolor. However, obsolescence is not the only trajectory, for as we will see, many of these techniques and technologies were adopted anew by the developing sound cinema.

A majority of what follows focuses on chromatic innovation in Hollywood and draws primarily from the U.S. trade press. Such an account of the era inevitably must deal with the rising ascendency of Technicolor, from its two-color phase into the three-strip era. Our aim is not to dismiss this

trajectory, but rather to contextualize it within the international transformation, surge, and decline of various color technologies at the end of the 1920s. Thus, we also stretch beyond the U.S. market to think about the global flows of technical and aesthetic innovation across the cinematic field at the turn of the decade when sound technologies were disrupting established distribution routes across linguistic borders. This contextual emphasis is in part because of the state of the film industry at the time: after the end of the First World War, Hollywood consolidated its hegemony throughout most of Europe and, as a result, was able to support much of the research and development into color that was occurring at U.S. firms such as Technicolor and Eastman Kodak. In contrast, studios such as Pathé Frères in France that had dominated color production before the war fell into financial hardship in the 1920s and were less able to fund extensive technical innovation, particularly as sound technology introduced a host of expensive technical issues for color application—for example, shooting with motorized rather than hand-cranked cameras and silencing them for sound—just as the worldwide Depression began.

If much, but certainly not all, of the technical development of color cinema was occurring in the United States by the end of the decade, another crucial factor was the cultural hegemony of American modernity in the global imaginary—the discourse of "Americanism" specifically in relation to how Hollywood came to exemplify it.[10] It is for these reasons that the previously cited article in the *Observer* of London looks specifically to America for a solution to the color question at the end of the 1920s, citing primarily U.S.-produced films in its account of recent chromatic innovation—specifically, the Technicolor films *The Toll of the Sea* (Chester M. Franklin, 1922), *Wanderer of the Wasteland* (Irvin Willat, 1924), *The Virgin Queen* (Roy William Neill, 1928), and *Broadway Melody* (Harry Beaumont, 1929). The article does note the strengths of the Prizmacolor British film *The Glorious Adventure* (J. Stuart Blackton, 1922) and the French-Italian stenciled film *Cirano di Bergerac* (Augusto Genina, 1923), but overall the focus is on U.S. invention.[11] Color innovation was certainly taking place in Britain, France, Germany, and elsewhere at the end of the 1920s, as detailed below, but the ascendency of U.S. technologies at the time cannot be overlooked. Still, to place U.S. color development in a global context, ascendency was not a given: Technicolor barely survived a slump in business in the early 1930s, because of its own failed technical performance in the late 1920s as well as the shifting taste cultures of the Depression. To trace these various currents, we begin with a discussion of photographic color and then turn to applied coloring techniques in the sound era. As we will show, the intermedial legacies of the period cast a prismatic afterglow not only on the 1930s but also on the decades to follow.

little remembered today. However, it is crucial to focus not just on industrial successes, for often the technologies, techniques, and styles that disappeared tell us more about an era than its official victors. This was as true for the 1920s as it was for early cinema and also for our own contemporary media culture.

Multicolor and Technicolor were two-color subtractive processes that were increasingly in competition with one another. Herbert Kalmus, for instance, explained in a 1929 letter to Leonard Troland: "The thorn in our side with respect to getting business from Fox and Metro is that they are fooling around with a color process called Multicolor."[13] To counter this, Kalmus stressed that Technicolor needed to move as quickly as possible into three-strip production, the fourth Technicolor process. Three months later, as a backup measure, Troland noted in his research diary, in an entry on Multicolor, that Technicolor "should try to acquire some patents that will circumvent them."[14] Technicolor was better established and funded, with strong Wall Street backing, and as of 1928 had rolled out its dye-transfer process that was successfully deployed in films such as *The Viking* (1928) and *Redskin* (1929). Because a light-splitting prism was required to expose a Technicolor negative—splitting the light passing through the camera lens to expose two successive frames at once that were filtered as separate red and green records—special Technicolor cameras and camera operators needed to be deployed for filming. Not only were these cameras more expensive to shoot with, but it was relatively difficult to schedule them for filming in the late 1920s because Technicolor had a very limited number of cameras and crews available. Print processing was even more elaborate, and unfortunately erratic, as business ramped up with what was now Technicolor process #3. The negative was developed and the alternating color records printed separately onto positive prints, which were then used as dye matrixes to transfer ink onto a new filmstrip through the imbibition process, thus building the color image in successive dye-transfer layers. Illustrative of the ways in which applied coloring processes were adapted into photographic color, Technicolor's method of imbibition was informed by the applied-color process of Handschiegl, which was itself developed intermedially from chromolithography.[15]

Multicolor was a newer system that William Crespinel helped develop after his work with Prizmacolor.[16] It was a bipack system that combined two negatives, one orthochromatic nearest to the lens and one panchromatic beneath it, that ran simultaneously through a standard camera with modified film magazines, which any operator could handle. The orthochromatic stock recorded blue and green light waves (as orange and red are invisible to orthochromatic emulsion) and was treated with a tint dye to filter light passing through to the panchromatic stock beneath it so that only yellow, orange, and red light waves would be exposed on the second negative. The two exposed negatives would then be developed and printed on a double-sided positive, which was dye-toned on opposite sides in complementary colors (iron blue and uranium red)

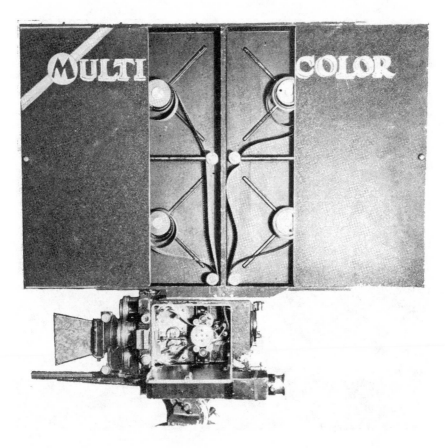

Figure 6.2 The Multicolor attachment on a Mitchell camera, from *International Photographer* 1, no. 12 (January 1930).

to produce the two-color positive image. Again, with this method, an applied coloring technique (dye toning) was adapted for the process. As Multicolor was meant to be deployed on normal cameras, as opposed to Technicolor's special beam-splitting cameras, it was a more affordable mode of production; however, its optics were softer. Though a number of shorts were produced with this process, and a variety of color inserts were used in feature films, the process never took off for feature filmmaking, and the company folded in 1932.

In contrast to Technicolor and Multicolor, Vitacolor was launched in 1928 as an additive system similar to Kinemacolor, in that it captured successive filtered frames on a black-and-white negative as red and green records. When developed and printed, the film could be projected back out through the same rotating colored filters to produce a two-color image. The filters were a simple lens attachment that could be used on standard cameras and projectors. Similar

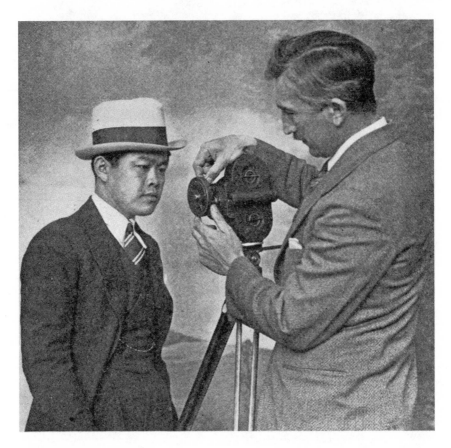

Figure 6.3 James Wong Howe and Max DuPont of Vitacolor, from *American Cinematographer* 10, no. 1 (April 1929).

modifications had proved unsustainable for Kinemacolor in the 1910s, but Vitacolor purportedly took advantage of more advanced filters and panchromatic stock during filming and projection to produce a fuller two-color image that required less intervention than Kinemacolor.[17] The process was developed by Max DuPont, a Hollywood cameraman originally from France. According to at least one biographical account, he was the son of Leon B. DuPont, "one of the foremost scenic painters of France and an *officier d'académie*," from whom he learned "the science of color combination and harmony."[18] Despite the shared name, Max DuPont and Vitacolor were not affiliated with E. I. du Pont de Nemours and Company, the U.S. chemical conglomerate that was also producing color and black-and-white filmstock at the time through the DuPont-Pathé Film Manufacturing Company.[19] Vitacolor could be used for 35mm filming and projection, but its larger appeal was in the amateur market, where it also

Color and the Coming of Sound 233

functioned well on 16mm to much fanfare during the years it was in operation; its chief competition was Kodacolor.[20] Vitacolor expanded rapidly at the end of the 1920s and made international inroads in the UK, Japan, and Shanghai, with Chinese American (later Oscar-winning) cameraman James Wong Howe showcasing the technology in East Asia.[21] The company bought up many of the existing Prizmacolor patents and proceeded to file lawsuits against a number of its competitors for patent infringement—in a way foreshadowing high-tech patent litigation of today. With the company's portfolio thus bolstered, Max DuPont sold his stock in 1930 to Consolidated Film Industries, which was not successful in developing Vitacolor further, and it soon largely disappeared from the public eye.[22] However, Vitacolor continued its patent lawsuits—for instance, in 1936 against Cinecolor, which had taken over from Multicolor.[23]

Integrating these various color processes with new sound technologies was clearly a pressing issue at the end of the 1920s. James Layton and David Pierce, in their history of early Technicolor, describe a strong push to combine sound and color, particularly going into 1928 with the novelty of sound. They explain: "Sound also brought a new sense of reality to films, and this led to an appetite for the widespread adoption of color. Producers who had gambled on sound had little fear committing to a program of color musicals, before knowing whether audiences would respond at the box office."[24] Synchronized sound disrupted established codes of cinematic realism at the time, expanding the audiovisual relation of cinema, as sound theorists such as Michel Chion have theorized.[25] This, in turn, proved lucrative for color companies such as Technicolor that were heavily marketing their processes in Hollywood, while also looking to expand globally. Herbert Kalmus explains:

> By early 1929 all the important studios in Hollywood had become thoroughly sound conscious. This was a great help to us in introducing color. Prior to that, studio executives were loath to permit any change whatsoever in their established method of photography and production. But with the adoption of sound, many radical changes became necessary. . . . The studios were beginning to be *color conscious*.[26]

In other words, one disruption to the structure of cinema begat another during the sound transition, when established audiovisual norms were open to revision on multiple fronts. What had previously been dominant within the cinematic field—the silent-film style of applied coloring—got "pushed into the status either of outmoded or of classic works," to apply Bourdieu's theory of literary innovation.[27] These dynamics around the transformation of the cinematic field reverberated in the trade press of the time, making the silent era seem like the uncanny shadow of Maxim Gorky's early film criticism.[28] As an article in *American Cinematographer* explained, "now that talking pictures are a

reality, color helps carry out the illusion and makes one forget that he is watching a shadow. What the future holds in the way of color is a question no one can answer, but the wind is blowing colorwise."[29]

Even with such changes to the cinematic field, color still coded a specific, generically, culturally, and often racially defined mode of realism that was deeply rooted in intermedial practices and cultural fields. Indeed, it is at moments of technical transition that medial and cultural connections often come to the fore to situate change. With regard to realism, as argued throughout this book, photographic color was not inherently aligned with the aesthetics of naturalism. Instead, in the late 1920s, color was used to code historical narratives like *The Viking*, to enhance indigenous and racialized locales in films such as *Redskin*, and to amplify the visual pleasure of female display; and of course it was most vibrant in the exemplar of the new audiovisual paradigm of cinema, the musical, which often combined all of these semantic elements. Simultaneously, there were narrative pressures placed on chromatic style. Harold Franklin at the Symposium on Color argued that color should merge with the background of a film: "When motion pictures can capture the blending hues of the spectrum so that they dissolve into the scene, so to speak—and not dominate the picture as has been the case in some instances in the past—then color will enhance the pictorial as well as the dramatic values in motion pictures."[30] Such emphasis on well-blended coloring has roots in cinema that date to the end of the first decade of the 1900s, when filmmakers began to subdue bright colors to work in harmony with narrative legibility; it is also in line with later Technicolor three-strip aesthetics, which coded color design to avoid visual distractions, particularly from the mid-1930s on. Such stylistic prerogatives, though, have always been fluid, depending on the context of the work.

Generically and sonically, Vitacolor was an outlier when compared to Technicolor and Multicolor, but it provides a useful example of the coded realism of photographic color at the time. Only a few fragments of Vitacolor material survive in the Earl Theisen Film Frame Collection at the Natural History Museum of Los Angeles County, but as early announcements of the process suggested, it was certainly feasible to synchronize the process with recorded sound.[31] The *Exhibitors Daily Review* explained in 1928, for example, that Vitacolor was "a new process of film manufacture embodying possibly sound and color photography"[32] In accounts of Vitacolor screenings, though, synchronized sound is not mentioned. Instead, the films displayed were largely nonfiction: scientific and surgical films, as well as scenes of bathing women.[33] Apparently, one of the first films that DuPont debuted to industry technicians was footage from the Santa Monica beach; according to a reviewer's description, it relied heavily on the color process to amplify the visual pleasure of female swimmers:

At last, a hushed quiet came over the long room. The lights were extinguished and the projection machine set up a whine, which settled down to a low, rhythmic purr. A few fitting titles flashed onto the screen. Then a group of bathing girls appeared in one of the most amazing motion picture reviews I have ever witnessed. Every color of the spectrum was represented in the combined shades of their swimming suits. Not all glaring colors, mind you, but exactly as they would appear to the eye in reality—some "noisy," others subdued. But the fact which impressed me most was that while one of the girls had red hair and wore a green suit and another along the line had on a red suit, yet neither of these brilliant colors persisted in the eye of the observer to draw his attention away from the other girls, any more than if he were peering at a row of "sunkist" specimens along Santa Monica's ocean front. The flesh tints were exact, ranging from a carefully nurtured "peach and cream" complexion down to a deeply tanned skin.[34]

Even as the Vitacolor system opened new inroads for color in the amateur market, it still recapitulated long-standing tropes of chromatic culture—the association of color with female spectacle, which dominated the earliest color

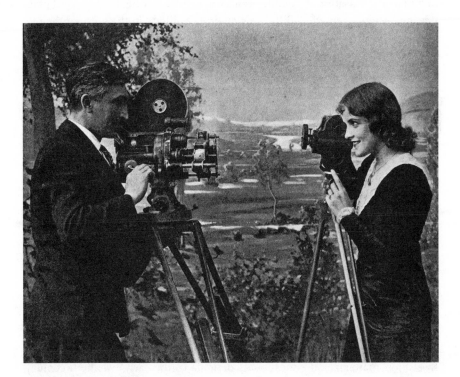

Figure 6.4 Max Du Pont and Mary Mabery, the "Vitacolor Girl, from *American Cinematographer* 9, no. 11 (February 1929).

films of the 1890s, when hand coloring was often used to add glamor to the image of dancing women, as in Annabelle Whitford's serpentine films for Edison. Vitacolor even promoted the young actor Mary Mabery as the "Vitacolor Girl," recapitulating the promotion of the "Biograph Girl" of early fandom in the 1910s. In one photograph of Mabery, she stands opposite DuPont against a painted landscape, both wielding cameras with Vitacolor filters focused on the other, he with a 35mm, she with a 16mm—a plucky Vitacolor romance of dueling formats.[35]

Beyond female spectacle, DuPont promoted Vitacolor in line with his own artistic training, emphasizing connections between painterly practice, color theory, and physiological discourse: "color composition in color photography is as important as in oil painting."[36] He explained elsewhere that "the Vitacolor method impresses upon the emulsion of panchromatic film the various colors of the scene being photographed in substantially the same manner as the artist blends his colors in painting a picture. . . . So, knowing that to create color sensation is just a matter of proper vibration irritating the nerves of the eye, it is easy to understand that a certain vibration transmitted by a mechanical means and in synchronization with the receptive optical nervous system will create natural color sensation."[37] Such references to gender, aesthetic theory and practice, and science remediated the new color technology in the guise of the old, as Vitacolor took part in the transformation of the cinematic field of the day.

If the place of sound in the Vitacolor system was underdeveloped (even as it expanded the potential of color into the amateur market), this was not the case with Multicolor and Technicolor. A discussion of Multicolor in *International Photographer* in 1929 noted that a key feature of the process was its adaptability for sound cinema:

> And a most important point to consider is the fact that with the Multicolor process sound can be recorded from the film itself. With the voice, or music or sound effects the result on the screen is identical with black and white. The sound track is an integral part of the film itself, is colored and is protected with a transparent coating which prevents abrasions and scratches to the sound track as well as to the picture itself.[38]

Similarly, in an advertisement in *Cinematographic Annual* in 1930, Multicolor promoted its ability to combine "color and sound-on-film in one process," and stressed that its process would appeal to the growing "color-conscious" public.[39] As we have discussed previously, color consciousness was a central aesthetic concept during the era across a wide range of fields, from scientific discourse to fashion manuals and educational curricula of the early twentieth century. At the end of the 1920s, it was invoked increasingly within the film industry, by Loyd Jones at Kodak and, most famously, by Herbert and Natalie Kalmus at

Technicolor. In the same issue of *Cinematographic Annual*, the volume's intro-
duction references the notion in a long section on color (quoted in the epigraph
to chapter 2), noting how color cinematography will affect intermedial taste
cultures for fashion and home décor, helping establish a new color conscious-
ness of color harmony among the public.[40] Bringing color consciousness to
bear on Multicolor's approach to sound, the company was clearly attempting to
promote itself in the context of the intermedial color boom of the time, noting
in the same *Cinematographic Annual* advertisement that its color process was
useful for "educational, industrial or regular dramatic films," thus applicable
cross-genre and cross-field, in keeping with the expansive understanding of
color consciousness at the time. The educational emphasis makes sense also in
the context of Multicolor's first sound production, the 1929 Max Sennett short
comedy *Jazz Mamas*, distributed through Earle Hammons's Educational Film
Exchanges—a company that, as the name indicates, had its roots in the educa-
tional market even though it quickly expanded into comedies in the 1920s.

As Hilde D'Haeyere has examined in detail regarding Max Sennett's color-
comedy work, Educational Film Exchanges promoted *Jazz Mamas* as the "first
all-color, all-talking comedy," and it proved to be mutually beneficial for both
Sennett and Multicolor.[41] The film is lost, but from reviews and advertising, it is
clear that it was a series of musical sketch comedies, including Sennett's famous
"bathing beauties" and an "international detective" spoof featuring a variety
of colorful national costumes. Sennett had already worked with Technicolor
in producing two-color sequences for silent comedies, and he had also pro-
duced sound comedies in black and white. Multicolor offered a more flexible
color technology than Technicolor, with its proprietary cameras and company-
assigned cameramen; Sennett benefited from the flexibility, using Crespinel, the
chief developer of Multicolor, in an advisory fashion. In return, as D'Haeyere,
explains, "Sennett provided Crespinel with a practical test-case and studio
facilities to complete the Multicolor process with sound-on-film."[42] Without
the extant film, it is difficult to judge the success of the collaboration, though
according to Russell Otis's technical analysis of the process in 1932, Multicolor
did have issues with adapting its process for sound because the soundtracks
had to be printed and toned in either blue or red—on one side or the other of
the positive print—because trying to print both sides would result in registra-
tion issues for the soundtrack.[43] The photoelectric cells that read soundtracks
were calibrated for black-and-white tracks, and this caused issues with volume
and sound quality, though Multicolor found that placing the soundtrack on
the blue-toned side worked better than on the red-toned one. Likely because
of the poor sound, as well as general dissatisfaction with the color quality itself,
only a handful of films were subsequently produced with Multicolor, includ-
ing *Married in Hollywood* (Marcel Silver, U.S., 1929), *The Great Gabbo* (James
Cruze, U.S., 1929), and *Hell's Angels* (Howard Hughes, U.S., 1930). The company

folded in 1932, and Cinecolor subsequently purchased its plant and patents and recruited William Crespinel to oversee its technical facilities.[44] Cinecolor, as opposed to Multicolor, did much better in the 1930s by not competing with Technicolor head-on in terms of quality, instead providing an acknowledged lesser but more affordable alternative for lower-budget productions.

In contrast, the Technicolor Corporation moved into a position of relative ascendency at the end of the 1920s, as it successfully adapted its new two-color dye-transfer process to all major forms of soundtrack technology at the time— Western Electric sound-on-disc as well as Movietone's and RCA Photophone's sound-on-film processes. By 1928, Herbert Kalmus saw this as a crucial priority for the company, arguing in corporate correspondence:

> If we do not get aboard the band wagon, we will soon be left behind. . . . It is only that we should arrange to have the existing synchronizing methods applied to color as well as to black and white; in other words, it is only the specific problems of our color method in connection with tone that I am advocating that we spend any money on. After a while everybody will have sound and the company who has color and sound will again be out in front.[45]

Technicolor was able to surmount the various issues that sound raised. However, the more pressing problem the company faced turned out to be a problem that it helped create. The surge in color productions in the late twenties overwhelmed Technicolor camera crews and printing labs, which could not keep up with the demand, and the quality of output suffered immensely, as Layton and Pierce have documented thoroughly.[46] Kalmus explained:

> During this boom period of 1929 and 1930, more work was undertaken than could be handled satisfactorily. The producers pressed us to the degree that cameras operated day and night. Laboratory crews worked three eight-hour shifts. Hundreds of new men were hastily trained to do work which properly required years of training.[47]

This, in turn, created openings for competitors such as Multicolor and also Eastman Kodak's Kodachrome process, which Fox Film Corporation licensed in 1929 and rebranded as Fox Color—though all of these processes faced similar if not worse issues of scale and quality control than Technicolor did. Over the next few years, because of these problems as well as the added cost of color production at the onset of the Depression, the high demand for color passed. Meanwhile, the generic conventions of color for musicals, fantasy, and exotic locales persisted from the silent era into the three-strip period of Technicolor production, setting up the aesthetic and stylistic parameters that defined the classical era of color-sound design.

Because of the overcommitted nature of Technicolor's position in the domestic market, its efforts were primarily U.S. focused at the time. In 1929, Kalmus did try to expand the company with new plants in London and Berlin, to make foreign-release prints cheaper and stimulate overseas color production.[48] These plans fell through, though, as Technicolor's resources were overcommitted. As Kalmus explained in a cable to his British collaborators at the end of 1930, "just now entire industry in slump and every would be competitor of Technicolor much worse off than Technicolor so what chances have they in London now."[49] It was not until 1935 that Technicolor was able to establish a coloring lab in Great Britain as Technicolor Ltd.[50] In the context of these international developments, Technicolor's genre-focused work in Hollywood in the late 1920s took on particular cultural and racial emphases that were both inward looking, with regard to the color-coding U.S. racial representation, and outward oriented in the context of Hollywood's and Technicolor's growing global sway. In other words, the confluence of racial and generic conventions in Technicolor productions served both domestic and cosmopolitan audiences, and this dual appeal is vital for understanding the company's practices at the time.

This dominance of generic and racial conventions can be seen in the Technicolor productions at the turn of the decade. In a 1930 Art Deco–style ad for Technicolor Musical Reviews by Vitaphone, for instance, four of the six promoted Roy Mack–directed shorts emphasize their exotic and Orientalist settings in Polynesia (*The South Sea Pearl*), the Middle East (*The Sultan's Jester*), California under Spanish rule (*The Military Post*), and Japan (*Poor Little Butterfly*).[51] As noted earlier, feature films such as *The Viking* and *Redskin* similarly deployed Technicolor to emphasize historical and exotic locales in conjunction with their soundtracks of music and effects. *The Viking* was Technicolor's first all-color feature printed with a Movietone sound-on-film track; it was meant to demonstrate the company's compatibility with sound through its newly unveiled dye-transfer process.[52] With Technicolor producing and MGM distributing, Herbert Kalmus served as executive producer, while Natalie Kalmus, for the first time on a feature film, served as color art director through the company's newly formed Color Control Department.[53] Technicolor wanted to return to the success of Douglas Fairbanks's *The Black Pirate* (1926) and showcase its dye-transfer process through another historical seafaring adventure. Given the technical and industrial importance of the production for Technicolor, it is significant that the film was staged mythically and racially as a national origins story of North America by Nordic-Anglo explorers. Set ca. A.D. 1000, it stages Leif Erikson's voyage to North America and founding of the Viking settlement of Vinland, today known to have stretched from Newfoundland to northern New Brunswick in Canada. The film, however, erroneously centers Vinland further south in Rhode Island by making a temporal leap in the film's ending coda to the 1920s where a Viking tower supposedly still stood

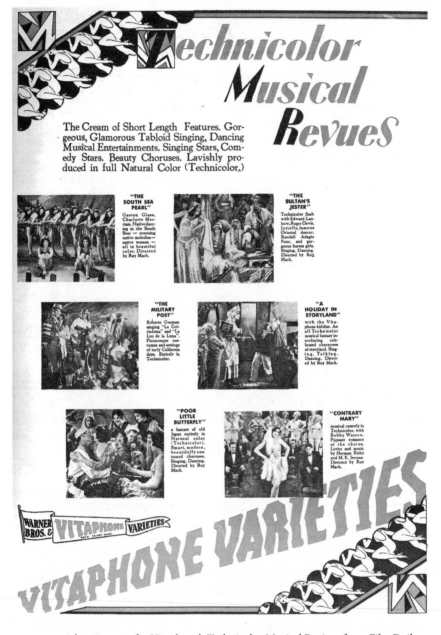

Figure 6.5 Advertisement for Vitaphone's Technicolor Musical Review, from *Film Daily* 4, no. 3 (January 6, 1930).

while the "Star-Spangled Banner" plays on the soundtrack. ("Newport Tower" was in fact built in the mid-seventeenth century.) Leif Erikson was played by Donald Crisp, who also had a key role in *The Black Pirate*; Anders Randolf also appeared in both films. Additionally, Kalmus hired the screenwriter Jack Cunningham and painter and art director Carl Oscar Borg from *The Black Pirate*. Borg in particular was vital in both films, developing their color designs and imbuing them with a cosmopolitan flair; he famously helped Fairbanks replicate the look of Howard Pyle's illustrations in the earlier film.

For *The Viking*, Borg also took an intermedial approach, drawing from the look of nineteenth-century Nordic Romanticism for the set and costume design, which the soundtrack also picks up. The color in the film was praised as a "work of art," even as its plot was generally found lacking.[54] In particular, as Arne Lunde argues, the film's invocation of Romanticism can be seen in the introduction of the character Helga Nilsson, the female protagonist played by Pauline Starke with dyed red hair.[55] A Viking princess who later becomes the wife of the kidnapped, turned Viking, Anglo-Saxon Lord Alwin, she is introduced unceremoniously as she is thrown from a horse. Nonetheless, she embodies the film's attempted Wagnerian aura: her costuming in early scenes is anachronistically adorned with a winged Valkyrie helmet and copper breast-plate, and when she flies off the horse in her first scene, the score alludes to "The Ride of the Valkyries" from Wagner's Ring cycle. The coloring also works to bring out these operatic and Romantic elements through bold clashing colors: Helga's red hair matches her short red skirt and copper skin, and together these contrast sharply with her blue-green cape. The coordinated clash of color pairs with the operatic swells of the score, which also amplifies the visual spectacle of the close medium shots of Helga to emphasize her heaving and barren upper chest.

Numerous other elements of set design and landscape in the film also rehearse a Nordic Romantic aesthetic, exemplified, for instance, in a later scene's depiction of rocky Greenland: a snowy and mountainous painted backdrop in green-blues and whites sets off the scene's reddish-brown Viking fort. A battle that shortly breaks out in the fort could be a scene from the conclusion of the German-Norse *Nibelungen-Niflung*, in line with (if not as bleak as) Fritz Lang's adaptation in *Kriemheld's Revenge* (Germany, 1924). Through these various generic references, the Technicolor hues work in the film to illuminate a mythic and racialized past, the Nordic and Anglo discovery and settlement of the Americas. Helga and Alwin ultimately stay behind to found the new world of Vinland, while Leif Erikson departs for home. Thus, as a racialized origin story that still resonates with white nationalist delusions today, the film imagines the European settlement of what would become the United States at the turn of the last millennium, deepening a sense of old world cosmopolitanism that was meant cinematically to play well both domestically and in Europe.

Color and race also factor prominently in Technicolor's *Redskin*, which, like *The Viking*, was produced with music and sound effects but no dialogue— though song vocals performed by Helen Clark were used on three of the reels, synchronized through the Vitaphone sound-on-disc method. Filmed in both Technicolor and black and white, the film was an ambitious undertaking, with extensive location shooting in the picturesque Canyon de Chelly in Arizona and the Valley of the Enchanted Mesa in New Mexico. Given the ambitious filming schedule, Technicolor set up a mobile lab to support the three-month production.[56] The black-and-white footage was used for foreign-release prints to cut down on costs, and presumably also because the narrative itself was U.S. centric and may not have had as much appeal for foreign distribution. Thus, it was only the U.S. domestic version that was released primarily in Technicolor, except for portions set in an Indian boarding school and subsequently at an eastern U.S. college that were filmed in black and white and tinted brown, likely with Sonochrome filmstock. In the U.S. version, this split between tinted and Technicolor sequences thematically matches a narrative split in the film between the subdued Anglo-American-dominated spaces and more colorful indigenous ones. Such a division affirms a generic and racialized convention for color design in which supposedly primitive spaces, bodies, and subjectivities are more closely aligned with saturated colors, whereas modern spaces are desaturated, ethnically white, and associated with Western European rationality. Technicolor's earlier *Toll of the Sea* (Chester M. Franklin, 1922) is a parallel exemplar of such a racialized chromatic logic, as detailed in chapter 2. Such chromophobic divides were also combined in the film with the use of redface by the film's nonnative star, Richard Dix, who was darkened up with brown makeup to play the part of Wing Foot, the Navajo protagonist of the film.

Despite these problematic racial ideologies and practices of color, the film itself is in fact surprisingly sensitive about issues of race, racism, and the politics of Native American assimilation. *Redskin* was produced in the wake of the Indian Citizenship Act of 1924, which granted citizenship to Native Americans, and especially of the Meriam Report of 1928 (officially titled "The Problem of Indian Administration"), which was highly critical of the U.S. Department of Interior's horrid oversite of Native Americans reservations. Specifically, *Redskin* picked up on the report's trenchant critique of Indian boarding schools, which since the late nineteenth century had forcibly removed children from reservations to segregated, and often poorly managed, boarding schools that attempted to assimilate the children into mainstream American culture. As the film shows through the plight of Wing Foot (named for his speed), who is taken from his Navajo village as a child and only returns after abandoning college, such practices left many Native Americans lost between worlds, never accepted in mainstream society yet too alienated from their indigenous heritage to be easily at home again on the reservation. The film is particularly

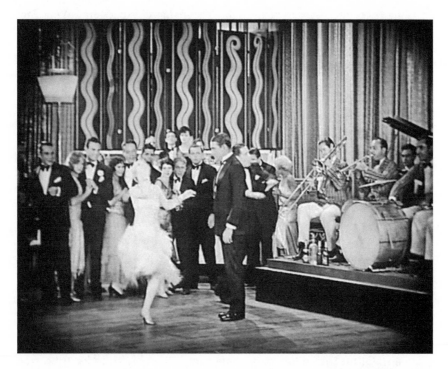

Figure 6.6 The jazz club, war dance scene, from *Redskin* (1929), originally tinted brown.

critical of the brown-tinted Indian school that Wing Foot is taken to, where, after leaving the Technicolor world of his village, he is stripped of his bright native clothing and redressed in denim jeans and a button-up shirt, and his long hair is cropped short. Finally, he is cruelly whipped into submission for refusing to salute the U.S. flag.

After a quick passing of years, the film subsequently shows Wing Foot's successful entry into college somewhere in the eastern United States on a running scholarship. Still tinted brown, the sequence continues the critique of education with a striking portrayal of Jazz Age racism. Wing Foot is invited to a college dance after he has won a prestigious race for the school. The setting is an Art Deco night club with big-band jazz playing on the soundtrack, and Wing Foot arrives appropriately dressed in a tuxedo. A young blonde woman, who had earlier invited him to the club, pulls him onto the dance floor in an attempt to get him to perform an Indian war dance, which she demonstrates stereo-typically by whooping and hopping around. The other dancers and the band join in, with a shift in the score to an Orientalized, klezmer-driven version of a war dance. Wing Foot uncomfortably, if politely, watches the racist parody unfold until the woman's boyfriend, who has become jealous of her attention

to Wing Foot, intervenes to pick a fight. The man's colleagues grab Wing Foot from behind as the man punches him in the face, telling him he bet on him at the race just as he would on a racehorse, while another man explains that if they did not need Wing Foot for the running team, he would not be tolerated at the school. Through this vicious confrontation, Wing Foot realizes he was mistaken to think he could ever fit into the supposedly tasteful and restrained white world, so he returns to the Technicolor lands of the Navajo reservation.

Wing Foot's return, though, is anything but smooth. He has become modernized, wearing a Western brown suit, and his father rejects him for not coming back looking like an Indian. However, even after changing into native garb, with a bright red headband and black shirt, he still cannot fully assimilate into Navajo culture. He rejects the tribe's medicine-man rituals as old-fashioned, insisting that they should also incorporate modern medicine into their ways. For this profession of cultural hybridity, he is formally kicked out of the tribe, thus fitting racially into neither the monochromatic nor the Technicolor world of the film. The film resolves itself in color, or rather through a certain rejection of color and an embrace of blackness, for in a *deus ex machina* moment, Wing Foot discovers oil on reservation lands and is able to stake a claim to it, which resolves all of the narrative's conflicts. As he dips his hand into the petroleum seep, the color of the oil corresponds tactilely to the blackness of his shirt (color plate 6.1). Of the impending oil income, half will legally go to his tribe, who happily accept Wing Foot back as a member; the other half he promises as a dowry to a nearby Pueblo tribe where his fiancée Corn Blossom resides, in Romeo-and-Juliet fashion, thus settling cross-tribal conflicts. In retrospect, the resolution of the film through the black oil of global capital is not necessarily a happy conclusion, but what is productive is the film's critical stance vis-à-vis Native American modernity. Critiquing both the inherent hypocrisy of Jazz Age racial divides and an unwavering and Romantic embrace of indigenous tradition, the film is forward looking and grounded firmly in Native American identity, yet open to the modern, globalized world. The film's final scene shows the Navajo and Pueblo tribes, made rich by the abundance of oil, meeting in the rocky desert among covered wagons as they set off to found a new, tolerant, intertribal Native society, with Wing Foot and Corn Blossom as their new royal family now dressed in the Technicolor reds of Native patterns. In its depiction of this new Edenic desert society, the film appropriates and rewrites Anglo-American myths of manifest destiny, imagining what an indigenous utopia might look like. By routing this through the generic and racialized conventions of color at the time, the film opens productive, if unsettling, dialogue about cultural hybridity in ways that resonate ambivalently with the saturated designs of the Arab Gulf states of today.

Parallel racial issues are also central to *King of Jazz* (1930), Technicolor's and Universal's ambitious all-talking and -singing musical revue of the year,

directed by John Murray Anderson, which we discussed briefly in chapter 3. The film has recently been meticulously restored, and James Layton and David Pierce have also published an in-depth book on the film, examining in detail its production, reception, and recent restoration.[57] We do not aim to replicate the detail of their analysis here, but the film does bring into focus the ways in which color and race coalesced at the end of the decade in the context of both the U.S. and global markets that the film was distributed in as a multilingual production. One of Carl Laemmle Jr.'s prestige pictures at Universal (along with *All Quiet on the Western Front*), the film was meant as a platform to show-case the musical prowess of Paul Whiteman, the renowned "king of jazz" of his day. Banking on Whiteman's fame, Universal signed a lavish contract with him, offering 40 percent of the profits with a guaranteed $200,000 payout.[58] Running over budget to more than two million dollars, it was Universal's most expensive film to date, exceeding even *All Quiet on the Western Front*. Unlike the latter film, which was profitable, *King of Jazz* ultimately lost approximately $1.3 million for the studio.

The budget problem largely grew out Universal's struggle to find the right narrative framework for the production. As part of his contract, Whiteman had final say on the script, and Universal went through numerous drafts that failed to gain his approval. The film also saw the exit of one eminently skilled direc-tor, Paul Fejos, in favor of Broadway stage director John Murray Anderson. Whiteman also insisted that the film use primarily prerecorded sound played back during filming, to improve the quality of the sound recordings. In the end, the film moved forward with a near bottomless budget as a loosely connected revue structured as a "scrapbook" of acts to showcase Whiteman and his band without interweaving narrative threads. However, by the time of release, such musical revues had saturated the market, and particularly coming in the wake of the stock market crash, the film failed to catch with U.S. audiences in par-ticular. Despite its weakness at the box office, the film is worth examining both for its remarkable color design and for its problematic racial narrative about the origins of jazz.

Jazz in the 1920s had many connotations. At its core, it grew out of the African American ragtime and blues music of New Orleans and circulated in speakeasies and nightclubs around the world from Harlem to Paris. If the origins of jazz are associated with African American musicians such as Louis Armstrong, King Oliver, and Duke Ellington, white musicians such as Paul Whiteman also became popular with white audiences in the 1920s for adapting and domesticating jazz syncopation to European symphonic form.[59] George Gershwin's *Rhapsody in Blue* is an exemplar of this transformation. Commis-sioned by Whiteman in 1924 for his orchestral performances and prominently featured in *King of Jazz*, it is an extraordinary exploration of jazz through clas-sical orchestration, borrowing tempos from ragtime and the Charleston, with a

modulating harmonic structure across numerous key changes. Universal paid Gershwin $50,000—an unheard-of fee—to license the work for the film.

The prologue in the film to *Rhapsody in Blue* provides one of the film's few, though highly problematic, acknowledgments of the African American roots of jazz, and the color coding of the music is significant. It presents Whiteman standing in front of his giant scrapbook announcing to the camera that "the most primitive and the most modern musical elements are combined in this rhapsody, for jazz was born in the African jungle to the beating of the voo-doo drum." Whiteman's introduction cues the sonic beginning of off-screen drums as the image cuts to a nearly nude white dancer Jacques Cartier painted entirely in onyx black and highlighted with scarlet red lighting while perform-ing a modernist witch-doctor dance upon a giant voodoo drum. Cartier's arti-ficially black skin thus becomes the epidermal embodiment of the primitivism of Whiteman's remarks.[60] In ethnographic-surrealist style, Cartier performs in long shot against a turquoise background that makes his blackened body shim-mer in front of a larger projected shadow of himself (color plate 6.2).

The negative space of Cartier's glistening body and primitive shadow form a counterpoint to the beginning of *Rhapsody in Blue*, as the film and drum-ming sharply cut to two matching women's bobbed heads—the German-Jewish Karla and Eleanor Gutöhrlein, aka the "Sisters G," who were internationally renowned flappers of the time. In medium framing among a multitude of tur-quoise feathers, their white faces contrast to the onyx of Cartier's flesh, while also forming an erotic connection between racialized primitivism and subver-sive flapper sexuality. The sound accompaniment also cuts from the African drumming to the sound of a Jewish klezmer clarinet, sounding the opening refrain of Gershwin's composition and shifting the score into big-band mode. The camera cranes over the flapper's faces, and the decadent feathers are pulled back to reveal an Art Deco extravaganza of female performers in evening gowns surrounding the male clarinetist, amazingly played by Cartier again, but now swapping blackface for white skin and tuxedo (color plate 6.3). The epider-mal primitivism of the prologue is thus replaced by modern Jazz Age glamor, focalized through Cartier and the visual pleasure of the Sisters G. As the shot unfolds, the orchestration begins, and the scene's iconic colossal turquoise grand piano comes into view, set off against a silvery palm tree and gray cur-tains. The enormous piano opens to reveal the orchestra sitting inside. A series of Deco-styled performances and kaleidoscopic abstractions accompany the song through its various modulations and hybridizations of jazz and orches-tral music, thus making the sound, rhythm, and visual pleasures palatable to a middlebrow audience. From its prologue through the end, the scene illustrates Whiteman's claim of sonic as well as visual fusion of the supposed primitive and modern, sublimating Cartier's black body to his later klezmer-style, dapper version, presented in tandem with the German-Jewish flapper erotics of the

Sisters G. Race and female sexuality are thus complexly entwined in the scene's color coding: the dangerous and primitive voodoo roots of jazz are made quasi-acceptable, though still charged with Jewish alterity, when filtered through Whiteman's rhapsodic orchestration.

If the hybridity of *Rhapsody in Blue* acknowledges at least some roots for jazz in African American culture, the film's opening and closing sketches are far more troubling in terms of color coding. At the film's beginning, actor Charles Irwin provides a general, master-of-ceremonies introduction, explaining the film's scrapbook structure. Cutting from Irwin's monologue to the first skit, the film shifts from live action to animation, providing an origin story of how Whiteman became the so-called "king of jazz." The scene was Technicolor's first foray into animation. Produced by Walter Lantz and Bill Nolan (of "Oswald the Lucky Rabbit" fame), it has a dominant color pattern of reds and green-blues. The setting is "darkest Africa," according to Irwin, and Whiteman is on safari. He runs into trouble on a lion hunt, and, abandoning his useless rifle, he turns to song and fiddle to perform the jazz tune "Music Has Charms," thereby taming the savage beasts and African natives, who dance and swing along. The scene concludes when a monkey lobs a coconut toward Whiteman, hitting him in the head and causing a crown-shaped protrusion to emerge.[61] The skit thus provides a buffoonish colonial fantasy of Whiteman conquering a supposed savage Africa through his improvised music, taking a few bruises along the way, which in turn become the royal mark of his victory.

If the opening skit presents a racist origin story for Whiteman, the film's closing "Melting Pot of Music" number avoids any mention of the African American roots of Whiteman's music. Instead, Irwin returns to introduce the skit, explaining that "America is a melting pot of music wherein the melodies of all nations are fused into one great new rhythm, jazz." In this context, "all nations" is in fact exclusive to European ethnicities, embodied in performances of various British, Austrian, Spanish, French, Russian, and Scottish songs and dances, all in colorful regional costumes. In his theatrical work, John Murray Anderson was best known in the 1920s on the Publix circuit of the United States for stage versions of this "Melting Pot" skit; as in those prior performances, the *King of Jazz*'s version culminates with all of the European ethnic performers being lowered into a giant melting pot. Whiteman then appears as a master conductor turned chef who stirs the pot while a series of neon turquoise and red circles float up in the air in whiffs of smoke. An overhead shot reveals the mixing of the various performers in abstract, kaleidoscopic fashion, with color-music streaks of turquoise and red swirling about. With grand mass-ornamental pomp, the bottom of the melting pot then swings open and dozens of performers dressed in shimmering gold rush march out performing a jazzed-up symphonic fusion of the previous song styles. Amid ostentatious classical columns mounted with eagles, the absurdity of the scene foreshadows what Guy Maddin would later

parody in *The Saddest Music in the World* (2003), or as J. Hoberman describes it, "This Eurocentric origin story is sung and danced on a set that, with its Doric columns and smoking caldron, suggests a cross between Albert Speer's design for the Nazi Party Nuremberg rally and Maria Montez's altar in the later Universal movie *Cobra Woman*."[62] In such a mix of the ominous and absurd, it is no surprise that the actual African American roots are problematically effaced in Whiteman's idealized version of orchestral jazz, aglow as it is in Technicolor turquoises, reds, and golds.

Even as *King of Jazz* presented a largely whitewashed history of jazz that was particular to the U.S. racial and cultural politics of its day, the film did surprisingly well on the global market. It took in approximately $1.2 million from the overseas box office, as opposed to an anemic $549,000 on the domestic market.[63] This was due in part to Whiteman's international fame, and also to the international market's not yet being fully saturated by staged musicals as the U.S. market was by 1930. Further, as Layton and Pierce richly document, Universal approached the film from the outset as a hybrid, multilingual early sound production. Like many U.S. companies in the 1920s, Universal was highly dependent on foreign sales—approximately 35 percent of its revenues— and the coming of sound threatened the bottom line of many studios because of the potential disruption of foreign sales across language barriers.[64] Multilingual productions—films produced simultaneously in multiple languages, typically on the same sets but with different actors and lower budgets—helped companies navigate the transition with minimal disruption. However, with the revue structure and international appeal of Whiteman, Universal undertook a hybrid approach to the multilingual production. It kept many of the Whiteman orchestral scenes while inserting new foreign-language skits and replacing the master of ceremonies, Charles Irwin, with native language speakers— for instance, with Bela Lugosi for the Hungarian version. Universal initially planned sixteen different multilingual versions of the film, but in the end only produced nine of them—in Hungarian, French, German, Italian, Spanish, Portuguese, Czech, Swedish, and Japanese.

In terms of color, however, Universal's multilingual approach raised problems for the company and for Technicolor. As mentioned earlier, Technicolor was not able to expand its factories internationally until the mid-1930s, when it set up Technicolor Ltd in Great Britain. Before then all foreign-release color prints had to be printed at Technicolor's U.S. labs, which increased shipping charges; for black-and-white prints, the negatives could be shipped internationally to be printed and distributed locally. In part to avoid the extra shipping expenses, Universal produced some of the new sequences in black and white, which could be printed overseas. Further, in an attempt to make the soundtrack as flexible as possible in foreign markets, Universal shifted the sound method from Movietone sound-on-film in the U.S. version to sound-on-disc for the

foreign prints.[65] The company thus produced an incredibly wide variety of international variations of the film, and this tailored approach proved successful in foreign markets, if not at home.

As these examples reveal, Technicolor and the Hollywood studios negotiated technical issues as well as the racial coding of color as they navigated the problems that sound and color raised for an international market at the beginning of a global Depression. Technicolor's difficulties with expansion in the United States to meet domestic demands created sustained opportunities for technical innovation abroad, even when other firms were less capitalized. Even as it moved into its renowned three-strip phase from 1932 on, Technicolor still struggled for much of the 1930s to find the right balance of style and cultural import as well as the technical capabilities to achieve it, as Scott Higgins has shown.[66] As the decade progressed, the company refined its color designs in relation to classical narration, particularly through the systematizing work of Natalie Kalmus and the Color Control Department, and with its stylistic standards locking in place, Technicolor began to expand more forcefully in the global market.

Technicolor's international moves did not take place in a vacuum, as various companies in Europe were also innovating color processes at the end of the 1920s. In Great Britain, systems such as Cinecolor, Raycol, Talkicolor, and Dufaycolor were developed in tandem with the transition to sound, with varying success. Many of these processes preceded the sound transition, as Britain had made substantial innovations in photographic color systems throughout the silent era, often with extensive international collaboration, as we have discussed. For example, the Austrian chemist Anton Bernardi developed Raycol and relocated to Great Britain in 1926 in an attempt to acquire financial backing for the process, which eventually resulted in the formation of Raycol Ltd in collaboration with filmmaker Maurice Elvey and others. A complicated two-color additive system, Raycol did not make a large impact. The company attempted to recruit the famous novelist Elinor Glyn to adapt one of her novels, *Knowing Men*, as a color and sound film using the process. These plans broke down, but Glyn ended up working with Bernardi through another color process he was involved with, Talkicolor, a two-color subtractive bipack system, and United Artists signed on to distribute the film internationally.[67] However, even as it was filmed in color, the transfer from the Talkicolor negative to a positive print proved problematic, and it could only be shown in black and white. Coupled with harsh reviews, the film flopped, and Talkicolor dissolved.[68]

Another process that illustrates the international development of color is the Keller-Dorian system, which was licensed in 1928 in Great Britain as the Blattner Keller-Dorian process and promoted as Moviecolor by Ludwig Blattner, a German-born inventor, director, and studio owner based in London. As François Ede has detailed, Keller-Dorian was a lenticular process developed in France beginning in 1908 by Rodolphe Berthon with the support of the

industrialist Albert Keller-Dorian.[69] It was not until 1922 that a functioning prototype was in operation for filmmaking, and during the 1920s it was experimented with by Able Gance for *Napoléon* and by Robert and Sonia Delaunay, among others, as discussed in chapter 5. Berthon and Keller-Dorian established the Société du film en couleurs Keller-Dorian to exploit the process in the 1920s. However, by the end of the decade, the company was in financial disorder and began selling off patents and distribution rights. Eastman Kodak acquired some of the Keller-Dorian patents in the United States (with rights also in Canada and Australia) and used them to develop Kodacolor for the amateur 16mm market. Blattner acquired the distribution rights for Great Britain and the rest of the world except for Kodak's regions of distribution.[70] Blattner debuted several short color films, with positive reviews:

> The programme on Sunday also included a demonstration of the Keller-Dorian colour film process known as Moviecolor, of which Mr. Blattner owns the British rights. In certain technical aspects this process is probably the best yet seen in this country. There is no chromatic flicker, and the colours—particularly towards the red end of the spectrum—are not unpleasant.[71]

Karl Freund, who was contracted with Blattner, was involved with the color process; it was announced that he was working on a feature sound and color film called *Refuge*, but apparently it was not completed.[72] Seemingly for technical and financial reasons, Blattner ended up selling his rights in the Keller-Dorian process to Technicolor in 1930, just as Technicolor was considering expansion into Great Britain:

> Technicolor has entered into an agreement with Keller-Dorian, it is announced by the Ludwig Blattner Pictures Corps., Ltd., which controls the latter color process. The statement reads in part: "The exploitation and manufacturing interests in connection with the Keller-Dorian color-processes, as contained in the license granted by Moviecolor, Ltd., to the Blattner Corp., are now solely controlled by the Technicolor Co."[73]

According to Troland's Technicolor diaries, he had been experimenting since 1929 with adapting Keller-Dorian negatives for imbibition printing.[74] However, as Layton and Pierce note, Technicolor was overall unimpressed with the process. Still, it continued into the 1940s, eventually being adapted as Thomsoncolor in France, where it was deployed unsuccessfully for Jacques Tati's *Jour de fête* in 1947.[75]

As Keller-Dorian exemplifies, the transnational circulation of color processes, inventors, and patents defined this era of color innovation. However, these developments occurred in fits and starts, as technical and financial as

well as cultural issues strongly shaped the renovation of color in the cinematic field. As a final note illustrating the complexities of such transnational negotiations, Moviecolor, following its failure to exploit the Keller-Dorian process, resurfaced to sue Technicolor and Kodak in the United States in 1959, claiming that the defendants had, in 1930, violated antitrust laws by colluding to suppress the process, causing Moviecolor to become insolvent.[76] The case made it to the federal appeals level, but found no traction in the courts. Still, such struggles illustrate the complexities, shifting power relations, and long durées of technical change within the cultural field. If photographic color systems struggled through this period of transition to sound, the effects on applied color systems were even more strongly felt.

Applied Color and Sound

The end of the 1920s has been seen as the end of applied coloring in cinema, but this is inaccurate: these earlier processes were not made obsolete with the coming of sound and the rise of Technicolor. However, they did lose their position of dominance in the industry. As already discussed, many photographic color systems adapted applied coloring techniques into their processes during the 1920s: Technicolor's imbibition printing was informed by the Handschiegl lithographic process, and tinting and toning methods were used in Multicolor's process to filter light and create two-color images. In these ways, the techniques of applied coloring had a long life after the 1920s, even if in relatively invisible ways. Beyond technical repurposing, however, one can examine applied coloring methods in their own right and trace their continued use at the end of the decade and beyond. The coming of sound as well as the influx of new photographic coloring processes reduced the practice of adding color manually to films, yet these techniques did not disappear. Even as the excitement over photographic color, and Technicolor in particular, surged in the late 1920s, it was far from clear that photographic color would in fact take over the industry, particularly in light of the downturn in international markets and variations in aesthetic preferences and technical developments around the world.

The trade press documents key examples of hand coloring, stenciling, tinting, and toning continuing into the 1930s and beyond. For instance, Gustav Brock explained his ongoing work as a hand colorist for feature films at the 1931 SMPE Symposium of Color, and he subsequently published his account, arguing for the vitality of hand coloring in an era of increased color consciousness.[77] His coloring studio was in New York City, and much of his work was for premiere screenings in the city. As examined in chapter 5, he promoted the use of color only for brief film sequences that were meant to enhance the diegetic meaning already inherent to a scene, rather than adding a new layer of

Gustav Brock

The finishing touch of refinement on an elaborate production is the handcoloring by

Figure 6.7 Advertisement by Gustav Brock promoting his work, from *Film Daily Yearbook* (1935).

meaning. The hand coloring of fire was his specialty. In 1925, he noted: "Where fire is shown on the screen, hand coloring is indispensable. To look at fire without coloring is like looking at a man playing a violin without hearing the tune. Fire makes every other thing look colorless in comparison."[78] Again, in 1931, he claimed that colored flames "always impress themselves so dominatingly on our sense of sight that all other surrounding colors are reduced to half-lights and shadows."[79] Brock's invocation of color consciousness was also related to fire: "At this time when motion picture audiences wherever films are shown are becoming 'color conscious' they are keenly disappointed if they are viewing a picture in which there are fire scenes and these scenes are not made to represent the actually [sic] coloring of flames."[80] It is as if Brock took to heart the old idea that color's Latin root was *calor*, fire, a heavenly property of light.

As exemplified in his comparison of color to the harmony of a violin, Brock frequently invoked a musical analogy to theorize color's function in film. Taking not just a musical but also a linguistic angle, he explained at the end of his 1931 SMPE article that "when intelligently used, there will be just enough coloring to permit the color to 'talk,' 'explain,' emphasize, and enhance the illusion which the picture is intended to create."[81] Beyond the analogy, he was also adept at hand coloring both silent and sound films, estimating that he could color on average approximately fifteen feet per hour.[82] With the coming of sound, he noted that, because sound films were now predominantly edited as negatives and printed to spliceless positive reels to avoid unnecessary pops on soundtracks (as opposed to positive-edited prints that made it easier to insert short color sequences, as discussed in chapter 4), colorists had to spend more time winding through films:

> Since the advent of the talking picture each color job contained in each reel of a picture has been delivered for coloring in a thousand-foot reel. In order to color a scene twenty feet long in a picture of a release of 200 prints, the hand-color man will have to wind and rewind 200,000 feet of film and carry responsibility for the proper handling of all that film, in addition to having to color it.[83]

In terms of sound films, Brock largely collaborated with S. L. "Roxy" Rothafel, coloring sound prints for Rothafel-managed cinemas in New York City, such as the Sound Picture Theatre of Rockefeller Center.[84] Based on summaries in the *Film Daily*, some of the U.S. films that Brock colored in the 1930s were *Pickanniny Blues* (Mannie Davis and John Foster, 1932), a short animation based on Aesop fables; *The Death Kiss* (Edwin L. Marin, 1932); *The Next War* (1933); *Captured!* (Roy Del Ruth, 1933); *Moonlight and Pretzels* (Karl Freund, 1933); *Little Women* (George Cukor, 1933), with work "on colored fireplaces and lighted candles which help tremendously in heightening the cozy atmosphere in contrast to the icy blasts outside and getting over the spirit of the

Yuletide"; *The Vampire Bat* (Frank Strayer, 1933); *Sisters Under the Skin* (David Burton, 1934); *Here Comes the Navy* (Lloyd Bacon, 1934), including "a booming gun, a fire in the gun turret of a boat approaching a battleship at night, a self-illuminating lifesaving buoy, and the American flag"; and "the fire scene which climaxes the action" in *Adventure Girl* (Herman Raymaker, 1934).[85] As the details from the *Film Daily* indicate, Brock indeed continued selective hand coloring in the sound era, particularly focusing on fire elements for U.S. releases.

Both *The Vampire Bat* and *The Death Kiss* are extant and worth further analysis. Color sequences in *The Vampire Bat* have been recreated by UCLA Film Archives; those in *The Death Kiss* have been preserved and restored by the Library of Congress. As Scott MacQueen of UCLA recounts, he discovered advertising by Brock indicating that *The Vampire Bat* had been colored during the film's "man hunt" scene, and the archive drew from the LOC material to model a reconstruction of the hand coloring.[86] The film was a poverty-row horror production by Majestic Pictures, starring Fay Wray and Lionel Atwill. The setting is an Eastern European village, where the townspeople mistakenly suspect that a mentally disabled man, Herman Glieb, is a vampire responsible for recent corpses that have turned up drained of their blood. In the hand-colored sequence set at night, townspeople chase Glieb with torches into a cave, where he sadly jumps to his death to escape. Unfortunately for the townspeople, they have the wrong man—a mad scientist being the real murderer. Knowing Brock's predilection for coloring fire effects, UCLA digitally rotoscoped and colored the torchlights in vibrant yellow-orange for a remarkable effect, as the saturated hues light up the night among the diegetic screams of Glieb pursued by the torch-wielding men and their howling hound dogs.

The Death Kiss is also spectacular in its use of hand coloring and sound, even as it too uses limited coloring effects. A Tiffany Pictures poverty-row production, the film presents a murder mystery reflexively set in a film studio; it

LOOK AT THE MAN HUNT IN "THE VAMPIRE BAT"

Brock.

HAND COLORING
of POSITIVE PRINTS

528 Riverside Drive New York City
UNiversity 4-2073

Figure 6.8 Advertisement by Gustav Brock for his work on *The Vampire Bat* (1933), from *Film Daily* 61, no. 19 (January 24, 1933).

reunites actors David Manners (playing a screenwriter), Bela Lugosi (a studio manager), and Edward Van Sloan (a director), all of whom were previously in *Dracula* (Tod Browning, U.S., 1931). Tiffany had specialized in color productions in the late 1920s, producing a series of short Color Symphony productions using two-color, dye-transfer Technicolor as well as the successful and much costlier dramatic feature *Mamba* (Albert S. Rogell, U.S., 1930), which was marketed as the first dramatic feature entirely in Technicolor and had a production budget running close to $500,000, in contrast to the $50,000 budget for *The Death Kiss*.

The murder in *The Death Kiss* takes place in the first scene, which turns out to be a film within a film (also titled *The Death Kiss*). A beautiful woman approaches a well-dressed man, Myles Brent, outside an Art Deco café, marks him with a kiss, and shortly afterward he is gunned down by unknown assailants. After his death, a dramatic pan to the right reveals that the killing was in fact part of a scene being shot in a studio—a "terrible" take, according to the director, Tom Avery (Van Sloan), in which Brent was overly "gymnastic" in his death. Brent does not react to the critique, as he has in fact been murdered: one of the prop guns has been replaced with a loaded one. After the police arrive and begin their investigation, they decide to watch the footage to see what clues might be gleaned from the shoot, which leads to the first of two hand-colored sequences in the film. As the police, studio execs, and actors file into a studio theater to watch the dailies, a single light sconce on the left of the screen is colored light yellow, and as the projector begins to cast light through the projection window, it too is colored yellow. The film cuts to the screen, and the scene that began the film is now replayed, though from a different angle (forty-five degrees to the right) and with the on-set directions now audible (the clapper, "rolling," "action"). The woman approaches and kisses Brent again, but just as he is about to be shot, the screen dramatically erupts in orange hand-colored flames and white noise fills the soundtrack (color plate 6.4). As the police quickly discover, the murderer, already disappeared, has slipped into the projection booth, knocked out the projectionist, and lit the nitrate print on fire with a cigarette. The second hand-colored sequence is at the film's climax, when the killer—who turns out to be Avery, the director, who is out for revenge on Brent for having an affair with his wife—is finally revealed and pursued by police among the catwalks above the soundstage. Avery has cut the lights, so the police resort to flashlights, colored yellow, and in the ensuing dramatic gunfight the bullet flashes are colored bright orange, amplifying the pop of the gunshots. All of these lighting effects were colored by Brock.

Purportedly at a preview screening, Brock's coloring created such a stir—presumably the shot of the burning film—that the producers decided to color all three hundred copies of the film for distribution, as opposed only to some

of the premier prints.[87] The large number of colored prints is probably the reason the Library of Congress has been able to preserve and restore a print of the film with Brock's coloring, whereas most of Brock's work from the 1920s and 1930s, which generally featured in much smaller premiere print runs, has now been lost—much as the fictional fire engulfs the scene of *The Death Kiss*. Color, like nitrate film, glows beautifully but too often without an archival shelf life.

Brock continued to color films into the 1940s, though his work appears to have tapered off after 1934, even though he adapted his methods in 1941 to incorporate 16mm Kodachrome stock to produce reduction copies of his 35mm hand-colored prints.[88] He even unsuccessfully propositioned Alfred Hitchcock about hand coloring the opening fire (of course) in *Saboteur* for twenty-five cents a foot, "which will startle the audience and which will make your fire scenes live and be remembered."[89] Hitchcock did not reply, but he would use a similar hand-tinting effect a few years later at the end of *Spellbound* (1945), though it functions differently from Brock's more dieget-ic-oriented work, adding an Expressionist red death tint to the film's final first-person-point-of-view suicide.

Just as hand coloring made the transition to sound through hand colorists such as Brock, so did stenciling, specifically through Pathé Cinema, which continued to use and innovate the process into the 1930s. The relative longevity of stenciling was due in part to Pathé's financial disarray in the 1920s, which limited investment in the development of new color technologies, even as laboratory technicians tested various possibilities.[90] Also, as discussed earlier, it was far from certain, particularly in Europe, that photographic color would dominate film production in the ensuing years, because of both the costs of systems such as Technicolor and the aesthetic resistance to the saturated palettes coming from the United States.[91] In this context, Pathé's stenciling system was continually refined, from the first decade of the 1900s, when the company introduced it as "Pathécolor," through the 1920s, when it made minor changes and rebranded it as "Pathéchrome." The company in fact trademarked Pathéchrome in 1914; however, it did not introduce it as a revised process until 1928.[92] From accounts, it is difficult to ascertain how much of a renovation of the stencil-cutting and coloring processes it actually was; it seems largely to be a rebranding to take advantage of the color boom at the end of the decade. William Kelley's account of the process at the 1931 Color Symposium, for instance, makes no technical distinction between Pathéchrome and what came before it, and the stencil-cutting and coloring devices pictured in the article appear to be the same as those used for Pathécolor stenciling—the dye-applicator device, in particular, dates back to 1908.[93] The main technical refinement with Pathéchrome appears to have been the deployment of a new DuPont-Pathé film stock

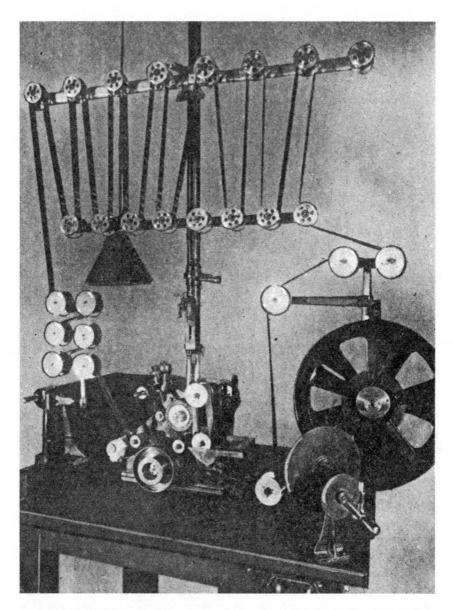

Figure 6.9 The Pathéchrome dye-applicator device as reproduced in William V. D. Kelley's article in *Journal of Society of Motion Picture Engineers* 17, no. 2 (August 1, 1931).

(developed by DuPont-Pathé Film Manufacturing Company) that was treated to enhance color dyes, giving them greater brilliance and higher clarity:

> The process, using a special color positive stock made by DuPont-Pathé, has been furthered by Terry Ramsaye, editor-in-chief for Pathé's non-dramatic production [. . .]. The special stock is said to have had chemical preparation which makes it more receptive to color, with a formula that permits transmission of light through the nitro-cellulose base with less color absorption and filtration than before.[94]

Ramsaye was the author of *Million and One Nights* (1926), a seminal history of some of silent film and of color, and as the *Moving Picture World* article just quoted makes clear, his previous experience with color cinema was extensive, including involvement with both Prizmacolor and Kinemacolor.[95]

Pathé's rebranding of the process was not just to draw attention to it during the color boom but also, as seen in the same article, to emphasize Pathéchrome's compatibility with sound: "A chromatic treatment of the Pathé rooster will be one of the coming demonstrations. What with the application of sound as well, there should be indeed a colorful crowing."[96] However, it was not a completely smooth combination. The *Film Daily* detailed some of the technical difficulties that Pathé faced with sound and color:

> Owing to the fact that prints for Pathéchrome have to be on special stock, the color being applied by machine through the medium of stencils which are made by hand, many difficulties for sound films were presented. They were finally overcome by the use of positive prints with sound track, made in the United States, to which the Pathéchrome coloring was added in the laboratory of the Pathé Cinema, Ltd., in Vincennes, in France. This is said to be the first time that prints made in the United States have been colored abroad.[97]

Though not mentioned directly, it is clear that the stencil-cutting and coloring processes required technicians to take great care around the soundtrack—the colorants used could easily interfere with the readability of the sound. Further, all Pathéchrome coloring took place in Paris, where Pathé's color lab had been established in the neighborhood of Vincennes since 1905, meaning that films produced and edited outside of France would be finished largely by technicians not involved with the production, introducing delays and also potential mismatches between overall film style and coloring. Nonetheless, reviews of Pathéchrome-sound films were generally positive, primarily centered on the newsreels that Ramsaye worked on in the United States. As the *Pathé Sun* noted in 1929, some of the newsreel items coming out in sound and color dealt with standard nonfiction material for the time—exoticism, travel locations, and

female spectacle: an episode on the Stoney Tribe of the Canadian Northwest that was "as colorful as an Indian blanket," a piece on Cape Cod, another on the wine regions of New York and California, and a "fairy story" about construction in Hollywood featuring "bathing girls" who are "nice to look at."[98] A few unidentified frame samples of three different Pathéchrome sound films can be found in the Kodak Film Samples Collection at the National Science and Media Museum in Bradford, England, including frames from a nonfiction film on a small river; from what appears to be a fiction film, combining sepia toning and stenciling, of two men talking possibly at a nightclub; and from a film featuring three women in elegant blue, pink, and green evening gowns (color plate 6.5).[99]

Other international newsreel examples, some of which are extant, can be found in the British Pathé archive, which would have been included in the serials Pathétone Weekly and the Pathé Pictorial, though these Pathéchrome sequences generally have unknown dates and are preserved without sound. Like the examples from the United States, though, they hew closely to the generic prescripts of nonfiction of the time: scenic views of England and Scotland, such as Lakeland Glimpses—With Camera and Car (ca. 1930) centered in the Lake District with views of Keswick, Derwentwater, and Skiddaw; London's Lungs (ca. 1929) focused on the parks around London; and Palace of the Stuarts (ca. 1929) about the Falkland Palace in Scotland.[100] Together, these late 1920s travelogues use Pathéchrome to craft a picturesque view of popular tourist sites in the UK. One of the intertitles in Lakeland Glimpses notes that the locales featured "conjure up visions of some of England's prettiest scenery," after which comes an extreme bird's-eye long shot looking down over a village with a lake and hills in the distance. The following shot is a relatively closer ground-level long shot of a man hiking along a road, away from the camera toward the distant hills among rolling farm fields, thus creating a structural movement into the scene for the spectator through identification with the walker. The stenciling of these shots in bucolic greens and blues harmonizes with the Romantic imagery, transporting one into the beauty of the landscape. The coloring, like the travelogue itself, works to establish the cultural capital of this landscape—both the value of the film and the way in which it compounds with the tourist imagery of the place.[101]

One of the more striking Pathéchrome British newsreels from the era examines carpet weaving in Spain; it comes as the second part of a Pathéchrome reel, the first part focusing on a waterfall near Portland, Oregon, and its Native American heritage.[102] Similarly, the Spanish sequence emphasizes the exotic and ancient Moorish origins of carpet weaving in El Albayzín, a district of Granada. It begins with a sepia-toned high-angle pan across El Albayzín before cutting inside a weaving workshop where two women are at work organizing wool. The interior sequence is a mix of stencil coloring, in pastel yellows, pinks, and blues, with sepia-toned shots of women working at weaving looms

and spinning wheels. Women's hands are shown at work on stencil-colored shuttle-looms, with the wool arranged by color. A final intertitle notes, "Every design is a tradition—frozen into form and color," before the film cuts to a final overhead image of a completed rug, resplendent in Orientalist design and stencil colors, which recalls the arabesque background designs of Pathé's earliest trick and fairy stencil films, such as Gaston Velle's *Les fleurs animées* (1906). This mixture of history, international exoticism, and the gendered labor practices of home fashions encodes the intermedial and cross-field nature of color at the end of the decade.

In addition to newsreels, Pathé also deployed Pathéchrome on a limited number of sound feature films at the turn of the decade, much as it had earlier outsourced its color services to films such as *Cirano di Bergerac* (Augusto Genina, France/Italy, 1923/1925) and *Casanova* (Alexandre Volkoff, France, 1927), as discussed in chapter 5. The British musical *Elstree Calling* (Adrian Brunel and others, British International Pictures, UK, 1930) is one of the only sound features with Pathéchrome sequences known to be extant. It is also a film that Alfred Hitchcock had a minor hand in shaping, along with a number of other directors contracted with the production company. It features Anna May Wong, in black and white, in one of her earliest speaking rolls (in Chinese) in a pie-throwing skit as Katherina adapted from Shakespeare's *Taming of the Shrew*.[103]

In keeping with U.S. musicals of the time—such as *Fox Movietone Follies of 1929* (David Butler, U.S., 1929) and *King of Jazz*—*Elstree Calling* is a variety revue of various well-known British performers loosely strung together with a few running gags, specifically through a fictional television broadcast being produced of the revue. Like other musicals of the era, its use of color is prominent. Lacking the resources of U.S. studios, the film was produced by outsourcing the work to Pathé for postproduction stenciling rather than filming in Technicolor or Multicolor. British reviews did not discuss the film's coloring in detail, but generally noted the discrepancy in style between U.S. revues and *Elstree Calling* while praising the film for its alternative and firmly British approach. Not all the reviews were positive: James Agate in the *Tatler* described the film as "unmitigated footle, which would have bored an infants' school."[104] In a much more positive review, the *Yorkshire Post* noted approvingly that "no effort has been made to rival the lavishness of Hollywood. No British company could at present afford to do this successfully, and in any case an ounce of brains is worth more to a revue than a ton of spectacular staging."[105] Similarly, the *Dundee Evening Telegraph* explained, "The American efforts go entirely for spectacle and lavishness, with the result that they have sacrificed intimacy that is the greatest charm of pictures of this sort," noting that *Elstree Calling* successfully captures this carrying a "feeling of intimacy" across the footlights through its use of close-ups.[106] Even if the film was relatively restrained in its staging,

the Alhambra Theatre that premiered it boosted its spectacular, and perhaps simultaneously intimate, nature by projecting it on a 50 percent larger screen than had been used before.[107]

The *Yorkshire Post* review was one of the few that referenced the topic of color, but not specifically regarding *Elstree Calling*. It noted that only Hollywood films had the resources to pursue the "colour question" in any serious way, but nonetheless predicted that "within a year from now British producers will be pursuing colour as anxiously—and as belatedly—as a year ago they were pursuing sound."[108] *Elstree Calling* deploys Pathéchrome in four scenes: Helen Burnell and the Adelphi Girls performing "My Heart Is Singing"; the Charlot Girls in maids' uniforms performing a chorus-line version of "The Lady's Maid Is Always in the Know"; Jack Hulbert and Helen Burnell performing "The Thought Never Entered My Head"; and the closing number with Cicely Courtneidge and the Adelphi Girls performing "I'm Falling in Love." As John Mundy astutely notes, through the choice of coloring for these particular skits, the film structures a "hierarchy of popular entertainment" within the film, as the Pathéchrome "numbers which come from the more respectable upmarket variety and West End shows . . . contrast to the black and white music-hall sequences" that comprise the rest of the film, as in the raucous pie-in-the-face Anna May Wong gag.[109] The actual performances of the colored sequences reinforce this, as Mundy points out, with a romantic quality that hearkens to the Tin Pan Alley tradition of Hollywood revues.

Such an upscale romantic aura is evident from the very beginning of Burnell's first Pathéchrome performance, approximately eleven and a half minutes into the film. In contrast to the music-hall performances of Teddy Brown and his Orchestra that open the film and the ensuing blackface performance by the Three Eddies, the Burnell scene that follows shifts registers to a resplendent boudoir. Dressed in a luxurious yellow-stenciled gown and sitting on a copper-colored bedspread against a blue-green Art Deco background, Burnell turns directly to the camera in intimate direct address and begins singing the opening lines, "Years ago, a poet said, fools rush in where angels fear to tread," with piano accompaniment. She stands and dances across the room, as the camera cuts to a wider long shot, as the Adelphi Girls, similarly robed in copper and yellow gowns, enter to accompany her classy love song and dance. Golden spotlights illuminate the scene, and in conjunction with the Art Deco design of the space, particularly through the room's wall sconces, the scene exemplifies the chromatic aura of the era. The other Burnell performance with Hulbert is similarly romantic and Art Deco themed, as are the other two stenciled performances, by the flapperesque Charlot Girls and by Courtneidge; all share a similar gold, copper, and blue-green palette.

British International Pictures promoted the film as being in color: "a riot of natural colour" and "Singing, Dancing, Colour Talkie."[110] The natural color

promotion further calls attention to the way in which what was considered natural about color in that era was not necessarily tied to photographic reproducibility, but instead was a matter of style and aesthetics. Additionally, the film played with Pathétone newsreels, so very likely it was not the only Pathéchrome film shown during screenings; if stenciled nonfiction screened alongside it, this too would have reinforced the naturalness of the applied colors.[111] *Elstree Calling* was a relative success within Britain, to the extent that British International Pictures made plans for nine multilingual versions of it to be distributed throughout Europe.[112] However, these never came to pass, and the film is known largely because of Hitchcock's minor role in producing it. It is uncertain how many other films British International Pictures produced with Pathéchrome sequences. The revue *Harmony Heaven* (Thomas Bentley, UK, 1930) had some sequences stenciled, as did *The Romance of Seville* (Norman Walker, UK, 1931).[113] Soon after these films, however, British International Pictures likely shifted focus to photographic color systems, as in its use of Dufaycolor in *Radio Parade of 1935* (Arthur B. Woods, UK, 1934).

In spite of these examples of hand coloring and stenciling, it is clear that they become relatively minor practices from the 1930s on. In a vibrant afterlife worth noting, these methods went underground, becoming anchored in experimental practices of the 1930s and in the postwar avant-garde, from Len Lye and Oskar Fischinger to Harry Smith, Norman McLaren, and Stan Brakhage, among others. Filmmakers such as Lye in particular adapted earlier hand coloring and stenciling techniques to photographic coloring, enhancing his artisanal works—and making them reproducible—through his experiments with Dufaycolor, Gasparcolor, and three-strip Technicolor during the 1930s. He hand colored and stenciled his original materials in a film such as *Rainbow Dance* (1936) with the intention of modifying them further through misaligning the print registration of the Gasparcolor process, thus hybridizing applied and photographic coloring processes for abstract, and musically rhythmic, ends.

Beyond hand coloring and stenciling, toning and particularly tinting were much more successful in making the sound transition. They also had lasting influence on the aesthetic ideals that shaped the use of photographic color in the sound era, as can be demonstrated through two opposing pages in *American Cinematographer* in June 1932. On the left page is an article by cinematographer and engineer Dr. L. M. Dieterich on "The Relative Values of Sound and Color," which is devoted to the synesthetic ways in which one processes sound and color in film—that is, how these audiovisual elements affect our senses and emotions holistically, flowing over individual sensory perceptions into a cross-modal experience, as in seeing sound and hearing color.[114] Dieterich proposes a more informed, "psychophysiological" approach to sound and color design that pays closer attention to the formal aspects of film to tap more thoroughly into the aesthetic perceptions of the spectator. This type of approach was prevalent

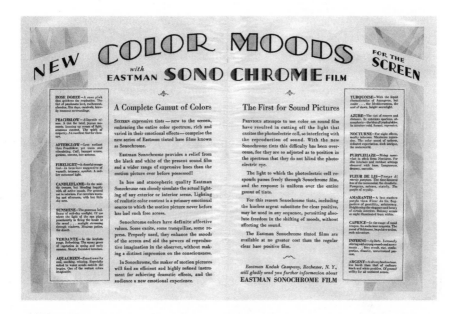

Figure 6.10 Kodak Sonochrome advertisement in *Film Daily* 53, no. 69 (September 21, 1930).

in both studies and technical treatises on color during the 1920s, and it was a common cross-disciplinary interest among artists as well as engineers, such as Loyd Jones at Kodak and Leonard Troland at Technicolor, as discussed in earlier chapters.

On the page opposite Dieterich's scientific analysis of color, the second article reflects the editorial connections being made about sound and color at the time: "Tinted Stock for Better Pictures," written by cinematographer Victor Milner, who worked for Paramount on the films of Rouben Mamoulian and Ernst Lubitsch, among others.[115] Milner extols the virtues of Kodak's Sonochrome pretinted film stocks. As discussed in chapter 1 in relation to *The Taming of the Shrew* (Sam Taylor, U.S., 1929), Sonochrome was introduced in 1929 as a positive print stock, available in sixteen colors, designed to be used with sound-on-film prints; the dyes were calibrated not to interfere with the soundtrack during projection (as opposed to many of the tints that had been applied previously, which obscured optical soundtracks, absorbing too much of the light passing through). When Kodak revised its stock in 1940 to produce a more fine-grain positive, the company reduced the total number of Sonochrome tints to three.[116] The name Sonochrome combines sound (*sono*) with color (*chrome*), invoking a synesthetic analogy—hence the editorial logic of juxtaposing the two articles.

Not only was Sonochrome based at least metaphorically on color-sound correspondences; also inherent to it was the codification of the sensual and

emotional resonance of its tints. The stock's promotional material claimed: "Sonochrome colors have definite affective values. Some excite, some tranquilize, some repress. Properly used, they enhance the moods of the screen and aid the powers of reproductive imagination in the observer, without making a distinct impression on the consciousness."[117] Promotional materials included color guides that elaborated the particular emotional and physiological meanings of the tints—for example, "VERDANTE: In the *larghetto* range [a musical term for a slow tempo]. Refreshing. The sunny green of vegetation in spring and early summer. Simply furnished interiors."[118]

Drawing from this promotional material, and specifically from Loyd Jones's writings on the film stock for Kodak, Milner discusses the cinematic potential of Sonochrome to help filmmakers "in photographing thoughts," by creating for the spectator "a definite series of emotional responses to color." Jones and Kodak often emphasized the scientific nature of these emotional responses: "that colors do have certain consistent emotional effects is well established by psychological tests."[119] Milner elaborates:

> Like all psychological factors that appeal to the subjective rather than the objective, color-reactions are somewhat stylized: they deal more with the sensation evoked in consciousness than with color as it actually is. . . . The correct tint to use for any given scene or sequence must be determined not alone by the actual coloration of the setting, but by the color-associations known to exist in the audience's mind. For instance, a scene printed on green stock is objectively correct for forest and garden scenes; but subjectively, the green connotes springtime—youth, freshness, hope, and aspiration."[120]

The type of scientific thinking inherent in this approach to color design, both in Milner and Sonochrome and also in the related synesthetic approach of Dieterich, revolves around the concept of "color consciousness" that Loyd Jones adopted for Kodak in 1929 from prior usages in colorant and art-education discourses, and which both Herbert Kalmus and more famously Natalie Kalmus took up and promoted for Technicolor.[121] It meant systemizing color scientifically, not only in practice but also by educating and uplifting the motion-picture public to be attuned to the emotional and aesthetic meanings of color.

While this type of aesthetic ideal was much discussed in relation to color cinema of the late 1920s and early 1930s, it is also important to look at how such notions were actually deployed at the time and throughout the classical era. Pretinted sound stocks by Kodak were in use for longer than one would assume. Kodak produced them until the 1960s, when photographic color became the norm over black-and-white film, and an incredible amount of material was tinted throughout this era—something that has largely been forgotten, as Anthony L'Abbate notes in the most extensive study of sound-film

tinting and toning.[122] As examples, Milner refers to two recent films he worked on with "directors who understood the value of tinted film in enhancing the pictorial and emotional appeal of their productions."[123] Based on Milner's credits and the timeline, one of these films was almost certainly Ernst Lubitsch's *One Hour with You* (1932). William Stull's review of the film specifically calls attention to the tinting:

> But the outstanding feature of the film, technically, is the extensive use that has been made of tinted-base positive stock for the release prints. The picture owes much of its visual charm to the fact that all of the night interior sequences have been printed to Candleflame stock, and the night exteriors on Lavender-based stock. Mr. Milner and Mr. Lubitsch deserve a vote of thanks from the cinematographic community for having persuaded the Paramount powers that to be take this step. And—the sound engineers who have held that tinted-base stock injured the quality of reproduced sound should by all means see this film, for (to this observer at least) the quality of the sound on the tinted portions of the film was distinctly better than that of those for which ordinary untinted film had been used.[124]

The UCLA Film and Television Archive has restored the film, with approximately half of it tinted in sepia and lavender hues. These colors, however, have not been transferred to video or streaming services, which is common for films of the era. Tints and tones almost never made the transition to safety stock in the 1950s, as many of these transfers were meant for rebroadcast on black-and-white televisions of the era, and as a result, the tinted and toned hues of sound films were largely forgotten. Stull notes a few months later that Milner was also involved in another tinted sound film, *This Is the Night* (Frank Tuttle, Paramount, US, 1932). Immediately after praising the film's use of sound, Stull points out that "several sequences in this picture, too, are printed on tinted-base positive, to excellent advantage."[125] Tinting also persisted outside of the United States. In Great Britain, Rachael Low notes that even as the process began to decline with the coming of sound, it was still deployed periodically. For instance, John Grierson's *Drifters* (1929) contained multiple tints:

> The exquisitely beautiful cold, green-grey gleam of a fisherman's glass float on the night swell, the deep green underwater shots and the palest lavender grey of dawn in the white-housed village on the shore show what could be done with tinting, and justify the nostalgic affection with which many early filmmakers looked back on it.[126]

Regarding the continued use of toning, J. I. Crabtree and W. Marsh discuss in 1931 Kodak's testing of toning processes with sound film: "Tests with

both the variable area and variable density types of sound records indicated that toning by the above method had little or no effect on sound quality. It is therefore possible to apply this method to sound prints."[127] Three sound examples from the British Pathé archives from ca. 1932 appear to be sepia toned: a reel about swimmers in Florida titled *Water Babies*; another about polar bears in the Miami zoo, *The Bear Truth*; and a reel about Japanese swordsmen, *Big Hits and Big Hitters*.[128] The specific methods used on these reels are unknown, and it appears that Kodak's toning process was not widely adopted. However, in 1937, MGM introduced a new sepia-toning process developed by technician John M. Nickolaus, which is most widely recognizable in the sepia tones of Kansas in *The Wizard of Oz* (Victor Fleming, U.S., 1939).[129] Through the process, MGM was able to produce not only sepia brown but also blue and blue-orange. A 1937 article on the process in the *Motion Picture Daily* sheds light on the difficulties of toning during the early sound era: newer, high-intensity projector bulbs in use then quickly burned off the coatings of older toned films; also, because of the harsh chemicals used in these earlier processes, the soundtracks themselves would be dissolved by the toning process. MGM was able to remedy these problems with Nickolaus's new method, which, according to the same article, it "bridged a gap between black

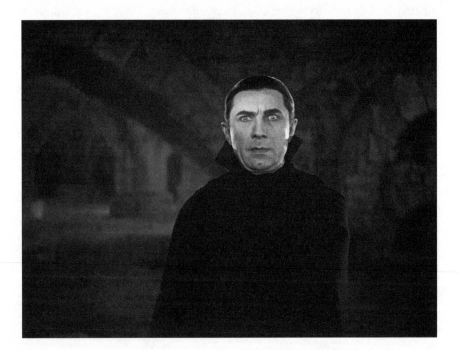

Figure 6.11 Dracula's direct address to the camera, originally tinted in green Verdante in *Dracula* (1931).

and white and color on the screen," without competing with Technicolor and other photographic color processes.[130]

Perhaps the most striking applied-color example from the early sound era is Tod Browning's 1931 *Dracula*, the progenitor of Universal's horror cycle.[131] Though all contemporary copies are in black and white, the film was originally tinted through the use of Sonochrome pretinted film stock, as confirmed by script and print analysis. Specifically, the film was tinted at points in Verdante, the green Sonochrome tint that Milner and Kodak referred to earlier as connoting physiologically "springtime—of youth, freshness, hope, and aspiration."[132] Browning and the designers at Universal may have missed Kodak's color guide, for instead they purportedly marketed this green as being the "color of fear," thematized domestically as well as internationally in the film's print publicity, which repeatedly deployed a deep, sickly green on a variety of posters.[133] Beyond advertisements, Philip J. Riley has noted that a blue-green hue, similar to Count Orlok in *Nosferatu* (F. W. Murnau, Germany, 1922), was also called for in the film's cutting continuity script: "One of the three cutting continuities calls for the introduction scenes in Dracula's Castle between Dracula and Renfield to be tinted a blue-green to enhance the full moon effect. This, as in Murnau's *Nosferatu*, creates a totally different and literally hair-raising mystique and tone missing in today's prints."[134] Confirming the continuity and intermedial promotions, the Library of Congress has preserved an original-picture duplicate negative of the film, cut into continuity, with tinting slugs included on reels five through eight indicating that they should be printed on Verdante stock. The scene referred to by Riley would have been in reel one, which is listed without tinting information on the negative, but the negative itself is splicey, and slug information very likely could have been removed at an earlier date.[135]

To think through the connection of *Dracula* to Verdante, one must reimagine the early scenes in color of Dracula's castle, leading up to when he and Renfield first meet. First, after two extreme long shots of the castle that dissolve into its underground dungeon lair, the film cuts to an elaborate track-in, filmed by Karl Freund, with the camera effortlessly floating across the room to a casket slowing creaking open. A hand inches out from the darkness before the film cuts away to a possum, then to another hand emerging from a different casket, followed by a cut to a wasp emerging from a wasp-sized casket. In the final three shots of the sequence, a woman rises from one of the caskets, a possum crawls into another amid a skeleton, and finally, over what are presumably possum squeaks, another remarkable track-in moves to a medium shot of Bela Lugosi's Dracula staring directly into the camera. This scene is obviously far removed from the springtime connotations of Verdante, even with the never-aging visage of Dracula and the wild fauna of his dungeon. Freshness, hope, and aspiration are not part of these early scenes—or the following one, which shows more of the crumbling castle, full of fake bats and real armadillos.

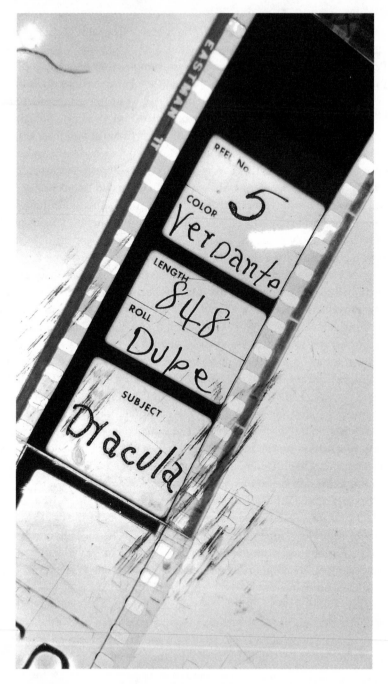

Figure 6.12 Frame slug from *Dracula*, photographed from original picture negative edited into continuity.

Courtesy of the Library of Congress National Audio-Visual Conservation Center, photograph by Abbey Taylor.

To saturate these uncanny creatures with the Verdante green of Sonochrome brings to mind Werner Herzog's famous jungle tirade in *Burden of Dreams* (Les Bank, U.S., 1982) about the perverse "obscenity" and "misery" of nature: "fornication and asphyxiation and choking and fighting for survival and growing and just rotting away." In other words, nature is death, which is fitting for the glowing green aura of both the rainforest surrounding Herzog and Dracula's castle. In the next scene, still in the castle, there is certainly something youthful about Renfield when he enters as the scene's gullible antagonist, but it is of course Lugosi's vampire who steals the show, with his famously slow, cadenced walk and introduction, "I am . . . Dracula." These scenes envisioned in Verdante push against most of Kodak's suggestions for the hue, though they do stay close to the *larghetto* aspect—the slowness of the tempo gives the scenes their glowingly green, uncanny power.[136]

It should be obvious from *Dracula* that Kodak's prescriptions for color meaning in the early sound era should not be taken literally, as they clearly were not during the era, at least by many. Indeed, what has always defined color is its mutability: springtime in one context is a deathly pallor in another. What is useful, though, in these aesthetic ideals are the ways in which they reveal how carefully sound and color were calibrated in terms of their overlapping sensory appeals. It is this coordination that illuminates the audiovisual experience of the era's chromatic modernity.

CHAPTER 7

CONCLUSION

Then the "talkies" came. For good or bad, they were a development—a stirring of the mass, a prod in the back of the industry. Film thought began to move. Tradition loosened, changed, broke. New men came into the studios, bringing with them fresh interests and knowledge—the idea of film entertainment grew beyond the old limits of a flat black-and-white image on a silent screen. The film with a voice made more possible and more desirable the film with colour and plastic form. The new men set to work to make actualities out of the old daydreams, and the pace of invention in the studios and laboratories is at the present moment so breathless that no one can prophesy with any certainty what the next week's development is going to be.

—Observer (1929)

The development of color and cinema in the 1920s was highly variable yet also interwoven, as each integrated profound changes in art, technology, and industry during the decade. As we have traced, color and cinema were hallmarks of the new mass culture of the era and central foci for modernist and avant-garde experimentation. The various transformations and exchanges between color and cinema across overlapping fields and media comprise what we have referred to as the chromatic modernity

of the 1920s. The *Observer*'s forward-looking editorial from 1929 reflects such exchanges, inflected with a British point of view yet one invested in international developments, citing *The Virgin Queen* (J. Stuart Blackton, UK, 1923) alongside the Soviet work of Sergei Eisenstein and Vsevolod Pudovkin, *Cirano di Bergerac* (Augusto Genina, France/Italy, 1923/1925) and *The Toll of the Sea* (Chester M. Franklin, U.S., 1922).[1] The editorial's attention to sound in relation to color—as being generative of new ideas, knowledge, medial convergences, and international innovation—is testament to the central place of color in the ever-changing understanding of what a total cinema might look like. André Bazin also saw color, alongside sound and stereoscopy, as vital to the myths that drove cinematic invention: the grasping for "an integral realism, a recreation of the world in its own image."[2] What such an image might be is both ancient, as Bazin elucidates, and also evolving: who knows what next week will bring, as the *Observer* points out. In these ways, technical change is both innovative and repetitive: just as new aesthetic horizons remediate the past, they expand the realm of possibilities. From the 1890s into the 1920s and ongoing through to our new century of digital imaging, color has always been integral to the myths and practices of total cinema—as in Abel Gance's *Napoléon* (France, 1927), with which we began this book. At another level, color's place in such accounts illustrates how cinema was itself interwoven with the chromatic modernity of the 1920s. Interrogating the dynamism of this relationship also reveals much about the intermedial legacy and future of color in the moving image.

In the 1920s, as well as now, cinema's intermedial engagements function, in the words of Ágnes Pethö, as "a kind of excess, a surplus in the cinematic image, as the medium is reaching beyond its own conventional boundaries," particularly at moments of transition.[3] Color embodies these excesses. It was conceived as being integral to the totality of the filmic image, yet also as spilling out of it. As such, it opens a multitude of possibilities for intermedial and cross-field exchange in cinema, even in the dominant classical structure that it coalesced into in the 1920s. The ability to move through color between and across media and cultural formations dynamically expands cinema's reach beyond itself. As we have shown, these leaps are often dynamized in filmic moments of chromatic tableau in which color comes to the fore and crystalizes its points of external reference.[4] The vibrant Technicolor red of *The Phantom of the Opera* (Rupert Julian, U.S., 1925)—which envelops Lon Chaney's Phantom when he is introduced and literally brings a raucous ball to a stop—resonates beyond the film itself with the "Phantom red" hue of its tie-up campaigns for fashion design and makeup, as we have discussed. Such excessive moments of chromatic exchange illuminate the transformations that cinema underwent during the 1920s, as it flourished as a mass cultural form of production and reception deeply interwoven within the cultural and industrial fabric of the time.

However, the intermediality of the era was not the same intermediality that structured the emergence of cinema in the 1890s, as an inchoate technology developed symbiotically out of an already established set of media and cultural forms, nor is it the exact structure of exchange for what has followed. Each era redefines the possibilities for medial exchange, and in the 1920s, with the medium entering its classical phase, cinema came to direct intermedial flows with increasing power, as the history of color delineates. With the coming of sound and the relative decline of tinting, toning, and other applied methods, it would seem that the rich, chromatic channels of exchange that had characterized the decade receded. However, it is crucial to recognize that rather than disappearing, cinema's intermedial engagements shifted again at the end of the 1920s, adjusting to different aesthetic, economic, and structural imperatives defined by technological change, increasing nationalist imperatives, and worldwide Depression. Cinema theaters remained colorful sites of exhibition, though the extravagant musical preludes and live shows associated with the silent era began to wane. The 1920s' building surge of new movie palaces had peaked, but it left an enduring physical legacy: the opulent foyers, complex lighting setups, colored stained-glass and tiled panels, vibrant advertising displays, and effervescent spirit of showmanship remained, as if in defiance of the Great Depression. This rich chromatic legacy still resonates today in a material sense through surviving movie palaces, such as the magnificent 1921 Art Nouveau Tuschinski Theatre in Amsterdam (color plate 3.8), and through the increasing restoration and exhibition of colored films of the era.

Cinema was part of an experience of color during the decade that shaped various media and cultural fields that connect color to a broad, transnational sweep of economic, social, and artistic developments. The interwar era crystalized what Miriam Hansen has described as "the modernity of mass production, mass consumption, and mass annihilation, of rationalization, standardization, and media publics."[5] From mustard gas to radiant light cathedrals and cinemas, color was foundational to these facets of 1920s modernity, and this is why the chromatic aura of the era continues to glimmer in our own, through veils of nostalgia, inspiration, and anxiety. To unpack these ambivalent layers, it has been productive to historicize industrial developments in colorimetry and knowledge exchange as indicators of how commercial imperatives circulated and affected cultural production and taste cultures at various levels. While industrial interests promoted the quest for greater standardization of color across media and commodity production, this was a more complex process than simply imposing a top-down mechanism to guide consumers into making predictable chromatic choices that could be exploited year after year. The drive toward harnessing color choices through the codification of ready-made dyes, paints, and fashions paradoxically liberated it in art and fashion, making color more accessible and variable and

enabling one to be more color conscious in personal choices, from clothing and décor to what one read and watched at movie theaters. The regulatory tinge to the logic of codification was motivated toward moderating rather than controlling the highly subjective and ever-expanding realm of color. At the same time, the intermedial energies unleashed by the color revolution led to scientific and artistic innovation, new alliances, and international collaboration. In this sense, the decade was one in which modernity was fundamentally negotiated through a chromatic lens that dynamized the field of cultural production and consumption.

Such dynamization is evident through the many individuals, organizations, artworks, and films we have examined. By emphasizing cinema's extensive connections with, among other things, industry, fashion, music, and artistic culture, we have delineated how the period constituted a rich, cosmopolitan network of intermedial and cross-field relations. While this empowered competitive forces within the culture industry, there were also subtle gradations and back-and-forth collaborations between the forces of commerce and artistic practice—across both large-scale and restricted forms of production, in Pierre Bourdieu's formulation. We have traced both the radical engagement by the avant-garde with prismatic forms of mass culture and the ways in which vernacular forms of the moving image critically responded to and helped shape the chromatic modernity of the decade and beyond. Through color, the sponsored films of Walter Ruttmann and the vernacular abstractions of *Ballet mécanique* in the 1920s are of a piece with Len Lye's advertising work for the British GPO in the 1930s; with the educational animation work of Norman McLaren for the National Film Board of Canada and UNESCO at midcentury; with the pop-art sensibilities of Andy Warhol's iconic color work in paintings, screen prints, and also films; and with the contemporary collage work of experimental animators such as Larry Jordan, Lewis Klahr, and Jodie Mack. Similar parallels can be drawn between the narrative experiments with intermedial color in films such as *Das Cabinet des Dr. Caligari* (Robert Wiene, 1920), *L'inhumaine* (Marcel L'Herbier, 1924), and *Lonesome* (Paul Fejos, 1928); Alfred Hitchcock's collaborations with designers, animators, and painters such as Saul Bass, John Whitney Sr., and John Ferren in *Vertigo* (1958); and Paul Thomas Anderson's work in *Punch-Drunk Love* (2002) with painter and digital animator Jeremy Blake, as well as his homage to Andreas Gursky's photograph *99 Cent* (1999). These moments of intermedial collaboration and allusion stand out in the films, crystallizing their references through chromatic tableaux in ways excessive to narration. Anderson's Gursky allusion, for instance, captures the phantasmagoria of a modern grocery store, bedecked in bright commodity packaging. In a single tracking shot, the camera begins slowly, not quite in tableau, tracking right, allowing one to appreciate the allusion to Gursky before—in a feat of cinematic bravura—speeding up in a blur of bright colors.

The decade's immediate chromatic legacy, both in the 1930s and beyond, is complex to unravel. Rooted in Depression-era pictorial conventions, this is the beginning of the worldwide association of black and white with aesthetic realism, which came to dominate the classical sound era, while color became increasingly relegated to the generic conventions of the musical, fantasy, melodrama, and historical fiction. With the attenuation of tinting and toning at the end of the 1920s, color was present but no longer a normative practice in feature films. The adoption of processes such as two-color and three-strip Technicolor, Dufaycolor, Gasparcolor, and Agfacolor occurred mainly in the United States, the UK, and Germany. With the linguistic disruptions that sound brought, the cosmopolitan networks of exchange—which had proliferated in the 1920s to the benefit of modernist experimentation with color—to an extent atrophied. The physical movement of émigré professionals who fled from Germany to Britain, France, and the United States during the 1930s, however, meant that artistic collaboration entered a new phase, but one that concentrated particularly on exchanges of knowledge and skills in black-and-white cinematography and set design, as in the work of the many German exiles who worked in British cinema.[6] The color exchanges that did occur—for instance, Oskar Fischinger's failed collaboration with Disney yet important influence on U.S. experimental work at midcentury—tended to be more insular, nationally bound, and relatively less traveled, at least initially, than the 1920s avant-garde.[7]

Chromatic experimentation did continue in other cultural fields such as advertising and fashion, both of which remained important to emerging photographic color styles for motion pictures. In this respect, many of the intermedial relationships surrounding cinema that had become firmly established in the 1920s persisted. Fox Movietone, for example, produced Vyvyan Donner's *Fashion Forecast* series of eight films in Technicolor in the late 1930s.[8] Technicolor also developed a range of industrial films that were part of the color revolution of the day, particularly its advertisement films for the American rayon industry at the 1939–1940 World's Fair in Flushing Meadows, New York.[9] From 1932 to 1952, Technicolor released more than a thousand shorts and advertising films across the United States, capitalizing on color's visceral power to enhance a range of products from toothpaste to textiles.[10] Disney's early use of three-strip Technicolor for animated cartoons and Gasparcolor's application in short advertising films were part of a continuum in terms of showcasing new color processes in the short-film market.

Conversations about color remained pressing in filmic discourse, largely focusing on classical issues of realism and the extent to which color might distract audiences' attention from plot-driven drama. Colin Bennett, a British color technician and reporter, argued that color must remain "only an adjunct," because there was always a danger that it might be "jarring" or "over-done" and thus distract from narration.[11] Yet as color became associated with the

aforementioned genres of the musical, fantasy, melodrama, and historical fic-
tion, stylistic practice increasingly diverged from such classical prescriptions
through their intermedial references, the very point of which was to crystalize
exterior allusions.

As international competition between film industries accelerated after the
1920s, debates about color also became more invested with nationalist over-
tones that further ruptured the cosmopolitan channels of exchange that had
previously flourished. As in Bernard Brunius's diatribe against color in the
1920s in France through his proposed *Ligue du noir et blanc*, Technicolor
increasingly came to embody such problematics. In the 1930s, the company
began to move into a position of global ascendency in the color field. Its strug-
gles and success were based in no small way on carefully navigating the legacy
of the 1920s in the midst of the Depression. Natalie Kalmus's brilliant mobi-
lization of the notion of color consciousness in her seminal essay from 1935
attests to this: taking a concept used extensively in the United States to promote
color's cultural value during the 1920s and adapting it to Technicolor's stan-
dardization of color design in the mid-1930s.[12] However, as Regina Blaszczyk
and Uwe Spiekermann have noted, the international success of the American
industry and consumer culture "triggered ideas of national supremacy in the
United States and led to ethnocentric discussions about 'primitive man.' Cul-
tures that preferred a bright palette to the subtle hues in vogue in advanced
industrial societies were compared to young children with their penchant for
primary colors."[13] While we have noted similar assumptions about color in the
1920s, these became accentuated as color, and particularly Technicolor in a
global context, became increasingly politicized and aligned with American cul-
tural hegemony in subsequent decades. Producing color cinema outside of the
United States—whether Jacques Tati's failed attempts with Thomsoncolor in
France for *Jour de fête* (1948) or Michael Powell and Emeric Pressburger's craft-
ing of a decidedly non-American, British style of Technicolor in masterpieces
such as *Black Narcissus* (1947)—meant veering away from the rich, candied
saturations of American color style.[14]

These national approaches to color in the 1930s and 1940s call into relief
the multivalent and expanding cosmopolitan nature of the chromatic culture
of the 1920s. In the face of subsequent reactions against the era, these qualities
are also essential for understanding the decade's palimpsestic longevity now in
our cultural imagination, not only in film, but also in art, architecture, adver-
tising, and literature.[15] Given the critical emphasis on global interconnected-
ness in our new millennium—enabled by the profound transformations that
digital media have wrought across the spaces of late capitalism's (neo)liberal
world order—it makes sense that the 1920s have returned in film and media.
Beyond material archaeologies, the fascination with looking back to the era
as a colorful time before economic crisis is a thriving trend in postmillennial

screen production—for example, in Rob Marshall's *Chicago* (U.S., 2002), Martin Scorsese's *The Aviator* (U.S., 2004), Woody Allen's *Midnight in Paris* (U.S., 2011), and Baz Luhrmann's *The Great Gatsby* (U.S., 2013), and in TV dramas such as *Boardwalk Empire* (HBO, U.S., 2010–2014), *Downton Abbey* (ITV, UK, 2010–2015), *Mildred Pierce* (HBO, U.S., 2011), *Peaky Blinders* (BBC, UK, 2013–), and *Babylon Berlin* (Sky 1, Germany, 2017–). These works are also often laden with crystalized allusions to films of the era, as in *Babylon Berlin*'s references to Fritz Lang, Marlene Dietrich, and Josef von Sternberg, among many others—variations on Walter Ruttmann's *Opus* films even play over its closing credits. Similar to other quality recreations of historical periods, these works' retrospective emphases on costuming, design, and texture bring into contemporary focus an imagined period when cosmopolitan style and visual display were foregrounded in chromatically rich *mise-en-scènes*. Compared with the somber, muted tones often evoked to represent the ensuing Depression era, the 1920s is associated with a vibrant visual culture in which new color technologies were rapidly expanding the global range of chromatic media. Given the recent influx of new digital coloring processes, it should be no surprise that the roaring chromatic culture of the 1920s serves as a commonly remediated point of reference. Yet, as with *Babylon Berlin*, which chillingly tracks the end of Weimar liberalism and the rise of fascism, such looks back raise pressing political questions about what may follow as fracture lines increasingly threaten our once taken-for-granted cosmopolitan networks.

This circularity of chromatic inspiration and cultural engagement mean that the developments we have traced in this book are far from buried in the past. Returning to a decade when so many ideas about color, cinema, and its intermedial contexts were formed offers a telescopic view on aesthetic impulses that resonate today. Although many of the films—and their colors—produced in the era no longer survive, the vitality of the 1920s within the history of film cannot be overstated. Restoration and preservation projects by major archives—such as the EYE Filmmuseum, the British Film Institute, the Cineteca di Bologna, and the George Eastman Museum—attest to our continued fascination with recovering how these works pushed the boundaries of color expression in ways that remain both aesthetically alluring and culturally charged. Thanks to this vital work, as the centenary of the 1920s approaches, the moving hues of the decade's chromatic modernity can once again be experienced in vivid intermedial splendor. The digital cultures of our new millennium echo and transform the colors of the last century, inspiring new creative formations across media, cultural fields, and collaborative networks. Aesthetically as well as politically, such palimpsestic movements of history necessitate critical engagement and action, now and for our chromatic future.

NOTES

Introduction

1. Paul Cuff, "Living History: Abel Gance's *Napoléon*," booklet accompanying digital restoration of *Napoléon* (British Film Institute, BFIV2109, 2016), 4. For extended analysis, also see Cuff's *A Revolution for the Screen: Abel Gance's Napoléon* (Amsterdam: Amsterdam University Press, 2015).

2. See Abel Gance, "Le Cinéma, c'est la musique de la lumière," *Cinéa-Ciné pour tous*, no. 3 (December 15, 1923): 11; and François Ede, "Un épisode de l'histoire de la couleur au cinéma: le procéde Keller-Dorian et les films lenticulaires," *1895, Revue d'histoire du cinéma* 71 (2013): 192–193. For further details on Gance's ongoing interest in color in the 1920s, see the correspondence between Gance and various firms such as Versicolor Dufay Films en Couleurs Naturelles des Films Hérault in "Dossier couleur: Abel Gance," GANCE388-B91, La Bibliothèque du film of La Cinémathèque française.

3. Paolo Cherchi Usai, *Silent Cinema: An Introduction* (London: British Film Institute, 2000), 23.

4. Roy Mack, "The Future of Color Photography," *Film Daily* 52, no. 49 (May 27, 1930): 4. Mack was a prolific director of musical shorts in the 1930s, some of which were in Technicolor.

5. For a general study of the development of film color, see Richard Misek, *Chromatic Cinema: A History of Screen Colour* (Oxford: Wiley-Blackwell, 2010).

6. Daan Hertogs and Nico de Klerk, ed., *"Disorderly Order": Colours in Silent Film: The 1995 Amsterdam Workshop* (Amsterdam: Stichting Nederlands Filmmuseum, 1996).

7. Giovanna Fossati, Tom Gunning, Jonathan Rosen, and Joshua Yumibe, *Fantasia of Color in Early Cinema* (Amsterdam: Amsterdam University Press, 2015). For accounts of coloring techniques in early cinema, also see Joshua Yumibe, *Moving Color: Early Film, Mass Culture, Modernism* (New Brunswick, N.J.: Rutgers University Press, 2012). For an overview of extant sources see Barbara Flueckiger, "Timeline of Historical Film Colors," Timeline of Historical Film Colors, accessed July 17, 2017, http://zauberklang.ch/filmcolors/.

8. Tom Gunning, "Colourful Metaphors: The Attraction of Color in Silent Cinema," in *Il Colore Nel Cinema Muto*, ed. Monica Dall'Asta, Guglielmo Pescatore, and Leonardo Quaresima (Udine, Italy: Atti del II Convegno Internazionale di Studi sul Cinema, 1995), 20–31.

9. Luke McKernan, *Charles Urban: Pioneering the Non-Fiction Film in Britain and America* (Exeter, UK: Exeter University Press, 2013); and James Layton and David Pierce, *The Dawn of Technicolor, 1915–35* (Rochester, N.Y.: George Eastman House, 2015).

10. Scott Higgins, *Harnessing the Technicolor Rainbow: Color Design in the 1930s* (Austin: University of Texas Press, 2007).

11. Kaveh Askari, *Making Movies Into Art: Picture Craft from the Magic Lantern to Early Hollywood* (London: British Film Institute, 2015); Thomas Elsaesser, *Weimar Cinema and After: Germany's Historical Imaginary* (New York: Routledge, 2000); Lucy Fischer, *Designing Women: Cinema, Art Deco, and the Female Form* (New York: Columbia University Press, 2003); Lucy Fischer, *Cinema by Design: Art Nouveau, Modernism, and Film History* (New York: Columbia University Press, 2017); Christine Gledhill, *Reframing British Cinema, 1918–1928: Between Restraint and Passion* (London: British Film Institute, 2003); Lee Grieveson, *Cinema and the Wealth of Nations: Media, Capital, and the Liberal World System* (Oakland: University of California Press, 2018); Lea Jacobs, *The Decline of Sentiment: American Film in the 1920s* (Berkeley: University of California Press, 2008); Richard Koszarski, *An Evening's Entertainment: The Age of the Silent Feature Picture, 1915–1928* (Berkeley: University of California Press, 1994).

12. See, for instance, the essays collected in Andrew Higson and Richard Maltby, *"Film Europe" and "Film America": Cinema, Commerce and Cultural Exchange, 1920–1939* (Exeter, UK: University of Exeter Press, 1999).

13. Olivier Zunz, *Why the American Century?* (Chicago: University of Chicago Press, 2000).

14. For a useful project that takes up Global South circulation in a parallel way, see in particular Nilo Couret's recent engagement with sound technology in Latin America, *Mock Classicism: Latin American Film Comedy, 1930–1960* (Oakland: University of California Press, 2018).

15. See Sieglinde Lemke, *Primitivist Modernism: Black Culture and the Origins of Transatlantic Modernism* (Oxford: Oxford University Press, 1998). For an approach to transnational exchange that examines modernist appropriation within the Global South, see Fereshteh Daftari's discussion of "old-master modernism" in Iran, "Redefining Modernism: Pluralist Art Before the 1979 Revolution," in *Iran Modern*, ed. Fereshteh Daftari and Layla Diba (New York: Asia Society Museum, 2013), 27. Also see Kaveh Askari, "Techniques in Circulation: Sovereignty, Imaging Technology, and Art Education in Qajar Iran," in *The Image in Early Cinema: Form and Material*, ed. Scott Curtis, Philippe Gauthier, Tom Gunning, and Joshua Yumibe (Bloomington: Indiana University Press, 2018), 164–173.

16. James Clifford, "On Ethnographic Surrealism," *Comparative Studies in Society and History* 23, no. 4 (1981): 539–564.

17. Antonin Artaud, *The Theater and Its Double*, trans. Mary Caroline Richards (New York: Grove, 1994), 54.

18. Janet Ward, *Weimar Surfaces: Urban Visual Culture in 1920s Germany* (Berkeley: University of California Press, 2001), 2.

19. Michael Cowan, *Walter Ruttmann and the Cinema of Multiplicity: Avant-Garde Film— Advertising—Modernity* (Amsterdam: Amsterdam University Press, 2014).

20. Miriam Bratu Hansen, "The Mass Production of the Senses: Classical Cinema as Vernacular Modernism," *Modernism/modernity* 6, no. 2 (April 1999): 59–77.

21. Walter Benjamin, "One-Way Street," in *Selected Writings*, ed. Marcus Bullock and Michael W. Jennings, trans. Edmund Jephcott, 4 vols. (Cambridge, Mass.: Belknap Press, 1996), 1:444–488.

22. Regina Lee Blaszczyk, *The Color Revolution* (Cambridge, Mass.: MIT Press, 2012). For other recent work on the era, see her recent coedited collection, Regina Lee Blaszczyk and Uwe Spiekermann, eds., *Bright Modernity: Color, Commerce, and Consumer Culture* (Cham, Switzerland: Palgrave Macmillan, 2017).

23. André Gaudreault and Philippe Marion, "A Medium Is Always Born Twice," *Early Popular Visual Culture* 3, no. 1 (May 2005): 3–15; Gaudreault develops this argument further in *Film and Attraction: From Kinematography to Cinema*, trans. Tim Barnard (Urbana: University of Illinois Press, 2011); also see our discussion in Sarah Street and Joshua Yumibe, "The Temporalities of Intermediality: Colour in Cinema and the Arts of the 1920s," *Early Popular Visual Culture* 11, no. 2 (2013): 140–157.

24. Ágnes Pethö, *Cinema and Intermediality: The Passion for the In-Between* (Newcastle upon Tyne, UK: Cambridge Scholars, 2011), 1.

25. Pierre Bourdieu, "The Field of Cultural Production, or: The Economic World Reversed [1983]," in *The Field of Cultural Production: Essays on Art and Literature*, ed. Randal Johnson, trans. Richard Nice (New York: Columbia University Press, 1993), 29–73. For the application of Bourdieu's theory to media, and its limitations, see David Hesmondhalgh, "Bourdieu, the Media and Cultural Production," *Media, Culture & Society* 28, no. 2 (March 1, 2006): 211–231; and the recent collection Guy Austin, ed., *New Uses of Bourdieu in Film and Media Studies* (New York: Berghahn, 2016), especially Chris Cagle's contribution, "Bourdieu and Film Studies: Beyond the Taste Agenda," 35–50.

26. Bourdieu, "The Field of Cultural Production," 32.

27. John Spencer Clark, Mary Dana Hicks, and Walter Scott Perry, *Teachers' Manual for the Prang Course in Drawing for Graded Schools* (Boston: Prang, 1897), 213.

28. "A British Estimate of Louis Prang," *Geyer's Stationer* 29, no. 608 (March 22, 1900): 23.

29. Natalie M. Kalmus, "Color Consciousness," *Journal of the Society of Motion Picture Engineers* 25, no. 2 (August 1935): 139–147. For other uses of "color consciousness," see Leonard Troland, "Psychology of Natural Color Motion Pictures," *American Journal of Physiological Optics* 7, no. 3 (1926): 382; "The Textile Color Card Association," *Color Trade Journal* 10, no. 4 (April 1922): 159–160; and Loyd A. Jones, "Tinted Films for Sound Positives," *Transactions of the Society of Motion Picture Engineers* 13, no. 37 (1929): 225.

30. Lois Shirley, "All Hollywood Has Now Gone Color Conscious," *Photoplay* 42, no. 3 (August 1932): 48–49, 118. For a similar pairing of color consciousness and female stars, see Selena Morrison, "Colorful Women—And You!," *Movie Classic* 9, no. 2 (October 1935): 40–41, 70.

31. Jonathan Crary, *Suspensions of Perception: Attention, Spectacle, and Modern Culture* (Cambridge, Mass.: MIT Press, 2001), 4. Also see Jonathan Crary, *Techniques of the Observer: On Vision and Modernity in the Nineteenth Century* (Cambridge, Mass.: MIT Press, 1992).

32. See "The New Age of Color," *Saturday Evening Post*, January 21, 1928, 22; and "Color in Industry," *Fortune* 1 (February 1930): 85–94.

33. Siegfried Kracauer, "Cult of Distraction: On Berlin's Picture Palaces" (1926), in *The Mass Ornament: Weimar Essays*, trans., ed., intro., Thomas Y. Levin (Cambridge, Mass.: Harvard University Press, 1995), 324.

34. See Adrian Bernard Klein, *Colour-Music: The Art of Light* (London: Crosby, Lockwood, 1926); and Louis Favre, *La Musique des couleurs et le cinéma* (Paris: Presses Universitaires de France, 1927).

35. H. Baer, "The Color Film [July 1930]," in *The Promise of Cinema: German Film Theory, 1907–1933*, ed. Anton Kaes, Nicholas Baer, and Michael Cowan, trans. Alex H. Bush (Oakland: University of California Press, 2016), 601.

36. Rudolf Arnheim, *Film as Art* (Berkeley: University of California Press, 1957), 159, 156.

37. "Lasky Chiefs Working on Color Process," *Moving Picture World* 35 (February 9, 1918): 832.

38. Cecil B. DeMille, "Color Problem of Film Production Reduced to an Exact Science," *Reel and Slide Magazine*, April 1919, 21.

39. Hesmondhalgh, "Bourdieu, the Media and Cultural Production," 218–223; and Bourdieu, "The Field of Cultural Production," 53.

1. Color Standards and the Industrial Field of Film

1. On these various transformations, see Neil Harris, "Color and Media: Some Comparisons and Speculations," in *Cultural Excursions: Marketing Appetites and Cultural Tastes in Modern America* (Chicago: University of Chicago Press, 1990), 318–336; and Joshua Yumibe, "Surfaces colorées et espaces de jeu dans la littérature enfantine, le cinéma des premiers temps et les féeries," trans. Priska Morrissey, *1895: Revue d'histoire du cinéma* 71 (2014): 31–44. On color and fashion of the nineteenth century, see Susan Hiner, *Accessories to Modernity: Fashion and the Feminine in Nineteenth-Century France* (Philadelphia: University of Pennsylvania Press, 2011).

2. See Lucy Fischer, *Designing Women: Cinema, Art Deco, and the Female Form* (New York: Columbia University Press, 2003); and Lucy Fischer, *Cinema by Design: Art Nouveau, Modernism, and Film History* (New York: Columbia University Press, 2017).

3. Pierre Bourdieu, "The Field of Cultural Production, or: The Economic World Reversed [1983]," in *The Field of Cultural Production: Essays on Art and Literature*, ed. Randal Johnson, trans. Richard Nice (New York: Columbia University Press, 1993), 29–73.

4. Olivier Zunz, *Why the American Century?* (Chicago: University of Chicago Press, 2000), x.

5. See, for instance, Luci Marzola's account of industrial professionalization in "A Society Apart: The Early Years of the Society of Motion Picture Engineers," *Film History* 28, no. 4 (2016): 1–28.

6. Esther Leslie, *Synthetic Worlds: Nature, Art and the Chemical Industry* (London: Reaktion Books, 2005), 9–10. Also see Alexander Engel, "Coloring the World: Marketing German Dyestuffs in the Late Nineteenth and Early Twentieth Centuries," in *Bright Modernity: Color, Commerce, and Consumer Culture*, ed. Regina Lee Blaszczyk and Uwe Spiekermann (Cham, Switzerland: Palgrave Macmillan, 2017), 37–53.

7. On the German industry's ties to academia, see Jeffrey Allan Johnson, "The Academic-Industrial Symbiosis in German Chemical Research, 1905–1939," in *The German Chemical Industry in the Twentieth Century*, ed. John E. Lesch (Dordrecht, Netherlands: Springer Science+Business Media, 2000), 15–56. Also see Zunz, *Why the American Century*, 4–23; Thomas S. Kuhn, *The Essential Tension: Selected Studies in Scientific Tradition and Change* (Chicago: University of Chicago Press, 1977), 143; and David F. Noble, *America by Design: Science, Technology, and the Rise of Corporate Capitalism* (Oxford: Oxford University Press, 1979).

8. Quoted in "How Chromos Are Made," *Prang's Chromo: A Journal of Popular Art* 1, no. 1 (January 1868): 1. Reprinted in Katharine Morrison McClinton, *The Chromolithographs of Louis Prang* (New York: C. N. Potter, 1973), 12. Also see Joshua Yumibe,

Moving Color : Early Film, Mass Culture, Modernism (New Brunswick, N.J.: Rutgers University Press, 2012), 29–32.

9. Nicholas Gaskill, "Learning to See with Milton Bradley," in *Bright Modernity: Color, Commerce, and Consumer Culture*, ed. Regina Lee Blaszczyk and Uwe Spiekermann (Cham, Switzerland: Palgrave Macmillan, 2017), 55–56.

10. Ann Temkin, "Color Shift," in *Color Chart: Reinventing Color, 1950 to Today*, ed. Emily Hall et al. (New York: Museum of Modern Art, 2008), 21.

11. Paul Scheerbart, *Glass Architecture* [1914], trans. James Palmes, in *Glass! Love!! Perpetual Motion!!!: A Paul Scheerbart Reader*, ed. Josiah McElheny and Christine Burgin (Chicago: University of Chicago Press, 2014), 85.

12. Quoted in T. J. Jackson Lears, *No Place of Grace: Antimodernism and the Transformation of American Culture: 1880–1920* (New York: Pantheon Books, 1981), 74.

13. Max Simon Nordau, *Degeneration* (New York: Appleton, 1895), 27.

14. Edwin Lawrence Godkin, "Chromo-Civilization," *Nation* 19, no. 482 (September 24, 1874): 201–202.

15. H. Baer, "The Color Film [July 1930]," in *The Promise of Cinema: German Film Theory, 1907–1933*, ed. Anton Kaes, Nicholas Baer, and Michael Cowan, trans. Alex H. Bush (Oakland: University of California Press, 2016), 600–602.

16. See Regina Lee Blaszczyk, *The Color Revolution* (Cambridge, Mass.: MIT Press, 2012), 30–33.

17. Temkin, "Color Shift," 16.

18. *Color Standardization* (New York: Textile Color Card Association of the United States, 1921), 7, 15.

19. See John Gage, *Color and Meaning: Art, Science, and Symbolism* (Berkeley: University of California Press, 1999); Michel Pastoureau, *Blue: The History of a Color*, trans. Markus Cruse (Princeton, N.J.: Princeton University Press, 2001); and Charles A. Riley, *Color Codes: Modern Theories of Color in Philosophy, Painting and Architecture, Literature, Music, and Psychology* (Hanover, N.H.: University Press of New England, 1995).

20. Jonathan Crary, *Techniques of the Observer: On Vision and Modernity in the Nineteenth Century* (Cambridge, Mass.: MIT Press, 1992), especially 67–96.

21. See Yumibe, *Moving Color*, 1.

22. See Blaszczyk, *The Color Revolution*, 45–70.

23. Marie Ann Frank, *Denman Ross and American Design Theory* (Hanover, N.H.: University Press of New England, 2011), 122.

24. R. Steven Turner, "The Origins of Colorimetry: What Did Helmholtz and Maxwell Learn from Grassmann?," in *Hermann Günther Graßmann (1809–1877): Visionary Mathematician, Scientist and Neohumanist Scholar*, ed. Gert Schubring (Dordrecht/ Boston: Springer, 1996), 71–86.

25. Sean F. Johnston, "The Construction of Colorimetry by Committee," *Science in Context* 9, no. 4 (1996): 394.

26. See Mira Wilkins, "German Chemical Firms in the United States from the Late Nineteenth Century to Post–World War II," in *The German Chemical Industry in the Twentieth Century*, ed. John E. Lesch (Dordrecht, Netherlands: Springer Science+ Business Media, 2000), 297.

27. "The Cargo of the Submarine *Deutschland*," *Journal of the Society of Chemical Industry* 35, no. 23 (December 15, 1916): 1205.

28. Wilkins, "German Chemical Firms in the United States," 298.

29. "Editorial: Not Guaranteed," *Price's Carpet and Rug News* 5, no. 3 (September 1918): 10.

30. See Blaszczyk, *The Color Revolution*, 71–93.

31. Miriam Bratu Hansen, "The Mass Production of the Senses: Classical Cinema as Vernacular Modernism," *Modernism/modernity* 6, no. 2 (1999): 69.

32. *Tinting and Toning of Eastman Positive Motion Picture Film*, 4th ed. rev. (Rochester, N.Y.: Eastman Kodak, 1927).

33. Cecil B. DeMille, "The Chances of Color Photography in Moving Pictures," *American Photoplay* 17 (January 1923): 15.

34. "The Evolution of Film," *Cinematographic Annual* 1 (1930): 38.

35. "Film Tints to Suit Film Subjects," *Motion Picture Projectionist* 5, no. 11 (September 1932): 16.

36. See Loyd A. Jones, "Tinted Films for Sound Positives," *Transactions of the Society of Motion Picture Engineers* 13, no. 37 (May 6, 1929): 199–226; and Lewis M. Townsend and Loyd A. Jones, "The Use of Color for the Embellishment of the Motion Picture Program," *Transactions of the Society of Motion Picture Engineers* 21 (August 1925): 41–42.

37. *Tinting and Toning of Eastman Positive Motion Picture Film*, 2nd ed. rev. (Rochester, N.Y. : The Company, 1918) 3.

38. Kathryn Steen, "German Chemicals and American Politics, 1919–1922," in *The German Chemical Industry in the Twentieth Century*, ed. John E. Lesch (Dordrecht, Netherlands: Springer Science+Business Media, 2000), 325. For the history of German colorant innovation and global circulation, we also draw in this section from Wilkins, "German Chemical Firms in the United States," 285–381. Also see Johann Peter Murmann's industrial analysis, *Knowledge and Competitive Advantage: The Coevolution of Firms, Technology, and National Institutions* (New York: Cambridge University Press, 2003).

39. Akira Kudo, "Dominance Through Cooperation: I.G. Farben's Japan Strategy," in Lesch, *The German Chemical Industry*, 243–283; Ulrich Marsch, "Transferring Strategy and Structure: The German Chemical Industry as an Exemplar for Great Britain," in Lesch, *The German Chemical Industry*, 217–241.

40. Wilkins, "German Chemical Firms in the United States," 303.

41. For more on the history of DuPont and film stock, see Luci Marzola, "Better Pictures Through Chemistry: DuPont and the Fight for the Hollywood Film Stock Market," *Velvet Light Trap* 76, no. 1 (August 30, 2015): 3–18.

42. Marzola, "Better Pictures Through Chemistry," 295.

43. See Luke McKernan, *Charles Urban: Pioneering the Non-Fiction Film in Britain and America, 1897–1925* (Exeter, UK: University of Exeter Press, 2013).

44. With further space, the DuPont corporation would make for another useful, comparative study. Fortunately, excellent work is already underway by Luci Marzola (see her article "Better Pictures Through Chemistry") and Kirsten Moana Thompson as part of her work on "Color, American Animation and Visual Culture."

45. C. E. Kenneth Mees, "The Kodak Research Laboratories," *Proceedings of the Royal Society of London: Series A, Mathematical and Physical Sciences* 192, no. 1031 (1948): 465; and Marzola, "Better Pictures Through Chemistry," 6. General Electric was the prime innovator of industrial research in the United States at the time, particularly through the work of Dr. Willis Whitney who helped found the GE Research Laboratory in 1900, which was influential not only on the Kodak Research Laboratories but also on the Technicolor Corporation. Whitney was also a professor at MIT and was the undergraduate adviser there of both Herbert Kalmus and Daniel Comstock. See James Layton and David Pierce, *The Dawn of Technicolor: 1915–1935*, ed. Paolo Cherchi Usai and Catherine A. Surowiec (Rochester, N.Y.: George Eastman House, 2015), 24, 27. For more on Mees, also see Frank Gray, "Kinemacolor and Kodak: The Enterprise of Colour," in *The Colour Fantastic: Chromatic Worlds of Silent Cinema*, ed. Giovanna Fossati et al. (Amsterdam: Amsterdam University Press, 2018), 145–159.

On the broader professionalizing shifts in research and development laboratories in the United States in the early twentieth century, see, for example, David C. Mowery and Nathan Rosenberg, *Paths of Innovation: Technological Change in Twentieth-Century America* (Cambridge: Cambridge University Press, 1999); and Jeffrey L. Furman and Megan J. MacGarvie, "Academic Science and the Birth of Industrial Research Laboratories in the U.S. Pharmaceutical Industry," *Journal of Economic Behavior & Organization* 63 (2007): 756–776. Specifically on Kodak's Research Laboratories, also see Marzola, "Better Pictures Through Chemistry," 3–18.

46. See John Hannavy, "Frederick Charles Luther Wratten (1840–1926)," in *Encyclopedia of Nineteenth Century Photography*, ed. John Hannavy (London: Routledge, 2013), 1513–1514.

47. C. E. Kenneth Mees, *The Photography of Coloured Objects* (London: Croydon, Wratten & Wainwright, 1909).

48. See, for instance, Mees's "The Organization of Industrial Scientific Research," *Science* 43, no. 1118 (June 2, 1916): 763–773; "The Production of Scientific Knowledge," *Science* 46, no. 1196 (November 30, 1917): 519–528; and "A Photographic Research Laboratory," *Scientific Monthly* 5, no. 6 (December 1917): 481–496.

49. See C. E. Kenneth Mees, "John George Capstaff," *Journal of the Society of Motion Picture Engineers* 44, no. 1 (January 1945): 10–17; and Glenn E. Matthews, "Obituary: Dr. Loyd A. Jones," *Journal of the SMPTE* 63, no. 1 (July 1954): 30–36.

50. "Dr. C. E. Kenneth Mees [Obituary]," *Image: The Bulletin of the George Eastman House* 10, no. 1 (January 1961): 2.

51. Mees, "A Photographic Research Laboratory," 483.

52. See "Fifty-Year History of the Optical Society of America," *Journal of the Optical Society of America* 56, no. 3 (1966): 274–339.

53. See "Constitution and By-Laws," *Transactions of the Society of Motion Picture Engineers* 1, no. 1 (1916): 3; and Janet Staiger, "Standardization and Independence: The Founding Objectives of the SMPTE," *SMPTE Motion Imaging Journal* 96, no. 6 (June 1, 1987): 532–537.

54. Sean F. Johnston, *A History of Light and Colour Measurement: Science in the Shadows* (Bristol, UK: Institute of Physics Publishing, 2001), 159.

55. G. Quaink, "The Industrial Laboratory," *Monthly Abstract Bulletin from the Kodak Research Laboratories* 5, no. 4 (April 1919): 75–76.

56. On the Troland article, the journal explains, "The author reviews the three most important theories of color vision, stating the good and bad points of each, these three theories being the Young-Helmholtz, the Hering, and the Ladd-Franklin. He seems to favor the last named theory as explaining most satisfactorily the observed facts, although even this fails to explain completely all such observations. The paper gives a very good idea of the present status of color theory, especially form the standpoint of a psychologist," in Leonard Troland, "The Enigma of Color Vision," *Monthly Abstract Bulletin from the Kodak Research Laboratories* 7, no. 4 (January 1921): 14.

57. C. E. Kenneth Mees, "The Kodachrome Process of Color Portraiture," *Abridged Scientific Publications from the Research Laboratory of the Eastman Kodak Company* 2 (1915–1916): 14–16.

58. Loyd A. Jones, "Color Analyses of Two Component Mixtures," *Abridged Scientific Publications from the Research Laboratory of the Eastman Kodak Company* 1 (1913): 31–35; Loyd A. Jones, "The Low Visibility Phase of Protective Coloration," *Abridged Scientific Publications from the Research Laboratory of the Eastman Kodak Company* 4 (1919): 42–62; and Lewis M. Townsend and Loyd A. Jones, "The Use of Color for the Embellishment of the Motion Picture Program," *Abridged Scientific Publications from the Research Laboratory of the Eastman Kodak Company* 9 (1925): 134–144.

59. Jones, "Color Analyses of Two Component Mixtures"; Townsend and Jones, "The Use of Color," 135.

60. Jones, "Color Analyses of Two Component Mixtures," 31.

61. The German article was actually written by a Kodak researcher, Perley G. Nutting, who had earlier studied in Germany before taking his Ph.D. from Cornell, but published in *Zeitschrift für Instrumentenkunde* in 1913. The material by Hilger is also referenced in "W. E. Forsythe: The Rotation of Prisms of Constant Deviation," *Monthly Abstract Bulletin from the Kodak Research Laboratories* 3, no. 6 (August 1917): 119.

62. Quoted in "Dr. C. E. Kenneth Mees [Obituary]," 2.

63. Marzola, "Better Pictures Through Chemistry," 9. As Marzola points out, this was a very different approach from the much more secretive labs of DuPont.

64. Zunz, *Why the American Century*, 5–6.

65. The cahiers des ingénieurs Pathé Frères have been preserved at the Fondation Jérôme Seydoux-Pathé, and we are grateful to Stéphanie Salmon and the foundation for access to them. See Joshua Yumibe, "Industrial Research Into Color at Pathé During the 1910s and 1920s," in *Recherches et innovations dans l'industrie du cinéma: Les cahiers des ingénieurs Pathé (1906–1927)*, ed. Jacques Malthête and Stéphanie Salmon (Paris: Fondation Jérôme Seydoux-Pathé, 2017), 197–208.

66. See Stéphanie Salmon, *Pathé: A la conquête du cinéma, 1896–1929* (Paris: Editions Tallandier, 2014), 505–526.

67. Elizabeth Brayer, *George Eastman: A Biography*, reprint edition (Rochester, N.Y.: University of Rochester Press, 2015), 115–116.

68. See Dubois, "Rapport de M. Dubois: émulsion Eastman" (CECIL et Fondation Jérôme Seydoux-Pathé, June 10, 1908), Cahier no. 33333; Dubois, "Essais de pellicule négative Lumière" (CECIL et Fondation Jérôme Seydoux-Pathé, October 10, 1908), Cahier no. 33333; and Dubois, "Examen de la pellicule de sûreté AGFA" (CECIL et Fondation Jérôme Seydoux-Pathé, December 19, 1908), Cahier no. 33333.

69. See Dubois, "Virages organiques" (CECIL et Fondation Jérôme Seydoux-Pathé, September 25, 1908), Cahier no. 33333. Also for a discussion of the notebooks and Dubois's work on color at Pathé, see Céline Ruivo, "Le Livre de Fabrication de La Compagnie Générale Des Phonographes Cinématographes et Appareils de Précision: The Pathé Frères Laboratory Logbook of Joinville-Le-Pont (1906–8)," *The Moving Image: The Journal of the Association of Moving Image Archivists* 15, no. 1 (2015): 85–92.

70. Alan Milward and S. B. Saul, *The Development of the Economies of Continental Europe 1850–1914* (New York: Routledge, 2012), 93.

71. See Vacher, "Rapport de M. Vacher" (CECIL et Fondation Jérôme Seydoux-Pathé, December 3, 1923), Cahier no. 33926.

72. Pinel, "Virage des films par teinture sur mordançage" (CECIL et Fondation Jérôme Seydoux-Pathé, August 18, 1924), Cahier no. 33691.

73. Vacher, "Teinture en grande vitesse" (CECIL et Fondation Jérôme Seydoux-Pathé, October 17, 1923), Cahier no. 33926.

74. Vacher, "Examen de brevets" (CECIL et Fondation Jérôme Seydoux-Pathé, October 31, 1923), Cahier no. 33926.

75. Barbier, "Rapport de M. Barbier sur la convention de la 'Society of Motion Picture Engineers'" (CECIL et Fondation Jérôme Seydoux-Pathé, May 19–22, 1924), Cahier 33111.

76. Barbier, "Rapport de M. Barbier sur la convention de la 'Society of Motion Picture Engineers.'" (CECIL et Fondation Jérôme Seydoux-Pathé, October 1, 1923), Cahier 33111.

77. Also see Nicolas Le Guern, "Des recherches de Rodolphe Berthon chez Pathé en 1913-1914 au procédé lenticulaire Kodacolor," in Malthête and Salmon, *Recherches et innovations dans l'industrie du cinéma*, 225-241.

78. Brayer, *George Eastman*, 222-223.

79. Brayer, *George Eastman*, 223.

80. François Ede, "Un épisode de l'histoire de la couleur au cinéma: le procéde Keller-Dorian et les films lenticulaires," *1895: Revue d'histoire du cinéma* 71 (2013): 187-202.

81. C. E. Kenneth Mees, "Amateur Cinematography and Kodacolor Process," in *Abridged Scientific Publications from the Kodak Research Laboratories* (London: Eastman Kodak Company, 1929), 129.

82. See the material collected in Cahier no. 33125 (CECIL et Fondation Jérôme Seydoux-Pathé, 1913-1914).

83. On this history, see Layton and Pierce, *The Dawn of Technicolor*, 25-29.

84. Layton and Pierce, *The Dawn of Technicolor*, 36-42.

85. Layton and Pierce, *The Dawn of Technicolor*, 145-148.

86. See, for instance, Leonard Troland's essays on Bergson, Fechner, and psychophysics, "Paraphysical Monism," *Philosophical Review* 27, no. 1 (1918): 39-62; on Freud and psychic phenomena, "The Freudian Psychology and Psychical Research," *Journal of Abnormal Psychology* 8, no. 6 (March 1914): 405-428; and on magical and psychical phenomena, "Listening in on the Universe, VI: The Tricks in the Trade: Much That Seems Psychic a Clever Conjurer Can Achieve by Magic," *Delineator* 98, no. 3 (April 1921): 20. For Theosophical praise of Troland and his autocatalytic view of the chemical origins of life, which was seen as being in line with Theosophy's conception of the "fundamental identity of all Souls," see "On the Lookout," *Theosophy: A Magazine Devoted to the Path* 6, no. 1 (November 1917): 45. Hugo Münsterberg vigorously opposed Troland's interest in psychical research; see Bruce Kuklick, *The Rise of American Philosophy: Cambridge, Massachusetts, 1860-1930* (New Haven, Conn.: Yale University Press, 1979), 420.

87. See the four letters "Hugo Münsterberg to Leonard Thompson Troland," March 24, March 30, April 30, and August 2, 1916, Hugo Münsterberg Collection, Folder 2415, Items 1-4, Boston Public Library; and Hugo Münsterberg, *The Photoplay: A Psychological Study* (New York: Appleton, 1916).

88. See the correspondence from March 30 and April 20, Hugo Münsterberg Collection, Folder 2415, Boston Public Library, as well as Kuklick, *The Rise of American Philosophy*, 420.

89. Leonard Troland, "Troland Diaries, March 11," 1926, E17, Technicolor Notebooks: Troland Diaries 1926-1929, George Eastman Museum. More generally on Münsterberg's Harvard lab, see Giuliana Bruno, "Hugo Münsterberg's Laboratory of Moving Images," *Grey Room* 36 (Summer 2009): 88-113.

90. Herbert Kalmus, "[H. T. Kalmus to L. T. Troland]," April 23, 1929, M0006 Technicolor Internal Correspondence, George Eastman Museum.

91. Kenneth Mees makes similar points in "The Organization of Industrial Scientific Research," 766.

92. Johnston, "The Construction of Colorimetry by Committee," 387-420.

93. Leonard Troland, "Report of the Colorimetry Committee of the Optical Society of America," *Journal of the Optical Society of America and Review* 6, no. 6 (1922): 527-596. On its influence, see, for example, Lewis M. Townsend and Loyd A. Jones, "The Use of Color for the Embellishment of the Motion Picture Program," 41-42.

Interestingly enough, growing out of his collaboration with Jones through the Colorimetry Committee, Troland even attempted to recruit Jones to Technicolor in 1929,

as Troland's diaries note: "L.A. Jones in NY asking if he could stop and see me Sunday. He wires: no and I call him on the phone at Hotel Pennsylvania. I ask him if he would consider our Hollywood job. He says his present rate 14k and he would not consider anything under 20. This seems to count him out. Eastman research men have no contracts," Leonard Troland, "Troland Diaries," February 22, 1929, E17, Technicolor Notebooks, Troland Diaries, 1926–1929, George Eastman Museum.

94. Johnston, "The Construction of Colorimetry by Committee," 404. Importantly, on this connection between Helmholtz and additive and subtractive color systems, the Optical Society of America translated and published Helmholtz's *Treatise on Physiological Optics*, trans. James P. C. Southall (Rochester, N.Y.: Optical Society of America, 1924).

95. Troland, "Report of the Colorimetry Committee," 531–532.

96. Johnston, "The Construction of Colorimetry by Committee," 400.

97. Sean Cubitt's discussion of CIE and its connection to film in the context of the history of "Ordering Color" is provocative, though he does not trace Troland's involvement in these various developments; in *The Practice of Light: A Genealogy of Visual Technologies from Prints to Pixels* (Cambridge, Mass.: MIT Press, 2014), 138–144.

98. "Taylor for Mary and Doug Film," *Film Daily*, April 15, 1929, 4.

99. Herbert Kalmus, "[H. T. Kalmus to L. T. Troland]," July 17, 1929, M0006 Technicolor Internal Correspondence, George Eastman Museum.

100. As Christel Schmidt notes, even though the film opened two days after the stock market crash, box office receipts were healthy, coming in at close to a million dollars. "Crown of Glory: The Rise and Fall of the Mary Pickford Curls," in *Mary Pickford: Queen of the Movies*, ed. Christel Schmidt (Lexington: University Press of Kentucky, 2012), 184. The film has recently been restored by the Museum of Modern Art.

101. "The Evolution of Film," 37–38.

102. "The Evolution of Film," 37. For more details on the tinting process, see Joshua Yumibe, *Moving Color*, 97–105.

103. "The Evolution of Film," 37.

104. In addition, see Loyd A. Jones, "Tinted Films for Sound Positives," 199–226; and advertisements such as "New Color Moods in Sound [Kodak Sonochrome Ad]," *Motion Picture News* 40, no. 6 (August 10, 1929): 635; "New Beauty for the Sound Screen [Kodak Sonochrome Ad]," *Motion Picture Projectionist* 3, no. 1 (November 1929): 27; and "Low Cost Tints That Match Every Mood in Sound Pictures [Kodak Sonochrome Ad]," *Motion Picture Projectionist* 3, no. 4 (February 1930): 40.

105. See "The New Age of Color," *Saturday Evening Post*, January 21, 1928, 22; and "Color in Industry," *Fortune* 1 (February 1930): 85–94.

106. "The Public Wants Color [Kodak Sonochrome Ad]," *Film Daily* 54, no. 45 (November 16, 1930): 13.

107. Matthew Luckiesh, *The Language of Color* (New York: Dodd, Mead, 1918), 109.

108. Jones, "Tinted Films for Sound Positives," 216. Luckiesh and Troland both participated in the 1916 annual convention of the Illuminating Engineering Society, when Troland was also in research residence at Nela Park with Luckiesh, and they continued to collaborate on various research committees until Troland's death in 1932. See "Happenings in the Industry," *Electrical Review and Western Electrician* 69, no. 13 (September 23, 1916): 539. Troland also reviewed Luckiesh's work, including *The Language of Color*, at various points: "[Luckiesh] discusses the problem of the emotional correlations of the various colors, the recent advances which have been made in the standardization of color and the technique of producing various colors," in Leonard Troland, "Vision—General Phenomena," *Psychological Bulletin* 16, no. 4 (April 1919): 123.

2. Advertising, Fashion, and Color

1. Pierre Bourdieu, "The Field of Cultural Production, or: The Economic World Reversed," in *The Field of Cultural Production: Essays on Art and Literature*, ed. Randal Johnson, trans. Richard Nice (New York: Columbia University Press, 1993), 53.
2. For a reflection on the significance of mass fashion—whether symbolic or sensual—and the influence it has had on the field of high fashion, see Agnès Rocamora, "Fields of Fashion: Critical Insights Into Bourdieu's Sociology of Culture," *Journal of Consumer Culture* 2, no. 3 (November 1, 2002): 341–362.
3. Miriam Hansen, "The Mass Production of the Senses: Classical Cinema as Vernacular Modernism," *Modernism/Modernity* 6, no. 2 (April 1999): 60.
4. Louis Weinberg, *Color in Everyday Life* (New York: Moffat, Yard, 1918): 105–106.
5. See Joshua Yumibe, "Stenciling Technologies and the Hybridized Image in Early Cinema," in *Exposing the Film Apparatus: The Film Archive as a Research Laboratory*, ed. Giovanna Fossati and Annie van den Oever (Amsterdam: Amsterdam University Press, 2016), 232–241.
6. Robert Mallet-Stevens, *A Modern City* (London: Benn Brothers, 1922).
7. Sarah Schleuning, *Moderne: Fashioning the French Interior* (Princeton, N.J.: Princeton Architectural Press, 2008), 11.
8. For the "garçonne look," see Valerie Mendes and Amy De La Haye, *Twentieth Century Fashion* (London: Thames & Hudson, 1999), 58–62.
9. Emily Burbank, *Woman as Decoration* (New York: Dodd, Mead, 1920), 81.
10. Burbank, *Woman as Decoration*, 81.
11. Edward Gordon Craig was the author of *On the Art of the Theatre* (London: Heinemann, 1911), a celebrated book on theater stage design. His approach was nonnaturalistic, and he was enthusiastic about exploiting electric lighting techniques in the theater.
12. Burbank, *Woman as Decoration*, 81.
13. Burbank, *Woman as Decoration*, 84.
14. Gabrielle Amati, "Cinéa-Ciné interviewe Lilian Gish à Florence," *Cinéa-Ciné pour tous*, June 1, 1924, 21–22.
15. David Kyvig, *Daily Life in the United States 1920–39: Decades of Promise and Pain* (Westport, Conn.: Greenwood Press, 2002), 47.
16. For a detailed discussion, see Victor Arwas, *Art Deco* (New York: Harry N. Abrams, 1980), 27–50.
17. Pascal Rousseau, "'Voyelles': Sonia Delaunay and the Universal Language of Colour Hearing," in *Sonia Delaunay*, ed. Anne Montfort (London: Tate, 2014), 72–73.
18. Wassily Kandinsky, "Über Bühnenkomposition" ("On Stage Composition"), *Almanac der Blaue Reiter* (1912), quoted in Rousseau, "'Voyelles,'" 75.
19. Léon Deshairs, *Intérieurs en couleurs: Exposition des arts décoratifs, Paris, 1925* (Paris: A. Lévy, 1926).
20. Lucy Fischer, *Designing Women: Cinema, Art Deco, and the Female Form* (New York: Columbia University Press, 2003), 17–19.
21. Deshairs, *Intérieurs en couleurs*, "Preface" (translated from French).
22. Léon Deshairs, *Modern French Decorative Art*, 2nd series (London: Architectural Press: 1930), "Introduction."
23. Matteo de Leeuw-de-Monti, "Sonia Delaunay: The Designs for Metz & Co," in *Sonia Delaunay*, ed. Anne Montfort (London: Tate, 2014), 175–181.
24. Regina Lee Blaszczyk, *The Color Revolution* (Cambridge, Mass.: MIT Press, 2012), 174.

25. Deborah Ryan, *"Daily Mail": The Ideal Home Through the Twentieth Century* (London: Hazar, 1997).
26. *Daily Mail Ideal Home Exhibition Catalogue* (London: Daily Mail, 1927), 21, 37.
27. Ellen Woolrich, "Colourful Homes," in *Daily Mail Ideal Home Exhibition Catalogue*, 47.
28. Woolrich, "Colourful Homes," 47.
29. Matthew Luckiesh, *Light and Color: Advertising and Merchandising* (London: Crosby, Lockwood, 1923), 14–15.
30. Sally Stein, "The Rhetoric of the Colorful and the Colorless: American Photography and Material Cultures Between the Wars" (Ph.D. diss., Yale University, 1991), 47.
31. Paul Nystrom, *Economics of Fashion* (New York: Ronald Press, 1928), 480.
32. "Lady Pepperell Colored Sheets and Pillow Cases [Ad]," *Photoplay* 35, no. 3 (February 1929): 80.
33. "How the Stars Make Their Homes Attractive," *Photoplay* 35, no. 3 (February 1929): 68–69, 81.
34. "How the Stars Make Their Homes Attractive," 81.
35. "Lady Pepperell Colored Sheets and Pillow Cases [Ad]," 80.
36. Bourdieu, *The Field of Cultural Production*, 121.
37. Millicent Melrose, *Color Harmony and Design in Dress* (New York: Social Mentor, 1922), 62.
38. Roland Marchand, *Advertising the American Dream: Making Way for Modernity, 1920–1940* (Berkeley: University of California Press, 1985), 132.
39. Blaszczyk, *The Color Revolution*, 78.
40. Margaret Hayden Rorke, "Color in Industry" speech, 13 April 1928, Hotel Astor, New York, Hagley Museum and Library, Box 41, Inter-Society Color Council, TCCA.
41. "The Textile Color Card Association," *Color Trade Journal* 10, no. 4 (April 1922): 159–160.
42. Margaret Hayden Rorke, *TCCA Annual Report, 1926*, Hagley Museum and Library, Box 1, Color Association of the United States (CAUS), TCCA.
43. Hagley Museum and Library, manuscripts and archives department, ISCC records, accession no. 2188, accessed July 13, 2015, http://findingaids.hagley.org/xtf/view?docId=ead/2188.xml.
44. Hagley Museum and Library, Box 56, Inter-Society Color Council, TCCA, 1922 and 1923.
45. Spring Season Card for 1923, Hagley Museum and Library, Box 56, Inter-Society Color Council, TCCA, 1922 and 1923.
46. *Salina Evening Journal*, March 10, 1923, 2.
47. When Claude Bragdon, American architect and theater designer whose color work is discussed in chapter 3, designed costumes for Ophelia in *Hamlet*, he chose turquoise blue and daffodil green "for she is spring, she is virginity." Bragdon, "Color and Costume," *Foreword* 17, no. 5 (February 1930): 3–4.
48. Margaret Hayden Rorke, "Color as a Silk Salesman" (TCCA, 1923), 2188 Inter Society Color Council (ISCC), Box 13, Hagley Museum and Library.
49. "New Colors Puzzle Mere Man," *Sun*, October 6, 1920, Hagley Library, 2188 Inter Society Color Council (ISCC), Box 43.
50. Aloys John Maerz and Morris Rea Paul, *Dictionary of Color* (New York: McGraw-Hill, 1930), v.
51. Maerz and Paul, *Dictionary of Color*, v.
52. Maerz and Paul, *Dictionary of Color*, 140.
53. Lynda Nead, *The Tiger in the Smoke: Art and Culture in Post-War Britain* (New Haven, Conn.: Yale University Press, 2017), 148.

54. TCCA, ISCC Spring Season Cards for 1923, 1926 and 1927, Hagley Museum, Box 56.

55. Maerz and Paul, *Dictionary of Color*, 200.

56. William Leach, *Land of Desire: Merchants, Power, and the Rise of a New American Culture* (New York: Pantheon Books, 1993), 311–312.

57. Blaszczyk, *The Color Revolution*, 141–144.

58. *Colour* 2, no. 11 (September 1930): 29.

59. "Color Schemes Declared to Have Effect on Health. Beatrice Irwin Wins Membership in Society of Illuminating Engineers by Study of Lighting," *Sunday Oregonian*, March 12, 1922, 11.

60. Dorothy Nickerson, *Color Measurement and Its Application to the Grading of Agricultural Products: A Handbook on the Method of Disk Colorimetry* (Washington, D.C.: U.S. Department of Agriculture, 1946).

61. Hagley Museum and Library, ISCC records, accession no. 2188, finding aid.

62. Sarah Street, "A Suitable Job for a Woman: Color and the Work of Natalie Kalmus," in *Doing Women's Film History: Reframing Cinemas, Past and Future*, ed. Christine Gledhill and Julia Knight (Champaign: University of Illinois Press, 2015), 206–217.

63. Amy De La Haye, "The Dissemination of Design from Haute Couture to Fashionable Ready-to-Wear During the 1920s with Specific Reference to the Hodson Dress Shop in Willenhall," *Textile History* 24, no. 1 (1993): 39–48.

64. Margaret Hayden Rorke, *TCCA Annual Report, 1925*, Hagley Museum, Box 1, Color Association of the United States (CAUS), TCCA.

65. Regina Lee Blaszczyk, "The Color Schemers: American Color Practice in Britain, 1920s–1960s," in *Bright Modernity: Color, Commerce, and Consumer Culture*, ed. Regina Lee Blaszczyk and Uwe Spiekermann (Cham, Switzerland: Palgrave Macmillan, 2017), 201–202.

66. Margaret Hayden Rorke, *TCCA Annual Report, 1928*, Hagley Museum, Box 1, Color Association of the United States (CAUS), TCCA.

67. The colors were seed pearl, miniature pink, stardew, glint o' gold, arcadian green, coquette, romantic green, antique fuchsia, moonmist, beige soirée, citronelle, venice, orchadee, piquant green, sunrise yellow, and flirt. TCCA, ISCC Fall Season Card 1928, Hagley Museum, Box 56.

68. Romanticism Leaflet 1928, TCCA, ISCC 2188, Hagley Museum, Box 13.

69. "Showing Paris Styles in Toronto," *Dry Goods Review* 33, no. 10 (October 1921): 142.

70. "Showing Paris Styles in Toronto," 142.

71. Marketa Uhlirova, "100 Years of the Fashion Film: Frameworks and Histories," *Fashion Theory*, 17, no. 2 (April 2013): 140.

72. Eirik Frisvold Hanssen, "Symptoms of Desire: Colour, Costume, and Commodities in Fashion Newsreels of the 1910s and 1920s," *Film History* 21, no. 2 (2009): 114–115.

73. Hanssen, "Symptoms of Desire," 116.

74. "Fashion Fun and Fancy" was the motto of the cinemagazine; see Jenny Hammerton, *For Ladies Only?: Eve's Film Review: Pathé Cinemagazine 1921–33* (Hastings, UK: Projection Box, 2001), 20.

75. Eve and Everybody's Film Review No. 362, nitrate reel viewed at the National Film Archive, Berkhamsted, UK.

76. Eve and Everybody's Film Review No. 373, nitrate reel viewed at the National Film Archive, Berkhamsted, UK.

77. Mendes and de la Haye, *Twentieth Century Fashion*, 66–70.

78. Mendes and de la Haye, *Twentieth Century Fashion*, 72.

79. Blaszczyk, *The Color Revolution*, 177.

80. Gaumont Graphic No. 154, Latest Paris Fashions, nitrate reel viewed at the National Film Archive, Berkhamsted, UK.

81. Eve's Film Review, *Fashions in Hairdressing*, 1925, 6143Ad, nitrate reel viewed at the National Film Archive, Berkhamsted, UK.

82. Eve's Film Review, *The Shoe Show*, 444, nitrate reel viewed at the National Film Archive, Berkhamsted, UK.

83. Hammerton, *For Ladies Only?*, 80–81.

84. Eve's Film Review, *Fashions in Colour*, 1925, 6143Ad, nitrate reel viewed at the National Film Archive, Berkhamsted, UK.

85. Emily Crosby, "The 'Colour Supplement' of the Cinema: The British Cinemagazine," *Journal of British Cinema and Television* 5, no. 1 (2008): 14.

86. Gilbert Adrian, "La Mode à Hollywood," *Cinéa-Ciné pour tous* 134 (June 1, 1929): 9–10.

87. Quoted in Hammerton, *For Ladies Only?*, 77; originally in F*ilm Renter and Moving Picture* 21 (May 1921).

88. The intertitle is a humorous allusion to Robert Burns's poem "Comin' thro' the Rye," a children's song and the title of Cecil Hepworth's 1923 British film.

89. François Ede, "Un épisode de l'histoire de la couleur au cinéma: le procéde Keller-Dorian et les films lenticulaires," *1895: Revue d'histoire du cinéma* 71 (2013): 187–202.

90. Natalie Snoyman, "Kodachrome's Hope: The Making and Promotion of McCall Colour Fashion News," in *The Colour Fantastic: Chromatic Worlds of Silent Cinema*, ed. Giovanna Fossati et al. (Amsterdam: Amsterdam University Press, 2018), 182.

91. "Illustrations in Color in Style Catalogue," *McCall's Ad-Sheet*, April 1927, 8; quoted in Snoyman, "Kodachrome's Hope," 189.

92. Snoyman, "Kodachrome's Hope," 190.

93. James Layton and David Pierce, *The Dawn of Technicolor* (Rochester, N.Y.: George Eastman House, 2015), 334.

94. "Moves," *Hollywood Filmograph* 10, no. 23 (June 21, 1930): 18. We are grateful to James Layton for sharing materials relating to the *Fashion News* films.

95. Natalie Snoyman, " 'In to Stay': Selling Three-Strip Technicolor and Fashion in the 1930s and 1940s" (Ph.D. diss., Stockholm University, 2017), 150.

96. "Fads and Fashions," *Hollywood Filmograph* 10, no. 14 (April 19, 1930): 9.

97. "Fashion News Follows Sound Trend," *Hollywood Filmograph* 9, no. 28 (July 13, 1929): 4; "Fashion News," *Hollywood Filmograph* 10, no. 9 (March 15, 1930): 9.

98. "Hollywood Styles," *Hollywood Filmograph* 9, no. 33 (August 17, 1929): 25; and report in the *Binghampton Press*, November 18, 1929, 25.

99. Colorart Pictures produced more than fifty Technicolor shorts 1926–29. Founded by two former Technicolor employees, Howard C. Brown and Curtis F. Nagel, the company collapsed in 1929 after a failed attempt to finance a South Seas project involving F. W. Murnau and Robert Flaherty.

100. "Tiffany Distributing Colorart Fashion Picture," *Motion Picture News* 35, no. 3 (January 21, 1927): 227.

101. "Sigrid Holmquist is seen in remarkable Fashion Color Film," *Moving Picture World* 84, no. 5 (January 29, 1927): 351.

102. Louise Wallenberg, "Fashion and the Moving Image," in *The Fashion History Reader: Global Perspectives*, ed. Giorgio Riello and Peter McNeil (London: Routledge, 2010), 496.

103. "Love Reappears: Transforming Failure Into Success," *Kinematograph Weekly* 72, no. 823 (February 1, 1923): 55.

104. "Love Reappears," 55.

105. "La Mode au cinéma," Cinéa-Ciné pour tous 1 (November 15, 1923): 24.

106. Charles Eckert, "The Carole Lombard in Macy's Window," reprinted from *Quarterly Review of Film Studies* 3, no. 1 (1978) in *Fabrications: Costume and the Female Body*, ed. Jane Gaines and Charlotte Herzog (London: Routledge, 1990), 106.

107. Sumiko Higashi, *Cecil B. DeMille and American Culture: The Silent Era* (Berkeley: University of California Press, 1994), 177.

108. Michelle Tolini Finamore, *Hollywood Before Glamour: Fashion in American Silent Film* (London: Palgrave Macmillan, 2013), 124–125.

109. "The Octopus Gown," *Photoplay* 20, no. 4 (September 1921): 20.

110. Erté is credited as having designed William Randolph Hearst's film *The Restless Sex* in 1920. The striking resemblance between West's gowns and Erté's style has possibly led many to believe that Erté worked on *The Affairs of Anatol*, even though he is not credited. A selection of Erté's designs confirms this view, particularly designs of 1920–21. See Erté, *Erté Fashions* (New York: St. Martin's Press, 1972); and Erté, *Erté's Fashion Design* (New York: Dover, 1981).

111. Drake Stutesman, "Clare West," in *Women Film Pioneers Project*, ed. Jane Gaines, Radha Vatsal, and Monica Dall'Asta (New York: Columbia University Libraries, Center for Digital Research and Scholarship, 2013), accessed May 18, 2018, https://wfpp.cdrs. columbia.edu/pioneer/ccp-clare-west/.

112. Mark Lynn Anderson, "1921: Movies and Personality," in *American Cinema of the 1920s: Themes and Variations*, ed. Lucy Fischer (New Brunswick, N.J.: Rutgers University Press, 2009), 57.

113. Lucy Fischer, *Cinema by Design: Art Nouveau, Modernism, and Film History* (New York: Columbia University Press, 2017), 78.

114. Fischer, *Cinema by Design*, 143.

115. Ruth Schwartz Cowan, "The 'Industrial Revolution' in the Home: Household Technology and Social Change in the 20th Century," *Technology and Culture* 17, no. 1 (1976): 1–23.

116. For a useful discussion of the film's Art Nouveau references, see Fischer, *Cinema by Design*, 75–80.

117. Cecil B. DeMille, "Color Problem of Film Production Reduced to an Exact Science," *Reel and Slide* 2, no. 4 (April 1919), 21.

118. Tim Bergfelder, Sue Harris, and Sarah Street, *Film Architecture and the Transnational Imagination: Set Design in 1930s European Cinema* (Amsterdam: Amsterdam University Press, 2007), 61. Also see Francois Albera, *Albatros: Des Russes á Paris, 1919–1929* (Paris: Cinémathèque Française, 1995).

119. See Flicker Alley's 2013 DVD collection of Albatros films restored by the Cinemathèque Française, *French Masterworks: Russian Émigrés in Paris 1923–1928* (FA0029).

120. Edward W. Said, *Orientalism: Western Conceptions of the Orient* (London: Penguin Books, 1995), 3.

121. Said, *Orientalism*, 3.

122. Matthew Bernstein, "Introduction," in *Visions of the East: Orientalism in Film*, ed. Matthew Bernstein and Gaylyn Studlar (New Brunswick, N.J.: Rutgers University Press, 1997), 3.

123. Mendes and de la Haye, *Twentieth Century Fashion*, 32.

124. Adam Geczy, *Fashion and Orientalism: Dress, Textiles and Culture from the Seventeenth to the Twenty-First Century* (London: Bloomsbury, 2013), 2.

125. It is notable that, in a parallel move, *Black Narcissus* (Michael Powell and Emeric Pressburger, U.K., 1947), a seminal use of three-strip Technicolor, created its Himalayan setting entirely in a British film studio in order to achieve Powell's vision of the East that was characterized as "other" and as alien to the experience of visiting nuns.

126. The advertisement is reproduced in Layton and Pierce, *The Dawn of Technicolor*, 95.

127. The child was played by Priscilla Moran, an American child actress. This casting was strategic, so that Allen's son appeared Caucasian, yet the cross-gender casting also allows for an element of gender fluidity to translate subtly as biracial alterity in the film.

128. Jeanne Thomas Allen, "Fig Leaves in Hollywood: Female Representation and Consumer Culture," in *Fabrications: Costume and the Female Body*, ed. Jane Gaines and Charlotte Herzog (London: Routledge, 1990), 128.

129. "Four in Color," *Motion Picture News* 34, no. 2 (July 10, 1926): 119.

130. Bryony Dixon, "Pretty in Pink," *Sight and Sound* 28, no. 6 (June 2018): 42.

131. See the discussion with Bryony Dixon about this recently discovered footage, in British Film Institute, *Early Technicolor Discoveries from the BFI National Archive*, accessed July 5, 2018, https://www.youtube.com/watch?v=a46tD6sjD58.

132. *The Dressmaker from Paris* (Paul Bern, U.S., 1925), a film believed lost, was about a mid-western American department store that employs a Parisian dressmaker to transform its approach to retailing. The film featured a spectacular fashion show; see Finamore, *Hollywood Before Glamour*, 171.

133. Layton and Pierce, *The Dawn of Technicolor*, 313. A French production called *Monte Carlo*, starring British actress Betty Balfour, had also been released in 1925. It is reported to have contained a fashion ball scene in color. "Movie Making at Monte," *Pictures and Picturegoer* 10, no. 54 (June 1925): 10–11.

134. Dudley Andrew and Steven Ungar, *Popular Front Paris and the Poetics of Culture* (Cambridge, Mass.: Harvard University Press, 2005), 255.

135. Mila Ganeva, *Women in Weimar Fashion: Discourses and Displays in German Culture, 1918–1933* (Rochester, N.Y.: Camden House, 2008), 129.

136. Ganeva, *Women in Weimar Fashion*, 129.

137. Eckert, "The Carole Lombard in Macy's Window," 107.

138. Janet Staiger, "Announcing Wares, Winning Patrons, Voicing Ideals: Thinking About the History and Theory of Film Advertising," *Cinema Journal* 29, no. 3 (1990): 11. On tie-ins in silent cinema, also see Jane Gaines, "The Queen Christina Tie-Ups: Convergence of Show Window and Screen," *Quarterly Review of Film and Video* 11, no. 1 (1989): 35–60.

139. "Window Displays Feature 'Christian' Campaign," *Motion Picture News* 28, no. 11 (September 15, 1923): 1325.

140. Victoria Jackson and Sarah Street, "Kevin Brownlow on Film Color," *Moving Image* 15, no. 1 (2015): 101–102.

141. *Kinematograph Year Book* (London: Kinematograph, 1927), 197.

142. Victoria Jackson and Bregt Lameris, "Phantom Colours: Alice Blue and Phantom Red: Changing Meanings of Two Fashionable Colours, 1905–30," *Catwalk: The Journal of Fashion, Beauty and Style* 3, no. 2 (2014): 19–46.

143. "Irene [Ad]," *Motion Picture News* 33, no. 10 (March 6, 1926): 1065–1070.

144. Matthew Luckiesh, *Color and Its Applications* (New York: Van Nostrand, 1927), 78.

145. Jackson and Lameris, "Phantom Colours," 26.

146. Jackson and Lameris, "Phantom Colours," 27.

147. Jackson and Lameris, "Phantom Colours," 31.

148. Hagley Archive, Box56, ISCC, TCCA, Fall Card 1926.

149. Layton and Pierce, *The Dawn of Technicolor*, 316. A British review of the film referred to "fine color photography" in the ballet sequence. "The Week's New Films Reviewed," *Hull Daily Mail*, January 4, 1927, 8.

150. "Midnight Sun Yellow Proving Popular Tie-Up," *Universal Weekly* 24, no. 11 (October 23, 1926): 23.

151. "Midnight Sun Color in England," *Universal Weekly* 24, no. 13 (November 6, 1926): 29. This was also reported in the UK press—in *Kinematograph Weekly* 116, no. 1018 (October 21, 1926): 72—as were many other exploitation initiatives.

152. Margaret Hayden Rorke, The Broadcast, July 1926, Hagley Archive, 2188-ISCC-TCCA, box 34.

153. "The Midnight Sun," *Film Daily* 38, no. 26 (August 1, 1926): 3; "The Midnight Sun," *Film Daily* 38, no. 77 (December 30, 1926): 6.

154. "The Midnight Sun [Ad]," *Kinematograph Weekly* 115, no. 1011 (September 2, 1926): 8; "What Managers Are Doing," *Kinematograph Weekly* 115 no. 1011 (September 2, 1926): 63.

155. The *Tamworth Herald* refers to "wonderful scenes in natural colour," January 1, 1927, 4. The *Gloucester Citizen* referred to "remarkable scenes" in a new color process, January 4, 1927.

156. "Production Menu—Looks Delightfully Appetizing," *Film Daily* 52, no. 39 (May 15, 1930): 2.

157. "Rhapsody Blue: Fashion Expert Names New Colour," *Times of India*, Cinema Supplement, July 18, 1930, 12.

158. According to *Universal Weekly*, a holiday was declared in California for the film, which entailed a premiere of the film accompanied with a ball, and various gold-themed *Sutter's Gold* fashion displays in cinema windows and jewelry stores. See Universal's "Declares California Holiday for *Sutter's Gold*," *Universal Weekly* 38, no. 8 (March 21, 1936): 9, 29; "*Sutter's Gold*: Color Is New Spring Shade," *Motion Picture Herald* 122, no. 10 (March 7, 1936): 96; and " 'Frisco Windows Glitter with 'Gold' Displays," *Universal Weekly* 38, no. 12 (April 25, 1936): 30.

159. "Movies Set a New Color Vogue," *Universal Weekly* 38, no. 4 (February 22, 1936): 22.

160. The number of color terms in everyday use tends to be limited to around twelve, but for cosmetics, paints, textiles, and horticulture, a much fuller, variable set is used. Siegfried Wyler, *Colour and Language: Colour Terms in English* (Tübingen, Germany: Gunter Narr Verlag, 1992), 101.

3. Synthetic Dreams: Expanded Spaces of Cinema

1. David Curtis, A. L. Rees, Duncan White, and Steven Ball, eds., *Expanded Cinema: Art, Performance, Film* (London: Tate, 2011), 12.

2. Pierre Bourdieu, *The Field of Cultural Production* (Oxford: Polity Press, 1993), 257–258.

3. Miriam Bratu Hansen, "The Mass Production of the Senses: Classical Cinema as Vernacular Modernism," *Modernism/Modernity* 6, no. 2 (1999): 59–77. On the relation of color to vernacular modernism, see also Joshua Yumibe, " 'Harmonious Sensations of Sound by Means of Colors': Vernacular Colour Abstractions in Silent Cinema," *Film History: An International Journal* 21, no. 2 (July 2009): 164–176.

4. Loyd A. Jones, "Tinted Films for Sound Positives," *Transactions of the Society of Motion Picture Engineers* 13, no. 37 (May 6, 1929): 199–226; and Natalie M. Kalmus, "Color Consciousness," *Journal of the Society of Motion Picture Engineers* 25, no. 2 (August 1935): 139–147.

5. Theo van Doesburg, "Notes on L'Aubette at Strasbourg [1928]," in *De Stijl*, ed. Hans L. C. Jaffé (New York: Abrams, 1971), 232–237. Van Doesburg was one of the leaders of De Stijl (the Style, also known as Neoplasticism), founded in 1917 in Amsterdam, which was also associated with painter Piet Mondrian.

6. *Colour* 2, no. 9 (1930): 28; *Colour* 2, no. 11 (1930): 29.

7. "New Process Sign: Animation Obtained in *Don Juan* Sign by Application of 'Color Absorption' Principle," *Film Daily* 37, no. 8 (July 11, 1926): 9.

8. "New Process Sign," 9.

9. P. Morton Shand, *The Architecture of Pleasure: Modern Theatres and Cinemas* (London: B. T. Batsford, 1930), 29.

10. Shand, *The Architecture of Pleasure*, figure 96.

11. Shand, *The Architecture of Pleasure*, 29.

12. Matthew Luckiesh, "The Potentiality of Color in Lighting," *Transactions of the Illuminating Engineering Society, Part 11—Papers* 13, no. 1 (1918): 1–6.

13. Sean F. Johnston, "The Construction of Colorimetry by Committee," *Science in Context* 9, no. 4 (1996): 392.

14. Luckiesh, "The Potentiality of Color in Lighting," 3.

15. Beatrice Irwin, *The Gates of Light: A Record of Progress in the Engineering of Color and Light* (London: Rider, 1920), 73.

16. Leonard Troland, "The Psychology of Color, in Relation to Illumination," *Transactions of the Illuminating Engineering Society, Part 11—Papers* 13, no. 1 (1918): 37.

17. Leonard Troland, "The Psychology of Natural Color Motion Pictures," *American Journal of Physiological Optics* 7, no. 3 (1926): 382.

18. Imbibition was Technicolor's breakthrough technique in terms of achieving greater image stability and contrast by printing from color separation negatives photographed on black and white using a beam-splitter Technicolor camera. On concerns about variable projection conditions for color films, see Leonard Troland, letter to Herbert Kalmus, December 30, 1925, M0006 Technicolor Internal Correspondence, George Eastman Museum, Rochester, New York.

19. "Exhibition on the Science and Art of Color," *Science* 73, no. 1881 (January 16, 1931): 69–70.

20. "Cultural capital" refers to the possession of knowledge, accomplishments, or taste by which an individual may secure a particular social position. See Pierre Bourdieu, *Distinction: A Social Critique of the Judgment of Taste* (Cambridge, Mass.: Harvard University Press, 1984).

21. A. L. Rees, *A History of Experimental Film and Video*, 2nd ed. (London: British Film Institute/Palgrave Macmillan, 2011), 1.

22. There are numerous overlapping definitions of the terms; see William Moritz, "The Dream of Color Music, and Machines That Made It Possible," *Animation World Magazine* 4, no. 2 (Spring 1996): 69–84.

23. "Says We Will Sleep Under Violet Rays: Dr. Luckiesh Predicts Light Bath Will Give Effect of Repose in Sunlit Meadow," *New York Times*, February 11, 1931, 24.

24. Troland, "The Psychology of Color," 36.

25. See Lewis M. Townsend and Loyd A. Jones, "The Use of Color for the Embellishment of the Motion Picture Program," *Transactions of the Society of Motion Picture Engineers* 21 (August 1925): 38–65; and Yumibe, " 'Harmonious Sensations of Sound by Means of Colors.' "

26. Jones, "Tinted Films for Sound Positives," 225.

27. Quoted in "Says We Will Sleep Under Violet Rays," 24.

28. Adrian Cornwell-Clyne, *Colour-Music: The Art of Light*, 2nd ed. (London: Crosby Lockwood, 1930), 150.

29. Frederick Bentham, *Sixty Years of Light Work* (Isleworth, UK: Strand Lighting, 1992), 31.

30. Bourdieu, *The Field of Cultural Production*, 225.

31. For useful discussions of color music, see Kerry Brougher, Olivia Mattis, Jeremy Strick, Ari Wiseman, and Judith Zilczer, eds., *Visual Music: Synaesthesia in Art and Music Since 1900* (London: Thames & Hudson, 2005); R. Bruce Elder, *Harmony and Dissent: Film and Avant-Garde Art Movements in the Early Twentieth Century* (Waterloo, Ont.: Wilfrid Laurier University Press, 2010), 2–200; and William Moritz, "Abstract Film and Color Music," in *The Spiritual in Art: Abstract Painting 1890–1985*, ed. Maurice Tuchman (New York: Abbeville Press, 1986), 297–311.

32. Joshua Yumibe, "On the Education of the Senses: Synaesthetic Perception from the 'Democratic Art' of Chromolithography to Modernism," *New Review of Film and Television Studies* 7, no. 3 (September 1, 2009): 269.

33. Cornwell-Clyne, *Colour-Music*, 179.

34. On the skirt-dance craze, see Catherine Hindson, "Interruptions by Inevitable Petticoats: Skirt Dancing and the Historiographical Problem of Late Nineteenth-Century Dance," *Nineteenth Century Theatre and Film* 35 (December 1, 2008): 48–64; and Joshua Yumibe, *Moving Color: Early Film, Mass Culture, Modernism* (New Brunswick, N.J.: Rutgers University Press, 2012), 49–58.

35. Andrew Robert Johnston, "The Color of Prometheus: Thomas Wilfred's Lumia and the Projection of Transcendence," in *Color and the Moving Image: History, Theory, Aesthetics, Archive*, ed. Sarah Street, Simon Brown, and Liz Watkins (New York: Routledge, 2013), 70. Also see Keely Orgeman, ed., *Lumia: Thomas Wilfred and the Art of Light* (New Haven, Conn.: Yale University Art Gallery, 2017).

36. Johnston, "The Color of Prometheus," 71.

37. Johnston, "The Color of Prometheus," 69.

38. Thomas Wilfred, "Light and the Artist" (1947), reprinted in *Thomas Wilfred's Clavilux*, ed. Michael Betancourt (Rockville, Md.: Wildside Press, 2006), 16.

39. George Vail, "Visible Music: The Birth of a New Art," *Educational Screen* 10 (1922): 255.

40. Vail, "Visible Music," 255.

41. "Color Organ Featured at N.Y. Rivoli," *Exhibitors Trade Review* 11, no. 15 (November 3, 1922): 1027.

42. "Clavilux Enthralls College," *Vassar Miscellany News* 7, no. 46 (April 21, 1923): 1, 4.

43. Alvin Leslie Powell, *The Coordination of Light and Music* (Cleveland, Ohio: General Electric, 1930): 12.

44. "Color Organ Paints Ballroom with Magic Light," *Popular Mechanics* 53, no. 3 (March 1930): 401.

45. "Color Organ Paints Ballroom with Magic Light."

46. Johnston, "The Color of Prometheus," 70.

47. Linda Dalrymple Henderson, *The Fourth Dimension and Non-Euclidean Geometry in Modern Art* (Cambridge, Mass.: MIT Press, 2013), 362.

48. Vail, "Visible Music," 253.

49. See Anne Ciecko, "Mary Hallock-Greenewalt's Spectral Middle East: Autobiographical Orientations and Reflexive Mediations," *Feminist Media Histories* 3, no. 1 (January 1, 2017): 25–49.

50. Regina Lee Blaszczyk, *The Color Revolution* (Cambridge, Mass.: MIT Press, 2012), 194–195.

51. J. H. Vallette, "[Vallette Machine Company to W. L. Washbourne]," December 31, 1924, MSS24049: Mary Elizabeth Hallock Greenewalt Papers, 1918–1942, Box 1, Library of Congress.

52. Blaszczyk, *The Color Revolution*, 194–195.

53. "[Letter to Paramount Famous Lasky Corporation]," February 6, 1928, MSS24049: Mary Elizabeth Hallock Greenewalt Papers, 1918–1942, Box 1, Library of Congress.

54. See MSS24049: Mary Elizabeth Hallock Greenewalt Papers, 1918–1942, Series III, Legal, b. Lawsuits, 1920–1936.

55. Rose Rosner, "New 'Color Organ' to Interpret Music," *New York Times*, November 12, 1922, 98.

56. Rosner, "New 'Color Organ' to Interpret Music."

57. Elder, *Harmony and Dissent*, 78.

58. Henderson, *The Fourth Dimension*, 324.

59. Henderson, *The Fourth Dimension*, 324.

60. For diagrams of Bragdon's various instruments, see Eugenia Victoria Ellis and Andrea Reithmayr, eds., *Claude Bragdon and the Beautiful Necessity* (Rochester, N.Y: RIT Cary Graphic Arts Press, 2010), 166–168.

61. Jonathan Massey, "Transnational Transmedia Modernism," in Ellis and Reithmayr, *Claude Bragdon and the Beautiful Necessity*, 51.

62. Claude Bragdon, *The Secret Springs: An Autobiography* (1938; reprint, New York: Cosimo, 2005), 122.

63. Claude Bragdon, *More Lives Than One* (New York: Knopf, 1938), 124.

64. Bragdon, *The Secret Springs*, 128.

65. "Beethoven's Moonlight Sonata," *Educational Screen* 1, no. 10 (1922): 329.

66. Adrian Bernard Klein, *Colour-Music: The Art of Light* (London: Crosby, Lockwood, 1926), vii.

67. William Moritz, "The Absolute Film," Lecture notes, WR099, Media Art Biennale, Wrodaw, Poland, 1999, accessed May 7, 2018, http://www.centerforvisualmusic.org/library/WMAbsoluteFilm.htm.

68. William Moritz, *Musique de la Couleur—Cinéma Intégral* in *Poétique de la Couleur* (Paris: Musée du Louvre, 1995), accessed May 7, 2018, http://www.centerforvisualmusic.org/WMCM_IC.htm.

69. Michael Cowan, *Walter Ruttmann and the Cinema of Multiplicity: Avant-Garde Film—Advertising—Modernity* (Amsterdam: Amsterdam University Press, 2014), esp. 12–13, 27–54; and Hansen, "The Mass Production of the Senses."

70. Rudolf Kurtz, *Expressionism and Film*, trans. Brenda Benthien (New Barnet, UK: John Libbey, 2016), 106–107; also quoted in Michael Cowan, "Absolute Advertising: Walter Ruttmann and the Weimar Advertising Film," *Cinema Journal* 52, no. 4 (2013): 63.

71. Cowan, *Walter Ruttmann and the Cinema of Multiplicity*, 36–37.

72. Cowan, *Walter Ruttmann and the Cinema of Multiplicity*, 57.

73. William Moritz, "The Absolute Film," *Center for Visual Music*, April 1999, accessed May 7, 2018, http://www.centerforvisualmusic.org/library/WMAbsoluteFilm.htm.

74. Michael Cowan, "Advertising, Rhythm, and the Filmic Avant-Garde in Weimar: Guido Seeber and Julius Pinschewer's *Kipho* Film," *October*, no. 131 (2010): 23–50; and Cowan, "Absolute Advertising," 49–73.

75. Cindy Keefer, "Raumlichtmusik: Early 20th Century Abstract Cinema Immersive Environments," *Leonardo Electronic Almanac* 16, no. 6–7 (October 2009): 1–5.

76. The project was reconstructed by restoring the 1920s nitrate film photochemically and digitizing the new preservation materials. Cindy Keefer, Centre for Visual Music, correspondence with authors, May 15, 2018.

77. The geometric, abstract films of Eggeling (*Symphonie diagonale*) and Richter (*Rhythmus*), for example, are referenced by critic Roger Burford in the film-as-art magazine *Close Up* as being models for successful use of color. Published in Switzerland by the Pool Group, *Close Up* featured many British writers who were impressed by modernist films, particularly from Germany. "From Abstract to Epic," *Close Up* 2, no. 3 (October 1928): 16–21.

78. Bauhaus Exhibition catalog (London: Barbican Gallery, 2012), 80.
79. Chiaki Yamane, "A New Art Fork for Common Experience: Hirschfeld-Mack's *Farben-lichtspiele*," *CARLS Series of Advanced Study of Logic and Sensibility* 4 (2010): 345–346.
80. Yamane, "A New Art Fork for Common Experience," 346.
81. Kurt Schwerdtfeger, *Bildende Kunst und Schule* (Hannover: Hermann Schroedel Verlag KG, 1957).
82. Georg Anschütz was a professor of music, psychology, and aesthetics in Hamburg in the 1920s, and a leading expert on synaesthesia. See Georg Anschütz, *Farbe-Ton-Forschungen 1* (Hamburg: Akademische Verlagsgesellschaft, 1927).
83. Loyd A. Jones, "Tinted Films for Sound Positives," 225.
84. Townsend and Jones, "The Use of Color for the Embellishment of the Motion Picture Program," 41.
85. Nitrate elements of these dynamic color effects were donated by Kodak to the George Eastman Museum in 1961, and a preservation of the material was presented at the Pordenone Silent Film Festival in 2007 as *[Kaleidoscope]* (c. 1925); see Daniela Currò, "*[Kaleidoscope]*," in *Twenty-Sixth Pordenone Silent Film Festival Catalog*, ed. David Robinson (Sacile, Italy: Le Giornate del Cinema Muto, 2007), 150–151.
86. Yumibe, "'Harmonious Sensations of Sound by Means of Colors,'" 171–172; Jones and Townsend refer to the use of abstract color effects as preludes to feature films in "The Use of Color," 39–40. For extant title sequences in films, see Kodak's demo reel of its lenticular Kodacolor process, *Garden Party* (1928), preserved at the George Eastman Museum.
87. Quoted in Harold B. Franklin, "Color," *Transactions of the Society of Motion Picture Engineers* 17, no. 1 (July 1931): 4.
88. Shand, *The Architecture of Pleasure*, 2.
89. There is a considerable literature on these developments. See, for example, David E. Nye, *Electrifying America: Social Meanings of a New Technology* (Cambridge, Mass.: MIT Press, 1990); Lucy Fischer, "'The Shock of the New': Electrification, Illumination, Urbanization, and the Cinema," in *Cinema and Modernity*, ed. Murray Pomerance (New Brunswick, N.J.: Rutgers University Press, 2006), 19–37; Kirsten Whissell, *Picturing American Modernity* (Durham, N.C.: Duke University Press, 2008); and Lauren Rabinovitz, *Electric Dreamland: Amusement Parks, Movies, and American Modernity* (New York: Columbia University Press, 2012).
90. Kirsten Moana Thompson, "Rainbow Ravine: Colour and Animated Advertising in Times Square," in *The Colour Fantastic: Chromatic Worlds of Silent Cinema*, ed. Giovanna Fossati, Victoria Jackson, B. G. Lameris, Elif Rongen-Kaynakci, Sarah Street, and Joshua Yumibe (Amsterdam: Amsterdam University Press, 2018), 168.
91. Catherine Saillant, "Pair Sheds New Light on L.A.'s Claim to Neon Fame," December 3, 2013, accessed February 28, 2018, http://www.latimes.com/local/la-me-c1-los-angeles-neon-20131203-dto-htmlstory.html.
92. Christoph Ribbat, *Flickering Light. A History of Neon* (London: Reaktion, 2013), 8, 35.
93. James Sedgeworth, "Signs to Success: The Importance of Light," *Kinematograph Weekly*, July 14, 1927, 67.
94. Thompson, "Rainbow Ravine," 168.
95. *Advertising World*, February 1929, 174.
96. *Advertising World*, November 1929, 526.
97. Federico Pierotti, "Chromatic Objects: Colour Advertising and French Avant-Garde Films of the 1920s," in Fossati et al., *The Colour Fantastic*, 197–198.
98. Pierotti, "Chromatic Objects," 205.

99. Janet Ward, *Weimar Surfaces: Urban Visual Culture in 1920s Germany* (Berkeley: University of California Press, 2001), 168.

100. Ward, *Weimar Surfaces*, 168–169.

101. Siegfried Kracauer, "Picture Postcards" (1930), quoted in Esther Leslie, "Kracauer's Weimar Geometry and Geomancy," *New Formations* 61 (2007): 46.

102. Kracauer, "Picture Postcards" (1930), quoted in Leslie, "Kracauer's Weimar Geometry and Geomancy," 46.

103. Siegfried Kracauer, "Cult of Distraction: On Berlin's Picture Palaces" (1926), in *The Mass Ornament: Weimar Essays*, ed. and trans. Thomas Y. Levin (Cambridge, Mass.: Harvard University Press, 1995), 324.

104. Kracauer, "Cult of Distraction: On Berlin's Picture Palaces," 324.

105. Tim Hatcher, "Holophane and the Golden Age of Colour Lighting," *Picture House* 35 (2010): 40.

106. "Introduction: Colour Lighting: Its Present Applications and Future Possibilities," *Holophane Illumination: The Journal of Better Lighting* 11, no. 3 (1929): 4.

107. R. Gillespie Williams, "Psychology of Entertainment," *Kinematograph Weekly* 142, no. 1129 (December 6, 1928): 79.

108. Williams, "Psychology of Entertainment," 79.

109. Williams, "Psychology of Entertainment," 79.

110. "Colour in the Kinema. A Practical Demonstration to Exhibitors," *Kinematograph Weekly* 119, no. 1032 (January 27, 1927): 79.

111. "Holophane Colour Lighting at the Ritz Cinema Birmingham," *Holophane Illumination. The Journal of Better Lighting* 11, no. 3 (1929): 21.

112. "Holophane Advert," *Kinematograph Weekly* 120, no. 1034 (February 10, 1927): 74.

113. "Colour in the Kinema." 79.

114. "Atmospheric Stage Curtains," *Holophane Illumination. The Journal of Better Lighting* 11, no. 3 (1929): 27.

115. "Atmospheric Stage Curtains," 27.

116. Alvin Leslie Powell, *The Coordination of Light and Music* (Cleveland, Ohio: General Electric, 1930), 3.

117. Powell, *The Coordination of Light and Music*, 5.

118. Yumibe, " 'Harmonious Sensations of Sound by Means of Colors,' " 170.

119. Klein, *Color-Music*, 25.

120. Douglas Gomery, *Shared Pleasures: A History of Movie Presentation in the United States* (London: British Film Institute, 1992), 48.

121. Julie Brown, "Framing the Atmospheric Film Prologue in Britain, 1919–26," in *The Sounds of the Silents in Britain*, ed. Julie Brown and Annette Davison (New York: Oxford University Press, 2013), 201–205.

122. "Science as an Aid to Religion: Coloured Lights in Church to Influence Mood," *Angus Evening Telegraph*, October 19, 1921, 5.

123. Claude Bragdon, "Lighting St Marks," *Edison Monthly*, 1921, 189–191.

124. Bragdon, "Lighting St Marks."

125. "Mr and Mrs Picturegoer at the Futurist, Birmingham," *Pictures and Picturegoer* 3, no. 16 (April 1922): 42.

126. See, for instance, Joshua Yumibe, "Colour Magic: Illusion and Abstraction in Silent and Experimental Cinemas," *Moving Image Review & Art Journal* 2, no. 2 (2013): 229–237.

127. Sarah Street, *Colour Films in Britain: The Negotiation of Innovation, 1900–55* (London: British Film Institute/Palgrave Macmillan, 2012): 184–197.

128. Wilfred, "Light and the Artist," 10.

129. Daan Hertogs and Nico de Klerk, *"Disorderly Order": Colors in Silent Film: The 1995 Amsterdam Workshop* (Amsterdam: Stichting Nederlands Filmmuseum, 1996), 30.
130. There was considerable variation in the size of orchestras in cinemas in the 1920s, depending on the location of the cinema and managers' interest in musical accompaniment. In the UK, the periodical *Musical Notes and Herald* detailed such trends in London. For general information on film and music in Britain during the silent period, see Brown and Davison, *The Sounds of the Silents in Britain*.
131. See, for instance, his writings on color in Sergei Eisenstein, "Vertical Montage," in *Towards a Theory of Montage: Sergei Eisenstein Selected Works*, ed. Michael Glenny and Richard Taylor, trans. Michael Glenny (London: I. B. Tauris, 2010), 327–400.
132. John F. Barry and Epes Winthrop Sargent, *Building Theatre Patronage* (New York: Chalmers, 1927), 383.
133. Edwin Evans, "Music and the Films: Associate or Accessory?," *Musical News and Herald* 62, no. 1554 (January 7, 1922): 19.
134. Barry and Sargent, *Building Theatre Patronage*, 389–390.
135. A. L. Powell, "Motion Picture Theatre Lighting," in *Motion Picture Theatre Lighting* 4, no. 2 (1923): 12, 22.
136. Lucy Fischer, *Cinema by Design: Art Nouveau, Modernism, and Film History* (New York: Columbia University Press, 2017), 112.
137. "The Function of the Organ: Its Characteristics Are Flexibility and Economy in Relation to Volume," *Kinematograph Weekly* 120, no. 1035 (February 17, 1927): *Kine Weekly Supplement* 41, 43.
138. "*The Glorious Adventure* [Ad]," *Pictures and Picturegoer* 3, no. 14 (February 1922): 3.
139. Felix Orman, "Music, Colour, and Human Emotion: Achieving an Artistic Triumvirate," *Musical News and Herald* 62, no. 1564 (March 18, 1922): 346–348.
140. Orman, "Music, Colour, and Human Emotion."
141. "The Films," *Musical News and Herald* 62, no. 1555 (January 14, 1922): 58.
142. Gilbert Stevens, "Technical Supplement: Picture Music," *Kinematograph Weekly* 59, no. 769 (January 19, 1922): viii.
143. "Technical Supplement: Picture Music," *Kinematograph Weekly* 60, no. 771 (February 2, 1922): ix.
144. "Music Written for the Kinema?" *Manchester Guardian*, June 20, 1922, 9.
145. Carroll H. Dunning, "Color Photography in 1922," *Film Year Book*, 1923, 171.
146. "'Music Films': New Series Designed to Bring About Perfect Synchronisation Between Orchestra and Film," *Film Daily* 20, no. 38 (May 8, 1922): 1.
147. "The Screen," *New York Times*, May 15, 1922, 24.
148. This is in juxtaposition to the problems experienced by other photographic color processes such as Cinecolor and Multicolor. See Adrian Cornwell-Clyne, *Colour Cinematography* (London: Chapman & Hall, 1951), 588.
149. Charles O'Brien, *Cinema's Conversion to Sound: Technology and Film Style in France and the U.S.* (Bloomington: Indiana University Press, 2005), 7.
150. Erwin Panofsky, "Style and Medium in the Motion Pictures" (1934, rev. 1947), in *Film Theory and Criticism: Introductory Readings*, 5th ed., ed. Leo Braudy and Marshall Cohen (New York: Oxford University Press, 1999), 279–292.
151. James Layton and David Pierce, *The Dawn of Technicolor, 1915–1935* (Rochester, N.Y.: George Eastman House, 2015), 248–250.
152. Charles O'Brien, "Color as Image Schema," in Street et al., *Color and the Moving Image*, 38.
153. Cornwell-Clyne, *Colour Cinematography*, 651.
154. Cornwell-Clyne, *Colour Cinematography*, 653.

155. J. A. Ball to L. Troland, January 5, 1927. George Eastman Museum, M0006 Technicolor Internal Correspondence.
156. Jones, "Tinted Films for Sound Positives," 224.
157. Kalmus, "Color Consciousness."
158. L. M. Dieterich, "The Relative Values of Sound and Color," *American Cinematographer*, 13, no.2, June 1932, 10, 44.

4. Color in the Art and Avant-Garde of the 1920s

1. Paul Scheerbart, "Glass Architecture (1914)," in *Glass! Love!! Perpetual Motion!!!: A Paul Scheerbart Reader*, ed. Josiah McElheny and Christine Burgin, trans. James Palmes (Chicago: University of Chicago Press, 2014), 48.
2. In examining the cosmopolitan flows of modernist practice, we draw here from Rebecca Walkowitz, *Cosmopolitan Style: Modernism Beyond the Nation* (New York: Columbia University Press, 2006).
3. See Iain Boyd Whyte, *Bruno Taut and the Architecture of Activism* (Cambridge: Cambridge University Press, 2010), 32–36.
4. Noam Elcott, " 'Kaleidoscope-Architecture': Scheerbart, Taut, and the Glass House," in Elheny and Burgin, *Glass! Love!! Perpetual Motion!!!*, 111–117.
5. See Bernard Smith, *Modernism's History: A Study in Twentieth-Century Art and Ideas* (New Haven, Conn.: Yale University Press, 1998), 76.
6. Walter Benjamin, "On Scheerbart," trans. Edmund Jephcott, in *Selected Writings*, vol. 4 (1938–1940), ed. Michael W. Jennings (Cambridge, Mass.: Belknap Press, 2003), 386; and "Edward Fuchs, Collector and Historian," trans. Howard Eiland and Michael W. Jennings, in *Selected Writings*, vol. 3 (1935–1938), 266.
7. See John Gage, *Color and Culture: Practice and Meaning from Antiquity to Abstraction* (Berkeley: University of California Press, 1999), 221–224.
8. Annie Besant and C. W. Leadbeater, *Thought Forms*, 2nd ed. (Wheaton, Ill.: Theosophical Publishing House, 1999), 22–25.
9. For useful discussions, see in particular the essays collected in Maurice Tuchman, ed., *The Spiritual in Art: Abstract Painting 1890–1985* (New York: Abbeville Press, 1986). Also see Kerry Brougher, Jeremy Strick, Ari Wiseman, and Judith Zilczer, eds., *Visual Music: Synaesthesia in Art and Music Since 1900* (New York: Thames & Hudson, 2005); Bruce R. Elder, *Harmony and Dissent: Film and Avant-Garde Art Movements in the Early Twentieth Century* (Waterloo, Ont.: Wilfrid Laurier University Press, 2008); and Sixten Ringbom, *The Sounding Cosmos: A Study in the Spiritualism of Kandinsky and the Genesis of Abstract Painting* (Åbo, Finland: Åbo Akademi, 1970).
10. Kerry Brougher, "Visual Music Culture," in Brougher et al., *Visual Music*, 96. Also see Joshua Yumibe, "Colour Magic: Illusion and Abstraction in Silent and Experimental Cinemas," *MIRAJ: Moving Image Review & Art Journal* 2, no. 2 (October 1, 2013): 228–237.
11. Smith, *Modernism's History*, 82.
12. László Moholy-Nagy, *Malerei, Photographie, Film*, vol. 8, *Bauhausbücher* (München: Albert Langen Verlag, 1925), revised and republished in 1927; references are to the English translation, *Painting, Photography, Film*, trans. Janet Seligman (Cambridge, Mass.: MIT Press, 1969), 13.
13. Pierre Bourdieu, "The Field of Cultural Production, or: The Economic World Reversed," in *The Field of Cultural Production: Essays on Art and Literature*, ed. Randal Johnson, trans. Richard Nice (New York: Columbia University Press, 1993), 53.

14. Charles Acland and Haidee Wasson, "Introduction: Utility and Cinema," in *Useful Cinema*, ed. Charles R. Acland and Haidee Wasson (Durham, N.C.: Duke University Press, 2011), 1–16.

15. See Malte Hagener, *Moving Forward, Looking Back: The European Avant-Garde and the Invention of Film Culture, 1919–1939* (Amsterdam: Amsterdam University Press, 2007), 130–131; and the essays in Thomas Tode, ed., "Bauhaus & Film," Special issue, *Maske Und Kothurn* 57, no. 1–2 (December 1, 2011).

16. For a discussion of Bayer's design in the context of the *Reklame-Architektur* of the interwar period, see Hal Foster, "Herbert Bayer: Advertising Structures, 1924–25," in *Bauhaus 1919–1933: Workshops for Modernity*, ed. Barry Bergdoll and Leah Dickerman (New York: Museum of Modern Art, 2009), 174–181.

17. Wassily Kandinsky, *Concerning the Spiritual in Art*, trans. Hilla Rebay (New York: Guggenheim Foundation, 1946), 71.

18. See Hajo Düchting, *Farbe am Bauhaus: Synthese und Synästhesie* (Berlin: Gebr. Mann, 1996); as well as John Gage, "Colour at the Bauhaus," *AA Files*, no. 2 (July 1, 1982): 50–54; and Philip Ball and Mario Ruben, "Color Theory in Science and Art: Ostwald and the Bauhaus," *Angewandte Chemie International Edition* 43, no. 37 (2004): 4842–4847.

19. Ball and Ruben, "Color Theory in Science and Art," 4845–4846.

20. Egbert Jacobson and Wilhelm Ostwald, *The Color Harmony Manual and How to Use It* (Chicago: Color Laboratories Division, Container Corporation of America, 1942); Egbert Jacobson, *Basic Color: An Interpretation of the Ostwald Color System* (Chicago: Theobald, 1948). The Container Corporation of America, founded by Walter Paepcke, was one of the key institutions that enabled the transatlantic movement of the European avant-garde into the United States during and after the Second World War. Paepcke was a financial supporter of Moholy as he founded the New Bauhaus in Chicago in 1937.

21. The most sustained study of color at the Bauhaus is Düchting, *Farbe am Bauhaus*.

22. See Joan Campbell, *The German Werkbund: The Politics of Reform in the Applied Arts* (Princeton, N.J.: Princeton University Press, 2015), 3.

23. Ostwald consulted with German paint and colorant producers in the 1910s and even synthesized his own colorants to paint with (he was an amateur painter), which eventually led him to found a colorant factory in Leipzig that operated from 1920 to 1923. Ball and Ruben, "Color Theory in Science and Art," 4844.

24. Walter Gropius, "Programme of the Staatliche Bauhaus in Weimar [1919]," republished in Catherine Ince and Lydia Yee, eds., *Bauhaus: Art as Life* (London: Walther König, 2012), 15–17.

25. For a thorough account of Itten's activities at the Bauhaus, see in particular Éva Forgács, *The Bauhaus Idea and Bauhaus Politics*, trans. John Bátki (Budapest: Central European University Press, 1995), 46–62.

26. Smith, *Modernism's History*, 76–77.

27. Rudolf Steiner, *Practical Advice to Teachers* (Great Barrington, Mass.: Anthroposophic Press, 2000), 35

28. Johannes Itten, *Design and Form: The Basic Course at the Bauhaus*, trans. John Maass (New York: Reinhold, 1964), 45.

29. See Gertrud Grunow, "The Creation of Living Form Through Color, Form and Sound," in *The Bauhaus: Weimar, Dessau, Berlin, Chicago*, ed. Hans M. Wingler and Joseph Stein, trans. Wolfgang Jabs and Basil Gilbert (Cambridge, Mass.: MIT Press, 1969), 69–71.

30. On the relation and distinctions between *Einfühlung* and empathy in relation to the moving image, see Robin Curtis, "*Einfühlung* and Abstraction in the Moving Image:

Historical and Contemporary Reflections," *Science in Context* 25, no. 3 (September 2012): 425–446. Also see Scott Curtis, *The Shape of Spectatorship: Art, Science, and Early Cinema in Germany* (New York: Columbia University Press, 2015), 214–230.

31. Lipps's notion of *Einfühlung* was more influential at the Bauhaus than Worringer's juxtaposition of it with abstraction in his groundbreaking 1907 dissertation, *Abstraction and Empathy: A Contribution to the Psychology of Style*, trans. Michael Bullock (Chicago: Elephant Paperbacks, 1997). For Worringer, alienation is one of the pivots between *Einfühlung* and abstraction: *Einfühlung* seeks an unalienated relation to the organic, whereas abstraction begins with one's self-alienation from the organic—it allows for an anxious and critical separation from the world. His theory was taken up at the Bauhaus, for instance, by Oskar Schlemmer, but Lipps's sense of *Einfühlung* was more in keeping with figures such as Itten and later Kandinsky and Moholy. The literature on Lipps and Worringer is vast, but specifically on Schlemmer, see Melissa Trimingham, *The Theatre of the Bauhaus: The Modern and Postmodern Stage of Oskar Schlemmer* (New York: Routledge, 2011), 17–18; and on Lipps's influence at the Bauhaus, see Harry Francis Mallgrave, *Architecture and Embodiment: The Implications of the New Sciences and Humanities for Design* (New York: Routledge, 2013), 128–130.

32. Rudolf Kurtz, *Expressionism and Film*, trans. Brenda Benthien (New Barnet, UK: John Libbey, 2016), 98. For a productive analysis of *Einfühlung* and abstraction in relation to Absolute Film, see Christine Brinckmann, "Abstraction and Empathy in the Early German Avant-Garde," in *Color and Empathy: Essays on Two Aspects of Film* (Amsterdam: Amsterdam University Press, 2015), 145–170.

33. Importantly, Michael Cowan has noted regarding this passage that *Einfühlung* and psychophysics cannot be collapsed into one another, as the corresponding bodily receptions that Kurtz describes were more of interest to experimental psychology than to the aesthetic theorization of *Einfühlung*, which attempted "to salvage a notion of disinterested aesthetic experience" separated from such motor reflexes. See *Walter Ruttmann and the Cinema of Multiplicity: Avant-Garde Film—Advertising—Modernity* (Amsterdam: Amsterdam University Press, 2014), 192 n. 14; also see 30–31.

34. Moholy-Nagy, *Painting, Photography, Film*, 122. Also see his discussion of film projects at the Bauhaus in László Moholy-Nagy, "Film im Bauhaus," *Film-Kurier* 296 (December 18, 1926).

35. Forgács, *The Bauhaus Idea*, 94.

36. Laszlo Moholy-Nagy, *The New Vision and Abstract of an Artist*, trans. Daphne M. Hoffman (New York: Wittenborn, Schultz, 1947), 71, 72.

37. Moholy-Nagy, *The New Vision and Abstract of an Artist*, 72

38. Jan-Christopher Horak, "László Moholy-Nagy: The Constructivist Urge," in *Making Images Move: Photographers and Avant-Garde Cinema* (Washington, D.C.: Smithsonian Institution Press), 109–135.

39. Brigid Doherty, "László Moholy-Nagy: Constructions in Enamel, 1923," in *Bauhaus 1919–1933: Workshops for Modernity*, ed. Barry Bergdoll and Leah Dickerman (New York: Museum of Modern Art, 2009), 130.

40. Wilhelm Ostwald, "Die Harmonie der Farben," *De Stijl—maandblad voor de beeldende vakken* 3, no. 7 (1920): 60–62; originally published in *Innen-Dekoration*, November 1919, 386–388.

41. Ise Gropius, "Typewritten English Translation of Ise Gropius' German Diary, 1924–1928" (Archives of American Art, Smithsonian Institution, 1982), Microfilm 2393, Ise Gropius Papers, June 13, 1927 entry, p. 222.

42. Gropius, "Typewritten English Translation."

43. On the New Typography, see Jan Tschichold, *The New Typography*, trans. Ruari McLean (Berkeley: University of California Press, 2006); on Moholy and Benjamin, see Frederic J. Schwartz, *Blind Spots: Critical Theory and the History of Art in Twentieth-Century Germany* (New Haven, Conn.: Yale University Press, 2005), 37–102.

44. See especially Andrea Nelson, "László Moholy-Nagy and Painting Photography Film: A Guide to Narrative Montage," *History of Photography* 30, no. 3 (September 1, 2006): 258–269; and Pepper Stetler, " 'The New Visual Literature': László Moholy-Nagy's *Painting, Photography, Film*," *Grey Room*, no. 32 (2008): 88–113. On the script "Dynamic of the Metropolis," see also Edward Dimendberg, "László Moholy-Nagy's Film Scenario 'Dynamic of the Metropolis,'" in *Camera Obscura, Camera Lucida: Essays in Honor of Annette Michelson*, ed. Allen Richard and Malcolm Turvey (Amsterdam: Amsterdam University Press, 2003), 109–126.

45. Moholy-Nagy, *Painting, Photography, Film*, 28; italics in original. This had significant influence on Benjamin's theory of the "optical unconscious," for instance in Walter Benjamin, "Little History of Photography" (1931), in *Selected Writings*, vol. 2 (1927–1934), ed. Michael W. Jennings, Howard Eiland, and Gary Smith, trans. Edmund Jephcott and Kingsley Shorter (Cambridge, Mass.: Belknap Press, 1999), 510–512.

46. Much has been written about such claims regarding the transformation of sensory perception and aesthetics in the early twentieth century. For a discussion, see Joshua Yumibe, "On the Education of the Senses: Synaesthetic Perception from the 'Democratic Art' of Chromolithography to Modernism," *New Review of Film and Television Studies* 7, no. 3 (September 1, 2009): 257–259.

47. Quoted in Walter Benjamin, "News About Flowers" (1928), in *Selected Writings*, vol. 2 (1927–1934), ed. Michael W. Jennings, Howard Eiland, and Gary Smith, trans. Michael Jennings (Cambridge, Mass.: Belknap Press, 1999), 155–156. Originally from László Moholy-Nagy, "Fotografie ist Lichtgestaltung," *Bauhaus: Zeitschrift für Bau und Gestaltung* 2, no. 1 (February 15, 1928): 3; also available as László Moholy-Nagy, "Photography Is Creation with Light," in *Moholy-Nagy*, ed. Krisztina Passuth, trans. Mátyás Esterházy (London: Thames & Hudson, 1987), 303.

48. Moholy-Nagy, *Painting, Photography, Film*, 15.

49. Moholy-Nagy, *Painting, Photography, Film*, 15.

50. Moholy's emphasis on the moving image and other forms of kinetic art as being the chromatic successors to painting was certainly not shared by all at the Bauhaus. In letters to his spouse, painter and Bauhaus teacher Lyonel Feininger railed against Moholy's writings, even as Feininger was himself an avid film viewer: "We can say that this is terrible and the end of all art—in itself a technical, very interesting mass endeavor—but why is this mechanization of all optics called art; the sole art of our time and even more of the future? Is this the atmosphere in which painters like Klee and some of us can continue to grow?" Our translation is from "Letters from Lyonel Feininger to Julia Feininger," March 9, 1925; quotations are from copies held by the Bauhaus Archiv of transcripts of the Lyonel Feininger letters held by the Busch-Reisinger Museum, Harvard University.

51. Moholy-Nagy, *Painting, Photography, Film*, 9. Benjamin made similar arguments: "In reaction to photography, painting begins to stress the elements of color in the picture"; Walter Benjamin, "Paris, the Capital of the Nineteenth Century (Exposé of 1935)," in *The Arcades Project*, ed. Ralph Tiedemann, trans. Howard Eiland and Kevin McLaughlin (Cambridge, Mass.: Belknap Press, 1999), 6; as did Siegfried Kracauer, with direct reference to Moholy-Nagy, in Siegfried Kracauer, *Theory of Film: The Redemption of Physical Reality*, intro. Miriam Hansen (Princeton, N.J.: Princeton University Press, 1997), 9–10.

52. Moholy-Nagy, *Painting, Photography, Film*, 8.

53. Moholy-Nagy, *Painting, Photography, Film*, 24.

54. On Moholy-Nagy and the senses, see Oliver Botar, *Sensing the Future: Moholy-Nagy, Media and the Arts* (Zürich: Lars Muller, 2014).

55. Moholy-Nagy, *Painting, Photography, Film*, 13.

56. Moholy-Nagy, *Painting, Photography, Film*, 20.

57. William Moritz, "Abstract Film and Color Music," in *The Spiritual in Art: Abstract Painting 1890–1985*, ed. Maurice Tuchman (New York: Abbeville Press, 1986), 301.

58. The only known precedent for such a move is Guillaume Apollinaire's 1914 account of Léopold Survage's abstract film animation *Colored Rhythm*. Apollinaire notes that the work "draws its origins from fireworks, fountains, electric signs, and those fairy-tale palaces which at every amusement park accustom the eyes to enjoy kaleidoscopic changes in hue"; Guillaume Apollinaire, "Colored Rhythm" (1914), trans. Cecile Starr, in *Experimental Animation*, ed. Robert Russett and Cecile Starr (New York: Van Nostrand Reinhold, 1976), 38.

59. Moholy-Nagy, *Painting, Photography, Film*, 21.

60. Moholy-Nagy, *Painting, Photography, Film*, 21.

61. See Bregt Lameris, "Colourful Projections: Bauhaus *Farbenlichtspiele* and their Various Reconstructions," in *At the Borders of (Film) History: Archaeology, Temporality, Theories*, ed. Alberto Beltrame and Andrea Mariani (Udine, Italy: Film Forum, 2015), 371–379.

62. Anton Kaes, "The Absolute Film," in *Inventing Abstraction, 1910–1925: How a Radical Idea Changed Modern Art*, ed. Leah Dickerman (New York: Museum of Modern Art, 2012), 346–348; and Joel Westerdale, "May 1925: French and German Avant-Garde Converge at Der Absolute Film," in *A New History of German Cinema*, ed. Jennifer M. Kapczynski and Michael D. Richardson (Rochester, N.Y.: Camden House, 2012), 160–166.

63. Kaes, "The Absolute Film," 346.

64. See especially Michael Cowan, "Taking It to the Street: Screening the Advertising Film in the Weimar Republic," *Screen* 54, no. 4 (2013): 463–479.

65. See Jeanpaul Goergen, "Julius Pinschewer: A Trade-Mark Cinema," in *A Second Life: German Cinema's First Decades*, ed. Thomas Elsaesser (Amsterdam: Amsterdam University Press, 1996), 168–174.

66. See Michael Cowan, "Absolute Advertising: Walter Ruttmann and the Weimar Advertising Film," *Cinema Journal* 52, no. 4 (Summer 2013): 49–73; as well as his longer study, *Walter Ruttmann and the Cinema of Multiplicity*.

67. Kurtz, *Expressionism and Film*, 106.

68. Hans Richter, *Hans Richter*, ed. Cleve Gray (New York: Holt, Rinehart and Winston, 1971), 60. As Brinckmann delineates, Richter and Eggeling were much more versed in Worringer's critique of *Einfühlung* for its naturalist emphasis on the organic and in favor of abstraction that embraces the alienating qualities of the inorganic; Brinckmann, *Color and Empathy*, 149–150. This can also be read in terms of Richter's Dadaist investments, as Malcolm Turvey does in his careful reading of the filmmaker in *The Filming of Modern Life: European Avant-Garde Film of the 1920s* (Cambridge: Mass.: MIT Press, 2011), 18–45.

69. Justin Hoffman, "Hans Richter: Constructivist Filmmaker," in *Hans Richter: Activism, Modernism, and the Avant-Garde*, ed. Stephen C. Foster, trans. Michaela Nierhaus (Cambridge, Mass.: MIT Press, 2000), 81–86.

70. Theo van Doesburg, "Film as Pure Form," trans. Standish Lawder, *Form* 1 (Summer 1966): 11; originally published as "Film als reine Gestaltung," *Die Form* 4, no. 10 (May 15, 1929): 241–248.

71. See Forgács, *The Bauhaus Idea*, 65–70; and Michael White, "Mechano-Facture: Dada/ Constructivism and the Bauhaus," in *Albers and Moholy-Nagy: From the Bauhaus to the New World*, ed. Achim Borchardt-Hume (New Haven, Conn.: Yale University Press, 2006), 79–84.

72. Moholy-Nagy, *Painting, Photography, Film*, 45.

73. On the complexities of identifying and defining Expressionist film, see Thomas Elsaesser's careful summary in *Weimar Cinema and After: Germany's Historical Imaginary* (New York: Routledge, 2000), 24–27.

74. Quoted in Elsaesser, *Weimar Cinema and After*, 26.

75. See Hagener, *Moving Forward, Looking Back*, 69–70.

76. Richard Abel, *French Cinema: The First Wave, 1915–1929* (Princeton, N.J.: Princeton University Press, 1987), 279–286.

77. Quoted in Kurtz, *Expressionism and Film*, 68; Siegfried Kracauer, *From Caligari to Hitler: A Psychological History of the German Film*, ed. Leonardo Quaresima, New Edition (Princeton, N.J.: Princeton University Press, 1966), 68; Lotte H. Eisner, *The Haunted Screen: Expressionism in the German Cinema and the Influence of Max Reinhardt*, trans. Roger Greaves, 2nd rev. ed. (Berkeley: University of California Press, 2008), 25.

78. Eisner, *The Haunted Screen*, 100.

79. Eisner, *The Haunted Screen*, 100.

80. Siegfried Kracauer, *Theory of Film: The Redemption of Physical Reality* (Princeton, N.J.: Princeton University Press, 1997), 136.

81. For a detailed account of surviving print material, see Anke Wilkening, "*Die Nibelungen*: A Restoration and Preservation Project by Friedrich-Wilhelm-Murnau-Stiftung, Wiesbaden," *Journal of Film Preservation* 79–80 (May 2009): 86–98. As Wilkening notes, the one exception to this is a Spanish intertitled print from the Archivo Nacional de la Imagine–Sodre, Montevideo, which primarily uses an orange tint but also features scenes with blue-green for night and red for fire; however, the camera negative on which the print is based still indicates that orange was the proper tint (91–92).

82. Anke Wilkening, email message to authors, December 21, 2016.

83. See John G. Capstaff and Merrill W. Seymour, "The Duplication of Motion Picture Negatives," *Transactions of the Society of Motion Picture Engineers* 10, no. 28 (February 1927): 223–229.

84. See J. H. McNabb, "Film Splicing," *Transactions of the Society of Motion Picture Engineers*, no. 14 (May 1922): 40–54; and Earl J. Denison, "Sprockets and Splices," *Transactions of the Society of Motion Picture Engineers* 7, no. 17 (October 1923): 179–184.

85. J. I. Crabtree, "The Development of Motion Picture Film by the Reel and Tank Systems," *Transactions of the Society of Motion Picture Engineers* 7, no. 16 (May 1923): 186.

86. Roscoe C. Hubbard, "Printing Motion Picture Film," *Transactions of the Society of Motion Picture Engineers* 10, no. 27 (October 1926): 252–278. This was also the case in Germany, as Anke Wilkening delineates, "The New Restoration of *The Cabinet of Dr Caligari*," *Bristol Silents*, August 29, 2014, https://bristolsilents.org.uk/2014/08/29/returning-to-the-cabinet-of-dr-caligari-1920-by-david-robinson/.

87. Wilkening, "*Die Nibelungen*," 98.

88. Translated in Wilkening, "*Die Nibelungen*," 97 n. 15.

89. Erwin Panofsky, "Style and Medium in the Motion Pictures," in *Film: An Anthology*, ed. Daniel Talbot (Los Angeles: University of California Press, 1966), 18–19.

90. See the discussion in Joshua Yumibe, *Moving Color: Early Film, Mass Culture, Modernism* (New Brunswick, N.J.: Rutgers University Press, 2012), 114–115.

91. Tom Gunning, *The Films of Fritz Lang: Allegories of Vision and Modernity* (London: British Film Institute, 2000), 36.

92. See Anton Kaes, *Shell Shock Cinema: Weimar Culture and the Wounds of War* (Princeton, N.J.: Princeton University Press, 2011), 135; and Franz Keim, *Die Nibelungen* (Vienna: Gerlach Wiedling, 1909).

93. Leo Lensing, "Lehrjahre Eines Großmeisters," *Frankfurter Allgemeine Zeitung*, no. 149 (June 29, 2016): N3.

94. Thea von Harbou, *Das Nibelungenbuch* (München: Drei Masken Verlag, 1924).

95. Kurtz, *Expressionism and Film*, 85.

96. For an insightful comparison between *Opus 1* and *Der Sieger*, see Cowan, "Taking It to the Street," 52–53.

97. Gunning, *The Films of Fritz Lang*, 47.

98. Kracauer, *From Caligari to Hitler*, 67–68.

99. David Robinson, *Das Cabinet des Dr. Caligari*, 2nd ed. (London: Palgrave Macmillan, 2013), 9–29, 46.

100. Kurtz, *Expressionism and Film*, 49–50.

101. J. L. Styan, *Modern Drama in Theory and Practice: Expressionism and Epic Theatre*, vol. 3 (Cambridge: Cambridge University Press, 1980), 99.

102. Anke Wilkening, "Die Restaurierung von *Das Cabinet des Dr. Caligari*," *VDR Beiträge Zur Erhaltung von Kunst—Und Kulturgut* 2 (2014): 27–47; Barbara Flueckiger, "Color Analysis for the Digital Restoration of *Das Cabinet des Dr. Caligari*," *Moving Image* 15, no. 1 (July 9, 2015): 22–43; Enno Patalas, "On the Way to *Nosferatu*," *Film History* 14, no. 1 (2002): 25–31; and Luciano Berriatúa, *Nosferatu: un film erótico-ocultista-espiritista-metafísico* (Valladolid, Spain: Divisa Ediciones, 2009).

103. Patalas, "On the Way to *Nosferatu*," 28–29.

104. Flueckiger, "Color Analysis," 24; Wilkening, "The New Restoration of *The Cabinet of Dr Caligari*."

105. Wilkening, "The New Restoration of *The Cabinet of Dr Caligari*."

106. Wilkening, "The New Restoration of *The Cabinet of Dr Caligari*."

107. Stephen Eskilson, *Graphic Design: A New History*, 2nd ed. (New Haven, Conn.: Yale University Press, 2012), 214.

108. Kurtz, *Expressionism and Film*, 55.

109. Blaise Cendrars, "On *The Cabinet of Doctor Caligari* [1922]," in *French Film Theory and Criticism: A History/Anthology, 1907–1939*, ed. Richard Abel, trans. Stuart Liebman, vol. 1 (Princeton, N.J.: Princeton University Press, 1988), 271.

110. Jean Epstein, "For a New Avant-Garde," in *Jean Epstein: Critical Essays and New Translations*, ed. Sarah Keller and Jason N. Paul, trans. Stuart Liebman (Amsterdam: Amsterdam University Press, 2012), 304.

111. On *Cinéma pur*, see especially Richard Abel, "The Great Debates," in *French Film Theory and Criticism: A History/Anthology*, vol. 1, 329–332; and Tami Williams, *Germaine Dulac: A Cinema of Sensations* (Urbana: University of Illinois Press, 2014), 158–159.

112. On these networks of the avant-garde, see in particular Hagener, *Moving Forward, Looking Back*.

113. On the complex and contested collaboration around *Ballet mécanique*, see especially Judi Freeman, "Bridging Purism and Surrealism: The Origins and Production of Fernand Léger's *Ballet Mécanique*," in *Dada and Surrealist Film* (Cambridge, Mass.: MIT Press, 1996), 28–45.

114. See Bregt Lameris, "Reading the Archive, Tracing Film History—*Ballet mécanique* Coloured or Black-and-White?," in *L'archivio/The Archive* (Udine, Italy: Università degli

Studi di Udine, 2012), 103–110; and Rossella Catanese, Guy Edmonds, and Bregt Lameris, "Hand-Painted Abstractions: Experimental Color in the Creation and Restoration of *Ballet mécanique*," *Moving Image* 15, no. 1 (July 9, 2015): 92–98.

For further discussions of color and *Ballet mécanique*, see especially William Moritz, "Strubbelingen Rond Een Kopie: *Ballet Mécanique*," *Versus*, no. 2 (1988): 132–140. Susan Delson also notes that a 16mm colored print was donated by Léger to the Museum of Modern Art in 1939, which U.S. colorist Gustav Brock had meticulously hand-colored, specifically the geometric shapes, similar to the Dutch print; Susan Delson, *Dudley Murphy, Hollywood Wild Card* (Minneapolis: University of Minnesota Press, 2006), 65.

115. Bregt Lameris, "La Ligue du Noir et Blanc: French Debates on Natural Colour Film and Art Cinema 1926–1927," in *The Colour Fantastic: Chromatic Worlds of Silent Cinema*, ed. Giovanna Fossati, Victoria Jackson, B. G. Lameris, Elif Rongen-Kaynakci, Sarah Street, and Joshua Yumibe (Amsterdam: Amsterdam University Press, 2018), 221–235. Bernard Brunius's articles include "Plaidoyer pour le noir et blanc," *Cinéa-Ciné pour tous*, September 15, 1926, 21–22; "Pour le noir et blanc," *Cinéa-Ciné pour tous*, January 15, 1927, 27; and "Pour le noir et blanc," *Cinéa-Ciné pour tous*, February 15, 1927, 14.

116. Quoted in and translated by Lameris, "La Ligue du Noir et Blanc." Originally published in Brunius, "Plaidoyer pour le noir et blanc."

117. In the German context, this position was most forcefully articulated by Rudolf Arnheim, who claims that cinema's difference from reality—being black and white instead of color, silent instead of with sound—is what gives it artistic possibilities, as opposed to being only a faithful reproduction of nature; see Rudolf Arnheim, *Film as Art* (Berkeley: University of California Press, 1957), 14–16.

118. René Jeanne, "La controverse de la couleur," *Cinéa-Ciné pour tous*, January 15, 1927, 27. For further discussion of *Cinéma pur* and color, see Lameris, "La Ligue du Noir et Blanc," 228–232.

119. Quoted in Abel, "The Great Debates," 331.

120. See Yumibe, *Moving Color*, 18; and Jennifer Wild, *The Parisian Avant-Garde in the Age of Cinema, 1900–1923* (Oakland: University of California Press, 2015), 110–114.

121. Guillaume Apollinaire, "Colored Rhythm".

122. Marcel Duchamp and Karl Gerstner, *Marcel Duchamp: Tu m': Puzzle Upon Puzzle* (New York: Hatje Cantz, 2003).

123. On the pulsing nature of these experiments by Duchamp, see Rosalind Krauss, "The Im/Pulse to See," in *Vision and Visuality*, ed. Hal Foster (Seattle: Bay Press, 1999), 60–62.

124. Ann Temkin, "Marcel Duchamp," in *Color Chart: Reinventing Color, 1950 to Today*, ed. Emily Hall, Anne Doran, Nell McClister, and Stephen Robert Frankel (New York: Museum of Modern Art, 2008), 42–43.

125. For instance, see Guillaume Apollinaire, *Calligrammes*, trans. Anne Hyde Greet (Berkeley: University of California Press, 1980), 390; and Guillaume Apollinaire, *Color of Time* (Cambridge, Mass.: Zone, 1980).

126. Among the many analyses of *Tu m'*, see, for instance, David Joselit, *Infinite Regress: Marcel Duchamp, 1910–1941* (Cambridge, Mass.: MIT Press, 2001), 69.

127. Quoted in Temkin, "Marcel Duchamp," 42.

128. Fernand Léger, "Film by Fernand Léger and Dudley Murphy, Musical Synchronism by George Antheil," *Little Review*, Autumn–Winter 1924, 43.

129. Fernand Léger, "Color in the World [1938]," in *Functions of Painting*, ed. Edward F. Fry, trans. Alexandra Anderson (New York: Viking Press, 1973), 120.

130. Fernand Léger, "The Spectacle: Light, Color, Moving Image, Objet-Spectacle [1924]," in *Functions of Painting*, 46.

131. Léger, "The Spectacle," 46.

132. "[C]ette histoire féerique de l'Art décoratif moderne," in Marcel L'Herbier, *La tête qui tourne* (Paris: Belfond, 1979), 102.

133. See Richard Abel, *French Cinema: The First Wave, 1915–1929* (Princeton, N.J.: Princeton University Press, 1987), 384–385; Tim Bergfelder, Sue Harris, and Sarah Street, *Film Architecture and the Transnational Imagination: Set Design in 1930s European Cinema* (Amsterdam: Amsterdam University Press, 2007), 58–60; Giuliana Bruno, *Atlas of Emotion: Journeys in Art, Architecture, and Film* (New York: Verso, 2002), 26; and Laurence Schifano, "Marcel L'Herbier 1925: De *L'inhumaine* à *Feu Mathias Pascal*, ou la naissance de la modernité," in *L'année 1925: L'esprit d'une époque*, ed. Myriam Boucharenc and Claude Leroy (Nanterre: Presses universitaires de Paris, 2014), 321–333.

134. Quoted in Abel, *French Cinema*, 384.

135. Ricciotto Canudo, "Reflections on the Seventh Art [1923]," in *French Film Theory and Criticism: A History/Anthology*, trans. Claudia Gorbman, vol. 1, 1907–1929 (Princeton, N.J.: Princeton University Press, 1988), 293; also see Prosper Hillairet, "*L'inhumaine*, L'Herbier, Canudo et la synthèse des arts," in *Marcel L'Herbier: L'art du cinéma*, ed. Laurent Véray (Paris: Association française de recherche sur l'histoire du cinéma, 2007), 101–108.

136. Canudo, "Reflections on the Seventh Art," 292; also see Abel, *French Cinema*, 383.

137. Jean-André Fieschi, "Autour du cinématographe: entretien avec Marcel L'Herbier," *Cahiers du cinéma*, no. 202 (July 1968): 34.

138. Fieschi, "Autour du cinématographe." Translated in Abel, *French Cinema*, 392.

139. Dorothee Binder, "Der Film *L'inhumaine* und Sein Verhältnis zu Kunst und Architektur Der Zwanziger Jahre," *Magisterarbeit, LMU München: Geschichts—Und Kunstwissenschaften* 29 (2005): 2–3; Gerwin Van der Pol and Karel Dibbets, "The Logic of Colour in *L'inhumaine*," in *Il Colore Nel Cinema Muto*, ed. Monica Dall'Asta, Guglielmo Pescatore, and Leonardo Quaresima (Udine, Italy: Atti del II Convegno Internazionale di Studi sul Cinema, 1995), 155–163.

140. Serge Bromberg and Catherine A. Surowiec, "*L'inhumaine*," In *Le Giornate del Cinema Muto 34: Catalog* (Sacile, Italy: Le Giornate del Cinema Muto, 2015), 155–158.

141. Translated in Abel, *French Cinema*, 392.

142. Freeman, "Bridging Purism and Surrealism," 36–38.

143. Antonia Lant, "Haptical Cinema," *October* 74 (Autumn 1995): 45–73.

144. Sergei Eisenstein, *Nonindifferent Nature: Film and the Structure of Things*, trans. Herbert Marshall (New York: Cambridge University Press, 1988), 53–54.

145. Oswell Blakeston, "Our Literary Screen," *Close Up* 6, no. 4 (April 1930): 309.

146. Samuel Brody, "Paris Hears Eisenstein," *Close Up* 6, no. 4 (April 1930): 288.

147. For a description of some of the titles, see Edwin M. Bradley, *The First Hollywood Sound Shorts, 1926–1931* (Jefferson, N.C.: McFarland, 2009), 328–329.

148. Oswell Blakeston, "Comment and Review," *Close Up* 5, no. 6 (December 1929): 521.

149. John Grierson earlier called for formal attention to film technique in a series of articles commissioned in the United States by the Famous Players–Lasky Corporation; they were republished in *Motion Picture News* in 1926. See, for instance, his discussion of the abstraction of visual symphonies and "cineplastic poems" as found in *Ballet mécanique* and *Battleship Potemkin*, in John Grierson, "Putting Punch in a Picture," *Motion Picture News* 34, no. 22 (November 27, 1926): 2025–2026. In his article the following week,

he offered similarly formal critiques of color and design in Fairbanks's *The Black Pirate*, or "The Pink Pirate" as he calls it, in John Grierson, "Putting Atmosphere in Pictures," *Motion Picture News* 34, no. 23 (December 4, 1926): 2025–2026.

150. Jan-Christopher Horak, "The First American Film Avant-Garde, 1919–1945," in *Lovers of Cinema: The First American Film Avant-Garde, 1919–1945*, ed. Jan-Christopher Horak (Madison: University of Wisconsin Press, 1995), 14–66.

151. Kristin Thompson, "The Limits of Experimentation in Hollywood," in Horak, *Lovers of Cinema*, 75–77. For lengthier discussions, see Patricia White, "Nazimova's Veils: Salome at the Intersection of Film Histories," in *A Feminist Reader in Early Cinema*, ed. Jennifer M. Bean and Diane Negra (Durham, N.C.: Duke University Press, 2002), 60–87; and Petra Dierkes-Thrun, *Salome's Modernity: Oscar Wilde and the Aesthetics of Transgression* (Ann Arbor: University of Michigan Press, 2011), 125–160.

152. See Elaine Showalter, *Sexual Anarchy: Gender and Culture at the Fin de Siècle* (New York: Viking, 1990): 149–150.

153. Oscar Wilde, *Salomé* (New York: Dover, 1967): 65.

154. Kaveh Askari, *Making Movies Into Art: Picture Craft from the Magic Lantern to Early Hollywood* (London: British Film Institute, 2015), 5–11. Askari's notion of "frame jumping," in which early art films foreground the appropriation of the other arts, thus moving between medial frames, has helped us theorize the ways in which color is frequently foregrounded in moments of intermedial and cross-field emphasis.

155. Joseph Dannenberg, ed., "Dudley Murphy: Director-Producer [Ad]," in *Film Daily Year Book* (New York: Film Daily, 1926), 620. For details on the production, see Delson, *Dudley Murphy*, 69–72.

156. Delson, *Dudley Murphy*, 3–5, 13–14.

157. Delson, *Dudley Murphy*, 24.

158. William Moritz, "Americans in Paris: Man Ray and Dudley Murphy," in Horak, *Lovers of Cinema*, 122.

159. William Moritz, "Americans in Paris," 25.

160. Sidney Woodward, "Colored Films Shown by Dudley Murphy," *Boston Post*, September 2, 1920.

161. Delson, *Dudley Murphy*, 194, 195 n. 10.

162. On the spirituality of Brigman, as well as the Theosophical and Arts and Crafts roots of Pictorialism, see Heather Waldroup, "Hard to Reach: Anne Brigman, Mountaineering, and Modernity in California," *Modernism/Modernity* 21, no. 2 (April 2014): 447–466.

163. Delson, *Dudley Murphy*, 18.

164. "Murphy and Macgowan Making One Reel 'Visual Symphonies,' " *Motion Picture News* 225, no. 5 (January 21, 1922): 606.

165. Matthew Josephson, "The Rise of the Little Cinema," *Motion Picture Classic* 24, no. 1 (September 1926): 34–35, 69, 82. For more on the Little Cinema movement, see Horak, "The First American Film Avant-Garde," 20–29.

166. Josephson, "The Rise of the Little Cinema," 69, 82.

167. Josephson, "The Rise of the Little Cinema," 69.

168. "Projection Jottings," *New York Times*, March 14, 1926, 5; and Delson, *Dudley Murphy*, 60. By chance, Mordaunt Hall reviewed Douglas Fairbanks's Technicolor extravaganza *The Black Pirate* on the same page.

169. Mordaunt Hall, "The Screen," *New York Times*, March 15, 1926, 18.

170. William J. Reilly, "When Is It a Moving Picture? Dudley Murphy Helps Answer the Question," *Moving Picture World* 80, no. 3 (May 15, 1926): 209, 235.

171. Quoted in Delson, *Dudley Murphy*, 61.

5. Chromatic Hybridity

1. Siegfried Kracauer, "Cult of Distraction: On Berlin's Picture Palaces" (1926), in *The Mass Ornament: Weimar Essays*, trans., ed., intro., Thomas Y. Levin (Cambridge, Mass.: Harvard University Press, 1995), 324.
2. Richard Misek, *Chromatic Cinema* (Oxford: Wiley-Blackwell), 69.
3. Misek, *Chromatic Cinema*, 70.
4. Cecil B. DeMille, *Autobiography* (London: W. H. Allen 1960), 230–231.
5. See Richard Koszarski, "'Foolish Wives': The Colour Restoration That Never Happened," *Film History* 12, no. 4 (2000): 341–343.
6. Susan Delson, *Dudley Murphy, Hollywood Wild Card* (Minneapolis: University of Minnesota Press, 2006), 65.
7. "Roxy to Use Color," *Film Daily* 59, no. 29 (May 4, 1932): 3; "Manhattan Films," *Brooklyn Standard Union*, November 23, 1927, 6.
8. Gustav Brock, "Hand-Coloring of Motion Picture Film," *Journal of the Society of Motion Picture Engineers* 16, no. 6 (June 1931): 751.
9. Gustav Brock, "Handcoloring Film," *Film Daily* 26, no. 45 (June 21, 1925): 35.
10. Brock, "Handcoloring Film," 35.
11. Gustav Brock, quoted in "Words of Wisdom," *Film Daily* 70, no. 43 (August 20, 1936): 14.
12. Edwin Carewe, quoted in Carl Adams, "The Silent Drama," *Cincinnati Enquirer*, November 19, 1922, 59.
13. Carewe, quoted in Adams, "The Silent Drama," 59.
14. Loyd A. Jones, "Tinted Films for Sound Positives," *Transactions of the Society of Motion Picture Engineers* 13, no. 37 (6 May 1929): 224.
15. Colin Bennett, "Tinting and Toning," in "Picture Making" supplement, *Kinematograph Weekly* 78, no. 849 (August 2, 1923): iii.
16. Bennett, "Tinting and Toning," iii.
17. "Some Trade Hints to Showmen Suggested by a Layman," *Kinematograph Weekly* 79, no. 855 (September 13, 1923): 73.
18. For a discussion of Prizmacolor, see Sarah Street, "Glorious and Other Adventures with Prizma," in *Color and the Moving Image: History, Theory, Aesthetics, Archive*, ed. Simon Brown, Sarah Street, and Liz Watkins (New York: Routledge, 2013), 56–66.
19. Lynn Sally, *Fighting the Flames: The Spectacular Performance of Fire at Coney Island* (New York: Routledge, 2006). Films of these fire reenactments were also exhibited at the parks, including Edwin S. Porter's *Fire and Flames at Luna Park, Coney Island* (U.S., 1904).
20. Gustav Brock, "Artist Explains Hand Color Role: Pioneer in Work Sees This Method as Indispensable to Treatment of Fire Sequences," *Motion Picture News* 41, no. 9 (March 1, 1930): 62.
21. Joshua Yumibe, *Moving Color: Early Film, Mass Culture, Modernism* (New Brunswick, N.J.: Rutgers University Press, 2012), 133–135.
22. Technicolor would later develop a similar method of dye transfer known as imbibition printing for its No. 3 and No. 4 processes. See the comparative discussion of these processes in William V. D. Kelley, "The Handschiegl and Pathéchrome Color Processes," *Journal of the Society of Motion Picture Engineers* 17, no. 2 (August 1931): 230–234.
23. Paolo Cherchi Usai, *Silent Cinema: An Introduction* (London: British Film Institute, 2000), 32–33.

24. Philip J. Riley, *The Making of the Phantom of the Opera* (Absecon, N.J.: MagicImage Filmbooks, 1999), 56.
25. We are grateful to James Layton for further details on the color sequences in this film. See also Lee Tsiantis, "*The Phantom of the Opera* (review)," *Moving Image* 4, no. 2 (2004): 126–128.
26. The second Technicolor sequence does not survive on film; Brownlow and Gill colorized the footage.
27. Jonathan Mack, "Finding Borderland: Intermediality in the Films of Marc Forster," *Cinema Journal* 56, no. 3 (May 10, 2017): 25.
28. "*The Phantom* Premiere Thrills Broadway," *Universal Weekly* 22, no. 6 (September 19, 1925): 11.
29. "*The Phantom* Premiere Thrills Broadway," 10.
30. Sarah Street, *Colour Films in Britain: The Negotiation of Innovation, 1900–55* (London: British Film Institute, 2012): 25–26.
31. Tim Bergfelder, Sue Harris, and Sarah Street, *Film Architecture and the Transnational Imagination: Set Design in 1930s European Cinema* (Amsterdam: Amsterdam University Press, 2007), 138–140.
32. Christine Gledhill, *Reframing British Cinema, 1918–1928* (London: British Film Institute, 2003), 93.
33. Paul Read and Mark-Paul Meyer, *Restoration of Motion Picture Film* (Oxford: Butterworth-Heinemann, 2000), 191.
34. Murray Pomerance, "Light, Looks and *The Lodger*," *Quarterly Review of Film and Video* 26, no. 5 (October 2009): 425–433.
35. See Richard Abel, "Memory Work: French Historical Epics, 1926–1927," *Film History: An International Journal* 17, no. 2 (September 9, 2005): 355.
36. Abel, "Memory Work," 357.
37. Victoria Jackson and Sarah Street, "Kevin Brownlow on Film Color," *Moving Image* 15, no. 1 (July 9, 2015): 99. For more on the Keller-Dorian process, including the work on *Napoléon*, see François Ede, "Un épisode de l'histoire de la couleur au cinéma: le procédé Keller-Dorian et les films lenticulaires," *1895: Revue d'histoire du cinéma* 71 (2013): 187–202.
38. This scene is shown in *The Charm of Dynamite* (Kevin Brownlow, Rath Films for BBC, UK, 1968), a documentary about Gance. The tinting of the scene, however, is not present or discussed.
39. For a full discussion of the film, see Joshua Yumibe, "The Illuminated Fairytale: The Colors of Paul Fejos's *Lonesome* (1928)," in *Color and the Moving Image: History, Theory, Aesthetics, Archive*, ed. Simon Brown, Sarah Street, Liz Watkins (New York: Routledge, 2013), 127–137.
40. See Siegfried Kracauer's 1929 review of *Lonesome*, quoted in Yumibe, "The Illuminated Fairytale," 127, 132–133, 136.
41. Kracauer, quoted in Yumibe, "The Illuminated Fairytale," 132.
42. Kracauer, quoted in Yumibe, "The Illuminated Fairytale," 135.
43. Charles Urban, Report on Prizma, October 11, 1916: Urban papers, National Media Museum, Bradford, UK: URB/9/10/1.
44. See Street, *Colour Films in Britain*, 9–21. *The Open Road* was restored by the British Film Institute and released on DVD in 2006. This version conveys the film's intentions because its faults on first release have been reduced. A new preservation negative was made using a digital intermediate so that colors could be combined, flicker controlled, and motion depicted at twenty-four frames per second.

45. Street, *Colour Films in Britain*, 35.
46. James Layton and David Pierce, *The Dawn of Technicolor, 1915–1935* (Rochester, N.Y.: George Eastman House, 2014), 149–157.
47. Layton and Pierce, *The Dawn of Technicolor*, 114–115.
48. Albert Parker, quoted in Layton and Pierce, *The Dawn of Technicolor*, 131.
49. Layton and Pierce, *The Dawn of Technicolor*, 141.
50. Layton and Pierce, *The Dawn of Technicolor*, 115–116.
51. Films in the *Wonderful London* series were restored and released on DVD in 2012 by the British Film Institute, BFIVD946.

6. Color and the Coming of Sound

1. See Hal Hall, "Society of Motion Picture Engineers Hollywood Meeting," *American Cinematographer* 12, no. 2 (June 1931): 10–11, 26, 45.
2. Pierre Bourdieu, *The Field of Cultural Production: Essays on Art and Literature*, ed. Randal Johnson (New York: Columbia University Press, 1993), 32.
3. "The New Age of Color," *Saturday Evening Post*, January 21, 1928, 22.
4. "Color in Industry," *Fortune Magazine* 1 (February 1930): 85–94.
5. "Report of Color Committee May 1930," *Journal of the Society of Motion Picture Engineers* 15, no. 5 (May 1930): 721–724.
6. John Belton, "Cinecolor," *Film History* 12, no. 4 (2000): 344–345.
7. "The Pictures: Colour in the Cinema," *Observer*, June 30, 1929, 20.
8. See Joshua Yumibe, *Moving Color: Early Film, Mass Culture, Modernism* (New Brunswick, N.J.: Rutgers University Press, 2012), 13.
9. See Laurent Mannoni, "Phono-Cinéma-Théâtre," in *Thirty-First Pordenone Silent Film Festival Catalog*, ed. Catherine A. Surowiec (Pordenone, Italy: Le Giornate del Cinema Muto, 2012), 24–28; and Victor Pranchère, "La sortie du laboratoire ou les stratégies d'exploitation du procédé trichrome de cinématographie en couleurs de la Société des Établissements Gaumont (1913–1921)," *1895: Revue d'histoire du cinéma* 71 (December 1, 2013): 61–80.
10. See Miriam Bratu Hansen, "America, Paris, the Alps: Kracauer (and Benjamin) on Cinema and Modernity," in *Cinema and the Invention of Modern Life*, ed. Leo Charney and Vanessa R Schwartz (Berkeley: University of California Press, 1995), 362–402.
11. "The Pictures: Colour in the Cinema," 20.
12. John W. Des Chenes, "Talkies in Color," *International Photographer* 1, no. 3 (April 1929): 5.
13. Herbert Kalmus, "[H. T. Kalmus to L. T. Troland]," April 23, 1929, M0006: Technicolor Internal Correspondence, George Eastman Museum.
14. Leonard Troland, "Troland Diaries," July 24, 1929, E17: Technicolor Notebooks: Troland Diaries, 1926–1929, George Eastman Museum.
15. Troland detailed in his research diary on September 1, 1926 that he had spent the day studying Handschiegl patents, and he was confident that Technicolor's newly developed dye-transfer machine would mostly not infringe on the Handschiegl process; however, a few years later, on July 24, 1929, he recommended to Kalmus that Technicolor should acquire a Handschiegl patent because of the overlap with Technicolor's imbibition printing. Leonard Troland, "Troland Diaries," entries September 1, 1926, and July 24, 1929, E17: Technicolor Notebooks: Troland Diaries, 1926–1929, George Eastman Museum.

16. See Russell M. Otis, "The Multicolor Process," *Journal of the Society of Motion Picture Engineers* 17, no. 1 (July 1931): 5–10; Roderick T. Ryan, *A History of Motion Picture Color Technology* (London: Focal Press, 1977), 100–102; and James Layton and David Pierce, *The Dawn of Technicolor: 1915–1935*, ed. Paolo Cherchi Usai and Catherine A. Surowiec (Rochester, N.Y.: George Eastman House, 2015), 228–229.

17. See Herbert C. McKay, "Reeling the Rainbow: A Discussion of Motion Pictures in Natural Color," *Movie Makers* 4, no. 8 (August 1929): 509–511, 538.

18. Earle C. Anthony, "Vitacolor Movies: Reporting a New Color Process for the Amateur," *Movie Makers* 3, no. 12 (December 1928): 772.

19. See Richard Lewis Ward, *When the Cock Crows: A History of the Pathé Exchange* (Carbondale: Southern Illinois University Press, 2016), 67–68, 129.

20. On the importance of color and the amateur market, see Charles Tepperman, "Color Unlimited: Amateur Color Cinema in the 1930s," in *Color and the Moving Image: History, Theory, Aesthetics, Archive*, ed. Simon Brown, Sarah Street, and Liz Watkins (New York: Routledge, 2013), 138–149; and John Beardslee Carrigan, "Portrait of the Pioneer: George Eastman," *Movie Makers* 3, no. 12 (December 1928): 770. As Eastman explains, "I believe that color films will be the making of the amateur cinema movement. Without them it could never have been so great. With them it has limitless possibilities."

21. See "*Yesterday in Santa Fe* Completed in Multicolor," *International Photographer* 3, no. 6 (July 1931): 23; "Multicolor Branch Slated for Construction in Japan," *International Photographer* 3, no. 5 (June 1931): 34; and "Howe Takes Vitacolor to the Orient," *American Cinematographer* 10, no. 1 (April 1929): 11.

22. See "News of the Day," *Film Daily* 51, no. 4 (January 6, 1930): 4; "Report of Color Committee May 1930," *Journal of the Society of Motion Picture Engineers* 15, no. 5 (May 1930): 721–724; and "Buys Vitacolor Processes," *Motion Picture News* 41, no. 14 (April 5, 1930): 22.

23. "Fix Jan. 5 as Trial Date for Vitacolor-Cinecolor," *Film Daily* 70, no. 101 (October 28, 1936): 2.

24. Layton and Pierce, *The Dawn of Technicolor*, 208.

25. Michel Chion, *Audio-Vision: Sound on Screen*, trans. Claudia Gorbman (New York: Columbia University Press, 1994).

26. Herbert T. Kalmus, "Technicolor Adventures in Cinemaland," *Journal of the Society of Motion Picture Engineers* 31, no. 6 (1938): 573–574.

27. Bourdieu, *The Field of Cultural Production*, 32.

28. Maxim Gorky, "A Review of the Lumière Programme at the Nizhni-Novgorod Fair," as printed in the *Nizhegorodski listok*, newspaper, July 4, 1896, and signed 'I. M. Pacatus,' reprinted in Maxim Gorky, "Maxim Gorky on the Lumière Programme, 1896," in *Kino: A History of the Russian and Soviet Film*, trans. 'Leda Swan,' ed. Jay Leyda (New York: Macmillan, 1960), 407–409.

29. "The Future of Color," *American Cinematographer* 10, no. 4 (July 1929): 12.

30. Harold B. Franklin, "Color," *Transactions of the Society of Motion Picture Engineers* 17, no. 1 (July 1931): 3.

31. See the finding aid for the Earl Theisen Film Frame Collection, Seaver Center for Western History Research, Natural History Museum of Los Angeles County, accessed April 11, 2018, http://www.oac.cdlib.org/findaid/ark:/13030/c82f7p84/.

32. "DuPont Vitacolor," *Exhibitors Daily Review* 24, no. 5 (July 9, 1928): 3.

33. Louis M. Bailey, "Educational Films," *Movie Makers* 4, no. 10 (October 1929): 662.

34. Anthony, "Vitacolor Movies," 771.

35. John W. Des Chenes, "A.S.C. Approves Vitacolor," *American Cinematographer* 9, no. 11 (February 1929): 26–27.
36. Max B. DuPont, "Color for the Amateur," *American Cinematographer* 10, no. 2 (May 1929): 32.
37. Quoted in Anthony, "Vitacolor Movies," 826.
38. "Multicolor Coming Fast," *International Photographer* 1, no. 11 (December 1929): 21.
39. "Multicolor Advert," *Cinematographic Annual* 1 (1930): Adv 4.
40. John Seitz, "Introduction," *Cinematographic Annual* 1 (1930): 16–17.
41. Hilde D'Haeyere, "Color Processes in Mark Sennett Comedies," in Brown, Street, and Watkins, *Color and the Moving Image*, 29–31.
42. D'Haeyere, "Color Processes in Mark Sennett Comedies," 30.
43. Otis, "The Multicolor Process," 9–10.
44. See Belton, "Cinecolor," 344–357; and Layton and Pierce, *The Dawn of Technicolor*, 274–275.
45. See Herbert Kalmus, "[H. T. Kalmus to Judge William Travers Jerome (copied to L. T. Troland)]," August 4, 1928, M0006 Technicolor Internal Correspondence, George Eastman Museum.
46. Layton and Pierce, *The Dawn of Technicolor*, 239–264.
47. Kalmus, "Technicolor Adventures in Cinemaland," 574.
48. "Technicolor Plans 2 Studios Abroad," *Variety* 97, no. 5 (November 13, 1929): 5.
49. Herbert Kalmus, "[Herbert T. Kalmus to Clarel Seelye (London)]," December 27, 1930, M0006: Technicolor Internal Correspondence, Box 2, doc 0986, George Eastman Museum.
50. Sarah Street, *Colour Films in Britain: The Negotiation of Innovation 1900–1955* (London: British Film Institute, 2012), 55–57.
51. "Technicolor Musical Reviews [Ad]," *Film Daily* 51, no. 4 (January 6, 1930): 3.
52. "Sound for *Viking*," *Variety* 93, no. 9 (December 12, 1928): 23; also see James Layton and David Pierce, "*The Viking*," in *Le Giornate Del Cinema Muto: Catalogue*, ed. Catherine A. Surowiec, vol. 31 (Gemona, Italy: La Cineteca del Friuli, 2012), 162.
53. See "Color Pictures Being Created: Natalie Kalmus Made First Color Art Director," *Calgary Daily Herald*, September 1, 1928, 11.
54. See Donald Beaton, "As They Appeal to a Youth," *Film Spectator* 6, no. 9 (November 17, 1928): 10.
55. Arne Lunde, *Nordic Exposures: Scandinavian Identities in Classical Hollywood Cinema* (Seattle: University of Washington Press, 2011), 28–29.
56. Layton and Pierce, *The Dawn of Technicolor*, 198.
57. James Layton and David Pierce, *King of Jazz: Paul Whiteman's Technicolor Revue* (Severn, Md.: Media History Press, 2016). On the restoration, also see Jan-Christopher Horak, "*King of Jazz*: Paul Whiteman's Technicolor Revue," January 6, 2017, https://www.cinema.ucla.edu/blogs/archival-spaces/2017/01/06/king-of-jazz.
58. Layton and Pierce, *King of Jazz*, 57.
59. See Paul Young's analysis of racial representation in the film in *The Cinema Dreams Its Rivals: Media Fantasy Films from Radio to the Internet* (Minneapolis: University of Minnesota Press, 2006), 73–135.
60. On epidermal readings of race, see Michelle Ann Stephens, *Skin Acts: Race, Psychoanalysis, and the Black Male Performer* (Durham, N.C.: Duke University Press, 2014).
61. See Layton and Pierce, *King of Jazz*, 136.
62. J. Hoberman, "*King of Jazz* Is Back, Burnished for Movie Fans," *New York Times*, May 10, 2016, http://www.nytimes.com/2016/05/11/movies/king-of-jazz-is-back-burnished-for-movie-fans.html.

63. Layton and Pierce, *King of Jazz*, 215.

64. Layton and Pierce, *King of Jazz*, 201.

65. Layton and Pierce, *King of Jazz*, 207–209.

66. Scott Higgins, *Harnessing the Technicolor Rainbow: Color Design in the 1930s* (Austin: University of Texas Press, 2007).

67. Sarah Street, *Colour Films in Britain*, 280–281, 283–284; and Frank Tilley, "British Film Field," *Variety* 97, no. 10 (December 18, 1929): 4.

68. Denise K. Cummings and Annette Kuhn, "Elinor Glyn," in *Women Film Pioneers Project*, ed. Jane Gaines, Vatsal Radha, and Monica Dall'Asta (New York: Center for Digital Research and Scholarship, Columbia University Libraries, 2013), accessed November 3, 2017, https://wfpp.cdrs.columbia.edu/pioneer/ccp-elinor-glyn.

69. François Ede, "Un épisode de l'histoire de la couleur au cinéma: le procédé Keller-Dorian et les films lenticulaires," *1895: Revue d'histoire du cinéma* 71 (2013): 187–202.

70. James P. Cunningham, "$24,250,000 Issue for New Moviecolor, Ltd," *Film Daily* 47, no. 16 (January 20, 1929): 10.

71. "Enter Moviecolor: Blattner's Double Demonstration: Use of the Keller-Dorian Process," *Kinematograph Weekly* 141, no. 1126 (November 15, 1928): 29.

72. Jack Cunningham, "*Refuge* First Color, Sound Blattner Film," *Film Daily* 48, no. 69 (March 24, 1929): 9.

73. "Technicolor in British Link with Keller-Dorian," *Film Daily* 51, no. 45 (February 23, 1930): 7.

74. Leonard Troland, "Troland Diaries, February 1, 1929," 1929, E17: Technicolor Notebooks: Troland Diaries, 1926–1929, George Eastman Museum.

75. Layton and Pierce, *The Dawn of Technicolor*, 258; and Ede, "Un épisode de l'histoire de la couleur au cinéma," 201.

76. Moviecolor Limited vs. Eastman Kodak Company, Technicolor, Inc. and Technicolor Motion Picture Corporation, No. 193, Docket 26470 (United States Court of Appeals Second Circuit, 1961).

77. Gustav Brock, "Hand-Coloring of Motion Picture Film," *Journal of the Society of Motion Picture Engineers* 16, no. 6 (June 1931): 751.

78. Gustav Brock, "Handcoloring Film," *Film Daily* 26, no. 45 (June 21, 1925): 35.

79. Brock, "Hand-Coloring of Motion Picture Film," 753.

80. Gustav Brock, "Artist Explains Hand Color Role: Pioneer in Work Sees this Method as Indispensable to Treatment of Fire Sequences," *Motion Picture News* 41, no. 9 (March 1, 1930): 62.

81. Brock, "Hand-Coloring of Motion Picture Film," 755.

82. Brock, "Hand-Coloring of Motion Picture Film," 754.

83. Brock, "Hand-Coloring of Motion Picture Film," 754–755.

84. See "Roxy to Use Color," *Film Daily* 59, no. 29 (May 4, 1932): 3; "Manhattan Films," *Brooklyn Standard Union*, November 23, 1927; and "Brock Handling Color Work on Roxy Newsreels," *Film Daily* 42, no. 52 (December 1, 1927): 10. For details on Brock's silent-film work, see Richard Koszarski, "*Foolish Wives*: The Colour Restoration That Never Happened," *Film History* 12, no. 4 (January 1, 2000): 341–343.

85. "Look at the Man Hunt in *The Vampire Bat* [Ad]," *Film Daily* 61, no. 19 (January 24, 1933): 2; "*Pickanniny Blues*," *Film Daily* 61, no. 45 (February 24, 1933): 7; "Brock Color for Film," *Film Daily* 63, no. 14 (July 18, 1933): 12; "Brock Colors Two Features," *Film Daily* 63, no. 42 (August 19, 1933): 2; Phil M. Daly, "Along the Rialto," *Film Daily* 64, no. 41 (November 18, 1933): 3; Phil M. Daly, "Along the Rialto," *Film Daily* 65, no. 132 (June 7, 1934): 3; Phil M. Daly, "Along the Rialto," *Film Daily* 66, no. 18 (July 23, 1934): 5; and "Brock Colors *Adventure Girl*," *Film Daily* 66, no. 31 (August 7, 1934): 2.

86. See Tom Weaver, "Scott MacQueen Interview," *Classic Images*, no. 504 (June 2017): 18–22; and Scott MacQueen, email correspondence with authors, August 2, 2017.

87. Weaver, "Scott MacQueen Interview," 21.

88. "New Gustav Brock Method," *Film Daily* 79, no. 29 (February 11, 1941): 9.

89. Gustav Brock, "Letter to Alfred Hitchcock About *Saboteur*," March 28, 1942, Alfred Hitchcock Papers, 53-f.636, Margaret Herrick Library of the Academy of Motion Picture Arts and Sciences; quoted in Murray Pomerance, *Alfred Hitchcock's America* (Cambridge, UK: Polity, 2013), 33 n. 16.

90. See Joshua Yumibe, "Industrial Research Into Color at Pathé During the 1910s & 1920s," in *Recherches et innovations dans l'industrie du cinema: les cahiers des ingénieurs Pathé: 1906–1927*, ed. Jacques Malthête and Stephanie Salmon (Paris: Fondation Jérôme Seydoux-Pathé, 2017), 196–208. More generally on the state of Pathé during the time, see especially Stéphanie Salmon, *Pathé: A la conquête du cinéma, 1896–1929* (Paris: Editions Tallandier, 2014); and Richard Lewis Ward, *When the Cock Crows: A History of the Pathé Exchange* (Carbondale: Southern Illinois University Press, 2016).

91. See Street, *Colour Films in Britain*, 38.

92. See the trademark details in M. H. Schoenbaum, "Inventions, Trade Marks, Patents," *Motion Picture News* 9, no. 12 (March 28, 1914): 25.

93. William V. D. Kelley, "The Handschiegl and Pathéchrome Color Processes," *Journal of Society of Motion Picture Engineers* 17, no. 2 (August 1, 1931): 230–234.

94. "Pathéchrome, New Color Process to Make Bow in Pathé Review," *Exhibitors Herald and Moving Picture World* 93, no. 8 (November 24, 1928): 34.

95. Terry Ramsaye, *Million and One Nights: A History of the Motion Picture Through 1925* (New York: Simon and Schuster, 1926); "Pathéchrome, New Color Process to Make Bow in Pathé Review," 34.

96. "Pathéchrome, New Color Process to Make Bow in Pathé Review," 34.

97. "Pathé Plans Color for Its Sound Pictures," *Film Daily* 48, no. 27 (May 1, 1929): 11.

98. "Pathéchrome-Sound Soon," *Pathé Sun* 14, no. 31 (December 6, 1929): 4.

99. See the frames collected on the Timeline of Historical Colors, accessed April 18, 2018, http://zauberklang.ch/filmcolors/galleries/stencil-colored-samples-kodak-film-samples-collection/.

100. *Lakeland Glimpses—With Camera and Car Around the English Lakes*, ca. 1930, https://www.britishpathe.com/video/lakeland-glimpses-with-camera-and-car-around-the/query/wildcard; *The Palace of the Stuarts*, ca. 1929, https://www.britishpathe.com/video/the-palace-of-the-stuarts-pathecolor-sic-in/query/wildcard.

101. For more on this process of bolstering the cultural capital of a landscape through film, see Tom Rice and Joshua Yumibe, "Chariots of Fire Rerun: Locating Film's Cultural Capital on a Contemporary Stage," *Journal of British Cinema and Television* 12, no. 3 (July 1, 2015): 321–341.

102. *An Old Indian Name*, ca. 1928, https://www.britishpathe.com/video/an-old-indian-name-aka-colour-film-of-1928/query/wildcard.

103. James M. Vest, "Alfred Hitchcock's Role in *Elstree Calling*," *Hitchcock Annual* 9 (2000): 116–126; and Ian Conrich and Estella Tincknell, *Film's Musical Moments* (Edinburgh: Edinburgh University Press, 2006).

104. Quoted in John Mundy, *Popular Music on Screen: From Hollywood Musical to Music Video* (Manchester, UK: Manchester University Press, 1999), 142; originally published in the *Tatler*, March 5, 1930.

105. "First British Talkie Revue," *Yorkshire Post*, February 11, 1930.

106. "*Elstree Calling*: Will Fyffe in a Big Talkie Revue," *Dundee Evening Telegraph*, February 14, 1930.

107. "*Elstree Calling*"; and "Big Image with 35mm Film Tested in London House," *Film Daily* 51, no. 45 (February 23, 1930): 7.

108. "First British Talkie Revue."

109. Mundy, *Popular Music on Screen*, 143.

110. "Rialto Briggate Leeds [Ad]," *Yorkshire Evening Post*, July 21, 1930; "B.I.P. Talkies Arouse the Industry in All Parts of the World [Ad]," *Variety* 100, no. 3 (July 30, 1930): 65.

111. "Picturedrome Bedford: *Elstree Calling* [Ad]," *Bedfordshire Times and Independent*, August 29, 1930.

112. "Famous Co-Optimists in Sound Film," *Dundee Evening Telegraph*, April 22, 1930.

113. "The Film World," *Times*, January 29, 1930; "A Romance of Seville," *Kinema Guide*, no. 8 (January 19–25, 1931): 20.

114. L. M. Dieterich, "The Relative Values of Sound and Color in Motion Pictures," *American Cinematographer* 13, no. 2 (June 1932): 10, 44.

115. Victor Milner, "Tinted Stock for Better Pictures," *American Cinematographer* 13, no. 2 (June 1932): 11, 28.

116. C. E. Kenneth Mees, "A Research Triumph: The Story of Black-and-White Film," *International Projectionist* 30, no. 7 (July 1955): 15.

117. "New Color Moods in Sound [Kodak Sonochrome Ad]," *Motion Picture News* 40, no. 12 (September 21, 1929): 1097.

118. "New Color Moods in Sound," 1097.

119. "Film Tints to Suit Film Subjects," *Motion Picture Projectionist* 5, no. 11 (September 1932): 16.

120. Milner, "Tinted Stock for Better Pictures," 11.

121. Loyd A. Jones, "Tinted Films for Sound Positives," *Transactions of the Society of Motion Picture Engineers* 13, no. 37 (May 6–9, 1929): 199–226.

122. Anthony L'Abbate, "L'aventure des films sonores teintés et virés aux États-Unis," trans. Céline Ruivo, *1895: Revue d'histoire du cinéma* 71 (December 1, 2013): 133–143; see also Kyle Westphal, "The True Story of Tinted Talkies: An Interview with Anthony L'Abbate," Northwest Chicago Film Society, September 3, 2013, http://www.northwestchicagofilm-society.org/2013/09/03/the-true-story-of-tinted-talkies-an-interview-with-anthony-labbate/.

123. Milner, "Tinted Stock for Better Pictures," 11.

124. William Stull, "Concerning Cinematography," *American Cinematographer* 12, no. 12 (April 1932): 24.

125. William Stull, "Concerning Cinematography," *American Cinematographer* 13, no. 2 (June 1932): 23.

126. Rachael Low, *History of British Film*, vol. 4, *The History of the British Film 1918–1929* (London: Allen & Unwin, 1997), 280.

127. J. I. Crabtree and W. Marsh, "Double Toning of Motion Picture Films," *Journal of the Society of Motion Picture Engineers* 16, no. 1 (January 1931): 60.

128. *Water Babies*, 1932, https://www.britishpathe.com/video/water-babies-tinted-version/; *The Bear Truth*, 1932, https://www.britishpathe.com/video/the-bear-truth-tinted-version/; *Big Hits*, 1932, https://www.britishpathe.com/video/big-hits-tinted-version/.

129. "Tone-Tint Merging," *Cine-Technician*, December–January, 1937–1938, 187.

130. "Sepia Tinting Bridges Gap of Color, Black and White," *Motion Picture Daily* 42, no. 98 (October 25, 1937): 1, 6.

131. Interestingly enough, Dudley Murphy worked on the script continuity with Tod Browning. See Susan Delson, *Dudley Murphy, Hollywood Wild Card* (Minneapolis: University of Minnesota Press, 2006), 221.

132. Milner, "Tinted Stock for Better Pictures," 11.

133. See Carlos Clarens, *An Illustrated History of Horror and Science-Fiction Films* (New York: Da Capo Press, 1997), 80.

134. Philip J. Riley, *Dracula: The Original 1931 Shooting Script* (Absecon, N.J.: MagicImage Filmbooks, 1990), 67.

135. We are grateful to George Willeman, Nitrate Film Vault Manager, National Audio-Visual Conservation Center of the Library of Congress, for assistance on the print, and to Jack Theakston for further information on the film.

136. For an excellent reading of the uncanny nature of the film, see the Robert Spadoni, *Uncanny Bodies: The Coming of Sound Film and the Origins of the Horror Genre* (Berkeley: University of California Press, 2007), 61–92.

7. Conclusion

1. "The Pictures: Colour in the Cinema," *Observer*, June 30, 1929, 20.

2. André Bazin, "The Myth of Total Cinema" (1946), in *What Is Cinema?*, vol. 1, selected and trans. Hugh Gray (Berkeley: University of California Press, 1967), 21.

3. Ágnes Pethö, *Cinema and Intermediality: The Passion for the In-Between* (Newcastle upon Tyne, UK: Cambridge Scholars, 2011), 6.

4. In exploring these moments of chromatic tableau, we are indebted to Kaveh Askari's notion of "frame jumping" in *Making Movies into Art: Picture Craft from the Magic Lantern to Early Hollywood* (London: British Film Institute, 2015), 51.

5. Miriam Bratu Hansen, "America, Paris, the Alps: Kracauer (and Benjamin) on Cinema and Modernity," in *Cinema and the Invention of Modern Life*, ed. Leo Charney and Vanessa R Schwartz (Berkeley: University of California Press, 1995), 363.

6. See the various essays in Tim Bergfelder and Christian Cargnelli, eds., *Destination London: German-Speaking Emigrés and British Cinema, 1925–1950* (New York: Berghahn, 2008).

7. On Fischinger at Disney, see William Moritz, "Fischinger at Disney, or Oskar in the Mousetrap," *Millimeter* 5, no. 2 (February 1977): 25–28, 65–67; for his relationship to U.S. experimental work, see the "testimonial section" in William Moritz, *Optical Poetry: The Life and Work of Oskar Fischinger* (Bloomington: Indiana University Press, 2004), 163–171.

8. For a full discussion of Vyvyan Donner and the *Fashion Forecast* films, see Natalie Snoyman, "'In to Stay': Selling Three-Strip Technicolor and Fashion in the 1930s and 1940s" (Ph.D. diss., Stockholm University, 2017), 151–178.

9. Snoyman, "'In to Stay,'" 179–218.

10. "Release Shipments, 1924 to 1951 Incl.," Technicolor Corporation 1951, Technicolor Corporate Archive, George Eastman Museum, quoted in Snoyman "'In to Stay,'" 180.

11. Colin Bennett, "Colour Is an Adjunct," *Kinematograph Weekly* 225, no. 1492 (November 21, 1935): 19.

12. Natalie Kalmus, "Color Consciousness," *Journal of the Society of Motion Picture Engineers* 25, no. 2 (August 1935): 139–147.

13. Regina Lee Blaszczyk and Uwe Spiekermann, "Bright Modernity: Color, Commerce, and Consumer Culture," in *Bright Modernity: Color, Commerce, and Consumer Culture*, ed. Regina Lee Blaszczyk and Uwe Spiekermann (Cham, Switzerland: Palgrave Macmillan, 2017), 13.

14. See Dudley Andrew, "The Postwar Struggle for Color," *Cinema Journal* 18, no. 2 (1979): 41–52; and Sarah Street, *Black Narcissus* (London: I. B. Tauris, 2005).
15. The enduring influence of 1920s modernism in contemporary literature, has been a topic of ongoing discussion in literary studies. See, for example, Rebecca Walkowitz, *Cosmopolitan Style: Modernism Beyond the Nation* (New York: Columbia University Press, 2006); and David James, *Modernist Futures: Innovation and Inheritance in the Contemporary Novel* (New York: Cambridge University Press, 2012).

SELECTED BIBLIOGRAPHY

Abel, Richard. *French Cinema: The First Wave, 1915–1929*. Princeton, N.J.: Princeton University Press, 1987.

——. "Memory Work: French Historical Epics, 1926–1927." *Film History: An International Journal* 17, no. 2 (September 9, 2005): 352–362.

——, ed. *French Film Theory and Criticism: A History/Anthology: 1907–1939*. 2 vols. Princeton, N.J.: Princeton University Press, 1988.

Andrew, Dudley. "The Postwar Struggle for Color." *Cinema Journal* 18, no. 2 (1979): 41–52.

Arnheim, Rudolf. *Film as Art*. Berkeley: University of California Press, 1957.

Arwas, Victor. *Art Deco*. New York: Harry N. Abrams, 1980.

Askari, Kaveh. *Making Movies Into Art: Picture Craft from the Magic Lantern to Early Hollywood*. London: British Film Institute, 2015.

——. "Techniques in Circulation: Sovereignty, Imaging Technology, and Art Education in Qajar Iran." In *The Image in Early Cinema: Form and Material*, ed. Scott Curtis, Philippe Gauthier, Joshua Yumibe, and Tom Gunning, 164–173. Bloomington: Indiana University Press, 2018.

Austin, Guy, ed. *New Uses of Bourdieu in Film and Media Studies*. New York: Berghahn Books, 2016.

Ball, Philip. *Bright Earth: Art and the Invention of Color*. Chicago: University of Chicago Press, 2003.

Ball, Philip, and Mario Ruben. "Color Theory in Science and Art: Ostwald and the Bauhaus." *Angewandte Chemie International Edition* 43, no. 37 (2004): 4842–4847.

Barasch, Moshe. *Modern Theories of Art 2: From Impressionism to Kandinsky*. New York: New York University Press, 1990.

Barry, John F., and Epes Winthrop Sargent. *Building Theatre Patronage*. New York: Chalmers, 1927.

Batchelor, David. *The Luminous and the Grey*. London: Reaktion Books, 2014.

Bazin, André. *What Is Cinema?* Vol. 1. Berkeley: University of California Press, 2005.

Bean, Jennifer M., and Diane Negra, eds. *A Feminist Reader in Early Cinema*. Durham, N.C.: Duke University Press, 2002.

Belton, John. "Cinecolor." *Film History* 12, no. 4 (2000): 344–357.

Bentham, Frederick. *Sixty Years of Light Work*. Isleworth, UK: Strand Lighting, 1992.

Bergdoll, Barry, and Leah Dickerman, eds. *Bauhaus 1919–1933: Workshops for Modernity*. New York: Museum of Modern Art, 2009.

Bergfelder, Tim, and Christian Cargnelli, eds. *Destination London: German-Speaking Emigrés and British Cinema, 1925–1950*. New York: Berghahn Books, 2008.

Bergfelder, Tim, Sue Harris, and Sarah Street. *Film Architecture and the Transnational Imagination: Set Design in 1930s European Cinema*. Amsterdam: Amsterdam University Press, 2007.

Bernstein, Matthew. "Introduction." In *Visions of the East: Orientalism in Film*, ed. Matthew Bernstein and Gaylyn Studlar, 1–18. New Brunswick, N.J.: Rutgers University Press, 1997.

Berriatúa, Luciano. *Nosferatu: un film erótico-ocultista-espiritista-metafísico*. Valladolid, Spain: Divisa Ediciones, 2009.

Binder, Dorothee. "Der Film *L'Inhumaine* und Sein Verhältnis Zu Kunst und Architektur der Zwanziger Jahre." *Magisterarbeit, LMU München: Geschichts- Und Kunstwissenschaften* 29 (2005): 1–108.

Blaszczyk, Regina Lee. *The Color Revolution*. Cambridge, Mass.: MIT Press, 2012.

——. "The Color Schemers: American Color Practice in Britain, 1920s–1960s." In *Bright Modernity: Color, Commerce, and Consumer Culture*, ed. Regina Lee Blaszczyk and Uwe Spiekermann, 191–226. Cham, Switzerland: Palgrave Macmillan, 2017.

Blaszczyk, Regina Lee, and Uwe Spiekermann, eds. *Bright Modernity: Color, Commerce, and Consumer Culture*. Cham, Switzerland: Palgrave Macmillan, 2017.

Blatter, Jeremy. "Screening the Psychological Laboratory: Hugo Münsterberg, Psychotechnics, and the Cinema, 1892–1916." *Science in Context* 28 (2015): 53–76.

Bolter, Jay David, and Richard Grusin. *Remediation: Understanding New Media*. Rev. ed. Cambridge, Mass.: MIT Press, 2000.

Borchardt-Hume, Achim, ed. *Albers and Moholy-Nagy: From the Bauhaus to the New World*. New Haven, Conn.: Yale University Press, 2006.

Botar, Oliver. *Sensing the Future: Moholy-Nagy, Media and the Arts*. Zürich: Lars Muller, 2014.

Bourdieu, Pierre. *Distinction: A Social Critique of the Judgement of Taste*. Cambridge, Mass.: Harvard University Press, 1984.

——. *The Field of Cultural Production: Essays on Art and Literature*. Ed. Randal Johnson. New York: Columbia University Press, 1993.

Brayer, Elizabeth. *George Eastman: A Biography*. Reprint. Rochester, N.Y.: University of Rochester Press, 2015.

Brinckmann, Christine. *Color and Empathy: Essays on Two Aspects of Film*. Amsterdam: Amsterdam University Press, 2015.

Brock, Gustav. "Artist Explains Hand Color Role: Pioneer in Work Sees This Method as Indispensable to Treatment of Fire Sequences." *Motion Picture News* 41, no. 9 (March 1, 1930): 62.

——. "Handcoloring Film." *Film Daily* 26, no. 45 (June 21, 1925): 35.

——. "Hand-Coloring of Motion Picture Film." *Journal of the Society of Motion Picture Engineers* 16, no. 6 (June 1931): 751.

Brougher, Kerry, Jeremy Strick, Ari Wiseman, and Judith Zilczer, eds. *Visual Music: Synaesthesia in Art and Music Since 1900*. London: Thames & Hudson, 2005.

Brown, Julie. "Framing the Atmospheric Film Prologue in Britain, 1919–26." In *The Sounds of the Silents in Britain*, ed. Julie Brown and Annette Davison. New York: Oxford University Press, 2013.

Bruno, Giuliana. *Atlas of Emotion: Journeys in Art, Architecture, and Film*. New York: Verso, 2002.

——. "Film, Aesthetics, Science: Hugo Münsterberg's Laboratory of Moving Images." *Grey Room*, no. 36 (July 16, 2009): 88–113.

Burbank, Emily. *Woman as Decoration*. New York: Dodd, Mead, 1920.

Campbell, Joan. *The German Werkbund: The Politics of Reform in the Applied Arts*. Princeton, N.J.: Princeton University Press, 2015.

Cherchi Usai, Paolo. *Silent Cinema: An Introduction*. London: British Film Institute, 2003.

Chion, Michel. *Audio-Vision: Sound on Screen*. Trans. Claudia Gorbman. New York: Columbia University Press, 1994.

Ciecko, Anne. "Mary Hallock-Greenewalt's Spectral Middle East: Autobiographical Orientations and Reflexive Mediations." *Feminist Media Histories* 3, no. 1 (January 1, 2017): 25–49.

Cornwell-Clyne, Adrian. *Colour Cinematography*. 3rd ed. London: Chapman & Hall, 1951.

——. *Colour-Music: The Art of Light*. 2nd ed. London: Crosby Lockwood, 1930.

Couret, Nilo. *Mock Classicism: Latin American Film Comedy, 1930–1960*. Oakland: University of California Press, 2018.

Cowan, Michael. "Absolute Advertising: Walter Ruttmann and the Weimar Advertising Film." *Cinema Journal* 52, no. 4 (Summer 2013): 49–73.

——. "Advertising, Rhythm, and the Filmic Avant-Garde in Weimar: Guido Seeber and Julius Pinschewer's Kipho Film." *October*, no. 131 (2010): 23–50.

——. *Walter Ruttmann and the Cinema of Multiplicity: Avant-Garde Film—Advertising—Modernity*. Amsterdam: Amsterdam University Press, 2014.

Cowan, Ruth Schwartz. "The 'Industrial Revolution' in the Home: Household Technology and Social Change in the Twentieth Century." *Technology and Culture* 17, no. 1 (1976): 1–23.

Crary, Jonathan. *Suspensions of Perception: Attention, Spectacle, and Modern Culture*. Cambridge, Mass.: MIT Press, 2001.

——. *Techniques of the Observer: On Vision and Modernity in the Nineteenth Century*. Cambridge, Mass.: MIT Press, 1992.

Crosby, Emily. "The 'Colour Supplement' of the Cinema: The British Cinemagazine, 1918–38." *Journal of British Cinema and Television* 5, no. 1 (May 2008): 1–18.

Cubitt, Sean. *The Practice of Light: A Genealogy of Visual Technologies from Prints to Pixels*. Cambridge, Mass.: MIT Press, 2014.

Cuff, Paul. "Presenting the Past: Abel Gance's Napoléon (1927), from Live Projection to Digital Reproduction." *Kinétraces Editions* 2 (February 2017): 120–142.

——. *A Revolution for the Screen: Abel Gance's Napoleon*. Amsterdam: Amsterdam University Press, 2015.

Cummings, Denise K., and Annette Kuhn. "Elinor Glyn." In *Women Film Pioneers Project*, ed. Jane Gaines, Vatsal Radha, and Monica Dall'Asta. New York: Center for Digital Research and Scholarship, Columbia University Libraries, 2013. https://wfpp.cdrs.columbia.edu /pioneer/ccp-elinor-glyn.

Curtis, Robin. "*Einfühlung* and Abstraction in the Moving Image: Historical and Contemporary Reflections." *Science in Context* 25, no. 3 (September 2012): 425–446.

Curtis, Scott. *The Shape of Spectatorship: Art, Science, and Early Cinema in Germany*. New York: Columbia University Press, 2015.

Daftari, Fereshteh. "Redefining Modernism: Pluralist Art Before the 1979 Revolution." In *Iran Modern*, ed. Fereshteh Daftari and Layla Diba, 25–43. New York: Asia Society Museum, 2013.

De Klerk, Nico, and Daan Hertogs, eds. *"Disorderly Order": Colours in Silent Film: The 1995 Amsterdam Workshop*. Amsterdam: Stichting Nederlands Film Museum, 1996.

De La Haye, Amy. "The Dissemination of Design from Haute Couture to Fashionable Ready-to-Wear During the 1920s with Specific Reference to the Hodson Dress Shop in Willenhall." *Textile History* 24, no. 1 (1993): 39–48.

Delson, Susan. *Dudley Murphy, Hollywood Wild Card*. Minneapolis: University of Minnesota Press, 2006.

DeMille, Cecil B. *Autobiography*. Ed. D Hayne. London: Allen, 1960.

——. "The Chances of Color Photography in Moving Pictures." *American Photoplay* 17 (January 1923): 15.

——. "Color Problem of Film Production Reduced to an Exact Science." *Reel and Slide* 2, no. 4 (April 1919): 21.

Deshairs, Léon. *Intérieurs en couleurs: Exposition des arts décoratifs, Paris, 1925*. Paris: A. Lévy, 1926.

——. *Modern French Decorative Art*. 2nd series. London: Architectural Press, 1930.

Dickerman, Leah, ed. *Inventing Abstraction, 1910–1925: How a Radical Idea Changed Modern Art*. New York: Museum of Modern Art, 2012.

Dierkes-Thrun, Petra. *Salome's Modernity: Oscar Wilde and the Aesthetics of Transgression*. Ann Arbor: University of Michigan Press, 2011.

Dimendberg, Edward. "László Moholy-Nagy's Film Scenario 'Dynamic of the Metropolis.'" In *Camera Obscura, Camera Lucida: Essays in Honor of Annette Michelson*, ed. Allen Richard and Malcolm Turvey, 109–126. Amsterdam: Amsterdam University Press, 2003.

Doesburg, Theo van. "Notes on L'Aubette at Strasbourg [1928]." In *De Stijl*, ed. Hans L. C. Jaffé, 232–237. New York: Abrams, 1971.

Duchamp, Marcel, and Karl Gerstner. *Marcel Duchamp: Tu m': Puzzle Upon Puzzle*. New York: Hatje Cantz, 2003.

Düchting, Hajo. *Farbe am Bauhaus: Synthese und Synästhesie*. Berlin: Gebr. Mann, 1996.

Eckert, Charles. "The Carole Lombard in Macy's Window." *Quarterly Review of Film Studies* 3, no. 1 (1978): 1–21.

Ede, François. "Un épisode de l'histoire de La couleur au cinéma: le procédé Keller-Dorian et les films lenticulaires." *1895: Revue d'histoire du cinéma* 71 (2013): 187–202.

Eisenstein, Sergei. *Nonindifferent Nature: Film and the Structure of Things*. Trans. Herbert Marshall. New York: Cambridge University Press, 1988.

——. *Towards a Theory of Montage: Sergei Eisenstein Selected Works*. Ed. Michael Glenny and Richard Taylor. London: I. B. Tauris, 2010.

Eisner, Lotte H. *The Haunted Screen: Expressionism in the German Cinema and the Influence of Max Reinhardt*. Trans. Roger Greaves. 2nd rev. ed. Berkeley: University of California Press, 2008.

Elcott, Noam. "'Kaleidoscope-Architecture': Scheerbart, Taut, and the Glass House." In *Glass! Love!! Perpetual Motion!!! A Paul Scheerbart Reader*, ed. Josiah McElheny and Christine Burgin, 111–117. Chicago: University of Chicago Press, 2014.

Elder, R. Bruce. *Harmony and Dissent: Film and Avant-Garde Art Movements in the Early Twentieth Century*. Waterloo, Ont.: Wilfrid Laurier University Press, 2010.

Ellis, Eugenia Victoria, and Andrea Reithmayr, eds. *Claude Bragdon and the Beautiful Necessity*. Rochester, N.Y: RIT Cary Graphic Arts Press, 2010.

Elsaesser, Thomas. *Weimar Cinema and After: Germany's Historical Imaginary*. New York: Routledge, 2000.

Erté. *Erté Fashions*. New York: St. Martin's Press, 1972.

——. *Erté's Fashion Designs*. New York: Dover Publications, 1981.

Eskilson, Stephen. *Graphic Design: A New History*. 2nd ed. New Haven, Conn.: Yale University Press, 2012.

Favre, Louis. *La Musique des couleurs et le cinéma*. Paris: Les Presses Universitaires de France, 1927.

Fieschi, Jean-André. "Autour du cinématographe: entretien avec Marcel L'Herbier." *Cahiers du cinéma*, no. 202 (July 1968): 26–43.

Finamore, Michelle Tolini. *Hollywood Before Glamour: Fashion in American Silent Film*. London: Palgrave Macmillan, 2013.

Fischer, Lucy, ed. *American Cinema of the 1920s: Themes and Variations*. New Brunswick, N.J.: Rutgers University Press, 2009.

——. *Cinema by Design: Art Nouveau, Modernism, and Film History*. New York: Columbia University Press, 2017.

——. *Designing Women: Cinema, Art Deco, and the Female Form*. New York: Columbia University Press, 2003.

——. " 'The Shock of the New': Electrification, Illumination, Urbanization, and the Cinema." In *Cinema and Modernity*, ed. Murray Pomerance, 19–37. New Brunswick, N.J.: Rutgers University Press, 2006.

Flueckiger, Barbara. "Color Analysis for the Digital Restoration of *Das Cabinet des Dr. Caligari*." *Moving Image* 15, no. 1 (July 9, 2015): 22–43.

Fore, Devin. *Realism After Modernism: The Rehumanization of Art and Literature*. Cambridge, Mass.: MIT Press, 2015.

Forgács, Éva. *The Bauhaus Idea and Bauhaus Politics*. Trans. John Bátki. Budapest: Central European University Press, 1995.

——. "Reinventing the Bauhaus: The 1923 Bauhaus Exhibition as a Turning Point in the Direction of the School." In *Bauhaus: Art as Life*, ed. Catherine Ince and Lydia Yee, 78–82. London: Walther König, 2012.

Fossati, Giovanna. *From Grain to Pixel: The Archival Life of Film in Transition*. Amsterdam: Amsterdam University Press, 2009.

Fossati, Giovanna, Tom Gunning, Jonathan Rosen, and Joshua Yumibe. *Fantasia of Color in Early Cinema*. Amsterdam: Amsterdam University Press, 2015.

Fossati, Giovanna, Vicky Jackson, Bregt Lameris, Elif Rongen-Kaynakçi, Sarah Street, and Joshua Yumibe, eds. *The Colour Fantastic: Chromatic Worlds of Silent Cinema*. Amsterdam: Amsterdam University Press, 2018.

Frank, Marie Ann. *Denman Ross and American Design Theory*. Hanover, N.H.: University Press of New England, 2011.

Furman, Jeffrey L., and Megan J. MacGarvie. "Academic Science and the Birth of Industrial Research Laboratories in the U.S. Pharmaceutical Industry." *Journal of Economic Behavior & Organization* 63 (2007): 756–776.

Gage, John. *Color and Meaning: Art, Science, and Symbolism*. Berkeley: University of California Press, 1999.

——. "Colour at the Bauhaus." *AA Files*, no. 2 (July 1, 1982): 50–54.

Gaines, Jane. "The *Queen Christina* Tie-ups: Convergence of Show Window and Screen." *Quarterly Review of Film and Video* 11, no. 1 (1989): 35–60.

Ganeva, Mila. *Women in Weimar Fashion: Discourses and Displays in German Culture, 1918–1933*. Rochester, N.Y.: Camden House, 2011.

Gaudreault, André. *Film and Attraction: From Kinematography to Cinema*. Trans. Tim Barnard. Urbana: University of Illinois Press, 2011.

Gaudreault, André, and Philippe Marion. "A Medium Is Always Born Twice" *Early Popular Visual Culture* 3, no. 1 (May 2005): 3–15.

Geczy, Adam. *Fashion and Orientalism: Dress, Textiles and Culture from the Seventeenth to the Twenty-First Century*. London: Bloomsbury, 2013.

Gledhill, Christine. *Reframing British Cinema, 1918–1928: Between Restraint and Passion*. London: British Film Institute, 2003.

Goergen, Jeanpaul. "Julius Pinschewer: A Trade-Mark Cinema." In *A Second Life: German Cinema's First Decades*, ed. Thomas Elsaesser, 168–174. Amsterdam: Amsterdam University Press, 1996.

Gomery, Douglas. *Shared Pleasures: A History of Movie Presentation in the United States*. London: British Film Institute, 1992.

Grieveson, Lee. *Cinema and the Wealth of Nations: Media, Capital, and the Liberal World System*. Oakland: University of California Press, 2018.

Gunning, Tom. "Colourful Metaphors: The Attraction of Color in Silent Cinema." In *Il Colore Nel Cinema Muto*, ed. Monica Dall'Asta, Guglielmo Pescatore, and Leonardo Quaresima, 20–31. Udine, Italy: Atti del II Convegno Internazionale di Studi sul Cinema, 1995.

——. *The Films of Fritz Lang: Allegories of Vision and Modernity*. London: British Film Institute, 2000.

Hagener, Malte. *Moving Forward, Looking Back: The European Avant-Garde and the Invention of Film Culture, 1919–1939*. Amsterdam: Amsterdam University Press, 2007.

Hammerton, Jenny. *For Ladies Only?: Eve's Film Review: Pathé Cinemagazine, 1921–33*. Hastings, UK: Projection Box, 2001.

Hansen, Miriam Bratu. "America, Paris, the Alps: Kracauer (and Benjamin) on Cinema and Modernity." In *Cinema and the Invention of Modern Life*, ed. Leo Charney and Vanessa R Schwartz, 362–402. Berkeley: University of California Press, 1995.

——. *Cinema and Experience: Siegfried Kracauer, Walter Benjamin, and Theodor W. Adorno*. Berkeley: University of California Press, 2012.

——. "The Mass Production of the Senses: Classical Cinema as Vernacular Modernism." *Modernism/Modernity* 6, no. 2 (1999): 59–77.

Harris, Neil. *The Chicagoan: A Lost Magazine of the Jazz Age*. Chicago: University of Chicago Press, 2008.

——. "Color and Media: Some Comparisons and Speculations." In *Cultural Excursions: Marketing Appetites and Cultural Tastes in Modern America*, 318–336. Chicago: University of Chicago Press, 1990.

Hatcher, Tim. "Holophane and the Golden Age of Colour Lighting." *Picture House* 35 (2010): 38–54.

Henderson, Linda Dalrymple. *The Fourth Dimension and Non-Euclidean Geometry in Modern Art*. Rev. ed. Cambridge, Mass.: MIT Press, 2013.

Herzog, Charlotte. " 'Powder Puff' Promotion: The Fashion Show-in-the-Film." In *Fabrications: Costume and the Female Body*, ed. Jane Gaines and Charlotte Herzog. London: Routledge, 1990.

Hesmondhalgh, David. "Bourdieu, the Media and Cultural Production." *Media, Culture & Society* 28, no. 2 (March 1, 2006): 211–231.

Higashi, Sumiko. *Cecil B. DeMille and American Culture: The Silent Era*. Berkeley: University of California Press, 1994.

Higgins, Scott. *Harnessing the Technicolor Rainbow: Color Design in the 1930s*. Austin: University of Texas Press, 2007.

Higson, Andrew, and Richard Maltby. *"Film Europe" and "Film America": Cinema, Commerce and Cultural Exchange, 1920–1939.* Exeter, UK: University of Exeter Press, 1999.

Hindson, Catherine. "Interruptions by Inevitable Petticoats: Skirt Dancing and the Historiographical Problem of Late Nineteenth-Century Dance." *Nineteenth Century Theatre and Film* 35 (December 1, 2008): 48–64.

Hiner, Susan. *Accessories to Modernity: Fashion and the Feminine in Nineteenth-Century France.* Philadelphia: University of Pennsylvania Press, 2011.

Hoffman, Justin. "Hans Richter: Constructivist Filmmaker." In *Hans Richter: Activism, Modernism, and the Avant-Garde,* ed. Stephen C. Foster, trans. Michaela Nierhaus, 72–91. Cambridge, Mass.: MIT Press, 2000.

Horak, Jan-Christopher, ed. *Lovers of Cinema: The First American Film Avant-Garde, 1919–1945.* Madison: University of Wisconsin Press, 1995.

——. *Making Images Move: Photographers and Avant-Garde Cinema.* Washington, D.C.: Smithsonian Institution Press, 1997.

Ince, Catherine, and Lydia Yee, eds. *Bauhaus: Art as Life.* London: Walther König, 2012.

Itten, Johannes. *Design and Form: The Basic Course at the Bauhaus.* Trans. John Maass. New York: Reinhold, 1964.

——. *The Elements of Color.* Trans. Ernst Van Hagen. New York: Van Nostrand Reinhold, 1970.

Jackson, Victoria, and Bregt Lameris. "Phantom Colours: Alice Blue and Phantom Red; Changing Meanings of Two Fashionable Colours (1905–1930)." *Catwalk: The Journal of Fashion, Beauty and Style* 3, no. 2 (2014): 19–46.

Jackson, Victoria, and Sarah Street. "Kevin Brownlow on Film Color." *Moving Image* 15, no. 1 (July 9, 2015): 99–103.

Jacobs, Lea. *The Decline of Sentiment: American Film in the 1920s.* Berkeley: University of California Press, 2008.

James, David. *Modernist Futures: Innovation and Inheritance in the Contemporary Novel.* New York: Cambridge University Press, 2012.

Johnston, Sean F. "The Construction of Colorimetry by Committee." *Science in Context* 9, no. 4 (1996): 387–420.

——. *A History of Light and Colour Measurement: Science in the Shadows.* Bristol, UK: Institute of Physics, 2001.

Jones, Loyd A. "Color Analyses of Two Component Mixtures." *Abridged Scientific Publications from the Research Laboratory of the Eastman Kodak Company* 1 (1913): 31–35.

——. "Tinted Films for Sound Positives." *Transactions of the Society of Motion Picture Engineers* 13, no. 37 (May 6, 1929): 199–226.

Joselit, David. *Infinite Regress: Marcel Duchamp, 1910–1941.* Cambridge, Mass.: MIT Press, 2001.

Kaes, Anton. "The Absolute Film." In *Inventing Abstraction, 1910–1925: How a Radical Idea Changed Modern Art,* ed. Leah Dickerman, 346–348. New York: Museum of Modern Art, 2012.

——. *Shell Shock Cinema: Weimar Culture and the Wounds of War.* Princeton, N.J.: Princeton University Press, 2011.

Kaes, Anton, Nicholas Baer, and Michael Cowan, eds. *The Promise of Cinema: German Film Theory, 1907–1933.* Oakland: University of California Press, 2016.

Kapczynski, Jennifer M., and Michael D. Richardson, eds. *A New History of German Cinema.* Rochester, N.Y.: Boydell & Brewer, 2014.

Keefer, Cindy. "Raumlichtmusik: Early 20th Century Abstract Cinema Immersive Environments." *Leonardo Electronic Almanac* 16, no. 6–7 (October 2009): 1–5.

Kelley, William V. D. "The Handschiegl and Pathéchrome Color Processes." *Journal of Society of Motion Picture Engineers* 17, no. 2 (August 1, 1931): 230–234.

Klein, Adrian Bernard. *Colour-Music: The Art of Light.* London: Crosby, Lockwood, 1926.

Koszarski, Richard. *An Evening's Entertainment: The Age of the Silent Feature Picture, 1915–1928.* Berkeley: University of California Press, 1994.

——. "'Foolish Wives': The Colour Restoration That Never Happened." *Film History* 12, no. 4 (January 1, 2000): 341–343.

Kracauer, Siegfried. *From Caligari to Hitler: A Psychological History of the German Film.* Ed. Leonardo Quaresima. Rev. ed. Princeton, N.J.: Princeton University Press, 1966.

——. *The Mass Ornament: Weimar Essays.* Trans. Thomas Y. Levin. Cambridge, Mass.: Harvard University Press, 1995.

Krauss, Rosalind. "The Im/Pulse to See." In *Vision and Visuality,* ed. Hal Foster. Seattle: Bay Press, 1999.

Kuehni, Rolf G., and Andreas Schwarz. *Color Ordered: A Survey of Color Systems from Antiquity to the Present.* Cary, N.C.: Oxford University Press, 2007.

Kuhn, Thomas S. *The Essential Tension: Selected Studies in Scientific Tradition and Change.* Chicago: University of Chicago Press, 1977.

Kurtz, Rudolf. *Expressionism and Film.* Trans. Brenda Benthien. New Barnet, UK: John Libbey, 2016.

L'Abbate, Anthony. "L'aventure des films sonores teintés et virés aux États-Unis." Trans. Céline Ruivo. *1895: Revue d'histoire du cinéma* 71 (December 1, 2013): 133–143.

Lameris, Bregt. "Colourful Projections: Bauhaus Farbenlichtspiele and Their Various Reconstructions." In *At the Borders of (Film) History. Archaeology, Temporality, Theories,* ed. Alberto Beltrame and Andrea Mariani, 371–379. Udine: Film Forum, 2015.

——. "Reading the Archive, Tracing Film History—Ballet Mécanique Coloured or Black-and-White?" In *L'archivio/The Archive,* 103–110. Udine: Università degli Studi di Udine, 2012.

Lant, Antonia. "Haptical Cinema." *October* 74 (Autumn 1995): 45–73.

Layton, James, and David Pierce. *The Dawn of Technicolor: 1915–1935.* Ed. Paolo Cherchi Usai and Catherine A. Surowiec. Rochester, N.Y.: George Eastman House, 2015.

——. *King of Jazz: Paul Whiteman's Technicolor Revue.* Severn, Md.: Media History Press, 2016.

Le Guern, Nicholas. "Des recherches de Rodolphe Berthon chez Pathé en 1913–1914 au procédé lenticulaire Kodacolor." In *Recherches et innovations dans l'industrie du cinéma: les cahiers des ingénieurs Pathé: 1906–1927,* ed. Jacques Malthête and Stephanie Salmon, 225–241. Paris: Fondation Jérôme Seydoux-Pathé, 2017.

Leach, William. *Land of Desire: Merchants, Power, and the Rise of a New American Culture.* New York: Pantheon Books, 1993.

Léger, Fernand. "Film by Fernand Léger and Dudley Murphy, Musical Synchronism by George Antheil." *Little Review,* Autumn-Winter 1924, 42–44.

——. *Functions of Painting.* Ed. Edward F. Fry. Trans. Alexandra Anderson. New York: Viking Press, 1973.

Lemke, Sieglinde. *Primitivist Modernism: Black Culture and the Origins of Transatlantic Modernism.* Oxford: Oxford University Press, 1998.

Lensing, Leo. "Lehrjahre Eines Großmeisters." *Frankfurter Allgemeine Zeitung,* no. 149 (June 29, 2016): N3.

Lesch, John E., ed. *The German Chemical Industry in the Twentieth Century.* Chemists and Chemistry 18. Dordrecht, Netherlands: Springer Science+Business Media, 2000.

Leslie, Esther. "Kracauer's Weimar Geometry and Geomancy." *New Formations* 61 (2007): 34–48.

——. *Synthetic Worlds: Nature, Art and the Chemical Industry*. Reaktion Books, 2005.

Licht, Fred, and Nicholas Fox Weber. *Josef Albers: Glass, Color, and Light*. London: Guggenheim Museum, 1994.

Lichtenstein, Jacqueline. *The Eloquence of Color: Rhetoric and Painting in the French Classical Age*. Trans. Emily McVarish. Berkeley: University of California Press, 1993.

Lobel, Léopold. *La technique cinématographique: projection et fabrication des films*. Paris: Dunod, 1922.

Luckiesh, Matthew. *Color and Its Applications*. 2nd ed. New York: Van Nostrand, 1921.

——. *The Language of Color*. New York: Dodd, Mead, 1918.

——. *Light and Color in Advertising and Merchandising*. New York: Van Nostrand, 1927.

Lunde, Arne. *Nordic Exposures: Scandinavian Identities in Classical Hollywood Cinema*. Seattle: University of Washington Press, 2011.

Maerz, Aloys John, and Morris Rea Paul. *Dictionary of Color*. New York: McGraw-Hill, 1930.

Mallet-Stevens, Robert. *A Modern City*. London: Benn Brothers, 1922.

Mallgrave, Harry Francis. *Architecture and Embodiment: The Implications of the New Sciences and Humanities for Design*. New York: Routledge, 2013.

Marchand, Roland. *Advertising the American Dream: Making Way for Modernity, 1920–1940*. Berkeley: University of California Press, 1985.

Marzola, Luci. "Better Pictures Through Chemistry: DuPont and the Fight for the Hollywood Film Stock Market." *Velvet Light Trap* 76, no. 1 (August 30, 2015): 3–18.

——. "A Society Apart: The Early Years of the Society of Motion Picture Engineers." *Film History* 28, no. 4 (2016): 1–28.

McKernan, Luke. *Charles Urban: Pioneering the Non-Fiction Film in Britain and America, 1897–1925*. Exeter, UK: University of Exeter Press, 2013.

Mees, C. E. Kenneth. "The Kodak Research Laboratories." *Proceedings of the Royal Society of London: Series A, Mathematical and Physical Sciences* 192, no. 1031 (1948): 465–479.

——. "The Organization of Industrial Scientific Research." *Science* 43, no. 1118 (June 2, 1916): 763–773.

——. "A Photographic Research Laboratory." *Scientific Monthly* 5, no. 6 (December 1917): 481–496.

——. "The Production of Scientific Knowledge." *Science* 46, no. 1196 (November 30, 1917): 519–528.

Melrose, Millicent. *Color Harmony and Design in Dress*. New York: Social Mentor, 1922.

Mendes, Valerie, and Amy De la Haye. *Twentieth Century Fashion*. London: Thames & Hudson, 1999.

Milward, Alan, and S. B. Saul. *The Development of the Economies of Continental Europe 1850–1914*. New York: Routledge, 2012.

Misek, Richard. *Chromatic Cinema: A History of Screen Color*. Oxford: Wiley, 2010.

Moholy-Nagy, László. *Malerei, Photographie, Film*. Vol. 8. Bauhausbücher. München: Albert Langen Verlag, 1925.

Montfort, Anne, ed. *Sonia Delaunay*. London: Tate, 2014.

Moritz, William. "Abstract Film and Color Music." In *The Spiritual in Art: Abstract Painting 1890–1985*, ed. Maurice Tuchman, 297–311. New York: Abbeville Press, 1986.

——. "The Dream of Color Music, and Machines that Made It Possible." *Animation World Magazine* 4, no. 2 (Spring 1996): 69–84.

——. "Fischinger at Disney, or Oskar in the Mousetrap." *Millimeter* 5, no. 2 (February 1977): 25–28, 65–67.

——. *Optical Poetry: The Life and Work of Oscar Fischinger* (Bloomington: Indiana University Press, 2004).

Mowery, David C., and Nathan Rosenberg. *Paths of Innovation: Technological Change in Twentieth-Century America*. Cambridge: Cambridge University Press, 1999.

Mundy, John. *Popular Music on Screen: From Hollywood Musical to Music Video*. Manchester, UK: Manchester University Press, 1999.

Münsterberg, Hugo. *The Photoplay: A Psychological Study*. New York: Appleton, 1916.

Murmann, Johann Peter. *Knowledge and Competitive Advantage: The Coevolution of Firms, Technology, and National Institutions*. New York: Cambridge University Press, 2003.

Nead, Lynda. *The Tiger in the Smoke: Art and Culture in Post-War Britain*. New Haven, Conn.: Yale University Press, 2017.

Nelson, Andrea. "László Moholy-Nagy and Painting Photography Film: A Guide to Narrative Montage." *History of Photography* 30, no. 3 (September 1, 2006): 258–269.

Noble, David F. *America by Design: Science, Technology, and the Rise of Corporate Capitalism*. Oxford: Oxford University Press, 1979.

Nye, David E. *Electrifying America: Social Meanings of a New Technology, 1880–1940*. Cambridge, Mass.: MIT Press, 1992.

O'Brien, Charles. *Cinema's Conversion to Sound: Technology and Film Style in France and the U.S.* Bloomington: Indiana University Press, 2005.

Orgeman, Keely, ed. *Lumia: Thomas Wilfred and the Art of Light*. New Haven, Conn.: Yale University Art Gallery, 2017.

Otis, Russell M. "The Multicolor Process." *Journal of the Society of Motion Picture Engineers* 17, no. 1 (July 1931): 5–10.

Passuth, Krisztina. *Moholy-Nagy*. London: Thames & Hudson, 1987.

Patalas, Enno. "On the Way to 'Nosferatu.'" *Film History* 14, no. 1 (2002): 25–31.

Peress, Maurice. *Dvořák to Duke Ellington: A Conductor Explores America's Music and Its African American Roots*. Oxford: Oxford University Press, 2008.

Pethö, Ágnes. *Cinema and Intermediality: The Passion for the In-Between*. Newcastle upon Tyne: Cambridge Scholars, 2011.

Pomerance, Murray. *Alfred Hitchcock's America*. Cambridge: Polity, 2013.

——. "Light, Looks, and *The Lodger*." *Quarterly Review of Film and Video* 26, no. 5 (October 2009): 425–433.

Powell, Alvin Leslie. *The Coordination of Light and Music*. Cleveland, Ohio: General Electric, 1930.

Pranchère, Victor. "La sortie du laboratoire ou les stratégies d'exploitation du procédé trichrome de cinématographie en couleurs de la Société des Établissements Gaumont (1913–1921)." *1895: Revue d'histoire du cinéma* 71 (December 1, 2013): 61–80.

Rabinovitz, Lauren. *Electric Dreamland: Amusement Parks, Movies, and American Modernity*. New York: Columbia University Press, 2012.

Ramsaye, Terry. *Million and One Nights: A History of the Motion Picture Through 1925*. New York: Simon and Schuster, 1926.

Rees, A. L. *A History of Experimental Film and Video*. 2nd ed. London: British Film Institute/ Palgrave Macmillan, 2011.

Rees, A. L., David Curtis, Duncan White, and Steven Ball, eds. *Expanded Cinema: Art, Performance, Film*. London: Tate, 2011.

Richter, Hans. *Hans Richter*. Ed. Cleve Gray. New York: Holt, Rinehart and Winston, 1971.

Riello, Giorgio, and Peter McNeil, eds. *The Fashion History Reader: Global Perspectives.* London: Routledge, 2010.

Riley, Charles A. *Color Codes: Modern Theories of Color in Philosophy, Painting and Architecture, Literature, Music, and Psychology.* Hanover, N.H.: University Press of New England, 1995.

Riley, Philip J. *Dracula: The Original 1931 Shooting Script.* Absecon, N.J.: MagicImage Filmbooks, 1990.

——. *The Making of the Phantom of the Opera.* Absecon, N.J.: MagicImage Filmbooks, 1999.

Robinson, David. *Das Cabinet des Dr. Caligari.* 2nd ed. London: Palgrave Macmillan, 2013.

Rocamora, Agnès. "Fields of Fashion: Critical Insights Into Bourdieu's Sociology of Culture." *Journal of Consumer Culture* 2, no. 3 (November 1, 2002): 341–362.

Rousseau, Pascal. " 'Voyelles': Sonia Delaunay and the Universal Language of Colour Hearing." In *Sonia Delaunay,* ed. Anne Montfort. London: Tate, 2014.

Ryan, Deborah. *"Daily Mail": The Ideal Home Through the Twentieth Century.* London: Hazar, 1997.

Said, Edward W. *Orientalism: Western Conceptions of the Orient.* London: Penguin Books, 1995.

Sally, Lynn. *Fighting the Flames: The Spectacular Performance of Fire at Coney Island.* New York: Routledge, 2006.

Salmon, Stéphanie. *Pathé: A la conquête du cinéma, 1896–1929.* Paris: Editions Tallandier, 2014.

Scheerbart, Paul. *Glass! Love!! Perpetual Motion!!!: A Paul Scheerbart Reader.* Ed. Josiah McElheny and Christine Burgin. Chicago: University of Chicago Press, 2014.

Schifano, Laurence. "Marcel L'Herbier 1925: De *L'Inhumaine* à *Feu Mathias Pascal,* ou la naissance de la modernité." In *L'année 1925: L'esprit d'une époque,* ed. Myriam Boucharenc and Claude Leroy, 321–333. Nanterre: Presses universitaires de Paris, 2014.

Schimma, Sabine. "The Living Power of Colours: The Colour Theories at the Weimar Bauhaus." In *The Bauhaus Comes from Weimar,* ed. Ute Ackermann and Ulrike Bestgen. Berlin: DKV, 2009.

Schleuning, Sarah. *Moderne: Fashioning the French Interior.* Princeton, N.J.: Princeton Architectural Press, 2008.

Schwartz, Frederic J. *Blind Spots: Critical Theory and the History of Art in Twentieth-Century Germany.* New Haven, Conn.: Yale University Press, 2005.

Shand, Philip Morton. *The Architecture of Pleasure: Modern Theatres and Cinemas.* London: B. T. Batsford, 1930.

Snoyman, Natalie. " 'In to Stay': Selling Three-Strip Technicolor and Fashion in the 1930s and 1940s." Ph.D. diss., Stockholm University, 2017.

Spadoni, Robert. *Uncanny Bodies: The Coming of Sound Film and the Origins of the Horror Genre.* Berkeley: University of California Press, 2007.

Staiger, Janet. "Standardization and Independence: The Founding Objectives of the SMPTE." *SMPTE Motion Imaging Journal* 96, no. 6 (June 1, 1987): 532–537.

Stein, Sally. "The Rhetoric of the Colorful and the Colorless: American Photography and Material Culture Between the Wars." Ph.D. diss., Yale University, 1991.

Stetler, Pepper. " 'The New Visual Literature': László Moholy-Nagy's Painting, Photography, Film." *Grey Room,* no. 32 (2008): 88–113.

Street, Sarah. *Black Narcissus.* London: I. B. Tauris, 2005.

——. *Colour Films in Britain: The Negotiation of Innovation 1900–1955.* London: British Film Institute, 2012.

——. "A Suitable Job for a Woman: Color and the Work of Natalie Kalmus." In *Doing Women's Film History: Reframing Cinemas, Past and Future*, ed. Christine Gledhill and Julia Knight, 206–217. Champaign: University of Illinois Press, 2015.

Stutesman, Drake. "Clare West." In *Women Film Pioneers Project*, ed. Jane Gaines, Radha Vatsal, and Monica Dall'Asta. New York: Columbia University Libraries, Center for Digital Research and Scholarship, 2013. https://wfpp.cdrs.columbia.edu/pioneer/ccp-clare-west/.

Temkin, Ann. *Color Chart: Reinventing Color, 1950 to Today*. Edited by Emily Hall, Anne Doran, Nell McClister, and Stephen Robert Frankel. New York: Museum of Modern Art, 2008.

Thomas Allen, Jeanne. "Fig Leaves in Hollywood: Female Representation and Consumer Culture." In *Fabrications Costume and the Female Body*, ed. Jane Gaines and Charlotte Herzog. London: Routledge, 1990.

Thompson, Kirsten Moana. "Rainbow Ravine: Colour and Animated Advertising in Times Square." In *The Colour Fantastic: Chromatic Worlds of Silent Cinema*, ed. Giovanna Fossati, Vicky Jackson, Bregt Lameris, Elif Rongen-Kaynakçi, Sarah Street, and Joshua Yumibe, 161–178. Amsterdam: Amsterdam University Press, 2018.

Tode, Thomas. "Bauhaus & Film: Mesalliance Oder Verpasstes Rendezvous?" *Maske und Kothurn* 57, no. 1–2 (2011): 7–16.

Townsend, Lewis M., and Loyd A. Jones. "The Use of Color for the Embellishment of the Motion Picture Program." *Transactions of the Society of Motion Picture Engineers* 21 (August 1925): 38–65.

Troland, Leonard. "The Enigma of Color Vision." *Monthly Abstract Bulletin from the Kodak Research Laboratories* 7, no. 1 (January 1921): 14.

——. "The Psychology of Natural Color Motion Pictures." *American Journal of Physiological Optics* 7, no. 3 (July 1926): 375–382.

——. "Report of the Colorimetry Committee of the Optical Society of America." *Journal of the Optical Society of America and Review* 6, no. 6 (1922): 527–596.

Tschichold, Jan. *The New Typography*. Trans. Ruari McLean. Berkeley: University of California Press, 2006.

Tuchman, Maurice, ed. *The Spiritual in Art: Abstract Painting 1890–1985*. New York: Abbeville Press, 1986.

Turner, R. Steven. "The Origins of Colorimetry: What Did Helmholtz and Maxwell Learn from Grassmann?" In *Hermann Günther Graßmann (1809–1877): Visionary Mathematician, Scientist and Neohumanist Scholar*, ed. Gert Schubring, 71–86. Dordrecht, Netherlands: Springer, 1996.

Uhlirova, Marketa. "100 Years of the Fashion Film: Frameworks and Histories." *Fashion Theory* 17, no. 2 (April 1, 2013): 137–157.

Vest, James M. "Alfred Hitchcock's Role in *Elstree Calling*." *Hitchcock Annual* 9 (2000): 116–126.

Waldroup, Heather. "Hard to Reach: Anne Brigman, Mountaineering, and Modernity in California." *Modernism/Modernity* 21, no. 2 (April 2014): 447–466.

Walkowitz, Rebecca. *Cosmopolitan Style: Modernism Beyond the Nation*. New York: Columbia University Press, 2006.

Wallenberg, Louise. "Fashion and the Moving Image." In *The Fashion History Reader: Global Perspectives*, ed. Giorgio Riello and Peter McNeil. London: Routledge, 2010.

Ward, Janet. *Weimar Surfaces: Urban Visual Culture in 1920s Germany*. Berkeley: University of California Press, 2001.

Ward, Richard Lewis. *When the Cock Crows: A History of the Pathé Exchange*. Carbondale: Southern Illinois University Press, 2016.

Weaver, Tom. "Scott MacQueen Interview." *Classic Images*, no. 504 (June 2017): 18–22.

Westerdale, Joel. "May 1925: French and German Avant-Garde Converge at Der Absolute Film." In *A New History of German Cinema*, ed. Jennifer M. Kapczynski and Michael D. Richardson, 160–166. Rochester, N.Y.: Camden House, 2012.

Whissel, Kristen. *Picturing American Modernity: Traffic, Technology, and the Silent Cinema*. Durham, N.C.: Duke University Press, 2008.

White, Michael. "Mechano-Facture: Dada/Constructivism and the Bauhaus." In *Albers and Moholy-Nagy: From the Bauhaus to the New World*, ed. Achim Borchardt-Hume, 79–84. New Haven, Conn.: Yale University Press, 2006.

White, Patricia. "Nazimova's Veils: *Salome* at the Intersection of Film Histories." In *A Feminist Reader in Early Cinema*, ed. Jennifer M. Bean and Diane Negra, 60–87. Durham, N.C.: Duke University Press, 2002.

Wild, Jennifer. *The Parisian Avant-Garde in the Age of Cinema, 1900–1923*. Oakland: University of California Press, 2015.

Wilkening, Anke. "*Die Nibelungen*: A Restoration and Preservation Project by Friedrich-Wilhelm-Murnau-Stiftung, Wiesbaden," *Journal of Film Preservation* 79/80 (May 2009): 86–98.

——. "Die Restaurierung von Das Cabinet des Dr. Caligari." *VDR Beiträge Zur Erhaltung von Kunst- Und Kulturgut* 2 (2014): 27–47.

Williams, Tami. *Germaine Dulac: A Cinema of Sensations*. Urbana: University of Illinois Press, 2014.

Worringer, Wilhelm. *Abstraction and Empathy: A Contribution to the Psychology of Style*. Trans. Michael Bullock. Chicago: Elephant Paperbacks, 1997.

Yamane, Chiaki. "A New Art Form for Common Experience: Hirschfeld-Mack's Farbenlicht-spiele." *CARLS Series of Advanced Study of Logic and Sensibility* 4 (2010): 343–350.

Young, Paul. *The Cinema Dreams Its Rivals: Media Fantasy Films from Radio to the Internet*. Minneapolis: University of Minnesota Press, 2006.

Yumibe, Joshua. "Industrial Research Into Color at Pathé During the 1910s and 1920s." In *Recherches et innovations dans l'industrie du cinéma: les cahiers des ingénieurs Pathé: 1906–1927*, ed. Jacques Malthête and Stephanie Salmon, 196–208. Paris: Fondation Jérôme Seydoux-Pathé, 2017.

——. *Moving Color: Early Film, Mass Culture, Modernism*. New Brunswick, N.J.: Rutgers University Press, 2012.

——. "Stenciling Technologies and the Hybridized Image in Early Cinema." In *Exposing the Film Apparatus: The Film Archive as a Research Laboratory*, ed. Giovanna Fossati and Annie van den Oever, 232–241. Amsterdam: Amsterdam University Press, 2016.

——. "Surfaces colorées et espaces de jeu dans la littérature enfantine: le cinéma des premiers temps et les féeries." Trans. Priska Morrissey. *1895: Revue d'histoire du cinéma* 71 (2014): 31–44.

Zunz, Olivier. *Why the American Century?* Chicago: University of Chicago Press, 2000.

INDEX

Page numbers in *italics* indicate figures.

absolute art, 125–128

Absolute Film, 18, 125–128, 139, 162–170, 178–180; Der Absolute Film screening, 165–169, *165*; color in, 168, 203; French film and, 183–185; Rudolf Kurtz and, 158, 178; useful abstraction and, 151–152

Absolute Music, 126

abstract color, 127, 149, 162–163, 188–189, 194, 297n86; in *Ballet mécanique*, 188–189; music, 14

abstraction, 150–151, 168–169, 180; *Ballet mécanique*, 185–186, 194; *Einfühlung* and, 150, 302n31; *L'inhumaine*, 194; useful, 151–169, 189; new paints and, 25; Thomas Wilfred and, 120

additive color systems, 4, 38, 57, 85, 231, 249

Adrian, Gilbert, 83; *Fig Leaves*, 98

advertising, 7–8, 27, 65, 66–103, 130–131, 149, 189; chromatic experimentation in, 274; clothing, 84; color-conscious, 74; consumer culture, 66, 186; electrical advertising signs, 130; film tie-ins, 100; interwar period, 189; media, 67; lighting and, 17, 22, 108, *109*, 111, 130, 134, 219; posters and, 22; Sonochrome, *263*;

sponsored films, 179, 226, 273; theory, 106, 126, 130–131, 143, 163, 168; trends, 74–80; window displays, 187, 272

aesthetics: Arts and Crafts and, 199; Bauhaus and, 154–158; Pierre Bourdieu and, 105; color and, 5, 23, 148, 236, 264, 303n46; *Einfühlung* and, 150–152, 156, 197; film preservation and, 3; knowledge transfer and, 36, 47, 57, 148; Fernand Léger and, 189–190; Marcel L'Herbier and, 192, 194; sensory perception and, 161, 164, 262; theories of, 5, 118, 168–169, 276; of realism, 4, 274; of technology, 154, 158, 205, 226, 228; ornamentation and, 15, 26; total-art, 70; Vienna Secession and, 175–178

Affairs of Anatol, The (1921), 18, 89–93, 97, 210, 291n110; coloring methods, 92–93; octopus gown, *90*, 91

Agfa, 49, 274

Alice blue, 101, 222

ambient mood lighting, 18, 69, 106, 129, 137, 143

Americanism, 228

American twentieth century, 6, 23

American Venus, The (1926), 98–99

Anderson, John Murray, 144, 245, 247

FILM AND CULTURE

A series of Columbia University Press

Edited by John Belton